Painting in the South: 1564-1980

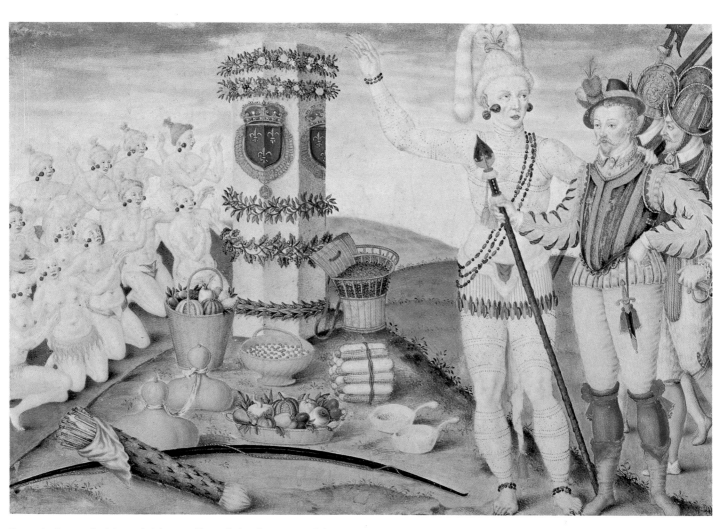

Figure 1. Jacques Le Moyne de Morgues, René de Laudonnière and the Indian Chief Athore Visit Ribaut's Column *(cat. no. 1).*

Painting in the South: 1564-1980

Introduction by
Ella-Prince Knox, Project Director

Essays by
Donald B. Kuspit
Jessie J. Poesch
Linda Crocker Simmons
Rick Stewart
Carolyn J. Weekley

Catalogue compiled by
David S. Bundy, Assistant Project Director

This book and the exhibition it documents were made possible
through the combined generosity of Philip Morris Incorporated,
the National Endowment for the Humanities, and The Fellows
of the Virginia Museum.

VIRGINIA MUSEUM, RICHMOND

Painting in the South: 1564-1980
EXHIBITION SCHEDULE

VIRGINIA MUSEUM
Richmond, Virginia
September 14-November 27, 1983

BIRMINGHAM MUSEUM OF ART
Birmingham, Alabama
January 8-March 4, 1984

NATIONAL ACADEMY OF DESIGN
New York, New York
April 12-May 27, 1984

MISSISSIPPI MUSEUM OF ART
Jackson, Mississippi
June 24-August 26, 1984

J. B. SPEED ART MUSEUM
Louisville, Kentucky
September 16-November 11, 1984

NEW ORLEANS MUSEUM OF ART
New Orleans, Louisiana
December 9, 1984-February 3, 1985

Library of Congress Cataloging in Publication Data
Main entry under title:

Painting in the South: 1564-1980

 Catalog of an exhibition held Sept. 14, 1983-
Feb. 3, 1985, at the Virginia Museum, Richmond, and
other museums.
 Bibliography: p. 345.
 Includes index.
 1. Painting, American—Southern States—Exhibitions.
2. Painting, American—Southern States—Addresses,
essays, lectures. I. Kuspit, Donald B. (Donald Burton),
1935- . II. Bundy, David S. III. Virginia Museum
of Fine Arts.

ND220.P34 1983 759.15'074'014 83-10196
ISBN 0-917046-14-5

The Virginia Museum of Fine Arts
Richmond, Virginia 23221
© 1983 by the Virginia Museum of Fine Arts. All rights reserved.
Published 1983
Printed in the United States of America

Cover: Sarah Miriam Peale, detail, *Still-Life of Watermelon and
Grapes*, 1820 (cat. no. 48).

Contents

Foreword vii

Acknowledgements viii

Lenders to the Exhibition x

Introduction xiii

The Early Years, 1564 to 1790 1
 CAROLYN J. WEEKLEY

The Emerging Nation, 1790 to 1830 43
 LINDA CROCKER SIMMONS

Growth and Development of the Old South,
 1830 to 1900 73
 JESSIE J. POESCH

Toward A New South:
 The Regionalist Approach, 1900 to 1950 105
 RICK STEWART

The Post-War Period, 1950 to 1980:
 A Critic's View 145
 DONALD B. KUSPIT

Catalogue 165
 1564 to 1790 167
 1790 to 1830 193
 1830 to 1900 225
 1900 to 1950 271
 1950 to 1980 311

Bibliography 345

Index 355

Figure 2. John Kelly Fitzpatrick, Negro Baptising *(cat. no. 123).*

Foreword

For the past twenty-five years, Philip Morris has sponsored many exhibitions of American art in an effort to introduce millions of Americans—our customers—to a cultural world that would otherwise remain foreign to them. It is with great enthusiasm now that we present *Painting in the South*—in association with the National Endowment for the Humanities and The Fellows of the Virginia Museum.

This project is very significant to our company: Philip Morris has its roots deeply implanted in the South, and the agricultural products that form the basis of our business are a vital part of the history and economy of this region. In addition, many of our manufacturing operations are housed throughout the South.

Appropriately, *Painting in the South* begins its tour in Richmond, home-base of Philip Morris U.S.A. operations. As the exhibition travels across the country, we hope many of our friends and associates will enjoy sharing in the distinctive cultural heritage represented by this first comprehensive exhibition of paintings from the South. This region's contribution to American art has finally received the recognition it so justly deserves. Philip Morris is proud to have played a role in bringing this about.

GEORGE WEISSMAN
Chairman of the Board
Philip Morris Incorporated

Although Virginia is recognized as an inextricable part of that broad path of urban and suburban growth marked by the Boston-to-Norfolk corridor of the Northeast, the Commonwealth still retains its identity in the American South. A leader among her Southern sister-states, Virginia, in a sense, is a bridge from the past to the future; from the rural, agricultural South to the Sun-belt economy of tomorrow. In this context, it is fitting that a project the magnitude of *Painting in the South: 1564-1980* be undertaken by the Virginia Museum of Fine Arts. Its history of leadership is recognized as America's first statewide arts system, and its home is in Richmond, a city that has always played a dramatic role in the history of America and of the South. We are proud that Virginia and its fine-arts museum can once again take the lead, this time by delving into the Southern sensibility and how that cultural stance has been reflected in the art of native and newcomer artists working in the South.

Much of the credit for this project must be given to Ella-Prince Knox, Project Director, and to her assistant, David Scott Bundy, who have devoted considerable time to research and organization of *Painting in the South*; and to guest curators Carolyn J. Weekley, Linda Crocker Simmons, Jessie J. Poesch, Rick Stewart, and Donald Kuspit. In their research, they were ably assisted by consultants Wanda Corn, Susan V. Donaldson, William Seale, Benjamin F. Williams, Peter H. Wood, and the late Richard Beale Davis. Moreover, a personal salute must be directed to those collectors, trustees, directors, curators, registrars, conservators, and other art-minded professionals and volunteers whose good advice and boundless cooperation transformed this project from an idea to a reality.

We are grateful for funding assistance from Philip Morris Incorporated, the National Endowment for the Humanities, and The Fellows of the Virginia Museum. The fascinating results of the combined efforts of these individuals and organizations are vividly demonstrated in *Painting in the South*.

BRUCE C. GOTTWALD
President, Board of Trustees
Virginia Museum

Acknowledgements

Many individuals have shared their knowledge, enthusiasm, interest, and suggestions with the organizing staff of the exhibition *Painting in the South: 1564-1980*. We take great pleasure in thanking each one of them for their thoughtful assistance and generous gifts of time and talent.

In particular, we would like to recognize the entire staff of the Virginia Museum, most especially the Fellows of the Virginia Museum, whose generous grant was an early indication of their enthusiastic support of the project; David Bradley, Associate Director of Development, who has assisted with the funding of *Painting in the South* from its initial planning stages; Richard Woodward, Curator of Exhibitions, for assisting with the many details of installation; David Noyes, exhibition designer, who has served as the Virginia Museum's staff liaison with our guest designer, Robert Zimmerman of the Baltimore Museum of Art; Registrar Lisa Hummel, Associate Registrar Bruce Young, and Assistant Registrar Diane Hart, who have orchestrated the monumental task of assembling the works of art; and Polly Bozorth, Secretary of the Collections Division.

We are also grateful to editors George Cruger and Monica Hamm, and graphic designer Raymond Geary; Public Relations Director David Griffith and his fine staff; William Rasmussen, Coordinator of Educational Services; Susan Kurtze and Cathy Eaton of Special Events; Julia Boyd, Coordinator of the Institute of Contemporary Art; and the student interns who assisted us, particularly Barbara Reese, Beth Holcomb, Lauri Crowe, Stuart Lingo, and Julia Smith.

We would also like to recognize the former members of the Museum staff who have made significant contributions to this project, among them Charles L. Reed, Jr., recently retired as president of the Board of Trustees; former director R. Peter Mooz, who developed the original concept for the exhibition; former assistant director Margaret Burke; and former project director Susan Strickler and her assistant Clarence Kelley.

In addition, we are greatly indebted to Philip Morris Incorporated for its financial support of this exhibition; it has been our privilege to work with several outstanding members of their Cultural Affairs staff, particularly Stephanie French and Gerry Rizzo.

At the outset, a planning grant from the National Endowment for the Humanities allowed the Museum to initiate research into the topic. Abbie Cutter, Nadina Gardner, and John Bennett of the Endowment

staff have been especially supportive of this effort.

For the first time, several local museums and institutions will join the Virginia Museum to present a variety of programs treating the art of the South. The staffs of these participating institutions have been consistently cooperative; we gratefully acknowledge the many helpful suggestions of Virginius Hall and Kip Campbell of the Virginia Historical Society; Jack Zehmer and Elizabeth Taylor Childs of the Valentine Museum; Betsy McKemie of the Museum of the Confederacy; Marilyn Zeitlin of Virginia Commonwealth University's Anderson Gallery; Jackie Bailey, formerly of the 1708 East Main gallery; and Charlotte Minor and Beverley Reynolds of the Reynolds-Minor Gallery.

The film that accompanies *Painting in the South* is the product of William Ferris, Director of the Center for Southern Culture at the University of Mississippi. We appreciate his guidance and the insight of Virginia Museum staff member Stan Woodward, who recommended him to us.

Several individuals have been invaluable in other ways: a personal "thank you" to Elinor Detlefsen, George Squires, Jean Jepson Page, Buck Pennington, James Pilkington, Richard G. Carrott, and the staff of Dynasty World Travel.

On its extended tour, *Painting in the South* will travel to five outstanding museums. We appreciate the foresight of the directors and staffs of each of these institutions, including Richard Murray of the Birmingham Museum of Art; John Dobkin of the National Academy of Design, New York; John Czarniecki of the Mississippi Museum of Art at Jackson and his exhibition director, John Henry; Addison Franklin Page of the J. B. Speed Museum, Louisville; and John Bullard of the New Orleans Museum of Art.

Finally, and most importantly, we thank those individuals who made the dream of *Painting in the South* a reality: the special curators, the consultants, and the many generous lenders to the exhibition.

ELLA-PRINCE KNOX
Project Director

DAVID SCOTT BUNDY
Assistant Project Director

Lenders to the Exhibition

Mrs. Anni Albers and the Josef Albers Foundation, Inc., Orange, Connecticut

Anglo-American Art Museum, Louisiana State University, Baton Rouge

The Baltimore Museum of Art

Robert G. Beck, courtesy of Belmont, the Gari Melchers Memorial Gallery, Fredericksburg, Virginia

Julien Binford, courtesy of Midtown Galleries, New York

George Bireline

Birmingham Museum of Art and the Birmingham Board of Education

Brenton National Bank of Des Moines

William F. Brodnax III

The Brooklyn Museum

Brooks Memorial Art Gallery, Memphis

Carolina Art Association/Gibbes Art Gallery, Charleston, South Carolina

Charleston Museum, Charleston, South Carolina

Chrysler Museum at Norfolk, Virginia

Cincinnati Art Museum

The City of Charleston, South Carolina

Robert P. Coggins Collection of American Art, Marietta, Georgia

The College of William and Mary in Virginia, Williamsburg

The Colonial Williamsburg Foundation

Commonwealth of Virginia, The Governor's Mansion, Richmond

Corcoran Gallery of Art, Washington, D.C.

David Anderson Gallery, Inc., New York

Judge John E. DeHardit

Mr. and Mrs. David C. Driskell

Edwin A. Ulrich Museum of Art, Wichita State University

Frank Faulkner

The Fine Arts Center, Cheekwood, Nashville

First Tennessee Bank, Heritage Collection, Memphis

Gordon Fraser Collection

Dr. and Mrs. James A. Freeman

Georgia Museum of Art, The University of Georgia, Athens

The Georgia State Law Library, Atlanta

Mr. and Mrs. W. E. Groves, Jr.

Guild Hall Museum, East Hampton, New York

William Halsey

Henry Francis duPont Winterthur Museum, Winterthur, Delaware

Henry Morrison Flagler Museum, Palm Beach, Florida

James Herbert

Robert Hering

Historic Columbia Foundation, Columbia, South Carolina

The Historic New Orleans Collection

Houghton Library, Harvard University

Hunter Museum of Art, Chattanooga

Ira Spanierman, Inc., New York

J.B. Speed Art Museum, Louisville

Ray Kass

Kentucky Supreme Court, Kentucky Historical Society, Frankfort

Mr. and Mrs. Alan Koppel, courtesy of Phyllis Kind Gallery, Chicago

Sydney and Frances Lewis Collection

Edith London

Louisiana State Museum, New Orleans

Richard Manney, courtesy of Nancy Hoffman Gallery, New York

The Maryland Historical Society, Baltimore

Mr. and Mrs. Jack M. McLarty

Mr. and Mrs. Paul Mellon

The Metropolitan Museum of Art, New York

Middendorf-Lane Gallery, Washington, D.C.

The Mint Museum, Charlotte, North Carolina

Mississippi Museum of Art, Jackson

Montgomery Museum of Fine Arts

Mordecai Square Historical Society, Inc., Raleigh, North Carolina
Museum of Art, Carnegie Institute, Pittsburgh
Museum of Art, Rhode Island School of Design, Providence
Museum of the Confederacy, Richmond
Museum of Contemporary Art, Chicago
Museum of Early Southern Decorative Arts, Winston-Salem, North Carolina
National Academy of Design, New York
National Museum of American Art, Smithsonian Institution, Washington, D.C.
National Portrait Gallery, Smithsonian Institution, Washington, D.C.
New Orleans Museum of Art
The New York Public Library
Mike Nicholson
Kenneth Noland
North Carolina Museum of Art, Raleigh
North Carolina Museum of History, Raleigh
North Carolina National Bank Corporation, Charlotte
Norton Gallery and School of Art, West Palm Beach, Florida
Pennsylvania Academy of the Fine Arts, Philadelphia
The Phillips Collection, Washington, D.C.
Mr. and Mrs. Thomas Pinckney
The Pitt County Mental Health Center, Greenville, North Carolina

Nona Hanes Porter, courtesy of Monique Knowlton Gallery, New York
Vernon Pratt
Randolph-Macon Woman's College Art Gallery, Lynchburg, Virginia
The Rosenberg Library, Galveston, Texas
St. John's Lutheran Church, Charleston, South Carolina
St. John's Museum of Art, Inc., Wilmington, North Carolina
San Antonio Museum Association
Charles Shannon
Martin Sklar, courtesy of Phyllis Kind Gallery, New York
Victor D. Spark
James Stringer
Mrs. Cabell Mayo Tabb
Telfair Academy of Arts and Sciences, Inc., Savannah, Georgia
Tulane University Art Collection, New Orleans
Valentine Museum, Richmond
Virginia Historical Society, Richmond
Virginia Museum, Richmond
Walters Art Gallery, Baltimore
Mr. and Mrs. Frank P. Ward, Jr., Raleigh, North Carolina
Whitney Museum of American Art, New York
Mrs. Nina Kaiden Wright
Yale University Art Gallery
and Private Collections

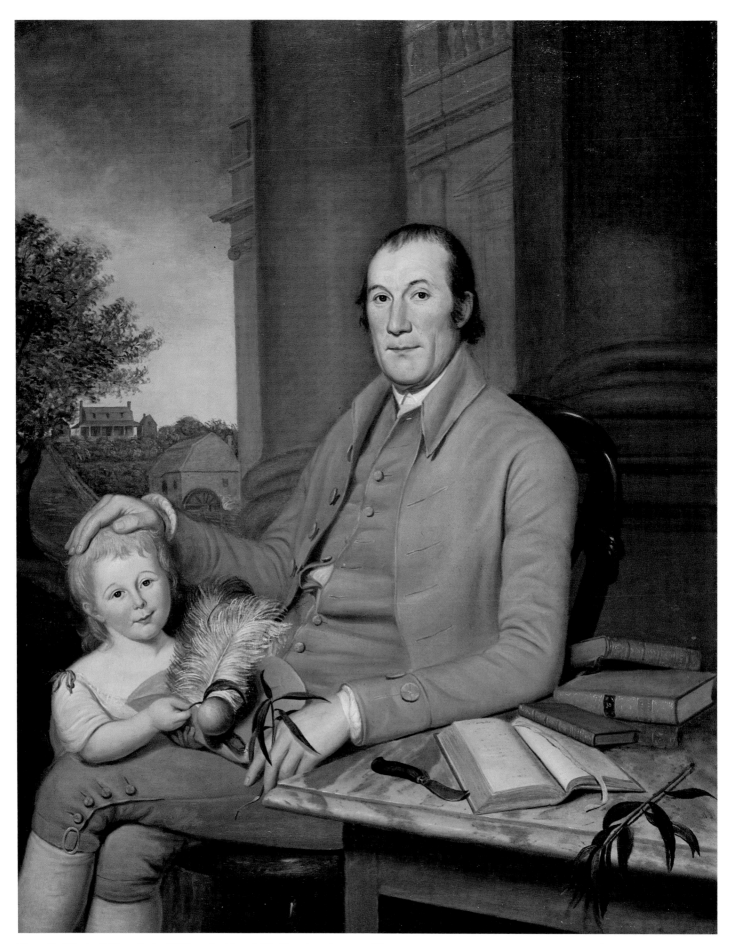

Figure 3. Charles Willson Peale, William Smith and His Grandson (cat. no. 30).

Introduction

by Ella-Prince Knox

There is no one way to say "This is the way the South is," anymore than one can describe in a single word the North or the West or any other section of this country. To some, the South is a land of mystery and legend, of leaders gone yet long-remembered, of strong family ties and the last vestiges of a genteel chivalry that is no more. For others, it is a land that sought to dissolve the Union, conquered yet strangely invincible, an area that by its very defeat became unique. Images of the South abound and are as varied as the region itself. For every columned plantation house, there is creaking shanty; for every magnolia, there is the ubiquitous kudzu; for every anguished racial confrontation, one finds the special type of individual black/white friendship that rarely exists in the same way outside the South.

Certain aspects of the South are familiar. Its history and folklore, its patterns of speech and culinary excellence have spread beyond its boundaries and are an important part of the larger American experience. Architectural distinction has traditionally been a part of the "look" of the South, beginning with the Georgian style of the eighteenth century. The Classical Revival that emerged in the same century created a domestic architecture that prevailed throughout the region, and is sometimes referred to today as "Southern" or "Antebellum."

Studies of American literature devote much attention to Southern writers. The lyricism of Sidney Lanier, the humor and irony of Joel Chandler Harris and Eudora Welty, the darker aspects of Edgar Allan Poe and William Faulkner make one aware of both the sense of pride in the Southern heritage and its sense of tragedy, the skeleton in the closet.

Recent literary criticism has given deserved attention to both Thomas Wolfe and the Fugitive-Agrarians, writers at work at Vanderbilt University in the 1930s, but for all the familiarity with the literature, architecture, and general culture of the South, there has been a haunting lack of attention to its art. It is surprising, for example, how little we know about the Southern painting tradition. Because of this deficiency, painting activity in the region has often appeared to be but a pallid reflection of artistic developments elsewhere. The current level of scholarship in this field is similar to the state of scholarship in American painting in general as late as the 1950s. Indeed, studies of American art itself did not accelerate until this time. Research and published writings by various scholars—among them E.P. Richardson, John McCoubrey, William Gerdts, Barbara Novak, and John Wilmerding—have since spearheaded an awareness of America's artists and their contributions.

There have been reasons, however, why progress in the research of Southern painting has lagged behind. The sheer size of the region, its predominantly rural nature, the dispersement of research materials, and the considerable expense of travel have hindered the advancement of scholarship. As a result, many Southern painters are not adequately documented. In

the cases of artists who worked in both the East and the South, research of the Southern portions of their careers is incomplete.

In addition, the basic format used for a number of volumes and courses treating the subject of American art has contributed to this neglect. A typical survey of painting in the United States begins in the eighteenth century in the Northeast, shifts direction in the nineteenth to the areas flanking the Hudson, Missouri, and upper Mississippi Rivers, and later in the century extends to the Rockies and the Far West. By the early years of the twentieth century the focus once again turns eastward to New York, thereafter the national center of American art. If one accepted the boundaries established in such surveys, the conclusion would be that American painting emanated largely from the area above the Mason-Dixon Line and well beyond the perimeters of the South.

There has been one previous attempt by a museum to correct this misconception. In 1960 the Corcoran Gallery of Art mounted a significant exhibition, *American Painters of the South,* which included 124 paintings spanning the period from 1710 to the 1860s. At the outset, the Corcoran's organizers intended the exhibition's geographic range to cover the area from Maryland west to Missouri and south to the Carolinas and to Louisiana. Difficulty in procuring works from the interior states and from the deep South, however, resulted in an exhibition that focused on Maryland, Virginia, South Carolina, and Washington, D.C.

In the introduction to the exhibition catalogue, Eleanor Swenson Quandt observed that "a history of painting in the American South has yet to be written." Almost twenty years after the Corcoran's pioneering effort, this statement still held true. In February of 1979, the Virginia Museum initiated research on the subject. The purpose, reflecting the need expressed by Quandt in 1960, was to present a comprehensive survey of the development of the art of the region.

At the outset, it was decided that *Painting in the South* would draw from that large territory extending from the Mason-Dixon Line to the Gulf of Mexico and from the Atlantic seaboard to the Mississippi River and East Texas. Some areas were problematical because their Southern connections are minimal in the twentieth century. Baltimore, Annapolis, and Washington, all once Southern cities, are now considered Eastern in outlook. Florida's current international tourist trade has overshadowed its role after the Civil War as a new Eden. The inclusion of East Texas was questionable, despite the clearly Southern orientation of a large number of its original North American settlers and the tendency of many of its current residents to identify with the South. It was clear, therefore, that the large territory defined as "the South" shifted its geographical perimeters from one historic period to another.

It was also decided that the time span of the exhibition would extend from the mid-sixteenth century to 1980. This general period was then divided into five sections, each of which was assigned to a recognized scholar. The curators of the first four sections benefited from hindsight in their evaluation of the influences of artists and artistic styles on later periods. Applying a historical perspective to contemporary Southern painting was more difficult. Consequently, curator Donald Kuspit, in considering the art of the recent past, had to take the role of critic as well as art historian. For him, "A display of 'sentiment' for the South, responsiveness to it as an environment and a mentality, unmistakable interest in what could be conventionally taken as signs of the South, were to count more as authentic indications of Southernness than the fact of their physical presence in it. Habitation *by* it was to count for more than habitation *in* it." Kuspit also looks outside the dates of his curatorial section to Edward Hopper's work in South Carolina and Josef Albers's and Willem de Kooning's at Black Mountain, North Carolina. In seeking to illustrate the South's sense of itself, its "Southern sensibility," he has often chosen works that reflect the influence of twentieth-century modernism on the art of the South and the beginning of international painting in the Southern states.

In order to document and clarify the art of the South, the curators have chosen to take a broad view, both geographically and chronologically. Their purpose has been to bring to light an image of the South free from the misinterpretations that often shroud and obscure it. With its themes at once divergent and distinct, the South has long had trouble looking at and interpreting itself; definitions of it come hard. For this reason, the curators did not attempt to set forth a definitive statement of what exactly is Southern about the painting of the South, nor did they apply the label "Southern" only to those artists who have lived exclusively within the region.

As Carolyn Weekley notes in the first essay of this volume, research on Southern painting is too complex,

too incomplete for rigid thematic analysis and generalities. Although "the South" as a term was used initially in the eighteenth century, regional consciousness developed largely during the nineteenth century, and the study of various regions of the United States has been a twentieth-century development. Two recent major exhibitions at the Museum of Fine Arts, Boston, *The Boston Tradition* of 1980 and *New England Begins* of 1982, are examples of this recent interest.

.

The first settlements on the Southeastern coast were established in the 1560s: the French in South Carolina, the Spanish in northern Florida. The later settlements established by the English, however, would become dominant, stretching north as far as Maryland. A century later, in 1682, the Frenchman Robert Cavalier, Sieur de La Salle, laid claim to the lands drained by the Mississippi. It was almost forty years, however, before the French established permanent settlements at Mobile and New Orleans. Although by 1803, the year of the Louisiana Purchase, the South was no longer linked politically to France, Spain, or England, the art of the South was still deeply rooted in the European tradition.

By 1850 the South was composed of a group of slave states. Its wealthier planters and merchants had made use of slave labor for over a century in an agricultural system dominated by the cotton industry. In 1861 eleven states sought, by secession from the Union, to maintain this established way of life. Failure to win the war that followed is the element that has made many white Southerners feel separate from their fellow Americans. C. Vann Woodward, in an article aptly titled "The Irony of Southern History," observes that "the South had undergone an experience that it could share with no other part of America—though it is shared by nearly all the peoples of Europe and Asia—the experience of military defeat, occupation, and reconstruction." Through this defeat the Southerner became an atypical American, separate from the stereotype of accomplishment and success. The South's awareness of itself, therefore, has been different from that of the North or the West.

In contrast to the Northeast, there is little public information about the painting traditions of the South. Large numbers of family portraits were commissioned during the eighteenth century in Virginia, Maryland, and South Carolina, but they remained in private homes, treasured possessions to be handed down from one generation to the next. Although the South can boast the first museum in America, the Charleston Museum of 1773, museums as repositories of art have come late to the South. Among Southern collectors there has been a certain reticence to display what they have to outsiders. Unfortunately, in some of these private collections the lack of climate control and the ravages of humidity have resulted in irreparable damage to works of art.

In addition, a large number of migratory artists, whom Anna Wells Rutledge refers to as "birds of passage," spent their winters in the South, making it difficult to separate those who were influenced by the South and those who made a definite contribution to Southern art from those who merely inhabited the region.

In the eighteenth and early nineteenth centuries, the traveling artist was graciously received in areas of the South where there were few native artists and where the Puritanical distaste for ornamentation did not exist. It was possible in Williamsburg and Charleston, and later, Savannah and New Orleans, to commission work from itinerant American-born painters or from English and European-born portraitists. Foreign artists would spend several years in one community, acquiring experience, a livelihood, and a reputation to take home with them. Such professional portrait painters, even those whose styles were outdated, were in great demand in Southern cities.

The self-taught folk artist, on the other hand, had less appeal for the aristocratic Southern patron, who not only could afford the fee for a professional but who might even travel abroad to sit for his portrait. As a result, several paintings that today more properly fall in the category of non-academic or folk art have been included in the first two sections of the exhibition in order to demonstrate something of the range and quality of work that was available. Folk painters were employed principally, but not exclusively, by the middle class because their pictures were affordable. Although less refined by European standards, they offered the less-discriminating client a combination of documentation and decoration. In the nineteenth century, the growing middle class often turned for status to the newly-affordable work of the professional artist.

The restlessness that often characterized the artist in the early South remains as a lingering characteristic of the twentieth-century painter in the region. Like his

predecessors, the modern Southern artist journeys in search of a beneficent climate and pleasant working conditions. Unlike them, he is more easily linked with the total expanse of the United States by the super-highways that span the country, as well as the relative ease of travel and the acceptability of uprootedness. The notion is evident in the works of Victor Huggins and Martin Hoffman, and is especially evoked in Ray Kass's *Winged Earth, St. John's Mountain* (cat. no. 166). From these artists and others, both past and present, a multi-faceted image of the South emerges, one that is based on their individual responses to the region.

If there are any elements that have conditioned the sensibility of painters in the South, from the early chroniclers to the modernists at Black Mountain, it is the Southern landscape—varied, primal, sensuous—and the Southern light—hot, fiery, filtered through atmosphere.

Depictions of the landscape provided patrons with permanent records of their surroundings. In the eighteenth century, planters and well-to-to citizens often commissioned portraits in which the land figured in a secondary role. The family farmhouse in Maryland rises on a hill above William Smith and his grandson in Charles Willson Peale's portrait of 1788 (cat. no. 30). In nineteenth-century equestrian paintings executed by Edward Troye throughout the South, a purebred racehorse was on occasion set on land overlooking the house and estate of its owner; the painting thus served as a visual inventory of valued possessions.

At times, interest in the setting took on a more clinical nature. Following in the tradition of the Englishman John White, naturalists Mark Catesby and John James Audubon were as exultant in their discoveries of rare flora and fauna as they were meticulous in recording their findings. Walter Inglis Anderson, a twentieth-century naturalist, was more reclusive in his search for the inhabitants of the Southern wilderness. His watercolors and detailed journals from Ocean Springs, Mississippi, and nearby Horn Island reveal his acute awareness of familiar and little-known natural specimens.

The painted landscape developed more slowly in the South than in the area bordering the Hudson River. Nonetheless, artists responded in picturesque fashion to the bayous, trees draped in Spanish moss, cottonfields, and other features unique to the region. Virginia's Natural Bridge and the great waters of the Mississippi offered painters the breathtaking grandeur

that had been described by Edmund Burke in his widely read 1756 treatise on the Sublime in nature. Many artists also chose to interpret the Southern landscape as a secret place, darkly threatening in the Faulknerian sense and necessitating escape.

Although countless artists painted the settlers of the land and the land itself, relatively few chose to depict scenes from the War Between the States. Among those who did were Conrad Wise Chapman, known for his on-site work in Mississippi and at Charleston, and Edward Lamson Henry, who painted Westover Mansion in Virginia with Union troops bivouacked on the front lawn. After 1865, however, Southern artists rarely looked to the battlefields for their themes, almost as if the war was too close and too painful. Instead, they sought out spaces that were uninhabited and that allowed a realm of total possibility. Unlike the fifth painting of Thomas Cole's *The Course of Empire,* a scene of desolation after destruction, Southern landscapes from the last thirty years of the nineteenth century often reflected the land as never having been inhabited and therefore without the potential for ruin and decay. In the far reaches of Florida's exotic glades and other secluded places, artists found a final offer of rebirth without Reconstruction.

Elements of the Southern lifestyle and scenes of everyday life, particularly that of the black, have lent themselves well to genre painting. Eastman Johnson's *Negro Life in the South* (later called *My Old Kentucky Home*) of 1860 sets forth the contrasts of mistress and servants, wealth and poverty, which to the nineteenth-century view were more picturesque than they were realistic. Winslow Homer in the 1870s and Richard Norris Brooke in the 1880s gave poignant insight into the life of the black, emancipated yet unable to abandon a way of life, a role in society, and a style of dress that had labeled him for decades as "other." In the hands of nineteenth-century artists such as John Elder and William Aiken Walker, the picturesque quality of black life in the South was emphasized; but by the end of the first quarter of the twentieth century the view had become less picturesque than painful, as other artists created sad reminders of Reconstruction's lack of progress.

Thus, the influences that have been at work in the South have been quite different from those in other regions of the United States. As the land and the climate and the means of livelihood and the legends are different, so is the work of artists in the South. This has been recognized by many individuals, including staff members of museums and galleries, historical societies, reference libraries, and archives. They agree that an exhibition like *Painting in the South* is long overdue, and they have been most cooperative and generous in their support of the project.

This exhibition reflects not only the art of the South from 1564 to 1980, but also the region's sense of itself during this period. Its purpose is not to define what the South is, for the South has many levels of meaning, nor is it to say that the art of the South is unrelated to the art of America, for the South *is* part of America. At times, works have reflected national and international trends and interests, expressed by curator Donald Kuspit as "the assimilation of modernist ideas of painting—the pursuit of materialist purity, involving an exaggerated sense of the medium's integrity." At other times they have expressed strictly regional phenomena.

For every recognized Southern artist prior to 1950 there are many others who are still little known; future interest in their work will contribute to these findings. The considerable number of artists currently at work in the South and the variety of their work are noteworthy, indicative of the creative energy that abounds in the region, a situation that has made curatorial decisions extremely difficult. In some cases, paintings that a curator wished to include were omitted because of the limited number of works allowed for each section. In other instances, extenuating circumstances did not permit the work to be part of the exhibition.

By documenting and presenting the art of the South in this major exhibition, the Virginia Museum hopes to provide a comprehensive view that will inspire and enable future historians to define more precisely the nature of this art and to acknowledge its contributions to the art of the nation.

In an article in the *Yale Review* of 1951, David Potter described the South as "a kind of sphinx on the American land." Sphinx-like, the South hints at a long history, a different culture, an undiscovered past. Sphinx-like, it is an enigmatic land, mythical and riddling. In our ongoing search for knowledge of the artists of the South and of their subjects and themes, however, we seek no more and no less than a greater knowledge of American art itself. ❧

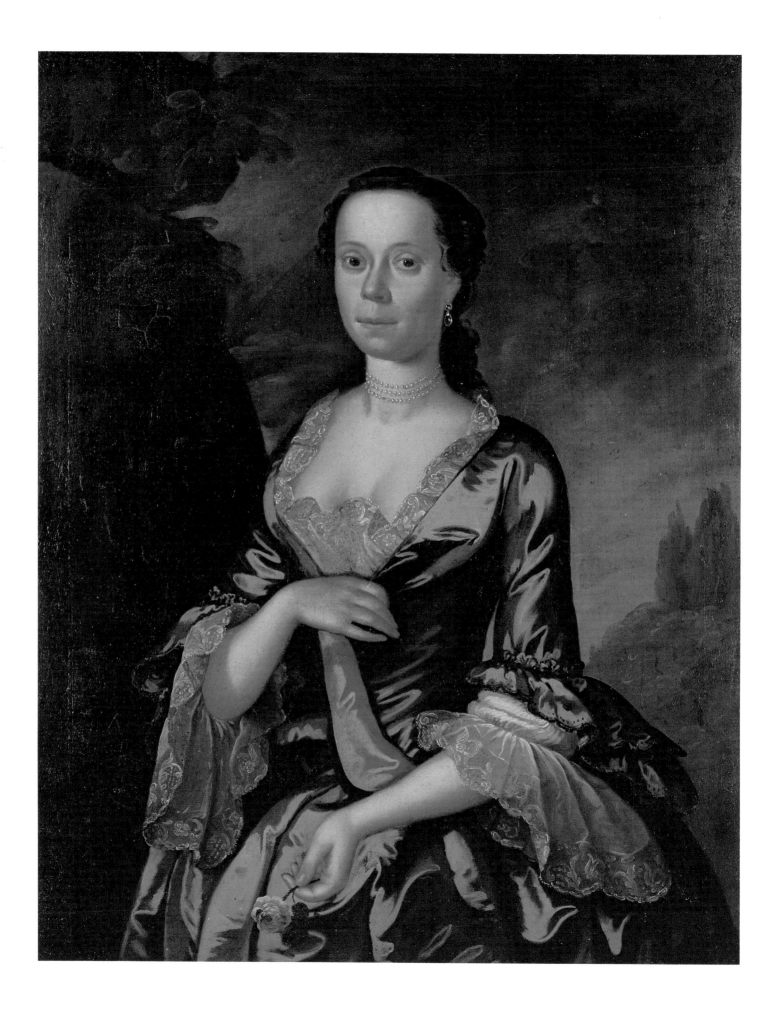

The Early Years, 1564 to 1790

by Carolyn J. Weekley

Establishing a meaningful parameter for this opening essay, which treats the South's paintings and painters from the late sixteenth century to about 1785-90, has been a challenging process. The subject is rich with images. Its research still offers scholars rewarding moments of discovery and reassessment. The unknowns of the subject are likely as intriguing as the knowns, and when one considers that the surviving paintings may represent only thirty to forty percent of those made by only one half of the total artist population for these years, one also realizes that historical and art-historical assessments are made cautiously, and somewhat tentatively.[1]

The traditional monographic approach to our colonial painters, in which factual data on a given artist is presented with a catalogue of his or her work, has been and will continue to be the critical first step in ongoing investigation. Much of this kind of material is gratefully acknowledged as borrowed from the published works of others and is incorporated in the essay's text and footnotes. But this is not a monographic survey of Southern painters, for the approach taken here is simultaneously general and highly selective— general in that the artists and works discussed are considered representative of patronage and artistic tastes in the South during its formative years; highly selective in that the paintings chosen rank among these artists' best known work in terms of aesthetic and cultural interest.

Therefore, what follows is neither purely art historical nor in-depth cultural history, but rather a blending of the two, however incompatible or tenuous that partnership may seem at times. The many interrelationships that existed among artists, or between artists and patrons, or even among patrons, and the level of arts awareness between both groups are often given only brief mention in traditional surveys of colonial American painting, especially in regard to the South.[2] Yet these factors are vital to this study and to our grasp of the artistic aspirations—simple or sophisticated—of both painters and their clientele. The ever-changing matrix of ideas, the land as both a source of livelihood and as a territory to be explored and settled, and the social, economic, political, and religious systems that existed during these years all must have had a profound effect on the artist, determining something of the look of his pictures, who his patrons were, the manner in which he conducted his business, and ultimately the degree of success he achieved. Our limited understanding of these intricately interwoven aspects of colonial life in the South have been explored by traditional historians—and the literature is impressive—but few of them accurately treat artists or paintings in a cultural context.[3] This essay seeks to explore some of these same concerns in simple terms as a beginning, as an invitation for future historians to address important questions that, for now, remain unanswered.

In a similar way, the art criticism and evaluation presented here is relative to existing research as found

Figure 4. *John Hesselius,* Portrait of Margaret Tilghman *(cat. no. 21).*

1

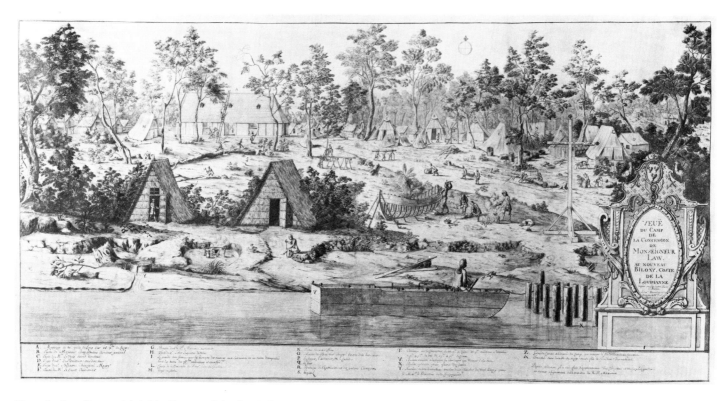

Figure 5. Jean-Baptiste Michel Le Bouteux, John Law's Concession
("Veuë du Camp de la Concession de Monseigneur Law. au nouveau
Biloxy. Coste de la Louisianne"), *ca. 1720, pen, ink, and wash, 19½ by
35⅜ inches (49.5 by 89.9 cm). Newberry Library, Chicago, Illinois, Ayer
Collection.*

in the published material on the subject, and that
begun by the author in 1970.[4] Much has been omitted
in the interest of space, and some material deserving
further investigation is cited in the notes accompany-
ing the essay.

Noted historians, like the late Richard Beale
Davis,[5] have outlined in depth the distinctions be-
tween the Southern and Northern colonies and have
suggested that the emergence of a "Southern charac-
ter" may also be evident in these early years. Certainly
there were general important differences revolving
around the nature of the land and the climate, charac-
teristics so firmly tied to the South's almost wholly
agricultural economy and its plantation system, which
relied heavily on slave labor. With regard to personal
attributes, Thomas Jefferson, writing in 1785 to the
Marquis de Chastellux, summarized what he thought
were the salient differences between the Southerner
and his Northern counterpart. He held that Southern-
ers were "cool, sober, laborious, independent, supersti-
tious, and hypocritical in their religion," while North-
erners were "fiery, voluptuary, indolent, unsteady, and
without attachment or pretensions to any religion but
that of the heart."[6]

The cultural diversity and regionalism of the early
South has also been a subject of intense investigation
by historians, who have identified three general soci-
eties.[7] The Chesapeake, beginning at the head of the
Chesapeake Bay and extending south to the Albemarle
Sound and westward to the foothills of the Appala-
chian Mountains, is considered the oldest mature
English civilization in the colonies. By the 1830s, the
Carolina Society embraced the area along the South
Carolina coast from just north of Winyah Bay to the
Savannah River plantations and the Georgia Sea
Islands, and extended about sixty miles inland. Fi-
nally, there was the vast Back Country, varying in
width from twenty to 160 miles, which comprised the
interior from the Mason-Dixon line stretching 600
miles southwest to just below the Savannah River.
This region was settled throughout the colonial years,
but it does not figure in this essay since no paintings or
painters predating 1785 have been documented in the
area.[8] With the exception of Le Bouteux's view of New
Biloxi (fig. 5), the same may be said for the Deep
South, particularly Louisiana. Thus the Carolina Low
Country and the Chesapeake area are the regions that
figure prominently in this discussion.

While all these distinctions, divisions, and categories are helpful in comprehending the history and growth of the early South, there is only minimal evidence of regional preferences in paintings executed for Southern patrons during these years. From the viewpoint of their art, both artists and patrons were transplanted Englishmen and Europeans whose tastes and motives for pictorial embellishments only mirrored those known from their homelands. Few distinctions exist in the South's early painted images, details, and attitudes that seem to distinguish them from those produced in colonies northward or from pictures made abroad; the few variations that exist fall perhaps more appropriately in the category of the atypical. This essay deals almost exclusively with what was typical.

For these reasons it has been difficult to forcefully introduce in this section of *Painting in the South* some of the key themes that emerge in the region's art in later years. The all-important Southern landscape, which held a fascination and mystery for later artists, is not evident in surviving colonial paintings. In its place we find a rather scientific, journalistic approach which sought to identify, categorize, and simultaneously disseminate information about the detailed aspects of flora and fauna indigenous to the area. The absence of any true landscape painting during these years may ultimately prove useful in understanding those later developments. Perhaps discovery and identification, the ability to comprehend and manipulate an environment to material advantage, precedes artistic interpretation. Perhaps in the South the artist responded to the land only after he knew it intimately, or when he and the land were endangered or encroached upon by settlement and expansion. Perhaps, in fact, we will never know why Southern colonial artists did not visually record the land in the same manner that their patrons evoked it in their writings.

Another thematic concern recognized as critical early on in this project was the impact of religious thought and ethos on Southern artists and their pictures. Religious freedom was an important factor in settlement and was often allied with the political purposes of nations, which dictated where, when, and by whom settlements would be made. The diverse religio-ethnic groups present in the colonial South did not exhibit any widespread or particularized preferences for formal religious subjects in their art, although it is eminently clear that many artists who emigrated to the colonies did so for religious reasons. Except in the rare case of portraits featuring prominent religious leaders, a few documented references, and one painting by Gustavus Hesselius, there are no overt visual references to the subject.

The nature of patronage during the colonial years in the South is more easily understood and reckoned with, since portraiture predominated and biographical information on sitters facilitates general conclusions. As will be seen, these were usually persons of wealth, position, and education—leading and influential planter families. It was not until the Revolutionary War years, or just before, that patronage in the South slowly crossed the elusive lines that distinguished the affluent planter-merchant class from the ambitious middle class of smaller planters, merchants, and tradesmen.

The level of arts awareness among patrons in the early South is more difficult to ascertain because so few of them made comment on their paintings or on the artists who created them. However, where this information exists, it is incorporated into the essay.

Finally, and most importantly, this writer was especially hopeful that new information on the role and representation of blacks in colonial Southern painting would be discovered in the months of research that preceded this essay. Regrettably, no paintings or revealing information were found beyond the very limited material in existing published works. Our knowledge of the subject therefore remains remote and incomplete.

The arrangement of this essay may seem disconcerting to some readers since it is neither strictly chronological nor totally regional in presentation. Those approaches were tried but were discarded because they did not enhance the naturally interwoven nature of the subject, which makes it exciting and relevant to the purposes of this book. If this essay accomplishes nothing more than to kindle a desire to read more on the subject and to inspire others to undertake the research so desperately needed in so many areas, then its simplest goal will have been achieved.

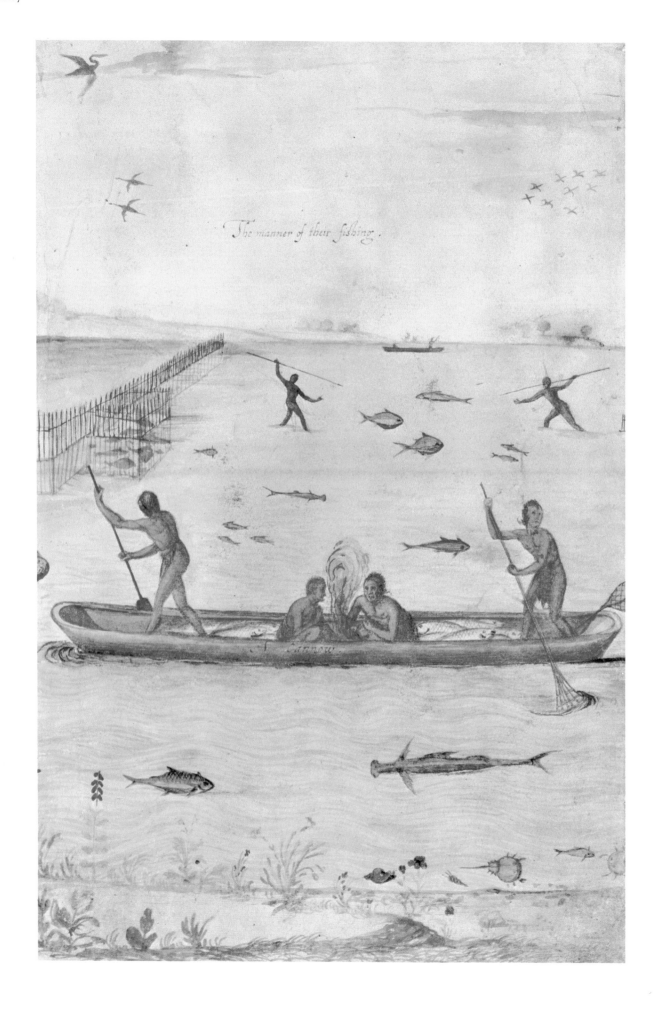

The manner of their fishing.

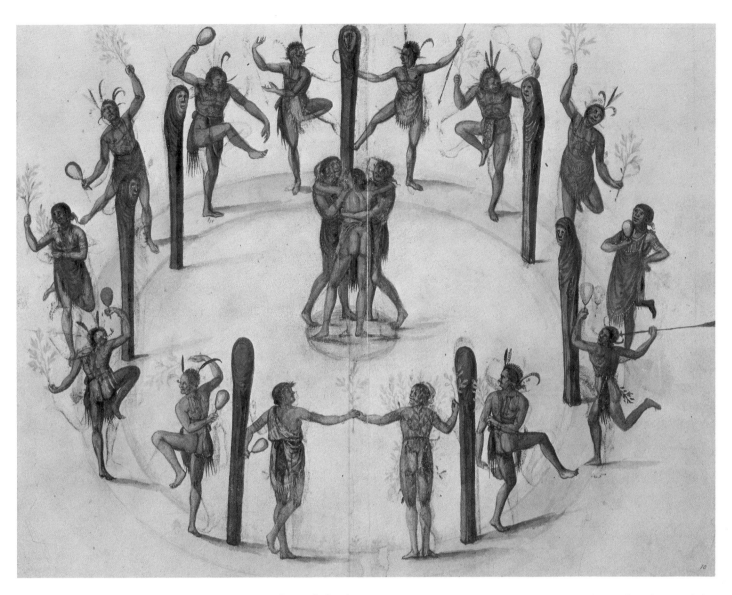

Figure 6. John White, Indians Fishing, *ca. 1585, watercolor touched with white and gold, 13⁷/₈ by 9¹/₄ inches (35.3 by 23.5 cm). British Museum, London, ECM:43.*

Figure 7. John White, Indians Dancing around a Circle Pole, *ca. 1585, watercolor over graphite touched with white, 10³/₄ by 14¹/₈ inches (27.4 by 35.8 cm). British Museum, London, ECM:39.*

The earliest pictorial renderings associated with North America and its coastal Southeast are traditionally credited to two early European explorers during the sixteenth century.[9] Nearly every history of American painting begins with either the one surviving small, jewel-like watercolor by Jacques LeMoyne de Morgues that depicts René de Laudonnière at the Column of Ribaut in about 1564 (fig. 1; cat. no. 1) or one or more of John White's pictures recording native American Indians and the flora and fauna of the New World (figs. 6, 7). It is from these small pictures that the impressive history of painting in the South also takes its departure.

When viewed, as they were intended, within the context of their accompanying narratives, and when placed within the political and philosophical aspirations of these exciting, though sometimes painful years, LeMoyne's and White's pictures have extraordinary meaning. Their purposes were quite different from and independent of their generally pleasing artistic qualities; they formed then, as they do now, a critical though incomplete record of how European explorers and settlers perceived themselves in relationship to "this strange land."[10] No doubt they saw themselves as superior to the native Indians, as missionaries and "planters" of Western civilization in an uncivilized

land, as rightful possessors of a virgin territory which they would tame and order to their particular purposes of settlement and economic gain.

The history of the pictures associated with these early attempts at settlement begins with LeMoyne and the year 1562, when the French Huguenot leader Gaspard de Coligny organized and sent a small group of religious refugees to the Florida coast under the command of Jean Ribaut.[11] LeMoyne was not with this party, but the events of the trip are central to his one surviving painting. Ribaut's group arrived in 1562, and the French commander was immediately impressed by what he found in that lush, tropical region. During his brief stay he placed two stone columns along the coast, one presumably in Florida, and the other probably on Lemon Island near Port Royal, South Carolina. Both columns bore the arms of France, and the intention of their placement was clear—to claim possession of the land for France. This first French party built a fortification called Charlesfort, near Port Royal in present-day South Carolina. Ribaut left thirty men there and returned to France to secure much-needed supplies. He was unexpectedly detained by the internal upheavals associated with the French Civil War and did not see the settlement again until 1565.

Charlesfort proved to be a tragic failure. Like most of the early settlements, its preparations had been inadequate. Without any knowledge of the settlement's demise, de Coligny, in France, was finalizing plans for a second voyage to Charlesfort. He selected René de Laudonnière as commander, and Jacques LeMoyne de Morgues as the artist-cartographer. LeMoyne's instructions were to map the seacoast and its tributaries, record any towns, and more generally to portray the place and all that was of interest. This second French party arrived in June of 1564 and remained there until September. According to the text that accompanies LeMoyne's drawings as published by Theodor De Bry, the French were welcomed by the Indians, who then accompanied them to one of the columns Ribaut had placed two years before.

This is the event shown in LeMoyne's watercolor, which apparently was meant to document something of the Europeans' early relationship with the American Indians. LeMoyne's clever arrangement, at the right of the painting, of the Indian chief, Athore, and de Laudonnière is a case in point.[12] The chief towers nearly a head in height over de Laudonnière, but he extends his arm in friendship around the Frenchman's shoulder. De Laudonnière's lance is placed diagonally across and in front of the Indian leader, presumably signifying his formal authority and control. Even more indicative of the superiority of the French are the bow and quiver of arrows, presumably the chief's, that are strewn on the ground before them. Ribaut's column vies as the focal point of the picture, but once again LeMoyne's message is quite clear: to the left, several Indians kneel to the column. The symbolic inference of the various vegetables and fruit, which had been gathered by the Indians and placed in front of the column, is also clear. Perhaps they were also meant to signify friendship, and most represented the various kinds of food plentiful in the new land. The Indians had been helpful to Ribaut's first party, supplying them with food and other provisions necessary for survival in the New World, and they were equally curious about and supportive of the second expedition. LeMoyne noted that eighty of their strongest men were assigned to help build the new fort and huts and that they supplied food on a daily basis during the establishment period.

As the year progressed, LeMoyne undoubtedly spent considerable time exploring the region, visiting Indian towns and sketching. De Laudonnière's leadership began to weaken during these months, and the various surviving accounts of what happened are often as confusing as the actual situation must have been. Some of the commander's deceptive dealings with the Indians were discovered, and his tactics alienated the natives, thus jeopardizing the company's chief source of food and security.[13] This, combined with de Laudonnière's bouts with sickness, growing unrest among the settlers, and, finally, their rebellion, insured the ultimate failure of the settlement.

The final blow came with a destructive attack by the Spanish under the command of Pedro Menendez.[14] Most of the French were captured and murdered, but LeMoyne, Laudonnière, and a few others managed to escape. They sailed for France, but the boat carrying LeMoyne was swept ashore in England. LeMoyne made his way to London, where he married, then was employed by Sir Walter Raleigh, half-brother of Sir Humphrey Gilbert, who had acquired a patent from Queen Elizabeth to obtain lands in America for the English throne. Raleigh renewed the patent in 1584, just after Gilbert was lost at sea.[15] Raleigh was probably among the first to meet with LeMoyne on his arrival in London. No documentation exists to confirm when and where LeMoyne completed his sketches, which Theodor De Bry ultimately used, including the single

surviving example (fig. 1; cat. no. 1). Since he was employed by Raleigh, who was inquisitive about the New World and was keen to claim American lands for the British, it is entirely possible that Raleigh encouraged LeMoyne to complete them.[16]

Theodor De Bry (1528-1598), a German Protestant goldsmith and engraver, and an acquaintance of Richard Hakluyt, the English geographer and historian,[17] had heard of LeMoyne's drawings. He traveled to London in 1587 or early in 1588 with the hope of purchasing them from the artist. LeMoyne refused to sell, but a few months later, after his death, De Bry was able to acquire them from the artist's widow. De Bry's intention was to engrave and publish them in a first volume on the New World settlements, but Hakluyt, who was obviously pro-British, convinced him to publish John White's drawings first. Thus, the politics of these years very much influenced what Europeans, especially prospective promoters of English settlements, saw first. In some ways, LeMoyne's pictures and the accompanying narrative are a more detailed bit of promotional literature than White's drawings and Thomas Hariot's writings.[18] With respect to understanding the Indians, LeMoyne seems to have been more objective and in accord with the impressions recorded by Philip Georg Friedrich Von Reck (1712-after 1792) of some 150 years later.[19]

LeMoyne was immensely impressed by the dignity and resourcefulness of the Indians. Though he detailed rituals that were savage and dehumanizing by European standards, he continually complimented aspects of their daily lives and habitat. Among a number of insightful notes made by the artist, we find one that seems to sum up his impressions of these "noble savages."[20] In his description of the Indian chief Athore, the Frenchman said he "was very handsome, wise, honorable, and strong . . . grave and modest, and his bearing was majestic."[21]

LeMoyne's association with Sir Walter Raleigh was perhaps a more significant twist in history than we will ever know from existing records. His firsthand knowledge of the New World, combined with his drawings, must have been extremely useful to Raleigh and his colleagues as they prepared for expeditions to Virginia.[22] By 1584, Raleigh had sent Philip Amadas and Arthur Barlowe to explore the American coast, and it was their report of the place and Hakluyt's influence that won the Crown's support of Raleigh's larger expedition to Virginia. This group, under the command of Sir Richard Grenville and the governor-

ship of Ralph Lane, arrived at Roanoke Island (in present-day North Carolina) in 1585. John White, the artist, was also among them.[23]

The fate of the English planters mirrored that of the French settlers. Ralph Lane reported that most of the colonists spent their time in quest of gold, exhausted their food supplies, and, like the French, eventually alienated the Indians. When Sir Francis Drake visited the small colony in 1586, the remaining colonists boarded one of his ships and abandoned the place. Thus Grenville, who had gone to England for supplies, found the Roanoke settlement deserted when he returned. He did, however, leave fifteen men to hold the area in England's name.

Raleigh organized a second expedition in 1587, this time under the leadership of John White. The adventure was nearly a repeat of England's first effort, and the inevitable shortage of supplies required White to return to England. The narrative accompanying his pictures indicates that he did not return until August 1590,[24] finding Roanoke abandoned and the word "CROATOAN" carved in one of the trees at the fort's entrance. Rough weather and near mutiny among the seamen forced White and his ships to abort any attempt to find the place by that name, and White had to "commit the relief of the uneasy company of planters in Virginia to the Merciful help of the Almighty."[25]

It was during White's stay at Roanoke in 1585 that he initiated his work on the sixty-three well-known watercolors featuring the American natives, some of their towns, and many other aspects of natural interest (figs. 6, 7). Richard Hakluyt maintained a keen interest in these drawings, and it was Hakluyt who convinced Theodor De Bry to obtain them and publish the volume on the English colony before those of LeMoyne, which De Bry had acquired about this same time.

The first volume was an immediate success, with editions in English, French, Latin (cat. nos. 2-4), and German. The book went through seventeen printings between 1590 and 1620. It was with this volume of engravings that White's drawings had their most significant impact, for few Englishmen or Europeans ever saw the original watercolors. No doubt a select coterie of court officials and explorers knew them, but their appreciation was undoubtedly one of interest in content, the details of dress and life-style of the Indians, or the various species of fish and the like. Any regard for their artistic merit must have been secondary. Today,

Figure 8. Sir Peter Lely, John Page the Immigrant, *1660, oil on canvas, 24 by 23 inches (61.0 by 58.4 cm). College of William and Mary in Virginia, Williamsburg, 1879.006.*

they tend to be valued in much the same way, but they deserve a place in Southern painting history because they are, after all, among the few visual sources we have for these early years. They can be praised for their fairly realistic coloration and clarity—all matters of concern to White in his purpose to record what he saw in the Roanoke Island region. It is worth remembering that no comparable detailed set of pictures survives for any other English colony in North America, despite the fact that this settlement took place so early and was unsuccessful.

The Roanoke Island expeditions must have been a miserable, if not humiliating, experience for the few who were directly involved in their planning and who luckily survived the ordeal. The English would not attempt another settlement until Jamestown in 1607. Spain, which had its strongest colonies in Mexico and various islands in the Caribbean, continued to hold Florida. France set up a trading post in Québec in 1608 but did not establish settlements in the South until

LaSalle's famous journey down the Mississippi in 1682. If sketches, watercolors, or any sort of paintings were made in Jamestown, in Florida, or during the Mississippi trip, they are unknown to us today.[27] Except for a few interesting maps, there is little evidence of any pictures having been created in the Southern colonies during these years. No artists of the period are known, either by name or by reference. Only a few surviving portraits that have histories of descent in Southern families and that possibly date from the 1600s are recorded. Most of these have been so altered or restored that physical evidence often offers only inconclusive information on date and origin. Among the best known of these for Virginia are the portraits of John Page the Immigrant (owned by the College of William and Mary), attributed to Sir Peter Lely (1618-1680) (fig. 8); of William Moseley II, attributed to Cornelius Janssen; of Robert Bolling the Immigrant, by an unidentified painter; and, possibly, of William and Mary (Isham) Randolph of Turkey Island.

Documentary references to pictures are equally sparse and vague, as revealed, for example, in the following notes taken randomly from Virginia records: in 1660, Colonel Thomas Ludlow of York County owned a waist-length picture of Judge Richardson; in 1669, John Brewer of Isle of Wight County listed twelve pictures in his inventory; Thomas Madestard of Lancaster County owned numerous pictures at his death in 1675; in 1690, David Fox had three pictures hanging in the parlor and twenty-five in the hall; in 1692, Edward Digges of York County owned six pictures.[28] The nature of these "pictures" is unknown, since period wills and inventories rarely cite medium or maker. Many of these references may only refer to prints, but they are extremely valuable because they prove that pictorial embellishments had become, less than three generations after the first permanent settlement in Jamestown, a rather common element of household furnishing.

The absence of documented Southern paintings throughout the seventeenth century may seem peculiar, particularly in comparison with the various portraits that survive for the Northern colonies. It is no more peculiar, however, than the relative scarcity of decorative useful wares and household furnishings for the same period. The reasons are not entirely clear, but several contributing factors have been identified by historians. First, the Southern settlements along the tributaries of the Chesapeake were small and scattered, and they lacked the binding social and religious forces that had strengthened New England towns. Second, few women immigrated in the early years to these settlements, a situation that must have affected household management and the whole concept of housekeeping and the family unit. Third, mortality rates, which were high, surely disrupted the flow of inheritable goods from one generation to another. Finally, the predominantly humid climate of the coastal Southeast and the impermanent nature of most dwellings must have had a deleterious effect on paintings. All of these factors combined may well have contributed to the impermanence of material goods and their maintenance.

It is with the slow but steady strengthening of the South's ports, its plantation system, and its towns in the early 1700s that we begin to find evidence of painters and a coterie of patrons in various regions who desired and acquired art for their homes. As crude as they may seem by the contemporaneous European and English studio styles that influenced them, these paintings were done by artists who probably attempted to be as knowledgeable and ambitious as colonial circumstances would allow.

In the South, as elsewhere in the colonies, portraiture emerged quickly as the favored format, and it would continue to be the chief artistic expression for painters throughout the eighteenth century. For many colonists the portrait served as a permanent record of a person, usually a family member, although there must have been a few institutional and governmental commissions during the 1700s.[29] Southern patrons during the generations prior to the Revolution were chiefly families with either wealth and/or some official status within their communities and colonies. Generally speaking, except for those in Charleston, South Carolina, the middle and lower classes of tradesmen, artisans, and small farmers or planters did not patronize portrait painters during the first half of the eighteenth century, although prints of various kinds may have served a similar function in their homes.

The decorative quality of many of these portraits—their color, pretentious compositions, elaborate settings and costumes, and striking and dignified poses—suggest a real preoccupation with social status, acceptable worldliness, correct deportment, and presentation of self. When viewed collectively from region to region, early Southern portraits consistently reveal this English/European-orientation toward good taste, which was conservative in nature as well as materialistic.

Justus Englehardt Kühn (died 1717) is still regarded as the earliest documented portrait painter to work in the South, although surviving portraits by unidentified artists from Virginia and Maryland predate Kühn's activity and may have been executed there.[30] It was the decorative sophistication of his portraits that appealed to Maryland's wealthy planters during these early years. Among Kühn's few surviving portraits is the impressive likeness of Henry Darnall III as a child (cat. no. 6). The elaborate architectural setting and formal landscape vista in which the child stands were probably contrived by the artist or borrowed from some European source still unknown to American scholars.

The servant standing at the left, behind Darnall and the balustrade, is one of the earliest depictions of a Negro known in American painting. While this is significant, especially to the representational history of blacks in North America, it would be misleading to consider this figure as anything more than a fashion-

able portrait convention of the times, the kind of stereotypical imagery that reflected the planter's social supremacy and aspects of colonial wealth. Depictions of this sort were not unique to Southern portraits, since the image of the black page is seen with some frequency in European paintings dating both before and after Kühn's period of activity.[31] Like Kühn's sketchy interpretation, many of them show a person with indistinct features standing or kneeling just behind or beside their master in an attitude of service. It was not until the late eighteenth and early nineteenth centuries that life-like portrayals of black Americans in the South were commissioned. Even for those years, we find only a handful of examples, and most, as one might anticipate, were executed for free blacks who had attained enough wealth to afford paintings. The black slave shown in Kühn's picture and in the few others that survive for the pre-Revolutionary War years are rather empty caricatures of a people in servitude, devoid of names and personal attributes.

Little is known about Kühn's life or career. He was one among a number of German immigrants who came to America during these years. His name first appears in Annapolis records for December 7, 1708, when he applied for naturalization as an English citizen. Various references to him occur after this date until his death and his estate settlement in Annapolis in 1717. The well-known artist Charles Willson Peale wrote many years later that in his estimation Kühn was the earliest portrait artist in the Maryland province.[32]

It is perhaps noteworthy that in 1708, the year Kühn probably arrived in Maryland, the small but growing town on the Severn River was granted its municipal charter as the City of Annapolis. Kühn did not live to enjoy the material or social sophistication that characterized this colonial capital and important seaport by mid-century,[33] but his few surviving portraits support the notion that there were wealthy, receptive clientele among its early planters. In addition to the Darnall commissions, he also painted portraits for other leading Catholic families in the area, including the Carrolls and the Diggeses. His portrait of Ignatius Digges as a boy, similar to that of young Darnall, is signed and dated 1710; it has served for years as the key picture in determining attributions to Kühn.

Gustavus Hesselius (1682-1755), a Swedish artist who worked earlier in both Delaware and Pennsylvania, came to Maryland sometime during the years following Kühn's death.[34] Hesselius apparently moved to Prince George's County, Maryland, before 1726, the year he sold land to John Haymond, a local carpenter. Various of his Maryland portraits have survived, including the rather wooden likeness of Mrs. Henry Darnall III, the wife of the young boy Kühn had painted some years before. Gustavus Hesselius may have made at least one painting trip to Virginia during his lifetime, but nothing is known of his work there.

His Maryland and Pennsylvania portraits tend to be rather stark and, although they were painted basically in the same European Baroque manner as Kühn's, they often lack charm and decorative interest. Hesselius is equally well known today as a religious and allegorical painter. In 1721 the artist created a version of the *Last Supper* (now lost) for St. Barnabas's Church in Prince George's County, Maryland.[35] About the same time he completed two mythological paintings, *Bacchus and Ariadne* and *Bacchanalian Revel* (fig. 9; cat. no. 13), for a patron who remains unidentified. Both are extraordinarily important because they are the earliest mythological paintings surviving by an artist working in America. We know little about the popularity of such images in America or the South prior to the Revolutionary War, and only scattered references mention paintings other than portraits. An A. Dooley, for instance, advertised his ability to paint altar pieces for churches, landscapes, history paintings, views of houses and estates, or "any other way of painting," on October 12, 1752, while Kühn left fourteen "pictures & Landskips" at the time of his death.[36]

By 1730, Hesselius had probably returned to Philadelphia, and thereafter he made only occasional trips to Maryland; he died in Philadelphia in 1755. His son, John, born circa 1728, had a more extensive painting career in Maryland and Virginia than did his father, but it was another twenty years before he would establish himself as a portraitist.

South of Maryland, in Virginia, there is some evidence of artists working during the first two decades of the eighteenth century, but most of their names and their pictures are unknown to us today. In North Carolina, where settlements were few and were sparsely populated, there is no indication of a painting tradition during these years. In fact, there may have been no limners or face painters in North Carolina until Boyle Aldworth and William Beastall, who are documented there as miniature painters in 1778.[37] In South Carolina the only artist of merit known for the period was a woman, Henrietta Johnston.[38]

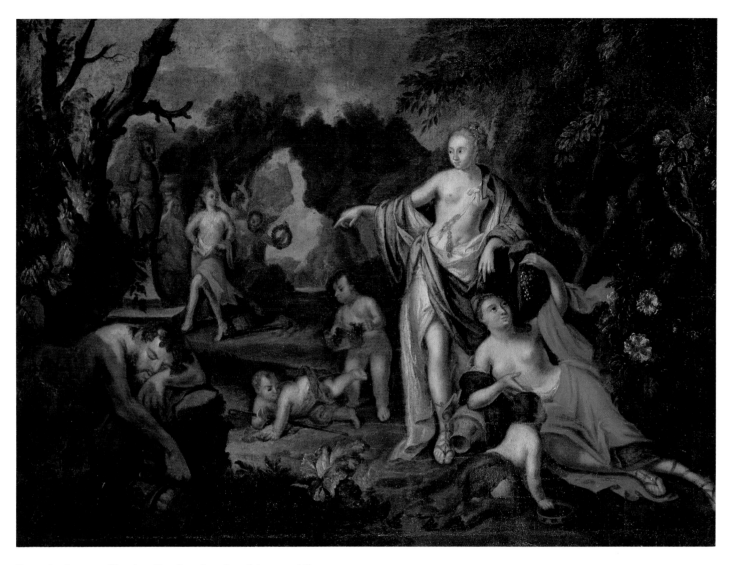

Figure 9. Gustavus Hesselius, Bacchanalian Revel *(cat. no. 13).*

Henrietta Johnston came to Charles Town (hereafter cited as Charleston) with her husband, Gideon, in the early 1700s, and as early as 1709 there are references to her having drawn a number of small pastel portraits.[39] Her husband was commissary of the Church of England and Rector of St. Philip's Church in Charleston. His papers, consisting of letters to church officials in England, are rich sources for understanding religious affairs and life in South Carolina during these years and particularly the many hardships he and his family encountered. In November 1709 Gideon acknowledged the much-needed support that his wife's drawing provided the family when he wrote, "Were it not for the Assistance my Wife gives me by drawing of Pictures (which can last but a little time in a place so ill peopled) I should not have been able to live."[40] In a letter of 1710, the Rector mentioned various personal ailments, the continued discomforts his family endured because of his low salary, and again the observation that "my Wife who greatly helped me, by drawing pictures, has long ago made an end of her materials."[41] The emphasis Gideon placed on Henrietta's income from drawing seems almost ironic in light of the small price these little likenesses must have commanded.

Both Gideon and Henrietta were of Irish birth. They married in 1705 at St. Andrew's Church in Dublin. Henrietta (née deBranlien) had previously been wedded to a man named Dering (Deering?). She presumably had children from that marriage, but existing records are confusing on this issue. When she and Gideon were in South Carolina in 1710, Gideon cited a family "Ten in number," which may have included two servants assigned to St. Philip's.[42] He later mentioned eleven persons in the household, and by the time of his death in 1716 his wife was left with two daughters and a niece, plus two sons in England.[43] The artist's biographer mentions that Henrietta made one trip to New York in the 1720s, and one suspects that she may have been visiting relatives there, perhaps one of her children.

In the strictest sense, Mrs. Johnston's pictures do not classify as paintings because they were drawn with pastel crayons, not painted with a brush. But the stylistic kinship between her work and painted portraits of these years is strong and therefore important to the broader subject of early eighteenth-century Charleston portraiture. Her likeness of Henriette C. Chastaigner (cat. no. 7) illustrates the typically modest size and simple format of her portraits, as well as her delicate coloring and drawing technique. A study of Gideon's papers reveals that many of her sitters were personal friends and supporters, while a few were distinguished officials of the colony. One could not consider Johnston's pastels as grand and imposing as Kühn's paintings, but they are visually appealing. Many of her female subjects, like the eleven-year-old Henriette Chastaigner, are posed identically, and for the most part the artist made little effort to individualize sitters' features or to provide any personalizing accoutrements.

In fact, most portraitists who worked in the South prior to 1750 seem to have given only superficial attention to individual characterizations. Whatever this says about the skills of the artists, it again reinforces the notion that the decorative aspects of these pictures were important to their patrons. If these early settlers ever objected, they have left us no significant record of their displeasure. Perhaps they were merely tolerant of their colonial situation, remote from any fashionable centers in a land where face-painters were few.

The formal poses and style of Henrietta Johnston's small pictures differ little from those observed in a group of Virginia oil portraits thought to have been executed sometime during the 1720s. At least one art historian has suggested a name for the artist responsible for these likenesses, but the documentation as presented is inconclusive.[44] In the context of this essay, therefore, the artist will be referred to by the traditional pseudonym, the Jaquelin-Brodnax Limner (cat. nos. 8-12). Since many of these portraits survive, eleven in all, and because they represent members of two well-known Virginia families, it is reasonable to assume that they were painted in the Jamestown-Yorktown areas where the sitters lived.

The compositions and poses for most of these paintings were probably inspired by those seen in the portrait prints of English notables that proliferated in the colonies during the eighteenth century. For instance, Elizabeth Brodnax's portrait compares in many details with the mezzotint of Princess Anne executed in 1720 by Simon after a painting by Sir Godfrey Kneller.[45] European and English paintings, brought to America with settlers or commissioned by them abroad, were another source from which artist and patron alike could select appropriate poses, drapery, backgrounds, and even costumes. Some of the hand gestures and fabric arrangements seen in the Jaquelin-Brodnax pictures were undoubtedly copied from prints

or imported portraits, but even so they seem exaggerated, awkward, and, perhaps, purposefully selected. For instance, if the portrait of Edward was singled out and exhibited by itself, much of its impact would be lost. The supposition is that his likeness was contrived to hang beside that of another member of the family. When the Brodnax pictures are arranged chronologically by the children's birth dates, a rather interesting compositional pattern emerges. Whether this kind of preconceived visual manifestation of familial relationships was actually intended is not known, but it is worth considering in light of the importance placed on the family in colonial Virginia, America, and abroad.

Large sets of family portraits by one artist were not uncommon in America during these and later years, but it must be noted that they were especially prevalent in the South, particularly in Virginia, Maryland, and South Carolina. A number of factors probably contributed to this: the infrequent visits and limited availability of artists to rural areas encouraged patrons to make the most of their visits; large homes, typical of the wealthy class in the colonial South, could accommodate significant numbers of pictures; and the documentation of patriarchal and dynastic family relations assumed increasing cultural importance.

Although we do not know the name of the painter responsible for the Jaquelin-Brodnax pictures, there is evidence that at least three artists worked in Virginia during the first three decades of the eighteenth century. Graham Hood, a leading scholar of early Virginia painters, has pointed out that in 1727 Robert "King" Carter mentioned sitting for a painter at his home, Corotoman, in Lancaster County and that Governor Gooch, writing to the Bishop of London in 1739, mentioned that one Peter Wagener (in Virginia from 1705 to 1707) "is much better remembered here as a bad Painter, than a Divine."[46] Additionally, the records of York County include an inventory for a Robert Dowsing dated May 16, 1737.[47] The list mentions brushes, mullers, stones for grinding pigments, and sixteen painting boards covered with canvas, suggesting that this man was also a painter. One presumes that Dowsing's career might have extended to the 1720s.

The first half of the eighteenth century saw the critical beginning of a recognizable arts patronage in the South, however small and naive (or tolerant) it may have been. But it continued to be a period of discovery and exploration as English settlements expanded westward from the coast. As noted in the introduction to this essay, images of the Southern landscape may have been produced by painters during these years, but none survive. However, a number of artist-naturalists traveled throughout the Southern colonies, recording in detail, through drawings and collections of specimens, the rich flora and fauna that existed. Mark Catesby (ca. 1679-1749), the self-taught English naturalist, was the most important of these artists.

Catesby made his first trip to the colonies in 1712 and stayed for most of the next seven years with his sister, Elizabeth, and her husband, Dr. William Cocke, in Williamsburg.[48] The Cockes had moved to Virginia from England sometime in 1700 or 1701, and by 1713 William was well-established and had achieved political position and social acceptibility. It was through his brother-in-law that Catesby met William Byrd II[49] and other large landowners who professed an interest in plant life native to the Tidewater, and on whose lands Catesby was invited to gather specimens. Catesby probably made some sketches or drawings at this time, and he noted that he spent his days in Virginia "observing and admiring." By 1719-20, just after his return to England, he had already become well acquainted with several of England's most important botanists, including William Sherard. It was primarily through Sherard's efforts and patronage that Catesby's plan for *The Natural History of Carolina, Florida and the Bahama Islands* took form and reached fruition. Sherard, a leading member of the prestigious Royal Society, was instrumental in securing the membership's official endorsement of Catesby's project, as well as spearheading the subscription effort that ultimately funded the naturalist's return research trip to the colonies. Colonel Francis Nicholson, newly appointed Royal Governor of South Carolina, also offered to finance, at the Crown's expense, a small portion of Catesby's proposed work. Thus, the English naturalist arrived in Charleston, South Carolina, on May 3, 1722 with perhaps the most impressive patronage any man in his profession could expect.

Plantations in the vicinity of Charleston owned by the Moore, Blake, Bull, Johnson, Waring, Chene, and other families proved to be fruitful areas for Catesby's work, and it was to these rural sites that he retreated on his first explorations. Such local excursions were followed by a series of trips inland, first to the lower Piedmont regions. By the winter of 1723–24, Catesby was planning to travel some 400 miles inland

to the Appalachian Mountains, with the dual purpose of collecting specimens and becoming acquainted with the Cherokee Indians. He probably attempted this long trek, but existing records indicate that he never completed it.

Catesby's interest in the Cherokees and other tribes located in the Carolinas was probably influenced by his 1712 visit to the Pamunkey Indian town in Virginia. He must have become keenly aware that these people, who lived and relied on the land, could provide considerable information.

During his travels to Fort Moor in South Carolina, a frontier post located on the south side of the Savannah River, Catesby was accompanied and assisted by Indians on his various collecting trips. In noting his indebtedness to them, Catesby wrote, "I not only subsisted on what they shot, but their First Care was to erect a Bark Hut, at the Approach of Rain to keep me and my Cargo from Wet."[50] Later in his life, in 1743, Catesby presented a paper to the Royal Society in London titled the "State and Conditions of the Indians in America," a version of which was incorporated in Volume II of The Natural History. Catesby's fascination with these native Americans was obviously more particularized than that of the early explorers. He was interested in learning from them about plant habitat and, most especially, about the medicinal uses of plant material.

After a brief trip to the Bahamas, Catesby returned to England in 1726. He was welcomed by Sherard and other members of the Society, but it soon became apparent that the organization could neither fund publication of his accounts and notes nor, more importantly, finance engravings after the large collection of detailed watercolor drawings Catesby had made abroad.[51]

With admirable determination and dedication to his project, Catesby set about the task alone, learning first how to etch the copper plates needed to mass-produce his illustrations of many species of plant and animal life he had studied in South Carolina, Florida, and the Bahamas.[52] Peter Collinson, a wealthy Quaker merchant whose strong interest in North American botanical studies were well known, lent Catesby money without interest. Presumably these funds provided subsistence and paid for the supplies the naturalist needed to produce the first volume of The Natural History. Sherard also offered financial support to the project for a brief period.

Catesby spent month after laborious month en-

graving the plates for the 1731–32 first edition of Volume I, and he even hand-colored the engravings pulled for the first sets (fig. 10; cat. no. 14). In time, he was able to hire assistants both to engrave and to color, but he is said to have monitored all aspects of production, frequently applying the final touches of color himself. He was also careful to explain to his readers his limitations as an artist:

> As I was not bred a Painter, I hope some faults in Perspective, and other Niceties may more readily be excused, for I humbly conceive Plants, and other Things done in a Flat, tho' exact manner, may serve the Purpose of Natural History, better in some Measure than in a more bold and Painter-like way.[53]

Volume II of Catesby's monumental work was not completed until 1743. The appendix, consisting principally of material sent back to England by John Bartram and other naturalists then collecting specimens in the colonies, was issued about three years later. Before his death in 1749, Catesby completed a third and smaller book, Britanus-Americanus, which was devoted to the domestication of North American plants in England.

In his own time and even today Mark Catesby is considered a pioneer in his field. He was the first major author and illustrator of North American ornithology, combining pictures of birds with complete descriptive texts. He was among the first to illustrate animals and birds in their natural habitats, establishing a format which others would follow, including America's John James Audubon in the nineteenth century.[54] One of the most important aspects of his work as an artist was his ability to portray movement and attitudes typical to the creatures he recorded.

The recently discovered drawings and journal of Philip Georg Friedrich Von Reck bring a related yet broader visual perspective to the colonial experience

Figure 10. Mark Catesby, Black Squirrel and Yellow Lady's Slipper (cat. no. 14).

T.73.

Sciurus Niger

Calceolus

during these years, one that reminds us again of the significant social and material contributions made by immigrant artisans and artists of non-English origins. Von Reck, a Protestant German, was exceptional neither as a scholar nor as an artist for his time, but the story of his colonial involvement reveals much about colonial-European politics and the continuing struggles of cultural transplantation and settlement.[55]

In respect to Von Reck, Justus Englehardt Kühn, and other German artists who came to the South, one must understand that the Catholic Reformation in Europe had tremendous ramifications over a long period of time. Many religious refugees arrived in America in the 1680s and 1690s, primarily in the northern colonies of New York and Pennsylvania, with some infiltration into Maryland and the Santee region of South Carolina. In 1710, with the renewed persecution of Protestants in Germany, refugees again immigrated to these areas and to North Carolina. In the late 1720s, the Catholic Archbishop of Salzburg, Germany, commenced yet another rigorous program against the Lutherans in his jurisdiction; by 1731 he had issued the "Emigrationspatent," a decree that ordered all avowed Protestants to leave Salzburg. What ensued was the most extensive population movement of the Reformation, with about 25,000 people going to Bavaria, Regensburg, and Augsburg. Ultimately, some of these refugees came to America. At least two European powers offered support to these people, King Frederick William I of Prussia and the Hanoverian Kings, George I and George II of England. The latter, in concert with various English political and benevolent groups, saw certain advantages in providing land for the refugees in the colonies.[56]

At about the same time, a charter was granted to the newly formed English Board of Trustees to establish a colony in Georgia. The first group of colonists sailed in 1732, under the command of General James Oglethorpe. It was during this same year that an extensive article by Samuel Urlsperger, the Lutheran leader from Augsburg, appeared in London's *Gentleman's Magazine*, detailing the plight of the Salzburgers in his area. Importantly, many of the Georgia trustees were members of the Society for Promoting Christian Knowledge, an English group that had already offered support to Protestant dissenters elsewhere in the world. It was natural for the Society and the Trustees to embrace the Salzburgers' cause, ultimately offering them passage, provisions, and land. Correspondence immediately followed between Henry Newman, secretary of the Society, and Urlsperger, who was assisted by Johann Von Reck in recruiting prospective colonists. It was Von Reck who in September 1733 nominated his twenty-three year old nephew, Philip Georg Friedrich Von Reck, to accompany the Salzburgers to Georgia.[57]

Von Reck left with his group for Rotterdam on November 2 to board the trustee's ship, the *Purrisburg*. Stopping in Dover, England, they met Captain Thomas Coram, a trustee, who immediately liked the enthusiastic Lutheran leader and wrote that "Mr. DeReck [sic] is a clever young gentleman very much like Mr. Oglethorpe . . . his behavior is very engaging."[58] By mid January the *Purrisburg* had left for Georgia with thirty-seven Salzburgers (including Von Reck and church leaders John Martin Bolzius and Christian Gronan) and some unidentified English colonists. They arrived in March 1734. Von Reck met immediately with Oglethorpe and selected a site for settlement some twenty miles north of Savannah. It would be called Ebenezer.[59] This trip to Georgia was the first of two made by Von Reck. He stayed only a few weeks, leaving in May for visits to various coastal cities before sailing for London.

Von Reck returned with additional settlers in 1736, and his plan at this time was to remain permanently in Georgia. One of his purposes was to obtain "ocular proof" of the settlement and other interesting aspects of the Georgia environment.[60] Thus it was during this time that he executed the watercolor sketches that we know today (fig. 11).

The ensuing months were difficult for Von Reck, due in part to internal rivalry among himself, Bolzius, and Gronan for the leading position in the Salzburger community. Illness and continuing difficulties with Bolzius finally forced Von Reck to leave Georgia. On October 24, 1736, he sailed for London, where he met with the trustees before proceeding to Augsburg. According to his biographer, Von Reck worked in various positions in Germany, and after 1763 he was a district revenue collector for the Danish king, Frederick V. Parts of Von Reck's diary were published by Urlsperger as early as 1740 in *Ausfuhrliche Nachrichten*. In 1777 the artist published a small account in Hamburg describing the Georgia settlement.[61] His drawings, never published in his lifetime, were presumably bequeathed to the Danish kings at his death sometime after 1792.[62]

Since few historians of American painting have actually examined the Von Reck watercolors, it may be too early for us to fully appreciate their significance,

Figure 11. *Philip Georg Friedrich Von Reck, Water Snake, Chestnut, and Alligator, ca. 1735, watercolor and ink on paper, 7¹/₂ by 10²/₅ inches (19.5 by 26.4 cm). Royal Library, Copenhagen, Denmark.*

but they are clearly important to the South as yet another expression of ideas and perceptions of a sensitive and inquisitive European on Southern soil. Von Reck's artistic abilities were modest, yet he was probably an honest recorder of what he saw around him in Georgia. His painting of Kipahalgwa might classify as a bona fide portrait. One of Von Reck's most compelling images, it is a rather moving interpretation of an American Indian chief, one that is totally devoid of the contrived poses and mannerisms seen earlier in the work of John White and Jacques LeMoyne. The caption at the top of the picture, written by Von Reck, makes detailed reference to the Yuchi Indian commander's dress and is keyed to the small numbers surrounding the figure.[63]

The particulars of Von Reck traveling to Georgia may also be indicative of the arrival of another more

highly skilled professional painter. Without documentation one can only wonder if the artist Charles Bridges (1670-1747) was not in some way connected with the Salzburger settlement in Georgia. Bridges had become an active agent for England's Society for Promoting Christian Knowledge in 1699, the year of its founding.[64] When he was sixty-three years old, he wrote to Henry Newman, secretary to the Society, saying that there was a "strong inclination in himself to go to Georgia and should soon come to a Resolution."[65] It was during this same year that Von Reck was gathering his group for the 1734 voyage to Georgia, an expedition in which the Society had a definite interest. Bridges must surely have had some knowledge of this project, but whether or not he accompanied them on one of their voyages is conjecture. It is curiously coincidental, however, that he arrived in Williams-

burg during this period, in May 1735, from parts unknown. Graham Hood's important study of the artist reveals that Bridges's purpose in coming to America, like Von Reck's, was principally to promote religious work.

Bridges was the son of John and Elizabeth Trumbull Bridges of Barton Seagrove, Northamptonshire, where he was christened on April 2, 1670. The particulars of his artistic training are unknown, but evidence of his painting activity in England prior to 1733 has been found. His biographer suggests that he may have been associated with the English painter Charles Jervas, since his Virginia work shows certain influences of that artist. His paintings simultaneously afforded him an income and an entrée into the homes of Virginia's governmental and religious leaders and its wealthiest families, all of whom were essential to the work that Bridges hoped to carry on for the Society in Virginia. Although he never fully realized his charitable plans, he became, probably without his knowing, the most important painter to work in Virginia before the 1750s.

We know that Bridges arrived in Virginia with "daughters and a son" and letters of introduction to Commissary James Blair and Lt. Governor William Gooch, whose brother the artist must have known in England. One of the most interesting comments on the artist, and particularly on a painter's place in colonial society, comes from Gooch's letter of reply to his brother:

> Mr. Bridges I have already loaded with civilities, tho' it looks a little odd for a Governour to show so much favor to a Painter, as to lend him a Coach, . . . His wagon for two days, . . . to entertain him at Dinner and Supper several times, . . . and to promise him as soon as He's settled that he will begin to show the country his art, by drawing my picture—but all this I have done upon your recommendation.[66]

Col. William Byrd also knew the artist, and his often-quoted letter to Governor Alexander Spotswood provides valuable insight into arts awareness and appreciation, at least as it prevailed among Virginia's elite during these years. After noting that Bridges was a man "of Good family" who had apparently suffered some financial setbacks, Byrd carefully qualified his assessment of the painter by saying, "Tho' he have not the Masterly Hand of a Lilly [sic] or a Kneller, yet had he lived so long ago as when places were given to the Most Deserving, he might have pretended to be the Sargeant-Painter of Virginia."[67]

It seems clear that Byrd and Spotswood were sufficiently familiar with the work of Sir Peter Lely and Sir Godfrey Kneller to cite them in a comparative context, referring to them by last names only. In fact, in 1702 or 1704 Byrd reportedly had his portrait done by Kneller in London.[68] Additionally, there are a handful of impressive English portraits surviving in Virginia families for these and later years, further supporting the idea that there was a limited degree of sophisticated taste and arts patronage among wealthy Virginia planters.[69]

Bridges did well in Virginia, executing portraits for Byrd and a number of principal families, including the Grymeses, Pages, Lees, Ludwells, Randolphs, Bollings, Custises, Carters, and others. His portraits of Alexander Spotswood and Commissary James Blair are among the most interesting in terms of monumentality and iconography, both exhibiting his sensitivity to colonial political and religious affairs.[70] Other portraits, like that of John Bolling, Jr. (cat. no. 17), are simpler in composition and smaller in scale, but they reflect a similar sensitivity to detail and characterization. Bridges's English training and his familiarity with formats and styles popularized in London studios (at this time largely based on the work of Kneller) are very evident in Bolling's likeness. The colors are pleasing, vibrant, and tonally well-balanced. The rich blue of Bolling's coat and the various siennas and pinks in the face demonstrate Bridges's fine sense of color and color balance. Other characteristics peculiar to his method include prominent noses with strong highlights, broad foreheads and undersized chins, well-defined lips, and sometimes prominent shading at the outer corners of the eyes, just below the brows.

Bridges's stay in Virginia can be documented by records through 1743, and it is believed that he was still painting there as late as 1744-45.[71] Shortly before his death he returned to England, where he was buried at Warkton, near his birthplace in Northamptonshire, on December 18, 1747. Bridges was an old man when he left Virginia, and the portrait style he had brought to the colonies was already being supplanted by the fanciful Rococo in London. It would be another decade before Virginians would have the services of an English artist working in this new fashion.

Jeremiah Theüs (ca. 1719-1774), roughly Bridges's contemporary in Charleston, South Carolina, was a younger man and was able to achieve far greater financial success. Theüs represents yet another of the South's early non-English painters who immigrated for

religious reasons. The Theüses were Protestants from Felsburg, Grison, in eastern Switzerland, near the German border. Continual religious persecutions had exiled many of the Swiss, like their fellow Germans, to foreign lands. Jean Pierre Purry, an early Swiss colonizer in Charleston, encouraged and promoted their eventual move to South Carolina.[72] The chief years of immigration were from 1733 to 1737, essentially the same period that Von Reck and the Salzburgers were settling Ebenezer in Georgia. The groups were known to each other. Von Reck's storekeeper, John Vat, was Swiss and had relations among Purry's South Carolina settlers before his own immigration with the Salzburgers in 1734.[73]

The Theüs family came on one of the two ships that arrived in Charleston during July 1735. They, along with some 460 other "Switzers," settled in Orangeburg, on the Edisto River, one of four townships established for them. How many members of the artist's family came is unknown, but records list the father, Simon Theüs, a brother by the same name who worked as a bookkeeper, and a second brother named Christian, who became a minister of the Reformed Church at Saxe-Gotha, the Congaree River settlement. Both Christian and Jeremiah knew leading religious men of their time. The Reverend Henry Melchoir Muhlenberg, a famous German missionary who visited the Swiss and Salzburger settlements, not only stayed with Theüs during his visits to Charleston but mentioned preaching to several German families in the artist's home. Jeremiah also entertained Israel Christian Gronan in his home, and he knew John Martin Bolzius.[74] One wonders if he did not also know of or meet the artist Von Reck before the latter's departure in 1736. Theüs may very well have been the "German Painter from Charlestown" who prepared two embellished copies of scripture verses for the Salzburgers in 1743.[75]

Theüs first advertised his services in Charleston on September 6, 1740. He noted that he did portraits, landscapes, crests, and coats of arms for coaches and chaises, and he pointed out that he was amenable to waiting on his customers at their plantations in the country. We know from records of the ensuing years that he did gilding and taught drawing, that he moved his place of business in Charleston several times, and that he married twice—first in 1741 to Catharina Elizabeth Shaumlefall (Shaumloffel) of Orangeburg and second, at an undetermined date, to Mrs. Eva Rosanna Hilt, a Charleston widow. Nine children

were born in these two marriages. In 1745 Theüs was elected a member of the South Carolina Society, a social, charitable, and educational group with no particular religious affiliation. Almost three decades later, the South Carolina Gazette made note of his death on May 17, 1774, adding that he was "A very ingenious and honest man." He left an impressive estate, further indicating the success this immigrant painter had achieved as a permanent resident of South Carolina's central port. That the artist could have carried on his profession almost exclusively in one Southern city and could have done so well is noteworthy because it reflects early on the special cosmopolitan, urban nature of Charleston, the South's most significant center during the colonial period.

Theüs was a meticulous painter, rendering likenesses in the conservative European and English Baroque manner, far superior to anything Charlestonians had been offered before. His portrait of Martha Vinson (cat. no. 24) of about 1765 reflects his best work. The colors are bright but realistically controlled through careful modeling. As is typical of Theüs's method, details of the costume and other accoutrements were executed in a precise, jewel-like manner. His compositional devices and formats are usually conservative and are based on conventional prototypes. Occasionally, Theüs would attempt, perhaps at the patron's request, grander full-length portraits, such as those of Mr. and Mrs. Barnard Elliott (figs. 12, 13) and Mrs. Peter Manigault. In each case the artist gave a wealth of detail, but the overall effect is awkward. Theüs was always at his best in smaller formats, and many of his children's portraits are distinguished by their charm and elegance, despite his inability to draw the human figure with accuracy. For Theüs, the Vinson portrait ranks a level above much of his usual output, for the figure has real presence.

There was little artistic competition for Theüs in Charleston during most of the years he worked there, and for this reason his patrons included most of the

OVERLEAF:

Figure 12. Jeremiah Theüs, Mrs. Barnard Elliott, 1766, oil on canvas, 50 by 40 inches (127.6 by 102.2 cm). Carolina Art Association, Gibbes Art Gallery, Charleston, 30.1.8.

Figure 13. Jeremiah Theüs, Colonel Barnard Elliott, 1766, oil on canvas, 50 by 40 inches (127.6 by 102.9 cm). Carolina Art Association, Gibbes Art Gallery, Charleston, 30.1.7.

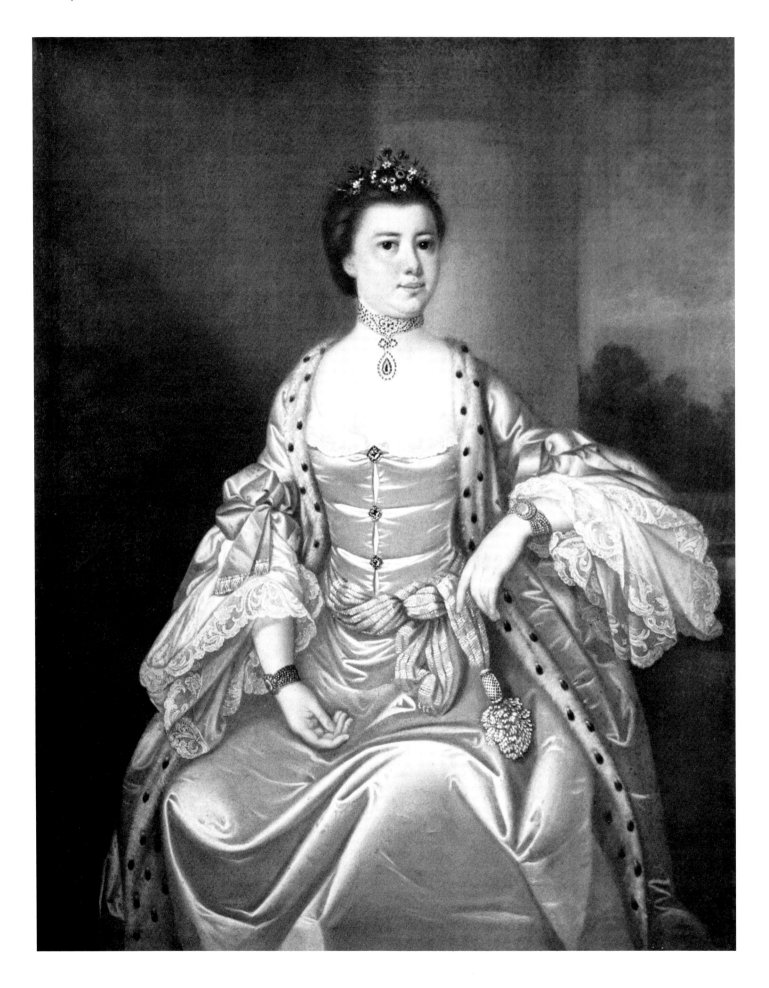

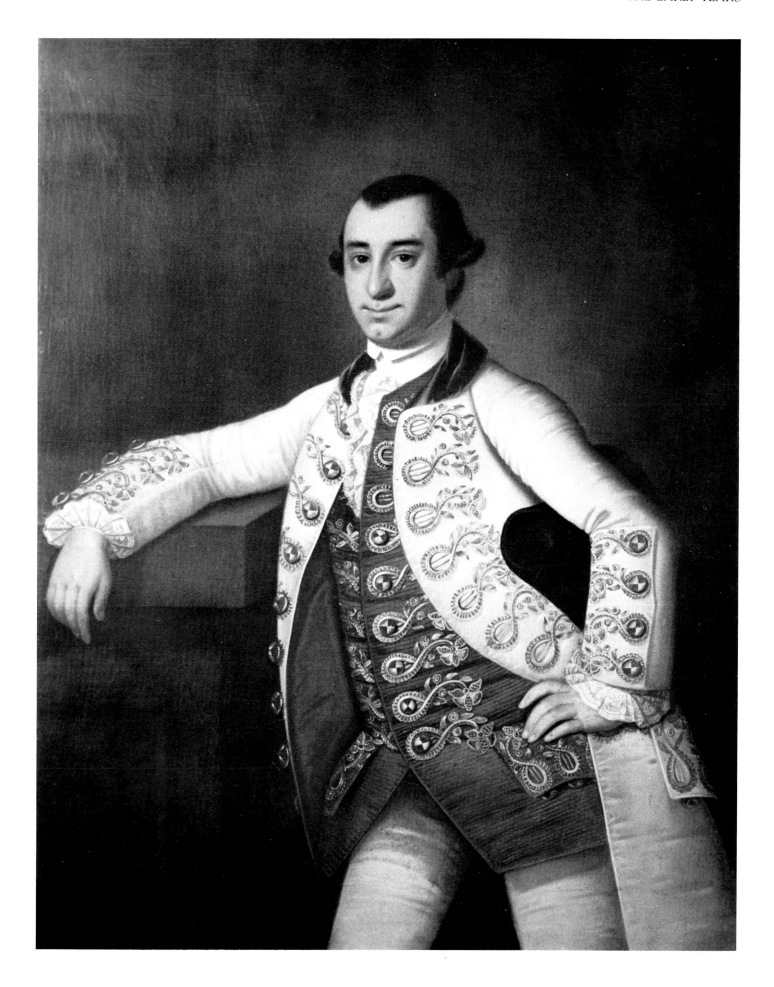

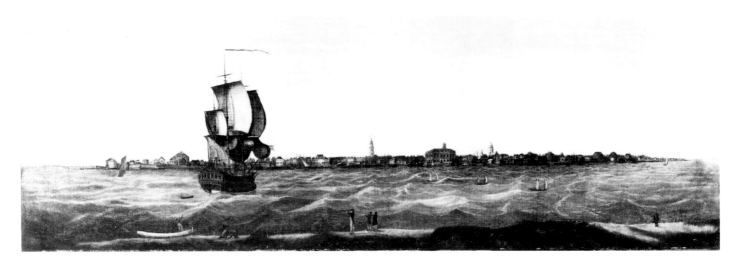

Figure 14. Thomas Leitch, View of Charleston, *1773-74, oil on canvas, 20 by 66 inches (50.8 by 167.6 cm). Museum of Early Southern Decorative Arts, Winston-Salem, North Carolina, 2024-30.*

city's wealthiest citizens, both planters and merchants, as well as its leading tradesmen, ministers, doctors, and attorneys. He may have known of or been acquainted with Bishop Roberts (died 1739) and Mary Roberts (died 1761), artists of modest ability and production. Our knowledge of the lives and careers of this couple is confined to information in their newspaper notices and research presented in Frank L. Horton's recent article on miniature portraits attributable to Mary Roberts.[76]

Both were probably active in Charleston by May 7, 1735, when Bishop Roberts advertised in the *South Carolina Gazette* that he did "Portrait-painting and Engraving, Heraldry and House painting." Additional notices by him appeared in Charleston papers for 1736 and 1737, the first expanding his repertoire to include landscape painting for "Chimney-Pieces of all Sizes" and views of houses in "Colour or India Ink." If works by him meeting the above descriptions survive, scholars have been unable to identify them.

Only one example by Bishop Roberts's hand is known, the "Prospect and Plan" of Charleston (cat. no. 16), now in the collections of the Colonial Williamsburg Foundation. This view, made from the opposite side of the Cooper River about 1737, was engraved by W. H. Toms in London and was probably distributed to subscribers in the colonies and abroad. It is considered the earliest surviving marine painting for

the coastal Southeast, since *A View of Savannah as it Stood on the 29th of March, 1734* by Peter Gordon (active ca. 1734) is known only through engravings.[77] A painting by Jean Baptiste Michel Le Bouteux (active ca. 1720) of John Law's concession, or trading post, at New Biloxi (in present-day Mississippi) (fig. 5) still ranks as the earliest of the Southern views of this type, and it equals the Charleston picture in detail and quality.[78]

Roberts's prospect was the first of at least three Charleston panoramas executed within a fairly brief period of time, spanning less than forty years. An artist by the name of T. Mellish (active ca. 1762) painted a similar scene sometime in or before 1762, when it was engraved by C. Canot in London.[79] By 1774 the English painter Thomas Leitch (Leech?) (active 1773-74) had completed the third prospect. Fortunately, Leitch's original oil-on-canvas version (fig. 14) survives, as does Roberts's watercolor. Together, they document something of the seaport's growth and activity during the mid eighteenth century. The Roberts work, the earliest of the three, illustrates a busy harbor with ships of various sizes, some fifty-two private residences, and a number of the city's public buildings. No doubt some of the color of this piece has faded through the years, but it remains a forceful statement in terms of architectural detail and the seaport's shipping activities.

Bishop Roberts died early in 1740, and it was his wife, Mary, who first advertised the engravings based on her husband's watercolor. The same 1740 advertisement also provides the earliest and sole mention of her work as a "face painter." Although no other records of her artistic career are known, an early miniature portrait of Charles Pinckney (cat. no. 19) signed "MR" is now believed to be by her. This likeness, dating circa 1745, is thought to be the earliest miniature executed in the South, if not in the American colonies. One other small likeness, of Samuel Prioleau of Charleston, has also been attributed to her. Both of these small portraits are capably rendered, each showing Roberts's mastery of the tedious stippling technique used for backgrounds by miniaturists working abroad. Perhaps she had learned the art there before coming to Charleston. Few miniature painters worked in the South prior to the Revolution. The popularity of such small, intimate likenesses in the South reached its zenith during the last decade of the eighteenth century and the early nineteenth century when numerous immigrant French miniaturists traveled throughout the area.[80]

William Dering (active 1735-1764?), a dancing master and artist with limited painting abilities, arrived in Charleston in 1750 and is documented there through part of 1751, but no pictures by him from South Carolina have been discovered.[81] He had been in Virginia and Pennsylvania before this. What we know of his career epitomizes the multi-faceted roles played by some less accomplished painters during these years, and the documented particulars of his life can be summed up rather quickly. In 1735 he advertised in the *Pennsylvania Gazette* as a dancing master and gave a description of his dancing classes. The next year a similar announcement of his Philadelphia business mentioned that he, and perhaps his wife, were teaching French, reading, writing, "marking," embroidery, "plain work," "and several other works."[82] It is not known if Dering was painting at this time, but he may have taught drawing at his school.

He arrived in Virginia sometime between February 1736, the date he is last mentioned in Pennsylvania, and November 18, 1737, the date of his first notice in Williamsburg's *Virginia Gazette*. Here, as in Philadelphia, Dering called himself a "Dancing-Master."

In 1739 he became a resident of Williamsburg, where he had purchased two lots and a dwelling (still standing, it is known today as the Brush-Everard House).[83] For the next eight years public records mention Dering only as a dancing master. The single reference to his painting activity is found in the ledger book of John Mercer, a Stafford County, Virginia merchant who traded paints to Dering for a portrait. Dering also provided accommodations for Mercer when he was in Williamsburg for general court sessions between 1748 and 1750. Only one of the eight pictures attributed to the artist is signed, that of Elizabeth (Drury) Stith (now owned by the Colonial Williamsburg Foundation).

The artist/dancing master was in financial trouble by the mid 1740s, and after mortgaging most of his property he apparently left Virginia for Charleston, South Carolina, where his name appeared in newspapers in 1750, along with that of a Mr. Scanlan, advertising a ball in Charleston. His name is found in other public records for Charleston during 1751, and a William Dering is mentioned there even as late as 1764.[84] The Dering (Deering, Dearing) surname is not common in Charleston, but it does occur in a few of the city's eighteenth-century records. In the constant search to interrelate or demonstrate some contact among artists in the South, Dering remains a possible candidate. The incomplete documentation of Henrietta de Branlein Dering Johnston's siblings offers an interesting possibility of the two artists being related. Perhaps Dering was, in fact, kin to the early Charleston pastellist and her children. Curiously, one of the New York pastels attributed to Johnston bears an uncanny resemblance to Dering's work.[85]

Dering's Virginia paintings, which are the only ones known, are less polished than those of Bridges, his predecessor, but they are as pretentious as any images commissioned by colonists. Dering tended to imitate the high Baroque style, and his flat areas of color, often brilliant and rich, are a delight to the viewer. The portrait of George Booth of Gloucester County, Virginia of ca. 1748-50 (cat. no. 18) is the most appealing of the eight portraits now attributed to him. The setting is elaborate, most likely inspired by mezzotint sources. Certain aspects of this picture, however, suggest that Dering relied on his own inventiveness. The presence of the bold female busts has no known direct parallel in print sources, while the exaggerated teeth on the young master's dog can best be described as whimsical. Attributes of masculinity, evident here with the bow, arrow, and retrieved game, are often seen in early Southern portraits of young gentlemen from the mid-Atlantic colonies.

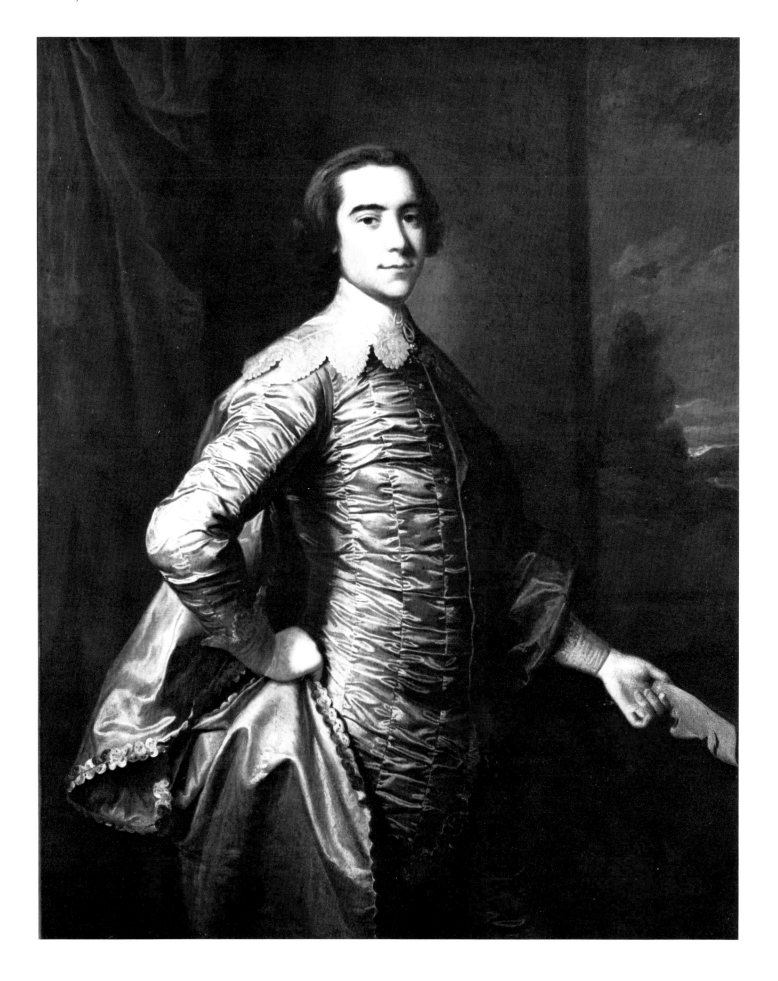

With the exception of Theüs, William Dering was the last of the known artists practicing a basically Baroque style in the South. Although artists of Dering's limited training and ability would continue to work in the South throughout the eighteenth century and the early years of the nineteenth, the names of most of these painters and frequently those of their sitters are unknown to us today.

It is evident that from the early years of the eighteenth century, most colonials looked to London as the cultural center of their world. What was fashionable there was often sought or imitated on this side of the Atlantic, whether it was in painting or cabinet-making or any other category of decorative-arts production. English craftsmen immigrating to the colonies frequently advertised that they were "late from London" or "London trained" as a means of informing prospective clients that their products would be fashioned in the latest London tastes. English goods of all sorts proliferated in the colonies, as indicated in the plethora of advertisements found in colonial newspapers. Merchants and planters sometimes ordered directly from London, and the latter, through their agents, often provided specific descriptions of items they wished to purchase. Portrait commissions to London-based painters were a further manifestation of the Southerner's English orientation. Various mid-eighteenth-century English portraits executed for Southern patrons, principally from Virginia and South Carolina, have survived, but few approach the splendor and quality of Thomas Hudson's likeness of Robert Carter (1728-1804) (fig. 15), executed in London about 1750, just after Carter's graduation from the College of William and Mary in Virginia.[86] The young man is shown in elaborate dress with a face masque in hand, evidently as he would have been attired for a masquerade ball.

Portraits like Carter's, while not executed on Southern soil, have importance in this discussion because they reflect the pinnacle of sophisticated Southern arts patronage and awareness. The Carter family figured prominently in Virginia politics throughout the eighteenth century.[87] Robert (King) Carter, the sitter's grandfather, was considered the richest man in the colony during his lifetime. Handsome houses were built for Carter and his children, and their furnishings must have been commensurate with their high architectural quality. Numerous Carter family portraits, which undoubtedly graced the walls of these houses, survive to document a long and impressive history of arts patronage on both sides of the Atlantic. Robert Carter's portrait by Hudson might be called the best of these pictures in terms of aesthetic quality and imagery. The opulent fabrics, the graceful demeanor, and the choice and meaning of the costume and masque assure us of the young colonial's personal and material worth as well as his self-confidence as a visiting gentleman in London society.

A preoccupation with leisurely pursuits, such as balls, dancing assemblies, horseracing, gaming, and the like, was central to the eighteenth-century upper class way of life. Direct pictorial references to these pleasurable moments are rare in Southern colonial painting, although gestures and iconographic detail sometimes reinforce the notion that life was graced with elegant pastimes. Portraits executed for wealthy planters and merchants in the Southeastern colonies show a real preference for such details by the 1750s. This was due to certain stylistic changes and developments occurring in London studios during these and earlier years, which reflected a shift in cultural and social attitudes. Lush pastel coloration, graceful curving lines, and an overall emphasis on the decorative aspects of costumes typify this new painting style which is sometimes referred to as the Rococo—a late manifestation of, or reaction to, the Baroque fashions that preceded it. The most important of the English painters to introduce this fashion to the colonies was John Wollaston (born ca. 1710, died after 1775).

Wollaston's early life is largely undocumented. He was the son of John Woolaston (or Wollaston), also a portrait painter, as indicated in Horace Walpole's 1765 edition of *Anecdotes of Painting in England*.[88] Charles Willson Peale recalled that the younger Wollaston had studied in London. He probably had his first lessons from his father and then moved on as a student in one of the many studios of painting then in the Covent Garden area of London. Peale further noted that Wollaston "had some instructions from a noted drapery painter in London."[89] Although there is no

evidence as to who this drapery painter was, Wollaston's style compares favorably with the early works of Thomas Hudson, a well-known English portraitist who furnished portraits for Virginians in the 1750s. Interestingly, Hudson's teacher was Peter Toms, an artist whose reputation as a drapery painter was well known during these years.

As in the case of Bridges, so few of Wollaston's English portraits are known that it is impossible to assess in detail his career there. The earliest of his known English work is a portrait of James Monk, dated 1733.[90] His *George Whitefield in the Attitude of Preaching* is, perhaps, his most interesting English picture.[91] It suggests, again, the binding religious involvements of a number of artists who came to America. Wollaston's father has been called a religious fanatic, and it may have been through him that John, Jr., met Whitefield.[92]

The last documented reference to Wollaston in London is for 1748. His father's death the next year may have influenced his decision to visit the colonies, for he had arrived in New York City by June 23, 1749.[93] He painted at least seventy-five likenesses during his stay in New York, where his clientele, as they would be elsewhere in the colonies, were the socially and politically prominent. He visited Philadelphia in 1752 and then moved to the Annapolis area, where, in March 1753, a Maryland admirer was moved to write several verses praising "Mr. Wollaston."[94]

Wollaston executed a number of likenesses in Maryland, including portraits for the Bordley, Calvert, Carroll, Johns, Key, and Dulany families. He continued south from Maryland into Virginia where, in 1755, he copied a portrait of Colonel William Randolph II. During the next two years more than sixty-five Virginians had their faces recorded by the artist. As an itinerant painter, he moved from one household to another, producing elegant portraits with facility and speed. On October 21, 1757, Mrs. Daniel Parke Custis paid Wollaston fifty-six pistoles for three portraits he had done for the family.[95]

The artist's Virginia likenesses are usually large, showing the sitters standing or sitting in three-quarter-length attitudes, as in the portrait of Mrs. Anthony Walke (cat. no. 22). His compositions and poses, basically those he knew from his studies in London, were drawn heavily from the Knelleresque and its various Rococo interpretations in London studios. His repeated use of landscape settings, however contrived they may seem, adds significantly to the splendid decorative effect of these images. Wollaston was an uninspired but competent painter in the sense that so much of his work is standardized and repetitive; facile modeling and brilliant passages of fabric compensated for his limited regard or facility for correct anatomical drawing and realistic, penetrating likenesses.

Wollaston left Virginia sometime in 1757 or early the next year and was either in or near Philadelphia in September 1758 when the *American Magazine* published Francis Hopkinson's poem eulogizing his pictures.[96] His stay there can be documented through part of 1759,[97] but it is not clear where he went immediately after this and before his arrival in South Carolina in 1765. Scholars once claimed that he went to the British East Indies, but recent research indicates that he was in the British West Indies at St. Christopher's Island (now known as St. Kitt's) during a portion of this time.[98] Just how long he stayed in the Leeward Islands and whether or not he painted there is not known. There can be little doubt that he journeyed directly from the Caribbean to Charleston, South Carolina, where he was working by September 27, 1765.[99] Commerce and trade between South Carolina and the West Indies was extensive during these years, with ships from the Caribbean arriving in the Charleston port almost daily.

Wollaston painted in Charleston through 1766 and most of 1767, but only a small number of his portraits have been found there. Near the end of his stay, Eliza Lucas Pinckney noted in a letter that "Wollaston had summon'd me today to put the finishin' stroke on my shadow, which streightens me for the time."[100] Unfortunately, Eliza's picture has not survived, but her reference and similar ones for Jeremiah Theüs give us a notion of the number of sittings required for a finished portrait.[101] Although not included in this exhibition, Wollaston's Charleston portraits are distinctive from those he did in Virginia and the Northern colonies. By this time he was painting with greater self-assurance, incorporating more up-to-date frontal poses and using a palette of colors far more delicate in tone.

Theüs was still active in Charleston during these years, and it would be interesting to know of his reaction to this Englishman's work. They must have been aware of each other, since Wollaston accepted commissions in several households where paintings by Theüs were hanging, including those of the Gibbes, Holmes, Pinckney, and Ravenel families. Two existing portraits of Benjamin Smith that are nearly identical in pose and costume detail suggest that either Wollaston copied a portrait by Theüs, or vice versa.[102]

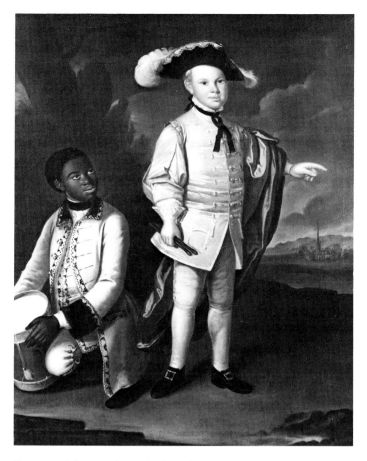

Figure 16. John Hesselius, Charles Calvert, 1761, oil on canvas, 50 by 39¾ inches (127.7 by 101.3 cm). Baltimore Museum of Art, Gift of Alfred R. and Henry G. Riggs, in memory of General Lawrason Riggs, BMA 1941.4.

Wollaston's stay in Charleston was probably cut short by the political controversies that ultimately culminated in the American Revolution. Charles Willson Peale noted that he was in London in 1769, and another reference indicates that he was still living in England in 1775.[103] His importance to Charleston's artistic heritage and to that of the Southern colonies cannot be overestimated. He popularized decorative portraiture more than any other artist of his time. He was the most prolific artist to work in the mid-eighteenth-century colonies, and a list of his sitters reads like an eighteenth-century social register. We may scoff at his insipid smiles, impossibly posed hands, elongated necks, and almond-shaped eyes, but these were important conventions of the style he practiced and they followed society's concept of fashion and correct deportment during these years.[104] Evidently this was the elegant, seemingly unrealistic, and carefree way many wealthy eighteenth-century Southern

colonials wished to be portrayed and remembered. Wollaston's visit was a timely one, for his style perfectly suited the needs of the aspiring Southern aristocracy, itself a bourgeois echo of the English gentry.

The dash and pomp of Wollaston's portraits were not ignored by other artists patronized by Southerners during this period. John Hesselius (1728-1778), the son of Gustavus Hesselius, was quick to adopt Wollaston's Rococo mannerisms. He had probably received his first painting lessons from his father, but he was more ambitious and sought out the academic and successful Baroque style of Robert Feke, whose work he doubtless saw in his home town of Philadelphia. In fact, he may have traveled to Virginia with Feke around 1750.[105] It was about this time that John Hesselius launched his career, not in Philadelphia, but in Virginia. His Virginia portrait of Alice Thornton Fitzhugh (cat. no. 20) typifies his early style and signifies his indebtedness to Feke in the formal, rigid pose, Baroque coloration, and details of the costume.

Hesselius worked in and out of Virginia and Maryland during the years that Wollaston was there, although he made his home in Philadelphia until 1760 and may have made additional painting trips to Delaware and New Jersey. In 1760 he moved permanently to Anne Arundel County, Maryland. The next year he received perhaps the most important of his Maryland commissions, to paint portraits of Benedict Calvert's children. Wollaston had worked in the same household just a few years earlier. The portrait of Charles Calvert (fig. 16) is reminiscent of Kühn's likeness of Henry Darnall in that it includes a page or attendant. Here, the black slave's facial features are more detailed than in Kühn's portrait, but the head is partially obscured in shadow and seems to disappear in the dark background. The treatment of the black figure and the absence of additional documentation make it especially difficult to determine whether the representation is mere symbolic imagery or a portrayal of an actual person. If the latter, one might wonder if the slave, like his young master, actually posed for the portrait and what his reaction to the likeness was. One might also wonder about Hesselius's own attitude towards the use of blacks in portraiture. He seems to have favored it because about six years later, in a portrait of his son, Gustavus, Jr., he included the child's black nurse.[106]

Among Hesselius's finest portraits is that of Mrs. William Tilghman (fig. 4; cat. no. 21), which dates circa 1765. The lovely blue color of her dress and the precise way in which the artist articulated and mod-

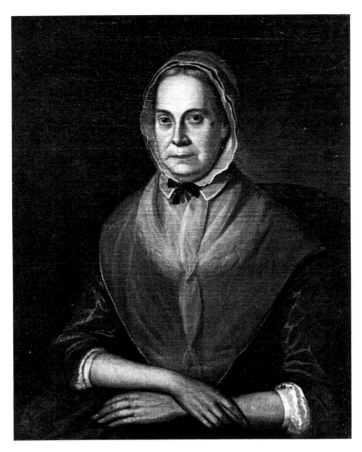

Figure 17. John Hesselius, Portrait of Mrs. Thomas Gough, *1777, oil on canvas, 30 by 25 inches (76.2 by 63.5 cm). Washington County Museum of Fine Arts, Hagerstown, Maryland, A 679,52.03.*

eled each fold and all the laces attest to Hesselius's skill. In terms of approach and artistic ability, one senses a real kinship between Hesselius and Jeremiah Theüs. Their works are tight, conservative, and superbly finished. Both were painters of detail rather than impression, and in this respect Hesselius never mastered Wollaston's much freer interpretation of fabrics and the like.

Hesselius is interesting to us not only because he was a successful and skilled painter in the Rococo style, but also because, like Theüs, he lived into the Revolutionary War years, dying in 1778. His portrait of Mrs. Thomas Gough of Maryland (fig. 17), painted in 1777,

the year before the artist's death, is the last known likeness documented to him; it is a curious departure from what we consider typical of Hesselius's style. [107] The lavish fabrics, the polished decorative quality, and the flaccid smile are not seen here. The opulence and English conventions he had learned first from Feke and then from Wollaston have vanished. In their place we find a sensitive, subdued rendering of a human being. One looks at the face of Mrs. Gough and realizes her quiet strength and a sense of her personality.

Why Hesselius turned to this more natural, realistic interpretation is not known. His contact with London studios, where the advent of realism and the new Neoclassical taste were already established by the 1760s, was probably minimal. In a small yet significant way, what Hesselius achieved in this single picture mirrors the work of Copley in New England and the paintings of Charles Willson Peale, who received his first painting lesson from John Hesselius. There are many interesting issues that could be raised here, particularly regarding the concept of an expanding arts patronage that coincided with the war years, when slogans of freedom and democracy were commonplace. Perhaps Hesselius had, in fact, made contact with Peale after his return to America from London in 1769. Whatever the reasons, Hesselius was among the first of the known Southern Rococo artists to discard the style and offer realistic portrayals of middle-class citizens in Maryland.

The Virginia work of John Durand (active 1765-82) provides an interesting and roughly contemporaneous parallel to that of John Hesselius. Durand was probably French, perhaps an immigrant to the colonies. [108] Facts about his early training and life continue to elude historians, but his early portraits executed in New York City suggest a knowledge of the Rococo likenesses of Lawrence Kilburn and possibly John Mare. Durand's work in New York has received far greater attention by historians than has his career in Virginia, which appears to have been equally, if not more, extensive. He is documented, through signed portraits and manuscript references, as having been in Virginia in 1765, from 1767 through 1771, again in 1775, and in 1780. [109] In 1782 his name appeared on a tax list for Dinwiddie County; the last known reference to him, it apparently indicates that he had established his residence there. [110]

Durand's portrait of Edward Archer II (fig. 18; cat no. 28) characterizes the best of the pictures he executed in Virginia. [111] Durand saw and depicted his

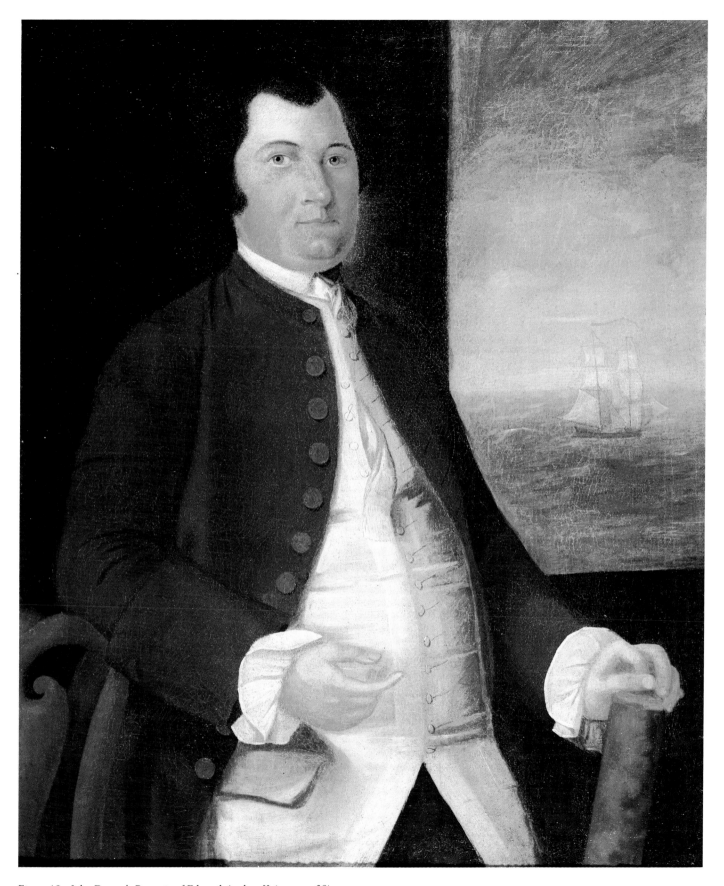

Figure 18. John Durand, Portrait of Edward Archer II *(cat. no. 28).*

figures in terms of outlines and flat areas of color, much as William Dering had done some twenty years earlier, but he did so with greater facility in rendering details. In Archer's likeness he used color for pattern, and through crisp delineation of the fabrics and other details he was able to achieve the kind of decorative interest that must have appealed to his patrons. He maintained this basically flat Rococo style until about 1771, working not only for wealthy planters but also for merchants and middle-class planters in Virginia. Between about 1771 and 1774 his work is inexplicably uneven, ranging from high quality pictures comparable to the Archer likeness to portraits lacking definition and his usual pastel coloration. His later work, exemplified by two 1775 portraits of Mr. and Mrs. Gray Briggs (figs. 19 and 20),[112] shows a distinct improvement in technique and vision. Although his portrait formats continued to be typically Rococo and similar to those popular throughout the first half of the eighteenth century, the characterization of his sitters' faces became increasingly realistic.

As with Hesselius, we do not know what artistic influences or events affected Durand's new realization and regard for his subjects. These changes also seem tied to the Revolutionary years, a shift and expansion in patronage, and the return to America of painters like Charles Willson Peale (1741-1821) and Henry Benbridge (1743-1812)—painters who brought with them a Neoclassical style embracing realism.

Peale, the elder of these two men by two years, was born on April 15, 1741, in Queen Anne's County, Maryland. A great deal is known and has been published about his life and work, far too much to relate in detail here. The late Charles Coleman Sellers, Peale's biographer, discusses his early life in one of his two volumes on the artist, noting that the family was poor and that Peale's widowed mother supported her five children by working as a needlewoman in Annapolis.[113] Peale was apprenticed to a saddler and wood carver at age twelve, and by 1762 he had established his own saddlery shop on Church Street in Annapolis. He eventually added watch and clock repairing to this business. His early interests in painting were aided by Hesselius who, in exchange for a saddle, gave Peale his first lessons in rendering portraits. Apparently the young Peale had real talent, since he fulfilled enough commissions for Annapolitans during this time to draw attention to his work. Less than four years later, eleven notable Annapolis gentlemen subscribed 74 guineas and 8 pounds to finance Peale's painting studies in

London under Benjamin West, the gifted Pennsylvania artist who would eventually become president of England's Royal Academy. Their investment was well made, for Peale was destined to become one of America's leading artists, a skillful engraver, the proprietor of one of America's first museums, a clever inventor, and, most importantly, the founder of a family dynasty of painters that has no parallel in the history of American painting.

When Peale returned to America in 1769 he made his home in Annapolis, traveling from there to areas in Maryland, Virginia, and throughout the middle colonies to paint portraits. He soon became the chief portrait painter in those areas, with patrons in many wealthy upper- and middle-class households. There were no other artists in the region who could compete with Peale's delicate precision and his realistic Neoclassical style. Wollaston had departed the colonies some years before (Peale had noted his appearance in London in 1769). John Hesselius's advanced age precluded extensive travel.

More central to Peale's success was that Peale the person and Peale the painter were particularly suited to the times and the needs of his patrons. He shared their colonial pride and their desire for achievement. His own middle-class background and struggles were legacy to his lifelong philosophy that one could accomplish whatever one wished. He always claimed that this was true of painting. He was genuinely interested in promoting the arts in America, observing in a 1771 letter to Benjamin Franklin that "The people here have a growing taste for the arts, and are becoming more and more fond of encouraging their progress amongst them." To this evocation, Franklin replied that

> The Arts have always travelled westward, and there is no doubt of their flourishing hereafter on our side of the Atlantic, as the number of wealthy inhabitants shall increase, who may be willing suitably to reward them; since, from several instances, it appears that our people are not deficient in genius.[114]

Peale was tremendously energetic, with broad interests ranging from the politics of the Revolution to many branches of the arts and sciences. These attributes culminated in Peale's intense loyalty to the American cause and his devotion to his art, and to all things that would enhance the lives of his family and countrymen.

Much of his enthusiasm and national pride is reflected in his painting, in both his historical pieces and his privately commissioned portraits. A superior

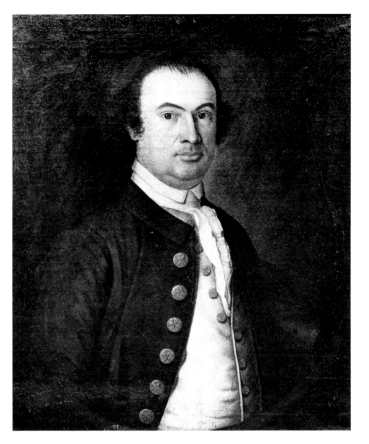

Figure 19. John Durand, Mr. Gray Briggs, 1775, oil on canvas, 30⅛ by 25 inches (76.5 by 63.5 cm). Private collection.

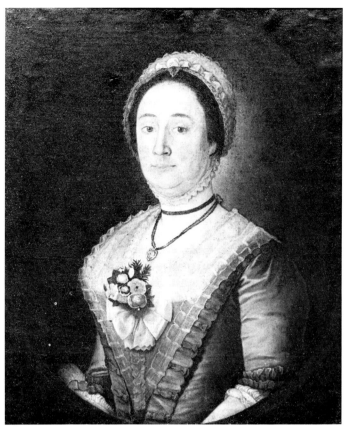

Figure 20. John Durand, Mrs. Gray Briggs, 1775, oil on canvas, 30 by 25 inches (76 by 63.5 cm). Private collection.

example of the latter is Peale's double portrait of William Smith and his grandson (fig. 3; cat. no. 30), painted in Baltimore in 1788. Because so much is known about this picture and the details of its commission and execution, it provides a rather important glimpse of Peale's method and his interaction with his patrons.[115]

Peale began working on the portrait on October 10, 1788. Just four days before, Smith had been elected a congressman to represent Maryland in the new federal government. The portrait was commissioned by Otho Holland Williams, Smith's son-in-law. Presumably the intent was for Peale to record Smith alone, in a manner reflecting his new role as statesman. But on October 11, Peale noted in his diary that "Mr. Smith sat this morning; and he desires me to paint his grandson in the same piece."[116] This was clearly a departure from the son-in-law's original request and the likely purpose of the portrait. It pleased the sitter, however, and it was equally agreeable to the artist, who was accustomed to including children in his domestic portraits. Peale noted that he added an additional seven guineas to the twelve guinea price for including the child.

The handsome finished portrait possesses what Charles Coleman Sellers appropriately called "Monumentality with Love."[117] Sellers elaborated further on the inclusion of two-year-old Robert Smith Williams and how it changed the conceptual aspects of the picture, making it "half state portrait, half domestic piece." Since Sellers's interpretation of this painting is particularly insightful, it is quoted in part here:

> Peale would add a view of the family homestead (Eutaw) and busy little mill outside of town, and then, to that, still life appropriate to the country gentleman . . . proclaiming in one breath the public and the private citizen. Foreground table and books are a thing apart from the columns and they from the Hall of Congress, which abuts directly upon the wall of the mill. By sloping path and lawn, however, Peale relates the home views to the child and foreground. The elements can be read without confusion, the domestic prevailing, the monumental a background statement only.[118]

Peale had already moved his family to Philadelphia at the time he painted the Smith likeness, but he maintained close ties with Maryland friends and continued to paint portraits for families in that area for many years. Several of his children would also live and work in Maryland in the ensuing years.

In Philadelphia, Peale served on the city's militia, was an officer in the regiment that fought at the Battle of Princeton, and visited the encampment at Valley Forge. These events and the men who led American campaigns against the British throughout the colonies became the chief preoccupation of the artist. He painted America's heroes whenever the opportunity arose, whether on the battlefield, in encampments, or later in their homes or in his studio. Peale possessed an intuitive sense of history, and to that end he dedicated his energies to paint all the American and French leaders of the Revolution. This collection of portraits, known as the "Gallery of Great Men," was shown during Peale's lifetime at the State House in Philadelphia. Among the pictures was Peale's memorable portrait of Washington at Yorktown (fig. 21), which had been commissioned by the State of Maryland in 1783.

During this same period Peale's interest in natural curiosities led him and his growing family of children on endless collecting forays to the countryside, ultimately culminating in his Museum of Natural History. When this remarkable man died in 1827 at age 86, he was still full of zest, and no doubt he had plans for even greater accomplishments. He left a large family, many of them talented painters who would continue for another century the tradition their father had begun. None of them, however, ever possessed the energy or degree of intellectual curiosity that had motivated their father. Peale himself expressed these qualities so well when he wrote, "Nature . . . expands the mind to embrace object after object, and the desire is still fed in an endless maze and contemplation of the wondrous works of Creation."[119]

On February 5-7, 1784, the *South Carolina Gazette and General Advertizer* carried a notice, signed anonymously "Another Patriot," which stated, in part:

> It is amazing what progress the Pencil made at Philadelphia, in the most distressing periods of the war, in the hands of a Peale. The season of peace, so favorable to Science, is now our own; let therefore, a generous emulation arise, and what our sister of Philadelphia has made a Peale, let Charleston make a Wright and a Banbridge [sic]. . . .[120]

There are three points worthy of scrutiny in this brief, capsulated quote. First, it seems clear that Charles Willson Peale's reputation was widespread in the colonies, and secondly, that Henry Benbridge was considered his equal by at least one Charleston admirer. Additionally, the author implies that Benbridge's and Wright's (Joseph Wright?) success depended upon Charlestonians and their patronage.

The unidentified author presented an accurate forecast of the role Peale's contemporary would play in Charleston during the next eight or so years. What the writer did not mention was Benbridge's earlier stay in Charleston. Fortunately, many of the details of his previous Charleston work and an in-depth appraisal of his career have already been researched and published by Robert G. Stewart of the National Portrait Gallery.

From this study we learn that Benbridge was born in 1743 in Philadelphia, that he began painting as early as 1758, and that he studied abroad and returned to his native Pennsylvania in 1770. In 1772 he married Esther Sage, an accomplished miniature painter who had taken some lessons from Charles Willson Peale. Sometime during 1772 the artist and his wife settled in Charleston, which Benbridge apparently selected as his permanent residence. Their only child, a son named after his father, was born in December 1772. Esther Benbridge (often called Hetty) probably died before May 1, 1773. The artist never remarried, and he resided in Charleston intermittently through part of 1792 and perhaps later. His son had established residence and opened a business in Norfolk, Virginia, by 1801, and it was to this home that the father moved, in or before 1801.[121]

Henry Benbridge, like Peale, was among the few American-born artists afforded the opportunity to study abroad in England and, in Benbridge's case, in Italy. There he met Thomas Patch (1725-1782), an English artist noted for his caricatures and small con-

Figure 21. Charles Willson Peale, George Washington at Yorktown, 1780, oil on canvas, 21³/8 by 29⁹/16 inches (54.3 by 75 cm). The Maryland Historical Society, 1845.3.1.

versation-size portraits. Stewart points out that Benbridge was influenced by Patch's work, but that the extent of that influence deserves further research. A survey of Benbridge's American paintings indicates that he executed a number of conversation-size portraits in which the heads of his sitters are sometimes a bit exaggerated or outsized, just as they often are in caricature. The artist's intention, however, was always to paint realistic likenesses of his fellow countrymen.

Most of Benbridge's full-size Charleston works are of superb quality. The colors are clear and the backgrounds sometimes take on the appearance of fully-developed landscapes. The classical pose and rich colors used in his portrait of Rachel Moore (fig. 22; cat. no. 25), mother of the artist Washington Allston, illustrate his indebtedness to those years spent abroad, since it was there that he probably learned to use glazes. This method of building up thin layers of translucent colors accounts for the slick texture and jewel-like coloration of his finest pictures.

Like Peale in Philadelphia, Benbridge brought to South Carolina an academic style suited to Charlestonians. His portraits are precise and realistic in detail, direct and formal in composition and pose. They reflect quiet dignity, wealth, and the sophisticated level of taste in Charleston during the late eighteeth century.

Benbridge also executed miniatures in Charleston. His small likeness of Richard Moncrief (cat. no. 26), a Charleston carpenter, typifies the best of his work in this medium and is remarkable for its realistic representation of this robust gentleman. Moncrief, who is mentioned as the contractor for the Miles Brewton house in 1769, was only one of numerous citizens from the merchant-craftsman class who by the 1770s could afford to commisson pictures from Charleston's chief artist.

Benbridge's artistic activities in Virginia are less well known, and only two paintings from that period of his life can be assigned to him at this time.[122] These conversation-size group portraits, featuring members of the families of Frances Stubbs Taylor and William Boswell Lamb (cat. no. 27), compare favorably in style and drawing with the artist's earlier Charleston and Philadelphia paintings. The modeling is solid but a bit less spectacular. While the faces of the Virginia sitters are convincingly realistic, the bodies are somewhat awkward in pose and proportion. Benbridge's life-long inability to draw the human figure accurately is often one of the most telling characteristics of his work.

The artist's Norfolk pictures seem, at first glance, totally unrelated to the striking and colorful portraits executed in Charleston and Philadelphia. There are some minor differences in technique, but the basic distinction is unrelated to the artist's method and has more to do with changes in fashion and fabrics at the turn of the century. The costumes in the Virginia portraits are dull in color and embellishment when compared with the satins, silks, laces, and other finery fashionable in Charleston during the 1770s and 1780s.

One wonders in passing whether Benbridge, as a Pennsylvania artist in the 1760s or as a Charleston widower in the mid 1770s, encountered William Bartram, the Quaker naturalist whose *Travels* (1791) introduced the Southern landscape to a generation of romantic European writers, including Wordsworth and Coleridge. The son of botanist John Bartram, he was born in Philadelphia in 1739, two years before Peale and four years before Benbridge. He resided for several years in North Carolina and then roamed extensively throughout the South on the eve of the American Revolution, supplementing the evocative and detailed notes of his journey with distinctive sketches and watercolors of the flora and fauna. These were shipped to John Fothergill, Catesby's English patron, and some survive in the British Museum, revealing the same blend of scientific observation and romantic awe toward nature that infuses his prose (fig. 23). Unlike Peale, Benbridge and Bartram concluded their lives quietly and with little recognition. Benbridge died early in 1812 and was interred on January 25 at the cemetery of Philadelphia's Christ Church.[123]

With the exception of Charles Willson Peale, Benbridge was the only American-born artist with formal training from abroad to work extensively in the South prior to the 1790s.[124] His decision to live in Charleston for most of his career is, again, related to the earlier observations that this was the South's leading seaport and that by Benbridge's time its inhabitants possessed considerable wealth and a degree of sophistication that was not exceeded elsewhere in the South. After the Revolution it would quickly reassert its leadership in attracting American and foreign painters. Savannah, Georgia, benefited from its proximity to Charleston, since artists from South Carolina, including Benbridge, are thought to have visited there.[125]

Art patronage in Charleston, as in Maryland and Virginia for at least part of the eighteenth century, was never confined to what was locally available. As early as 1750, wealthy South Carolinians, like Peter Mani-

Figure 22. Henry Benbridge, Rachel Moore (cat. no. 25).

Figure 23. *William Bartram, Turtle, 1791, copperplate engraving from* Travels through North and South Carolina, Georgia, East and West Florida, the Cherokee Country, the extensive territories of the Muscogules, or Creek Confederacy, and the Country of the Choctaws . . ., *Philadelphia, 1791. Virginia Historical Society, Richmond.*

gault, were commissioning portraits from leading London painters such as Allan Ramsay.[126] Judge Egerton Leigh of Charleston had amassed an impressive collection of European pictures (either originals or copies) by the time of his death in 1774, including works by Paolo Veronese, Carladossi, Luca Giordano, Ghisoli, Correggio, and Guido Reni.[127] Three years earlier, Arthur Middleton and his wife had engaged Benjamin West in London to paint a formal portrait of them with their son Henry,[126] and in 1775 another prominent Charleston couple, the Ralph Izards, commissioned a far more elaborate double portrait from the London-based American John Singleton Copley.[128]

Charleston's Henry Laurens also sat for his portrait in Copley's London studio (cat. no. 29). The sitting took place shortly after his release from the Tower of London on December 31, 1781. This important portrait ranks among the most powerful and revealing images of an American done during these years. Rich in coloration and detail, as was typical of Copley's technique, it also seems to evoke issues that were peculiar to Laurens the man, as an American patriot and a Southern gentleman. There is a great deal in this picture to assure us of Laurens's wealth and sophistication—conservative yet expensive velvet attire, the stylish, elaborately carved, and gilded chair and footstool, a spacious setting with all the trappings of grand portraiture.

It is an aristocratic image, but it goes far beyond the kind of formularized decorative pictures popularized by Hesselius, Wollaston, Theüs and, to a lesser degree, Benbridge. Much of this can be credited to Copley's realism and Neoclassical style, and very likely to Laurens's supervision of the portrait in progress. It is a difficult portrait to interpret with any degree of accuracy because Laurens was himself a man of diverse interests and complexity. George C. Rogers, Jr., noted Laurens scholar, has said that the "attitude of Henry Laurens was American, not European; it was republican, not aristocratic. Land and objects were to be acquired for use rather than ornament."[129] Rogers explains the Copley portrait by noting that "Laurens did . . . have his share of vanity . . . [and] wanted to be remembered by posterity."[130] Perhaps after the facts are researched and evaluated we will find that Laurens was, like his fellow statesman John Adams, "a man wracked by conflicting feelings of vanity and modesty."[131] Finally, perhaps this conflict was indicative of the times and of a much broader segment of America's wealthy class than we now know.

Laurens, the wealthy American statesman, and many others of his generation and financial station would undoubtedly continue to see themselves and their lifestyles in images like these, but their children and grandchildren would eventually champion a less opulent, more conservative style. These changes would be gradual even though before 1782 they had already begun with artists working on the home front such as Charles Willson Peale, and before him John Hesselius and John Durand.

Art patronage in the South and throughout America was expanding almost as fast as the country's rising middle class during these years. Naturally, with an increase in patronage came a swell in the numbers of artists offering their services. The 1780s and 1790s, therefore, were exciting years, since they introduced budding new painters who would learn their art anyway they could—in the studios of a Peale or a Benbridge, abroad, or, if necessary, by their own devices.

Competition had never been a critical issue among the artists traveling throughout the South during the colonial period, but it would figure prominently in the 1790s. This was due, in part, to the large number of immigrant painters who came to America as refugees of the French Revolution. The result of this diversity in the various types of painters, who ranged widely in expertise and offerings, would be a rich mixture of personal styles, formats, and mediums. The aristocractic ideals that nurtured arts patronage in the colonial South gave way to less pretentious, in some ways more profound, and in most ways more realistic portrayals of the American Southerner. ✖

NOTES

1. Percentage calculations are based on data collected and compiled by the author, Whaley Batson, and others at the Museum of Early Southern Decorative Arts, Winston-Salem, N. C., in "A Checklist of Artists Working in the South," an ongoing study. The checklist probably includes only half of the artists working between 1565 and 1790 since documentary sources for some areas are either incomplete or have yet to be fully researched. The current tally reveals the names of 112 painters of various types, and of those only 54 have been associated with existing works, in many cases only one or two pictures per artist.

2. For example, see E. P. Richardson, *Painting in America: The Story of 450 Years* (New York: Thomas Y. Crowell Company, 1956); James Thomas Flexner, *First Flowers of Our Wilderness: American Painting, The Colonial Period* (New York: Dover Publications, Inc., 1969); Oliver W. Larkin, *Art and Life in America* (New York: Holt, Rinehart, and Winston, 1966); Virgil Barker, *American Painting: History and Interpretation* (New York: The Macmillan Company, 1950).

3. For example, see Carl Bridenbaugh, *Myths and Realities: Societies of the Colonial South* (New York: Atheneum, 1979); Bridenbaugh, *The Colonial Craftsman* (Chicago: The University of Chicago Press, 1950); Richard Beale Davis, *Intellectual Life in the Colonial South: 1585-1763*, 3 vols. (Knoxville: The University of Tennessee Press, 1979). Bridenbaugh's sweeping generalities are based on the work and lives of only a very few artists who were patronized by Southerners, and in some cases he uses obscure artists to make significant points. Davis's research is nearly impeccable; he gives a wealth of information on painters and patronage but draws few conclusions.

4. The author is especially indebted to Dr. Wayne Craven of the University of Delaware for his encouragement since 1969 and for the many generous hours of consultation offered by Frank L. Horton and the staff of the Museum of Early Southern Decorative Arts, Winston-Salem, N. C., since 1971.

5. Richard Beale Davis, "The South: 1690-1820," research files for *Painting in the South*, Virginia Museum of Fine Arts, Richmond, Virginia.

6. Ibid., p. 1.

7. Ibid., pp. 3-25. See also Bridenbaugh, *Myths and Realities*, which is totally devoted to the discussion of regions and regional differences in the South.

8. The circa 1785 date is a conservative estimate. Artists like Frederick Kemmelmeyer who were active in the late 1780s in East-coast towns may have worked before that in interior areas, as suggested in ongoing research.

9. The Spanish, who had claimed lands in North America long before the English and the French, may have made sketches and paintings of what they found in the New World, but they are unknown to scholars today.

10. Quote from Von Reck's journal in Kristian Hvidt, ed., *Von Reck's Voyage: Drawings and Journal of Philip Georg Friedrich Von Reck* (Savannah: The Beehive Press, 1980), p. 33.

11. All information following on the early French settlement and Jacques LeMoyne's drawings is taken from Stefan Lorant, ed., *The New World: The First Pictures of America* (New York: Duell, Sloane and Pearce, 1946), pp. 5-32, unless noted otherwise.

12. Athore was the son of Saturiba, the Indian chief mentioned early on in LeMoyne's narrative. The Frenchman noted that Saturiba "kept our actions under steady observation." Saturiba's territory extended from the area of St. John's River to near the Savannah River. LeMoyne described this picture in detail in the caption accompanying the De Bry engraving, noting that the Indians kissed the column and asked the French to do likewise. He described Athore as a tall man. See Lorant, *New World*, pp. 38, 51.

13. Lorant, *New World*, pp. 50-68 reprints LeMoyne's account of the involved dealings that transpired between Chiefs Saturiba and Outina, and others in the region, all of whom the French traded with during their stay.

14. Spain's offensive followed repeated warnings and attempts to dissuade the French from settling on the Florida coast, the area Spain claimed as its own and considered vital to its shipping through the Bahama Channel and its other land possessions in the area. See Lorant, *New World*, pp. 17-29, for details of the bloody encounter that ensued.

15. Lorant, *New World*, p. 123.

16. Scholars have debated where and when LeMoyne completed his pictures. The highly finished quality of the one surviving example lends credence to the theory that the pictures were completed in London from drawings and sketches the artist brought back from the New World.

17. Richard Hakluyt was born in England in 1552 and died in 1616. After years of university training he devoted most of his life to geographical and historical studies, particularly of travelers' and explorers' accounts of North America. He was ultimately instrumental in publishing many of these accounts. See David B. Quinn, *Virginia Voyagers from Hakluyt* (London: Oxford University Press, 1973).

18. John White's captions for his pictures are far less detailed than LeMoyne's, and the former's *Journal* (1587) and *Report* (1590) give only brief descriptions of the place and its inhabitants. There is the further observation that some of White's drawings appear to be copies after LeMoyne's earlier work.

19. Hvidt, *Von Reck's Voyage*, pp. 27-50.

20. Davis, *Intellectual Life*, vol. 3, pp. 113-18. Davis gives a particularly useful summary of what he calls the "contraditory or complimentary idea or ideal of the noble savage," which characterized early settlers' concept of the American Indians.

21. Quoted from LeMoyne in Lorant, *New World*, p. 51.

22. Quinn, *Hakluyt*, p. xiv. Quinn notes that Raleigh ordered and personally paid for a copy set of LeMoyne's drawings in 1587.

23. All information following on the early English settlements and John White's watercolors is from Lorant, *New World*, pp. 121-29 unless otherwise noted.

24. There seems to be some confusion on how many voyages White actually made to the colonies. He notes in his 1593 letter to Richard Hakluyt that it was his "fifth" and "last." See Lorant, *New World*, pp. 167-68.

25. Quoted from White in Lorant, *New World*, p. 168.

26. As with LeMoyne, scholars have not determined where and at what date White completed his watercolors. A portion of them must have been completed by 1587-88 since Richard Hakluyt had convinced De Bry to publish them at that time. In 1587, of course, John White returned to the colony. Since De Bry's Volume One was not published until 1590, it is entirely possible that White's drawings span a number of years from 1585 (the year of his first voyage) to 1587, or perhaps even 1589.

27. Davis, *Intellectual Life*, vol. 3, p. 1224. Various early European and English pictures may have been brought over with settlers at Jamestown or by relatives who arrived later; the histories of these portraits is not always well documented. Chief among those that may have been here are cited on pp. 1224-25 in that text.

28. Mary Newton Stanard, *Colonial Virginia: Its People and Customs* (Philadelphia: J.B. Lippincott Company, 1917), pp. 316-17.

29. Very little is known about governmental or institutional patronage in the early South. Perhaps the most important image of this type was executed by Charles Willson Peale for the Virginia patron Edmund Jenings. Jenings commissioned Peale to paint a portrait of William Pitt, the important English Whig leader, in the 1760s. The painting was presented by Jenings to the "Gentlemen of Westmoreland" County in 1768. Although it was not an institutional or governmental commission, it soon became, through Peale's efforts and ingenuity, an icon of the American cause.

30. All biographical information following on Justus Englehardt Kühn is taken from J. Hall Pleasants, "Justus Englehardt Kuhn: An Early 18th Century Maryland Portrait Painter," *Proceedings of the American Antiquarian Society*, Oct. 1936, pp. 243-80, unless otherwise noted.

31. Ellis Waterhouse, *Painting in Britain: 1530 to 1790* (Baltimore: Penguin Books, Inc., 1969). See *Lady Barbara Fitzroy*, illus. p. 58; *Lord Baltimore*, illus. p. 60; *Duchess of Portsmouth*, illus. p. 83; *Hon. John Spencer and his Son*, illus. p. 109; *The Price Family*, illus. p. 110. Paul Kaplan of the Art History Department of Wake Forest University, Winston-Salem, N. C., is treating this subject in his forthcoming doctoral dissertation.

32. Peale wrote, "Before these times [Peale's] there had been in Maryland only four persons professing the art of portrait painting. The first was a Mr. Cain. . . ." Quoted from Peale in Charles Coleman Sellers, *The Artist of the Revolution, The Early Life of Charles Willson Peale* (Hebron, Conn.: Feather and Good, 1939), p. 52.

33. When Kühn died in 1717 he left a widow and one son; the executor of his estate was Charles Carroll (1660-1720). Davis, *Intellectual Life*, pp. 1228, 1231.

34. The standard works on Gustavus Hesselius are E. P. Richardson, "Gustavus Hesselius," *The Art Quarterly* 12, no. 3 (1949): 220-26; Roland E. Fleischer, "Gustavus Hesselius: A Study of His Style," in *Winterthur Conference Report: American Painting to 1776, A Reappraisal*, ed. Ian M. G. Quimby (Charlottesville, Va.: University Press of Virginia, 1971), pp. 127-58.

35. Davis, *Intellectual Life*, vol. 3, p. 1233.

36. Ibid., p. 1231.

37. Manuscript research files, Museum of Early Southern Decorative Arts, Winston-Salem, N. C. The artist John Mare (1739-ca. 1802) had moved to Edenton, North Carolina as early as 1777 from New York City, where he had enjoyed a successful career as a portrait painter. Apparently he gave up painting when he moved south since no works by him have been identified. Mare was probably directly responsible, however, for the arrival in the 1780s in North Carolina of his nephew, William (Joseph) Williams. The latter would become one of the most prolific pastel portrait artists to work in the South at the end of the eighteenth century.

38. The Carolina Art Association owns portraits of Sir Nathaniel Johnson (ca. 1644-1713) and his wife, Lady Johnson (Anne Overton) (died 1690). These may have been executed in South Carolina, since Johnson was governor there from 1703 to 1709 and his picture is inscribed "Aetatis 61/April 7th/1705." The artist has yet to be ascertained. Another South Carolina painting traditionally called a self-portrait and attributed to Mrs. Jacques Le Serrurier could possibly date before 1700. See Anna Wells Rutledge, *Artists in the Life of Charleston* (Columbia: University of South Carolina Press, 1980), fig. 3, p. 172 (hereafter cited as *Artists in Charleston*).

39. All biographical information following on Henrietta Johnston is taken from Margaret Simons Middleton, *Henrietta Johnston of Charles Town, South Carolina: America's First Pastellist* (Columbia, S.C.: University of South Carolina Press, 1966), unless noted otherwise.

40. Frank J. Klingburg, ed., *Carolina Chronicle: The Papers of Gideon Johnston: 1707-1716* (Berkeley and Los Angeles: University of California Press, 1946), p. 31.

41. Ibid., p. 35.

42. Ibid., p. 172.

43. Ibid.

44. Mary Black, "Contributions Toward a History of Early Eighteenth-Century New York Portraiture," *The American Art Journal* 12, no. 4 (1980): 5-31. Black identifies the artist as Nehemiah Partridge, based on a reference in Evert Wendell's *Day Book* for May 13, 1718. Wendell was one of a number of New Yorkers who had their portraits painted by a limner whose style closely parallels that of the Jaquelin-Brodnax Limner. Those similarities are obvious and are acknowledged as astute observations on the author's part, but there are dissimilarities that need further study and explanation; also to be considered is the fact that Partridge's name has not been found in Virginia records. See also Mary Black, "The Case of the Red and Green Birds," *Arts in Virginia* 3, no. 2 (1963), pp. 2-9.

45. Black, "The Case," pp.6-8.

46. Graham Hood, *Charles Bridges and William Dering: Two Virginia Painters, 1735-1750* (Williamsburg: The Colonial Williamsburg Foundation, 1978), note 8, p. 5; note 33, p. 29.

47. Unpublished manuscript by Holger Cahill, *Information for the Hostesses of the Williamsburg Restoration . . . Concerning Mrs. John D. Rockefeller, Jr.'s Loan Collection of American Folk Art*. Dowsing's Inventory is listed at the back of this report on p. 2 of a section titled "Excerpts from the Research Department Report on Craftsmen and Artists in Virginia."

48. All information following on Mark Catesby is taken from George Frederick Frick and Raymond Phineas Stearns, *Mark Catesby: The Colonial Audubon* (Urbana: University of Illinois Press, 1961), unless noted otherwise.

49. William Byrd II was also a member of London's Royal Society and had encouraged the group to send a naturalist to the colonies to record and study specimens before Catesby's first trip. Byrd might have urged Catesby to undertake the project. See Davis, *Intellectual Life*, vol. 2, p. 820.

50. Quoted from Catesby in Frick and Stearns, *Mark Catesby*, p. 25.

51. Ibid., p. 35. Catesby's patrons were genuinely pleased with the results of his work abroad and encouraged him to have them published, despite their inability to finance the project.

52. Ibid. Catesby sought out Joseph Goupy, a Frency etcher and watercolorist then in London, for advice in preparing the plates.

53. Quoted from Catesby in Rutledge, *Artists in Charleston*, p. 111.

54. Frick and Stearns, *Mark Catesby*, pp. 55-57. His biographers point out that Catesby always considered himself to be a botanist even though his greatest contribution was in ornithology. The naturalist explained that his reason for including "a greater Variety of the feather'd Kind" was based on their beauty and great numbers, and because they had such a close relationship to the plants.

55. All information following on Von Reck and the Catholic Reformation is from Hvidt, *Von Reck's Voyage*, pp. 7-50 unless otherwise noted.

56. Ibid., p. 12.

57. Ibid. The young Von Reck had been educated at the University of Helmstedt, where he studied law; he also had some mastery of the French and Italian languages.

58. Ibid., p. 13, as quoted from Thomas Coram.

59. Ebenezer was the first site of settlement. At the time of Von Reck's second visit the settlers moved to a second location, which was called New Ebenezer and was located about five miles from the original site.

60. As quoted from Von Reck in Hvidt, *Von Reck's Voyage*, p. 14.

61. Ibid., p. 137. This book, titled *Kurzgefasste Nachricht von dem Etablissement derer Salzburgischen Emigranten zu Ebenezer in der Provinz Georgien in Nord-Amerika* (Hamburg, 1777), has not been translated into English.

62. The sketchbooks were not known again until 1976 when a Danish researcher discovered them among papers in the Royal Library at Copenhagen, Denmark.

63. Hvidt, *Von Reck's Voyage*, p. 114–15.

64. All biographical information following on Charles Bridges is from Hood, *Bridges and Dering*, pp. 1-98 unless noted otherwise.

65. Ibid., p.3, as quoted from Bridges.

66. Ibid., as quoted from Gooch.

67. Ibid., p. 4, as quoted from Byrd.

68. Davis, *Intellectual Life*, vol. 3, p. 1229.

69. Ibid., pp. 1129–31. Davis cites a portrait of Col. Daniel Parke Custis attributed to Kneller, a London commissioned portrait of Commissary James Blair, several portraits (presumably English) left in 1726 by Robert "King" Carter to his heirs, and early portraits of Philip Ludwell II and his wife Hannah Harrison Ludwell as being by Sir Godfrey Kneller. The Carter pictures may have been those executed by the unidentified painter Carter "sat to," perhaps again, in 1727, as mentioned in note 65. The Blair portrait is probably the one attributed to the London painter Hargreaves and mentioned in Hood, *Bridges and Dering*, note 35, pp. 29, 35. Davis does not identify the whereabouts of the Ludwell pictures. The Parke portrait is illustrated in Alexander W. Weddell, *Memorial Volume of Virginia Historical Portraiture 1585-1830* (Richmond: The William Byrd Press, 1930), opposite p. 138.

70. See Hood, *Bridges and Dering*, pp. 29, 34-37, and 40-41 for a full discussion of these important portraits.

71. Ibid., p. 10. Hood arrived at the 1744–45 date on the basis of the portrait of Mrs. Mann Page II and child. The Pages' first child was born in April 1743, and the infant shown in Bridges's portrait appears to be about a year old.

72. All information following on Jeremiah Theüs and the Swiss colonizers is taken from Margaret Simons Middleton, *Jeremiah Theüs: Colonial Artist of Charles Town* (Columbia: University of South Carolina Press, 1953), pp. 14-54 unless otherwise noted.

73. Hvidt, *Von Reck's Voyage*, p. 13.

74. Middleton, *Theüs*, pp. 25-27. Muhlenberg reported in 1774 that Theüs, the painter, "received me most kindly into his house . . . thirty-two years ago." This must have been on his first visit to the colonies in 1742.

75. Ibid., p. 40. It is not known whether these scripture verses survive, but if they do and can be located they might give us some idea of Theüs's talent as a decorative painter. Additionally, one wonders how similar such works might be to the fraktur drawings with verses and/or inscriptions that proliferated among various Germanic cultures in America. There is, for instance, at least one South Carolina fraktur surviving that bears the name of the minister Christian Theüs. See John Christian Kolbe and Brent Holcomb, "Fraktur in the 'Dutch Fork' Area of South Carolina," *The Journal of Early Southern Decorative Arts* 5, no. 2 (Nov. 1979): 41.

76. All information following on Bishop and Mary Roberts is taken from Frank L. Horton, "America's Earliest Woman Miniaturist," *Journal of Early Southern Decorative Arts* 5, no. 2 (November 1979): 1-5 unless otherwise noted.

77. Raymond D. White, "Marine Art in the South: A Brief Overview," *Journal of Early Southern Decorative Arts* 2, no. 2 (November 1980): 53, and fig. 3, p. 52.

78. Ibid., pp. 50-51.

79. Ibid., pp. 54-55 (illus. as fig. 66 on p. 55).

80. Among these miniature painters who are believed to have been French are David Boudon (Virginia, Georgia, and North Carolina), Jean Zolbius Belzons (South Carolina and Georgia), possibly John Francis Butet (South Carolina), Lewis Chefdebien (Virginia and Maryland), possibly Charles Francis Chevalier (Georgia), Joseph-Pierre de Picot de Limoëlan de la Clorivière (Maryland, Georgia, South Carolina), Henry De Barrac (South Carolina), Michael Samuel De Bruhl (South Carolina), Du Suaw (South Carolina), Jean Pierri Henri Elouis (Virginia, Maryland), Monsieur Faugère (Maryland), possibly Joseph Fournier (South Carolina, Georgia), Geslain the younger (South Carolina), Pierri Henri (Virginia, South Carolina, North Carolina, Maryland), possibly J. C. Imbert (South Carolina), F. J. Jocelyn (Virginia, North Carolina), possibly Isador Labatur (South Carolina), possibly De Barnville Langlois (South Carolina), A. Mauvois (Georgia), Etienne Morange (Maryland), Philip Parisen (South Carolina), Lewis Pise (Peis) (Maryland), possibly Popenot (Maryland), John Baptist Rossetti (Rosette) (South Carolina), Charles Balthazar Julien Fevret de Saint Memin (South Carolina, Maryland, Virginia, District of Columbia), possibly Lewis Shafteberg (Maryland), possibly Thomas Valdenuit (Maryland), and Yonge (South Carolina).

81. All information following on William Dering is taken from Hood, *Bridges and Dering*, pp. 99-122 unless noted otherwise. See also Carolyn J. Weekley, "Further Notes on William Dering, Colonial Virginia Portrait Painter, *Journal of Early Southern Decorative Arts* 1, no. 1 (May 1975): 21-28, and J. Hall Pleasants, "William Dering, a Mid-Eighteenth Century Portrait Painter," *Virginia Magazine of History and Biography* 60 (January 1952): 56-63.

82. *Pennsylvania Gazette*, February 11, 1736, as quoted in Hood, *Bridges and Dering*, p. 99.

83. The Brush-Everard House, located on Palace Green, across from the Robert Carter House, is one of the Colonial Williamsburg exhibition buildings.

84. The author is grateful to John Christian Kolbe for the following references believed to relate to the artist William Dering in Charleston: 1751, William Dering served as a special juror, M. B. Warren, comp., *South Carolina Jury Lists, 1718-1783* (Daniellsville, Ga.: Heritage Papers, 1977), p. 48; 1764, a house formerly owned by William Derring [sic] of Charleston, *Judgment Rolls*, The South Carolina State Archives, Columbia, S. C. (hereafter cited as JR, SC), computer call no. 0151 002 063A, 0219A 00; 1764, William Dering charges John Smith for assault and battery, JR, SC, computer call no. 0151 002 070A 0162A 00.

85. This observance was made simultaneously by the author and Miss Molly Prince, and published in Hood, *Bridges and Dering*, n. 68, p. 101.

86. Virginius Cornick Hall, Jr., "Early Portraits in the Virginia Historical Society," *The Magazine Antiques* 126, no. 5 (November 1979): 1133, illus. plate x.

87. Davis, *Intellectual Life*, vol. 3, pp. 1522, 1526.

88. Horace Walpole, *Anecdotes of Painting in England*, second ed. (England: Printed for J. Dodsley, 1782). The entire quote was first reproduced in Theodore Bolton and Harry L. Binsse, "Wollaston, An Early American Portrait Manufacturer," *The Antiquarian* 28 (June 1931): 30.

89. In a letter from Charles Willson Peale to Rembrandt Peale, October 28, 1812, as published in John Sartain, *The Reminiscences of a Very Old Man, 1808-1897* (New York: D. Appleton and Company, 1899), p. 147.

90. Carolyn J. Weekley, "John Wollaston, Portrait Painter: His Career in Virginia, 1754-1758" (master's thesis, University of Delaware, 1976), pp. 11-12, 45. James Monk's portrait was privately owned in Canada in 1976. Interestingly, Monk's signed and dated portrait and a companion picture, presumed to be his wife and also attributed to Wollaston, had come to the colonies (Boston) nine years prior to the artist's arrival.

91. The Whitefield picture, owned by the National Portrait Gallery in London, is attributed to Wollaston on the basis of a mezzotint taken after the painting; the engraving bears the inscription "John Wollaston, Jr. Pinxt, 1742."

92. The Reverend Whitefield visited the American colonies in 1738 and 1740; perhaps his first-hand knowledge of the place was shared with the younger Wollaston.

93. Wollaston appeared as a trial witness in the New York City court on this date, according to George C. Groce, "John Wollaston (fl. 1736-67): A Cosmopolitan Painter in the British Colonies," *The Art Quarterly* 15, no. 2 (Summer 1952), n. 17, p. 147. I am grateful to Sir Ellis Waterhouse, Oxford, England, for this information regarding the elder Wollaston's death date.

94. Weekley, "John Wollaston," pp. 16-17.

95. Manuscript in the Martha Washington Collection, Virginia Historical Society, Richmond, Virginia.

96. Hopkinson wrote the poem on September 18, 1758, but it was not published until October 1758 in *The American Magazine and Monthly Chronicle of the British Colonies* 1:608. It was first reproduced in Bolton and Binsse, "Wollaston," p. 31.

97. Arthur W. Leibundguth, "The Furniture-Making Crafts in Philadelphia ca. 1730-1760" (master's thesis, University of Delaware, 1964), pp. 23-24. Leibundguth cites a reference to the artist in the daybook of Samual P. Moore of Philadelphia for May 19, 1759.

98. The author is grateful to Sir Ellis Waterhouse, Oxford, England for this information, as found by him in *The Diary of John Baker*, Philip C. Yorke, ed. (London: Hutchinson & Co., Ltd., 1931).

99. Harriet Ravenel, *Eliza (Lucas) Pinckney* (New York: The Macmillan Company, 1986), p. 65.

100. Ibid.

101. Middleton, *Theüs*, p. 9.

102. Jeremiah Theüs's portrait of Smith is at the Gibbes Art Gallery, Charleston, S. C.; Wollaston's version was on loan to the Gibbes until 1976–77, at which time it was apparently sold to an unidentified collector.

103. See note 96.

104. The subject of deportment and posture in the eighteenth century is one that few painting scholars have considered in reference to costumes and poses seen in portraits. Recent research by Gretchen Schneider, former Research Fellow at the Colonial Williamsburg Foundation, has revealed that many of the seemingly unnatural hand positions, etc. seen in mid-eighteenth-century Virginia portraits, particularly those by Wollaston, correlate closely with rules and principles governing deportment during those years.

105. Robert Feke's presence in Virginia has never been proved by documentary reference, although portraits of the Thomas Nelson family of Yorktown are attributed to him on the basis of stylistic comparison and a reference in Elizabeth Nelson's (Mrs. Thomas Nelson) will written in 1793 which mentions a portrait of her husband as by "Feake." All information following on John Hesselius is from Richard K. Doud, "John Hesselius, Maryland Limner," *Winterthur Portfolio 5* (Charlottesville: University Press of Virginia, 1969), pp. 129–53, unless otherwise noted.

106. The portrait is owned by the Baltimore Museum of Art, Baltimore, Maryland.

107. See Doud, "John Hesselius," pp. 139–40 for a particularly good discussion of this picture.

108. All information following on John Durand is from Carolyn J. Weekley, "Artists Working in the South, 1750-1820," *The Magazine Antiques*, 110, no. 5 (November 1976): 1046–47, unless otherwise noted.

109. Ibid., p. 1046. The 1765 Virginia portrait by Durand is currently the earliest record of his painting activity.

110. Ibid., p. 1046. The author is grateful to Pepper Potter, former field researcher for the Museum of Early Southern Decorative Arts, for sharing this information.

111. See Dr. Robert Archer, *Archer and Silvester Families: A History Written in 1870* (privately published for Andrew D. Christian, 1937), pp. 12-15.

112. See Alexander Wilbourne Weddell, *Memorial Volume of Virginia Historical Portraiture 1585-1830* (Richmond: The William Byrd Press, Inc., 1930), pp. 205–06.

113. All information following on Charles Willson Peale is from Charles Coleman Sellers, *The Artist of the Revolution, The Early Life of William Peale*, unless otherwise noted.

114. Carl Bridenbaugh, *Cities in Revolt: Urban Life in America, 1743-1776* (New York: Knopf, 1955), p. 398.

115. Charles Coleman Sellers, "Monumentality with Love: Charles Willson Peale's Portrait of William Smith and his Grandson," *Arts in Virginia*, 16, no. 2/3 (1976): 14-21.

116. Ibid., p. 16.

117. Ibid., p. 14.

118. Ibid., p. 16.

119. As quoted in Eugenia Calvert Holland and others, *Four Generations of Commissions: The Peale Collection of the Maryland Historical Society* (Baltimore: The Maryland Historical Society, 1975), p. 6.

120. Robert G. Stewart, *Henry Benbridge (1743-1812): American Portrait Painter* (Washington, D. C.: Smithsonian Institution Press, 1971), p. 21.

121. Carolyn J. Weekley, "Henry Benbridge: Portraits in Small from Norfolk, Virginia," *Journal of Early Southern Decorative Arts* 4, no. 2 (1978): 52-55.

122. Ibid., p. 51.

123. The author is grateful to Peter H. Wood of the Department of History, Duke University in Durham, N.C., for this brief discussion on Bartram. For additional information see Joseph Ewan, *William Bartram: Botanical and Zoological Drawings, 1756-1788* (American Philosophical Society, Philadelphia, 1968).

124. No doubt various other American-born painters who were trained abroad painted in the South during these years, including Matthew Pratt, but there is little remaining of their work. See Hall, "Early Portraits," p. 1132 pl. viii, for a particularly fine Virginia portrait of Mary Jemima Balfour which is attributed to Pratt.

125. Stewart, *Benbridge*, p. 20, See also Middleton, *Theüs*, p. 10; ibid., pp. 146–47; Rutledge, *Artists in Charleston* p. 116. Rutledge's book provides valuable insight into many aspects of arts patronage in Charleston, and remains the single most valuable and scholarly discussion of painting in early South Carolina.

126. Davis, *Intellectual Life*, vol. 3, p. 1243.

127. Rutledge, *Artists in Charleston*, p. 116.

128. Ibid.

129. George C. Rogers, Jr., "Changes in Taste in the Eighteenth Century: A Shift from the Useful to the Ornamental," *Journal of Early Southern Decorative Arts* 8, no. 1 (1982): 3.

130. Ibid., p. 9

131. Ibid.

ACKNOWLEDGEMENTS

Many individuals and institutions have contributed to the study of early painters and paintings in the South, through their on-going scholarship and through their generous sharing of information discovered in the research process. Chief among these has been the Museum of Early Southern Decorative Arts in Winston-Salem, North Carolina. Frank L. Horton, Sally Gant, Whaley Batson, Elizabeth Putney, and Rosemary Estes of that institution were supportive of the project from its inception, and their assistance has been a source of comfort through the entire process. Other individuals and museums who have made available important materials, either directly or indirectly, through recent published works include Stiles Colwill of the Maryland Historical Society, Graham Hood of the Colonial Williamsburg Foundation, and Martha Severens of the Gibbes Art Gallery in Charleston, South Carolina.

Special thanks go to John Christian Kolbe for his research assistance on various artists' careers and lives in Charleston and to Beatrix T. Rumford of the Colonial Williamsburg Foundation for her willingness to read and offer comments on many drafts of the manuscript.

The project's consultants—Wanda Corn, the late Richard Beale Davis, Susan Donaldson, William Seale, Ben Williams, and Peter H. Wood—deserve an accolade for their many patient hours of reading, editing, and offering comment on the essay in its many stages. Finally, to Ella-Prince Knox and David Bundy, the Virginia Museum's capable coordinators of *Painting in the South*, I express warm and sincere appreciation for the helpful gathering of many details regarding loans for the exhibition and for notes within the essay.—*C.J.W.*

Figure 24. Unidentified Artist, William Bowles and the Creek Indians
(*cat. no.* 40).

The Emerging Nation, 1790 to 1830

by Linda Crocker Simmons

For the South, as for the nation, the four decades from 1790 to 1830 brought territorial expansion and unification, political division and consolidation. The new Constitution, ratified in 1787, provided the structure for the federal government that began to function in November 1788. The capital was moved from Philadelphia to its new site in the South on the Potomac in 1800. Three years later Louisiana was purchased from the French. And in 1804 the Lewis and Clark expedition departed from the South to make its great exploratory trek across the continent. The young nation further increased its territory when Florida was acquired by treaty with Spain in 1819.

National energy in these years was directed towards securing complete independence from British domination politically, militarily, and economically. With the War of 1812 and the Treaty of Ghent, this separation was finally achieved.

While the new expansion meant dispossession for the native Indian population, it ultimately led to the admission of eleven new states into the Union of the original thirteen. Differences between slave and free states led to such solutions as the Missouri Compromise of 1820. But it was also an era of mutual good will, arising from the common quest for national identity.

As the national image developed and varied, artists—both native and foreign-born—sought to define it in their work. The portrait dominated the period, with history painting beginning to take a more prominent position in the early nineteenth century.

While still-life and genre paintings were virtually non-existent, city-scapes provided popular records of specific sites, giving way late in the period to the Romantic movement's devotion to the landscape tradition. The format of certain types of work would vary; while artists might employ several mediums, oil painting predominated.

As individual cities such as Baltimore, Washington, Richmond, Charleston, Nashville, and Lexington grew in importance, there was an increased interest in certain civilizing amenities: in academies to train the artist, and in museums or galleries to display his work. Although certain subjects and themes carried over from pre-Revolutionary times, there was a greater feeling of the South as part of a unified nation than there had been in the preceding period of smaller, more separate urban communities.

PORTRAIT ARTISTS

Portraiture was the dominant, overriding popular subject requested by patrons in the South. Although the academically-trained artists were aware of and followed the styles in European painting as they changed from the Baroque and Rococo to the Neoclassical and Romantic, the tastes and desires of American patrons in the decades before and after 1800 frequently remained conservative and primarily devoted to portraiture. Artistic convention, however, had established a hierarchy of subjects that ranked portraiture far below allegory, history, landscape, and still life. But these

distinctions and the aspirations of the painters to follow them were often dashed by the American public. America's first major Neoclassical painter, John Vanderlyn (1775-1852), did well in Europe with his idealized figure studies; however, on his return to the United States in 1815, he failed to find a market for anything other than portraits and the exhibition of panoramas. Washington Allston (1779-1843), a native of Georgetown, South Carolina, studied in England and became an ardent Romantic artist only to receive little public acclaim upon his return to America.

The volume of demand in the South, as in the North, led to popularity and financial success for some portrait painters. Many were attracted to the region, while others were native-born and spent most of their careers in their home states. The major portrait painters who visited the South included Thomas Sully, John Trumbull, Samuel F.B. Morse, John Wesley Jarvis, James Earl, Henry Inman, and Rembrandt Peale. The native-born artists and the "birds of passage"[1] who established residences in the South are a smaller group. They include in their number Charles Bird King, Ralph E.W. Earl, Philip Tilyard, Joseph Henry Bush, Pietro Bonanni, Oliver Frazer, Matthew Harris Jouett.

Available also to the public were artists working in other mediums such as pastel and watercolor on ivory. The public in the South had considerable variety to choose from, and in the field of portraiture their continuing commissions assured the well-being and ever-growing numbers of resident and itinerant portraitists.

James Earl, the younger brother of the New England painter Ralph Earl, was active and successful in the South during the 1790s. Trained in England, Earl arrived in Charleston, South Carolina, about 1794 to be met by citizens eager for his work. The painting *Elizabeth Fales Paine and Her Aunt Martha Paine* (cat. no. 31)[2] demonstrates the style that attracted sitters to his studio. Broad painterly brushstrokes in the areas of fabric contrast with the smooth precision accorded face and hair. The painting's composition and appealing rendering of textures indicates Earl's training and his attraction in a city closely attuned to English cultural and artistic development.

Like Earl, another "bird of passage," Samuel F.B. Morse, an artist of established reputation in the North, found the pleasant Charleston climate and eager Charleston patrons to his liking. During his first visit to the city in March 1818, Morse wrote to his

father: "I am completely occupied. I have found and begun 27 portraits large and small and have upwards of forty more engaged."[3] Six days later he wrote to his fiancée: "I have already done to the amount of $1300 and am constantly in my room from eight in the morning until dark."[4]

Morse's success continued on subsequent visits to Charleston during which he painted many portraits, including one of Mrs. Robert Young Hayne (fig. 25; cat. no. 56), wife of a distinguished lawyer and United States senator. The overall pink tonality and gracefulness of line show the influences of Stuart and Sully on Morse's style.

With his abilities thus confirmed, Morse received a commission from the City Council of Charleston to paint a full-length likeness of President James Monroe on the occasion of his visit to the city.[5] Sittings began in Charleston and continued at the White House, and the portrait was delivered to the Council on December 22, 1820.[6]

Following the Panic of 1819, Morse fared less well, despite the Council's commission. On returning to Charleston in 1821, he wrote: "I wish I could write encouraging as to my professional pursuits but I cannot. Not withstanding the diminished price [of my portraits] . . . I receive no new commissions, cold and procrastinating answers from those to whom I write and who had put their names on my list."[7]

Conditions were better in other cities for some painters. One foreign-born and -trained painter, Pietro Bonanni, was attracted to the United States by the work being done on the decoration of the United States Capitol. His best known work may be his decoration for the ceiling of the Old House of Representatives chamber in Washington, but his portraits provided income necessary for sustenance.[8] Bonanni's 1820 oil painting of Mary Sumner Blount (cat. no. 47) is a fine example of the artist's beautiful, precise portrait style.

Thomas Sully was a leader in his generation of American portrait painters and was one of the most successful. During a long career he completed more than 2,000 portraits and some 500 subject pictures, history scenes, and landscapes. Sully's work was eagerly sought-after during his lifetime and has been treasured by Southerners ever since.

The Sully family came to Charleston in 1792 when Thomas was nine years old. He began his artistic studies with his brother-in-law, Jean Belzons, a miniaturist and theatrical scene painter who had trained in

Figure 25. Samuel F. B. Morse, Portrait of Mrs. Robert Young Hayne
(cat. no. 56).

France.[9] In 1799, at the age of sixteen, Sully went to Richmond for study with an older brother, Lawrence, a miniature painter trained in England. He also ventured to Norfolk to receive his first instruction in oil painting from Henry Benbridge.[10] In 1804 Sully began his independent career, meticulously recording each work in his "Register" for the rest of his life.[11] Following his brother's death, Thomas Sully left in 1805 for New York and Boston to work briefly as an assistant to John Wesley Jarvis and to study intermittently with Gilbert Stuart.

Four years later Sully settled in Philadelphia, where a group of businessmen provided him with funds to continue his studies in England.[12] Upon his arrival in London he met Charles Bird King, and the two became lifelong friends. With King, Sully visited the Royal Academy and the studio of Benjamin West, with whom he studied until his return to Philadelphia in 1810. West recommended the study of anatomy, advice which—if fully followed—might have alleviated one of Sully's major failings.[13]

The young artist also sought out the popular portraitist Sir Thomas Lawrence. Although Sully's fluid brushstroke was evident before his London sojourn, much that is lovely and brilliant in his style— the aristocratic verve and the dramatic use of light and shadow—can be traced to Lawrence. Sometimes called "The Lawrence of America," Sully was very popular throughout the South as a result of his many journeys within the region and through his successful romantic portraits, especially those of women and children. Henry Tuckerman, the nineteenth-century art historian, noted that Sully's "organization fits him to sympathize with the fair and the lovely. . . . His women have an air of breeding, a high tone, and a gentle carriage. . . . One always feels . . . in good society among his portraits."[14] The portrait of Conway Robinson (cat. no. 60) is typical of Sully's work at its best. Robinson, a noted Richmond lawyer and author, is shown bust-length, chin held level, his gaze directed slightly to one side. The artist's flowing brushstroke, although somewhat suppressed, is evident in the treatment of the hair and modeling of the facial features, capturing with ease the strength and obvious intelligence of his sitter and avoiding the excessive sweetness that sometimes marked his female portraits.

With its soft flowing forms and elegant compositions, Sully's style represents well the period between the War of 1812 and the 1850s. A genial and gracious man, Sully aided and influenced many young artists,

among them William Edward West, Henry James Brown, James Deveaux, Aaron Corwine, Matthew Harris Jouett, Joseph Henry Bush and Oliver Frazer. The latter three were Kentucky natives and achieved prominence in their home state.

Jouett, who was born in Mercer County, Kentucky, had studied law at Transylvania College before turning to painting. He studied in Boston with Gilbert Stuart in 1816 before he met Thomas Sully. His portrait of Justice Thomas Todd (cat. no. 53), painted between 1818 and 1826,[15] clearly indicates the influence of Stuart in composition, modeling, and color. Like Stuart, Jouett employed spare shading, atmospheric backgrounds, fluid but controlled brushwork, and the inclusion of architectural detail. Later in his career, Jouett responded to Sully's influence, softening and romanticizing his portraits.

Joseph H. Bush, born in Frankfort, was second only to Jouett among the native Kentucky artists of these years. At the age of seventeen, Bush left for Philadelphia where—like the other Kentucky-born painters—he responded to the charm and influence of Sully. The effect of several years of study with him is clearly apparent in Bush's portraits of women and children with enlarged eyes and full lips. In order to facilitate Bush's training, Henry Clay assisted him from 1814 to 1817 by paying his student expenses. After 1819 Bush made his home in Louisville, wintering in Louisiana and Mississippi, visiting New Orleans, Natchez, Vicksburg, and many plantation sites.[16]

A third Kentuckian, Oliver Frazer, studied first with Jouett and then with Sully. After four years in Europe, Frazer returned to Kentucky in 1838. Although Frazer—like Bush—adopted a style that reflected Sully's influence, his extended studies in Europe and his resulting knowledge of Old Masters increased his skills as a colorist. In spite of early successes as a portrait painter, Frazer's failing eyesight in the 1850s prevented him from realizing the full extent of his talents.[17]

Directly south of Kentucky, in a section of the South recently settled and admitted to the Union, Ralph E. W. Earl dominated the art of Tennessee in the early nineteenth century. The son of Ralph Earl of Connecticut, the younger Earl resided in Nashville following his 1818 marriage to the niece of Rachel Jackson. In addition to numerous portraits of Andrew Jackson, Earl maintained a busy painting career in Nashville. An outstanding example of Earl's work is his painting *Mr. and Mrs. Ephraim Hubbard Foster and*

Figure 26. Ralph E. W. Earl, Mr. and Mrs. Ephraim Hubbard Foster
and their Children (cat. no. 51).

their Children (fig. 26; cat. no. 51), executed about
1824. Foster, secretary to Andrew Jackson during the
Creek War and his color-bearer at the Battle of New
Orleans, is shown surrounded by his wife and children,
with his vibrant daughter Jane Ellen silhouetted
against an open window.[19]

If the discussion of portraiture in and of the South
in these forty years were limited to the subject of
George Washington, many of the period's major paint-
ers would still be included. Gilbert Stuart's famous
icon, although painted first in Philadelphia, was cop-
ied during the artist's sojourn in Washington, 1803-
05, and was cherished by the General's fellow South-
erners. Edward Savage, painting in New York in 1789,

portrayed the Washington family against the Potomac
River landscape seen from Mount Vernon. In 1816 the
North Carolina Legislature commissioned Thomas
Sully to execute a grand historical piece, *The Passage of
the Delaware by the American Troops under the Command
of General Washington*. The folk painter William J.
Williams set down his likeness in pastel on commission
from Washington's own Masonic Lodge (fig. 27).

Philippe Abraham Peticolas painted a miniature
of George Washington in 1796 while working in
Philadelphia. Although only three replicas are known,
the artist was proud of the work and, as Peticolas
family tradition recalls, "wherever he traveled he
showed this miniature of Washington and it brought

Figure 27. *William Joseph Williams, George Washington in Masonic Regalia, 1794, pastel on paper, 27 by 32 inches (68.6 by 81.2 cm). Masonic Lodge No. 22, Alexandria, Virginia.*

him many commissions."[20] Another limner, Charles Peale Polk, made a substantial part of his living selling his portraits of Washington in Maryland and Virginia.

The interest in Washington was strong throughout the South. In Charleston, the City Council in 1791 commissioned John Trumbull to paint a full-length portrait of Washington (fig. 28). The Council acted on the suggestion of South Carolina Senator William L. Smith, who had written from New York that the artist was painting the President for the Corporation and that they should "have such a one in Charleston."[21] With Senator Smith in charge of arrangements, Trumbull, working in Philadelphia, completed a portrait that he said was "the best in existence of Washington's military character, depicting him at the most sublime moment of its exertion, the evening previous to the Battle of Princeton."[22]

Although he admired the canvas, Smith rejected it, and Trumbull painted a second portrait with a South Carolina setting. In the second work, the full-length figure of Washington stands near Haddrill's Point overlooking the Cooper River and the town beyond. His horse stands nearby and at his feet are spread palmetto fronds, the state laurels.[23] The portrait was delivered and hung in the Charleston City Hall in mid July of 1792 to much acclaim.[24] Trumbull kept the rejected work, which eventually came to the Yale University Art Gallery.

PORTRAITS IN OTHER MEDIUMS

In addition to oil, portraitists utilized a range of mediums, including pencil, ink, watercolor, and pastel. Three itinerant artists who worked almost exclusively in pastel were William Joseph Williams, Felix Thomas Sharples, and Charles Balthazar Julien Fevret de Saint-Mémin. In spite of their use of the same medium, they differed markedly in training, style, and course of career.

Williams, born in 1759 in New York, trained and worked there as a portrait painter. Although he is known to have worked in oil, no known examples of his work in this medium exist. By 1798 he had worked in both North Carolina and Virginia and had moved on to paint and teach in Charleston. Leaving Charleston, he lived in New Bern, North Carolina, for three years before settling in New York. In 1817 Williams returned to New Bern to spend the rest of his life painting and teaching at the New Bern Academy.

Among Williams's known portraits, the quality of work varies significantly. His most noted portrait is one of George Washington (fig. 27) that was commissioned by Masonic Lodge Number 22 of Alexandria, Virginia, where Washington had been Charter Worshipful Master. By resolution in 1793, the Lodge requested Washington to sit for Williams, instructing the artist to "paint him as he is."[25] The result, startlingly different from the oils by Stuart, Charles Willson Peale, Rembrandt Peale, and others, is the likeness of an old man: the lines of strain and care show clearly, as do the disfiguring scar on the left cheek, the black mole under the right ear, and the smallpox scars on nose and cheeks. Washington wears

Figure 28. *John Trumbull, General George Washington, 1792, oil on canvas, 90½ by 63 inches (229.9 by 160 cm). City of Charleston, South Carolina.*

not the appurtenances of public office, but the Master Mason's regalia of apron, sash, and jewels.[26]

A second pastellist, Felix Thomas Sharples, arrived in the United States from England in 1793 with his parents, sister, and brother, all skilled in the medium. In 1801, after traveling through New England, New Jersey, Pennsylvania, and Maryland seeking commissions and selling their portraits of the notables of the day, they returned to England. Felix Thomas journeyed to America again five years later, working first in Philadelphia before proceeding South.[27] From 1808 to 1811 he traveled in Maryland, Virginia, and South Carolina, advertising oil and miniature portraits as well as pastel. His sitters—unlike those portrayed by other members of his family—were generally represented in three-quarter or nearly full view.

The artist's last known work was done about 1814 in Mathews and Gloucester Counties, Virginia. Since his step-sister, Rolinda Sharples, does not mention him in her diary after 1823,[28] it is presumed that he died soon thereafter.

The third itinerant pastellist, the Frenchman Saint-Mémin, is today the best known of the three. By means of a physiognotrace, he executed a phenomenal number of profiles in Baltimore, Washington, D.C., and Virginia, from 1803 to 1807, and subsequently in Charleston, South Carolina in 1808 and possibly 1809.[29] The artist's method involved first securing an exact, life-sized profile of the subject on a sheet of tinted paper, then drawing in the hair, features, and clothing with black and white crayons. With a pantograph, he then reduced the crayon profile to a miniature about two inches in diameter. This small image was transferred to a copper plate from which the artist could produce as many prints as desired.[30] Among the more than 800 sitters who posed for Saint-Mémin were a majority of the distinguished personages of the South and other areas of the United States during the first quarter of the nineteenth century.[31] Near the end of his first term as President, Thomas Jefferson sat for Saint-Mémin. On November 27, 1807, Jefferson recorded his purchase of the life-sized drawing and forty-eight engravings: "Gave St. Memin order on bk US for 29.50."[32]

Saint-Mémin's watercolor profiles, although less well-known, are equally crisp and fine in detail. Two bust-length portraits, of Mrs. William Tower Proud (*nee* Mary Abigale Coale) and Mrs. John Robert Murray (*nee* Harriet Rogers) (cat. nos. 41 and 42), are executed in his usual watercolor format, which frequently included landscape settings and furniture.[33] In the latter work, Druid Hill, home of Harriet's father, Colonel Nicholas Rogers of Baltimore, is visible to the sitter's left.

PAINTERS OF MINIATURES

From 1790 to 1830 the production of miniatures, diminutive portraits in watercolor on ivory, flourished throughout the United States, especially in the South.[34] A definite change in style and technique from the preceding decades occurred in the 1790s with the arrival of a number of English artists. Their influence in America is evident not only in the use of the larger-sized, oval ivories but in the finer modeling, freer brushwork, and lighter tonalities. Before 1830 a new naturalism would become evident, as would a gradual change in style from the Neoclassical to the Romantic.[35]

A personal object with intimate associations, the miniature had formerly been hidden from view, perhaps in a locket; but at the end of the eighteenth century it began to be displayed on a chain or ribbon, and it was sometimes pinned to clothing. In 1797 Rembrandt Peale advertised his services in Annapolis, Maryland, and suggested that "at the . . . assemblies, a Miniature Picture will be no inelegant decoration to the bosom of a fair one."[36]

Many members of the Peale family produced miniatures, and it is often difficult to distinguish between the early work of Charles Willson Peale and his brother and student, James Peale. Both worked in a style characterized by sharp outlines, heavy shadows, and opaque backgrounds. During this period, changes in James Peale's style paralleled those of miniature painting in general. By the mid 1790s, as can be seen in his 1797 miniature of Marcia Burns Van Ness (cat. no. 35), he was working in a large oval format, had begun to soften his palette by using pale transparent backgrounds, and was drawing with a surer description of form. After 1800 his draughtsmanship became less descriptive and his colors more pastel, and he began to use more bare ivory and greater washes of pigment.

Anna Claypoole Peale, James Peale's daughter, was also an active miniaturist. Instructed by her father in the use of oil on canvas as well as watercolor on ivory, she may have received additional instruction from her uncle, Charles Willson Peale, whom she accompanied on a visit to Washington in 1818. In the years from 1820 to 1827, Anna Peale worked in Baltimore, exhibiting at the Peale Museum[37] and re-

ceiving favorable reviews in the local press: "Miss P has very much improved of late, in force and precision; her likenesses are better, her finish firmer and resolute, and her laces and muslin truer."[38] Among her sitters during her early career were General Andrew Jackson (cat. no. 46), Mrs. Jackson, and President James Monroe.

Some of the finest miniature painters of this period were active in the South, including Edward Green Malbone, Benjamin Trott, and Charles Fraser. Malbone, who began to paint while still in his teens, had a successful career that spanned North and South before his death at the age of 29. Born in Newport, Rhode Island, he was first successful in New York and other northern cities. In 1801 he visited Charleston, where he met Charles Fraser, then a student of law, and Washington Allston, whom he had known earlier in New England. He also found a public eager to sit for his brushes. Malbone's miniature of Washington All-ston (fig. 29), distinctive in its clear color and exqui-site crosshatching, was probably painted in Charleston between February and May of 1801.[39] Malbone has sometimes been accused of having depicted women with excessive sentimentality and men with a boyish attractiveness. However, it is very likely his portrayals were accurate since many of his sitters were beardless youths and teen-aged girls. A miniature of James MacPherson (cat. no. 39) at about five years of age displays a delicate balance between the sentimentality for extreme youth and the almost morbid sobriety that often characterized children's portraits, which was possibly a reflection of the high infant mortality of the time.

In May 1801 Malbone sailed with Allston for England to visit the Royal Academy and to meet Benjamin West and other artists at work in London. Malbone recorded in his journal West's response to his work: "Yesterday was the first time he [West] had seen a picture of my painting: today he condescended to walk a mile and pay me a visit, and told me I should not look forward to anything short of the highest excellence. He was surprised to see how far I had advanced without instruction."[40]

Returning to New England by way of Charleston, Malbone again enjoyed great success. On a later visit to the city in 1806, he contracted an illness that would lead to his premature death one year later in Savan-nah, Georgia.

For the South, the most notable miniaturist of the three proved to be Charles Fraser, a Charlestonian who spent his entire life in the city except for occa-sional trips to the North. Although his friendship with

Figure 29. Edward Malbone, Washington Allston, ca. 1800-1801, watercolor on ivory, 3 1/8 by 3 3/4 inches (7.9 by 9.5 cm). Museum of Fine Arts, Boston, Otis Norcross Fund, 97.599.

Malbone and Allston influenced his ultimate choice of a career,[41] Fraser's artistic activity began long before he met the two miniaturists. As a schoolboy, he kept a sketchbook of landscape views of the region and tried his hand at miniatures and oils. To finance his career as an artist, he studied and practiced law for eleven years before devoting himself entirely to serious painting.

Malbone's 1801 visit to Charleston strongly influ-enced Fraser's style. However, within the following decade, Fraser realized his own style, which was noted for the vivid and accurate characterizations of his sitters.

Well-liked and appreciated throughout his life-time, Fraser received many commissions from his fellow Charlestonians, who also expressed their regard for him in 1857 with a retrospective exhibition of more than 400 of his miniatures. Among the works included was one of a pair ordered by the City of Charleston upon the occasion of Lafayette's return visit in 1825. The Marquis' ties to the city were long-standing and sincere. Almost fifty years earlier in 1777, he had arrived in Charleston to offer his services to the American cause. At the time, he had been housed and entertained by Major Benjamin Huger, a local revolu-tionary. Later, during the French Revolution, Huger's

Figure 30. Charles Peale Polk, Portrait of Thomas Jefferson, 1799, oil on canvas, 26¹/₂ by 23¹/₈ inches (67.3 by 58.7 cm). Collection of Victor Spark, New York.

son Francis had attempted unsuccessfully to free Lafayette from an Austrian prison. To commemorate the 1825 visit, Fraser was commissioned to paint a miniature of the younger Huger for the city to present to Lafayette and to paint a portrait of Lafayette for the City of Charleston to keep.[42] Although the Huger portrait is unlocated, the little portrait of the Marquis was exhibited in 1857 and remains a treasured possession of the City Council of Charleston.

Malbone, Trott, and Fraser were followed by others of varying skills, in addition to artists better known for their work in oil such as Thomas Sully, John Wesley Jarvis, and Rembrandt Peale. Many foreign-born artists were also active, their continental training evident in the linear treatment of form and detail and in the dark opaque backgrounds of their miniatures. Among these were Philippe Abraham Peticolas, Louis Antoine Collas, Jean François de Vallée, and Joseph Pierre Picot de Limoëlan de Clorivière.

Philippe Peticolas was born in Meziers, France, and spent an adventurous youth in the army of the King of Bavaria; during that time he also studied miniature painting. In 1790 Peticolas was serving as an infantry captain in Santo Domingo during an attempt to suppress a slave rebellion. Deciding to end his military service, he moved with his family to Philadelphia to embark on a career as a miniaturist. He subsequently moved to Lancaster, Pennsylvania, then to Richmond, Virginia, where he resided until his death in 1841.[43] Leaving his family at home, Peticolas traveled as an itinerant; these journeys are documented by signed and dated miniatures found in Maryland and northwestern Virginia. While in Winchester, Virginia, during 1797 he painted Mary Briscoe Baldwin's miniature. The following year in Baltimore he painted a minuscule depiction of two unidentified young women seated in Windsor chairs before a pianoforte displaying French sheet music (cat. no. 36). Both works are painted with the linear brushstrokes and opaque background typical of Peticolas's style.

Another European-trained miniature painter active in the South was Louis Antoine Collas. French-born and trained, Collas reportedly enjoyed success working as a miniaturist in St. Petersburg, Russia, from 1808 to 1811. His name first appeared in the New York City Directory in 1816, presumably soon after his arrival in the United States. In the same year Collas advertised his services in Charleston,[44] where in 1817 he painted a miniature of two children of a distinguished Charleston family, *Portrait of the Ralph Izard Children* (cat. no. 44). The small portrait, in which the two children are shown playing with a small carriage, is representative of the artist's work in its elaborate landscape setting and genre subject. As in other paintings, he employed a dry pigment applied in meticulous strokes. Although Collas was in New York City again in 1820, records indicate that from 1822 to 1824 and from 1826 to 1829 he worked in New Orleans. The facts of his subsequent life and career are unknown.[45]

By the 1830s manners and taste in American society had begun to change, and the miniature painter responded. Miniatures were now worn infrequently as jewelry, were usually rectangular in shape, and were displayed in hinged, free-standing cases as small versions of contemporary full-scale portraiture.[46] The refined elegance of the Age of Jefferson had given way to the tastes of the rising bourgeoisie.

FOLK PAINTERS

Folk painting during the period from 1790 to 1830 coincided with the flowering of folk art elsewhere in the country. Until the early 1970s this aspect of the history of painting in the South went unrecognized. However, scholarship and research now testify to both the variety and abundance of folk-art activity in the South.

Like their northern counterparts, folk painters in the South worked as itinerants, traveling widely, frequently revisiting the same places. Certain families were painted *en suite*, at one time or during successive visits.[47] Portraits, the preferred form, were far more numerous than landscapes, genre paintings, or history paintings. Best known today are such folk painters as Charles Peale Polk, Jacob Frymire, Joshua Johnston, Ralph Eleazer Whiteside Earl, and Cephas Thompson.

Charles Peale Polk was taught to paint by his distinguished uncle, Charles Willson Peale, in whose household he was raised. At the age of eighteen, Polk set forth on his own career. Initially successful in Baltimore as a portraitist, he briefly turned to shopkeeping to support his ever-increasing family. In 1796 Polk moved to Frederick, Maryland, and spent the next few years as an itinerant limner in western Maryland and Virginia.[48]

During the 1799 Presidential campaign, Polk was active in Frederick in Thomas Jefferson's Republican party. Typical of Polk's mature style is his insightful portrait of Jefferson (fig. 30), which was painted at

Monticello in November of 1799 at the request of Isaac Hite, brother-in-law of James Madison.[49] The candidate is shown red-haired and alert, imbued with a republican dignity on the eve of his election as the third President of the United States.

At the time of the Jefferson portrait, Polk's career as an artist had reached a low point, perhaps through poor financial management (as hinted by his uncle), perhaps because the artist's political persuasion was at odds with that of potential patrons.[50] In this regard, Polk wrote: "In the County where I reside, Tho vastly wealthy, that wealth lies in the hands of a Class of Citizens, whose political principles seem to have forbidden not only the encouragement of those who dared to differ in opinion from them, But they have even gone so far as to cherish a spirit of persecution against every man who presumed to apposed [sic] them."[51]

After Polk petitioned for and finally received an appointment as a government clerk in Washington, D.C., he produced few paintings. During the sixteen years of his clerkship, he continued to draw portraits in the medium of verre églomisé.[52] Late in his life, Polk retired to Richmond County, Virginia, where he spent his last two years on a farm inherited by his third wife. Although the presence of artists' supplies in his inventory suggests that he may have continued to paint in these final years, his obituary makes no reference to his career as an artist.[53]

Joshua Johnston, a contemporary of Charles Peale Polk and one of the earliest known black painters in the United States, was active in Maryland in the years after Polk moved to Frederick. Since his work appears to be related to Polk's, it has been suggested that Polk may have been Johnston's master, both as slave-owner and teacher.[54] While certain similarities between the two men's work exist, Johnston's paintings are the more restrained: his highlights less vivid, his modeling less three-dimensional, his color more subdued and subtle.

Both Johnston and Polk derived their compositions from the type of late Baroque portraits executed in America during the eighteenth century. Print reproductions provided a selection of stock props—costumes, furniture, poses, architectural elements—which were freely adapted by the folk artists in their work. In spite of recurring similarities, it is unlikely that Polk and Johnston were related either as teacher and pupil or as owner and slave.[55] Johnston, in his advertisements, disclaimed any such relationship, noting of himself:

He takes liberty to observe, That by dint of industrious application, he has so far improved and matured his talents, that he can insure the most precise and natural likenesses.
As a self-taught genius, deriving from nature and industry his knowledge of the Art: and having experienced many insuperable obstacles in the pursuit of his studies; it is highly gratifying to him to make assurances of his ability to execute all commands, with an effect, and in a style which must give satisfaction.[56]

Little is known of Johnston's life beyond his inclusion in the Baltimore City Directories from 1796 to 1817 and in the Federal Census of 1810.[57] In one of these citations, reference to Johnston as a black lends further credence to the various family traditions of slave-artists whose paintings (along with the accounts of how they were executed) were handed down to the sitters' descendants.[58] Only one portrait signed by Johnston has been found, that of Sarah Ogden Gustin, a resident of Beckley County, Virginia (today West Virginia). Mrs. Thomas Everette and Children (cat. no. 45) is attributed to Johnston both on the basis of style and from a reference to a bequest in the will of Mrs. Thomas Everette.[59] Both paintings give evidence to Johnston's disarming directness and simplicity, and to a certain mannered stiffness. The distinctive brass upholstery tacks depicted in the Everette group appear frequently in his work.

Polk and Johnston worked in the parts of the South where they lived. Two of their contemporaries—Cephas Thompson and Jacob Frymire—maintained residences and families in the North while they established significant reputations by the portraits they executed in the South.

Thompson was born in Middleboro, Massachusetts. Although his connections with the New England town were lifelong, the self-taught artist spent his winters in the South, traveling to every major community between Philadelphia and New Orleans.[60] In 1804 he visited Charleston, where he advertised that he would cut likenesses in paper as well as "paint profiles and execute them in gold."[61] On one such trip, in 1805, he painted the widowed Charlestonian James Miles with his son and young daughter.

The painting shows Miles seated at center with his daughter on his knee and his son standing at his side. The spartan yellow interior includes a niche and a neoclassical funerary urn (containing the ashes of Miles's late wife) placed to the rear of the group, visible between father and son. The sobriety of dress, sad expressions, and stark theatrical setting combine to make this work a monumental conversation piece

eloquently expressing the sorrow and loneliness of the family. Thompson is not known to have produced other works of this size and complexity. Most of his portraits include only one or two figures.

Like Thompson, Frymire is known for his portraits of solitary individuals. He worked in both watercolor on ivory and oil on canvas. Since no newspaper advertisements for Frymire have been discovered, there is no record of his work in other mediums or any knowledge that he taught or pursued other crafts. Born sometime between 1765 and 1774, Frymire was the son of a farmer in Lancaster, Pennsylvania. By 1790 he was established as an itinerant limner, traveling and seeking work in New Jersey, Pennsylvania, Maryland, Virginia, and Kentucky.[62] It is not known whether he was entirely self-taught or whether he was at one time apprenticed to an established artist in Lancaster or nearby Philadelphia.[63] According to court records and other archival sources, about 1791 he followed his father, Henry, to Franklin County in central Pennsylvania.

Between painting expeditions, Frymire established residence at his father's farm in Hamilton Township, Pennsylvania; he was taxed there until 1810, with his profession given as "limner." In 1810, a few years after his marriage, he purchased a house and lot in Shippensburg, Cumberland County, Pennsylvania. There he apparently opened his painting-room, since he continued to be taxed as a limner.[64] Upon his father's death in 1816, Frymire inherited part of the family estate and subsequently moved to the Hamilton Township farm, where he remained until his death in 1822.

Frymire's trips to the South are established by the inscriptions on his paintings and by their known subjects, usually noted on the back: Winchester, Virginia, in 1799, 1801, and 1805; Alexandria, Virginia, in 1800 and 1801; Warrenton, Virginia, in 1803. For the years after 1806, when Frymire executed some impressive portraits in Kentucky, only one work, dated 1813, has been located. To date, only thirty-one known portraits exist from a distinguished career of twenty-four years.[65]

Economy of form and a strong linearity are typical of Frymire's work. A simple setting suffused with a uniform, glowing light is combined with attention to detail to create, in works like the portrait of Amelia Lauck, images of strength and beauty. In this portrait, the wife of the locally noted Winchester, Virginia, innkeeper, Peter Lauck, is depicted with an intensity and perception of character that places it among the

artist's strongest works. Frymire's ability to capture the mystery of childhood is appealingly evident in the portrait of Ann Lucretia Deneale (cat. no. 38), which was painted in 1800 in Alexandria, Virginia. In this work, an engaging child with curly blond ringlets stands beside her pet bird as she scatters berries to it. This work is filled with lovely passages, such as the treatment of the key in the lock, the salmon-colored paneling, and the vivid patterning of the rug.

THE TOURING EXHIBITION

Portraiture was the most acceptable subject for the general public in the South; if an artist possessed ability, he could usually earn a living as a portrait artist. Concurrent developments in European art, however, placed portraiture at the lowest level of acceptable subject matter. In the Salons of the French Academy, history painting reigned supreme, with its subjects designed to uplift or edify. The large historical canvases of the early nineteenth century usually depicted subjects that were so awesome, sublime, or otherwise exceptional that purchasers could not often be found for them. Of necessity, therefore, the artist became a showman, exhibiting his painting for an admission fee. In the South, touring exhibitions of such large-scale canvases were popular in the years following 1800.

One large painting that toured the South was produced as a commission received from the North Carolina Legislature. Thomas Sully was requested to execute a portrait of George Washington for the capitol in Raleigh. However, the finished painting, which depicted Washington crossing the Delaware at Trenton, was so enormous that it would not fit into the space allotted to it and the legislature refused to accept it. Sully toured the work and eventually sold it to a Boston frame-maker, from whom it eventually reached the Museum of Fine Arts in Boston, where it hangs today. Sully also toured his copy of François Granet's *Capuchin Chapel*, which was first exhibited in Charleston in 1822.

Rembrandt Peale found marked success with his *Court of Death* on its tour of the South. Crowds in many cities flocked to see the painting, providing its creator with approximately $9,000.00 in fees during one year of touring.[66] And Madame Anthony Plantou's *Treaty of Ghent* was shown in Washington, D.C., in 1819 and in New Orleans in 1820.

William Dunlap, a frequent traveler in the South, recorded the overlapping network of touring historical

and religious paintings. Visiting Norfolk, Virginia, in 1822, he saw Sully's copy of *Capuchin Chapel*, and in Baltimore, Gruin's *Descent from the Cross*. Dunlap noted that he found the experience of viewing Sully's painting so inspiring that he returned to his studio to work on his own *Christ Rejected*.[67]

The "blockbuster" exhibitions of their day fortuitously combined monetary gain for the artist with the hoped-for elevation of public taste and character.

GENRE SUBJECTS

In depicting scenes from the Bible or events from the American Revolution, artists thus provided more elevated subject matter than mere portraiture. Paintings of everyday events, or genre scenes, however, did not become common until the 1840s. An early example dating from the late 1830s is the *Arrival of the Mail* (cat. no. 58) by John Blake White. The scene, the vista down Broad Street in Charleston, South Carolina, is framed by the archway of the Exchange or Custom House at the foot of the street. As noted by the Charleston *Courier*, White subordinated the importance of the location to the events taking place:

> Mr. WHITE has judiciously given to the street the effect of a secondary object, having introduced it in the character of a background, to a couple of bold and striking figures, that are immediately within the archway, on the fore-ground—the one a genteel figure, reading a letter, just received out of the Post-Office—the other a sturdy post-rider, dragging in a heavy leathern mail, thereby giving character and locality to the scene. Other figures are on the plat-form and along the extent of the street, which mark the perspective, and give interest, animation and verisimilitude to the picture.[68]

White is also noted for later works that specialized in scenes from American history. Although he had three years of study with Benjamin West in London, he met with little success as a painter. He earned a living as a lawyer, pursuing painting in his leisure time.[69]

INDIAN SUBJECTS

Aristocrats of wealth and newly-established members of the middle class were not the only subjects to which painters turned at the beginning of the nineteenth century. A growing concern for the fate of the native Indian, in conjunction with scientific curiosity and ethnological studies, encouraged the creation of a number of Indian portraits.

One of the earliest known groups of portraits was executed by Saint-Mémin in Washington, D.C.. In 1807 the explorer Meriwether Lewis, newly returned from his famous expedition to the Northwest, commissioned him to take "likenesses of the Indians necessary to my publication"[70] (the expedition journals). Washington society found itself intrigued with the six chiefs of the Osage tribe who had returned with Lewis and his associate William Clark. They appeared as "noble specimens of the human race . . . tall, erect, finely proportioned and majestic in their appearance, dignified and lofty in their demeanor."[71] Saint-Mémin, who had already completed portraits of both Lewis and Clark, produced a set of Indian portraits in pastel for Lewis, followed by a second set in watercolor for Sir Augustus John Foster, Secretary of the British Legation, who took them to England. It was probably because of Foster's interest in the customs, manners, and costumes of the American Indians that Saint-Mémin replaced the army uniform worn by the chief in one of the pastel portraits with a costume of blankets, beads, feathers, and silver ornaments in the watercolor version.[72]

Fascination with Indian subjects continued in Washington. During the winter of 1821-22, the Bureau of Indian Affairs commissioned Charles Bird King, a local resident, to paint the visiting delegation of chiefs from the Great Plains tribes of the Upper Missouri River, for which he received $160.00. The idea for the paintings was conceived by Thomas L. McKenney, then head of the Bureau of Indian Affairs in the Department of War, as part of an archive. This archive was actually to be an ethnological museum that would contain objects relating to "the aboriginal man [that] can be rescued from the ultimate destruction that awaits his race." Of the 143 portraits painted by 1842, the year the project ended, all but twenty-three had been executed between 1821 and 1830, among them the forceful image of Chief Push-ma-ta-ha, who had been westernized in top hat and black suit. Recognized for the realistic details of costume and jewelry, King's portraits were also criticized for their failure to capture the facial characteristics of the Indians: "very rarely do we find in these portraits a suggestion of the non-Caucasoid physical features that we know . . . to be characteristic of North American Indians."[73]

Such criticism is valid in King's portrait of Mistippee (cat. no. 54), who appears less a Creek warrior than a young man casually posed in a modified West-

ern costume. His facial features, with their gentle shadows and highlights, suggest the Caucasian race, while his "Indian-ness" is apparent in details such as the bow and arrow in his right hand.

For many years, King's Indian portraits hung in the Bureau's office in the War Department Building west of the White House, where they became one of the city's major tourist attractions.[74] Unfortunately, many survive today only in replicas made by the artist, in certain copies by Henry Inman, and through the lithographs produced for a three-volume publication by McKenney and Hall: *The Indian Tribes of North America, with Biographical Sketches and Anecdotes of the Principal Chiefs.* The originals, one of the few instances of Federal patronage during this period,[75] perished in a tragic fire at the Smithsonian Institution in 1865.

Far from Washington, an unidentified artist chose for his subject *William Bowles and the Creek Indians* (fig. 24; cat. no. 40). The artist may have been Bowles himself, as it is known that on occasion he painted his own portrait with important Indians for propaganda purposes. In this work of about 1800, Creek Indians in native dress bring corn and other fresh produce for barter with the colorful adventurer from Maryland. Married to the daughter of a Creek chief in Florida, Bowles in 1781 led the Creek Indians against the Spanish in the defense of Pensacola. After a trip to England in 1790 to promote an invasion of Mexico, Bowles turned to piracy. In 1792 he was captured and sent to a Spanish dungeon, where he died at the age of forty-two.[76]

STUDIES FROM NATURE

In these same years, naturalist painters rode and hiked through the South's forests and fields to record birds, animals, plants, and trees, in addition to the native Indians and their way of life. The work of these painters continued that begun by the earliest European visitors to the Southern coasts in the sixteenth and seventeenth centuries.

Undoubtedly the most important and original naturalist at work in the South in the first decades of the nineteenth century was John James Audubon. Born in Haiti to French parents, Audubon was educated in France, where he is said to have studied painting briefly with Jacques-Louis David. In 1803, at the age of eighteen, he settled in Mill Grove, Pennsylvania; in 1806, after a brief visit to France, he moved on to Louisville, Kentucky. There he operated a store, but his primary interests were in hunting, collecting, and drawing the native wildlife. Neglect of his business resulted in financial disaster and, two years later, caused Audubon to turn to portraiture as a means of support.[77]

Audubon traveled extensively, furthering his research and enlarging his portfolio of bird studies until they numbered in the hundreds (cat. no. 50). In 1826, unable to find an American publisher for his proposed volume of bird plates, he left for England, where for more than a decade he devoted his efforts to the production and printing of *The Birds of America.* Publication of the double-elephant folio containing 435 life-sized, hand-colored aquatints began in 1826 and continued until 1838, appearing in eighty-seven parts. The five-volume text for the edition, entitled *Ornithological Biography,* was published between the years 1831 and 1839.

Audubon returned to the United States in 1839. He settled on the Hudson River in 1842 to start work on his second great project, *The Quadrupeds of North America.* The ensuing plates, reproduced by lithography, were published in thirty parts in 1845-46.[78]

LANDSCAPES

Western expansion at the end of the eighteenth century opened new vistas and previously unknown natural wonders, spurring an interest in landscape painting. Some painters were attracted to the production of estate portraits, providing owners of plantations or more modest residences with a permanent record of home and grounds. Others produced views of the land and of communities, producing topographical records that today are important documents of the growth of major cities and towns. Through their attention to and treatment of the fresh beauty of the countryside, some of these painters became precursors of the great tradition of landscape painting, the Hudson River School, that was to emerge later in the century.

The strongest influence on the early native landscapists in the South came from British-trained painters such as George Beck, Francis Guy, William Groombridge, and Joshua Shaw. The picturesque view of nature introduced by Beck, Groombridge, and Shaw added drama and grandeur to the depictions of youthful cities and towns in the South not previously seen. Furthermore, the presence of Beck, Groombridge, and Guy in Baltimore for almost a decade no doubt contributed to a public interest that encouraged the land-

Figure 31. *George Beck,* View of Baltimore from Howard's Park *(cat. no. 32).*

scape painters who followed them: Cornelius de Beet, Thomas Ruckle, and the early Hudson River School painter Thomas Doughty.[79]

One of the earliest trained landscape painters to work in Baltimore, George Beck arrived in 1795 with his wife Mary, also a painter. Their residency was brief; little more than a year later they departed for Philadelphia, and in 1806 they moved to Lexington, Kentucky. Beck's full, loose brushstroke and other aspects of his English training are apparent in his *View of Baltimore from Howard's Park* (fig. 31; cat. no. 32) of about 1796. In spite of acclaim from the Baltimore art critic Eliza Godefroy in the *Observer* of 1807 that he was a better painter than Francis Guy or William Groombridge, Beck's career unfortunately languished. Later in life, struggling to support themselves, he and his wife opened a school for young ladies in Lexington. He died there in 1812, unrecognized and embittered.[80]

In 1804 another English landscape painter arrived in Baltimore. William Groombridge, who was born in 1748 in Kent, was a student of the landscape painter James Lambert of Lewes and a frequent exhibitor at London's Royal Academy until the early 1790s, when he departed for the United States. In 1794 he was recorded as one of the founders of Philadelphia's short-lived Columbianum. Groombridge's wife was herself an amateur painter, as well as the director of a girls' school.[81]

Joshua Shaw, who was like Beck and Groombridge an English-born and -trained artist, was encouraged to emigrate to America by Benjamin West. After his arrival in 1817, Shaw traveled throughout the South making drawings, watercolors, and oils of the best and most popular views and of life among the Indians and frontiersmen.[82] Some of Shaw's work was engraved by another English immigrant, John Hill, and was published by M. Carey and Sons, Philadelphia, as *Picturesque Views of American Scenery.* Included in the series were a number of Southern views from Virginia, the Carolinas, Georgia, and Mississippi, as well as a depiction of the burning of Savannah, which Shaw had witnessed in 1820.

Shaw's picturesque painting style was characterized by the use of classically composed groups of trees and figures, contrasting areas of light and dramatic shadows, and the inclusion of idealized landscape features. In the landscape tradition of the South, he spanned the period between the pure topographical interests of the eighteenth century and the first stirrings of the Romantic landscape developed later by the Hudson River School.

An important visitor from the North, Thomas Doughty, spent much time working in Baltimore and Washington during the 1820s. Doughty received his first encouragement from the early Baltimore collector Robert Gilmor. Gilmor's collection, which contained landscapes by various European masters including Albert Cuyp, Jacob van Ruisdael, Nicolas Poussin, and Claude Lorrain, provided artists who visited or resided in Baltimore with exposure to European art which was not generally available elsewhere. Through the study of these paintings and prints, European landscape styles were transmitted to Doughty and others. Evidently Doughty learned quickly, because his two early views of Baltimore from Beech Hill, Gilmor's home, were highly regarded by the collector.[82a]

Francis Guy was another artist who learned from the range of landscapes in Gilmor's collection. Guy painted essentially estate or city portraits, which went beyond mere mechanical rendering but were free of excessive imaginings. His sharply drawn paintings of Baltimore and of Mount Vernon and other Southern plantations contain realistic genre scenes of people in their daily activities.[83]

At the same time the landscape tradition was flourishing in Baltimore, artists in Charleston, South Carolina, were also painting landscapes, among them Charles Fraser, Thomas Coram, John Blake White, Francis C. Hill, and Joshua Cantor. As a group, however, they did not receive the wide public attention given their contemporaries in Maryland.

One of the Charlestonians, Francis C. Hill, first advertised his services as a furniture maker and sign painter in 1804. Three years later he was listed with the limners and miniature painters of the city. Surviving sketchbooks, which attest to his interest in landscape and cityscape, include a number of views of St. John's Lutheran Church, where Hill was a member and served on the vestry. Various surviving oil paintings and prints based on these sketches show the original church, which was erected in 1756 and taken down in 1818. *Old St. John's Lutheran Church, East* (cat. no. 59), signed and dated 1818, was apparently done—as were the others—to record the building as it appeared before its destruction.[84] Hill silhouetted the simple white clapboard structure against the sky and added a few solitary figures among the grave markers and a single gnarled tree by the sanctuary door. The quiet setting and the lack of nearby structures reaffirm the graphic strength of Hill's portrait of the simple building.

Another artist who recorded views in and around Charleston was Charles Fraser, the miniaturist. From his early youth through the beginning decades of the nineteenth century Fraser kept a sketchbook, which he filled with watercolor views of buildings and places in and around Charleston. As observed in the November 26, 1818 issue of the Charleston *Courier*, Fraser had "executed twenty very beautiful drawings of scenes, in different parts of the United States: the whole have been purchased by the proprietors of this Journal. . . . The execution is, we think, as fine as any we have ever had occasion to inspect."[85]

While Hill and Fraser were among the artists at work in Charleston, other painters worked throughout the South to supply views of cities and well-known locations such as Mount Vernon, Harper's Ferry, Tallulah Falls, and the Natural Bridge of Virginia. On occasion their paintings were used as sources of prints that were to be issued in sets or individually.

George Cooke's views of Southern cities were engraved during the 1830s. Included were Washington, D.C., and Charleston, South Carolina, as well as two Virginia cities, Petersburg and Richmond.[86] His view of Tallulah Falls, Georgia (cat. no. 57), executed sometime during the 1830s or 1840s, is representative of the style seen in his city views. These expansive landscapes are among Cooke's most attractive work and, as in the views of Charleston and Tallulah Falls, demonstrate a sensitive observation and rendering of both environment and atmospheric conditions.

The itinerant artist John L. Boqueta de Woiseri was trained as a portrait painter but worked in a primitive landscape style that indicated little or no knowledge of European traditions. Between 1797 and 1815, Boqueta de Woiseri sketched the various views for his print *First Cities of the United States*. This six-section print, which was published in 1810, included views of Philadelphia, New York, and Boston in the North, and Baltimore, Charleston, and Richmond in the South. In 1804 he executed an oil painting (which he reproduced in aquatint) of *A View of New Orleans Taken from the Plantation of Marigny*. The crescent city stretches to left and right beneath the outspread wings of an American eagle. In the eagle's claws is a banner, which reads, "Under my Wings Everything Prospers." Publication of this print and an accompanying plan of the city of New Orleans coincided with the Louisiana Purchase in Jefferson's administration.[87]

In addition to those by Boqueta de Woiseri, landscapes of Southern scenes were produced by primitive painters and other untrained artists. Joshua Tucker, a South Carolina dentist, executed a number of early views of Greenville, North Carolina. To the west, portrait painter Jacob Marling, a resident of Raleigh, recorded in its sylvan setting the North Carolina State House (cat. no. 55), a building that would be destroyed by fire in 1831.

Benjamin Henry Latrobe, although best known as an architect and engineer, was also an accomplished landscape and topographical painter. Born in England and educated in Germany, he studied architecture and engineering in London for three years. Latrobe arrived in the United States in 1796. As the Federal Government's Chief Architect of public buildings from 1803 to 1817, he was largely responsible for the present design of the Capitol in Washington. From his arrival in America until his death in New Orleans in 1820, he planned some of the principal buildings in Pennsylvania, Maryland, Virginia, and the District of Columbia; he also filled his voluminous sketchbooks with pencil and watercolor drawings of the natural and architectural scenery of Maryland, Virginia, and areas to the South.[88]

An 1810 watercolor, *The Capitol at Washington* (cat. no. 34), represents the seat of government in the middle distance, with a tree-shaded group of figures on the left. Shown in bright sunlight, the Capitol is rendered in a precise linear style that clearly reveals the details of window treatment, stone work, and balustrades, as well as the ornamentation of the drum. A number of arriving and departing horse-drawn carriages and casually-placed figures add life to the scene, while the relatively large size of the piece—$16\frac{1}{2}$ by $25\frac{1}{2}$ inches—gives it a presence uncommon to the medium of watercolor.

ART IN URBAN CENTERS OF THE SOUTH

Because the South was supported by a predominantly agrarian economy, its population was less prosperous and less economically diversified than that of the Northeast. Resources necessary for successful cultural developments were often lacking. In the seaport towns, mercantile activities increased at the end of the eighteenth century and again following the War of 1812. Accumulated capital, however, was usually tied up in land, labor, and equipment, and was consequently not readily available for luxuries such as the purchase or commission of paintings or for the patron-

age of organizations necessary to encourage and support a local flowering of the fine arts.[89]

Despite these handicaps, during the first three decades of the nineteenth century, both Charleston and Baltimore boasted organizations that sponsored exhibitions of paintings and encouraged public interest and education in the arts. Neither Charleston's South Carolina Academy of Fine Arts nor Baltimore's Peale Museum survived long, but they added depth to the artistic life of their communities, provided public recognition for artists, and laid the foundations of public consciousness that would later foster more permanent arts institutions. Other communities in the South repeated the experience of these centers in varying degrees. In the valleys of Virginia and North Carolina, in Kentucky and Tennessee, several communities emerged during these years as art centers that would attract the sustained interest of painters working in the South.

By 1799 Baltimore was the third largest commercial port in the United States. Three banks and an active import-export trade of coffee and grain with South America made many Baltimore families wealthy for decades to come. An artistic tradition already existed in the city; many families could boast owning works by Gustavus Hesselius and his son John, Justus Englehardt Kühn, John Wollaston, and Charles Willson Peale.

For some citizens of Baltimore there was a strong interest in the formation of libraries and the collecting of paintings. Foremost among them was Robert Gilmor, Jr., whose prints and paintings served as inspirations for many resident or visiting artists. A number of major painters, attracted to the city by Gilmor's collection, enjoyed the opportunity for patronage that they found there. Among those who visited the city at the turn of the century were John Wesley Jarvis, Jacob Eichholtz, Gilbert Stuart, Charles Bird King, Chester Harding, and Thomas Sully.

Portraiture continued as the most popular subject in Baltimore. Washington Irving, visiting in 1814, reported that Jarvis was "in great vogue in Baltimore—painting all the people of note and fashion, and universally passing for a great wit, a fellow of infinite jest."[90] Jarvis, he said, "was overwhelmed with business and pleasure, his pictures admired and extolled to the skies, and his jokes industriously repeated and laughed at."[91]

Many artists took up longer residence in the city or were themselves native-born to Maryland: Caleb Boyd, Joshua Johnston, Frederick Kemmelmeyer, James McGibbons, Philip Tilyard, and Jeremiah Paul, Jr. Various members of the Peale family, both first and second generation, were active in Baltimore, notably James Peale, his daughter Sarah Miriam Peale, and her cousin Rembrandt Peale.

Sarah Miriam Peale, a resident of Baltimore between 1820 and 1827, maintained a studio at the Peale Museum, which was run by Rembrandt Peale.[92] A successful portraitist, she was also interested in other subjects, including still life. Her painting *Still-Life of Watermelon and Grapes* (fig. 32; cat. no. 48), executed sometime during the 1820s, is characteristic of her work. The ripe moistness of the massive slice of gleaming watermelon is accented by the rows of shiny black seeds, which contrast with the matte surfaces of the grape leaves and the dry sheen of the green- and ruby-toned grapes. Some of the leaves and grapes cascade forward over the table's edge, lending a sense of depth to the painting. This emphasis on surface and volume, as well as the choice of a still-life subject, unite Sarah Peale's work with that of her father and another cousin, Raphaelle Peale, then active in Philadelphia.

Rembrandt Peale, following studies with his father, Charles Willson Peale, began his career at age thirteen. His further artistic education included a year in London with Benjamin West from 1802 to 1803, trips to France in 1808 and 1809-10, and two subsequent visits to Europe in the late 1820s and early 1830s. The influence of Peale's French visits is evident in his style of painting and choice of subjects. He painted portraits, but like many of his contemporaries he preferred the grandiose historical compositions favored in the European art centers. Unfortunately, of the seven large history paintings Rembrandt Peale is known to have painted, only two survive. One of these, *The Court of Death*, was executed in Baltimore in 1820.

Rembrandt Peale's portraits survive in greater number. They include an especially sensitive depiction of Benjamin Latrobe, architect and artist, during his residence in Baltimore. This work is not overpowered by the high finish and smooth surface Peale had learned from his French contemporary, Jacques-Louis David. Although the brushstrokes are barely perceptible, the portrait is painterly, looking back to the artist's earlier training with Benjamin West.

While members of the Peale family were active in Baltimore for many years, they were not native to the

Figure 32. Sarah Miriam Peale, Still-Life of Watermelon and Grapes
(cat. no. 48).

city. Perhaps the most talented of those born there was Philip Tilyard. Described by William Dunlap as an "honest and unfortunate man of genius,"[93] Tilyard was initially trained as a sign painter. Induced by a $20,000 lottery prize to become a dry-goods merchant, he suffered a miserable financial failure which forced his return to painting. In spite of his interrupted career, Tilyard came to the attention of Baltimore's two most important art patrons, Robert Gilmor, Jr., and John Pendleton Kennedy. Both men recognized Tilyard's abilities, Kennedy having his portrait painted in April 1827. Further encouragement came from Thomas Sully, who exerted a strong influence on the Baltimore painter.[93a]

One of Tilyard's subjects was Jonathan Granville, the First Envoy from Santo Domingo (cat. no. 49). Granville visited Baltimore sometime in the autumn of 1824 on a trip to promote the emigration of free blacks from the United States to Haiti in an effort to further the development of that country. Circumstances under which the small and informal portrait were made are not known. The painting displays the moist skin tones for which Tilyard is known and which reflect Thomas Sully's influence on him. Granville is dressed in a dark-blue European-style coat with white vest and shirt. His dark cropped hair lies close to his face and covers his left ear, which is decorated with a small silver pierced earring. The unusual article of jewelry and the ethnic characteristics of Granville's features add an aura of genteel exotica to an otherwise simple and direct portrait.

Community support for a public art gallery or academy was to come later in Baltimore than in Charleston. A privately sponsored museum existed intermittently from 1791 until 1813, when it emerged as the Peale Museum, or "Baltimore Museum," founded by Rembrandt Peale. Like its model, the Peale Museum in Philadelphia, this institution was devoted to educating the public in art and science, to improving taste, and to providing entertainment. It offered natural history specimens and paintings that ranged from portraits of national heroes to allegorical and historical subjects. The tours of history paintings included Baltimore on their itineraries and the Peale Museum exhibited large-scale works by Sully, Dunlap, and Rembrandt Peale in the 1820s.

The first formal group art exhibitions in Baltimore were held at the Peale Museum in 1822 and 1823. Although successful, they were not followed by further exhibitions. After the mid 1820s, the Museum

began to decline and was ultimately sold in the 1840s.[94] Despite shortcomings, such as its failure to provide regular exhibitions and its lack of facilities for training artists, the Peale Museum did much to enhance the cultural life of the city. It contributed, together with the presence of the collector Gilmor, and the activities of a sizable resident and itinerant artist community, toward making Baltimore a major center for the arts in the South during the early decades of the nineteenth century.

The District of Columbia was created in 1788 and was designated by the Constitution as the site for the City of Washington, the nation's capital. For the next twelve years, however, Philadelphia continued to serve as the temporary capital while the design and survey of the city were completed and construction was underway. Although the ten-mile-square area ceded by Maryland and Virginia included Georgetown and Alexandria, the largest part of the District was undeveloped and remained an open space of former farmland and forest well into the nineteenth century. Early accounts repeatedly stress the emptiness of the place. John Caldwell left the following description after a visit in 1808:

> Had the original plan of this capital of the United States been more moderate, the 1200 houses which it now contains would have made a neat and compact city, but scattered as they are, on hills and vallies, and avenues and dales, it is difficult to give you an idea of the confusion that strikes the eye, the first and most prominent object is the capitol, of which only the two wings are finished, and a vacant space left between them, where is to be erected the centre . . . it is situated on the most elevated site in the city . . . The Pennsylvania avenue runs in a direct line from the centre of the capitol to the President's house, it is 160 feet wide, and a noble walk on each side for foot passengers; the President's house in a neat, plain building, of hewn stone. . . .[95]

Artists nevertheless began to add Washington to their north-south travels early in the nineteenth century, drawn by the prospect of federal patronage and the presence at one time or another of nearly every individual of note in the political life of the country.[96] Gilbert Stuart spent a lengthy sojourn from 1803 to 1805, painting James and Dolley Madison and a number of other important Southern personages, including John Randolph and John Tayloe. Charles Willson Peale and his son Rembrandt arrived in 1805. The city was host to many other painters, but few stayed to make Washington their place of residence. The small size of the community and the transience of many of its

residents combined to prevent sustained support for artists.

Charles Peale Polk, who arrived from Maryland in 1801 looking for a government job, seems not to have found sufficient patronage for his oil portraits.[97] Charles Bird King, however, met with a different response. Following the Panic of 1819, having announced his intention to leave the city, he found that the depression and a family inheritance made it feasible to remain. King's presence added substantially to the cultural life of the capital. In addition to his own studio-gallery, which he maintained for the next forty years, he produced the portraits shown at the Indian Gallery, one of the few instances of federal patronage during this period.[98]

Both Northern and Southern artists saw the government's financial support as a natural way to encourage the development of a native art. No consistent policy of federal patronage, however, was formulated at that time or later.[99] Economic and political issues facing Congress outweighed all other considerations.

The construction program for the Capitol did include mural decoration, but several European artists, such as Pietro Bonanni, were engaged rather than native-born painters. After John Trumbull was commissioned to paint four large canvases for the Rotunda, dissatisfaction with the works and rising doubts as to the appropriateness of federal involvement in the arts led to the defeat of further governmental patronage. The four remaining Rotunda panels were not commissioned until the 1830s. Executed by Henry Inman, Robert Weir, John Gadsby Chapman, and John Vanderlyn, they received little enthusiasm from Congress.[100]

To the south of the District, Richmond was an active business center and port, the capital of Virginia, and seat of the state legislature. In the early years of the nineteenth century, the city attracted many of the same artists who visited Baltimore and Washington. However, as in those cities, only a few of them became residents. The transient painters were numerous and notable. Thomas Sully and John Wesley Jarvis worked there at one time or other, in addition to the following: Raphaelle Peale, Charles Bird King, Benjamin Henry Latrobe, David Boudon, Joseph Wood, George Cooke, Pierre Henri, Cephas Thompson, James Gray, Peter Grain, James McGibbons, and C. Schroeder. But looking beyond these "birds of passage," other individuals made Richmond their home.

Lawrence Sully arrived around 1792, and he was joined by his brother, Thomas, in 1799. Both were then working as miniaturists, as was Philippe A. Peticolas when he moved to Richmond in 1805 or 1806 with his wife and teen-aged sons. The third son, Edward, studied in his youth with Thomas Sully; a year later, at age fourteen, he advertised: "Master Edward Peticolas will take likenesses in miniature."[101]

Peticolas went on to Europe in 1815, returning after four years to set up "an exhibition room" at his residence in Richmond, where as "Portrait Painter" he met considerable success. William Dunlap, after a visit to Richmond in 1821, noted of Edward Peticolas: "There was a modest manner in the artist, and rather a want of boldness in his work." Sully wrote of him that, although "beloved in Richmond," his work was "timid and cramped."[102] Peticolas painted for only a few more years after an attack of rheumatism in the 1830s.[103]

Much of Peticolas's competition during the 1820s came from George Cooke, who had settled in Richmond after his marriage to a local girl in 1816. Cooke was a congenial and popular man, and within a very few years he received many portrait commissions. In September of 1825, at the end of a two-year period Cooke stated that he had painted one hundred thirty portraits, forty of which had been done in Richmond.[104] Wishing to develop his abilities further, Cooke departed Richmond in 1826 for three years of art studies in Italy and France. He never reestablished a permanent residence in Richmond.

During the decades of both Cooke's and Peticolas's activity, a third artist, James Warrell, was also living and painting in Richmond, and also operating a museum. Warrell was a portrait and history painter who began his career around 1806, painting theater scenery in Petersburg, Virginia. Like the Sully brothers, he had been born into a theatrical family, making his stage debut in 1794 in Philadelphia. By 1810, Warrell had advertised himself as a portrait painter. In Philadelphia, upon the exhibition of his work, it was reported: "This young artist had made a successful attempt . . . and with proper application should succeed as an historical painter."

After 1812, Warrell's notices appeared regularly in Richmond newspapers. In 1815, a group of patrons petitioned the Legislature to grant him the use of land "in the Capital Square" to erect a "handsome edifice which would remain always as a public repository of natural and artistic curiosities." The petition granted, Warrell and his partner, Richard Lorton, began solici-

ting subscribers to the Virginia Museum. On November 12, 1816, it was announced that construction of the building would soon be finished, and contributions of artists' works and of natural curiosities were requested. The Virginia Museum opened in the summer of 1817 to great enthusiasm. On special occasions visitors were entertained there with illuminations and band music. Casts of antique statues were received from Paris, and the work of contemporary artists was shown. In April 1820, Thomas Sully's gigantic canvas, *The Passage of the Delaware by the American Troops under the Command of General Washington*, was exhibited.[105]

Despite its initial success, the Virginia Museum survived only twenty years. In 1832, Lorton enforced a lien on the building, offered it for sale, then bought it himself. After attempting to operate the museum for a few years, he gave up and in 1836 sold both the building and the lot back to the Governor.[106] There is no further record of Warrell until 1854, when his widow and daughter referred to him in court documents as being deceased.[107]

Throughout the early decades of the century, itinerant painters passed through North Carolina on their north-south route, stopping at various towns and cities. Francis Rabineau arrived between 1797 and 1799, and he was one of the first to advertise his portrait services, although there were other unidentified artists before him.[108] Itinerants working in a variety of mediums included Nathaniel Jocelyn, F. J. Belanger, William Joseph Williams, Jacob Marling and his wife, Louisa Marling, and James McGibbons.

By the 1820s, Raleigh was the principal art center in North Carolina. Art instruction was available at the Raleigh Academy, founded in 1800, and from private teachers.[109] The North Carolina Museum in Raleigh was founded in 1813. An advertisement in the *Raleigh Register* in 1818 noted:

N.C. Museum. This establishment is now open for the reception of visitors. Admittance, 25¢. Ticket for the year, $5.00. As the plan embraces a Reading Room where most of the principal newspapers, literary works, reviews, etc., are filed, it is confidently believed that it will afford an agreeable and useful place of resort. Natural and artificial curiosities, sketches, maps, drawings and paintings, rare coins and books will be thankfully received and added to the collection, with the name of the liberal donor appended to them. General Calvin Jones has obligingly transferred the whole of his collection to this institution. Jacob Marling[110]

Marling, a portrait and landscape painter, was director of the Museum, while his wife taught at the Academy and gave private art lessons. Other artists working in Raleigh were James McGibbons, Francis Rabineau, Thomas Sanbourne, and Charles Weinedel.[111]

Charleston, the great rival to Baltimore in encouraging artists and art in the early nineteenth century, enjoyed wealth derived from the production of rice in the late eighteenth century and from the later introduction of cotton. Merchants traded successfully with the eastern United States, the West Indies, and Europe, insuring prosperity for the city and attracting artists to it. There was a large demand for portraits and an interest in landscapes and religious history painting. The creation of a center for the arts was discussed early in the 1780s, but nothing materialized until the 1820s.

In the final years of the eighteenth century and during the first three decades of the nineteenth, many artists were active in Charleston, a city whose population by 1820 had reached 24,780. James Earl was active there for two years before his death in the 1796 yellow fever epidemic. Anna Wells Rutledge lists 101 painters working in Charleston between 1800 and 1825.[112] Among the itinerants were such well-known artists as John Trumbull, Samuel F. B. Morse, Alvan Fisher, John Wesley Jarvis, Samuel L. Waldo, Rembrandt Peale, Edward Malbone, John Vanderlyn, and Benjamin Trott.

Native-born artists, while not numerous, included Charles Fraser, John Blake White, John S. Cogdell, and Francis C. Hill. Washington Allston spent his career in the North and in Europe, but his work was exhibited and collected with pride in his native city.

Fraser and Morse appear to have been the dominant artists in Charleston during these early years. Dunlap noted in 1819: "Morse is the Oil painter of Charleston, Fraser the Miniature."[113]

In 1822-23, John Vanderlyn was successful in finding work in Charleston. He exhibited there, among other items, his noted panorama, *The Palace and Gardens of Versailles*, a show calculated to draw attention to his abilities.[114] In 1824 he received the City Council's commission to paint a portrait of General Andrew Jackson, who had just been defeated by John Quincy Adams in the presidential election. Jackson graciously agreed to sittings at the Hermitage, his Tennessee home. The painting was finished in New

York and delivered to Charleston by March of 1825.[115]

This type of private and municipal patronage was reinforced in 1820, when, in spite of the apparent recession, a number of artists and amateurs organized to form the South Carolina Academy of the Fine Arts. The Academy was incorporated by the state, which authorized fund-raising for its operation. Hopes were high that the organization, the first of its kind in South Carolina, would be a lasting part of the cultural scene of Charleston. A proposed three-part program comprised instruction in drawing, annual exhibitions, and the awarding of prizes. No evidence survives to indicate that drawing classes were conducted or prizes actually given out. But from 1822, when the Academy building was erected, through 1828, annual exhibitions were organized.[116] Although public interest continued, active support for the Academy faded in the years following the first exhibition. One of the founders, artist John S. Cogdell, later wrote to Dunlap:

> The Legislature granted a Charter, my good Sir, but as they possessed no powers under the Constitution to confer taste or talent, and possessed none of those feelings which prompt patronage—they gave none to the infant Academy. . . . The institution was allowed, from apathy and opposition, to die.[117]

Although the works exhibited included such European masters as Romney, Reynolds, Raeburn, and Benjamin West, and the Americans Gilbert Stuart, J. W. Jarvis, Samuel W. Waldo, Charles Fraser, and Francis Hill, the exhibitions changed little from year to year. The Council's portraits of Washington, Monroe, and Jackson made annual appearances in company with many works shown in previous years, but the organizers failed to draw selectively upon resources of private collections in Charleston and elsewhere in the state.[118]

Sources of income proved inadequate to pay the Academy's expenses, let alone to retire the debts incurred in the construction of the building. To pay off this indebtedness, the building was sold in 1835.[119]

Charleston began to decline as a port following the Panic of 1819, and the vibrancy of the regional center shifted further south to New Orleans. By the early 1830s, the city was retreating from its role as a major artistic center in the South and as an attraction for aspiring artists.

Newspaper evidence indicates that Savannah, Georgia, was attractive to artists during the early decades of the century. The city, a seaport like Charleston and Baltimore, was well established but was devastated by fire in 1820, an event witnessed and recorded by the landscape painter Joshua Shaw. Early visitors included the Peale brothers, Rembrandt and Raphaelle; Nathaniel Jocelyn; David Boudon; Jean Belzons; Jeremiah Paul, Jr.; Henry Williams Finn; and Charles Renaldo Floyd. The relative proximity to Charleston made it possible for many artists to visit both places, as did Paul and Bourdon.

One of the most colorful art figures to visit Savannah was the miniaturist Joseph Pierre Picot de Limoëlan de Clorivière. A French loyalist, Picot fled France in 1803 after participating in an unsuccessful attempt to assassinate Napoleon. A devout Catholic, he was saddened by the memory of the crime in which he had participated, as well as by the end of romance (his fiancée refused to flee with him).[120] For the few years he remained in Savannah, Picot worked as a miniature painter, executing among other portraits one of Catherine L. Greene (two versions are known), the widow of Revolutionary General Nathaniel Greene.

Undoubtedly, more works by artists active in Savannah survived the 1820 fire and will come to light with further research.

Lexington, Kentucky, began to attract painters in the late eighteenth century. By the nineteenth it had become the state's art center, the so-called "Athens of the West."[122] Transylvania College, the first institution of higher learning west of the Alleghenies, was founded in Lexington in 1787. The first library west of the mountains followed in 1790. These facilities contributed to the town's cultural life and attracted a number of itinerant artists to it. Among the earliest to arrive were Asa Park, a portrait and still-life painter; George Jacob Beck and his wife, Mary Renessier Beck, both painters and teachers; Jacob Frymire and Samuel H. Dearborn, folk painters; and John James Audubon, portrait painter and naturalist.[123] Later arrivals included James Reid Lambdin, Horace Harding, Chester Harding, John Neagle, Benjamin Trott, and Thomas Jefferson Wright.

Kentucky-born painters did not begin to appear until 1815. The earliest known include Matthew Harris Jouett, William Edward West, Joseph H. Bush, Oliver Frazer, Aaron Houghton Corwine, and John Grimes.[124]

West and Corwine, both artists of exceptional ability, left Kentucky to study first in the Northeast and subsequently in Europe. Although Corwine died

at a young age, West pursued a long career as a portrait painter in New York City, Baltimore, and Nashville, where he died in 1857.

Jouett, Bush, and Frazer, an outstanding group of native sons, achieved the highest level of professional competence. All three received national recognition, and in most writings on Kentucky art they are considered painters who reflect the best artistic trends of their time.

Jouett's accomplishments were such that John Neagle, arriving in Lexington in 1818 with the intention of establishing a clientele there, immediately moved on. After visiting Jouett's painting room and finding him "a good and well-instructed artist," Neagle realized that he himself "had no prospect of being the leading painter in Lexington."[125]

Jouett both dominated the Lexington art market and overworked it, finding it necessary on occasion to make painting trips to Louisiana and Mississipi. He is also known to have painted a few landscapes and to have organized art exhibitions for various philanthropic causes.[126] In January 1825, the Kentucky Legislature commissioned him to paint a portrait of the Marquis de Lafayette. Because of scheduling difficulties, however, Jouett had to copy Ary Scheffer's full-length portrait of Lafayette (now in the United States Capitol), and the Frenchman posed only for the finishing touches.[127]

Records of painters active in Tennessee before 1815 are meager; however, works survive by a number of itinerants. The earliest identified artists of importance are Ralph E. W. Earl, W. E. West, and Washington Bogart Cooper, a native of Jonesboro, Tennessee, who was active throughout the state.[128]

Earl, both as artist and as museum founder, contributed much to the cultural life of Nashville. In July 1818, he and a partner, George Tunstall, who was a junior editor of the *Nashville Whig,* established a "museum of Natural and Artificial curiosities."[129] Like the museums of Richmond, Baltimore, and Raleigh, this one was modeled on the Peale Museum of Philadelphia. The museum prospectus said that it would collect "such materials and remains of the arts as may throw light upon the early history of this country. . . . Stones, earths, and minerals. . . . The whole animal creation. . . . The portraits of distinguished characters in Tennessee and those elsewhere. . . . Many of these will be produced by the pencil of one of us and others will be procured."[130]

In 1819 Earl was appointed custodian of the Tennessee Antiquarian Society. On Rachel Jackson's death in 1828, the artist accompanied Jackson, the newly-elected President, to Washington. Earl remained a member of the household, returning with Jackson to Nashville at the completion of his term of office. He died at the Hermitage, Jackson's home outside Nashville, in 1838.

In the years from 1790 to 1830, no distinctly Southern style of painting emerged. The work of painters in the South was not unlike that of artists in the country as a whole. The influence of European Neoclassicism and Romanticism was felt in both the North and the South. Painters passed freely back and forth across the Mason-Dixon Line to pursue studies and patronage. By the early nineteenth century, the South, like the North, had a tradition of public interest and a desire for art that was well-established. Evidence of this exists in the large number of itinerant painters, major and minor, who found commissions and encouragement in the South. Their subject matter reflects the regional quality of painting in this period. Whatever was characteristic or distinctive about the Southern people and Southern places was to appear in their works.

Still-life and genre were rarely found during this period. Historical paintings gained in interest in later years with the popular shows of gigantic canvases. Landscapes, limited primarily to views of cities and estates, were often more concerned with record than interpretation, although there were indications of the first stirrings of the nineteenth-century American landscape achievements of the Hudson River School and its descendants.

Portraiture, however, remained the strong, constant, abiding interest throughout the South, and it provided work for the overwhelming majority of painters. Images of loved ones were a necessary record in a region bound by strong family ties. Photography, a fast, less expensive, and "novel" art, would not be introduced into the United States until the 1840s. A well-known artist, arriving in a Southern city to set up a "painting room," might be astounded at the enormous response to his advertisements, especially in periods of prosperity. Itinerant folk painters also took advantage of this apparent need; research in the past decade has uncovered a larger number of their works than was previously thought to exist.

As in other parts of the country, art museums, galleries, and academies arose throughout the South. Most were privately founded and funded. Although none was to survive for long, their activities and collections laid the foundations for continuing public awareness and interest, from which subsequent institutions were to arise.

Although no distinctly Southern style of painting emerged during this forty-year period, there was a recognition of place. Differences of climate and of Southern ways of life attracted some visitors and repelled others. Some Northerners (among them William Dunlap) reviled slavery; others never mentioned it. The use of painting for propaganda did not appear in this period. The land of the South, however, was different from the North. The people had distinctive life styles—as evidenced by their customs, manner of dress, architecture, even their eating and drinking habits—and these things were reflected in the art of the region.

Perhaps because of the recent movement for unity expressed in the still reverberating experience of the American Revolution, and recurring in the War of 1812, more overt and obvious differences in the painting of the South would not emerge until a later era. ❀

NOTES

1. Anna Wells Rutledge, *Artists in the Life of Charleston, Through Colony and State, from Restoration to Reconstruction* (1949; reprint ed., Columbia, South Carolina: University of South Carolina, 1980).

2. *The American Earls: Ralph Earl, James Earl, R.E.W. Earl*, exhibition catalogue (Storrs, Connecticut: The William Benton Museum of Art, The University of Connecticut, 1972), p. 38.

3. Samuel F. B. Morse to Jedidiah Morse, 25 March 1818, Morse Papers, Library of Congress, Washington, D.C.

4. Samuel F. B. Morse to Lucretia Walker, 29 March 1818, Morse Papers, Library of Congress, Washington, D.C.

5. Edward Lind Morse, ed., *Samuel F. B. Morse, His Letters and Journals*, 2 vols. (Boston and New York: Houghton Mifflin Company, 1914), 1:222.

6. Anna Wells Rutledge, *Catalogue of Paintings and Sculpture in the Council Chamber, City Hall, Charleston, South Carolina* (Charleston: The City Council of Charleston, 1943), p. 24.

7. Samuel F. B. Morse to Lucretia Walker Morse, 28 January 1821, Morse Papers, Library of Congress, Washington, D.C.

8. Charles E. Fairman, *Art and Artists of the Capitol of the United States of America* (Washington, D.C.: United States Government Printing office, 1927), pp. 34-35, 44, 46.

9. Beth N. Rossheim, "Thomas Sully (1783-1872): Beginning Portraitist in Norfolk" (Master's thesis, Old Dominion University, 1981), pp. 17-18.

10. William Dunlap, *History of the Rise and Progress of the Arts of Design in the United States* (1834; reprint ed., New York: Dover Publications, Inc., 1969), 1:143-44.

11. Charles Henry Hart, *A Register of Portraits Painted by Thomas Sully* (Philadelphia, 1909), pp. 11-17.

12. Dunlap, *Rise and Progress*, 2:117.

13. Ibid., 2:123-24.

14. Albert Ten Eyck Gardner and Stuart P. Feld, *American Paintings: A Catalogue of the Collection of the Metropolitan Museum of Art*, vol. 1, *Painters Born by 1815* (New York: The Metropolitan Museum of Art, 1965), pp. 156-57.

15. William Barrow Floyd, *Matthew Harris Jouett, Portraitist of the Ante-Bellum South* (Lexington, Kentucky: Transylvania University, 1980), p. 60.

16. Ibid., pp. 86, 88.

17. Bruce Weber, "In Pursuit of Success: Kentucky and the Visiting Artist, 1805-1865," *The Kentucky Painter from the Frontier Era to the Great War* (Lexington, Kentucky: University of Kentucky Art Museum, 1981), p. 51.

18. *The American Earls*, p. 150.

19. Jerome R. MacBeth, "Portraits by Ralph E. W. Earl," *Antiques* 100 (September 1971): 390.

20. Typed and notarized statement from Charles Lee Frank, 12 June 1929, Accession Records, R. W. Norton Art Gallery, Shreveport, Louisiana.

21. Anna Wells Rutledge, "Paintings in the Council Chamber of Charleston City Hall," *Antiques* 48 (November 1970): 794.

22. Rutledge, *Catalogue of Paintings and Sculpture*, p. 30. The actual quotation taken from Trumbull's autobiography: ". . . the best, in my estimation, which exists, in his heroic military character."

23. Ibid., p. 31.

24. Rutledge, "Paintings in the Council Chamber," p. 795.

25. Mantle Fielding and John Hill Morgan, *The Life Portraits of Washington and their Replicas* (Philadelphia: by the authors, 1931), p. 202.

26. Ibid.

27. Katherine McCook Knox, *The Sharples Family, Their Portraits of George Washington and his Contemporaries* (New Haven, Connecticut, 1930), pp. 25, 39, 45-46.

28. Knox, *Sharples Family*, pp. 48-49. See also Corcoran Gallery of Art, *American Painters of the South* (Washington, D.C.: Corcoran, 1960.), p. 31.

29. Fillmore Norfleet, *Saint-Mémin in Virginia: Portraits and Biographies* (Richmond, Virginia: The Dietz Press, 1972), pp. 28-48.

30. Saint-Mémin kept two sets of engraved profile portraits; one is at the National Portrait Gallery, the other at the Corcoran Gallery of Art, both in Washington, D.C.

31. Richard Beale Davis, *Intellectual Life in Jefferson's Virginia 1790-1830* (Knoxville, Tennessee: University of Tennessee Press, 1964), p. 222.

32. Louisa Dresser, "A Life Portrait of Thomas Jefferson," Worcester Art Museum *New Bulletin and Calendar*, vol. 17, no. 3 (1951): 9.

33. *Two Hundred and Fifty Years of Painting in Maryland* (Baltimore: Baltimore Museum of Art, 1945), p. 35.

34. Robin Bolton-Smith, *Portrait Miniatures From Private Collections* (Washington, D.C.: The National Collection of Fine Arts, 1977), p. 2.

35. Ibid., p. 4.

36. *Federal Gazette and Baltimore Party Advertiser*, 25 November 1799.

37. *250 Years of Maryland Painting*, p. 24.

38. *Philadelphia, Three Centuries of American Art* (Philadelphia: Philadelphia Museum of Art, 1976), p. 255.

39. It is possible that Malbone painted the miniature of Allston during the summer of 1800, prior to the trip to Charleston. Cf. William H. Gerdts and Theodore E. Stebbins, Jr., *A Man of Genius, The Art of Washington Allston (1779-1843)* (Boston: The Museum of Fine Arts, 1980), p. 24.

40. Harry B. Wehle and Theodore Bolton, *American Miniatures 1730-1850: One Hundred and Seventy-Three Portraits Selected with a Descriptive Account* (New York: Garden City Publishing Company, Inc., 1937), pp. 36-40.

41. Gerdts and Stebbins, *A Man of Genius*, p. 24.

42. Rutledge, "Paintings in the Council Chamber," p. 79.

43. *Richmond Portraits in an Exhibition of Makers of Richmond 1737-1860* (Richmond, Virginia: Valentine Museum, 1949), pp. 228-30.

44. Anna Wells Rutledge files, Charleston, South Carolina.

45. E. Bénézit, ed., *Dictionnaire critique et documentaire des Peintres, Sculpteurs, Dessinateurs et Graveurs . . .* , 1969 edition, s.v. Collas, Louis-Antoine, notes that Collas made his debut at the Paris Salon of 1798; he exhibited again in 1833.

46. Bolton-Smith, *Portrait Miniatures*, p. 6.

47. Linda Crocker Simmons, *Jacob Frymire, American Limner* (Washington, D.C.: The Corcoran Gallery of Art, 1975), pp. 13-14.

48. Linda Crocker Simmons, *Charles Peale Polk: A Limner and His Likenesses* (Washington, D.C.: The Corcoran Gallery of Art, 1981), pp. 6-7.

49. Simmons, *Polk*, pp. 64-65.

50. Ibid., p. 14.

51. Charles Peale Polk to James Madison, 2 April 1801, James Madison Papers, Library of Congress, Washington, D.C.

52. Simmons, *Polk*, pp. 10-11, 71-77.

53. Ibid., p. 17.

54. Jacob Hall Pleasants, *Joshua Johnston, The First American Negro Portrait Painter* (1942; reprint ed., Baltimore, Maryland: The Maryland Historical Society, 1970), pp. 10-13.

55. Simmons, *Polk*, p. 84.

56. *Baltimore Intelligencer*, 19 December 1798.

57. Pleasants, *Johnston*, pp. 8-9.

58. Ibid., pp. 10-11.

59. Will of Mrs. Thomas Everett (Rebecca Myring), manuscript in the Maryland Historical Society Library, Baltimore. (Legacies of 1831 folder, film g, case A. Will indicates that Johnston also painted the father in the same year. The one of the father was given to the oldest son, the other to the oldest daughter.)

60. George C. Groce and David H. Wallace, *Dictionary of Artists in America, 1564-1860* (New Haven, Connecticut: Yale University Press, 1957), pp. 625-626.

61. Whaley Batson, "Charles Peale Polk: Gold Profiles on Glass," *Journal of Early Southern Decorative Arts*, vol. 3, no. 2 (November 1977) (Winston-Salem, North Carolina: Old Salem, 1977), p. 51.

62. Simmons, *Frymire*, pp. 9-12.

63. Ibid.

64. Ibid., p. 11.

65. Ibid.

66. Dunlap, *Rise and Progress*, 2:54. *The City of Washington [D.C.] Gazette*, 25 October 1820: "Philadelphia, Oct. 24—We understand that the *Picture of the Court of Death*, now exhibiting in the city, excited in Baltimore, the most lively interest, and was visited, in a short time, by upwards of 5000 persons."

67. Ibid., 1:288.

68. Rutledge, *Catalogue of Paintings and Sculpture*, p. 35.

69. George C. Groce and David H. Wallace, *Dictionary of Artists in America, 1564-1860* (New Haven, Connecticut: Yale University Press, 1957), s.v. John Blake White.

70. "MS. 'Account Book,' Meriwether Lewis Anderson Collection, Missouri Historical Society," cited in Norfleet, *Saint-Mémin*, p. 36, note 3.

71. Margaret Bayard Smith, *The First Forty Years of Washington Society*, (New York: Charles Scribner's Sons, 1906), p. 36, cited in Norfleet, *Saint-Memin*, p. 36, note 3.

72. Norfleet, *Saint-Memin*, p. 37.

73. Peter C. Marzio and William C. Sturtevant, *Perfect Likenesses for a History of the Indian Tribes of North America (1837-44)* (Washington, D.C.: National Museum of History and Technology, 1977), p. 13.

74. Andrew J. Cosentino, *The Paintings of Charles Bird King (1785-1862)* (Washington, D.C.: The National Collection of Fine Arts, 1977), p. 60.

75. Ibid., pp. 37-38, 42.

76. Hugh Honour, *The European Vision of America* (Cleveland: The Cleveland Museum of Art, 1975), plate 187.

77. Edwin Way Teale, *Audubon's Wildlife with Selections from the Writings of John James Audubon* (New York: Viking Press, 1964), pp. 1-4.

78. Ibid.

79. Jacob Hall Pleasants, *Four Late Eighteenth Century Anglo-American Painters* (Worcester, Massachusetts: American Antiquarian Society, 1943).

80. Jacob Hall Pleasants, *Four Landscape Painters* (Worcester, Massachusetts: American Antiquarian Society, 1943), pp. 1-30.

81. *American and Commercial Daily Advertiser* (Baltimore), 25 September 1804; *American and Commercial Daily Advertiser* (Baltimore), 30 May 1811.

82. *M. and M. Karolik Collection of American Paintings, 1815 to 1865* (Cambridge, Massachusetts: Harvard University Press, for the Museum of Fine Arts, Boston, 1949), pp. 218-20.

83. Stiles Tuttle Colwill, *Francis Guy, 1760-1820* (Baltimore, Maryland: The Maryland Historical Society, 1981), pp. 52, 54, 57, 58.

84. Artists' files, the Museum of Early Southern Decorative Arts, Winston-Salem, North Carolina.

85. *Courier* (Charleston, South Carolina), 29 November 1816.

86. William Nathaniel Banks, "George Cook, Painter of the American Scene," *Antiques* (September 1972): 450.

87. Wendy J. Shadwell, *American Printmaking: The First 150 Years* (Washington, D.C.: Smithsonian Institution Press, 1969), plate 92.

88. Stiles T. Colwill, Eugenia C. Holland, Romaine S. Somerville, and K. Beverley W. Young, *Four Generations of Commissions: The Peale Collection of the Maryland Historical Society* (Baltimore, Maryland: The Maryland Historical Society, 1975), pp. 149-50.

89. Lillian B. Miller, *Patrons and Patriotism, The Environment of the Fine Arts in the United States, 1790-1860* (Chicago: University of Chicago, 1966), p. 192.

90. George S. Hellman, ed., Letters of Washington Irving to Henry Brevort (1918), p. S1, cited in Harold E. Dickson, *John Wesley Jarvis, American Painter 1780-1840* (New York: The New-York Historical Society, 1949), p. 143.

91. Leah Lipton, "William Dunlap, Samuel F. B. Morse, John Wesley Jarvis, and Chester Harding: Their Careers as Itinerant Portrait Painters," *The American Art Journal* 13 (Summer 1981): 42.

92. *250 Years of Maryland Painting*, p. 25.

93. Dunlap, *Diary*, 2:238. Wilbur Hunter, *The Paintings of Philip Tilyard* (Baltimore: Peale Museum, 1949), unpaginated.

94. Miller, *Patrons and Patriotism*, p. 132.

95. John E. Caldwell, *A Tour Through Part of Virginia in the Summer of 1808*, ed. William M. E. Rachal (1810; reprint ed., Richmond, Virginia: The Dietz Press, Inc., 1951), pp. 43-44.

96. "Mr. Rembrandt Peale, it is stated, has repaired to the city of Washington, for the purpose of *taking off the heads* of distinguished characters for his museum in Philadelphia," in the *American and Commercial Daily Advertiser* (Baltimore), 8 February 1805.

97. Simmons, *Polk*, pp. 14-17.

98. Cosentino, *King*, pp. 37-38, 42.

99. Miller, *Patrons and Patriotism*, pp. 35-36.

100. Fairman, *Art and Artists*, pp. 32-37, 44-47.

101. Dunlap, *Rise and Progress*, 2:321. *Richmond Portraits*, p. 150.

102. Ibid.

103. *Richmond Portraits*, p. 151.

104. William Nathanial Banks, "George Cooke, Painter of the American Scene," *Antiques* (September 1972): 450.

105. *Richmond Portraits*, pp. 235-38.

106. Davis, *Intellectual Life*, pp. 225-26.

107. *Richmond Portraits*, p. 239.

108. James H. Craig, *The Arts and Crafts in North Carolina, 1699-1840* (Winston-Salem, North Carolina: The Museum of Early Southern Decorative Arts, 1965), p. 1.

109. Benjamin F. Williams, *Jacob Marling, Early Raleigh Painter, 1774-1833* (Raleigh, North Carolina: North Carolina Museum of Art, 1964), pp. 5-10.

110. Ibid., p. 5-11.

111. Williams, *Marling*, pp. 5-10.

112. The definitive source of information on the arts in Charleston is *Rutledge, Artists in the Life of Charleston, Through Colony and State, from Restoration to Reconstruction*; see note 2, pp. 131-32, 222.

113. William Dunlap, *Diary of William Dunlap (1766-1839): The Memoirs of a Dramatist, Theatrical Manager, Painter, Critic, Novelist, and Historian*, 3 vols. (New York: The New-York Historical Society, 1930), 2:474.

114. Rutledge, *Artists in the Life of Charleston*, pp. 131-32, 222.

115. Rutledge, *Catalogue of Paintings and Sculpture*, p. 32.

116. Paul Staiti, "The 1823 Exhibition of the South Carolina Academy of Fine Arts: A Paradigm of Charleston Taste," in *Art in the Lives of South Carolinians* (Charleston: Carolina Art Association, 1979), p. PSb-3.

117. Dunlap, *Rise and Progress*, 2:285.

118. Staiti, "Exhibition," p. PSb-3.

119. Rutledge, *Artists in the Life of Charleston*, pp. 131-32, 222.

120. Manuscript (life of the artist), registration files, Telfair Academy, Savannah, Georgia.

121. Georgia Historical Society *Quarterly* (Winter 1978-79): 340-41.

122. Miller, *Patrons*, p. 180.

123. Arthur F. Jones and Bruce Weber, *The Kentucky Painter from the Frontier Era to the Great War* (Lexington, Kentucky: University of Kentucky Art Museum, 1981), pp. 11-12, 23.

124. Edna Talbott Whitley, *Kentucky Ante-Bellum Portraiture* (Richmond, Kentucky: The National Society of Colonial Dames of America in the Commonwealth of Kentucky, 1956).

125. Dunlap, *Rise and Progress*, 2:374, cited in William Barrow Floyd, *Jouett-Bush-Frazer: Early Kentucky Artists* (Lexington, Kentucky, 1968).

126. Floyd, *Jouett-Bush-Frazer*, pp. 21, 37, 54.

127. Ibid., pp. 60-63.

128. Budd H. Bishop, "Art in Tennessee: The Early 19th Century," *Tennessee Historical Journal* 29 (1970): 383-88. Bishop, "Three Tennessee Painters: Samuel M. Shaver, Washington B. Cooper, and James Cameron," *Antiques* 50 (1971), 3:432-37.

130. MacBeth, "Portraits by Ralph Earl," p. 390.

ACKNOWLEDGEMENTS

As with any project in a new field of research, this exhibition was made possible only through the assistance of many individuals. Among the people listed below are many who work at the numerous art and historical institutions of the region. Their willing answers to my letters, replies to telephone inquiries, and assistance during research trips made this project not only possible but easier and much more enjoyable than it otherwise would have been. If I have overlooked anyone, I beg their apologies.

I wish to thank the following for their help: Jerry M. Bloomer, Virginius C. Hall, Jr., Stiles Tuttle Colwill, Sonia Johnson, Martha Severens, Bruce Weber, Frank Horton, Winston Broadfoot, Steve Harvey, Clarence Kelley, Peter Mooz, Susan E. Strickler, Doreen Bolger Burke, Charles Wyrick, Charles Olin, Bryding Adams, the late Richard Beale Davis, Elizabeth Miller, Perry Fisher, Anne Gutherie Bennett, Richard Doud, Julia Haifley, Buck Pennington, Robert Stewart, Michael Berry, Jean Federico, Clement Conger, David Sellin, Andrew Cosentino, Nancy Richards, Kathy Kovacs, Robert Scott Wiles, Anna Wells Rutledge, Lillian Miller, Robin Bolton-Smith, Elizabeth Shatto Scott, William Vose Elder, Ellen Miles, Betsy Fahlman, Bess N. Rossheim, William Barrow Floyd, Martha Andrews, John O. Sands, Elizabeth Pratt Fox, Joyce Hill Stoner, and Mary Black.

The staff of the *Painting in the South* project at the Virginia Museum was always helpful and consistently supportive. Most especially to Ella-Prince Knox and David Bundy go sincere thanks for their hard work on my behalf. The guest curators and consultants participating in the project were also of assistance and were willing to share information or ideas, always furthering the progress of the exhibition. A number of individuals patiently labored over typing of the manuscript: Lynn Berg, Vivi Spicer, and Jonathan Wonder.

Finally, I must thank my husband for once again being the most perfect partner in a research and writing endeavor for whom anyone could have asked. Quite literally, without his intelligent and patient help my contribution to this exhibition and publication would never have been completed.—L.C.S.

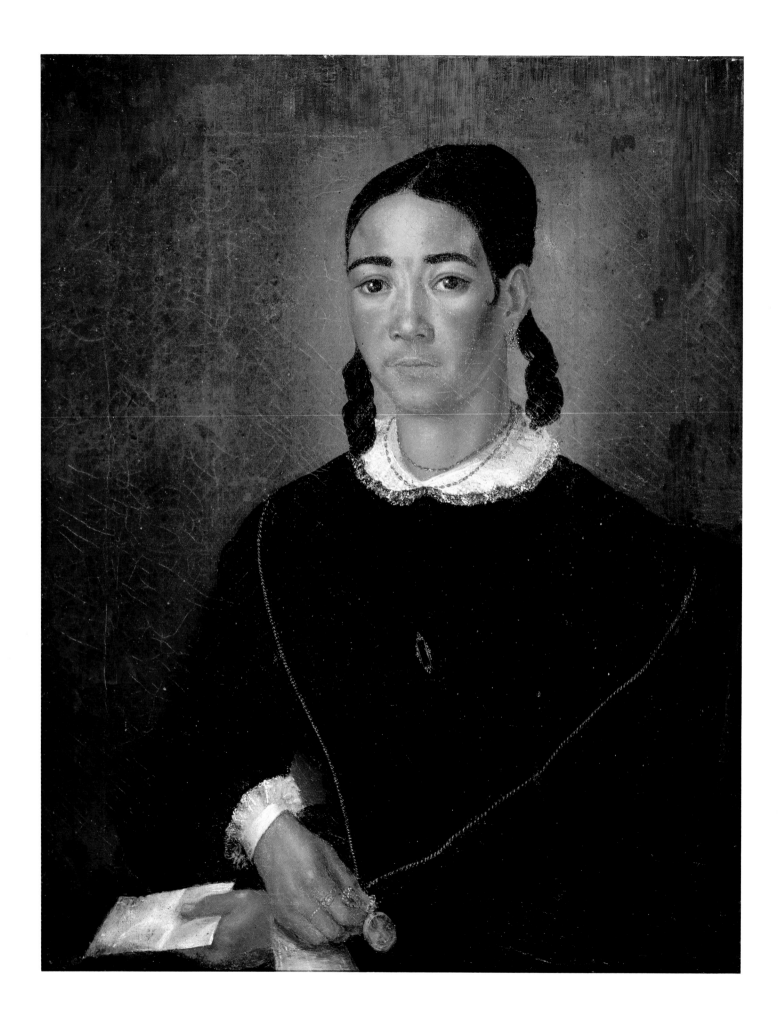

Growth and Development of the Old South: 1830 to 1900

by Jessie J. Poesch

The South, as perceived by many Americans during the late nineteenth and early twentieth centuries, was taking definable shape during the second quarter of the nineteenth century. The debates of 1819-21 about the status of slavery in Missouri generated feelings of sectionalism along North-South lines, with the resulting political divisions. Slave and non-slave states were differentiated, and thus a definition of the South as biracial was reinforced.

The geographical area of the South was being expanded during this period. The Southwest, embracing what we now call the Deep South, and the western edges of the South, were the new frontiers. The Indian Removal Act passed by Congress in 1830 and the series of treaties that helped to effect this meant that a large proportion of Indians living east of the Mississippi were removed, or driven, to areas west of that river. Many died en route. Thus the majority of the peoples of the Five Civilized Nations—the Creek, Seminole, Chickasaw, Choctaw, and Cherokee—left their lands in Georgia, North Carolina, Mississippi, and Alabama. Only a few remained behind, living in small, isolated groups. White settlers were poised to fill the vacuum.

Speculators, land-hungry adventurers, and hard-working sober citizens from Kentucky, Tennessee, and elsewhere, came down the Ohio and Mississippi. Another group came overland along more southerly routes from South Carolina and Virginia and laid claim to lands in Georgia, Alabama, Mississippi, and Louisiana. Some had left depleted land in the Carolinas and Virginia. Anglo-American colonists under the leadership of Moses Austin and his son Stephen had established a foothold in East Texas in 1820. By 1835 something like 20,000 settlers with 4,000 slaves were creating new homes and towns on the coastal plains of what was still Mexican territory.

Cotton was the crop from which many hoped to gain an income, while sugar was best suited to the low-lying land of south-central Louisiana. The hemp grown in Kentucky was used in baling the cotton. From a virtually negligible production of cotton in the South at the end of the War of 1812, the land and people of the South produced around 4,824,000 bales in 1860. From 1830 to 1860 the phrase "cotton is king" had the ring of truth, for the production and marketing of cotton dominated the lives of many.

A large proportion of the people of the old Southwest were newcomers to the area where they now began to establish themselves, and throughout the South people were on the move. Some were transients, coming for a time to increase their fortunes; others came with the intent to settle permanently, and they did so.

Figure 33. Attributed to François Fleischbein, Portrait of Marie LeVeau's Daughter (cat. no. 78).

Artists, and their patrons, were among these newcomers. Though we still know too little about the careers of many of the artists who lived and worked in the South at this time, one is struck by the number of foreign-born among them. Among the native-born artists, many had some training or had traveled in Europe. Some suffered to a greater or lesser degree from lack of training. Most had occasional problems finding clients or patrons. Most faced difficulties with travel; some endured disease. For some, their way of life was lonely because, despite sporadic efforts, there were few institutions or societies where they could come together with fellow artists for study, discussion, and exhibition. In spite of the diversity of backgrounds and training, and the hazards of their trade, most nonetheless shared academic concepts about the purpose and nature of painting. Among most artists, for example, it was felt that a fairly high finish, that is, a surface in which individual brushstrokes were not particularly noticeable, was desirable. The subject of a painting was considered an important aspect of its aesthetic message.

Whether it was to be a portrait, a view, a landscape, or yet another kind of subject, the painting was meant to convey information by visual means, as well as to stimulate the imagination, create an attractive object, or suggest a mood. The paintings done in the South in this period represent the people and the land there. If they differ from painting elsewhere, it is because of the special combinations of people, the particular qualities of the land, and the ambiance created by changing historical conditions.

A measure of the population shift to the Southwest is the growth of New Orleans during the first four decades of the nineteenth century. In 1800 this port city, perched on a crescent of land near the mouth of the Mississippi, just on the edge of the swamps, had a population of around 8,000. By 1810 the census gave the population as 17,242, by 1820 it was 27,176, and by 1830 it had increased to about 50,122. In 1835 the resident population was reported as 70,000, with a transient population of forty to fifty thousand who spent only the winter months there.[1] This large transient population during the winter remained a peculiar characteristic of the city at least until the Civil War years. They came in the winter not only because it was pleasant to do business then, but because they feared the fevers—yellow fever and cholera among them—that were often epidemic in the brutally hot summers. The mortality rate was high,

averaging as much as forty-four per thousand per year in the late 1830s. By 1838 the editor of *Gibson's Guide and Directory of Louisiana* boasted, with pardonable pride, that the population was "no less than 90,000," and that New Orleans was rated as "the third city of the Union; but she is in reality the third only in population, and *second* in a commercial point of view. Her imports are exceeded now only by New York and Boston, and her exports are nearly triple any port in the United States, except New York, which New Orleans exceeds one-third."[2] By 1840 the population was over 100,000, and if it was not the third largest, it rivaled Boston as the fourth largest city in the U.S., being surpassed only by New York, Philadelphia, and Baltimore.[3] Louisville, Mobile, Savannah, Natchez, and Montgomery are among the other Southern cities or towns that experienced growth during this period, though none did so quite as dramatically as New Orleans.

For a number of years New Orleans had been attracting artists during the pleasant winter season. Indeed, the phenomenon of the artist as winter resident was—and still is—an important part of the history of painting in the South. The practice began in the eighteenth century and became very much a pattern in the nineteenth century. Patronage in either the North or South alone was often not enough to support an artist, and hence some artists traveled seasonally. Others, particularly nowadays, move South in the winter because of the more pleasant weather.

Cephas Thompson is recorded as having visited New Orleans as early as 1816.[4] French-born Louis-Antoine Collas, the miniaturist Ambrose Duval, John Vanderlyn, John Wesley Jarvis, and Edmund Brewster of Philadelphia, as well as the little-known John Stein, had all crossed paths with the still-unknown John James Audubon in the early 1820s.[5] The Kentucky painter Matthew Harris Jouett spent several seasons in the 1820s painting portraits in Natchez, New Orleans, and points nearby.[6]

News of the prosperity of New Orleans reached beyond American shores. During the 1830s and after, a number of French artists made their way to the Crescent City. Jean Joseph Vaudechamp (1790–1866) probably went there for the first time for the winter of 1831–32. Announcements in New Orleans newspapers, city directory listings, and dated paintings suggest that he came every winter until 1839, and that he may have been in the city again in 1845.[7] He usually

arrived in late November or early December and returned to Europe in the spring. On May 1, 1834, William Dunlap, the chronicler of American art who lived in New York, noted in his diary, "Vaudechamp $30,000 & is going home, a good painter and a gentleman, having made his fortune in three years."[8] Jacques G. L. Amans (1801–1888) probably first arrived during the winter of 1836–1837.[9] He and Vaudechamp sailed on the same ship that year and the next, and in 1838 Amans had the studio Vaudechamp had had two years before. This suggests that the two men were friends and that Vaudechamp may have encouraged the younger man to visit New Orleans. Both had exhibited at the Paris Salon in the years 1831–37; Vaudechamp continued to exhibit there until 1848. Amans's connection with Louisiana was to last for twenty years, until 1856.

The portraits painted by these artists (seventy-eight by Vaudechamp and over seventy signed or attributed works by Amans are known) reflect the discipline of French academic training. Features and details of dress are carefully delineated. The backgrounds are often plain. Vaudechamp at his best shows sympathy and rapport with his sitters, realistically depicting them as he perceived them. This is true of *A Creole Lady* (cat. no. 61), a portrait of a mature New Orleans woman. There is no pretense; her hair is tangled, her figure ample, her hands just slightly puffy. In *Portrait of a Gentleman* (cat. no. 69), Amans catches something of the style and dash, even studied insouciance, that must have characterized many of the young men who staked their fortunes in ventures in the deep South.

Another French artist who visited Louisiana, after having exhibited in the Paris Salons in 1833 and 1838, is the little-known female artist L. Sotta.[10] Penetrating realism characterizes her portrait of Mrs. Leonard Wiltz (cat. no. 68), which was painted in New Orleans during the winter of 1841–42. Etienne-Constant Carlin, Alexandre Charles Jaume, Aimable Désiré Lansot, and Adolph D. Rinck were among still other French-born or French-speaking artists who visited or settled in New Orleans for a time in the 1830s, 1840s, and 1850s, devoting their skills to recording the diverse physiognomies of local citizens.[11] Among these, Lansot and Jaume died in New Orleans, and Rinck was to return after the Civil War, in 1871.

A dignified and sensitively rendered portrait of a young woman (fig. 33; cat. no. 78) has been attributed to Franz (or François) Fleischbein (ca. 1804–1868).

The subject of the painting was a free woman of color, or *femme de couleur libre*, which was designated "f.w.c." or "f.c.l." in the city directories.[12] These free people had a legal but uneasy status between the slaves and the dominant white population. During the 1830s, 1840s, and 1850s, a number of people in this category attained a measure of economic and cultural distinction, and became property owners, masters of skilled crafts, musicians, poets, and preachers. The bourgeois status of this young woman, who is thought to be the daughter of Marie LeVeau, is evident from her well-groomed mien, the neat black dress with white, lace-trimmed collar and cuffs, and the long chain attached to a watch or locket that she holds. Fleischbein, a native of Bavaria, studied in Paris,[13] and he was in New Orleans by 1834, making it his home until his death in 1868. Though he was initially a portrait painter, he later made the transition to photography, as indicated by newspaper advertisements in which he identified himself as a daguerreotypist and an ambrotypist.

Neither the subject nor the artist of a straightforward portrait known as *Maid of the Douglas Family* (cat. no. 67) are precisely known. Here, too, the likeness conveys the impression of a direct and dignified individual who may have been a slave or a free person of color. The artist might have been Jules (or Julien) Hudson, himself a free person of color, who worked as a miniaturist and portrait painter in New Orleans between circa 1831 and 1844.[14] He is known to have studied with Antonio Meucci, who worked in New Orleans in 1818 and 1826-27. In this painting, as well as in a self-portrait owned by the Louisana State Museum, the bust-length figure is set against a simple and evenly lighted background. Surviving portraits of blacks are rare, and pictures like these, striking in their own right, are all the more valuable as documents of a people who comprised a major component of the population of the South.

The French-born artists who worked in and around New Orleans were particularly known for their sharp realism and precise draftsmanship. Their subjects, even those few who commissioned full-length or three-quarter length portraits, seem to have been bourgeois in appearance and taste, well and properly dressed but seldom ostentatious. These qualities hold true in general for their compatriots in other parts of the South, as depicted by the portraits of this period.[15] This contrasts with a number of eighteenth-century portraits of Southerners, in which an aristocratic image of landed gentry was projected. The wealthiest

planter-merchants, large slaveholders, certainly continued to have a strong influence upon political thinking, but statistics show they were in a minority. The modest-sized portraits of record, which were the choice of the majority of patrons, reflect their predominant middle-class character, as well as a new egalitarian spirit. It is no surprise that photography ultimately satisfied this market.

Even though the distances between towns and cities were often great, and parts of the region were still sparsely settled, portrait painters found their way to many corners of the expanded South. For example, Thomas Cantwell Healy, the younger brother of the more famous G.P.A. Healy (who also painted in the South; see cat. no. 73), first came to Mississippi and Louisiana in 1843, worked for a season in Jackson and New Orleans, moved to Claiborne and Copiah Counties in Mississippi in the 1850s, then settled in Port Gibson; he died in Mississippi in 1889.[16] Joseph Thoits Moore opened a studio in Montgomery, Alabama, in 1830 and painted many prominent citizens of that city and of Huntsville. William Frye, a native of Bohemia, came to America in order to record the visages of Indians. Instead, he settled in Huntsville, Alabama, in 1848 and faithfully portrayed many inhabitants of the area, including soldiers during the Civil War. P. Roemer, Thomas S. Officer, and C. R. Parker are among those who memorialized many citizens of Mobile in oil on canvas; Parker also traveled in various parts of Mississippi, Alabama, Louisiana, and Georgia.[17] Another native of Germany, Nicola Marschall, arrived in Mobile in 1849, and he then taught music, painting, and languages at the seminary in Marion, Alabama. He designed the first Confederate flag and uniform and served with its forces. After the war he settled in Louisville, Kentucky.[18] William Henry Scarborough, operating from his home in up-country South Carolina, in the capital city of Columbia, painted portraits and miniatures in North Carolina, South Carolina, and Georgia from the 1830s until his death in 1871.[19]

In 1841, after his second sojourn in Europe, English-born William James Hubard (1807–1862) settled in Richmond, Virginia, where he lived until his death in 1862. There he enjoyed the friendship of a literary and artistic circle that included Mann S. Valentine II, whose extensive collection was the foundation of the present Valentine Museum. In Hubard's portrait of the sisters Henrietta and Sarah Mayo, whose family numbered among the artist's close friends, he made no attempt to idealize or flatter these somewhat plain young women, yet he nonetheless conveyed a sense of warm sympathy and compassion.[20]

During a fairly long career, William Garl Brown (1823–1894), who was brought from England to America as a child, visited and traveled in the South both before and after the Civil War.[21] North Carolinians, Virginians, and Marylanders were among his subjects. For a time after 1846, and again in the later years of his life, he too made Richmond his home. John Maier (1819-1877) is generally considered the first professional painter of Atlanta. He emigrated to the United States in 1840 from his native Germany and was settled in Atlanta by 1850. Several of his large-scale portraits, replete with fully developed settings, now hang in the Georgia state capitol.[22]

William Edward West (1788–1857), a native of Kentucky, found patrons during his early career in Natchez and New Orleans. He then spent four years in Italy, part of a year in Paris, and the period 1825–1838 in London. The Countess Guicciolo, Byron, Shelley, and Trelawny were perhaps his most famous clients. Financial losses precipitated his return. Though West's oeuvre included ambitious large-size and "fancy cabinet" portraits, and some allegorical or story-telling subjects, he also painted a number of modest-sized portraits suited to the egalitarian spirit of the times. Among these is a pair of portraits, one of *Robert E. Lee in the Dress Uniform of a Lieutenant of Engineers* (fig. 34), and the other of his wife, Mary Custis; both were of old-line Virginia families, among whom there was a tradition of having family likenesses taken. At the time, the thirty-one-year-old Lee was in Baltimore, en route to an assignment in St. Louis. The possible dangers of the long journey may have influenced the decision to have portraits painted then. West's later career was spent in Baltimore (where the Lees were painted), New York, and Nashville.[23]

G. P. A. Healy visited the South several times during the years 1844 to 1860.[24] (He was in Charleston at the bombing of Fort Sumter.) By this time, the Boston-born artist, who had studied in France, already enjoyed a good reputation as a portrait painter in Europe. In this he is somewhat similar to William Edward West. One of his most interesting works is a half-length portrait of the diminutive Alexander Hamilton Stephens (cat. no. 73). He shows the brilliant Georgia politician in an unusual but probably characteristic pose, seated by a table, his frail body hunched over as he pauses to look up from a book. At the time

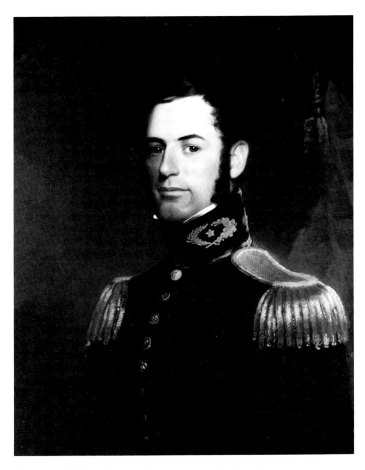

Figure 34. William Edward West, Portrait of Robert E. Lee in the Uniform of a Lieutenant of Engineers, United States Army, *1838, oil on canvas, 30 by 25 inches (76.2 by 63.5 cm), Washington and Lee University, Lexington, Virginia, Washington/Custis/Lee Collection.*

of the painting, 1858, Stephens was serving as a member of the United States Congress. He was to become vice-president of the Confederacy, and he ultimately died while Governor of Georgia, in 1883.

George Catlin (1796–1872) did not seek patronage among capable young military officers or established politicians. Rather, as is well-known, he recorded the likenesses of America's native peoples, creating a monumental visual record of American Indians.[25] However, within this large corpus, which was done on a series of expeditions and journeys during the years 1830 through 1838, his paintings of the Indians of the Southeast are less known than those he did of the more romantic tribes of the Western Plains. Catlin twice recorded the Seminole Indians of Florida, first in their own environment during the winter of 1834–35, which he spent in and around Pensacola. In January 1838 he visited Fort Moultrie, near Charleston, South Carolina, where a group of Seminoles were held prisoner as a result of the Seminole War. The "lusty and dignified" Mick-e-no-pah agreed to sit for the artist only after considerable persuasion, and then only if the artist would start with his legs, as he was wearing a handsome pair of red leggings.[26] The painting of this chief (cat. no. 64), whose full face reveals a blend of black and Indian features, is one of Catlin's most accomplished portraits. The frequent complexities of economic, social, and race relations in the South at this time are suggested by Catlin's notes, which indicate that the stocky Mick-e-no-pah "owned 100 negroes when the [Seminole] war broke out, and was raising large and valuable crops of corn and cotton."

Catlin also painted a number of Southeastern Indians after they had been removed to the West. There are several impressive portraits of Cherokee. The ball game of the Choctaw, from which the present game of lacrosse originated, caught his attention; it is still played by the descendants of the Choctaw who continue to live in the state of Mississippi.[27]

Though most of the portraits representing the diverse people of the South project an essentially bourgeois image, the appeal of the life of the landed gentry did not die out. It was manifested in the large houses—some on plantations, some in towns—built by the most ambitious of them, and it was also seen in the popularity of horse racing. Racing began as an impromptu, unorganized sport in Virginia and Maryland during the earliest years of colonization, but the first fragmentary records of the sport there date to the 1670s and 1680s.[28] In 1674 an unfortunate "Labourer,"

a tailor in York County, Virginia, was fined for having raced a mare, which was considered an offense because this was "a sport only for Gentlemen." In Virginia, Maryland, and South Carolina, horse-breeding and horse-racing gained steadily in popularity among the rural landed gentry, many of whom were of English ancestry. As the population spread westward, so did the tradition of the turf. Before the Revolution, Virginia and Maryland were the most famous centers of breeding, but then Kentucky gradually replaced them and became the foremost race-horse region. According to John Harvey, the noted historian of racing in America, by the time of the Civil War "the turf had become pre-eminently something in and of the South, with New Orleans its captial city, Charleston, Savannah, Mobile, Nashville, Memphis, Louisville, Lexington and other points in liaison with them the outstanding 'places of sport.' "[29] It is only natural, therefore, that Edward Troye (1808–1874), the most highly regarded horse painter of America during the nineteenth century, spent the majority of his artistic career in the South (see cat. nos. 62 and 63).

Troye was born in Switzerland and grew up in London, where, according to him, he "had the advantage of the best masters."[30] His father was a sculptor; his brother, a painter, settled in Antwerp; and a sister was a sculptor of medallions in Italy. When Troye first exhibited in the United States in 1832, he identified himself as a "Painter of Animals."[31] By November 1834 he was in Lexington, Kentucky—he called it "the Western Country"—where he announced that he would paint "the most noble of animals, the Horse." He had come to Kentucky by way of Philadelphia, New York, Virginia, South Carolina, New York and Philadelphia again, then Tennessee. Within a year, he had established a word-of-mouth reputation among horsemen, and he seldom lacked for clients the rest of his life. This meant that he traveled frequently in order to fulfill the wishes of his patrons. One of the happiest periods of his life, from 1849 to 1855, was spent in Spring Hill, Alabama (near Mobile), where he served as Professor of Drawing and French at Spring Hill College. In a number of his paintings of thoroughbreds he included trainers, grooms, and jockeys—though never owners—thus suggesting the special ambiance that existed among the people of the stables and the track. Three hundred fifty-six paintings and eleven drawings by Troye have been recorded. The vast majority of these depict horses, though prize livestock and a few portraits are included. Many of these works

are still in private collections throughout the South and are still possessed by descendants of the original owners.

Two other enterprising artists, both apparently of foreign birth, Robert Brammer and Augustus Von Smith, located themselves in Louisville, Kentucky, during the period 1838-41. They advertised that they would "always have on hand a number of oil paintings & views of the United States which we will dispose of on moderate terms."[32] Very few works from their brushes are known, yet their painting of the *Oakland House and Race Course* (cat. no. 65) testifies to their competence. Here they captured the color and excitement of the commencement of a racing event and its setting. The white fences, white house, and barn are set off sharply against the light-filled and lush-green Kentucky landscape.

Little is known of Brammer's career, but it seems to have been relatively short-lived. He visited New Orleans several times, advertising there in November 1847 as a landscape painter.[33] One of his surviving works, a swamp scene reminiscent of the bayou country of south Louisiana, is one of several beginnings of "pure" landscape painting in the Deep South.[34] Brammer died in his summer home in Biloxi, Mississippi, in 1853.[35]

Hugh Reinagle, a scene painter from New York who came to New Orleans in the winter of 1833–34 and died of cholera there in May 1834, also did at least one painting of the bayou country.[36] And Toussaint François Bigot, who taught drawing and painting in New Orleans for a number of years, is also known to have done landscapes.[37] But these efforts appear to have been sporadic and, except for panorama painters, no artist is known to have made a successful career of landscape painting in the lower Mississippi Valley or the Gulf Coast in the period before the Civil War.

In the November 1834 issue of the newly-launched journal *The Southern Literary Messenger*, and again in November 1840, George Cooke wrote two descriptive essays—the first on the Cyclopean Towers in Augusta County, Virginia, and the other titled "Sketches of Georgia." Cooke described the "hilly and picturesque country" of western Virginia and Georgia's "thousand isolated peaks and picturesque valleys," which "throw wide their varied beauties" and invite "the wandering steps" of the artist.[38] The publication of this journal in Richmond was in itself an indication of the growing sense of identity that was being felt by Southerners. In addition, though the essays were

short, they suggest an awakening interest in the Southern landscape as a fit subject for painters. Cooke, a native of Maryland, was a portrait artist of some competence whose somewhat itinerant career included several periods of residence in Richmond, New York City, and Washington, D.C., and an eventual move to the new university community of Athens, Georgia. He exhibited his own paintings and the works of others in a "National Gallery" he maintained in New Orleans seasonally between 1844 and 1849, the year of his death, from the all too predictable cholera. He is known to have done several topographical views of some distinction, but his own surviving paintings of the Georgia countryside are somewhat amateurish.[39]

In 1842, T. Addison Richards, then a young artist of twenty-two years, issued, with his brother, a slim book titled *Georgia Illustrated.* Small steel engravings, based on pencil sketches that still survive, accompanied the text. The authors also called attention to the beauties of the landscape of that state, citing such diverse attractions as the "exquisite beauty, blended with fearful sublimity," of Tallulah Falls, and the serene loveliness of "the sweet vale of Nacoochee." Here, they suggest, "poets might find themes for songs, and the artist for the pencil." The next year Richards apparently took his sketches to Charleston for an exhibition, as a publication there noted that "his drawings of the beautiful Southern States are almost the first pictures which have been made from this rich storehouse of nature," and that "From these Southern sketches, the artist designs painting cabinet pictures, and those who desire to ornament their parlors with exquisite home views will do well to commission some from his easel."[40] He must have been unsuccessful, for he was soon involved in another literary project with his brother. By 1845 he was in New York, and in 1852 he was made Corresponding Secretary of the American Academy of Design, a post he held for the next forty years.

Richards's love for the South continued, and in May of 1853 he published an illustrated essay in *Harper's New Monthly Magazine* on "The Landscape of the South," in which he complained, "But little has yet been said, either in picture or story, of the natural scenery of the Southern States; so inadequately is its beauty known abroad or appreciated at home."[41] His descriptions, eloquent and passionate, were introduced by the sort of competitive North-South comparision that was frequent in the literature and politics of the time:

Proud mountain heights lift their voice of praise to Heaven; the thunders of Niagara are echoed by Tallulah; as the gentler prattle of Kaiterskill and Trenton, is answered by Ammicalolah and Tocca. For the verdant meadows of the North, dotted with cottages and grazing herds, the South has her broad savannas, calm in the shadow of the palmetto and the magnolia: for the magnificence of the Hudson, the Delaware and the Susquehanna, are her mystical lagunes, in whose stately arcades of cypress, fancy floats at will through all the wilds of past and future.

Richards went on to extol the virtues of the "mighty Alleghanian chain," the languid beauties of the lowlands, and the South's growing number of attractive watering places and medical springs. But his reader was brought up abruptly with his candid statement that the "Northern voyager will sadly miss the superior conveniences and comforts of his own more traveled and better ordered routes; the by-ways are miserable, the people ignorant, the fare scant and wretched, the expense of travel disproportionately great."[42] The physical difficulties of traveling in an area still sparsely settled, with cities few and far between, account in part for the slow development of landscape painting in the hill and mountain regions of the South at this time.

The very diffuseness of the natural wonders of the South, from the great mountain chain of the Appalachians to the length of the mighty Mississippi, might also have discouraged aspiring artists. In another publication, Richards—who increasingly turned his talents to writing—mentioned the vast extent of the landscape of Virginia alone, and again noted the problem of access: "That the landscape of the Northern States should first win the study of our artists, is natural enough, if but from the more ready access they have of it—the chief portion of them being gathered in this great centralizing city of New York." In other chapters he speaks, in passing, of the "too much isolated regions of the South-east," and of the "hearty, yet rude people, thinly scattered over the still desolate interior of Alabama and Mississippi," and, along with attractive descriptions of the variety of scenery to be encountered along the Mississippi, he has an artist tell a friend of the "mosquitoes and Miasmas against which I have had to battle."[43]

Despite such difficulties, several artists seem to have captured something of the variety and drama of the Mississippi. John Banvard, John Rowson Smith, Sam Stockwell, and Henry Lewis all painted panoramas of the river, including the southernmost portions.

These long picture sequences were shown as popular entertainment.[44] Banvard's was exhibited in Louisville, New Orleans, Boston, New York, and Washington, then taken to London, where its success prompted a command performance at Windsor Castle. Smith, who may have been a more talented artist and who was known to pride himself on his accuracy, also exhibited in a number of American cities, in London, and on the Continent. Stockwell and Lewis seem to have evoked memorable images of the landscape of the South, but not a trace of the former's work remains, while only an idea of the flavor of the latter's can be seen in the series of lithographs issued in Germany between 1854 and 1858.[45] Leon Pomarede was a French-born artist who arrived in New Orleans in 1830 and whose known works include large altarpieces based on compositions of old masters for churches in New Orleans and St. Louis. He, too, painted a panorama of the upper Mississippi, but unfortunately it was burned shortly after it had been shown in St. Louis and New Orleans. Thus, virtually nothing of these ambitious panoramas has survived. Though they were apparently done with a certain free, theatrical style, what little we can learn of them suggests they may have had some artistic merit. As popular and "cultural" entertainment, they were an important source of visual pleasure for many people during the 1840s and 1850s.

The great stone arch, the Natural Bridge of Virginia, is the single phenomenon of nature in the South that is in some ways comparable to the awesome falls of Niagara in the North. One early visitor described it as "the sublime associated with the pleasing," "not allied to the terrific, as at Niagara."[46] Jefferson also described it as capable of arousing those emotions associated with the sublime. In 1774 he acquired it and the adjoining land from the British Crown, and throughout his life he kept it unspoiled yet open to visitors.[47] Among those he persuaded to visit and study it were the Marquis de Chastellux and Baron de Turpin, two Frenchmen who had served with the French Expeditionary Forces during the American Revolution; de Turpin's engravings of it were the first published views.[48] Other artists and visitors continued to seek it out, including Jacob O. Ward, Frederick Church, and the New York-based artist David Johnson. Each caught something of its grandeur and mellow coloring, yet as both artists and photographers have often learned to their sorrow, the beauty or sublimity one feels in the presence of a natural phenomenon cannot be easily conveyed.

The difficulties of travel notwithstanding, a scattering of artists with an interest in landscape were attracted to various regions of the South. John H. B. Latrobe, a talented amateur, made watercolors of the resorts of White Sulphur Springs and Botetourt Springs when he visited them in the early 1830s.[49] Edward Beyer was a German landscape and panorama painter who worked in America from 1848 until around 1857. A major result of his visit was the large *Album of Virginia* published in Richmond in 1858, the lithographs having been done in Germany. William Charles Anthony Frerichs, a Belgian artist, settled in Greensboro, North Carolina, where he taught until 1863. He made the Smoky Mountains the subject of several of his canvases.[50] David Hunter Strother, a native of Martinsburg, Virginia (now West Virginia) found little success with his oil paintings but blossomed as an illustrator for *Harper's* in the 1850s, delineating the people and the landscapes of the South in the pictures that accompanied his lively travel narratives.[51]

Given the problem that transportation must have been for some artists, it is fitting that the financial interests of Colonel James A. Whiteside, patron of the Scottish-born artist James Cameron (1817-1882), included railroads.[52] Whiteside seems to have invited Cameron to Chattanooga, Tennessee, in the early 1850s in order to enrich the cultural life of the community. Cameron's surviving paintings include several wide-angle vistas of the valleys and mountains of the region, as well as an unusual portrait of the colonel and his family, including a black nursemaid and houseboy, set against a landscape vista (fig. 35; cat. no. 75). Proper Victorian family life is exalted in this work. It is precise in detail, but the perspective is slightly foreshortened, making it curiously reminiscent of Flemish paintings of the fifteenth century. Cameron's career was cut short by the Civil War. He left Chattanooga at the beginning of the war, and when he returned, the area was too devastated and poverty-stricken for him to find patrons.

During this time several artists in the South essayed multi-figure story-telling paintings, which were intended to educate or uplift the spirit of the viewer by pointing a moral. "History painting" of this kind was deemed the highest form of art. Such grand efforts were known to take months, even years to complete, and therefore were seldom started without a commission. Such commissions were rare, however, and one of the most sought-after was for the embellish-

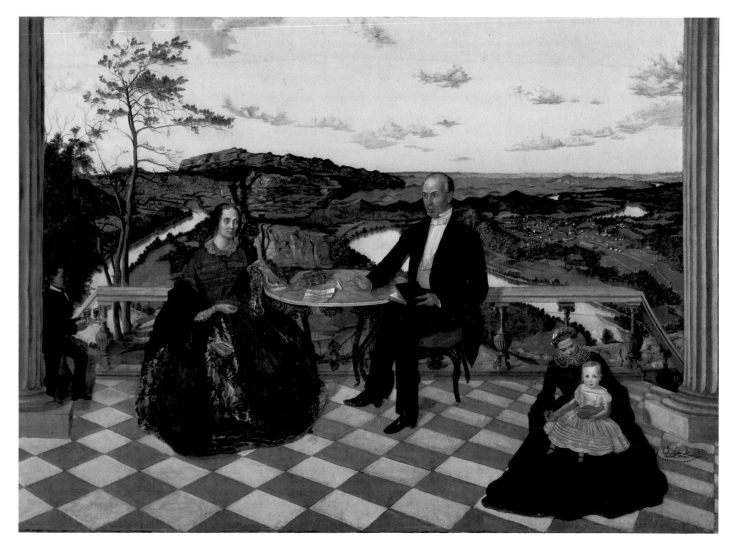

Figure 35. James A. Cameron, Colonel and Mrs. James A. Whiteside, Son Charles, and Servants *(cat. no. 75)*.

ment of the U.S. Capitol.

John Gadsby Chapman, a native of Alexandria, Virginia, was one of the lucky few.[53] In 1831, having spent several years of study and travel in Italy, he returned to America and, seeking to establish his reputation, set up studios in both Alexandria and Washington, D.C. Portraits were his bread-and-butter. He also took time to paint a number of small landscapes, most of historic places, including a distant view of Mt. Vernon; he may have been thinking of these as studies for settings to be used in larger paintings. In March 1837, Chapman was one of four artists selected to paint "subjects relating to the history of our country" for the Capitol Rotunda.[54] At the time, it must have seemed a stroke of luck. The artist labored for most of four years, from 1837 to 1840, on his large monumental painting of the *Baptism of Pocahontas*. As

with all too many ambitious paintings of its genre—including the other three for the Rotunda—it is more laudable for the effort than for the effect. Chapman, who was dogged by financial difficulties all of his life, found greater success as an illustrator. In 1847 he returned to Italy, where he spent much of the remainder of his life.

John Blake White's painting of *General Marion Inviting a British Officer to Dinner*, popularly called *Marion in the Swamp*, became one of the best-known American history or genre paintings in the 1840s after it was selected by the newly-founded Apollo Association in New York as the first painting to be reproduced in an engraving and circulated to its members.[55] The portrayal of South Carolina's Francis Marion and his men honored the simple, plain virtues of American soldiers during the Revolution. It showed the famous

Swamp Fox and his troops offering simple roasted sweet potatoes—no more than roots—to a British officer who arrived in their camp under a flag of truce. The officer was so astounded by the devotion of these men to the joys of liberty and freedom that he subsequently left the British forces—or at least this was the story as recorded by none other than Parson Weems.[56] The message of this painting expressed the patriotic optimism of all Americans, but it had special appeal to Southerners because Marion was one of their own.

White, a South Carolinian who had aspired to a career as an artist in his youth, studied with Benjamin West in London for three years, 1800 to 1803. Upon his return he found that he could not support himself, so he turned to law. During his mature years he returned to painting from time to time, and on several occasions he tried his hand at complex history paintings. These works appear to have been small in scale, and they did not attract the kind of patronage he hoped for. Whether this was simply because they were not good enough, or whether there was not enough public interest in them, is difficult to discern. The fact that he tried this type of painting testifies to artists' attempts to introduce a diversity of subject matter.

The Indians who lived among the bayous of Louisiana were selected as a fit subject for a painting by the French-born Alfred Boisseau (1823-1901). Boisseau visited New Orleans around 1845-48, when his brother was secretary to the French consul there. In 1848 he sent back to France, for exhibition at the Paris Salon of that year, a painting he had titled *Marche d'Indiens de la Louisiane* (or *Louisiana Indians Walking along a Bayou*) (fig. 36; cat. no. 70).[57] The work shows several members of an Indian family walking along a forest path. Boisseau's skillful handling of color creates a sparkling effect in his depiction of the play of light on the dense foilage in the background of the scene. Fortunately, this painting found its way back to America, as did the artist, whose later career was spent largely in Canada.

Hippolyte Sebron, another French artist who chose to live in New Orleans for a time, appears to have utilized his previous experience as an assistant to L.J.M. Daguerre (the inventor of the daguerreotype and creator of dioramas) in composing his canvas *Giant Steamboats at New Orleans* of 1853 (cat. no. 71).[58] The view is somewhat from above. A variety of activities of everyday life on the crowded waterfront are shown, with no sharp focus on any one of them: the loading and unloading of goods, passengers coming

and going, and fruit vendors, draymen, factors, and planters carrying out their separate activities, all amidst the ordered chaos of barrels, boxes, bales, and hogsheads. This type of painting has roots in the older topographic view paintings of the eighteenth century, and it also portends the realistic imagery and "slice of life" concepts that were to become popular later in the nineteenth century. In neither Sebron's nor Boisseau's painting is there any attempt to tell a story or to point a moral. They seem instead to be concerned with recording aspects of everyday life that they observed in the New World, a world which to them must have seemed not a little romantic and exotic.

Francis Blackwell Mayer (1827-1899) of Baltimore used the people of rural Maryland as subjects for some of his canvases, and in these he somewhat obliquely pointed a moral or told a story.[59] In *Independence* (or *Squire Jack Porter*)(cat. no. 74), he shows Captain John M. Porter—a veteran of the War of 1812 and, at the time of the painting, owner of a farm in Frostburg, in western Maryland—posed informally, relaxing on the porch of his modest home. But it is not so much a portrait as a statement of an attitude of mind and spirit. One senses—and the title encourages this speculation—that this is a man who is a master of his own fate. He works when he needs to. He rests when he wishes to. He can easily take care of his material needs, which are modest. The painting, which is characterized by warm colors and soft brushwork, may indirectly reflect Mayer's own attitudes. He seems to have remained aloof from political events during the Civil War, and he spent part of this time in Europe.

Well before the Civil War, the lives of black Southerners became a logical subject in pictures that blended the spirit of genre painting with the tendency to tell a story or point a moral. Christian Mayr, a German-born artist, did a sympathetic painting called *Kitchen Ball at White Sulphur Springs* in 1838; it is essentially a lively genre scene.[60] Eyre Crowe, the English artist-companion to Thackeray during the latter's American lecture tour in 1852–53, made a sketch of a slave market that he later developed.into a painting.[61] Similar scenes were painted by unknown artists.[62]

An ambitious scheme of John Antrobus (1837–1907) to paint a series of twelve pictures of "Southern life and nature" was announced in the New Orleans *Daily Crescent* of January 26, 1859. According to the article, the English-born artist (who had come to this country around or before 1850) "was impelled to the

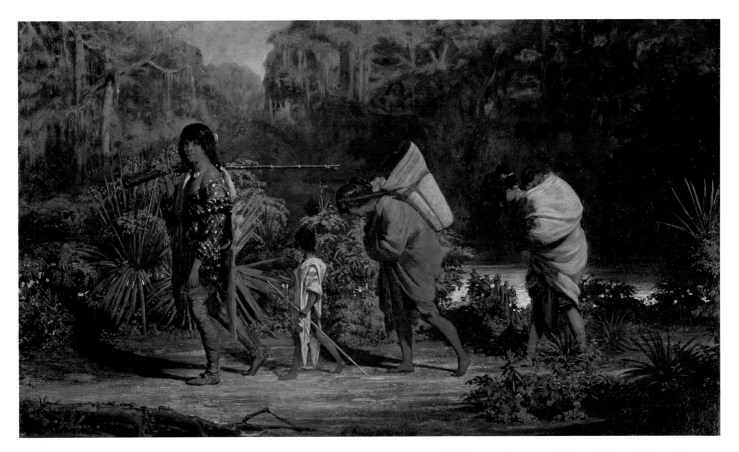

Figure 36. Alfred Boisseau, Louisiana Indians Walking Along a Bayou
(cat. no. 70).

immense undertaking by the determination to vindicate the claims of the scenery of the South to the consideration of artists. . . . Artists roam the country of the North, turning out pictures by the hundred yearly, but none come to glean the treasures with which the grand and beautiful country of the South and its peculiar life abound." Here, as in other writing emanating from the South at this time, there is an effort to identify and proclaim cultural distinctiveness and to rival the North.

Antrobus's first painting (whereabouts unknown) was titled *Cotton Picking,* a quintessential Southern subject, and it was also probably significant as an early image of poor and working-class people. (The artist may have been familiar with the writings of the French critics who were advocating a new realism and recommending the artistic possibilities of themes taken from the lives of the humble and poor.[63]) The writer of the *Crescent* article admired the painting for the "rich and

mellow coloring," for its beauty "as a work of art," and because it was "so truthful . . . as a representation of peculiar and locally characteristic life and nature."

Antrobus spent the next winter season in northern Louisiana and in the spring of 1860 was again in New Orleans, exhibiting the next work in the series, *A Plantation Burial.*[64] While the first painting apparently showed blacks toiling, this one illustrated a very private aspect of black life in the South. The central group, framed and shadowed by close-set, towering trees, depicts family, friends, and a preacher gathered around a coffin. The mood of the painting is melancholy and uncomfortable, the tone being set by the oppressive atmosphere of the near-tropical forest in which the event occurs. The figures are somewhat rudely characterized, but their varied stances suggest the universal human experience of grief. Whites are mere accessories to the scene; on the far left is a man who may be the overseer, on the far right, the white

Figure 37. Eastman Johnson, My Old Kentucky Home—Life in the South, 1859, oil on canvas, 36 by 45¼ inches (91.4 by 114.9 cm). The New-York Historical Society, Robert L. Stuart Collection, Stuart 225.

master and mistress. Here, in a commanding way, is a glimpse of a sorrowful aspect of the separate communal life blacks were partially able to maintain while they lived in bondage. A reporter described the painting as "drawn from life" from an event that had taken place at the plantation of the "late Governor Tucker of Carroll Parish."

Insofar as is known, only two of the proposed twelve paintings were completed. The artist is next heard of as a Confederate soldier. After the war he established himself in Detroit, where he died in 1907. Though praised and admired in New Orleans, there is no evidence that Antrobus's paintings of the South were displayed elsewhere.

Another painting dealing with the South was exhibited in New York the same year that Antrobus's *Cotton Picking* was exhibited in New Orleans. Painted by Eastman Johnson, a Northerner, it was called *Negro Life in the South* (fig. 37).[65] (This was Johnson's title; by 1867 it was being called *My Old Kentucky Home*, after Stephen Foster's popular song.) Shown in the "great centralizing city" of New York, the picture received critical acclaim among artistic circles. Based on observations and studies Johnson made while visiting relatives in Washington, D.C., it was one of the first major paintings he exhibited after his return from several years of study in Europe. As far as can be judged, the artist selected his subject not because he had a social statement to make, negatively or positively, but rather because he wished to create a picturesque and evocative picture of what both American and European artists and critics identified as "lowly life," of the sort which, when skillfully depicted, could excite and "reveal the play of human sympathy."[66] One critic, very possibly as the artist intended, saw varying moods and ideas, a "melancholy" banjo-player, noisy children, self-absorbed lovers. The same critic does not seem to have intended irony or tragedy when he wrote that he "never saw a better rendering of American architectural ruins . . . all these objects are perfectly painted, and in perfect harmony with the characters portrayed." This particular critic, preoccupied with artistic rather than social values, did not raise the question as to whether or not the work was a pro-slavery or an abolitionist statement, nor did it seem to provoke that kind of comment when first displayed. The picture was apparently generally popular, and those who so wished, Northerner and Southerner, could interpret it as showing healthy slaves absorbed in their own activities. By 1867 one critic, with the hindsight of history, commented that "the dilapidated and decaying negro quarters typify the approaching destruction of the 'system' that they serve to illustrate."[67] The picture even today provokes a variety of reactions. For example, some people do not like anecdotal and sentimentalizing pictures of this type, however well painted. Also, different people still "read" this painting in various ways, thus resulting in different interpretations of what it conveys about the lives of slaves.

In interpreting the paintings of Antrobus and Johnson, it should be remembered that by this time the idea of blacks as humorous characters and as entertainers was established as a stereotype. This was rooted in large part in the minstrel shows that became immensely popular after 1843 and continued to be so until the end of the nineteenth century.[68] Exaggerated caricatures were illustrated on dozens of popular sheet-music covers. It is to the credit of Johnson and Antrobus, therefore, that they ignored this recurring stereotype.

Johnson's canvas was one of the American paintings sent to the Paris Universal Exposition in 1867. This was apparently when the title was changed from the neutral *Life in the South* to *My Old Kentucky Home*, suggesting that Northerners now preferred to see this painting as a pastoral scene and an evocation of the moment when "the darkies are gay," and with little hint of melancholy. For those who knew the whole song, however, there was an implication of weariness and death in the last verse: "A few more days and the trouble all will end."

Johnson's *Life in the South* was his first important painting after his return from Europe. The attention it received undoubtedly contributed to his election as an Associate to the National Academy of Design in 1859 and as a full Academician in 1860. As was the customary procedure, he contributed two paintings to that organization's permanent collection. One of these was *Negro Boy* (cat. no. 77).[69] This is a direct, engaging picture of a young black boy absorbed in playing his homemade flute. It is one of the most intimate of a number of paintings Johnson did of black subjects during the 1860s. Others included the story-telling *Fiddling His Way* and *Washington's Kitchen at Mount Vernon*, a simpler genre scene.

During the Civil War Johnson spent some time following the Union troops, and in 1862 he painted an explicit social statement. *The Ride for Liberty—the Fugitive Slave*, done in several versions, shows slaves

fleeing on a horse. On one version he inscribed on the back, "A veritable incident in the Civil War, seen by myself at Centerville on the morning of McClellan's advance to Manassas, March 2, 1862."[70] Other of his wartime paintings deal with the home front and are anecdotal in nature.

The reaction of artists to the Civil War was no doubt as varied as the artists themselves. Without attempting to trace individual careers, it is fair to say that for many of the artists in the South it meant an interruption in their careers, either because they joined the Confederacy (or in some cases the Union), or because they lacked patrons. A few, such as Francis Blackwell Mayer and Edward Troye, spent part of this period in Europe. (Mayer settled in Annapolis after 1870; a subsequent speciality of his was nostalgic historic genre scenes of the colonial period.) Conrad Wise Chapman, John Elder, and William D. Washington, all from Virginia, are among those who, during or immediately after the war, memorialized aspects of it in paintings.

The war brought several Northern artists to the South, including Eastman Johnson (as mentioned), Winslow Homer, and Edward Lamson Henry. The first two were New Englanders. Henry, though born in Charleston, South Carolina, grew up in New York. Homer was in his twenties when he served intermittently as an illustrator commissioned by *Harper's* to do episodes of the war. As is well known, the majority of the scenes he drew were of military life behind the Union lines. In some of these he depicts Southern blacks as loafing, laughing, or preoccupied with music and dancing, thus conforming to the stereotype of the easy-going Negro. However, Lloyd Goodrich correctly observed in his 1944 study that even here the artist's sense of Negro "character and physiognomy was already more realistic than the average artist's minstrel-show conception."[71] Among Homer's wartime paintings, moreover, is one that reveals a sharper observation of the circumstances of the Southern black during the final years of enslavement. Dated both 1865 and 1866, it shows a dignified black woman standing alone in the doorway of a cabin, while in the background Union soldiers are being led off by Confederate troops. The original title, *Captured Liberators,* sums up the situation. The artist succeeded in conveying a mixture of outward acceptance, cautious attention, and inner longing that must have characterized such an experience.[72]

Another aspect of the war, as painted by a captain's clerk who served with the Union Army, shows one of Virginia's most famous mansions, Westover—which had been built in the eighteenth century by the Byrd family—being occupied by Union troops. In *Old Westover Mansion* (cat. no. 87), soldiers are bivouacking in the front yard, others are signaling from a platform erected on the roof; broken fences are visible, and one of the dependencies is in ruins. The painting is done in bright colors, and there is a jewel-like attention to detail. The irony of the shifts of fortune that accompany a war, and the chaos that war brings to the home front as well as the battlefield, are clearly the subjects of this work.[73]

The captain's clerk, Edward Lamson Henry, had made a drawing for the painting when he was with Grant's campaign of 1864-65. He, too, was still in his twenties at the time, but he had already studied for two years in Europe. The painting was done after the war, in 1869-70, having been commissioned by a Philadelphian. Henry's appreciation of the architectural heritage of America, as shown in many of his later paintings in which he recreated historical scenes, is foreshadowed here. During the latter part of his life, he revisited the South at least once, and he is known to have traveled extensively and visited the mountain regions of Georgia, North Carolina, and Tennessee in 1888. Negro genre paintings are frequent among his subjects.

Among Southern artists, Conrad Wise Chapman's paintings make one aware of the everyday events, duties, and settings of military life. They are quiet in mood, precise in rendering, and sensitive in the use of color.[74] Chapman, a member of a family long associated with Alexandria, Virginia, was nineteen years old and living in Rome with his parents—he was the son of artist John Gadsby Chapman—when the war broke out. He sold some of his paintings, went to Paris, and departed for America. He then managed to reach Kentucky, where, on September 30, 1861, he enlisted in the Confederate forces. During his service he made occasional sketches, watercolors, and small oil paintings, at times at the request of colleagues, who called him "Old Rome." One such work was *Camp Near Corinth, Mississippi* (cat. no. 81). In September 1863, thanks in part to the family friendship with former Governor Wise of Virginia, he was ordered to Charleston to paint the forts and batteries there, including Fort Sumter (fig. 38; cat. no. 85). After six months he was granted leave of absence to visit his mother, who was ill, in Rome. There he completed a remarkable series of thirty-one small oil paintings recording various military installations, among them

Figure 38. Conrad Wise Chapman, Fort Sumter Interior *(cat. no. 85).*

Battery Marshall (cat. no. 82), *Submarine Torpedo Boat* (cat. no. 84), and *Quaker Battery* (cat. no. 83). Though these works are important as historical documents, as paintings they are equally important for their clarity of color and for the way the artist was able to convey the effect of light, especially the clear, bright, and warm light of the winter's sun.

The painting that touched the hearts of white Southerners, particularly Virginians, was the *Burial of Latane* (cat. no. 86), completed by William D. Washington in 1864.[75] The artist recorded an incident that had happened in 1862. A young Confederate officer had been killed, and his body brought to a nearby plantation. Because the Union soldiers would not allow a clergyman through the lines and no other men of the family were home and available to help, a "Virginia matron read the solemn and beautiful burial service over the cold, still form."[76] She was helped by other women, a few faithful slaves, and several children. A poetic eulogy, published in the summer of 1862, raised the episode to a symbolic level. A Virginian, Washington had served for a time with the Engineer Corps of the Army of Virginia. He decided to paint the episode in 1864, and he assembled a number of models in order to complete the task. Though it might seem to be on the melodramatic and sentimen-

tal side to us today, the painting struck a chord of sympathy among those fighting for the Confederacy when first displayed in Richmond. It epitomized the tragic and untimely death of so many young Southern men, alone and away from home, and, perhaps even more importantly, the steadfastness, strength, and compassion of the women who had to face many difficult tasks while their men were away.[77] According to tradition, a bucket was placed under the canvas so that viewers could make contributions for aid to wounded Confederate veterans. After the war, an engraving was cut, and in the 1870s *The Southern Magazine* offered copies to readers who had paid a full year's subscription. Hence, it was a widely distributed image, and many Southerners today still remember the large engraving of it that hung in their parents' or grandparents' home. It became a symbol of the sacrifice and courage of the women and men who had experienced the debacle of war, and, as such, it became an emblem of "the Lost Cause."

During and after the Civil War many of the leaders of the Confederacy were memorialized in painting. The recognition that portraits had propaganda value during the war is borne out by a brief notice in a New Orleans newspaper of December 20, 1862, stating that the artist J. E. Mondelli had been arrested by the

Union Army for painting a portrait of Stonewall Jackson.[78] Among the Confederate leaders, Jackson and Lee emerged as the most popular heroes. Jackson was revered as the beloved, exacting soldier who fell in the field, Lee as the near-blameless leader who accepted defeat with dignity and tried to heal the wounds of war. An engraving of a large painting by Everett B. D. Fabrino Julio, a New Orleans painter, called *The Last Meeting of Lee and Jackson,* appears to have enjoyed equal popularity with the *Burial of Latane* as a symbol of the Southern cause.[79] A double equestrian portrait, it was an imagined scene of the two men conferring on the eve of the battle of Chancellorsville. Jackson was struck down at the end of the next day's battle, on May 2, 1863, and died a little over a week later of pneumonia. A visitor to a Southern home, writing in 1871, reported that "Upon the walls were portraits of Gen. R. E. Lee, and Stonewall Jackson, and Jefferson Davis—indeed, the two first-mentioned I see everywhere in the South, in private as well as in public houses—and other Rebels of distinction."[80]

John Adams Elder, a native of Virginia who had studied in Dusseldorf, served with the War Department in Richmond and as an aide in the Confederate Army.[81] Shortly after the Battle of the Crater near Petersburg in 1864 he made a painting commemorating the event. The original was destroyed in the 1865 evacuation of Richmond, but by 1869 he had completed a second version. The Washington art patron William Wilson Corcoran, a Confederate sympathizer, competed for the painting against General William Mahone, who had led the Confederate forces there, but Mahone secured it. Corcoran subsequently commissioned several portraits from Elder, including a notable posthumous portrait of Stonewall Jackson, who was depicted wearing his famous weather-beaten field cap.

In the post-Civil War period the population of the South grew at a slower rate than in the North, and only a small proportion of the new immigrants from Europe went to the South. Veterans of the Civil War in both North and South lived on until well into the second quarter of the twentieth century, but in the hustling, changing North less attention seems to have been given them. In the South these veterans—colonels and drummer-boys alike, the drummer-boys lasting the longest—represented living history, and memories of the war were kept alive and transmitted as oral history. Printed images and paintings (Lee was most frequently painted, both during his later years and posthumously) of the heroes of the war reinforced this oral tradition. If images of the Confederacy and its veterans have emerged in the late twentieth century—and they have—either in Pop Art or, sadly, as racist symbol, it is because they have been present, or were at least latent, since April 1865.

The trauma of defeat, the memory of that defeat, and the effects of destruction and poverty affected the citizens of the South in specific and real ways, as well as in attitudes and moods of the spirit. Thus, the sense of the South as separate or different from the rest of the nation, a phenomenon that had already begun to evolve earlier in the century, was magnified and sharply defined by the war—and this sense endured and continues in varying degrees even to this day. The resulting cultural differences could be defined in dozens of different ways—by speech, flagrant racial segregation, dietary habits, a strong sense of history, and family, to name but a few—at least until the advent of World War II, though in this long post-Civil War period the advent of a "New South" was heralded with some frequency, and still is today.

It is less easy to define the effect on painting. There was no major or abrupt change either in techniques or choice of subject matter. Technically, artists who worked in the South were influenced by the same trends as artists in other parts of the country. Brushwork gradually became looser and more fluid, and palettes became brighter. The development of organizations where the arts might be taught or paintings exhibited was slow and sporadic. Portraiture became less important, partly because the new art of photography provided clear, almost instant, likenesses, which were also less expensive. As a result, easel painters turned more towards landscape and other subjects, seeking out characteristic aspects of the Southern landscape. The life of the Negro as typical of the South was taken up again by a number of artists and became an important theme for a time. A slowly increasing network of railroads, especially to Florida and the Gulf Coast, brought about the development of small resorts, which in turn attracted tourists, some patrons, and the artists themselves. The pattern of the painter who spent the winter season in the South began to recur.

One of John Adams Elder's most successful postwar paintings is *A Virginny Breakdown* of ca. 1877 (fig. 39; cat. no. 93). He shows a young black boy dancing in a cabin, while members of the family watch. His figure is silhouetted against the light that pours in from

Figure 39. John Adams Elder, A Virginny Breakdown (cat. no. 93).

the doorway. There is a direct and careful observation of the humble setting. Though the blacks were now freed, their living conditions had changed little. It could be argued, with good reason, that this painting shows the white man's wishful idea that blacks, however poor, were nonetheless contented and enjoyed themselves with the simple pleasures of music and dancing. But this is not caricature, and to so categorize this painting and to dismiss it as a stereotype is to forget that music was a major creative and emotional outlet for blacks both during and after slavery, and that black music often fascinated whites. When Benjamin Henry Latrobe, the architect, was in New Orleans in 1819-20, he described at some length the Sunday afternoon dancing that regularly took place on a public square: "I heard a most extraordinary noise . . . I found . . . that it proceeded from a crowd of 5 or 600 persons assembled in an open space or public square." He went on to describe the dancing and the instruments in some detail. "An old man sat astride of a Cylindrical drum about a foot in diameter, and beat it with incredible quickness with the edge of his hand and fingers. . . . The most curious instrument however was a stringed instrument which no doubt was imported from Africa. On top of the finger board was the rude figure of a man in a sitting posture, and two pegs behind him to which the strings were fashioned."[82]

Latrobe's description and drawings are among the most precise, but many other writers wrote similar accounts of the African-based music they heard in the South.[83] T. Addison Richards, writing again in *Harper's* in 1859, also described the "impromptu music wonderously sweet and wild and weird which, well counterfeited on the lyric stage, would bring fame and fortune."[84] Many a modern musicologist wishes that recordings of such music could have been made. We now know that ragtime, bluegrass, blues, and jazz evolved out of the interaction of African and European musical traditions in America. The "breakdown" shown by Elder is one of many possible expressions of that mingling of musical traditions. It is a rapid shuffling dance, often a fast version of traditional forms such as the jig and reel—sometimes a two-step, sometimes three—which was performed individually or in pairs, and sometimes competitively, by both blacks and whites.

Winslow Homer's interest in the life of the blacks, and in the South, had obviously been awakened by his war experiences. He visited Virginia one or more times in the 1870s, during which time he did a number of Negro subjects.[85] These are among the finest of his oils and among the finest depictions of blacks in the history of American painting. Included are *The Visit from the Old Mistress* of 1876 (cat. no. 90), *The Carnival* of 1877 (cat. no. 91), and *Sunday Morning in Virginia* (cat. no. 92). All three are relatively small in scale, and somewhat frieze-like in composition, with figures placed within a relatively shallow space.

In *The Visit from the Old Mistress*, a well-dressed white mistress is seen in profile inside a rude cabin, as if she had just entered. In the center is a portly, aproned Negro woman, flanked by another, younger woman holding a child. A third black woman watches the scene from her vantage on a low stool. Homer not so much tells a story as suggests a relationship—a relationship fraught with history and complexity, with the intimacy and distance, familiarity and alienation that have characterized relationships between blacks and whites in the South. It is a sober, dignified, thought-provoking picture which, like Johnson's *Life in the South*, has evoked many different responses among commentators at different times and with differing points of view.

The Carnival, which seems to suggest an event such as the Catholic pre-Lenten festival, was so titled by Homer himself. The picture shows a black man in a bright pierrot, or clown, costume; two women are helping to put the finishing touches on it, as children of various sizes observe. An anecdote published about the painting in July of 1898 gives a clue to the meaning of the title, but despite this, art historians have been baffled and unable to pinpoint the meaning of the term within the context of Virginia. One theory suggested that the painting might represent a Fourth of July celebration. The anecdote went as follows:

> Mr. Homer had been working at Smithtown, Virginia. Like many another artist, he found picturesque subjects in the people of color. He had painted them as he found them, in tatters. So they saw themselves in "The Old Mistress" and other pictures. At last the models demurred; they objected to this—that such undignified likenesses of themselves should go up to the North. Excitement ran high: they almost mobbed the painter. At length, by way of compromise the latter agreed to paint them in their finery, as they were accustomed to deck themselves for their Christmas festivities.[86]

Costume-party dress, then, was worn by blacks at Christmas in Virginia, and in fact the custom was called "carnival." A poem by Irwin Russell, first published in *Scribner's Monthly* in January of 1878, de-

scribes the "high carnival" "At Uncle Johnny Booker's ball," "when merry Christmas day is done/And Christmas night has just begun."[87] Some Virginia residents remember being told of a related old-time Christmas practice in which rural blacks dressed up and went about asking for presents. (A somewhat similar custom is known to have taken place at Christmas in some parts of North Carolina; it developed from a West African dance ritual.[88]) The roots and ramifications of these holiday traditions are varied and intertwined. In addition to a possible African source, the custom of blacks dressing up at Christmas is also probably related to the English practice of relieving servants of all duties the day after Christmas and giving each a Christmas box (Boxing Day), as well as to the traditional Catholic pre-Lenten Carnival season, which is characterized by dress-up and masking, and which often begins on Twelfth Night (the Twelfth Night tradition in turn has its roots in the ancient Saturnalia, celebrated in December, during which the roles of masters and slaves were reversed).

The anecdote as related is probably accurate. The black models did not like being shown in tatters, and decided to dress up. This finery not only pleased them because it was bright and colorful, but it was also associated with a time when they were free of duties and could revel among themselves. Homer had the wit and sympathy to catch this festive mood.

The setting for Homer's *Sunday Morning in Virginia* is a simple cabin similar to that in *The Visit from the Old Mistress.* A well-dressed young black woman appears to be reading aloud from the Bible, while three children cluster around as if listening carefully. On the right an older woman sits in front of a closed door. This simple scene suggests the faith and hope of the blacks—a faith in religion, and perhaps also the desire for learning. Quiet Sunday mornings may have been the only time when the young woman was free to read or to teach her younger colleagues. It is a poignant and sympathetic depiction.

In each of these paintings there are wonderfully rich and somber color harmonies. In *The Carnival,* the figures are shown in an outdoor setting distinguished by varied and fairly deep green tones. The dark-skinned figures and parts of their costumes almost blend into the background, while the brighter areas and glints of yellows, reds, and blues are made richer by their juxtaposition against this background.

In *The Visit from the Old Mistress,* all of the figures are seen against the sienna and red umber tones of the room setting. Here again, many of the colors used to build the figures, such as the reddish apron of the young mother, are in close harmony with the background colors, and the bluish whites and shadows present subtle contrasts.

In *Sunday Morning in Virginia,* the combinations of browns, reds, umbers, and muted greens create an immediate impression of subtle dark tones.[89] A bright note is struck by the touches of red of the older woman's scarf, and lighter notes by the muted white of the young woman's dress and apron. The somberness of the colors are appropriate to the grave and serious mood of the subject.

When another of Homer's paintings of Negro subjects was exhibited in 1879, a now oft-quoted critic spoke of the "deep, queer colours like the Japanese, dull greens, dim reds and strange, neutral blues and pinks."[90] Homer may or may not have been influenced by things Japanese at this time. It is equally probable that, as throughout his career, he was working through, and thinking through, the complex effects of color contrasts and analogies as enunciated by Chevreul, such as "the painter . . . who knows all these things and is conscious of his power, will be restrained in the use of harmonies of contrast, and prodigal of the harmonies of analogy."[91] Chevreul's *Principles of Harmony and Contrast of Colors and Their Application to the Arts* was, according to Homer, his "Bible," and he is known to have had a copy since 1860.[92]

Homer was attracted again and again to tropical Southern climes during the latter part of his career. From 1884-85 onwards he made fairly regular winter sojourns, either to the islands of Nassau, Cuba, Bahama, and Bermuda, or to Florida, which he visited in 1886, 1890, 1904, 1905, 1907, and 1908. At these times he often made blacks the subjects of his watercolors or paintings, and he recorded in myriad ways the tropical beauty of these places in his superb watercolors.

Richard Norris Brooke (1847-1920), a native of Warrenton, Virginia, established a reputation in the 1880s as a painter of Negro subjects. His *Pastoral Visit* of 1880 was for many years one of the most popular paintings at the Corcoran Gallery in Washington.[93] *Dog Swap* (fig. 40) was less well-known, but it is perhaps the finer painting. Brooke's choices of subject and his reasons for these choices, as well as the critical reaction the painting received, reflect artistic and social values of the time. His embryonic artistic career

Figure 40. Richard Norris Brooke, Dog Swap, 1881, oil on canvas, 47⅛ by 65⅞ inches (119.7 by 167.3 cm). National Museum of American Art, Smithsonian Institution, Gift of Colonel Thomas G. Young, 1956.11.2.

was interrupted by the Civil War. Afterwards, he was able to study at the Pennsylvania Academy, and in 1877-78 he studied in Paris with Leon Bonnat, the realist and fashionable portrait painter who was also a mentor of Thomas Eakins. A large canvas, *The Pastoral Visit,* was his first major painting after his return from France. In it he showed a dignified elderly black minister seated at a table with a family of his parishioners. When Brooke offered this to the Board of the Corcoran for purchase, he explained his purpose:

> It does not of course become me to define the artistic merit of this work further than to say that it is the result of conscientious study, yet it is proper, while offering it for purchase by your Board, that I should make the following statement.

It must have struck many of you that the fine range of subject afforded by Negro domestic life has been strangely abandoned to works of flimsy treatment and vulgar exaggeration. That peculiar humor which is characteristic of the race, and varies with the individual, cannot be thus crudely conveyed.

In entering this field, by the advice of many of my Artist friends, and with the equipment of a foreign training, I have had a deliberate purpose in view. It has been my aim, while recognizing in proper measure the humorous features of my subject, to elevate it to that plane of sober and truthful treatment which, in French Art, has dignified the Peasant subjects of Jules Breton, and should characterize every work of Art. I am pleased to think, from the reception given by the public to this effort, that my object, however realized, has been felt and appreciated.[94]

In *The Pastoral Visit*, then, the artist was trying to avoid the stereotype of the "vulgar exaggeration" that characterized many people's view of blacks, and to give a "sober and truthful" rendering. The letter may have been necessary to persuade the Board, as one of the museum's curators had already recorded a negative opinion of the painting in his personal journal: "though it is well done, there is too much nigger in it for so large a picture, and is of a coarse homeliness that I dislike" [the underlines appear in the original journal].[95] The picture was purchased and was for many years a favorite at the Corcoran. By 1931 this type of painting had gone out of style, and a critic tartly commented, with some accuracy, "The anecdotal subject charmed a nation that probably always will love the more homely aspects of negro sociology. For the most arrogant Nordic takes a negro as long as he remains a peasant."[96]

Dog Swap was first exhibited in Brooke's studio in the fall of 1881.[97] Two black men are engaged in shrewd bargaining over the exchange of a pair of dogs, as members of the family or friends watch. The composition is well organized and well painted, and the brushwork is often thick and juicy. Broad areas, such as the faded whitewash of the cabin, contribute to an overall muted tonality. This is enlivened by subtle and brighter contrasts of color, such as the light-colored clothing of the man on the right, and the green of the cabbages in the foreground on the same side. The fish net, the pan of apples on the bench, and the wash pan hanging on a post all suggest that life was essentially lived outside the cabin during the warm months. Because it is a story-telling picture in which the major figures are deeply engrossed and seem to be enjoying themselves despite the obvious poverty of their setting, the modern viewer may be inclined to see it, like Elder's *Virginny Breakdown* (fig. 39; cat. no. 93), as edging into the sentimental and patronizing, and with some justification. Though the artist, a man of his time, may have unconsciously harbored such attitudes, he surely did not intend to convey them in his work, as the letter to the Corcoran board indicates.

The varying critical attitudes towards *Dog Swap* may have been similar to those accorded the more famous Corcoran picture. Both are well painted. What is also important here is that in the 1880s a Southern artist wished to depict his fellow Southerners, the Negroes, in a sympathetic and dignified light, even though he saw them in a hierarchical status different from his own, just as French middle-class artists saw their peasants as different from themselves. Brooke saw the Negroes as an integral part of Southern culture and wanted to represent them as such.

French and European training and attitudes towards landscape as subject matter are reflected in the work of the New Orleans artist Richard Clague (1821-1873), who absorbed them during his youth.[98] Clague was Parisian-born but of New Orleans parents, and the family maintained strong French connections. Thus his artistic training took place partly in New Orleans under the panorama painter Leon Pomarede, and partly in France and Switzerland. He exhibited one landscape and two portraits at the Paris Salons of 1848, 1849, and 1853. Clague was established in New Orleans by December 1857, though his artistic career was interrupted when he served with the Confederate Army in 1861-62. He subsequently settled in New Orleans.

During what was the last decade of his life, Clague frequently painted landscapes of the flat, low-lying countryside of Louisiana, Mississippi, and Alabama. As seen in *Trapper's Cabin* (cat. no. 79) and *Spring Hill, Alabama* (cat. no. 80), the rustic shacks of fishermen and trappers, farmers' residences, and even the simple cottages used by vacationers were all a source of attraction to him. The canvases are often small, the scale unpretentious; they convey a sense of clarity and serenity, a sense of measure, and a sure feeling for form. Clague is one of the first to make the landscape of the lower Mississippi River area and the Gulf Coast his recurring theme, and probably the first to earn his living in this way. A contemporary critic correctly praised the "quiet beauty" of his landscapes, which caught "the characteristics of our peculiar scenery."[99] In what may have been an oblique reference to the grand and sometimes bombastic paintings of artists such as Church and Bierstadt, the critic also wrote of Clague's work, "There is no meretricious glare about these fine studies, no straining after effect, no clap-trap of any kind." During the latter years of his life, Clague taught or was acquainted with a number of artists who lived and worked in New Orleans.

Marshall J. Smith, Jr. (1854-1923) was one of these. The homes and rural activities of the farmers and fisherman who lived along the bayous and waterways of lower Louisiana were a recurring theme for him (cat. no. 98). Smith grew up in New Orleans and in nearby Mississippi. After Clague's death he studied briefly with Theodore Moise, then spent approximately two years in Europe, traveling and studying in

Rome, Munich, and Paris. In 1880 he was one of the founders of the Southern Art Union, a group composed mostly of New Orleans artists.[100] Other artists and colleagues of Clague, who made this area of the rural South their theme, include William Buck, George Coulon, and E. B. D. Fabrino Julio.

Joseph Rusling Meeker (1827-1889), originally from New Jersey, discovered the peculiar and special beauties of the Deep South while serving with federal forces there.[101] As a member of the U.S. Navy, he came to know the entire length of the lower Mississippi River, as well as the adjacent rivers, bayous, and swamps of Louisiana and the Gulf Coast. These waterways seem to have made an indelible impression, for after the war they became Meeker's specialty, even an obsession. He returned to the region at fairly regular intervals to refresh and renew his inspiration. At his best, he captured the muted but glowing light that flashes through thick foliage and the calm of the still waters—as in *Bayou Scene* (cat. no. 95)—and he was able to suggest the presence of the teeming life that inhabited these lonely places.

In quite another part of the South, Flavius Fisher (1832-1905) of Virginia and Tennessee also turned his skills to landscape painting.[102] He lived in Lynchburg, Virginia, from about 1860 to 1882. Among his works is a painting of the Great Dismal Swamp (cat. no. 72). The glow of light in the sky and on the water and the shapes and shadows of the foliage are the essential subjects of his canvas; it is a setting in which human figures are virtually lost in the expanse of space. Andrew Melrose (1836-1901) is a little-known artist who was drawn to the South on more than one occasion; scenes of the mountains of North Carolina and the Shenandoah Valley of Virginia are included among his work.[103] In *Whiskey Still by Moonlight* (cat. no. 96), the details of the still and the men working are subordinated to the setting. The glow of the moon and the dark forested hills are the real theme.

Clarence Boyd (1855-1883), a Kentucky artist who had studied in France in the 1870s, exhibited a painting entitled *Futurity* (cat. no. 99) at the National Academy of Design in 1882.[104] We see a young woman in a forest setting, leaning against a large log and bathing her feet in a small stream—altogether a quiet, rustic scene. The title, however, suggests that it is to be read on more than one level of meaning. The young woman may have been the artist's fiancée. If so, the title suggests promise and hope for the future, since in racing parlance familiar to Kentuckians, "futurity" is

the gamble on future performance. Indeed, there is a gamble in any close personal relationship. Tragically, the artist was murdered the following year, cutting short a promising career and his own gamble on success and happiness in the future. The painting is notable from a technical point of view because of the artist's use of rich and muted colors and a scumbling technique reminiscent of the work of Corot, a method he may have learned during his two years in France.

Thus, though the South after the war was poor and its people felt the force of defeat in a variety of direct and subtle ways, artists from the region, and those who had come to know it, found what they considered beautiful, dignified, and appropriate subjects in their own people and in the natural and rural settings that surrounded them. The still sparsely settled areas of the land itself were gradually becoming more accessible by trains and boats. More often than not, artists seem to have sought the quiet and the familiar, rather than the exceptional or the dramatic.

As far as we know, relatively few artists who painted in the South made a specialty of still life during the nineteenth century,[105] possibly because there wasn't enough patronage; or perhaps there are works that have not yet been discovered. Thomas Bangs Thorpe, who lived in Louisiana off and on between 1836 and 1854, is known to have painted still lifes in addition to his other activities as painter, author, and journalist. In Charleston, William Wightman and his brother Thomas created a number of luscious still-life paintings in the 1840s and 1850s.

During the 1870s, Andrew John Henry Way (1826-1888), a Baltimore artist, established a reputation for excellence in still life.[106] One of his specialties was the painting of grapes, often shown as if hanging from the vine and against a wall, so that a large shadow repeats the basic form of the fruit. One such work was *A Bunch of Black Grapes* (cat. no. 97). He was so accurate that those who were knowledgeable—and these included his patrons—could readily identify the variety of grape.

Much later in the century, Miss Willie M. Chambers (dates unknown), who it is believed was a professional seamstress in Atlanta, took time off during the summers to paint.[107] In *A Basket of Cherries* (fig. 41; cat. no. 106), she used varied greens in a woodsy setting in order to heighten the effect of the bright red cherries. We do not know how Chambers developed her talents, but she obviously understood the manner in which the juxtaposition of complementary colors

Figure 41. Miss Willie M. Chambers, Still Life: Basket of Cherries *(cat. no. 106).*

serves to heighten their intensity. (She may never have read Chevreul, but, like that Frenchman, she might have learned her awareness of the effects of different kinds of color contrasts through her familiarity with textiles.)

The painting of flowers became a forte of Martin J. Heade (1819-1904) as early as the 1860s. When he first visited Florida in 1883, and then settled there permanently in 1884, it was only natural that he would choose to depict the luxuriant flowers: roses, orange blossoms (and occasionally oranges), lotuses, and the sensuous and redolent magnolias. In the most successful of these—including works like *Four Cherokee Roses* (cat. no. 103)—he shows the blossoms casually laid on a table, "reclining," as it were.[108] This unusual approach seems to emphasize the freshness and abundance of blossoming plants in a region where they can be gathered with ease all year round.

Heade was one of a generation of artists who found their way to the South during the 1870s, 1880s, and 1890s. Some came simply for the winter months, others remained for longer periods. It is possible that some were stimulated by a series of articles published in 1873-74 in *Scribner's Monthly*. Written by Edward King, the series was commissioned by the editors in order to "present to the public, through the medium of a popular periodical, an account of the material resources, and the present social and political condition, of the people of the States formerly under the dominion of Slavery," and "to give the reading public a truthful picture of life in a section of the country which has, since the close of a devastating war, been overwhelmed by a variety of misfortunes, but upon which the dawn of a better day is breaking."[109] These articles, in a sense, heralded the first of the successive "new Souths" that emerged, or appeared to emerge, since the Civil War. Each month a different part of the South was described, so that ultimately the whole area was covered in all its diversity, from Texas to the Carolinas. Each article was accompanied by steel engravings showing the scenery, the people, the memorable architecture, and, occasionally, portraits. Most of these were based on sketches by J. Wells Champney; some were redrawn for publication by Thomas Moran. In 1874 the series, with some additions and rearrangement, was published as a thick 800-plus page book, and in 1875 a second edition was published in England.

Robert J. Onderdonk (1852–1917), a native of Catonsville, Maryland, was one of those who migrated to the Deep South at this time. According to tradition, he was persuaded by boyhood friends to go to Texas to seek his fortune.[110] He arrived in San Antonio in September 1879, at the age of twenty-seven. Except for occasional travel and living several years in Dallas, he was to remain in San Antonio for the rest of his life. He and his children, several of whom became artists, helped to shape the artistic and cultural life of that city. Onderdonk had studied at both the National Academy of Design and the newly-founded Art Students' League, both in New York. He did portraits and some still lifes, and he even tried his hand at a large history painting, *The Fall of the Alamo*. Among his most successful paintings, however, are small-scale scenes done in and around San Antonio in which a building or two and one or more figures are shown. Typical is the painting called simply *House and Figure* (cat. no. 101). A Mexican girl is shown seated by the side of a road, in front of a cluster of ramshackle huts, which were called jacals. One is struck more by the quiet serenity of the scene, and the harmonies of green and umber tones that dominate the composition, than by any suggestion of poverty.

Several German-born artists had come to Texas from the late 1840s on, including Carl Iwonski, Richard Petri, Hermann Lungkwitz, and Louisa Heuser Wueste.[111] Members of the family of Julius Stockfleth (1857–1935) first came to America around 1872, while the artist and still other relatives seem to have arrived in 1883.[112] By 1885 all of them had settled in Galveston. Aspects of this city and its environs became the subject of Stockfleth's work. One such painting is a quiet landscape of a dairy farm—*The T. J. Gallagher Dairy, Galveston* (cat. no. 107)—a scene of flat, open land that seems to stretch away unbounded on either side. Galveston Harbor and its boats were also favorite themes. Twelve of his relatives were killed in the devastating 1900 hurricane, and among his later canvases are several based on this storm, which obviously was a haunting memory for him. Though they are slightly awkward renditions, these late paintings suggest the fury with which hurricanes have battered southern shores over the years, along the eastern seaboard and as well as the Gulf Coast.

View of Galveston Harbor (cat. no. 89), showing a calm sea, was painted by William Aiken Walker (1838–1921) in 1874, during a sojourn there. A native of Charleston, Walker was the itinerant artist extraordinary, and his career is associated with the growing resort business of the New South.[113] He reached matu-

rity during the Civil War, and among his duties with the Confederate Army were drawing maps and sketching the defenses of Charleston. Though he subsequently based himself in Baltimore during the years 1868–72, and at other times in New Orleans, Charleston, and Augusta, Walker evolved a leisurely transient existence that included spending part of each year in resort communities such as Arden, North Carolina, in the Blue Ridge Mountains, or Ponce Park, Florida, on the Atlantic coast. Thus he had a number of homes away from home. Walker is best known for his small-scale paintings of scenes showing blacks pursuing everyday activities around their simple cabins, or at work in the fields, and for his paintings of individuals in their work clothes. They seem to be mementos of the Old South, for the lives of many blacks, though emancipated, had not changed markedly. These works were seen through the tempered and slightly idealized vision of the picturesque, yet the artist was not without a feeling of rapport with his subjects. In his painting of Galveston Harbor, Walker achieved a breadth and scale relatively rare in his work; it is reminiscent of much earlier views of harbors on the eastern seaboard, including Charleston and Baltimore, which were intended to suggest the prospering life of the city.

When Edward King, the author of the *Scribner's* articles, visited Florida in 1873–74 he went by rail from Savannah to Jacksonville. He described Jacksonville as "the chief city of Florida, and the rendezvous for all travelers who intend to penetrate to the interior of the beautiful peninsula."[114] At this time Florida was just being discovered by Northerners as an earthly paradise, a place to spend the winter away from the snow and chill of the North and, in search of health or pleasure, a place to enjoy fishing and hunting, or simply a quiet life in the sun, gardening or gossiping.[115] One of these early winter visitors to Florida was the financier and railroad executive John Murray Forbes. Forbes's grandfather had been rector of a church in St. Augustine in the early nineteenth century, and so the family had a long connection with the state. In the spring of 1873, Forbes invited William Morris Hunt, who was still somewhat depressed after his studio had burned the year before, to join him. Hunt's work was much respected in Boston, and he was also admired because he had introduced many art patrons there to the new work of the French Barbizon artists who painted out-of-doors, or *en plein air*. Though Hunt was advocating the work of his French contemporaries, he

had not devoted much of his own time to landscape painting.[116] He stayed at Magnolia Springs, a resort near Jacksonville, and his paintings of the quiet, still waters and tropical settings there were well received when he returned to Boston. He went again to Florida the following year, when he painted *View of the St. John's River, Florida Sunset* (cat. no. 88). His two Florida winters are considered a turning point in his career, since from this time on he turned increasingly to landscape painting, even outfitting a painting van for himself in which he traveled about New England in search of subjects.

In 1877 *Scribner's* asked Julia E. Dodge to do a piece on the island of Fort George, one of the Sea Islands near the mouth of the St. John's River in Florida. This island, where long-fiber cotton had been grown before the war, and where orange groves had just recently been planted, was little known to most visitors. Thomas Moran (1837–1926) was asked to accompany her in order to illustrate the article, which appeared in the September 1877 issue. Moran at this time was forty years old, and he had spent time in England and Italy, where he had admired and studied the work of Turner. Having already sold two large panoramic paintings of Yellowstone and the Grand Canyon to Congress,[117] he hoped to follow his success with a large history painting of Ponce de León in Florida. He completed the picture after his return but failed to sell it to Congress. Perhaps because they had already purchased two of his works, the Congressmen chose instead to favor another artist. Though his painting was well received when later exhibited in England, it was not sold until 1886.[118] If he had been more successful with this ambitious undertaking, he might have returned more frequently to the South. Instead, he made the American West the subject of a large portion of his subsequent work. He did, however, paint twenty or so paintings of Florida, and he returned for at least one more visit. Moran's liquid brushwork, apparent in *Florida Scene* (cat. no. 94), sometimes suggests the fluidity of watercolors.

Martin J. Heade was apparently first attracted to Florida because of favorable reports of the excellent hunting and fishing; his first visit there was in the spring of 1883.[119] It suited him, and therefore this sixty-four year old artist who had lived a restless life decided to make it his home. In the same year he married for the first time, and by 1884 he and his wife were settled in St. Augustine. He spent the remainder of his long life there. He may have met Henry Morri-

Figure 42. Martin Johnson Heade, Afterglow, Florida *(cat. no. 104).*

son Flagler during that first visit. Flagler had gone to Florida for the first time in 1883, and he was soon embarked on the first of his many hotel and railroad enterprises, which sparked a Florida boom. At any rate, they were certainly acquainted by 1884, and Flagler subsequently became a faithful and regular patron of Heade's. In fact, Flagler himself designed the long building that was built behind the Ponce de León Hotel in 1888; a number of artists had their studios there, thus creating "the atmosphere of Renaissance civilization" that Flagler wanted.[120] Heade was the doyen of this small artists' colony.

One of Heade's late Florida landscapes is *Afterglow, Florida* (fig. 42; cat. no. 104). Here the artist captures the muted light and sultry atmosphere of Florida. The work served as a salute to the state, and to the tropical edge of America, a still-primitive wilderness that was only then being discovered by visitors from further north.

Johannes Adam Simon Oertel (1823–1909) was also a mature artist when he found his way to the South, although for quite different reasons. As a youth in Germany he had wished to study for the ministry, but because of his skill in drawing he was encouraged

to study art.[121] By 1871, when he was finally ordained a minister in the Protestant Episcopal Church, his career included the designing of decorations for the ceiling of the U.S. House of Representatives, as well as service in the Army of the Potomac. After the war he was put in charge of a rural church and two mission stations in Lenoir, North Carolina, and in subsequent years he lived in Morganton, North Carolina, in Florida, in Sewanee, Tennessee, in St. Louis, and in Washington, D.C. Though his greatest interest was in painting religious subjects, portraits and landscapes are among his works. One of these, *Chincoteague Ponies* (also called *Marsh Ponies in North Carolina*) of 1882 (cat. no. 100), portrays the wild ponies that still roam the islands off the eastern shore of Virginia and North Carolina—Assateague and Chincoteague in Virginia and Ocracoke in North Carolina—wild, open places Oertel may have visited during vacations or in the course of his ministerial duties.

A tie with North Carolina began for Elliott Daingerfield (1859–1932) when he was a boy.[122] Born in Harpers Ferry, West Virginia, his early education took place in North Carolina, where his father had been ordered as a member of the Confederate govern-

ment. He later studied in New York and in Europe, and taught for a time at the Philadelphia School of Design. His first wife was from North Carolina, and Daingerfield maintained contact with the region, though he lived most of the time in metropolitan areas. As early as 1886 he visited the mountain town of Blowing Rock in order to recover from an illness. In 1896 he exhibited sketches and studies of the North Carolina mountains at the New York Watercolor Club. In 1900 he established a second home in Blowing Rock, which he visited regularly for the rest of his life. A friend and admirer of George Inness (who also visited Florida and Virginia during his later years), Daingerfield had a style that was influenced by the soft-edged manner of that artist. Rural themes were favored subjects for him throughout his life (see *Carolina Sunlight,* cat. no. 113), a life that bridged the centuries. He found many such themes in the South, which was still largely rural at the beginning of the new century. Among these is a landscape of North Carolina done in the early twentieth century that shows a typical tobacco barn—one in which his daughter and her friends played as children and of a type that can still be seen today.

William P. Silva was another artist whose career bridged the centuries. A native of Savannah, he established himself in business in Tennessee. Though he was a talented amateur, he did not begin formal artistic training until the turn of the century. He later received numerous prizes for his colorful impressionistic paintings, such as *Georgia Pines at Sunset* (cat. no. 108).

Both the concept and the fact of the South as a clearly identifiable entity in American life was formed in the middle years of the nineteenth century, and it was still thought of as such by the end of the century, though changes were taking place and a "new South" was, or at least appeared to be, emerging. Artists captured a portion of this complex, diverse, and sometimes contradictory place and people.

They also began to represent everyday life during this period, the life of working people and, most especially, the Southern black. Blacks were seen not only as typical of the South, but also as emblematic of it. This theme was to be carried over into the twentieth century. At times, such depictions seemed to be somewhat defensive, at least as interpreted by journalists, for white Southerners became increasingly defensive about the institution of slavery in the years immediately preceding the Civil War and wanted it to be seen in its best light. But there was also the desire to have the South presented as it was, and the recognition that black people were an important component of life there.

Within the larger framework of the history of nineteenth-century painting in Europe and America, Negroes were the most easily identifiable group representing low and humble life. European critics and artists who advocated such subjects were moved in part by an impulse to reform, but also by a romantic nostalgia for what seemed to be a picturesque and simpler existence, removed from the ugliness of urban life yet full of dignity, stoic endurance, or gentle humor. Their American confreres learned these values during their studies abroad. These were the same values that emphasized regional and national themes, and so they could be translated into a search for artistic subjects based upon one's own people and own land.

The land itself, its waterways, and the people living there were chosen as subjects by the painters—native Southerners, those who settled there, others who visited seasonally. Many of their paintings portray a quiet land or quiet waters, images that could be interpreted as depicting a region stilled by defeat or, more simply, a rural place where ordinary people, like trappers and fishermen, along with the birds and the beasts, seemed to blend in with the landscape. Other scenes, perhaps more lyrical, were seen through the eyes of the South's visitors, who saw the rural lands and waters as places of retreat and refreshment, even as a new frontier, as a familiar, yet ever-changing presence.❈

NOTES

1. U. S. Census Office, *Third Census, 1810* (Washington, D.C., 1811), and *Fifth Census, 1830* (Washington, D.C., 1832). See also T. P. Thompson, "Early Financing in New Orleans, 1831—Being the Story of the Canal Bank—1915," in *Publications of the Louisiana Historical Society, 7* (New Orleans: Louisiana Historical Society, 1915), pp. 11-16, 18, 20, 23, and 37. Thompson gave a population of 27,126 for 1820; it should read 27,176. See also *Characteristics of the population, Number of inhabitants, Louisiana, 1980 Census of Population* (Washington, D.C.: U.S. Dept of Commerce, Bureau of the Census), pp. 20-27. These figures include slaves and free people of color, but not Indians. Depending on how large an area is used, these figures could vary; for example, John G. Clark, *New Orleans 1718-1812* (Baton Rouge: Louisiana State Univ., 1970), p. 275 gives a figure of 24,522 as the 1810 population of New Orleans. To get this he includes the "precincts of New Orleans," as well as "the city and suburbs of New Orleans." Using these, his figure should read 24,552. For 1830 Thompson gives the population of New Orleans as 52,455, while *Characteristics* gives it as 46,082. My own addition of the relevant areas adds up to 50,122.

2. *Gibson's Guide and Directory of Louisiana, New Orleans and Lafayette* (New Orleans, 1838), p.iii.

3. U. S. Dept. of State, *Compendium of the Enumeration of the Inhabitants and Statistics of the United States* (Washington, D.C., 1841).

4. Ms. 42, Isaac Delgado Museum of Art Project, W.P.A., Howard-Tilton Library, Tulane University, citing *L'Ami des Lois et Journal du Soir,* 21 January 1816 (hereafter cited as Ms. 42, W.P.A.).

5. Howard Corning, ed., *Journal of John James Audubon Made During His Trip to New Orleans in 1820-21* (Boston: The Club of Old Volumes, 1929), pp. 115-16, 143-46, 149, 153, 199-200, 202-04, 209-10, 217-218, 220, 222, and 225.

6. William Barrow Floyd, *Matthew Harris Jouett, Portraitist of the Ante-Bellum South* (Lexington, Kentucky: Transylvania University, 1980), p. 15.

7. Lynn W. Farwell, *Jean Joseph Vaudechamp* (New Orleans: Louisiana State Museum, 1967); and idem, "Jean Joseph Vaudechamp and New Orleans," *Antiques* 94 (September 1968): 271-75.

8. *Diary of William Dunlap,* New-York Historical Society Collections, vol. 64 (New York, 1931):785.

9. Mary Louise Tucker, "Jacques Amans, Portrait Painter in Louisiana, 1836-1856" (Master's thesis, Tulane University, 1970).

10. John Burton Harter and Mary Louise Tucker, *The Louisiana Portrait Gallery, to 1870,* vol. 1. (New Orleans: Louisiana State Museum, 1979), pp. 9, 62, 66, 67, and 125. Exact birth and death dates are unknown.

11. Ibid., for Carlin, pp. 65 and 119; for Jaume, 88, 106 and 122; for Lansot, 65 and 122; for Rinck, 65, 66, 68, 84, 102, and 124.

12. For a general discussion of this group, see H. E. Sterkx, *The Free Negro in Ante-Bellum Louisiana* (Cranbury, New Jersey: Associated University Presses, 1972), and Ira Berlin, *Slaves Without Masters* (New York: Vintage Books, 1976). For a discussion of free people of color as property owners in New Orleans, see Sally Kittredge Evans, "Free Persons of Color," in *New Orleans Architecture,* vol. 4, *The Creole Faubourgs* (Gretna, La.: Pelican Publishing Company, 1974), pp. 25-26.

13. George E. Jordan, "Old Sketch Books Recall Early N. O. Artist," *Times-Picayune* (New Orleans), April 4, 1976, section two, p. 2; and catalogue information, New Orleans Museum of Art.

14. Ms. 42, W.P.A., citing newspaper references cited for 6 June 1831; 3 December 1831; 7 January 1832; and 10 January 1832. Also *Gibson's Guide.*

15. To confirm this, one has only to examine the portraits shown in the various state surveys published by the National Society of Colonial Dames of America. For example, Mrs. Thomas Nelson Carter Bruns, *Louisiana Portraits* (New Orleans, 1975); Mrs. Orville Lay, *Alabama Portraits Prior to 1870* (Mobile, 1969); and Marion Converse Bright, *Early Georgia Portraits 1715-1870* (Athens: University of Georgia, 1975).

16. Elizabeth P. Reynolds, *To Live Upon Canvas, The Portrait Art of Thomas Cantwell Healy* (Jackson: Mississippi Museum of Art, 1980).

17. See Lay, *Alabama Portraits,* and Bright, *Early Georgia Portraits.* See also Ms. 42, W.P.A.; newspaper references of Dec. 2, 1826, April 11, 1832, December 4, 1845 and Feb. 1846.

18. Edgar Erskine Hume, "Nicola Marschall, The German Artist Who Designed the Confederate Flag and Uniform," *German-American Review* 6 (August 1940): 6-10, and 39-40.

19. Helen K. Hennig, *William Harrison Scarborough, Portraitist and Miniaturist* (Columbia, S.C.: R.L. Bryan Company, 1937).

20. Helen G. McCormack, *William James Hubard, 1807-1862* (Richmond: The Valentine Museum and the Virginia Museum of Fine Arts, 1948), and Robert Bowers Mayo, "The fine arts collection at the Virginia Museum," *Antiques* 103 (January 1973): 156-65.

21. George C. Groce and David H. Wallace, *The New-York Historical Society's Dictionary of Artists in America, 1564-1860* (New Haven: Yale University Press, 1957), p. 89 (hereafter cited as *Dictionary of American Artists).*

22. Bright, *Georgia Portraits,* p. 308; and information sent from the Atlanta Historical Society by Adair Massey.

23. Groce and Wallace, *Dictionary of American Artists,* p. 676. The paintings of Lee and his wife are owned by Washington and Lee University. I am grateful to Sara Lewis, formerly of the Mississippi State Historical Museum, for information concerning the circumstances of the Lee paintings.

24. For Healy's portraits, see *A Souvenir of the Exhibition Entitled Healy's Sitters* (Richmond: Virginia Museum, 1950), and *A Catalogue of the Collection of American Paintings in the Corcoran Gallery of Art, 1, Painters Born Before 1850* (Washington, D.C., 1966), pp. 86-92. The artist, date, and location of this painting of Alexander Hamilton Stephens are inaccurately given in Bright, *Georgia Portraits,* p. 215. I am grateful to Elissa W. Jones (Mrs. A. Waldo Jones) of Atlanta for locating the correct information.

25. William H. Truettner, *The Natural Man Observed: A Study of Catlin's Indian Gallery* (Washington, D.C.: National Museum of American Art, 1979), no. 300, p. 227.

26. George Catlin, *North American Indians, Being Letters and Notes on Their Manners, Customs and Condition During Eight Years' Travel Among the Wildest Tribes of Indians in North America,* 2 vols. (Edinburgh, 1926; first published in 1841), 2:250; and Truettner, *Natural Man Observed,* p. 227.

27. Truettner, *Natural Man Observed,* pp. 227-65.

28. Court records of York County, Virginia, as cited by John Harvey, *Racing in America 1665-1865,* 3 vols. (New York: The Jockey Club, 1944), 1:17.

29. Ibid., 2:339.

30. Alexander Mackay-Smith, *The Race Horses of America 1832-1872, Portraits and Other Paintings by Edward Troye* (Saratoga Springs: The National Museum of Racing, 1981), pp. 1, 358-60.

31. Ibid., p. 369.

32. P. S. H., "A Painting of Oakland," *The J. B. Speed Art Museum Bulletin,* 18 (April 1957), no pagination.

33. Ms. 42, W.P.A., citing *Commercial Times,* (New Orleans) 25 November 1847.

34. *Louisiana Landscape and Genre Paintings of the 19th Century* (Shreveport: R.V. Norton Art Gallery, 1981), p. 7.

35. Ms. 42, W.P.A., citing *Daily Orleanian,* 6 August 1853.

36. Private collection, see *250 Years of Life in New Orleans; The Rosemonde E. and Emile Kuntz Collection and the Felix H. Kuntz Collection,* (New Orleans: Louisiana State Museum, 1968), p. 50, no. 38.

37. W. Joseph Fulton and Roulhac B. Toledano, "New Orleans landscape painting of the nineteenth century," *Antiques* 93 (April 1968): 504-10.

38. George Cooke, "The Cyclopean Towers," *The Southern Literary Messenger,* 1 (1834-5): 98-99; idem, "Sketches of Georgia," ibid. 6 (1840): 775-77.

39. Marilou Alston Rudulph, "George Cooke and His Paintings," *Georgia Historical Quarterly* 44 (June 1960): 117-53; and William Nathaniel Banks, "George Cooke, painter of the American scene," *Antiques* 102 (September 1972): 449-54.

40. William C. Richards, ed., *Georgia Illustrated* (Penfield, Georgia, 1842), esp. pp. 1 and 12; Anna Wells Rutledge, *Artists in the Life of Charleston,* Transactions of the American Philosophical Society, vol. 39 (Philadelphia, 1950), p. 166 (hereafter cited as Rutledge, *Artists in Charleston).*

41. T. Addison Richards, "The Landscape of the South," *Harper's New Monthly Magazine* 6 (May 1853): 721-33.

42. Ibid., p. 732.

43. T. Addison Richards, *The Romance of the American Landscape* (New York: Leavitt and Allen, 1855), pp. 49, 113, 137, and 141.

44. John Francis McDermott, *The Lost Panoramas of the Mississippi* (Chicago: University of Chicago, 1958).

45. Henry Lewis, *Das Illustrirte Mississippithal . . .* (Dusseldorf: Arnz and Co., 1854 and 1858).

46. Andrew Reed and James Matheson, *A Narrative of the Visit to the American Churches,* 2 vols. (New York: Harper and Brothers, 1835), 1:167-69; see also Pamela H. Simpson, *So Beautiful an Arch: Images of the Natural Bridge 1787-1890* (Lexington: Washington and Lee University, 1982).

47. *The Natural Bridge of Virginia* (Natural Bridge, n.d.), pp. 14-45; see also Thomas Jefferson, *Notes on the State of Virginia,* ed., intro., and notes by William Peden (Chapel Hill: University of North Carolina Press, 1955), pp. 24-5 and 263-64, note 5.

48. Marquis François Jean de Chastellux, *Travels in North America*, 2 vols, ed. Howard C. Rice (Chapel Hill: University of North Carolina Press, 1963), 1:16; 2:viii, engravings between 446 and 447, 406 and 408, and 455 and 456.

49. John E. Semmes, *John H. B. Latrobe and His Times 1803-1891* (Baltimore: The Norman Remington Co., 1917), pp. 242, 248, 254, 258, 262, 308, 318.

50. North Carolina Museum of Art, *William C. A. Frerichs 1829-1905* (Raleigh: North Carolina Museum of Art, 1974).

51. Cecil D. Eby, Jr., *"Porte Crayon": The Life of David Hunter Strother* (Chapel Hill: University of North Carolina Press, 1960).

52. Budd H. Bishop, "Art in Tennessee: The Early 19th Century," *Tennessee Historical Quarterly* 29 (Winter 1970-71): 379-89; ibid., "Three Tennessee Painters," *Antiques* 100 (September 1971): 432-37.

53. William C. Campbell, *John Gadsby Chapman* (Washington, D.C.: National Gallery of Art 1962); Georgia S. Chamberlain, "John Gadsby Chapman, Painter of Virginia," *The Art Quarterly*, 24 (Winter 1961): 378-90.

54. Charles E. Fairman, *Art and Artists of the Capitol of the United States of America* (Washington, D.C.: U.S. Government Printing Office, 1927), p. 78.

55. For an engraving and paintings based on White's work, see Francis W. Biloteau, Mrs. Thomas J. Tobias, and E. Milby Burton, *Art in South Carolina 1670-1970* (Charleston: The South Carolina Tricentennial Commission, 1970), pp. 92-93; see also Rutledge, *Artists in Charleston*, p. 136.

56. Brig. Gen. P. Horry and M. L. Weems, *The Life of Gen. Francis Marion, A Celebrated Partisan Officer in the Revolutionary War Against the British and Tories in South Carolina and Georgia* (Philadelphia, 1845), pp. 153-56.

57. Hugh Honour, *The European Vision of America* (Cleveland: Cleveland Museum of Art, 1975), no. 299; J. Russell Harper, *Early Painters and Engravers in Canada* (Toronto: University of Toronto Press, 1970), p. 37.

58. E. Bénézit, ed., *Dictionnaire critique et documentaire des Peintres, Sculpteurs, Dessinateurs et Graveurs*, s.v. Sebron, Hippolyte.

59. Jean Jepson Page, "Francis Blackwell Mayer," *Antiques* 109 (February 1976): 316-23. I am grateful to Ms. Page for calling my attention to the painting *Jonathan, the Blacksmith* and for other information on Mayer.

60. Patricia Hills, *The Painters' America, Rural and Urban Life 1810-1910* (New York: Praeger, 1974), p. 59.

61. Eyre Crowe, *With Thackeray in America* (London: Cassell and Co., 1893), pp. 133-36.

62. The Museum of Art, Carnegie Institute in Pittsburgh, Yale University Art Gallery, and the Historic New Orleans Collection all have a painting or watercolor on this theme.

63. Gabriel P. Weisberg, *The Realist Tradition. French Painting and Drawing 1830-1900*, The Cleveland Museum of Art (Bloomington: Indiana University Press, 1980), pp. 1-3. Another painting of cotton picking, possibly earlier, was done by a French artist, Paul Dominick Philippoteux, who came to New Orleans after the French Revolution of 1848. See *Antiques* 45 (April 1944), p. 161 (advertisement of C. W. Lyon); present location of painting unknown.

64. *The Daily Times Delta* (New Orleans), April 22, 1960.

65. Patricia Hills, *Eastman Johnson* (New York: Clarkson N. Potter, Inc., in association with the Whitney Museum of Art, 1972), pp. 30-34; idem, *The Genre Painting of Eastman Johnson, The Sources and Development of His Style and Themes* (New York and London, 1977), pp. 55-60.

66. *The Crayon* (June 1859):191.

67. As quoted in Henry T. Tuckerman, *Book of the Artists* (New York: G. P. Putnam & Son, 1867), p. 470.

68. Hans Nathan, *Dan Emmett and the rise of early Negro minstrelsy* (Norman: University of Oklahoma Press, 1962), see esp. pp. 116-22 and 228-29. Nathan's book reproduces pictures of these cover illustrations.

69. Hills, *Eastman Johnson*, pp. 33, 38; Hills, *Genre Painting*, pp. 60-65.

70. Hills, *Eastman Johnson*, no. 39.

71. Lloyd Goodrich, *Winslow Homer* (New York: Macmillan, 1940), p. 20.

72. Mary Ann Calo, "Winslow Homer's Visits to Virginia During Reconstruction," *The American Art Journal* 12 (Winter 1980): 5-27; see also *The Portrayal of the Negro in American Painting* (Bowdoin, Maine: Bowdoin College Museum of Art, 1964), fig. 43. For Homer's Civil War illustrations, see Julian Grossman, *Echo of a Distant Drum, Winslow Homer and the Civil War* (New York: H. N. Abrams, 1974).

73. Elizabeth McCausland, *The Life and Work of Edward Lamson Henry* (Albany: New York State Museum Bulletin, number 339, 1945), pp. 29, 91, 156-57, and 163; also nos. 51, 57, and 84; *A Catalogue of the Collection of American Paintings in The Corcoran Gallery of Art*, 2 vols. (Washington, D.C.: Corcoran Gallery of Art, 1966) 1:143-44.

74. *Conrad Wise Chapman, 1842-1910* (Richmond: The Valentine Museum, 1962).

75. Emily J. Salmon, "The Burial of Latane, Symbol of the Lost Cause," *Virginia Cavalcade* (Winter 1979): 118-29. For the artist's career, see Ethelbert Nelson Ott, "William D. Washington, Artist of the Old South" (Master's thesis, University of Delaware, 1968).

76. In the introduction to John R. Thompson's poem, "The Burial of Latane," in an 1862 broadside. As reproduced in Salmon, "Burial," p. 124. This poem was first published in the *Southern Literary Messenger* 34 (July-August 1862): 475-76.

77. See for example, Katharine M. Jones, ed., *Heroines of Dixie: Spring of High Hopes* (St. Simons Island, Ga.: Mockingbird Books, second printing, 1979); and idem., *Heroines of Dixie: Winter of Desperation* (St. Simons Island, Ga.: Mockingbird Books, 1979).

78. *Bee* (New Orleans), 30 December 1862, p. 1, col. 3.

79. The painting is in a private collection in New Orleans and was painted in St. Louis in 1869. At least two engravings were published in 1873. Copies of these can be seen at the Confederate Museum in New Orleans. A second version was painted in 1871 for Louisiana State University in Baton Rouge. For a detailed study of this painting, I am grateful to Eva S. Lamothe for a paper submitted in a graduate seminar in American art.

80. Ernest Estercourt, "Letters from the South," *The Southern Magazine* 8 (April 1871):559.

81. Edward Morriss Davis III, *A Retrospective Exhibition of the Work of John Adams Elder 1833-1895* (Richmond: Virginia Museum of Fine Arts, 1947); and Margaret Coons, "A Portrait of His Times," *The Virginia Cavalcade* 16 (Spring 1967): 15-31. Elder's painting of *The Battle of the Crater* is owned by the Commonwealth Club in Richmond. The posthumous portrait of Jackson is in the Corcoran Gallery of Art.

82. Edward C. Carter II, John C. Van Horne, and Lee W. Formwalt, eds., *The Journals of Benjamin Henry Latrobe 1799-1820, From Philadelphia to New Orleans* (New Haven and London: Yale University Press, 1980), pp. xiv and 203-05.

83. Dena J. Epstein, *Sinful Tunes and Spirituals, Black Folk Music to the Civil War* (Urbana: University of Illinois Press, 1977), cites many recorded descriptions of black music.

84. T. Addison Richards, "The Rice Lands of the South," *Harpers* 17 (November 1859): 735.

85. The bibliography on Homer is vast. Among most relevant references are Mary Ann Calo, "Winslow Homer's Visits to Virginia During Construction," *American Art Journal* 12 (Winter 1980): 5-27; Michael Quick, "Homer in Virginia," *Los Angeles County Museum of Art Bulletin* 24 (1978): 61-81; Lloyd Goodrich, *Winslow Homer* (New York: Macmillan, 1944); and Gordon Hendricks, *The Life and Work of Winslow Homer* (New York: H.N. Abrams, 1979).

86. C. W. Knauff, "Winslow Homer," *Churchman* (July 23, 1898), as quoted in Calo, "Homer's Visits to Virginia," p. 20. For some of the confusion about the title, see her note 28, p. 19, and Hendricks, *Life and Work of Homer*, p. 104. For a description of somewhat similar festivities in Georgia, see Lester B. Shippee, *Bishop Whipple's Southern Diary, 1843-1844* (Minneapolis: University of Minnesota Press, 1937), pp. 48-51. There the slaves were given several days' holiday at Christmas, and on December 27 they staged a parade, with "flags flying." Since Homer's painting also shows a flag, something similar may have occurred there.

87. See also Joel Chandler Harris, introduction to *Poems of Irwin Russell* (New York: The Century Co., 1888), pp. 1-15. This volume was published after Russell's death. I am grateful to Alexander G. Gilliam, Jr., of the University of Virginia and to Ella-Prince Knox of the Virginia Museum for calling this poem to my attention.

88. Edward Warren, *A Doctor's Experience in Three Continents* (Baltimore, 1885), pp. 200-02. See also Maggie Lewis, "Somerset's untold history. Bringing a slave village to light," *The Christian Science Monitor*, 30 September 1982, p. B4. (I am grateful to Dr. Peter Wood for calling this article to my attention).

89. Since I had not seen this work at the time of writing, I am grateful to Kenneth Trapp of the Cincinnati Art Museum for discussing with me the color and other qualities of the painting.

90. "The Academy Exhibition," *The Art Journal* 41 (1879): 158-9.

91. M.E. Chevreul, *The Principles of Harmony and Contrast of Colors and Their Application to the Arts*, intro. by Faber Birren (1854; reprint ed., New York: Reinhold, 1967), p. 216.

92. David Tatham, "Winslow Homer's Library," *The American Art Journal* 9 (May 1977): 92-98.

93. Biographical data from curatorial files, Corcoran Gallery of Art, Washington, D.C. I am grateful to Lynne Berggren, Curatorial Intern, for supplying this material.

94. Richard Norris Brooke to Directors of the Corcoran Gallery, April 18, 1881, curatorial files, Corcoran Gallery of Art.

95. McLeod's curator's journal (March 8, 1881); curatorial files, Corcoran Gallery of Art.

96. Undated and unidentified clipping in curatorial files, Corcoran Gallery of Art. It is presumably 1931, as the critic, Stanley Olmsted, speaks of Brooke's death eleven years ago.

97. Curatorial files, National Museum of American Art.

98. Roulhac Toledano, *Richard Clague 1821-1873* (New Orleans: New Orleans Museum of Art, 1974), esp. pp. 13-32, cat. nos. 46 and 76.

99. *Commercial Bulletin* (New Orleans), 21 January 1871, p. 1, col. 4.

100. [L.Q.C.], "Marshall J. Smith, Jr., Artist," in May W. Mount, *Some Notables of New Orleans, Biographical and Descriptive Sketches of the Artists of New Orleans* (New Orleans, 1896), pp. 118-21; and *Louisiana Landscapes and Genre Paintings of the 19th Century* (Shreveport, La.: R. W. Norton Art Gallery, 1981), pp. 34-38, fig. no. 59.

101. C. Reynolds Brown, *Joseph Rusling Meeker, Images of the Mississippi Delta* (Montgomery: Montgomery Museum of Fine Arts, 1981); and *Louisiana Landscape and Genre*, pp. 25-8.

102. Mary Frances Williams, *Catalogue of the Collection of American Art at Randolph-Macon Woman's College* (Charlottesville: 1977), no. 68, p. 80; Groce and Wallace, *Dictionary of American Artists*, p. 228.

103. Groce and Wallace, *Dictionary of American Artists*, p. 438. Two paintings by Melrose of the Shenandoah Valley belong to the state of Virginia and are hanging in the Governor's Mansion in Richmond.

104. Arthur F. Jones and Bruce Weber, *The Kentucky Painter from the Frontier Era to the Great War* (Lexington: University of Kentucky Art Museum, 1981), pp. 41-42. The composition is very similar to one by Harvey Joiner, *Portrait of the Artist's Wife* of 1885, ibid., no. 61.

105. William H. Gerdts and Russell Burke, *American Still-Life Painting* (New York: Praeger, 1971), pp. 60 and 240, note 5-1.

106. Edward S. King and Marvin C. Ross, *Catalogue of the American Works of Art, The Walters Art Gallery* (Baltimore: Trustees of the Walters Art Gallery, 1956), p. 11, no. 37; and William R. Johnston, "American paintings in the Walters Art Gallery," *Antiques* 106 (November 1974): 853-61, pl. III.

107. She was from Montezuma, Georgia, and according to tradition she returned there in the summers, when she painted; she died in Montezuma in 1919. Information from owner, Dr. Robert Coggins.

108. Theodore E. Stebbins, Jr., *The Life and Works of Martin Johnson Heade* (New Haven: Yale University Press, 1975), p. 166-72 (hereafter cited as *Heade*).

109. Edward King, *The Great South, A Record of Journeys* (Hartford: American Publishing Company, 1875), preface, p. i.

110. Cecilia Steinfeldt, *The Onderdonks: A Family of Texas Painters* (San Antonio: San Antonio Museum Association, 1976), pp. 11-31 and 56.

111. Pauline E. Pinckney, *Painting in Texas, the Nineteenth Century* (Austin: University of Texas Press, 1967), pp. 74-138; James Patrick McGuire, *Iwonski in Texas, Painter and Citizen* (San Antonio: San Antonio Museum Association, 1976); and William W. Newcomb, Jr., *German Artist on the Texas Frontier, Friedrich Richard Petri* (Austin: University of Texas Press, 1978).

112. James Patrick McGuire, *Julius Stockfleth, Gulf Coast Marine and Landscape Painter* (San Antonio and Galveston: Trinity University Press and Rosenberg Library, 1976), no. 25, p. 68.

113. August P. Trovaioli and Roulhac B. Toledano, *William Aiken Walker, Southern Genre Painter* (Baton Rouge: Louisiana State University Press, 1972); they do not mention Walker's sojourn in Galveston. For information on this see Pinckney, *Painting in Texas*, p. 213, citing a listing in the Galveston Directory of 1876, and *Galveston Daily News*, October 1874, p. 4, col. 1. I am grateful to Lisa Darst of the Rosenberg Library, Galveston, for calling the latter two items to my attention.

114. King, *The Great South*, p. 377.

115. Elliott James Mackle, Jr., "The Eden of the South: Florida's Image in American Travel Literature and Painting 1865-1900" (doctoral dissertation, Emory University, 1977; Ann Arbor: University Microfilms International, 1980).

116. Marchal E. Landgren and Sharman Wallace McGurn, *The Late Landscapes of William Morris Hunt* (College Park, Md., and Albany, N.Y.: University of Maryland Art Gallery and Albany Institute of History and Art, 1976), pp. 32 and 70.

117. Thurman Wilkins, *Thomas Moran, Artist of the Mountains* (Norman: University of Oklahoma Press, 1966), esp. pp. 108-119.

118. Ibid., pp. 159 and 186.

119. Stebbins, *Heade*, 155-180.

120. Ibid., p. 163.

121. William Howe Downes, in *Dictionary of American Biography*, s.v. Oertel, Johannes Adam Simon; J. F. Oertel, *A Vision Realized, A Life Story of Rev. J. A. Oertel, D.D., Artist, Priest, Missionary* (Milwaukee: The Young Churchman Company, 1917); and T. Holmes, "Some Account of the Wild Horses of the Sea Islands of Virginia and Maryland," *Farmers' Register* 3 (November 1835): 417-19, as reprinted in Eugene L. Schwaab, *Travels in the Old South, Selected from Periodicals of the Times*, 2 vols. (Lexington, Ky.: 1973), 1:226-31.

122. Robert Hobbs, *Elliott Daingerfeld, Retrospective Exhibition* (Charlotte: The Mint Museum of Art, 1971).

ACKNOWLEDGEMENTS

A host of friends and acquaintances helped me in selecting the paintings and gathering information for this exhibition. Among the curators and museum staff members who took time from their busy schedules so that I might study collections in their charge are H. Parrott Bacot of the Anglo-American Museum at Louisiana State University, Jackson Blanton of the Federal Reserve Bank in Richmond, Elizabeth Childs of the Valentine Museum in Richmond, Willard Cooper of the Meadows Museum at Centenary College, William Cullison III of Tulane University, William Fageley of the New Orleans Museum of Art, Diane Gannaway of the Cheekwood Fine Arts Center, Phyllis Kathryn Guy of the Henry Morrison Flagler Museum, John Halatsky of the Lowe Art Museum at the University of Miami, John Burton Harter of the Louisiana State Museum, David B. Lawall of the University of Virginia Art Museum, Dr. John Palmer Leeper of the McNay Institute, Roseanne McCaffrey of the Historic New Orleans Collection, Betsy McKemie of the Museum of the Confederacy in Richmond, Nancy Mathews of Randolph-Macon College, Mrs. Julia Smith Martin of the Virginia Military Institute, Cecelia Steinfeldt of the San Antonio Museum Association, Bruce Weber of the University of Kentucky Art Museum (and now at the Norton in Palm Beach), and John Zehmer of the Valentine Museum. To each I am grateful. To the individuals and institutions named here, as well as others whose boards of trustees and directors helped to make possible the loans of individual paintings to the exhibition, I am equally grateful.

Private collectors and owners were generous in opening their doors to me so that I might study their paintings, and they often further helped by providing photographs for me. These include William Nathaniel Banks, Dr. and Mrs. Philip Brewer, Dr. Robert Coggins, Gordon Fraser, Judge John de Hardit, Mr. and Mrs. William Groves, Dr. and Mrs. A. Everette James, Victor Kirkpatrick, Dr. and Mrs. James Nelson, Mrs. J. Proddy Sessions, and Mr. and Mrs. Morgan Whitney.

Still others—curators, scholars, librarians, collectors, owners, and dealers—were generous in answering specific queries. It is not possible to name each and every person, but they know who they are, and I much appreciate their help and promptness in answering unexpected letters. Among these I wish especially to acknowledge the aid of several: Theodore E. Stebbins of the Museum of Fine Arts, Boston, shared with me his expertise on Martin Heade; William H. Truettner of the National Museum of American Art, on George Catlin; Jean Jepson Page, who gave advice about Francis Blackwell Mayer; and Mary Louise Tucker, on Jacques Amans. Robert W. Schlageter of the Cummer Gallery in Jacksonville answered more than one telephone call for help and advice. Steve Harvey has been generous in sharing his knowledge of painting in the South, lent me two rare books, and sent copies of other hard-to-find publications. Mrs. Waldo Jones, Katharine Farnham, and William N. Banks helped to sort out the confusion concerning the painting of Alexander Hamilton Stephens by G. P. A. Healy. Gérard Maurice Doyon introduced me to the work of Frank Buchser, though we were not able to include that artist in this exhibition. Lisa Darst of the Rosenberg Library supplied new documentation about William Aiken Walker in Galveston, and Lynne Berggren delved through the Corcoran's files for material about Richard Norris Brooke. Daniel W. Fagg, Jr., sent me information on Henry Byrd, another artist we were unable to include, and Swannee Bennett on several other artists who worked in Arkansas. Judith Oertel Singley, Bettie T. Cobb, May S. Stuntz, and Nancy C. Brown provided leads concerning Oertel. Mitchell D. Kahan and Kathleen Burck helped in locating paintings by Meeker. Ron Frantz and Kenneth Trapp examined paintings by Thomas Moran and Winslow Homer, respectively, in areas where they live. DeeDee Wigmore provided information and helped lead me to at least one painting; Jay Cantor provided several leads. John Winters and Jim Furr made valuable suggestions. John Joyce was an informal consultant on the history of music.

Judith Hernstadt, Bethany Lambdin, Sarah Bailey Luster, Rodris Roth, and Margaret Pace Wilson provided generous hospitality during several phases of my research travels, smoothing my way considerably.

Mary Shipman Andrews and her staff at the Bicentennial Inventory of American Art were ever helpful in making their invaluable files available to me. The staffs of the library at the National Museum of American Art and of the Archives of American Art, both in Washington, facilitated my research. Much of the research for writing this essay was done at the Howard-Tilton Library of Tulane University, and I wish to thank Philip Leinback and his staff for their help and encouragement—most especially those in Special Collections and in the Louisiana Collection.

Staff members of the Virginia Museum, and the group of curators and consultants, proved to be stimulating and ever-helpful colleagues. Wanda Corn, Susan Donaldson, William Seale, Peter Wood, and Benjamin Williams provided constructive suggestions and editorial comments, as did Carroll Mace, who read the essay in draft. My research for this study overlapped with that for my book, *The Art of the Old South*, so that there are still other curators, collectors, and institutions with whom I consulted earlier and who helped me in one way or another in enlarging my knowledge of painting in the South—they too I wish to thank.—*J.P.*

Figure 43. Francis Speight, Demolition of Avoca *(cat. no. 143).*

Toward a New South: The Regionalist Approach, 1900 to 1950

by Rick Stewart

During the first seventy years of the twentieth century, painting in the South can be said to have three rather distinct periods. The first, encompassing thirty years or so, involves a group of artists whose roots and training lay largely outside the South but whose later life and work in the region developed in a clearly defined pattern paralleling the quickening resurgence and self-definition of the South itself. Their work and their actions constitute the contribution of "pioneers" in the arts, in some respects no different from the activity of Southern painters in the late nineteenth century. The second period begins at about the time of the Depression and includes the period during, but not immediately following, the Second World War. For the South this was an extraordinarily rich period of discovery, exploration, and creative expression in all of the arts. While the considerable literary achievement of this period has been studied, the artistic has been virtually ignored. Although art never rose to the heights of literature, it nevertheless made an important and lasting contribution to regional and national culture. The final period, which comes after 1945, can be seen as one of consolidation and synthesis, a maturation of the Southern painter, an artist who knew his roots but who fashioned work that transcended them.

The painters represented in this section are Southern not because they were born of the soil but because they were "born" of its sensibility. These artists represent only a fraction of those who lived and worked in the South, and who contributed to the richest and most distinctive regional cultures that we as a nation possess. It is both revealing and rewarding to discover how the artistic and cultural legacies described in the previous sections became intertwined with modern forms of identity and expression, gradually molding the culture we know today.

VISIONS OF ORDER AND PROMISE

For many painters around the beginning of the century, the Southern landscape continued to be a predominant theme, as illustrated by William Posey Silva's *Georgia Pines at Sunset* (cat. no. 108; see page 99) and Elliott Daingerfield's *Carolina Sunlight* (cat. no. 113). Daingerfield was born in Harper's Ferry, West Virginia, in 1859 and was raised in Fayetteville, North Carolina. Like many other famous artists of his time, he left his native South to live and work in New York, first studying at the Art Students' League and later traveling to Europe to paint. But beginning in 1885 he regularly returned to the South of his youth, specifically the region in the Great Smoky Mountains around Blowing Rock, North Carolina, where he painted many landscapes of Grandfather Mountain and its environs. The barn depicted in *Carolina Sunlight* purportedly stood near Boone, a few miles north of Blowing Rock. The style of the painting reveals the

influence of George Inness. Daingerfield had met the older master in 1884 and soon after moved into an adjoining studio in New York. From Inness he learned the glazing technique of applying thin alternating layers of color and varnish to the canvas.[1]

Even though he was influenced by Inness, Daingerfield had a vision of nature that was particularly suited to Southern post-bellum aesthetics. For Daingerfield, as for many of the other artists to be examined in this section, the Southern landscape was at once inscrutable and providential. The view of nature in *Carolina Sunlight* begins as an evocation of the artist's own childhood in North Carolina but passes quickly to a higher "vision of order," to borrow a phrase from Richard Weaver, who articulated the concept in his seminal study of post-bellum thought (*Visions of Order: The Cultural Crisis of Our Time* [Baton Rouge: Louisiana State University Press, 1964]). A deeply religious and poetic artist, Daingerfield sought to combine a traditional Christian outlook on nature with the more mystical, imaginative, pantheistic view of a Symbolist. Nature in *Carolina Sunlight* thus becomes, in Weaver's words, "a refuge of sentiments and values." Weaver expressed the idea that the South, as a traditional Christian milieu, had the most potential of any region in the country for forging a positive link with modern culture.[2] What sets an artist like Daingerfield apart from his immediate predecessors was his apparent recognition of this concept. The "vision of order" conveyed in works like *Carolina Sunlight* is an attempt to reconcile what Weaver termed "the permanent moral reality" of the Southern landscape with the larger goals of the creative imagination. Daingerfield once defined art to a Kentucky audience as "the language of the spirit," an act, divinely inspired, of the perception of beauty. To him, the artist did not just paint nature but actually became nature in his work. Like so many Southern landscape artists of the period, he had an individual view that began with a highly developed sense of place, including the belief that the artist had to draw his material from his native area in order to achieve spiritual and artistic regeneration. The art that resulted was not superficial but was instead deeply felt. "The great truth remains," Daingerfield wrote in 1914, "that true art is personal."[3]

The foregoing qualities seem evident as well in Gilbert Gaul's painting of the Tennessee midlands, *Sunset Landscape* (cat. no. 105). Gaul was fast achieving notoriety as a widely-travelled painter of military subjects when he inherited a small farm in Van Buren

County, Tennessee, in 1881. He built a small studio there and began to paint the people and surrounding countryside, forging a bond with the locale that would last his lifetime. Intellectual historians of the South have written extensively of the powerful legacy of guilt that stained the Southern conscience after the Civil War. Gaul was one of those artists caught up in a desire to recall what to him had been the region's greatest glory. After moving more permanently to Nashville in 1904 in order to paint and teach, he began work on a portfolio titled *With the Confederate Colors*, which was eventually brought out in 1907 by the Southern Art Publishing Company. A projected second volume never materialized, and ill health soon forced him to sharply curtail his activities. A consistent preoccupation, however, had been painting the Tennessee countryside, and *Sunset Landscape* affords a sympathetic view of the rural South that he had come to adopt as a young, newly-married, and gifted artist.[4]

The idea of a "moral reality" in nature holds true as well for Alexander Drysdale's *Early Morning in a Louisiana Marsh* (cat. no. 111), painted in 1912. Drysdale was born in Marietta, Georgia, and, like Daingerfield, studied in New York at the Art Students' League with Charles Curran and Frank Vincent Dumond, two painters with strong Symbolist proclivities. After three years in New York, Drysdale returned south to New Orleans, where he painted mostly landscapes, particularly the mysterious and vaporous bayous of Barataria, Teche, Chef Menteur, and the Black River. He was fond of painting with kerosene-thinned paint, using almost a watercolor technique. He exhibited his work in the annual exhibitions of the Artists Association of New Orleans in the first part of this century. Drysdale referred to himself as an Impressionist who sacrificed "everything to atmosphere and color," but *Early Morning in a Louisiana Marsh* is far more meaningful as an evocation of the tonal moods inherent in the landscape paintings of the Symbolists. His work was described in his own time as having a "warm glow," a "soft gloom," or "faint shadows," things seen more in the mind than by the eye.[5]

Drysdale arrived in New Orleans from New York in 1903, at a time when economic panic was making times difficult for everyone, let alone a painter. Nevertheless, he made a living for himself because he shrewdly acted as his own agent. The New Orleans *Daily Picayune* described his method in 1913:

> He went to work to find out the names of people who were in the market. Did a wealthy woman build a new home? He telephoned her, asking permission to call and

exhibit a few of his canvases which, he thought, would look well on her walls. Did a bold cotton broker engineer a successful coup on the exchange? Mr. Drysdale was on hand to explain to him why he ought to invest a part of his winnings in a picture or two. The method worked surprisingly well.[6]

So well, in fact, that a small Drysdale painting of a Louisiana marsh hangs today in the corner of the drawing room in Theodore Roosevelt's summer home at Sagamore Hill, and nobody knows how it got there.

The newspaper also described his habits in his studio, which he referred to as his "workroom," where he could complete two paintings in a single day. Since his death in 1934, many people who live in the region have devalued his paintings because of their number and superficial sameness. He was sensitive to this criticism and took pains to point out that other noted American artists, like Robert Henri, John Singer Sargent, and William Merritt Chase, did the same thing. Like Daingerfield, Drysdale was greatly influenced by the work of George Inness, whom he termed "wonderful in his facility as well as in his genius." Drysdale was unconsciously describing his own work when he spoke of the older artist's "transitory effects of nature" that he "painted much from memory." For Drysdale as for Daingerfield, the labor of art lay mostly in the mind.[7]

At the same time, across the Mississippi, Julian Onderdonk was experiencing his own rediscovery of his local Texas surroundings in much the same way as Daingerfield and Drysdale had theirs. Born in San Antonio in 1882, the son of painter Robert Jenkins Onderdonk, he was encouraged to paint from a very early age. He studied at the Art Students' League with Kenyon Cox and later, more lastingly for his art, with William Merritt Chase at his summer school at Shinnecock, Long Island. He returned to Texas in 1908 and almost immediately became involved with the development of art in East Texas, particularly through his chairmanship of the art exhibition committees at the Dallas State Fair. His biographer, Cecilia Steinfeldt, relates how the young painter would spend much time in New York visiting galleries and museums in order to bring the best examples of painting to the area. "His selective judgement," she writes, "was instrumental in bringing to Texas paintings of quality that had a widespread and lasting influence on the local area."[8]

Similarly, his own paintings of the broad Texas landscape were attracting increasingly wide attention.

He began exhibiting regularly in San Antonio and also aided the San Antonio Art League with its projects. By 1922 Onderdonk was much in demand for his paintings, as well as his time; it seems incredible that he accomplished as much as he did, considering the number of local projects to which he allied himself. Tragically, he was not to realize his full potential as a painter, for he died suddenly in San Antonio in October 1922, at the age of forty. His last painting, *Dawn in the Hills* (fig. 44; cat. no. 116), was one of the works chosen as a memorial to him, to hang in the National Academy of Design in New York that same year. Onderdonk's friends mounted a drive to secure this painting permanently for San Antonio, which they were eventually able to do.[9] *Dawn in the Hills* is an eloquent example of Onderdonk's style, related as it is to similar evocations of the landscape by Daingerfield and Drysdale, although Onderdonk's work belies a stronger adherence to late Impressionist work—something he had doubtless learned through his study with Chase. *Dawn in the Hills*, like his other works, conveys a romantic sense of the Southern landscape derived from a realistic rendering of time and place. For these painters, the Southern wilderness, with its emotive expanses and evocative atmospheres, became a direct vehicle for a landscape of poetic, spiritual revelation.

During this period the artistic life of New Orleans was immeasurably enriched by the accomplishments of two brothers, William and Ellsworth Woodward. William, the older of the two, was born in Bristol County, Massachusetts, in 1859. He studied at the Rhode Island School of Design and the Massachusetts College of Art before journeying south in 1884 to begin teaching at the newly-established Tulane University. In 1887, after a year's study in Paris at the Académie Julian, he returned to New Orleans to help with the organization of Newcomb College, the coordinate college for women at Tulane, where he installed his younger brother Ellsworth as head of the new art department.[10] Ellsworth, who was two years younger, had also attended the Rhode Island School of Design, but instead of going to Paris he had gone to Munich to study with Carl Marr. After receiving the Newcomb College position, he held it for forty-one years, until his retirement in 1931. In 1907 William was instrumental in founding the Tulane School of Architecture, one of the pioneer schools of architecture in the South. He also formed the Louisiana Art Teachers Association, serving as its president. In addition, he revitalized the Artists Association of New Orleans and

Figure 44. Julian Onderdonk, Dawn in the Hills *(cat. no. 116).*

also became its president. Reading the comments of the Woodward brothers today, one notes the strong feelings they had of themselves as artistic pioneers and as tamers of a Southern cultural wilderness. For them the arrival of higher education linked with the fine arts was "the first important step towards reconstruction."[11]

The Woodwards found plenty of time to paint, even though they seemed to be involved in several careers at once. William's oil crayon study, the *Old Mattress Factory* (cat. no. 110) of 1904, reflects another facet of his remarkable range of interests: the historic architecture of New Orleans. In 1895 he had helped block a proposal to demolish the Spanish Cabildo on Jackson Square. As a part of this activity, he began to chronicle the architectural heritage of the city, including, with a true preservationist's eye, nondescript buildings that appeared to have no significance. *Old Mattress Factory* was done with oil crayons on the site, in order to capture the immediacy of an area he had come to call his own. He began to understand, in the words of his brother Ellsworth, "the qualities of a locality and [to] value them for what they are." In 1920 John Dewey would proclaim the same mission for art in his essay "Americanism and Localism," which was one of the first attempts to articulate the concept of "place" in art, a concept crucial to an understanding of painting in the South during this period.[12]

If William Woodward was active in the art and life of New Orleans and Louisiana, Ellsworth Woodward embraced the whole South with his missionary zeal. Like his brother he worked with local organizations, including the Delgado Museum of Art, where he served as both director and president of the board of trustees. But his principal claim to fame in the context of Southern painting must be his participation in the formation in 1921 of the Southern States Art League, which had its headquarters in New Orleans. Modeled after the American Federation of Arts, the League was founded "to encourage art and its appreciation in the South." Its method was to bring together artists and patrons from the region in annual conventions held in different states, and to sponsor annual exhibitions of Southern art that would be circulated to many towns and cities throughout the South.[13] Ellsworth Woodward was president of the League from 1923 until his death in 1939. The growth of the organization illustrates the growth in art interest and support throughout the South. A Secretary's Report for 1930 showed that the number of member institutions had grown six-fold, to 600, since the League's founding, and established the number of practicing artists in the South as 428. Woodward himself was a tireless supporter of the League and of the cause of Southern art. In his annual address to members in 1927, he stated:

> Do you realize that Southern artists do not attain distinction in the South? Or, knowing this, do you also know the reason for such a situation? . . . This League stands four-square in its wish and effort to bring back Southern artists now expatriated, and require of them to do for their homeland what the artist has always done for homelands possessed of a spirit of understanding.[14]

Woodward chastised those who purchased paintings from other locales. "You will be the sufferer because you have failed to understand that art must always begin at home."[15]

Woodward practiced this maxim in his own painting, which was as prolific as his brother's. A typical work is *Winter in Southern Louisiana* (cat. no. 112), which he painted in 1912. Towards the end of his life he made what he called "annual pilgrimages" to places where he could find "the incomparable trees and flowers." Paradoxically, he felt that he could not, in the end, capture the South's sense of place because he was not "Southerner-born." Of the artists who were, he asked: "What of the Southern land you know? What Southern artist has made a symbol of it?" But if his pictures did not always convey to some "those relations to the soil" that he thought so important, he did succeed in his vigorous efforts in other arenas to make that soil fertile for the growth of Southern culture.[16]

The establishment of Newcomb College in New Orleans finally gave Southern women the opportunity to excel in the arts. Although the overall role of women in the development of painting in the South has not been adequately recognized, it was nevertheless considerable. An indication of this can be seen in the careers of two Alabama painters, Clara Weaver Parrish and Anne Goldthwaite. Parrish, who was born in 1861 in Dallas County, went to New York in the 1880s to study at the Art Students' League under William Merritt Chase, Kenyon Cox, and Julian Alden Weir. In the early 1890s she achieved both a reputation as a pastelist and oil painter, and a position of influence in the Women's Art Club. Throughout this period she regularly returned to Alabama for visits. She had become involved in designing stained-glass windows for Tiffany and Company, and among her assignments were windows for churches in several

Alabama locales, including Uniontown, Tuscaloosa, and Selma. She is remembered as an artist who was continually active in her native state, lecturing to various groups on "the necessity of art museums" and "creating interest in the local town." She was determined to quit New York and return to Selma in order to found an art museum and an active studio; unfortunately, she died before that goal could be attained.[17]

Nevertheless, her example must have been instructive to a young art student from Montgomery, Alabama, who arrived in New York in 1898 to study at the National Academy of Design. Parrish's *Portrait of Anne Goldthwaite* (cat. no. 109) portrays the intensity and self-confidence of an artist who was destined to become influential to Southern painting. Born in 1869 in Montgomery, Goldthwaite had early focused on a career in art. After a brief period in New York, she went to Paris for further study; she became a member of the American Modernists, meeting Gertrude Stein and helping to organize the Académie Moderne, where Othon Friesz and Albert Marquet gave critiques and lectures. Returning to America, she exhibited one work in the Armory Show and became a friend of Katherine Dreier, future founder of the Société Anonyme, Inc. After setting up a studio in New York she began to spend summers in Montgomery, turning out numerous paintings of the Alabama locale. From 1922 until her death in 1944, she held a teaching post at the Art Students' League, and she became an ardent champion of women's rights. At her death she was hailed not only as one of the country's leading female painters but also as the leading painter of the South.[18]

Like other Southern painters, Goldthwaite drew her subject matter from her native region. *Springtime in Alabama* (cat. no. 127) is a good example of her spontaneous sketch-like style; she once remarked that the vitality of her initial conception would be lost if she carried her works any farther. Her subject matter was most often rural and small-town scenes in Alabama. As one historian wrote:

> From almost everything she drew or painted there emanates a breath of wit, not mere whimsy but a wiser sort of gaiety which looks with more tolerance into the hearts of her sitters. . . . She knew them all and delighted in them and much of her delicate humor in depicting them is actually a function of her pungent, insouciant, elusive way of painting.[19]

In 1934 Goldthwaite spoke on radio in support of women artists, saying, "We want to speak to eyes and ears wide open and without prejudice—[to] an audience that asks simply, 'Is it good?' Not, 'Was it done by a woman?' "[20] Despite Goldthwaite's pioneering example, however, few Southern women artists were as successful during this period, largely due to the conservative social climate. Kate Freeman Clark, born in Holly Springs, Mississippi, and a contemporary of Goldthwaite's, is a case in point. She managed to study very successfully in New York with Robert Henri and William Merritt Chase, and was on her way to achieving a notable career. But on the advice of her mother, who had gone to New York with her, she concealed her sex by signing her paintings "Freeman Clark." She never sold a work, even though she was given several "one-man" shows. After the death of her mother in 1923 she returned to Holly Springs and all but abandoned painting. At her own death in 1957 at age eighty-three, she bequeathed her art, which had been stored since 1923 in a warehouse in New York, to her unsuspecting community, along with enough funds to establish an art center named after her. One particularly fine landscape, *Summer Afternoon,* now at the Brooks Memorial Art Gallery in Memphis, calls to mind a comparison with the best of Chase's Shinnecock scenes; it is altogether unfortunate that she cut short her career.[21]

Consider also the example of Josephine Crawford, who lived and worked in New Orleans and was contemporary to the two women just mentioned. After studying art in New Orleans at the newly-established Arts and Crafts School, Crawford journeyed to Paris in 1927 and studied with André Lhôte. She became friends with some of the most important French painters of the period: Raoul Dufy, Albert Gleizes, Fernand Léger, Jean Metzinger, Francis Picabia, and Pablo Picasso. While in Paris she developed a hybrid modern style loosely based on the representational cubism of her teacher. Yet she was not happy, it appears. She wrote in her journal: "I feel very much discouraged—I am too old to learn and there is no use going back. . . ." When she returned to New Orleans the following year she began to paint local scenes in the style she had acquired abroad. *Throwing the Net, Biloxi,* now in the Historic New Orleans Collection, is a typical example of her better efforts. Being somewhat reticent, she could not have been very comfortable with the controversies, however minor, such an artistic style was sure to cause. Her life was spent relatively quietly, with no strong commitments to her work beyond personal satisfaction. Her modern style was not, in the end, fully accomplished or lastingly influential.[22]

Perhaps the best example of a gifted woman artist torn between her Southern background and a more progressive lifestyle was Zelda Sayre Fitzgerald, whose paintings reveal the legacy of shattered promise that marked the work of so many members of the "lost generation." Born in Montgomery at the turn of the century, she married Francis Scott Key Fitzgerald in 1920 and embarked on a fast-paced life that has since become legend. In between her husband's periods of writing, the two travelled often to Europe throughout the 1920s, becoming friends with many of the wealthy expatriates who swam listlessly in the sea of postwar life. It was in 1925, while on the island of Capri, that Zelda Fitzgerald first began to paint; it became a lifelong habit but was limited by her chronically weak eyesight, since she refused to wear glasses.

In time, the Fitzgeralds' turbulent relationship and lifestyle took its toll, and she suffered the first of several mental breakdowns in Europe in 1931. Returning to Montgomery after fifteen months of treatment, she attempted to assemble a career as a writer. Some of her stories were set in a Southern locale, around her complacent native city, which seemed to her little affected by the events of the Depression. She eventually published an autobiographical novel, *Save Me the Waltz,* in 1934; its heroine, Alabama Beggs, was a mirror-image of Fitzgerald herself. She had been painting as well during this period; Malcolm Cowley, who visited Fitzgerald in 1934 and saw her paintings, later recalled that they were better than he had expected. Scott Fitzgerald was interested enough in her paintings at this point to organize an exhibition of them in the same year at the Cary Ross Galleries in New York. Zelda took little part in this, protesting that her painting was too personal to her. Sadly, she suffered a severe mental relapse and was hospitalized. Although the exhibition was reviewed extensively in the press, it was in the context of her role as the "jazz-age priestess" and not as an artist. To her friends her work was too disturbing and emotional; she was too close to it, as she had been with her autobiographical novel. "The work of a brilliant introvert," *Time* intoned. "They were vividly painted, intensely rhythmic." As Zelda Fitzgerald's biographer, Nancy Milford, has so tellingly noted, the article read like an obituary.[23]

In December 1940 Scott Fitzgerald died; soon after, Zelda moved to Montgomery to be with her mother, and she continued to paint. In 1942 she exhibited her work at the Montgomery Museum of Fine Arts, where it was warmly received as a "tri-umph." One of the paintings from this period, titled *Circus* (cat. no. 138), indicates her continuing fascination with figures that appear to be trancelike, dancing. Their poses are reminiscent of the countless paper dolls she was in the habit of making for her only child, as is the predominant use of red in the composition. Fitzgerald was obviously influenced by the work of contemporary French artists like André Lhôte, Louis Marcoussis, and André Derain, and her figural style compares favorably with lesser American painters of the Jazz Age now forgotten. She continued to live the 1920s in her art, as well as her life, and it is comforting to know that her paintings received at least a measure of local encouragement before her tragic death in a hospital fire in 1948. Her work only partially indicates the titanic struggle that developed within herself between her structured Southern background as a female member of a respected family and the relentless, destructive pull of unrealized artistic talent.[24]

For the South, the spirit of the post-World War I period was characterized by an overriding theme: expansion. Urban and industrial growth surged ahead, causing one Alabama observer to maintain that the realtor had replaced the planter as a controlling factor in Southern life. For many, the South became a "new frontier" of great economic promise. "There is a thrill in the air," enthused one writer in *The New Republic.* "Big tomorrows seem to be coming around the corner."[25] Whether or not people believed this optimistic pronouncement, they did realize that the character of the South was changing. Old patterns were being broken as the area established more contact with other regions. The rigid system of social stratification was being challenged by industrial prosperity and expansion. The great migration of blacks from the rural areas of the South to the industrial North was underway; by 1930, 26.3 per cent of all Afro-Americans born in the Southeast were living elsewhere.[26]

In turn, high unemployment and low wages brought new industry to the South. In Birmingham, Alabama, for example, U.S. Steel had acquired the local steel mills and was expanding rapidly, with concomitant activity in the building of schools, hospitals, recreational facilities, and welfare centers. In 1921, when the Alabama artist Roderick MacKenzie painted *Mixers and Converters* (cat. no. 114), the Birmingham steel mills were pioneering in the development of the carefully planned industrial community in the South.[27]

MacKenzie, who was born in London in 1865,

came to Mobile, Alabama, with his parents in 1872. Trained at the School of the Museum of Fine Arts, Boston, and the Académie Julian and l'École des Beaux Arts in Paris, MacKenzie embarked on an intriguing and notable twenty-year career as a painter of subjects and scenery in British India. In 1913 he returned to Alabama to live and work for the rest of his life. Attracted to the burgeoning steel industry in Birmingham, he began a series of approximately forty large-scale pastels of the plants at Ensley and Westfield. Working swiftly on the site during the night shifts, MacKenzie depicted the dark and massive interiors as they were suddenly shot through with the blinding light of molten metal. Works like *Mixers and Converters* drew immediate praise from art critics and exponents of Southern industrialization. At the invitation of the American Iron and Steel Institute, MacKenzie was invited to exhibit his work at their spring meeting in New York in 1923. Two years later, when the famous Southern Exposition was held at the Grand Central Palace, his evocations of the South's growing industrial power again received wide acclaim.[28]

MacKenzie's interpretation of the Southern industrial scene was similar to Elliott Daingerfield's examination of nature: it embodied a vision of "moral reality," an attempt to reconcile the materialistic world with the spiritual one. For the individual, MacKenzie's steel mills were as dark and satanic as they were exciting; the romanticizing elements of bursting light and dramatic spaces could not completely hide the moral dilemma that the encroaching industrial age put before an artist whose training lay in the previous century. Nevertheless, like Daingerfield, MacKenzie recognized the changes, and he grappled with them in his work. His struggle to resolve the conflict between the materialistic values of a new age of expansion and the traditional spiritual values of the past was shared by most of the significant Southern painters of this period.

One of the interesting concerns of the artists we have examined thus far is the captivating lure of the South as a subject to be consciously explored in order to yield important truths. As Daingerfield implied in his comments about his own work, to rediscover the South was to rediscover the self. Many artists like Daingerfield did not come to this conclusion until they had spent much of their lives away from their native region, in search of the training and experience that would give them insight. To be sure, travel was necessary in order to gain a proper art education; the first concerted activity in art schools did not take place in the South until after the Depression. On the other hand, there were other artists, like Julian Onderdonk, who early on showed a preference for their own regions, presaging the general rise of art activities at the local level that characterized the 1930s.

Several artists in this period stand out as much or more for their actions on behalf of painting in the South than for their attempts as artists to delineate a Southern aesthetic. Gari Melchers did for Virginia what William and Ellsworth Woodward had done for the Mississippi Valley. Like them, Melchers was an outsider who adopted the South. Born in Detroit in 1860, the son of a well-to-do Westphalian sculptor who had immigrated to this country, he was sent by his father at the age of seventeen to the Royal Academy at Dusseldorf for formal academic training. In 1883 he moved to Paris to study at the École des Beaux Arts. Six years later he shared gold-medal honors with John Singer Sargent at the Exposition Universelle, and in 1893 he was selected as one of the artists to decorate a building at the World's Columbian Exposition in Chicago. Several important mural commissions followed, including projects for the Library of Congress, the Detroit Public Library, and the Missouri State House. Melchers's lasting reputation as a portrait painter was also established in this period when he was invited to paint many wealthy and powerful members of American society, including Theodore Roosevelt and William K. Vanderbilt.[29]

Melchers's relationship with the South actually began with his marriage in 1902 to Corinne Lawton Mackall, daughter of a well-known Savannah family and a painter in her own right. But it was strengthened in 1916 when they purchased Belmont, an eighteenth-century house on twenty acres in Stafford County, Virginia, on the Rappahannock River. For the remaining sixteen years of his life he would live there, gradually increasing his involvement with the development of art and art appreciation in his adopted state. Melchers also increasingly turned his attention to painting rural scenes in Stafford County, using a bright palette and a usually coarse impasto style, of which *The Hunters* (fig. 45; cat. no. 115), painted in the 1920s, is a typical example.[30]

Even though Melchers remained active in the art life of New York City, where he continued to keep a studio, he involved himself in art matters closer to home. Like William Woodward in New Orleans, he

Figure 45. Gari Melchers, The Hunters *(cat. no. 115).*

participated in the early efforts to preserve historic architecture, this time in Fredericksburg. From 1923 until his death he served as chairman of the federal commission to establish a National Gallery of Art. In addition, he was nominated to the Virginia Arts Commission, whose later deliberations led to the establishment of the Virginia Museum of Fine Arts in 1936. Fortuitously, Melchers had earlier painted a portrait of Judge John Barton Payne, who would bequeath his collection to the Commonwealth of Virginia, forming the nucleus of the new museum's holdings. In the brief time that he was on the Commission, Melchers oversaw the restoration of Jefferson's Virginia Capitol and aided in the redesigning of the seal of the Commonwealth. He died suddenly in 1932 and was mourned nationwide. Although he was clearly only just beginning his association with the art affairs of Virginia, he had already accomplished enough to make him a pioneer figure. Today his home, Belmont, which contains a collection of works by him and other American artists, is open to the public, having been deeded to the Commonwealth of Virginia at the death of his wife in 1955.[31]

In South Carolina, the work of Alice Ravenel Huger Smith brought about a similar resurgence in local awareness. Like Alexander Drysdale, Smith was deeply attracted to the landscape of the Ashley River country near her native Charleston. Although she received some instruction at the Carolina Art Association and from her friend Birge Harrison, who spent time painting in the area, she was primarily self-taught. She was attracted to the delicate sensuality of oriental painting, and by the early 1920s she had developed a watercolor style that was as fluid as it was assured. Her father, Daniel Elliott Huger Smith, was an avid local historian and naturalist, and the two worked on a number of projects, including illustrated accounts of early architecture in Charleston and a biography of the artist Charles Fraser. Her most famous works appear to have been the illustrations for an autobiographical reminiscence worked on by her father up until his death in 1932 titled A Carolina Rice Plantation of the Fifties; one watercolor, The Pinelands (cat. no. 129), is included in this exhibition.[32] The local flavor of this work, with its agreeably romantic vision, is consistent with the cultural events in the area at the time.

Charleston had witnessed the rise of the Poetry Society of South Carolina, which was dedicated to the revival of a Southern literary renaissance. It was led by DuBose Heyward and Hervey Allen, two poets whose work appeared in 1922 in an influential collection titled Carolina Chansons. Their poetry—and the whole Charleston movement, for that matter—was an overly conscious attempt to glorify the values of local life by means of a reliance on lyricism and tradition. Perhaps the same things can be said of Alice Ravenel Huger Smith's watercolors, which are venerated today for those very reasons. Apart from that, The Pinelands typifies the attitude of Southern painters toward a landscape of "moral reality" during this early modern period.[33]

The first period of artistic activity in the history of painting in the South drew to a close during the latter part of the decade, with the rise of a remarkable group of writers and artists devoted to the emergence of a new Southern aesthetic. The artists we have seen thus far were linked in their beliefs, going back to the postbellum period, that the South was isolated and unique unto itself—an embattled system of values and sentiments that had to cope with the forces of a revolutionary age. They were not prepared to come to grips with the modern forces of industrialism, technology, and urbanism that threatened to alter the region forever. Instead, there was a retreat to romanticism and nostalgia, with a concurrent refusal to consider the revolutionary changes in artistic style that were being absorbed farther north.[34]

All this began to change with the rise of two disparate groups of intellectuals whose eventual achievement was to usher in the period known as "the Southern renaissance." Both the Fugitive group in Nashville and the Double-Dealer circle in New Orleans placed the problem of the definition of a Southern aesthetic in the general context of the modern crisis of the individual in society that had been engendered by the First World War. Once again, writers and artists returned to the South of their heritage and incorporated it into their work. This time, however, they began to infuse the work with a larger historical meaning that carried it beyond provincial boundaries. In the first period, many artists seemed to have retreated into a dream world of the imagination, or of the past; now that outlook was to be balanced by an eye to the future. The myth of the "lost cause" was to give way to the promise of another New South, a community to come. The friction between these two poles marked the work of the most important artists in the South until the end of the Second World War.

PAINTING AND THE SOUTHERN RENAISSANCE

The Fugitive group surfaced at Vanderbilt University in the immediate post-war period, along with their poetry magazine, *The Fugitive*, which began publication in April 1922. The four major figures were the poets Donald Davidson, John Crowe Ransom, Allen Tate, and Robert Penn Warren. Concerning the group, Tate recalled:

> After the war the South again knew the world, but it had a memory of another war; with us, entering the world once more meant not the obliteration of the past, but a heightened consciousness of it.[35]

Yet the importance of the Fugitives lies in their cosmopolitan attitude toward creative expression. Their tendency toward nationalist sentiment was tempered by a respect for international modernism, especially for Tate. In fact, some of them at first resented the idea that they were regarded as Southern poets. In a letter to Davidson, Tate responded to Harriet Monroe's call in a special "Southern Number" of *Poetry* magazine for a "strongly localized indigenous art," saying that the Fugitives should strive not for superficial locality but for the creative interpretation of its values.[36] For the Southern artist, however, this was easier said than done. "Our culture is dissolving," Tate wrote to Donald Davidson in 1926, and indeed it seemed that the rich legacy of Southern thought was about to be obliterated by the changes of a new industrial age. Like the modern artist in general, the Fugitives struggled with the rift between reason and the imagination, between science and faith. They assumed the mantle of the modern sensibility but made it uniquely Southern as well. The artist's dilemma was addressed in a poem by John Crowe Ransom published in *The Fugitive* and titled "Antique Harvesters." It reads, in part:

> The treasure is full bronze
> Which you will garner for the Lady, and the moon
> Could tinge it no yellower than does this noon;
> But grey will quench it shortly—the field, men, stones.
> Pluck fast, dreamers; prove as you amble slowly
> Not less than men, not wholly.[37]

After the demise of the magazine in 1925, the Fugitives grew more rigid in their sectionalism, partially due to their perception of industrial expansion as villainy and partially due to a defensive attitude toward the South adopted after the sensational anti-Southern coverage of the Scopes trial in Dayton in 1925.

Davidson, always the Fugitive with the strongest sense of his Southern roots, wrote an essay for the *Saturday Review* in May 1926 titled "The Artist as Southerner." He felt that any artist who chose his materials exclusively from his surroundings was provincial, not innovative or modern, yet he recognized the peculiar clash between tradition and Modernism that marked the dilemma of the Southern artist. "We have in the South a dissociation of the artist from his environment," Davidson wrote.[38] He cited recent influential works of Southern fiction, like Ellen Glasgow's *Barren Ground* and DuBose Heyward's *Porgy*, as overt examples of local expression too argumentative in their sectionalist bias. Instead, he wrote, "the true autochthonous writer moves from the particular to the universal, and this process is not very common in Southern literature." However, he concluded with the following statement:

> Local pride may have its defects, but the impulse which leads the Southerner to give the traditional cheer when Dixie is played represents a capacity for emotion that deserves not to be stifled. And, if ever the time of realization arrives, to be Southern should mean much to any writer who has had the courage and endurance to remain in his own country and fight the battle out. For it may be his privilege to discover, in himself and in his art, something of the bold and incisive American character that Whitman celebrated in prophecy.[39]

One example of cultural maturity in expression that Davidson singled out was the magazine *The Double Dealer*, published in New Orleans from 1921 to 1926. Its editors wanted to be known as "rebuilders," to end the artistic backwardness that they, like the Fugitives, had perceived had been the South's lot since the Civil War. Thus they billed the *Double Dealer* as a "National Magazine from the South," determined to spark a cultural awareness. Besides the early work of the Fugitives, the magazine printed essays by the young William Faulkner, whose later work would most fulfill Davidson's prophecy. In matters of art, readers were treated to the latest material, from work by members of the circle of Alfred Stieglitz to the less well-received gestures of Dada. If there was one overriding theme to the magazine, it was the desire to somehow interweave the exciting discoveries of modernism into the fabric of a more nationalist expression.[40]

Other new Southern magazines picked up this theme. *The Reviewer* in Richmond strove, through more conservative and sectional means, to find and develop Southern authors. *The New South*, begun in

Figure 46. Thomas Hart Benton, Cotton Pickers, Georgia, *1928-29, oil and egg-tempera on canvas, 30 by 35¾ inches (76.2 by 90.8 cm). The Metropolitan Museum of Art, George A. Hearn Fund, 33.144.2.*

1927 in Chattanooga, turned matters in its first issue more expressly to art. In a spirited essay on "The South in American Art," a writer extolled the Southern artists who painted the local yet American scene. He issued a directive:

> We must build and maintain schools of art and museums of art wherein Southern talent may be educated and trained, and thereby interpret the spirit and traditions of the South, which can only be expressed by native artists. We must teach them that the new South is a splendid, vital part of America.[41]

Even though the optimistic economic picture was to change drastically for the South in a few years, his call for schools and museums was nevertheless to be heeded.

One painter whose work in the South paralleled the temper of the twenties was Thomas Hart Benton. Born in Neosho, Missouri, a small town on the fringe of the Ozarks, Benton studied at the Art Institute of Chicago and in Paris from 1908 to 1912. He was one of the members of the avant-garde circle of American painters who came under the spell of modern painting, and his work immediately after his return to America went in several intriguing directions, including color abstraction taken in part from the Synchromists and figural works derived from a careful study of Cézanne and Michelangelo. However, after a brief stint in the Navy in World War I, Benton reacquired an abiding interest in representational art based on the American experience, past and present. In preparation for a series of paintings dealing with this theme, he studied the work of Italian sixteenth-century artists like Tintoretto in order to gain more complete knowledge of perspective, chiaroscuro, and three-dimensional form. By the middle 1920s he was exhibiting studies and completed sections of his projected "American Historical Epic Series" and was publishing numerous essays on his particular theory of art, which involved a deepening nationalist attitude.[42]

Beginning in 1924 Benton began a series of wanderings that would take him to every section of the country, recording the ordinary existence of out-of-the-way people and places. In 1928 and 1929 he travelled extensively over the back roads of the Deep South, producing canvases like *Cotton Pickers, Georgia* (fig. 46). These paintings were exhibited at the Delphic Studios in New York in March 1930, and the experience gained from his travels and doing these works resulted in his two major New York mural programs of the early 1930s: the sequence of murals titled *America Today* at the New School for Social

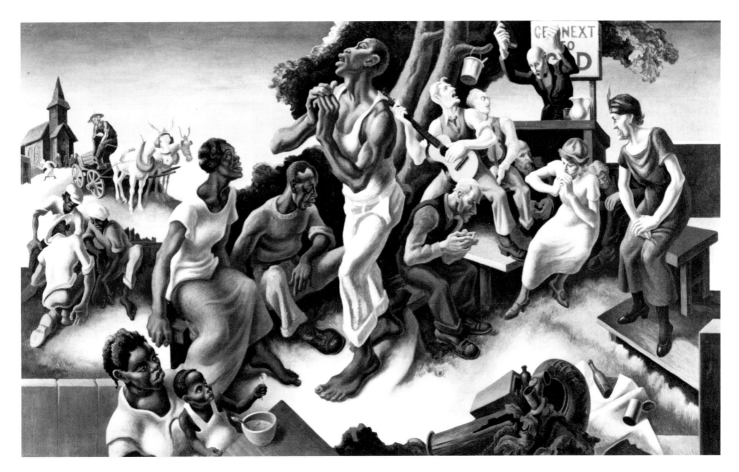

Figure 47. Thomas Hart Benton, Arts of the South, 1932, tempera with oil glaze, 96 by 156 inches (243.8 by 396.2 cm). The New Britain Museum of American Art, New Britain, Connecticut, H. R. Stanley Fund, 1953.20.

Research; and *The Arts of Life in America* series for the library of the Whitney Museum of American Art.[43] One of the panels from the *Arts of Life* series is illustrated here (fig. 47); entitled *The Arts of the South*, it shows evocative figures writhing under the competing influences of sin and redemption.

Cotton Pickers, Georgia indicates Benton's chief interest in this period in the South: the life of the rural black. He approached his travels throughout the region as a Northern liberal who was determined to portray Southern life accurately by making on-the-spot records. Benton recalled his impressions in an autobiography titled *An Artist in America*, published in 1937. Though largely a collection of character studies, the section on the South is notable for its overriding focus on Southern blacks and the problems they faced in a constricted, tradition-bound society. He vividly portrayed the scenes that he reacted to as a sympathetic outsider. Of the Georgia cotton fields at harvest, he wrote:

The green of the cotton plant leaves was slightly bronzed about the edges. The stalks stuck out with dry angular jagged turns. The pods were full, bursting with white fluff. The ground under the September sun was a bright gay pink color. It was cut and criss-crossed with narrow purple shadows from the cotton plants and the big shadows thrown from the bodies of the pickers. The field stretched out a long ways. A few feet from where I stood, the pink ground was lost in a spotted canopy, irridescent in the heat, of green, bronze, and fluffy white. Far away, beyond the field's end, a clump of tall dark pines stood out against the sky. . . . Standing by the overseer, a kindly pleasant Southerner, I was making drawings of the cotton pickers, men, women, and children, who, bending over the white-mouthed cotton pods, dragged their long canvas bags on the ground as they went deftly from plant to plant.[44]

The paintings that Benton produced on his trip through the South were prophetic of the kind of work many native Southern painters would turn to in the 1930s. Likewise, one of the dominating themes for

these artists would be the Southern Negro, living and working in an environment that was still 66.9 per cent rural in 1930.[45]

In contrast to the rather topical quality of Benton's work during this period is the more straightforward work of a painter like Edward Hopper. Although Hopper has always been associated with New England, particularly Cape Cod, he travelled almost as extensively as Benton in the 1920s and 1930s, producing a notable body of regionally-inspired work. *The Battery, Charleston, S.C.* (cat. no. 118), a watercolor painted in 1929, reflects that sensitive artist's visit to South Carolina in that year. Hopper, like so many artists before or since, found a ready subject in the Southern scene; but it was Thomas Hart Benton's example that would have the greater impact on Southern painting.[46]

If Benton's painting foreshadowed the work of the Southern regionalists, Conrad Albrizio's mural cycle for the Louisiana State Capitol building, completed in 1930, presaged the eventual rise of public commissions for Southern painters. Born in New York City in 1892, Albrizio studied at the Art Students' League in New York under George Luks. In 1936 he was appointed Professor of Art at Louisiana State University at Baton Rouge, a post he held until his retirement. Throughout his life he was a frequent spokesman for the development of art in his region, effectively continuing the work of Ellsworth and William Woodward.[47] The Louisiana Capitol was the brainchild of the flamboyant governor Huey P. Long, who personally selected the architectural firm of Weiss, Dreyfous, and Seiferth to design it. The notoriety of the building, however, rests upon the extensive art program within its walls. In the words of a recent historian of the building, the architects wished "to create a dramatic image of modernity and progress within an architectural tradition that was respectably conservative."[48]

Certainly the same thing can be said of Albrizio's murals for the governor's reception room. Unfortunately, the original work was destroyed in 1955, and we are forced to imagine their appearance from his studies for the four walls. The panel on the north wall (cat. no. 119) depicted antebellum plantation life in modern Louisiana, with references on either side to urban and agricultural life. The south wall (cat. no. 121), less allegorical and more documentary, showed the trucking of cotton and cutting of sugar cane, with a riverboat being loaded in the distance. The east wall (cat. no. 120) depicted antebellum plantation life in Louisiana, with all its mythical harmony and simplicity: a Greek Revival house in the background and

black workers picking cotton in the foreground. Finally, the west wall (cat. no. 122) was an interpretation of industrial Louisiana, featuring the exploration and development of an oil field, with a modern tanker anchored in the background. The original paintings were in the fresco technique, which Albrizio had learned during his studies in Europe. The imagery of the allegorical north wall was very much in keeping with the traditional mural practice of the day; however, the other three walls are more adventurous, since they were done from life. Albrizio's later work would be more in the manner of the Mexican muralist José Clemente Orozco, who had a very great influence on Benton as well, and at least a partial impact on other Southern artists who were called upon to do mural commissions.[49]

Albrizio's cycle was not the only one in the South in this period; Roderick MacKenzie completed four large panels in the domed central portion of the Alabama Statehouse that interpreted the history of the Commonwealth.[50] Beyond that, however, the work does show that artistic activity on this scale existed in the South independently of the New Deal programs to follow. The effects of the Depression on the South are well known and have been the result of intensive study; the South was particularly hard hit. Franklin Roosevelt, who had a demonstrated interest in the South, saw to it that the various programs of the New Deal turned much of their attention to particular relief needs. The Farm Security Administration (FSA) was directed toward the hardest-hit rural areas, including northeastern Arkansas, the Mississippi Delta, and much of Alabama. Further, it is estimated that between January 1933 and April 1939 the Social Service wings of the New Deal, which included the Federal Emergency Relief Administration (FERA), the Civil Works Administration (CWA), and the Works Progress Administration (WPA), poured nearly two billion dollars into the Southern states, providing large-scale relief and resulting in many wide-ranging physical improvements. The federal art programs had an equally direct and profound effect on painting activity in the South. One thing that happened rapidly was the emergence of an even greater sectional feeling with regard to the development of the arts. By encouraging a regional focus, the New Deal programs had the effect of turning Southern communities inward.[51]

In order to comprehend fully the nature of painting in the South during the 1930s, it is necessary to understand the Agrarian and Regionalist movement, which formed the backdrop for creative expression in

the period. The Agrarian philosophy, which grew out of the earlier Fugitive movement in Nashville, crystallized in the 1931 anthology titled *I'll Take My Stand*. If any unified idea could be gleaned from this miscellany of essays, it was a desire, in Allen Tate's words, for "getting back to the roots" of Southern experience.[52] The Agrarians posited a duality of agrarian and industrial society, with the latter viewed as a threat to Southern civilization. However, the Agrarian movement was far from simplistic; the arguments of the best writers were impassioned and stimulating. Donald Davidson, in his essay "A Mirror for Artists," addressed the problem of the artist in Southern society, writing that "the making of an industrial society will extinguish the meaning of the arts . . . by changing the conditions of life that have given art a meaning."[53] Davidson also explored the idea that the artist would be alienated in an indifferent society if his work was either eccentric and inward-looking or simplistically realisitic in its conveyance of unassimilated data. In order to reverse this trend, Davidson wrote, the Southern artist "must be a person first of all, even though for the time being he may become less of an artist. He must enter the common arena and become a citizen."[54] To the Southern painter, Davidson's article was a call to arms for the artist as activist, a call that was to be heeded in the course of the decade.

Seen in this context, the participation of an artist like Conrad Albrizio in a symposium in 1936 titled "The Arts in the Community" makes sense. Like Davidson, Albrizio argued for work that would "appraise the people of the community, their spirit, and their degree of culture." Albrizio praised the establishment of a federal art project at the local level in order to help raise the level of awareness of art in the community to enrich the lives of ordinary citizens.[55] Albrizio himself took these ideas to heart when he accepted extensive mural commissions in De Ridder, Louisiana (1938), Russellville, Alabama (1938), Shreveport (1939), and New Iberia (1940). In all these works, Albrizio sought an expression based on his perception of the "existing conditions" of his locality. While doing the New Iberia murals he told a local newspaper:

> The artist can do a great deal in helping the citizen decide what are the real values of everyday life in learning that the material things are not always the precious things, but that the beauty in simple things contributes much more to the general happiness. The artist's function comes in developing this discriminating ability.[56]

These were widespread sentiments in the art of the 1930s. Richard Coe, whose *Birmingham Steel Mill* (cat. no. 124) was executed in 1934, had an identical view of art in the South. Born in Selma, Alabama, in 1904, he studied first at the Grand Central Art School in New York under George Elmer Browne, then at the School of the Museum of Fine Arts, Boston, with Philip Leslie Hale. After two years of study in Europe, he returned to Birmingham in 1934 to head the Alabama section of the WPA. "The government is doing its best . . . to do art for the education and delight of the people," Coe told the *Birmingham News*. "American art for and by the American people is a slogan worth heeding."[57] Coe painted a series of murals for the State Library in Birmingham and, obviously inspired by Roderick MacKenzie's earlier example, embarked on a series of industrial paintings, including *Birmingham Steel Mill*, that attracted critical attention. Coe's interpretation of industry was more openly celebratory than MacKenzie's and was unencumbered by romantic sensibility. The vigorous handling of the paint underscores the vitality and optimism of the scene.

Coe's position as an influential artist in Alabama was more than matched by Kelly Fitzpatrick, who likewise sought to establish an art based on an understanding of his surroundings. Born in Kellyton, Alabama, in 1888, Fitzpatrick studied art at the University of Alabama, and after serving in France in World War I he returned there to study at the Académie Julian. Despite traveling occasionally to Europe to paint, Fitzpatrick involved himself almost exclusively with living and working in his native state. In 1930, in Montgomery, he helped establish the Alabama Art League, becoming its first president; soon after, the Montgomery Museum of Fine Arts and its art school were founded, with Fitzpatrick as Director. In 1933 he founded the Poka-Hutchi Art Colony on the banks of the Coosa River in Elmore County, which flourished during the summers until 1948, attracting some of the South's leading artists, among them Anne Goldthwaite. These are only a few of his achievements, and a few years later, by the time one of his paintings was selected by President and Mrs. Roosevelt for the White House, he was recognized as Alabama's leading artist.[58]

Negro Baptising (fig. 2; cat. no. 123), painted in 1931 in Fitzpatrick's characteristically vibrant palette, marked his intense preoccupation with the Southern black, an interest he shared with Thomas Hart Benton. Prior to one of the many lectures he gave in the

South in the early part of the decade, Benton had been asked by a member of the audience what the most important "cultural factor" was for the South as a whole. With typical directness, Benton answered "the Southern Negro," and added:

> In your childhood they taught you the language by which you express yourself, they made your songs, your jokes, and all else that will stand in your civilization as unique and characterful. They made your political theories, in that it was their peculiar position among you that was responsible for them. . . . Nearly everything you have can be traced to their influence except your architecture, and that is borrowed.[59]

The scene depicted in *Negro Baptising* is saved from being overly picturesque or sentimental by Fitzpatrick's forthright representation. Unlike any other region of the country, the South was experiencing an increase in evangelical Protestantism and church influence during this period, and it showed no signs of abating. Fitzpatrick's vivid account in *Negro Baptising* was only one of a great number of such scenes that he painted in the middle 1930s. "If anywhere in the world the Christian faith is still touched with the hand of God it is among the Southern Negroes of the back country who cling to traditional ways," Benton wrote in *An Artist in America*. "In the old-time services the shouts of the faithful, punctuating the hymns, are pure unmeditated cries to God."[60]

Interest in the rural people of the South in general was what motivated an artist like Howard Cook. Born in 1901, Cook had already achieved a reputation as an illustrator for several of New York's most important magazines, and in 1934 he received a Guggenheim fellowship to travel for two years throughout the South, much as Benton had done earlier. He desired, in his own words, to record "the Virginia and Alabama Negroes and their rituals, the poor whites and remote mountain people of the Cumberland Mountains, steel workers, miners, cattlemen, and the diverse activities connected with these rural workers."[61] This trip resulted in literally hundreds of field drawings, of which *Alabama Cotton Pickers* (cat. no. 125) is a more finished example. The style of these works, while revealing Cook's background as a printmaker, also indicated his eventual desire to use them as raw material for future mural projects, which he was to do. Cook's activity as an artistic explorer was typical of a whole generation of artists who seemed fascinated with what he termed "the essential character of representa-tive American individuals in a reflection of their own particular station in society and in relation to differing environmental influences."[62] Cook's work was typical, too, in that it sought to portray realistically, yet with some dignity, the life of the common man. This was a hallmark of Regionalist painting in the period. In 1937 Cook was awarded a PWAP mural commission in San Antonio, and he later began teaching at the University of Texas.

In many respects, the concerns of these artists mirrored those of Regionalist thinkers like Howard Odum of the University of North Carolina at Chapel Hill who steered the old Southern sectionalism into a constructive investigation of the local level as a part of a larger national picture. For Odum, the Agrarian opposition to an industrial outlook was in fact an interweaving of those worlds into the story of the New South.[63] Surely one of the most important manifestations of this philosophy was the publication at Chapel Hill, in 1934, of a large volume titled *Culture in the South*, edited by W.T. Couch. Thirty-one sections of the book, each by a different author, reported on the state of the subject in question in the South of that time. Unfortunately, the section on fine arts was marred by a lack of knowledge of the kind of activity that had been going on, for example, in Alabama. Nevertheless, *Culture in the South* was an exhaustive attempt to summarize recent trends in order to ask scientifically whether the South possessed any distinct cultural identity. The answer seemed to be in the affirmative.[64]

During the mid 1930s a young painter from Georgia named Lamar Dodd was working in Birmingham in an art supply store and painting at night. Born in 1909 in Fairburn, Georgia, Dodd studied intermittently at the Art Students' League with Charles Bridgeman, Boardman Robinson, Jean Charlot, and John Steuart Curry. By the time he arrived in Birmingham, he had already had one-man exhibitions in New York and Atlanta. *The Railroad Cut* (cat. no. 128), painted in 1936, won a major award for him at the annual exhibition of the Art Institute of Chicago, and it went on to be exhibited at the Whitney Museum of American Art the following year. The scene, according to the artist, is a slag dump outside Wylan, Alabama, where he produced a number of works that captured, in his words, "the mood of the place."[65] The same year Dodd was appointed to the art faculty of the University of Georgia at Athens, a post he held until his retirement. In the interim he gained a reputation as

the outstanding artist in Georgia, and he was active in many educational, civic, and professional groups, including the Association of Georgia Artists and the Southeastern Arts Association. His painting continued to develop along thematic lines established during his early days in Birmingham, even after he delved more deeply into abstraction.[66]

In the context of Dodd's career, it should be mentioned that one of the by-products of this period was scrutiny into the shortcomings of the Southern educational system. This self-criticism resulted in the Southern University Conference, which was dedicated to elevating areas of study at the university level and improving the overall quality of higher education. One of the end products of the Conference's extensive activity was the immeasurable strengthening of some colleges as cultural centers. An artist such as Lamar Dodd, aided in part by this climate of educational progress, was able to found a large and important center for art at the University of Georgia.[67]

Activity was under way in Mississippi, as well. The Mississippi Art Association, founded in 1911, was followed in 1926 by the Gulf Coast Art Association of Biloxi, with William Woodward as president. Individual painters in Mississippi, while not as numerous as in the neighboring states of Alabama and Louisiana, nevertheless mirrored similar social concerns in their work, as in Marie Hull's 1938 painting *Sharecroppers* (cat. no. 131). Born in 1890 in Summit, Mississippi, Hull studied at the Pennsylvania Academy of the Fine Arts under Virginia-born Hugh Breckenridge. She returned to her native state to teach art at Hillman College but left again to study at the Art Students' League with Frank Vincent Dumond and Robert Vonnoh—a further example of how prevalent League teaching was in the lives of Southern painters in this period; it had the effect of exposing them to a range of works and a wide variety of methods.

True to form, Hull studied in Europe before returning to Mississippi, where she painted portraits and studies of the dispossessed sharecroppers and tenant farmers, both white and black, of the Mississippi Delta.[68] By the time Hull painted *Sharecroppers*, it was estimated that one out of every four Southerners lived in a tenant family with virtually no capital. Devastated by the fall of cotton prices, inhabitants of the rural South struggled for simple subsistence. Hull recalled that she had no trouble getting her subjects to model for small sums of money. Farm incomes had fallen to thirty-nine percent of their 1929 level, and it is estimated that on one day in April of 1932 a fourth of all the land in Mississippi went under the auctioneer's hammer in forced sales of farmland.[69] Yet Marie Hull's painting depicts dignity, not defeat. A newspaper account of her work noted that she had caught the farmer's "clear sharp eye and the indomitable spirit of a man who has known the sun and rain and seasons of hard work; slightly stooped by his toiling decades but strengthened rather than broken by them."[70]

The Mississippi artist who gained greatest recognition in the 1930s was John McCrady, whose painting of an Oxford political rally (cat. no. 126) was completed in 1935. McCrady was born in Canton, Mississippi, the son of a clergyman who later became the dean of the philosophy department at the University of Mississippi at Oxford. McCrady attended the university but left early to study first at the New Orleans Art School, then at the Art Students' League with Kenneth Hayes Miller. Returning to Oxford in the summer of 1934, he painted works like *Political Rally* which to him captured the essence of his own region. In an article in *Life* magazine in 1937, he recalled how he had been dissatisfied with his work at the League because he felt out of touch with his homeland.[71] Soon after his Oxford sojourn, he set up a studio in New Orleans, where he achieved a national reputation as a regionalist while completing work for the WPA. In 1938 he was instrumental in the establishment in New Orleans of an association of artists called A New Southern Group. The following year, he and Robert Penn Warren were awarded Guggenheim Fellowships; McCrady's intent was to paint a series of works on "The Life and Faith of the Southern Negro." In the same year, *Life* commissioned him to do a painting in their "Series of Dramatic Scenes in 20th Century American History . . . by America's Foremost Contemporary Artists." McCrady chose to paint *The Shooting of Huey Long*, which became one of his most famous works.[72]

McCrady's interest in Southern politics is evident in *Political Rally*, which was painted the year that Long was assassinated. He later recalled the feelings of inspiration he felt in the Oxford Square on a hot summer's day. "The spirit of days and people were embodied in these things," he wrote.[73] The scene was a "bottom-rail" political rally for Senator Theodore "The Man" Bilbo, the "pride of Poplarville" and a demagogic politician in the mold of Huey Long. The dogs and children rhythmically circle the tightly-packed crowd of bewildered onlookers, who are por-

Figure 48. Alexandre Hogue, Drouth-Stricken Area, 1934, oil on canvas, 30 by 42¼ inches (76.2 by 107.3 cm). The Dallas Museum of Fine Arts, Dallas Art Association Purchase, 1945.6.

trayed with the grim humor of an Erskine Caldwell novel. To the right, a small group of onlookers seem to be as interested in the scene itself as in the speech. The figure in the foreground, at least, is easily recognizable. "Bill Faulkner was in this crowd and it was easy to paint his image," McCrady recalled. "Tweeds, pipe, little of stature, and everybody who ever saw him walk among the checkerboard players on the 'square' remembers the way he wore his hat."[74] Indeed, looking at the diminutive figure in McCrady's painting today, one can very well imagine the writer metamorphosing the scene in Oxford, Lafayette County, to Jefferson, Yoknapatawpha County, as he had been doing in a fabulous burst of creative energy over the preceding five years.

Further west, in Arkansas and Texas, the activity started by pioneers like Julian Onderdonk bore fruit in the work of Alexandre Hogue and Everett Spruce. Hogue, who was born in Memphis, Missouri, in 1898, spent a brief period of study at the Minneapolis Art Institute and with Ernest Blumenschein in Taos before settling in Dallas to work as a painter, teacher, and art critic. By the early 1930s Hogue was an effective spokesman for the development of regional art. All great artists, Hogue wrote in the *Art Digest* in 1933, derived their art from local sources. "It is because their work transcends the colloquial and becomes universal in its appeal that they have won their place," Hogue wrote, "not because they set out first to become universal."[75] Thus Hogue's paintings of the Texas landscape, like *Drouth Stricken Area* (fig. 48), painted in the same year, spoke of their time and place. The destructive cycle of dry weather, which had begun three years earlier, was transforming the fertile land of East Texas into a lifeless hell. Many witnessed the black cloud of dust that blotted out the sun like a vast shroud, and Hogue became noted for his stark portrayals of the great American desert. It is sometimes forgotten that this severe drought was felt east of the Mississippi, especially in the lower delta. Hogue's painting portrayed the plight of the whole region. "The nearness of the American scene requires of the artist a clarity of conception that is not conducive to misty critical discussions of false values," the artist wrote in 1936.[76] In the best Regionalist manner, he went on to compare contemporary American painting with the art of early Italian Renaissance; both, he said, produced "straightforward records" of a people and a place, and he concluded that the regional painter was at the forefront of a new appreciation of art.

Hogue's view was shared by his colleagues in Texas. Richard Foster Howard, director of the newly-established Dallas Art Museum, seemed to reject the kind of painting that had been done by artists like Julian Onderdonk, when he wrote:

> The use of local material has more excuse and greater length of tradition behind it here than in most places. Even the older men painted the local scene. In fact, they came here for that purpose. It failed to excite the same furor merely because they brought their academic tradition with them and bathed the plains and mountains in a romanticism which hid the reality. The difference in the younger men is one of technical and intellectual approach. . . . Acceptance of facts and adaptation to them is the scientific trend which has encouraged painters as well as other members of the community to look at their own locality, and make the best of it.[77]

Howard's view thus underscores the differences that existed between the artists of the post-bellum period and those, like Hogue, who seemed to belong to the forefront of a new renaissance in Southern painting.

Another artist who was part of this resurgence was Everett Spruce, a younger contemporary of Hogue's who hailed from Faulkner County, Arkansas, and who was the assistant director of the Dallas Art Museum. His 1938 painting *Arkansas Landscape* (cat. no. 132) reflected the ideas of a group of painters who billed themselves as "The Nine." Other members of the group included Jerry Bywaters, Otis Dozier, Lloyd Goff, and William Lester. These artists sought to move beyond a merely local art to one of "experimentation and ideas."[78] Spruce was one of the early members of a generation of Southern painters who were trained in the region and who adopted a style that many contemporary writers viewed as primitive and folklike due to its severe and stylized forms. The work of such painters was viewed to advantage, since regionalist studies like Couch's *Culture in the South* had shown that an understanding of folklore and folklife was one of the clearest paths to the establishment of a cultural identity.[79]

Clearly, the regional movement had an overriding effect on the painting of the South in this period, and just as clearly, regionalism to them was less a matter of blind nativism than cultural growth. Throughout the Depression era, as has been mentioned, white Southern painters often felt compelled to portray the Southern black as a way of coming to grips with the reality of their own environment. In a similar way, the decade of the 1930s witnessed the expanding struggles of the Afro-American artist's

search for his own roots—roots far deeper and harder to trace. This exhibition contains the work of two seminal black artists who seem to have found their own expression but who arrived at it through very different means.

As early as 1921, W.E.B. DuBois, writing in *The Crisis*, had maintained that "the transforming hand and seeing eye of the artist, white or black," was needed to help in the struggle for African-American identity.[80] Alain Locke's *The New Negro*, published in 1925, began to spur interest in African-American folklore and art as a method of turning social disillusionment to race pride. DuBois mapped a strategy for this in an important essay titled "Criteria for Negro Art," which appeared in *The Crisis* in 1926. DuBois urged his audience to recognize black artists who were attempting to express themselves, because it was a sign of interracial progress. He continued:

> I do not doubt that the ultimate art coming from black folk is going to be just as beautiful, and beautiful largely in the same ways, as the art that comes from white folk, or yellow, or red; but the point today is that until the art of the black folk compels recognition, they will not be rated as human. And when through art they compel recognition, then let the world discover if it will, that their art is as new as it is old and old as new.[81]

The rejuvenation of racial pride mirrored in the art and literature of the "Harlem Renaissance" marked a decade of emergence for the four major black colleges of the South: Fisk University in Nashville, Howard University in Washington, D.C., Atlanta University in Atlanta, and Dillard University in New Orleans. In 1931 Locke, then professor of philosophy at Howard, published an article in the *American Magazine of Art* titled "The American Negro as Artist"; in it he surveyed the work of the major African-American artists of the period, many of whom had come from the South. Locke was convinced that these artists were attempting to rediscover the link between themselves and their African heritage, lost by a century of slavery; "for in his latest developments in formal fine art, the Negro artist is really trying to recapture ancestral gifts and reinstate lost arts and skill."[82] Locke had warm words of praise for a younger generation of artists who aimed to express in their art the "race spirit and background as well as the individual skill and temperament of the artist."[83] He realized that the new freedom and dignity being attained in the arts was the beneficial result of paying more attention to African-American life in the contemporary world. Locke listed three

categories of contemporary African-American expression, beginning with the "traditionalists." These older painters, like Edwin Harleston of Charleston, South Carolina, were valuable chiefly because they documented "Southern Negro peasant types in a competent way" and because they made lasting records.[84]

Locke felt that the romanticism inherent in the traditional group served as a foil for the artists of his second category, whom he described as "modernists." These painters aimed at what Locke called a "hard realism" that verged at times on a "grotesque" style influenced by their racial background. The leading artist in this category, Locke said, was William H. Johnson, who was then just beginning his remarkable career. Born in Florence, South Carolina, in 1901, Johnson had gone to New York and worked at menial jobs until he could afford art school. His considerable talent gained him admission to the Art Students' League as a full student in 1922. He studied with Charles W. Hawthorne and George Luks in Provincetown and New York, working part-time for the latter in return for art instruction. Largely through the efforts of Hawthorne, who recognized his talent, Johnson managed to go to Paris to study. In 1930 he was awarded the William E. Harmon Foundation Prize for Distinguished Achievement Among Negroes, and he exhibited his paintings to wide acclaim. In the same year, however, he was arrested in his native city as a "vagrant" while painting at a local street corner; his bitterness at this incident caused him to return to Europe to live and paint for eight years.[85] It was neither the first nor the last time that an African-American artist had sought refuge abroad.

In 1938 Johnson returned to New York and immediately went to work for the WPA; he also taught at the Harlem Community Center. His painting style of this period, epitomized in *Chain Gang* (fig. 49; cat. no. 135), was derived from his knowledge of expressionist art but was strengthened by his own powerful emotions. The subject matter, which typically dealt with his life as a Southern black, seems as raw and vigorous as the blues lament "Chain Gang Trouble":[86]

How long,	I rise
How long,	With the blues
How long,	And I wake
How long,	With the blues;
How long,	Nothing I
Oh how	Can't get
Can I go on?	But bad news.

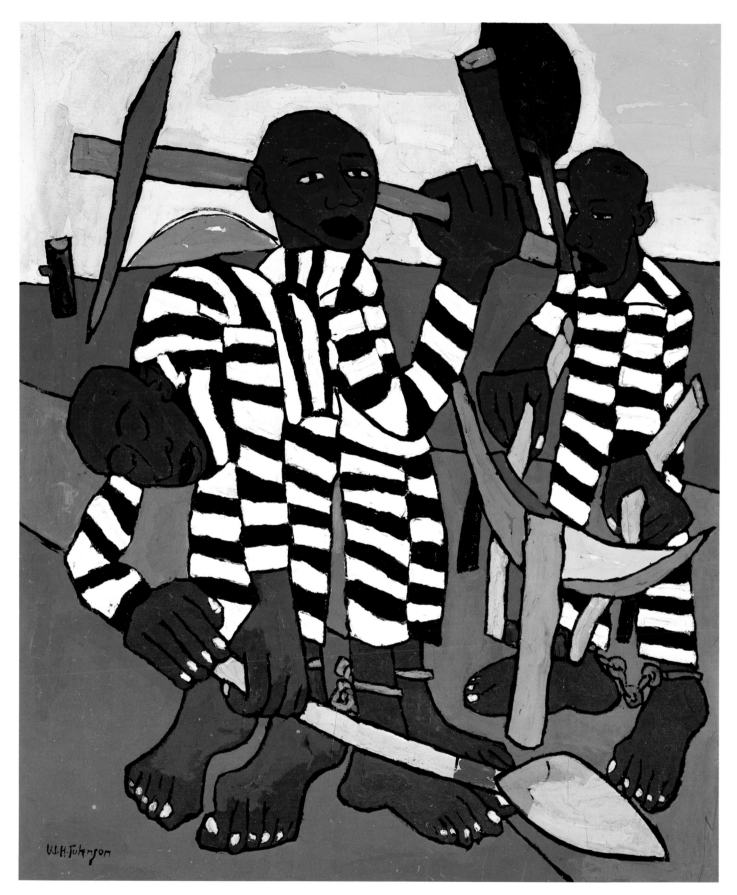

Figure 49. William H. Johnson, Chain Gang (cat. no. 135).

Some of Johnson's paintings were exhibited at the New York World's Fair in 1939. His subsequent life, however, was marked by personal confusion and considerable wandering. His genius was not to be recognized in his lifetime except by sensitive members of his own race.[87]

If he had written his survey of African-American art a few years later, Alain Locke could have placed Johnson in his third category, which he labeled "Africanists or neo-primitives." These artists, Locke felt, reached into the forms of the African past to create their work, often adapting direct expressionist styles. For Locke, the pioneer of this "Africanist" style was Aaron Douglas, a young artist who had just completed a series of murals in the library of Fisk University.[88] Born in Kansas in 1898, Douglas moved to New York to enroll in the Winold Reiss Art School. Reiss was an influential teacher, well-known for his deep interest in folk and primitive art. Douglas immediately began to evolve a planar, semi-abstract style that combined recognizable African motifs with the subject matter of racial aspiration. He became a major figure in the Harlem Renaissance, beginning with the publication of six of his drawings in Locke's pioneering study of *The New Negro*. He also designed cover jackets and plates for many books by the leading writers of the movement; his illustrations for James Weldon Johnson's *God's Trombones* became the most famous. Johnson's poems were sermons from his Savannah background set to meter; Douglas, in a similar way, set his visions in the rhythm of jazz. His mural series at Fisk, executed with the help of Edwin Harleston, evokes the course of "Negro history" from ancient Africa through the trans-Atlantic experience into the present day. The title of one of his works, *Build Thee More Stately Mansions*, illustrates the social direction of his art at the time.[89]

Douglas's association with Fisk was not to end with this mural commission. In the mid 1930s Johnson went there to teach creative writing, and in 1937 Douglas became the first instructor of art, beginning a lifelong association with the university. As David Driskell has written:

> Here began an association between Douglas and the younger energetic socialist, Charles S. Johnson, who later became the President of Fisk University. Douglas, founder of the Department of Art at Fisk, was then the only art teacher. He continued a healthy association with poets, writers, and musicians whom he had known in Harlem and was able to influence many of his friends to visit Fisk when they were on tours in the South.[90]

Douglas's painting *Go Down, Death* (cat. no. 117), typifies the unique style he brought to Fisk. In such works, he later recalled, he wanted to "place himself where the people are" through stylization and interpretation that would parallel the visual and emotional eloquence of a spiritual. He told an interviewer late in his life: "I had to try to think about how a person with a piece of paper, which they didn't have, a brush, a pencil, which they didn't have, paint, which they didn't have, how would he go about setting this thing down?"[91] Douglas attempted to answer that question for generations of young artists. His importance for the development of black art consciousness in the South cannot be overemphasized.

A number of younger Southern painters, although white, were interested in the sympathetic portrayal of the Afro-American along the lines suggested by Aaron Douglas, and were committed to change during this regional period. One such artist was Charles Shannon, who was born and raised in Montgomery, Alabama. After four years of study at the Cleveland School of Art, he returned to Alabama in 1935. He built a log cabin in Butler County and proceeded to paint a number of expressionistic works of Southern blacks; *The Lover* (cat. no. 130), completed in 1937, is a typical example. Shannon exhibited these works at the Jacques Seligmann Galleries in May 1938. In the flyer for the exhibition, the artist wrote:

> I began to feel what this country down here really meant to me. I worked with the Negroes in building my cabin for two months—cutting down trees (Comet on the other end of a crosscut saw singing to its rhythm): snaking them with mules to the site of the cabin—building it. I went to their churches with them, to their dances and drank with them—I saw expressions of primitive souls. I came to love this land—the plants and people that grew from it.[92]

The Lover carries a similar kind of humanistic concern, which is conveyed by an articulate sense of form. "In those days I felt that most painting being done was illustration and not plastically expressive," he recalled in a recent letter. "My attempt was to make the whole of the color and rhythm work with the figure-landscape image to make the expression."[93] In this he was not far removed from Douglas's goals. Following a successful New York showing, Shannon received a Julius Rosenwald Fellowship "for Southerners who are working on problems distinctive to the South." He used the income to finance his continuing work in Butler County.[94]

In 1939 Shannon and a group of friends organized a cooperative venture in Montgomery that they called New South. "We secured a downtown building space, a third floor that had originally been cotton sampling rooms," Shannon recalled. "There were skylights and lots of windows and, though dilapidated, it was beautiful."[95] New South was designed to enrich the cultural life of the area by gathering together artists and artisans to work in a gallery and a theater, and to teach workshops and classes in all the arts. One of the exhibitions, for example, featured the work of Bill Traylor, an 85-year-old former slave who produced abstractions on cardboard similar to African rock paintings. Shannon praised his work at the time for its African roots, calling it some of the most significant work yet produced by a native African-American artist.[96] In 1981 a major exhibition of Southern African-American folk art organized by the Corcoran Gallery in Washington, D.C., drew wide acclaim; Traylor's work, which many people saw for the first time, became the center of discussion and praise. Such attention could not have been possible without the pioneering efforts of Charles Shannon and the New South Gallery more than forty years earlier.

There were still many artists in this period who, like Benton, visited the South to gain a firsthand impression. Alexander Brook's painting *Georgia Jungle* (cat. no. 133), exhibited at the Carnegie International in 1939, won first prize and was widely reproduced. Brook was a member of the initial Whitney Studio Club group and later lived and worked in Woodstock, New York. During the Depression he retained his popularity as a painter and enjoyed enough sales to keep him comfortable. In 1938 he moved to Savannah and rented a studio and apartment overlooking the Savannah River. Soon he discovered a district west of the city called the Yamacraw, named for the area's original Indian inhabitants, where poor blacks lived. His unpublished autobiography mentions that he spent almost all his free time there in a bar called the Silver Tavern.[97] *Georgia Jungle* likely depicts part of that district, a settlement on a dump heap where, in the words of a *Life* magazine correspondent, "shacks, fences, outhouses are built entirely out of metal scraps and the earth itself looks like rusty iron." Brook stated more simply, "I was appalled by the poverty."[98] The December 1939 issue of *Art News* named Alexander Brook's *Georgia Jungle* "the most important American painting acquired by a U.S. museum in 1939."[99]

POST-WAR PAINTING: A BROADER VISION AND A DEFENSIVE REACTION

World War II, in the words of historian George Tindall, "activated another cycle of change in the South." The climate, the ports, the undeveloped areas, and the available labor attracted defense industries. It is estimated that altogether in excess of four billion dollars was poured into the region for military contracts. Apart from that, a longer-lasting effect was that it put a large sector of the South on the move, intensifying already established trends in social and economic development. Unfortunately, this continuation was anything but smooth, marked as it was by conservative efforts to undermine the gains made in the past for the sake of an increasingly outmoded sectionalism. Concerning this period, Tindall has written:

> The region was more an integral part of the union than ever before. But its political leaders, internationalist and parochial at the same time, embodied a curious paradox. In foreign affairs they had advanced boldly toward new horizons in their support of plans for "winning the peace." But in domestic affairs they had retreated back within the parapets of the embattled South, where they stood fast against the incursions of social change. The inconsistency could not long endure, and a critical question for the postwar South, facing eventual issues of economic and racial adjustment, was which would prevail, the broader vision or the defensive reaction.[100]

This paradoxical attitude may explain why some Southern painters, during the war, felt compelled to adopt an art that addressed *both* "the broader vision" and "the defensive reaction." The early 1940s was a period of increasing internationalism for American art, not simply an internationalism of style, but one of spirit. The artist began to move away from an overt contact with place, which had marked his work of the preceding decades. Yet for the Southern painter, that contact had been a source of strength and identity. A larger dilemma with regard to painting also surfaced in this period, and that was the increasing debate about the true "subject" of art. The personal aspect of subject, vis-à-vis the individual artistic consciousness, was not eschewed but was made more universal, by means of intuitive responses to the paint on the canvas. Despite what Clement Greenberg and others had written about the need for painting to divest itself of subject matter in a literary sense, many American painters continued to proclaim a dialogue with tradi-

tional subject matter through a very different medium—that of the paint itself. To paraphrase Marshall McLuhan, the medium became the message. Painting, in order to convey its new sense of subject, adopted form itself as a language. In other words, post-war painting, including painting in the South, was not innovative because it dispensed with subject matter to inaugurate a hermetic language of form, paint, and surface; but rather, it was because of the adoption of form, paint, and surface as the principal indicators of subject matter.[101]

For the Southern painter during and immediately following the Second World War this transition was gradual. Consider the example of Julien Binford. Born in Powhatan, Virginia, Binford studied at the Art Institute in Chicago under Boris Anisfeld. After using a Ryerson travelling fellowship to go to Europe, he returned to New York in 1936 and realized that he needed to rediscover his roots in order to be a successful artist in a regionalist age. Accordingly, he bought a piece of land in Fine Creek, Virginia, and converted the ruins of an old foundry into a house and studio. His earlier, more abstract works gave way to more representational renderings, yet from the very beginning he retained a desire to let color and form carry the message. In *The Crapshooter* (fig. 50; cat. no. 137), Binford posed several neighbors around the blue square of linoleum so that only one figure—who, judging from what he is betting, is on the verge of losing all—is fully depicted. The remaining seven figures are represented by feet and hands. The painting is not regionalist in the narrow sense, because it does not show a particular scene, but Binford did use his native Virginians in their surroundings though as a springboard for a more formal, generalized statement.[102]

Binford was fortunate enough to gain the support of Thomas Colt, newly-appointed director of the Virginia Museum. It was Colt's belief that art in the Old Dominon would not develop properly unless artists were given impetus to stay and work there. He thus initiated a far-reaching program, a series of exhibitions devoted to native Virginia artists, along with an annual Virginia Artist Fellowship to a promising younger artist.[103] One of the first Fellowship recipients was Julien Binford, who agreed to conduct classes at the Craig House Negro Art Center in Richmond. Binford was also given a well-publicized exhibition at the Museum in November 1940, and was cited by Colt as an artist who used color and form to express his primary meaning. Indeed, the artist himself took pains

to point this out as well. Binford also taught fundamentals of mural painting at the Richmond Art School, and in 1942 he painted a much-heralded mural for the black congregation of the Shiloh Baptist Church near his home. In this period, his flirtation with African-American subject matter and his strongly expressionist style cost him at least one mural comission, but after the war he became Virginia's most famous mural artist. His more abstract portrayal of the signing of the Virginia Declaration of Rights for the State Library in Richmond drew wide acclaim. Part of his printed statement concerning the work bears repeating:

> The symbols of a painter are not those of a statesman, a scholar, a philosopher, or a poet. His symbols are not words, they are colors. And even though the splendor of the word as it reaches human perceptions can doubtless be compared to the splendor of color, their substance is not to be confused. The one is made of our thoughts and incantations. The other is made of the light. Each seeks its own perception.[104]

Binford's paintings in the period bear out his feeling for an aesthetic based on color and form, which would alone be the carriers of meaning.

Yet subject matter still remained a necessary part of Binford's art. He continued to utilize figures and situations from his own surroundings to achieve his larger ends. For Robert Gwathmey, another Virginia artist, those "larger ends" meant a strong social commitment augmented by a more abstract style. Born in Richmond in 1903, Gwathmey studied at the Pennsylvania Academy of the Fine Arts and subsequently travelled in Europe. Like Binford, he secured a mural commission under the New Deal for an Alabama Post Office, giving him valuable experience. After a brief period as an art teacher at the Carnegie Institute in Pittsburgh from 1939 to 1942, Gwathmey was appointed art instructor at the Cooper Union in New York, a post he held for twenty-five years until his retirement. Summers, however, were frequently spent in Virginia, which inspired much of his painting.

Hoeing (cat. no. 139), dated 1943, is a typical work of the period. Gwathmey painted the poor sharecropper, white and black, set against his bleak, emaciated world. The individual elements of the work—the large central figure, the dilapidated church, or the parched, dead countryside—serve not as details but as symbols of a broader social commentary. Just as serious writers in the South in the 1940s brought these figures

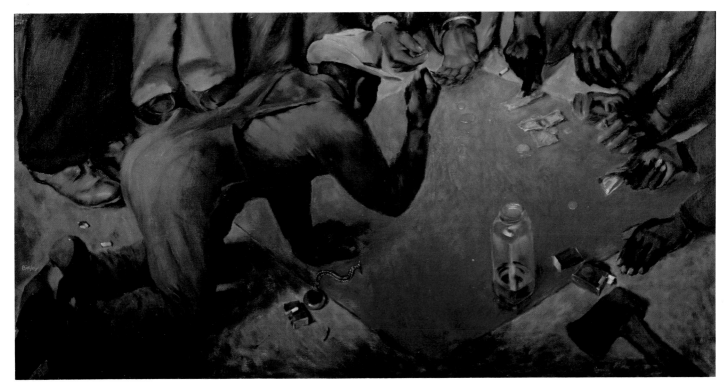

Figure 50. Julien Binford, The Crapshooter *(cat. no. 137).*

into the foreground of their work as a common vehicle for social criticism, so too an artist like Gwathmey portrayed the economically and socially enslaved classes of his native South in thinly-veiled criticism. "I don't want to get labeled as a painter of the South," Gwathmey told *Art News* in 1946. "But then I go back home every summer to Virginia and I see these things—and they affect me all over again, sort of shock me—and I paint them."[105] Some of the elements in *Hoeing,* like the single strand of corn and the placarded fence post, had come to symbolize for him the failures of both men and the land. Yet Gwathmey's paintings seem to exude more pathos than hate. As a Southern painter he was angry, but he also seemed to shoulder some of the guilt. He was particularly sensitive to the plight of the black soldier returning home to find the basic freedoms he had fought for still not his own. The turbulent debate over the black Southerner's role in the war effort that raged through the region in the early 1940s left an indelible mark on Gwathmey's paintings.[106]

In January 1946 Gwathmey was given a large exhibition of his paintings at the ACA Galleries in New York. Paul Robeson, who wrote the introduction to the catalogue, praised Gwathmey's "responsibility to the exploited people of the South." For Robeson,

Gwathmey's art successfully fused the formal elements of modern expression with the deeper, older tradition of "humanity and reality." He continued:

> His paintings deal with the South, but they are not to be confused with another regionalist movement. For just as social content art dealt with the hopes of all people for a better life, so his portrayal of the South shows the aspirations and contributions of the Negro people and the failure of our society to recognize them. Thus Gwathmey, a white Southerner, expresses his region in the democratic tradition and in the best fusion of esthetic and social principles.[107]

Gwathmey's art was a restrained yet forceful call for equal opportunity, at a time when political events were slowly beginning to move in the same direction. Gwathmey explained his feelings to Elizabeth McCausland of *The Magazine of Art* in April of that year:

> When any people can depict any other people as picturesque, it degenerates into romantic mockery. And this is true not only of the Negro, but of all oppressed groups—and also women. . . .
>
> I believe that in painting the use of limited imagery is the best method of presentation of your content.
>
> I believe that if the symbols are strong enough and simple enough and inventive enough, they can transcend the literary in painting.[108]

Eventually, the figures in Gwathmey's paintings grew more abstract and became circumscribed with an increasingly weblike patterning against ever-flattening background. His art is a good example of the triumph of what was earlier referred to as a broader vision over a more parochial one. Rather than retreat into a hermetic world of regionalist imagery, Gwathmey was turning the imagery against itself to extend the boundaries of his art. If there was a dilemma in all this, it was the continuing question of Southern identity, and the extent to which it should be visible in the work of art.

In the same way, Romare Bearden has explored a similar dilemma in his own art, yet he faced an additional problem as well. As an Afro-American artist he needed to discover, as Aaron Douglas had done, a style that would serve as a proper vehicle for the expression of the lives of his people and the context of his race. Early on in his career, Bearden found the answer in his own Southern background. Born in 1914 in Charlotte, North Carolina, he moved with his parents to New York at an early age, becoming one of the thousands in the post-war northward migration. From the beginning he lived in a stimulating environment; while his father worked for the New York City Department of Health, his mother joined the New York staff of the *Chicago Defender,* and became founder and first president of the Negro Women's Democratic Association. In 1936 Bearden began his studies at the Art Students' League under George Grosz, and he joined various associations of black artists living in Harlem. Four years later the young artist met Stuart Davis, who reinforced his notion of musical analogy in his work by directing him to listen to the improvisational structures and sequences of jazz. At the same time, he discovered the source for his imagery. "I thought about who I was and what I liked," he later recalled, "and I began to paint pictures of the people I knew and remembered down South."[109] This parallels the autobiographical statement of Mississippi-born Richard Wright, whose brilliant *Native Son* was published in 1940: "There had been slowly instilled into my personality and consciousness, black though I was, the culture of the South."[110]

After service in World War II Bearden enjoyed a number of well-publicized exhibitions, and in 1950 he went to Paris to study philosophy at the Sorbonne. Returning to America, Bearden tried a brief stint as a popular songwriter but was back painting by 1954, mostly in an abstract style equivalent to the type of work being done by the second-generation New York School. In 1963, however, his art underwent a profound change. Galvanized by the social atmosphere of the burgeoning civil rights movement, Bearden discovered collage as a medium to express the narrative and aesthetic concerns of the modern African-American artist, developing a method that seemed to combine the formal structures of modern painting with the polyrhythmic sequences of black music. As Ralph Ellison has so aptly written:

> His combination of techniques is in itself eloquent of the sharp breaks, leaps in consciousness, distortions, paradoxes, reversals, telescoping of time and surreal blending of styles, values, hopes and dreams which characterize much of Negro American history.[111]

Bearden devised a series based on his own background that he titled *The Prevalence of Ritual.* One of these, *Tidings* (cat. no. 145), reflects his concept of the underlying pattern of customs and ceremonies that unified the Southern black family. Yet he was careful to oppose the characterization of his art as simply Southern or black. "I create social images within the work so far as the subjects are Negro, but I have not created protest images because the world within the collage, if it is authentic, retains the right to speak for itself," he told *Art News* in 1964.[112] Bearden was nevertheless committed to an activist career on behalf of the African-American artist; in 1961 he and many other Harlem artists founded the Spiral Group to discuss the role they were to play in the Civil Rights movement. But in spite of these efforts, he emphasized the predominance of an artist's personal vision; subject matter was important only insofar as it carried a meaning that could be individually understood. Bearden himself recently summarized this most eloquently:

> I paint out of a tradition of the Blues, of call and recall. . . . I never left Charlotte, except physically. . . . As a young boy, I'd go to the Lafayette Theater in Harlem, and I'd hear Bessie Smith or some other singer. What they sang would usually go like this: "I woke up this morning and my man left me a note. He said he was leaving, and I'm feeling so blue, so blue. I'm goin' down by the river and if I feel bad as I do now, I'm gonna jump in." Here she's talking about a poignant personal event—her love is gone. But behind her the musicians are "riffing," changing something tragic into something positive and farcical. This is why I've gone back to the South and to jazz. Even though you go through these terrible experiences, you come out feeling good. That's what the Blues say and that's what I believe—life will prevail.[113]

Attitudes of remembrance, personal visions, poems of place: these subjective elements underlie an accurate interpretation of much post-war Southern painting. Not long after Bearden painted his *Prevalence of Ritual: Tidings,* Carroll Cloar finished *Where the Southern Cross the Yellow Dog* (cat. no. 144). Cloar, originally from Arkansas, achieved a limited reputation as a painter in New York in the late 1940s and early 1950s. By 1955, however, he had returned to Memphis to begin a series of paintings based on his boyhood in the Arkansas Delta. "There is a joy in the sense of belonging, of possessing and being possessed, by the land where you were born."[114]

Even though Cloar had studied at the Art Students' League, he allowed the belief to flourish that he was a "primitive" artist, largely self-taught, whose work was imbued with the timelessness of folklore. *Where the Southern Cross the Yellow Dog,* painted at a time when the Blues revival was well under way, depicts the legendary railroad crossing in Moorhead, Mississippi, that W.C. Handy and others had immortalized in song.[115] The meticulous, vibrant scene, showing tracks shooting off into unknown distances, became for him a metaphor for the Southern experience. Cloar also painted a great many scenes and stories from his childhood, for, like Bearden, he was searching for his own identity in his art, not other people's. Like Bearden, Cloar took much of his imagery from photographs, which he used as sparks for his fertile imagination. "Cloar's real power, and it enables him to transcend mere eclecticism, derives from his feeling for time, especially past time," wrote Sidney Tillim, himself a noted painter, in 1968. "It is an identification so strong that even contemporary events or portraits, when represented by Cloar in his fastidious style, appear to have occurred long ago or seem to be passing into timelessness."[116]

A similar feeling can be discerned in Francis Speight's painting *Demolition of Avoca* (fig. 43; cat. no. 143), finished in 1963. Speight, like Bearden, is an example of a painter who was raised in the South and returned to it primarily in his work. Born in Windsor, North Carolina, he enrolled at the Pennsylvania Academy of the Fine Arts, and eventually became an instructor there, teaching until his retirement in 1961. He was a visiting professor of art on many campuses, including the University of North Carolina at Chapel Hill in 1934–35; the following year he received a PWAP commission to paint a mural tracing the history of cotton for the Post Office in Gastonia. In 1961 he was appointed artist-in-residence at East Carolina University in Greenville and was given a large retrospective at the North Carolina Museum of Art in Raleigh. Reestablished in Greenville, he again discovered the region he had once known.[117]

Avoca was a plantation in Bertie County, on Albemarle Sound; today it is the site of a large experimental tobacco plant. In the painting, the sensitive brushwork, pale colors, and depiction of waning light carries not meaning but intuitive feeling. The first few lines of James Dickey's poem "Approaching Prayer,"[118] published at about the same time, help clarify Speight's intention:

> A moment tries to come in
> Through the windows, when one must go
> Beyond what there is in the room,
>
> But it must come straight down.
> Lord, it is time,
>
> And I must get up and start
> To circle through my father's empty house
> Looking for things to put on
> Or to strip myself of
> So that I can fall to my knees
> And produce a work I can't say
> Until all my reason is slain.

Hobson Pittman's painting, although more contrived, follows lines similar to Speight's. Like Speight, Pittman was a North Carolinian, having been reared on a plantation in Epworth. The house he grew up in was a high-ceilinged post-Civil War structure filled with Victorian furniture and art. He spent the better part of his career teaching and working in Pennsylvania, and by the 1940s he was a well-known artist. In 1945 he began teaching at the Philadelphia Museum College of Art; the following year he received a commission from *Life* magazine to paint a series of interiors of houses in Charleston.[119] His imaginary, rather dreamlike interiors became famous.

In 1948 he painted *The Conversation* (cat. no. 141), and here again is the strong feeling of remembrance in a Southern painter, but it is not a specific, easily understandable feeling. Pittman's interiors—like Cloar's stories and Bearden's ceremonies—are attempts to recapture an other-worldly Southern past that perhaps exists only in fiction. For Pittman, "the large windows, the rambling stairs, the great doors" of his childhood held meaning only for him.[120] The small matronly figures, dwarfed by the interior, seem too far away from us to be overheard. The gauzy screens are too diaphanous to hold back the summer air. The

colors are muted as if by time itself. Looking at Pittman's mysterious evocations of a remembered, yet vague Southern past, one is reminded of one of the first sentences in Hodding Carter's *Southern Legacy,* which was published only two years after *The Conversation* was completed:

> Call them feudal or provincial or patriarchal or archaic. They may be all of these, but they represent also something deeper and longer lasting and more inspiriting; a unity that fuses families and clans and, spreading out, brings together whole peoples, marking them with a certain likeness of manners and convictions and purpose.[121]

This overriding belief in the unity and depth of a collective Southern identity is what unites the work of Southern painters of all three periods discussed so far.

Introspection pervades the remarkable work of Walter Inglis Anderson, who like many earlier painters found his identity in the Southern wilderness. Born in New Orleans, Anderson studied at the Pennsylvania Academy of the Fine Arts and travelled to Europe. During the Depression he moved to Ocean Springs, Mississippi, and painted in virtual seclusion, although he did once do work for the PWAP. In 1937 he became mentally ill and was hospitalized for intermittent periods. Four years later he was released in the care of his wife's family, and in 1947 he moved to Ocean Springs and lived as a recluse in a small cottage, filling the walls with vibrant, semi-abstract murals depicting the local flora and fauna. Throughout the 1950s Anderson spent most of his time on Horn Island, a small, ever-changing sand bar rich in plants and wildlife. He produced thousands of striking watercolors of this microcosm, his southern Walden; indeed, he kept detailed journals of his impressions to go with them. Anderson died in 1965, and eighty-two logs chronicling his trips to Horn Island were discovered in a safe in his kitchen. These logs recorded his journeys by skiff to Horn Island and other barrier islands within the Mississippi Sound. In the tradition of Audubon and Thoreau, he fancied himself an explorer and naturalist, an artist of the known as well as the unknown.[122]

Even though Anderson spent his life in relative seclusion, his art easily transcends his surroundings and symbolizes something greater. Like many painters of the Southern landscape, Anderson was captivated by its mysterious grandeur; but unlike many earlier artists, he knew that it was irrevocably changing. In the early to mid 1940s, when he began keeping his records, he would row past the Barrier Islands, which had not yet been freed of military occupation, on out

to the Chandeleur group, low-lying sand flats that were once a part of an ancient Mississippi River delta. Here he drew and studied the pelicans that nested there and, according to his biographer, Redding Sugg, "came to believe he understood their language, of which he attempted to make a phonetic transcription." Here, too, he witnessed the pelican's virtual extinction, the result of eating fish contaminated by pesticides. He knew the Sound was becoming increasingly polluted; sewage from the Gulf towns, chemicals from the paper mills, oil leaks from the Louisiana coastal wells—all conspired to destroy the world he had grown to love and celebrate. Perhaps this is one reason he seemed so unconcerned in his journals when a captive creature that he was drawing died. "He is often to be found under the compulsion to paint the dying and dead creatures of the sea before the colors fade," Sugg has written. Anderson doubtless felt the same way about the islands themselves.[123]

Once on his island Anderson became one with it. He built rude camps, sometimes simply careening his boat, gathered fat pine and driftwood, and built fires for warmth and for cooking his meagre repast. He stalked his island in his tattered hat, trapping some of the creatures he wished to paint; he crawled endlessly through the high grass and floated silently in the still lagoons to watch the natural process of things. His logs throughout the 1950s chronicle with rapt attention the change of seasons, the drift of the tides, the life of a single plant. A journal entry dated January 1959 reads: "Thursday afternoon I walked to the west on the outside beach. I found two lady crabs and the remains of others—the first I've ever found."[124] *Horn Island* (fig. 51; cat. no. 142), the watercolor in this exhibition, is undated, but an entry in July of that year records as follows:

> Yesterday afternoon a walk on the front—caught a blue crab, light midnight sky with stars. I did a water color of it. . . .
>
> To the intellectual life is an incidental thing generating from form.
>
> To the islander form itself is a miracle, and realization comes from the form.[125]

His watercolors portrayed a pulsating world of forms, with colors and rhythms interlocked by the larger, less fathomable laws of nature. He was the quintessential artist, who saw the relationship of things and in so seeing, saw for the rest of us. The clouds, trees, lagoons, birds, fishes, and insects were part of a greater picture; he knew that he, as a painter and observer,

Figure 51. Walter I. Anderson, Horn Island (cat. no. 142).

was an equal part of that picture, too. In 1965, a few months before he succumbed to lung cancer, he wrote:

> In the bay where the dried sargassum had collected and I had found the sargassum crabs on last trip and where the mosquitoes had collected—and apparently multiplied, for there were twice as many this trip—in this narrow bay the least terns were fishing. The water was muddy and they would hover a long time before diving. With the birds and the strong winds and the clouds casting moving shadows—and the white wave caps, and the dark rain squalls on the horizon—and growing cumulus thunder heads that changed every minute—it was a dramatic effect of strong contrast, the glare of the white sand at one end and the dark shadows on the water, with the white star set in a black widow's peak on the forehead of each tern. There was light in everything. No lost places disappearing without definition—everything needed to be considered in relating the parts to the strange and transient unity.[126]

Anderson, like so many artists in this period, turned inward to a personal vision in his art. His work bordered on the abstract because he was affected by the innermost, unified "forms" of nature. Will Henry Stevens, on the other hand, could not reconcile these two worlds; instead, as an artist he seemed to lead a double life.

Born in Indiana, Stevens received his initial art training at the Cincinnati Art Institute, then at the Art Students' League under William Merritt Chase. In 1921 he was appointed to a teaching position at the Newcomb School of Art in New Orleans, a post he held until his retirement in 1948. Stevens travelled a great deal and spent nearly all his summers in western North Carolina, painting the woods and hillsides. Like Anderson, he was deeply affected by the Southern landscape. "The best thing a human can do in life is to get rid of his separateness or selflessness and hand himself over to the nature of things," he was quoted as saying late in life, "to this mysterious thing called the universal order, that any artist must sense."[127] His aesthetic was formed from older sources: Walt Whitman's songs of the self and Oriental philosophers like Lao-Tzu. Accordingly, his "pastel paintings" of the Southern woodlands—using a non-rubbing chalk of his own invention—were praised when they were exhibited in 1941 as having a formal language of "deft patterns" that mirrored "a depth that grows out of real feeling."[128] Yet Stevens was careful to characterize this feeling as an "impersonal state of consciousness" that was reached by "getting relationships of objects and colors in space."[129]

Curiously, Stevens also painted in a more purely nonobjective style in the same period. Works like *Abstraction* (cat. no. 136), dated circa 1943, came from his interest in the paintings of Paul Klee and Wassily Kandinsky. He could have seen these works in the South as early as 1936, when 128 paintings belonging to Solomon Guggenheim were shown at the Gibbes Art Gallery in Charleston. This marked the first public showing of this great collection, and Guggenheim himself donated several thousand dollars to remodel the galleries. Southerners who attended the exhibition saw many works by Klee, Kandinsky, Bauer, Leger, Seurat, Chagall, Moholy-Nagy, Delaunay, and others.[130] Stevens's *Abstraction* obviously derives from such contact. In December 1941 he showed work simultaneously at two New Orleans galleries: his pastels of the Southern woodlands at Kleeman Galleries and a group of nonobjective paintings at the Willard Galleries Downtown. To be sure, in some works the two styles overlapped, but Stevens seems to have felt that a full commitment to the nether worlds of nonobjective painting was impossible, so he catered to both impulses. In his case, his art was constrained by the dilemma between the broader vision and the defensive reaction. It took the form of the adoption of a more conservative, regional style where continuation of an abstract, internationalized aesthetic was not welcomed.[131]

Very near where Stevens spent his summers, an experimental community of artists and writers was entering an important new phase of its already problematic existence. It was Black Mountain College, which had been founded in the fall of 1933 by John Andrew Rice in buildings owned by the Blue Ridge Assembly of the Protestant Church near Black Mountain, North Carolina. The aims and achievements of the school are best characterized by Martin Duberman:

> A full history of Black Mountain is more intricate and poignant than a recitation of the famous names associated with it. It is the story of a small group of men and women—ranging in time from a dozen to a hundred, most of them anonymous as judged by standard measurements of achievement—who attempted to find some consonance between their ideas and their lives, who risked the intimacy and exposure that most of us emotionally yearn for and rhetorically defend, but in practice shun. Black Mountain shifted focus, personnel, definitions and strategies so often that its history is unified by little more than a disdain for life as usually lived and some unsettled notions—sometimes confused and self-glamorizing, sometimes startlingly courageous—as to how it might be made different and better.[132]

Figure 52. Joseph Albers, Untitled (Adobe) *(cat. no. 149).*

Every student at Black Mountain was encouraged to take courses in the arts; it was Rice's belief that art "should be at the very center of things." Accordingly, after speaking with Philip Johnson, the young curator at the Museum of Modern Art in New York, Rice hired Josef Albers, newly arrived from Germany and unable to speak a word of English, to begin a teaching career at Black Mountain that would last until 1949. A work like *Adobe* (fig. 52; cat. no. 149) reflects Albers's artistic quest during this period.

Albers, like Rice, conceived of art, in Duberman's words, "as a process of sensitization and insight applicable to every facet of life."[133] He respected his students' cultural heritage but also encouraged a healthy internationalism. His art teaching stressed the value of everyday objects, the directness of feeling, economy of statement, and the integration of form and meaning. Albers was the only artist to stay at Black

Mountain for an extended period, and his influence on painting in the South is uncertain. The relationship between the school and the local communities that surrounded it was, at best, courteous. Black Mountain was largely viewed as a radical community not to be trusted for its mores and values. These feelings were underscored in 1943 when the college facilities were rented to an interracial conference on "Problems in the South" sponsored by the YMCA. The resulting debates within the Black Mountain community over racial issues in the following few years tore the faculty and students apart and very nearly forced its closing.[134]

But post-war prosperity brought the community to its feet again, and a new emphasis on the arts was begun. With the advent of a summer teaching program, many key avant-garde figures in the arts were invited to come to Black Mountain. These eventually included John Cage, Merce Cunningham, Lionel

Feininger, Walter Gropius, Jacob Lawrence, Robert Motherwell, Willem de Kooning, Ossip Zadkine, Balcomb Greene, Clement Greenberg, Beaumont Newhall, Franz Kline, Richard Lippold, and Buckminster Fuller. The only Southern painter to receive an invitation to teach was Robert Gwathmey, and the effect of all this activity for the development of painting in the South seems to have been minimal.[135]

The work we have seen thus far indicates the dominating influence of regionalism and representational styles on the painting of the South in the post-war period. Up to this point, artists who wished to work in a more non-representational mode and to involve themselves in international art currents were essentially faced with three choices: they could leave the South entirely and have little more to do with it, as did Patrick Henry Bruce of Virginia; they could develop as artistic recluses from Southern society, as did Walter Anderson, Josephine Crawford, or William H. Johnson; or, more rarely, they could lead a "double existence," as Will Henry Stevens had done. All this seems to have changed with the advent of the New York School in the 1950s. With the establishment of solid art centers in the cities and universities during the 1930s, the new artists and teachers of the post-war generation began to transform Southern painting under the influence of Abstract Expressionism. For the first time, impetus for change was generated from within the South itself. Several artists who were also notably active as teachers deserve special mention.

Ralston Crawford's activity in the post-war period typifies the beginnings of a new outlook in Southern painting. Having adapted the aesthetic approach of synthetic cubism to a more abstract version of Precisionism, Crawford turned to an increasingly non-representational style of geometric abstraction, where austere shapes and patterns became suggestive equivalents of the American industrial landscape. After the war Crawford began to spend more and more time in New Orleans, and he obtained a teaching post at Louisiana State University at Baton Rouge in 1949. Like Stuart Davis, Crawford was deeply influenced by jazz, and he eventually became a photographic research consultant at Tulane University for the Archive of American Jazz.[136] In his paintings, he conveyed the hard light and busy, jazz-derived counter-rhythms of modern industrial and maritime activity.

In 1954 the painter Fairfield Porter praised Crawford's New Orleans works, noting that "the accuracy is not a matter of observation of nature, but of observation of the picture."[137] In such works Crawford was not yet ready to completely dissolve the figure-and-ground relationship, but he went a long way toward it in his paintings using a smaller inventory of forms. As abstract as his New Orleans paintings are, one can easily grasp the artist's desire—however far removed in the work—to convey a dialogue of place.

In 1953 Crawford was given a major retrospective at the University of Alabama. In an accompanying monograph, Richard B. Freeman described his work as "an international language that can be understood wherever contemporary ideas are discussed in modern pictorial idioms."[138] Freeman discussed Crawford's output in the context of what he termed a "new reality," while he rejected "recognizability" as one of its components. But at the heart of his work is an attitude best articulated by James Johnson Sweeney, writing in the catalogue of a retrospective exhibition at Louisiana State University in 1950:

> Selection is the base of all art. Nothing comes of nothing. Everything in an artist's work is drawn from the world outside him save the energy to discover, prefer, and combine. . . . [T]he essence of artistic beauty is harmony within the work, not truth to the life which begat it. And what guides an artist in his selection remains the essential signature of his work—something which will make its appearance consistently in every realized work of an authentic artist.[139]

Like Crawford, George Cress developed his art in a new idiom, but he did it as a member of the first generation of artists to rise to prominence within the Southern art educational system. Born in Anniston, Alabama, in 1921, Cress attended Emory University and then studied art under Lamar Dodd and Jean Charlot at the University of Georgia. His activity since that time is a case study in the development of the post-war generation of Southern painters and their relationship to the art of the South. After teaching at a number of colleges, including the Universities of Georgia and Maryland, Cress was appointed to the two-person art faculty of the University of Chattanooga, where he still resides. He was active in the Southern States Art League and the Southeastern College Art Conference, served as chairman of the Tennessee Arts Council, and headed up a summer school sponsored by the University of South Carolina on Hilton Head Island from 1967 to 1970. Clearly, Cress was committed as an artist to the growth of an art audience not only in his own locality but also in the South as a whole. As such, he typifies the post-war

Figure 53. George Cress, Spring Earth, 1965, polymer on paper, 23 by 35 inches (58.3 by 88.9 cm). Georgia Museum of Art, University of Georgia, Gift of the Artist and Patrons' Fund Purchase, GMOA 65.1262.

Southern painter's desire to encourage the development of cultural institutions in his native region.[140]

Cress evolved his artistic style in the context of the second generation of the New York School. In *Spring Earth* (fig. 53), painted in 1965, he seems to have identified with a group of artists influenced by the stark gestural abstractions of Clyfford Still. Unlike Still, however, Cress and these other painters relied on a greater lyricism and a closer contact with nature. *Spring Earth*, its patches of color paying obvious homage to the landscape forms of the Chattanooga bluffs, is such a work. Next to Still's less accessible paintings, Cress's have a more open, even sensuous feeling, certainly more suggestive of nature, although it could be argued that this was a landscape style derived from expressionistic feeling. Nevertheless, the gestural paintings of the New York School doubtless pointed

out to a number of younger painters in the South that there was an alternative road to the geometric abstraction of a Ralston Crawford and the representational expressionism of an influential teacher like Lamar Dodd.

It should be remembered that some elements of Southern life had had a decisive influence on the development of the New York School. One was the overriding interest in the analogy of jazz with modern painting, which seemed to be a way of reinforcing the intensely individualistic, interpretive work of the gestural painters. We have seen how Southern painters, beginning with Aaron Douglas, embraced jazz as a new structural and rhythmic language. Another source of influence was Black Mountain College, after the establishment of Charles Olson as the dominant figure in 1951. Even though he was a poet, Olson developed

Figure 54. Claude Howell, Beach Cottage, 1981, oil on canvas, 40 by 50 inches (106.7 by 127.1 cm). St. John's Museum of Art, Wilmington, North Carolina, Gift of Suzanne Ruffin Roth.

theories of expression that were partially based on visually-oriented interpretations of inner creative experiences. In an important series of lectures at Black Mountain called "A Special View of History," he argued that art should be created with the knowledge "that life is the historical function of the individual." The process of self-discovery, and of creation itself, was paramount. As he put it:

> Frequently I employ the expression history promiscuously with life. That's my point. A function is how a thing acts. There is a natural proper or characteristic action of anything. That is its function. As of a human life I say it is its history. It is the how. There can be no other. But there must be this one. It is. The point is, to drag it out. There it is. That's—history.[141]

Olson's influential observations can help us understand the meaning of much post-war Southern painting. Consider the aesthetic distance between two works by Claude Howell: *Mullet Haul* (cat. no. 140), painted in 1947, and *Beach Cottage* (fig. 54), completed in 1981. Born and raised in Wilmington, North Carolina, Howell has had an active life as an artist in that state, having headed the art department of the University of North Carolina at Wilmington since the department's inception in 1953. Unlike Cress and others, however, Howell chose to work in a more representational style that begins with a work like *Mullet Haul.* He painted in a rather conventional manner in realistically depicting a straightforward Southern scene by means of a vibrant modernist style. *Beach Cottage,* however, is much more than that; it is not so much illustrative as *evocative* of the artist's Southern locale. The view of nature is more impersonal, uninvolved in the traditional sense. Howell thus paints not a location, but a *sensibility.* He followed Olson's dictum and chose to work with something that was familiar, something that he as an artist could fully know:

> I stress this, only to get you out of a modern dilemma: nature. Seen this way, nature is only conceivably observable in one of two ways—from one of two vantage points. Either she is primarily known (as she is known) as any one of us alive human creatures issue from her
> (I am being literally generic)
> or she becomes what she also but only, for us, secondarily is: environment, that which surrounds us, indeed, even to the inclusion of any other human being, mind you.[142]

Howell chose his scene not because he liked the view but because he liked its structured sensibility as a painting. Thus he exemplifies the Southern painter not because he paints Southern subjects but because he chooses to work in his Southern environment, in Olson's second sense. He shows us the surface of things in his world—his own special view of history.[143]

In the same vein, Michael O'Brien, in his exemplary study *The Idea of the American South*, writes of the difference between "seeing the South itself as an idea, used to organize and comprehend disparate facts of social reality, or viewing the South as a solid and integrated social reality about which there have been disparate ideas."[144] O'Brien takes a minority view and posits the existence of the former aspect over the latter. Having briefly examined the development of painting in the South during the same period, one would have to agree with O'Brien's assessment. Many of the artists we have seen assumed a kind of inviolable Southern "center" to their work, composed as it was of widely varying aesthetic beliefs and individual experiences.

For painting in the South, the period between the two World Wars was marked by the problematical relationship between a romantic sectionalism and a modernist internationalism. The tension in this relationship affected the work and actions of the best Southern painters. Ultimately, neither outlook triumphed; modernism was accepted only in terms of some of the beliefs that had characterized painters of the genteel tradition. For the Southern painter in the modern period, a new perception was created that more accurately seemed to reflect the process of modernization by which the South was changing. The industrialization, democratization, economic upheaval, and secularization that characterized the period as a whole was felt in varying degrees of intensity throughout the South; Southern painters were aware of this process of change but reacted to it individually. One of the long-term results of all this was the eventual formation of an artistic intelligentsia for the region, as well as a network for the diffusion of art and ideas, at the center of which was the belief that the South indeed possessed an artistic identity, whether embattled or emerging, that needed to be recognized.

Everywhere in this period Southern artists sought to preserve a regional identity as opposed to a national one. It was a period of paradox and crossed signals, where older sectional beliefs were cloaked in a new nationalism. The anti-industrial and sectional aesthetic of the agrarians, for example, existed side-by-side with the broader nationalistic activity of the New

Deal programs. Just as the leading Southern writers turned to the more conservative modernism of T. S. Eliot, so the painters followed Thomas Hart Benton's lead in allying modern perception with the older idea of art as having the moral obligation to instruct. Artists in the South prior to World War II could not be classified in the avant-garde sense as independent; in the traditional sense, they thought of themselves as integral members of—even interpreters for—their own Southern society. It is only after the establishment of a comprehensive network of key teaching centers in the South, at both museums and universities, that we find the growth of the independent sensibility, where the Southern artist is fully subsumed into the international art movement. That development is best left to the next section of the exhibition.

Returning to my first observation, can we say that there is a Southern art in the period from 1900 to 1960? The answer is, of course, yes; the existence of a Southern aesthetic was accepted even by those who rejected it. Moreover, since its existence was assumed, there never seemed to be the need to adopt a unified vision. "The idea of the South," as Michael O'Brien concludes, "was a common property, on whose broad back one could rear the details of one's particular vision."[145] So it was with the artists. Although the "reality" of the perceived South could be disparate and fragmentary, its "idea" always seemed to remain whole and shared.

William Harmon, a North Carolina poet, wrote a poem in this period which he titled "To Redound."[146] It is a wonderful verb, full of the kind of connotations that seem to refer to the South. On the one hand, it means to advance, to surge or superabound; in quite another sense it refers to a return, to go back; and finally, it can also refer to a rendering of honor or disgrace. Harmon's poem, in its entirety, seems addressed to the artist and his contemporary world, so it is fitting to end with it:

> Responsively
> Our whole house shakes to the thunder's psalm,
> Windows react
> To the wind's offices, and I am turned all the way around
> By the bold sound
> That represents, in one sense, almost nothing at all,
> In another sense,
> The presence of one of the old popular gods,
> Avuncular,
> Gullible, petty, sports-minded, omnipotent, girl-crazy,
> But nothing now
> But noise to us, with some nominal vestiges of awe.
> One could tell it
> To roar on. Lord Byron told the deep blue sea to roll,
> Longfellow told
> The flower of the lily to bloom on. Romanticism
> Consists of things
> Of that sort. Redundant. So, what the hell. Throw
> Your hammer, Thor!
> Thunder, Thunder. Provoke apostrophes. Be yourself.
> That's it.

NOTES

1. Robert Hobbs, *Elliott Daingerfield Memorial Exhibition* (Charlotte: Mint Museum of Art, 1971), p. 14. Jessie Poesch kindly provided information regarding the location of the subject of the work.

2. George Core, "One View of the Castle: Richard Weaver and the Incarnate World of the South," *Spectrum* 2 (June 1972): 1-9. The Symbolist elements in Daingerfield's work can be readily understood by consulting Charles C. Eldredge's excellent study, *American Imagination and Symbolist Painting* (Lawrence: Helen Foresman Spencer Museum of Art, University of Kansas, 1979), pp. 110-11.

3. Elliott Daingerfield, "Ralph Albert Blakelock," *Art In America* 2 (December 1914): 55-68.

4. See James F. Reeves, *Gilbert Gaul* (Nashville: Tennessee Fine Arts Center, 1975), pp. 55-68.

5. Mary W. Mount, *Some Notables of New Orleans: Biographical and Descriptive Sketches of the Artists of New Orleans . . .* (New Orleans: privately printed, 1896), pp. 50-52. Information on Drysdale has been drawn from the research files in the Historic New Orleans Collection, part of which was compiled by George E. Jordan. I wish to thank John A. Mahe II, curator of the collection, for his invaluable help with Drysdale and other New Orleans artists in this project.

6. *New Orleans Daily Picayune*, July 6, 1913, p. 6.

7. Ibid. See also Ben Earl Looney, "Historical Sketch of Art in Louisiana," *Louisiana Historical Quarterly* 18, no. 2 (April 1935): 385-86.

8. Celia Steinfeldt, *The Onderdonks: A Family of Texas Painters* (San Antonio: San Antonio Museum Association/Trinity University Press, 1976), p. 103.

9. Ibid., p. 111.

10. Michelle Favrot Heidelberg, "William Woodward" (master's thesis, Tulane University, 1974), pp. 4-12. I am indebted to the author for permission to cite her important work.

11. Ibid., pp. 13-15.

12. Ibid., p. 30. See John Dewey, "Americanism and Localism," *The Dial* 68 (June 1920): 687-88.

13. Ethel Hutson, "The Southern States Art League," *The American Magazine of Art* 30 (February 1930): 86-92.

14. "In the South," *The Art Digest* 1 (May 15, 1927), p. 5.

15. Ibid.

16. Ellsworth Woodward, "Advice to the South," *The Art Digest* 10 (December 1, 1935): 9.

17. C. Reynolds Brown, *Clara Weaver Parrish* (Montgomery: Montgomery Museum of Fine Arts, 1980), pp. 7-18.

18. See the introduction by Adelyn Breeskin in *Anne Goldthwaite 1869-1944* (Montgomery: Montgomery Museum of Fine Arts, 1980), pp. 9-17.

19. Ibid., p. 17.

20. Ibid., p. 9.

21. Clark's life is summarized in a biographical sketch contained in the research files of the Virginia Museum of Fine Arts, Richmond. I would also like to thank Deborah Emont, curator at the Brooks Memorial Art Gallery, for her assistance.

22. See James R. Mellow, *The World of Miss Josephine Crawford 1878-1952* (New Orleans: Delgado Museum of Art, 1965). Crawford's journal and other papers are owned by the Historic New Orleans Collection.

23. Nancy Milford, *Zelda: A Biography* (New York: Harper & Row, 1970), pp. 281-84.

24. For further information on Zelda Fitzgerald's painting, see Edward Pattillo, *Zelda Sayre Fitzgerald Retrospective* (Montgomery: Montgomery Museum of Fine Arts, 1974), and Jery and Robbie Tillotson, "Zelda Fitzgerald Still Lives," *Feminist Art Journal* 4 (Spring 1975): 31-33.

25. Quoted in George Tindall, *The Emergence of the New South, 1913-1945* (Baton Rouge: Louisiana State University Press, 1967), p. 98.

26. Ibid., pp. 146-47.

27. Ibid., p. 330.

28. See Frank Hartley Anderson, "Roderick D. MacKenzie's 'Spirit of the Furnaces'," *American Magazine of Art* 14 (October 1923), pp. 540-45. I wish to thank Richard Murray and his staff at the Birmingham Museum of Art for further information on the artist.

29. Janice C. Oresman, *Gari Melchers 1860-1932: American Painter* (New York: Graham Gallery, 1978), pp. 9-16.

30. Richard S. Reid, "Gari Melchers: An American Artist in Virginia," *Virginia Cavalcade* 28 (Spring 1979): 162-63.

31. Ibid., pp. 167, 171. See also Bruce M. Donaldson, *Gari Melchers: A Memorial Exhibition of his Work* (Richmond: The Virginia Museum of Fine Arts, 1938), pp. 11-20.

32. See the following two articles by Martha Severens: "Reveries: The Work of Alice Ravenel Huger Smith," *Art Voices South* 1 (January-February 1978): 74-76; and "Lady of the Lowcountry," *South Carolina Wildlife* (March-April 1979): 16-25. I would like to thank the author, Curator of the Gibbes Memorial Art Gallery in Charleston, for her helpful advice on Miss Smith and other Charleston artists.

33. Tindall, *Emergence of the New South*, p. 293.

34. Richard Weaver examined this attitude in his book *The Southern Tradition at Bay: A History of Postbellum Thought*, ed. George Core and M. E. Bradford (New Rochelle, New York: Arlington House, 1968), pp. 388-91.

35. Tindall, *Emergence of the New South*, p. 287.

36. Louise Cowan, *The Fugitive Group: A Literary History* (Baton Rouge: Louisiana State University Press, 1959), p. 115.

37. John Crowe Ransom, "Antique Harvesters," in *The Fugitive Poets*, ed. William Pratt (New York: Dutton, 1965), p. 70. My thanks to Susan V. Donaldson for calling this passage to my attention.

38. Donald Davidson, "The Artist as Southerner," *The Saturday Review of Literature* 2 (May 15, 1926), p. 782.

39. Ibid., p. 783.

40. See, for example, the editorial calling for a new Southern literature in *The Double Dealer* 2 (July 1921), unpaginated. The Fugitives were well published in the magazine: see vol. 6 (August-September 1924): 191, 214; or vol. 7 (October 1924): 2, for particular instances. For a historical overview of the magazine's existence, see Frances Jean Bowen, "The New Orleans *Double Dealer*, 1921-26," *Louisiana Historical Quarterly* 34 (1956): 443-56.

41. "The South and Art," *The Art Digest* 1 (May 1, 1927): 6.

42. For an overview Benton's early career, see Philip Dennis Cate, *Thomas Hart Benton: A Retrospective of his Early Years, 1907-1929* (New Brunswick, N.J.: Rutgers University Art Gallery, 1972). For one of the best examples of his early writing, see "Form and the Subject," *The Arts* 5 (June 1924): 303-08. Comments on the artist's American Historical Epic series can be found in the pages of the same magazine; see especially vol. 6 (December 1924): 338.

43. Either of these important mural cycles deserve a monographic study. See Alvin Johnson, *Notes on the New School Murals* (New York: New School for Social Research, 1931), and Thomas Hart Benton, *The Arts of Life in America* (New York: Whitney Museum of American Art, 1932).

44. Thomas Hart Benton, *The Artist in America* (New York: Robert M. McBride & Co., 1937), p. 162.

45. Tindall, *Emergence of the New South*, p. 111.

46. See Gail Levin, *Edward Hopper: The Art and the Artist* (New York: W. W. Norton & Co. and Whitney Museum of American Art, 1980), p. 302.

47. Biographical information is taken from an article in the *Baton Rouge Morning Advocate*, April 21, 1940, p. 10A, and other clippings in a research file housed in the Special Collections archive of the Louisiana State University Library. I am greatly indebted to H. Parrott Bacot, Director of the Anglo-American Art Museum, Louisiana State University, for sharing his information on the artist.

48. William Seale, review of Vincent F. Kubly, *The Louisiana Capitol: Its Art and Architecture* (Gretna, Louisiana: Pelican Publishing Co., 1977) in *The Journal of the Society of Architectural Historians* 38 (December 1979): 399.

49. Descriptive information on the studies of the mural cycle is taken from the registrar's records in the Anglo-American Art Museum, Louisiana State University.

50. "Alabama Murals," *The Art Digest* 2 (September 1928): 11.

51. Tindall, *Emergence of the New South*, 354-90.

52. Ibid., p. 582.

53. Donald Davidson, "A Mirror for Artists," in *I'll Take My Stand: The South and the Agrarian Tradition*, ed. Louis B. Rubin (Baton Rouge: Louisiana State University Press, 1977), p. 29.

54. Ibid., p. 60.

55. Conrad Albrizio, "Plastic Arts and the Community," in *The University Bulletin* (Louisiana State University) 28 N.S. (October 1936): pp. 31-44.

56. *The Baton Rouge Morning Advocate*, April 21, 1940, p. 10A.

57. From a clipping in the files of the Department of Art and Music, Birmingham Public Library. I would like to thank Patsy Sweeney, Librarian, for her invaluable assistance.

58. Mae Belle Gay, *John Kelly Fitzpatrick Memorial Exhibition* (Montgomery: Montgomery Museum of Fine Arts, 1970), unpaginated; Gwen Pearson, ed., "Kelly Fitzpatrick Memorial Issue," *Alabama Artist* 2 (May 1953): 3-11. I wish to thank Mitchell Kahan, Curator, and C. Reynolds Brown, Assistant to the Director, Montgomery Museum of Fine Arts, for material on Fitzpatrick and other Alabama artists in the museum's archives.

59. Benton, *The Artist in America*, pp. 197-98.

60. Ibid., p. 169.

61. Howard Cook, "The Road From Prints to Frescoes," *Magazine of Art* 34 (January 1942), p. 4.

62. Exhibition brochure, *Prints and Drawings by Howard Cook* (New York: Weyhe Gallery, 1937), unpaginated. See also "A Cook Tour," *Art Digest*, 9 (February 15, 1937): 6.

63. Tindall, *Emergence of the New South*, 583-85.

64. W. T. Couch, *Culture in the South* (Chapel Hill: University of North Carolina Press, 1934), pp. 270-98.

65. Lloyd Goodrich, *Lamar Dodd: A Retrospective Exhibition* (Athens, Georgia: University of Georgia Press, 1970), p. 12. Appreciation is expressed to Linda Stiegleder, Registrar of the University of Georgia Museum, for obtaining further information on the work from the artist.

66. Ibid., pp. 15-16.

67. Tindall, *Emergence of the New South*, p. 498.

68. Malcolm M. Norwood, Virginia McGehee Elias, and William S. Haynie, *The Art of Marie Hull* (Jackson: University Press of Mississippi, 1975), pp. 14-15.

69. Tindall, *Emergence of the New South*, p. 355.

70. Undated newspaper clipping, *Jackson Daily News*, in the Marie Hull file, National Museum of American Art Library, Washington, D.C.

71. "John McCrady's Paintings A Feature of Art Festival," *Jackson Daily News*, April 9, 1970, p. 12A. See also Keith Marshall, *John McCrady 1911-1968* (New Orleans: New Orleans Museum of Art, 1975), p. 18.

72. Marshall, *John McCrady*, p. 32.

73. John McCrady, manuscript autobiography, unpaginated. I am indebted to Jack M. McLarty, owner of *Political Rally*, for so generously sharing his McCrady material with me, and to Valerie B. Braybrooke, Director of the University of Mississippi Art Museum, for help and suggestions about McCrady's work.

74. McCrady, manuscript autobiography, unpaginated.

75. "A Texas View," *The Art Digest* 8 (January 1, 1933), p. 26.

76. " 'Pococurantesque' Art Criticism is Assailed by Hogue of Texas," *The Art Digest*, 9 (May 15, 1936), p. 12.

77. "Art of Texas Presents an Epitome of Aesthetics of Modern Age," *The Art Digest*, 20 (June 1, 1936), p. 14.

78. "Young Texans, All Under 30, Show in Dallas," *The Art Digest* 6 (March 15, 1932), p. 8. See also John Palmer Leeper, *Everett Spruce* (New York: American Federation of Arts, 1959), pp. 7-8, and Gibson Danes, "Everett Spruce: Painter of the Southwest," *Magazine of Art* 38 (January, 1944), p. 13.

79. See the important essay by B. A. Botkin, "Folk and Folklore," in Couch, *Culture in the South*, pp. 570-93.

80. W.E.B. DuBois, "Negro Art," in Meyer Weinberg, ed., *W.E.B. DuBois: A Reader* (New York: Harper & Row, 1970), p. 240.

81. W.E.B. DuBois, "Criteria for Negro Art," in Weinberg, *DuBois: A Reader*, p. 260.

82. Alain Locke, "The American Negro as Artist," *The American Magazine of Art* 23 (July-December 1931): 211.

83. Ibid., p. 214.

84. Ibid., p. 215.

85. Adelyn Breeskin, *William H. Johnson* (Washington, D.C.: Smithsonian Institution Press, 1971), pp. 11-14.

86. Eric Sackheim, *The Blues Line: A Collection of Blues Lyrics* (New York: Grossman Publishers, 1969), p. 314.

87. Breeskin, *William H. Johnson*, pp. 16-21. Locke felt that Johnson's work was of immense social significance and that it reeked of irony and satire, which would not receive "local appreciation till long after he has put his birthplace on the artistic map." Locke, "The American Negro as Artist," p. 217.

88. Locke, "The American Negro as Artist," p. 218.

89. David C. Driskell, Gregory D. Ridley, and D. L. Graham, *Retrospective Exhibition: Paintings by Aaron Douglas* (Nashville: Carl Van Vechten Gallery of Fine Arts, Fisk University, 1971), unpaginated. I would like to thank Robert Hall, Curator of the Van Vechten Gallery, for his assistance. For Douglas's work in the Harlem Renaissance, see Nathan I. Huggins, *Harlem Renaissance* (New York: Oxford University Press, 1971), pp. 168-70.

90. Driskell, Ridley, and Graham, *Retrospective Exhibition: Paintings by Aaron Douglas*; see also David C. Driskell, *Two Centuries of Black American Art* (New York: Alfred A. Knopf, 1976), p. 153.

91. Driskell, Ridley, and Graham, *Retrospective Exhibition: Paintings by Aaron Douglas*.

92. Exhibition brochure, *Charles Shannon: Paintings of the South* (New York: Jacques Seligmann and Co., 1938), unpaginated.

93. Letter, Charles Shannon to the author, October 6, 1981. I wish to thank the artist for his important recollections of this period, and his willingness to share them.

94. Ibid. See also Diane Gingold, *Charles Shannon: Paintings and Drawings* (Montgomery, Alabama: Art South, Inc., 1981), pp. 30-31.

95. Letter, Charles Shannon to the author, October 6, 1981.

96. Undated clipping from *The Montgomery Advertiser* in the possession of the artist.

97. Material from the artist's unpublished biography, *My Life and Others*, has been graciously provided by Alexander Brook, Jr., through Lawrence Salander of Salander-O'Reilly Galleries, Inc. I wish to thank Mr. Salander and his assistant, Andrew W. Kelly, for their generous help with the exhibition.

98. The same year that *Georgia Jungle* was painted, a writer described the bleak landscape of the Southern tenant farmer as "a miserable panorama of unpainted shacks, rain-gullied fields, straggling fences, rattle-trap Fords, dirt, poverty, disease, drudgery, and monotony that stretches for a thousand miles across the cotton belt." Tindall, *Emergence of the New South*, p. 411.

99. "The Year in Art: A Review of 1939," *Art News* 37 (December 30, 1939) 8. See also "Patrons Art Fund Purchase: 'Georgia Jungle' by Alexander Brook Added to Permanent Collection," *Carnegie Magazine* 13 (1939): 214-15.

100. Tindall, *Emergence of the New South*, p. 731.

101. See Barbara Cavaliere and Robert C. Hobbs, "Against a Newer Laocoon," *Artsmagazine* 51 (April 1977): 110-17.

102. See "Julien Binford: Return of the Native," *Artnews* 41 (November 15, 1942): 24, and Elizabeth Binford, "Julien Binford," *American Artist* 17 (April 1953): 24-29, 70.

103. "Julien Binford, Young Virginia Colorist, Honored at Home," *The Art Digest* 15 (November 15, 1940): 12. See also "Julien Binford Shows the North the South," *The Art Digest* 17 (November 15, 1942): 9.

104. "Binford Mural Meets Richmond Approval," *The Art Digest* 25 (August 1951): 19.

105. "Gwathmey Adds Scale to Pattern," *Artnews* 44 (January 1946): 20. For biographical information on the artist, see Jonathan Ingersoll, *Robert Gwathmey* (St. Mary's City, Maryland: St. Mary's College of Maryland, 1976), p. 35.

106. For the historical background to this, see Tindall, *Emergence of the New South*, p. 711.

107. Paul Robeson, *Robert Gwathmey* (New York: ACA Gallery, Inc., 1946), unpaginated.

108. Elizabeth McCausland, "Robert Gwathmey," *The Magazine of Art* 39 (April 1946): 151.

109. Avis Berman, "Romare Bearden: 'I Paint out of the Tradition of the Blues'," *Artnews* 79 (December 1980): 65. See also: Albert Murray and Dore Ashton, *Romare Bearden: 1970-1980* (Charlotte, North Carolina: The Mint Museum of Art, 1980); and Mary Schmidt Campbell, "Romare Bearden: Rites and Riffs," *Art in America* 69 (December 1981): 134-41.

110. Quoted in Tindall, *Emergence of the New South*, p. 664.

111. *Romare Bearden: Paintings and Projections*, introduction by Ralph Ellison (Albany, New York: The Art Gallery, State University of New York, 1968), unpaginated.

112. Charles Childs, "Bearden: Identification and Identity," *Artnews* 63 (October 1964): 25.

113. Berman, "Romare Bearden," p. 62.

114. Quoted in *Catalog of Paintings by Carroll Cloar* (Memphis: Southwestern University, Burrow Library Monograph #6, 1963), unpaginated. For background material on the artist, see Guy Northrup, *Hostile Butterflies and Other Paintings by Carroll Cloar* (Memphis: Memphis State University Press, 1977), pp. 23-38.

115. For the background to this subject, see Robert Palmer, *Deep Blues* (New York: Viking Press, 1981), pp. 44-45.

116. Northrup, *Hostile Butterflies*, p. 38.

117. William Hull, *Manayunk and Other Places: Paintings and Drawings by Francis Speight* (University Park, Pennsylvania: Museum of Art, the Pennsylvania State University, 1974), p. 6.

118. James Dickey, "Approaching Prayer," in *James Dickey: Poems 1957-1967* (New York: Collier Books, 1968), p. 163.

119. William Hull, *The World of Hobson Pittman* (University Park, Pennsylvania: Museum of Art, the Pennsylvania State University, 1972), unpaginated.

120. Evan H. Turner, *Hobson Pittman* (New York: Babcock Galleries, 1970), p. 5.

121. Hodding Carter, *Southern Legacy* (Baton Rouge: Louisiana State University Press, 1966), p. 1.

122. Redding S. Sugg, *The Horn Island Logs of Walter Inglis Anderson* (Memphis: Memphis State University Press, 1979), pp. xi-xxxvi.

123. Ibid., pp. xxii-xxiii.

124. Ibid., p. 38.

125. Ibid., p. 90.

126. Ibid., p. 164.

127. Quoted in James E. Neumann, *An Exhibition of the Late Works of Will Henry Stevens* (Greenville, North Carolina: Greenville County Museum of Art, 1967), unpaginated.

128. "Stevens Changes," *The Art Digest*, 15 (March 1, 1941), p. 23.

129. Neumann, *Exhibition of Late Works by Will Henry Stevens*, unpaginated.

130. "Abstractionists Invade the Solid South," *The Art Digest* 10 (April 1, 1936): 9.

131. See the review in *Art News* 40 (December 1, 1941): 33.

132. Martin Duberman, *Black Mountain: An Experiment in Community* (New York: Dutton, 1972), p. 11.

133. Ibid., p. 62.

134. Ibid., p. 175.

135. Ibid., pp. 279-80, 329.

136. Richard B. Freeman, *Ralston Crawford* (University, Alabama: University of Alabama Press, 1953), pp. 28-29.

137. Quoted in an exhibition review in *Art News* 53 (December 1954), pp. 49-50.

138. Freeman, *Ralston Crawford*, p. 11.

139. James Johnson Sweeney, *Ralston Crawford* (Baton Rouge: Louisiana State University Art Gallery, 1950), unpaginated.

140. John Benz, Lamar Dodd, and Gail Hammond, *George Cress: Twenty Years* (Chattanooga, Tennessee: Hunter Gallery of Art, 1971), unpaginated.

141. Charles Olson, *The Special View of History* (Berkeley: Oyez Press, 1970), p. 18.

142. Ibid., pp. 29-30.

143. For background on the artist, see Virginia A. Tucker, *Claude Howell: A Retrospective Exhibition of his Paintings* (Raleigh: North Carolina Museum of Art, 1975), pp. 7-17.

144. Michael O'Brien, *The Idea of the American South, 1920-1941* (Baltimore: Johns Hopkins University Press, 1979), p. xiii.

145. Ibid., p. 226.

146. William Harmon, "To Redound," in *Contemporary Southern Poetry*, Guy Owen and Mary C. Williams, eds. (Baton Rouge: Louisiana State University Press, 1979), p. 99.

ACKNOWLEDGEMENTS

Anne Arnold, Cataloger, Baltimore Museum of Art

H. Parrott Bacot, Director, Anglo-American Art Museum, Louisiana State University

Mrs. Paul Bartlett, Charlotte, N.C.

Betty Dahill Beam, Assistant Registrar, North Carolina Museum of Art

Julien Binford, Powhatan, Va.

Valerie B. Braybrooke, Director, University of Mississippi Art Museum

Elise Brevard, Registrar, Mississippi Museum of Art

C. Reynolds Brown, Assistant to the Director, Montgomery Museum of Fine Arts

Susan Cole, Manuscripts Curator, Historic New Orleans Collection

Boyd Cruise, New Orleans, La.

James Czarniecki, Director, Mississippi Museum of Art

Deborah Emont, Curator, Brooks Memorial Art Gallery

Elsa Honig Fine, Editor, *Woman's Art Journal*, Knoxville, Tenn.

Robert Hall, Curator, Van Vechten Art Gallery, Fisk University

William Halsey, Charleston, S.C.

Michelle F. Heidelberg, Hattiesburg, Miss.

Patricia Hendricks, Assistant Curator, Archer M. Huntington Art Gallery, University of Texas at Austin

William T. Henning, Jr., Curator of Collections, Hunter Museum of Art

John Henry, Curator, Mississippi Museum of Art

Earl Hooks, Director, Van Vechten Art Gallery, Fisk University

A. Everette James, Jr., Nashville, Tenn.

Mitchell Kahan, Curator, Montgomery Museum of Fine Arts

David B. Lawall, Curator, University of Virginia Art Museum

Marsden London, Darien, Conn.

John A. Mahe, II, Curator, Historic New Orleans Collection

Nancy Mathews, Curator, Randolph-Macon Woman's College Art Gallery

John M. McLarty, Jackson, Miss.

Richard Murray, Director, Birmingham Museum of Art

Valerie Olson, Registrar, New Orleans Museum of Art

Lawrence Salander, Salander-O'Reilly Galleries, Inc.

Martha Severens, Curator, Gibbes Memorial Art Gallery

Charles Shannon, Montgomery, Ala.

Celia Steinfeldt, Curator, Witte Memorial Museum

Linda Stiegleder, Registrar, Georgia Museum of Art

Patsy Sweeney, Art Librarian, Birmingham Public Library

Mrs. Eugene Thomason, Nebo, N.C.

Martha G. Tonissen, Registrar, Mint Museum of Art

—R.S.

Figure 55. Kenneth Noland, Virginia Site, *1959, acrylic on canvas, 70 by 70 inches (177.8 by 177.8 cm). Courtesy Joseph Helman, New York.*

The Post-War Period, 1950 to 1980:
A Critic's View

by Donald B. Kuspit

Examples illustrate a point of view: the works chosen here are meant to illustrate the South's sense of itself. They are representative of a half-mythical, half-factual construct, a mix of fact and fiction—to borrow from the title of Goethe's autobiography—about the life of painting in the South during the last thirty years. Not that I won't deal with trenchant themes, such as the assimilation of modernist ideals of painting—the pursuit of materialist purity, involving an exaggerated sense of the medium's integrity. But I want to deal with them suggestively, even speculatively—up to a point—as when I want to insist that at one important moment in the general development of modernism, a moment usually associated with the turn to stained canvas by Kenneth Noland and Morris Louis (mid fifties), the Southern sense of nature as ideal was catalytic and indispensable, however much it was no more (no less?) than an unconscious presence in their painting. Yet Southern light and a latent if indeterminate sense of Southern landscape—the experience of the South as a place where landscape rather than cityscape was for a long time dominant—conditioned the sensibility of the serious Southern modernists as much as modernist practice.

The works selected for this exhibition count toward an understanding of Southern ideology because of my sense of what criticism is, not because they are all "Southern" in some elementary if finally inexplica-

ble way. (It should be self-evident that every curatorial selection is a profoundly critical, interpretive act.) To be critical is, in Alfred North Whitehead's words, to fuse "a large generality with an insistent particularity."[1] It is also to assume that no work of art has any durable insistence without the power of generality to sustain it. The "Southern" aspect of the exhibition unavoidably introduces and necessitates the note of generality; it is central to curatorial responsibility to extend it until it adequately covers the works chosen.

One of the curatorial decisions imposed by the curators as a group and happily accepted by me was that, for the sake of maximum flexibility and openness, my section of the exhibition should contain a sampling of works by non-Southern artists. This was not to indicate that the boundaries of the South were in doubt, but to extend the problematic aspects of the exhibition. Birth or residence in the South was not to be the most crucial criterion of inclusion, but imaginative affiliation with the region was to count highly. A display of "sentiment" for the South, responsiveness to it as an environment and a mentality, unmistakable interest in what could be conventionally taken as signs of the South were to count as more authentic indications of Southernness than the fact of physical presence in it. Habitation *by* it was to count for more than habitation *in* it. Thus, I was free to include Larry Rivers's *The Last Civil War Veteran* (1959) (cat. no.

Figure 56. Edward Hopper, Carolina Morning, 1955, oil on canvas, 30 by 40 inches (76.2 by 101.6 cm). Whitney Museum of American Art, New York 67.13.

151), and to illustrate Edward Hopper's *Carolina Morning* (1955) (fig. 56). Both—memento moris in the current climate of Southern opinion—are poignantly Southern, less by reason of the associations they evoke than by the way they isolate and vividly articulate semi-autonomous emblems of Southernness, symptomatic scenes of some enigmatic entity called "the South." Also, these two works tell us something about the society that conditioned representation of the South, just as the light in Noland and Louis tells us something about the nature that conditioned the making of abstract art in the South.

Integrating Southern and non-Southern artists also allowed me to jump right into the problem of regionalism, which conditions the entire analysis. Southern art sometimes seems the case in point of a regionalist art, which is why particular effort was made to view the works in the exhibition in terms of the regionalist issue and to use that as my leading generality. Inclusion of George Bireline, therefore, is in part to illustrate the conflict between cosmopolitanism and regionalism. In his 1965 painting *Malcolm's Last Address* (cat. no. 153), which signals his first major phase of development, Bireline shows a cosmopolitan acceptance of modernism. But in *Crushed Cups, Coat Hanger, Tape* of 1981 (cat. no. 154), an example of his second major phase, Bireline retreats to more realist, and thereby indirectly regionalist, interests while retaining the modernist concept of the shaped canvas. The use of seemingly incidental subject matter at hand is emblematic of rootedness. Acceptance of the concreteness of place is implicit in the acceptance of objects. The welcome given to their commonplaceness is a welcome given to the local—or locale.

Similarly, inclusion of pictures such as Martin Hoffman's *Open Road* (1972) (cat. no. 158) and Victor Huggins's *Pilot Mountain* (1976) (cat. no. 161), raises the issue of relationship to the land, a fighting matter—bedrock problem—for regionalists. These works subtly expose the conflict between the forces of modernization, symbolized by the seemingly invincible and inevitable flow of the highway, and the natural environment, with its slower rhythm and, for the regionalist, finally stronger current. For all its apparent tranquility, nature has the effect of undertow in these works. The sense of nature as obviously sublime in Hoffman and more subtly sublime in Huggins counteracts the sense of social progress the highway brings. Modern regionalism arises in part in response to such presumed progress. Refusing to be indifferent to the fate of nature in the face of technology, it asserts nature as the ultimate. The South is among the last places in America where its stand can be sustained. Its pro-nature position is inseparable from the South's sense of integrity, and it is also an expression of its instinct for self-preservation, its desire to retain its myth of itself.

To conclude this preface, I would like to note something else that is obvious: I have deliberately tried to offer a differentiated view of modern Southern painting, forcing the spectator to contrast rather than fetishize single works. Singularity in art has been exaggerated, but this does not mean we must assume dominance by a collective uniform style. Works instead fall inevitably into constellations, which, like those in the sky, may indicate a propensity for myth-making. The simple point, however, is that they do not stand alone, stylistically or culturally. An obvious enough point, but fetishism runs rampant in the art world. The urge to create a totemic hierarchy of value is pervasive. Only by fighting that urge can one make clear that there is more at stake in art than art, a fact that seems to be truly the case in Southern art.

I

One can regard the post-World War II prospects for painting in the South either optimistically or pessimistically—both of which deny that there is any particular "problem" of painting in the South. Writing generally about the arts in the South, Pat Watters observed, in 1969:

> So the arts, cut off from the bloody yet beautiful soil of the South's racial reality, its prime reality, have mostly been playthings of the rich and powerful in their more frivolous, harmless moments. They have been caught in systems of dependency, not unlike those of education, and have moved easily into the less arbitrary, less ignorant systems of national foundation grants and federal grants and federal and even state government subsidies. They have little relevancy to the life of the South or to the mass of the people and, as under the old system of private patronage, have continued to lack spontaneity and originality and have gone on being bland and tame and given to authentic imitation. There were brave efforts in nearly every large city and many of the small places to break away from such a pattern—independent, experimental theatres, dance groups, musical efforts, painting, and the like. But these were overshadowed by such pre-emptive moves of public and private power as the craze for massive and expensive 'culture centers' and by such degradation of public taste as the high priority placed by governments on sports arenas.[2]

147

Elizabeth C. Baker, writing more optimistically in 1976, notes that while "dispersal is a key word for art in the Southeast," and that "it certainly does not constitute an art *center*," not only is "the region . . . full of art" but "the level of artistic practice is immeasurably more professional than it was, let's say, 20 years ago. Serious art-making is increasingly widespread, and the strength of all kinds of local art institutions is growing." Finally, writes Baker,

> Regional art today has a totally different meaning from the one it had in the '30's. Then it was a self-consciously conservative, embattled, anti-modern movement. Today's 'regionalism' is simply today's art made in various regions. It usually features a relaxed, almost casual move of once avant-garde forms—as does most of the art made in major art centers. The fact that today's regional art is so eclectic and knowledgeable bespeaks an almost universal acceptance of the modern vernacular. Can today's regional art still suggest provincialism in its old, pejorative sense? Yes, at times. But the conditions for making good art are now widespread.[3]

Watters is unequivocally negative about the quality of art produced in the South. It is "bland and tame," lacks "spontaneity and originality," and is altogether derivative. Just how comfortably derivative it is Watters suggests by associating authenticity with imitation rather than originality, as if the South was more genuinely itself when it was following rather than leading. Baker seems more positive, but she in fact is evasive. While she acknowledges the "professional" character of recent art produced in the South, she attributes this more to the "almost universal acceptance of the modern vernacular" than to the quality of individual initiative.

Both writers avoid meeting the issue of regionalism head-on, even though it is implicit in Watters's observation of the derivative character of Southern art and in Baker's remark about the "self-consciously conservative, embattled, anti-modern" character of thirties' regionalism. Perhaps from the regionalist point of view, to be conservative—which would include being imitative, refining already accepted styles—is far from the worst thing that one can be. It may be that to be "anti-modern" is of greater value than to accept every "experiment" that comes down the road just because it is "original." These issues can be met only with a full-fledged sense of what regionalism implies, which neither Watters nor Baker offers.

Is regionalism still a viable issue in this age of information, in which universal instant communication makes us all cosmopolitan? I think so, and Baker hints at the way it is so: as a kind of reaction and resistance to what is conceived of as modern, where "modern" means whatever claims to uproot us from where we think we are—to devalue our own "space" in the name of some supposedly universal space. It is as if not to share in this universality was to lose the value of our particularity. The region may no longer exist in a strictly physical sense, but it certainly exists in a mental sense. As I have written elsewhere, "the region is defunct as an effective reality, although the myth of the region is not."[4] This "mythical regionalism," as I called it, is a form of "compensatory idealism," "an abstraction which means to assert humanity in the abstract" and thereby to counteract and undo the dehumanizing effect of abstractions and of the abstract frame of mind itself in our lives. It is especially the universality imposed by technology and the inevitable consequence of what Jacques Ellul called the technical state of mind that regionalism means to thwart and outwit.

Mythical regionalism begins to do this "through a yearning for a neighborly or for a simpler, 'landed' existence, in which one is as bound to nature as one is to people." This insistence on a more rooted, fundamental, particular existence is reflected not simply in the subject matter of art but in the cautious way "universal" styles are assimilated, the way they are broken in for use. From the modern regionalist perspective, the point is not where one's culture comes from but how one uses it locally, how one makes it one's own. To regard this process of appropriation simply as a matter of "derivation" or "professionalization" is to misunderstand it profoundly. Regionalism amounts to a kind of heroic opposition to modernity, or at least a determined modification of it in the process of absorbing it. At the same time, the revision of regionalism under the pressures of modernity broadens the concept of nativeness. Defenders of the region are not just native sons but are also those who have a concept of it and who believe in living in terms of their concept, those who "think regionally."

The dialectic between regionalism and cosmopolitanism—in art, between minority and mainstream styles—is an aspect of what John Higham calls "the interplay between pluralism and opposing theories of assimilation."[5] Regionalism implies pluralism, cosmopolitanism represents the opposing theory of assimilation. They are not irreconcilable, however, as Higham makes clear:

Figure 57. Ray Kass, Winged Earth, St. John's Mountain. *(cat. no. 166).*

Thus pluralism posits a situation in which minorities retain their plurality and effectiveness; but it does not welcome all such situations. A pluralist wants to develop a mutually tolerable relationship between discrete groups, and the social system in which they reside. Specifically, he seeks a relationship that will allow the individual groups both autonomy and unimpeded influence. He opposes assimilation on the one hand, because that threatens group survival; but he also opposes separatism, because that will exclude him from the larger society. Accordingly, pluralism addresses itself to the character and viability of an aggregate that has several components, and its special challenge arises from the attempt to define the aggregate in terms that none of its principal components need find unacceptable.

Higham also notes:

The belief that a well ordered society should sustain the diversity of its component groups has, of course, deep roots in early American experience, but it became subordinated during the 19th century to the quest for unity.

One might say that modernism represents a unified, self-consistent style to which all other styles must submit. From the pluralist point of view, moreover, the question is whether these other styles can retain any semblance of autonomy while assimilating the style of the larger society of art. The advanced Southern painter does not want to be separatist, but he also does not want to lose his individuality. He wants to join the mainstream of modernist abstraction, but he does not want to give up his Southernness in the process. "Southernness," whatever that may finally be, survives only as a disguised residue, as in the case of Howard Thomas, who used pigments handmade from native soil, a fact that one can hardly know looking at his abstractions. Southernness may be the trace of an attitude, represented by a title, as in Ray Kass's *Winged Earth, St. John's Mountain* (1980) (fig. 57; cat. no. 166), or by an image, as in Jasper Johns's *Studio* (cat. no. 152), where a palmetto leaf makes a shadowy appearance.

The point is that the assimilation of modernist style is a cognitive matter, a matter of the acquisition of a kind of knowledge. As the psychologist Jean Piaget shows, all such acquisition is authentic to the extent that it is a matter of accommodation as well as assimilation. Watters directly and Baker indirectly regard Southern art as entirely assimilative, essentially derivative. I see it as accommodative as well; I see the best Southern artists as bringing something of their own to modernist style, creating a synergistic effect between it and their attitude to it. The assimilation of modernist style is particularly demanding from the point of view of accommodation, for modernism seems to dissolve all other values in its fundamentalism. Cultural values in particular seem lost in the face of modernism's absolute sense of art. They become an incidental ideology distracting from the ineffable concreteness of art. But from the cultural point of view—from the point of view that there is no escaping a cultural pre-conditioning—modernist style is an opportune new matrix for nourishing culturally neutral style.

There is a larger general issue here: whether abstraction as such escapes cultural pre-conditioning, as it sometimes seems to want to do. Heinrich Wölfflin has written that within the homogeneity of any style "we must reckon with the permanent differences of national types,"[6] and we might add of regional types, each of which conveys a distinct "life-feeling" and has different "emotional values."[7] This is perhaps overstated, but it makes the issue clear: the concept of the regional retains its value only if it implies an alternative orientation to art. Only if it poses a threat to the hegemony of mainstream style—perhaps thereby saving it from itself—does it make sense. It may no longer make sense in itself, as it once seemed to in provincial America; but it still makes sense as a reminder of a culturally creative individuality, however inconsequential that might appear in the face of a transcultural style. The regionalist attitude may finally be as shallow as the cosmopolitan attitude sometimes appears to be, but it represents critical resistance to what fraudulently declares itself inevitable.

John Shelton Reed notes that "region is a summary construct," which "often captures (imperfectly to be sure) a set of historical experiences, socialization patterns, life styles, and . . . cultural differences." There is also "an *intrinsic* aspect of region," having to do with "the simple fact of residence in a particular area, implying exposure to a peculiar climate, soil, and terrain."[8] Such residence—and I would argue that it can be entirely an emotional matter, although the strongest emotion is undoubtedly the result of physical dependence on the area—ideally creates an active identity. It is not simply taken for granted but consciously asserts itself in an alien area as a reminder of its own values. To the extent that this is true, a region, as Reed remarks, "serves not only as a membership group, but as a *reference* group"; this is why it is a "variable" concept, as much psychological as geographical in import.

In the South, what one refers to when one refers to oneself as Southern is a highly emotional awareness of nature as a dominant force in life and the sense of a social style that at once codifies that awareness of nature and represents an accommodation to it. As Richard M. Weaver writes:

> Southern piety is basically an acceptance of the inscrutability of nature. Under its impulse the individual Southerner feels that nature is not something which he is to make over or change; it is rather something for him to come to terms with.[9]

The South is not quite the Mediterranean world of Matisse, but there is still a sense of "luxury, calm, and voluptuousness"—the promise of happiness—to it. At the same time, as in every potential paradise, there is the sense of something amiss in it; for this reason, as Robert Gordy has said, "artists in the South seem to share . . . an interest in Surrealism, a wacky, oblique American version."[10] Or, as Colin L. Westerbeck, Jr. writes, "they share a sense that there is about the South something incongruous, manic, vaguely sinister," which demands a "baroque, quasi-surreal style like William Faulkner's."[11] This "incongruous, manic, vaguely sinister" aspect of the South emerges directly from—and is the not so invisible other side of—its nature, which, uncontrolled, can be as dangerous as it is decorative. Its very decorativeness can make it dangerous, for naive appreciation of it can lead to letting it run wild. Thus Westerbeck singles out as emblematic of the South a photograph of "two black men standing in a road literally engulfed in kudzu." The "craziness" of this "extraordinary image" shows the self-destructiveness of a natural paradise.

What is extraordinary about the South is that it is a realm of *intrinsic* self-contradictions, contradictions that grow from within, both in nature and society. Consciousness of these contradictions and of the need to accommodate them is what has led to the South, until recently, bypassing what Arnold Hauser calls the

modern "experience of the world." This involves the sense of it as being all "motion and change," entirely an "experience of time" in which time is not a matter of "permanence and continuity" but "the dominion of the moment."[12] To accept such "unprecedented dynamism" would be to graft what is extrinsic on what is intrinsic, to grapple with external rather than internal problems. The best in Southern art has always emerged from a grasping of and struggle with inherent contradictions. One might call them originative contradictions, contradictions there apparently from the beginning of time, conditioning history, offering a sense of permanence and continuity to counteract its changes and motion. It is the way these often stark contradictions emerge through time-bound style—the way the best in Southern art is not only the mediation of a historically important style but the use of it to articulate inescapable contradictions—that my part of the exhibition is about.

II

Let's begin with something pure and simple, Josef Albers's *Adobe* (fig. 52; cat. no. 149), a work that epitomizes the fundamentalism of modernism and that has the additional value of reminding us of Black Mountain College in North Carolina, where Albers taught for many years (1933-49). The work seems to deal with strictly formal values, to denote them in a direct way, as if to remind us that, strictly speaking, a painting, in Maurice Denis's words, is nothing but "a plane surface with colors assembled in a certain order."[13] Albers's work represents the mainstream of modern art as well as the reductionism of modernism, and Albers's residence at Black Mountain represents the serious beginnings of modernism in the South. Strict planarity, the use of gestalts in whatever pattern of interaction, color that remains skin deep: the whole point is to stay on the surface with presumably no cost to connotation, which in any case is hardly desired. Albers represents cosmopolitan painting, a mainstream style—an art that insists on what might be called presence without point, presence which is the only point. Whether Albers's Black Mountain residence, with its idyllic rural setting emblematic of Southern nature in general, affected his style is a matter of conjecture which, in the context of our discussion, hardly matters. Albers's noted "Prussianism"[14] indicates a certain inflexibility, a rigid outlook that seems the ironic apotheosis of the Bauhaus "sense of cleanliness and order based upon the proper subordi-

nation of material to function and of function to communication."[15]

"Despite the fact that in his own work Albers is so centrally concerned with demonstrating to us the illusive nature of symmetry, the asymmetrical reality that lies behind all seeming equilibrium,"[16] he came to symbolize the discipline of modernism. Called "a disciplined romantic" by one of his Black Mountain students,[17] in the South he was more important for his discipline than for his romanticism, of which the South had enough. He taught the discipline of working with a limited vocabulary and a definite syntax, and perhaps above all the discipline of limited expectations and precise results. The sense of an art that was describable and measurable, that did not lend itself to mystification, was tonic for Southern art, which until Black Mountain had been essentially a variant of American Scene painting. The tautness Albers demanded and his sense of art as an autonomous enterprise, if eventually influential on life through design, were enlightening in a scene where art was not only dependent on nature but had no sophisticated sense of nature. Nature was a fact of life and a source of nostalgic emotion, which at once reinforced its dominance and mystified it. As visible in Southern art, the Southern relation to nature was not particularly profound but steady. Albers swept away what had hitherto been taken for granted, putting art-making in the South on an entirely new basis. What the immigration to America during World War II of modern European masters meant for the New York School, Albers almost single-handedly meant for Southern painting.

Albers affected individuals, however, rather than generated a school. George Bireline's painting *Malcolm's Last Address* (cat. no. 153) shows this influence directly. Bireline, who exhibited in the *Post-Painterly Abstraction* exhibition organized by Clement Greenberg in New York (1965), completely assimilated the reductionist mentality. All is ironical order and indirect regularity in his work; its mural scale reflects the sensibility of the New York School. This work is free of any kind of environmental influence and parochialism but represents a self-certain high modernism. The edge—the rectilinear shape of the canvas—determines the work, so that all of its aspects remain intrinsic. There is nothing particularly Southern about this work; it represents "professional" abstract painting at its best and before it has been "vernacularized." Yet the fact that it was made in the South—in North Carolina—shows something about

the way the South had changed, the way it was ready for the "modern," if not in an indiscriminate way. Bireline's painting represents not only the acculturation of a style but also the readiness of the South for a new style. Paradoxically, his cosmopolitanism introduces a fundamental change in the conception of what regional art can be. Rather than defensively closed in the name of intrinsic values, it can be truly pluralist—free of any suggestion of separatism. At the time Bireline painted the exhibited piece, Southern art was largely realist (if less so than in the past), so that to accept authentically non-objective art was to be authentically pluralist. The abstraction that hitherto existed was less formalistic and austere, more a matter of an abstracted love of nature than the assertion of an autonomous art.

Prior to Bireline, the artist who seems to me to have been the most full of non-objective potential and to have most understood the formal values and spiritual issues at stake in modern art was Howard Thomas. Thomas's paintings exemplify what might be called a de-assimilation of nature, which is left as a kind of memory-trace in the pigments he used, handmade from native soil, and in his titles. While there is continuity of naturalistic reference in Thomas's work, more importantly there is an understanding of Mondrian's conception of dynamic equilibrium and of Cubism. Working with a more or less explicit grid and with a conception of strong color establishing a rhythmic beat essentially independent of linear control, Thomas establishes a subtly vibrating yet non-illusionistic surface. As in *Festival Mountain* (cat. no. 155), his work takes its place in the modern tradition of the energized surface, the surface that exists for itself in all its simultaneity and equivalence of parts, the surface that exists musically with that all-overness and gives a sense of instantaneousness. While Thomas's methods are accretive, his results are holistic, but in a sense of totality that owes more to Mondrian than Pollock. There is a lyric effect to Thomas's handling that is the result both of the staccato way the grid structure manifests itself and the way the color "spots" the picture's surface. It is this effect—as well as Thomas's loyalty to the right angle, the Cartesian coordinates, as an organizing principle—that makes his pictures less than insular yet delicately restrained. His handling does not altogether free his energy, which remains carefully regulated. He builds density with the frailest of means, offering us compact works with a slowly mounting "transcendental" effect. The arguments that have been used to discover transcendence in nineteenth-century Luminist paintings can be brought to

bear on Thomas's "interior landscapes." Yet from the point of view of the development of post-World War II painting in the South, what counts is his full understanding of how far one can go with purely formal means—how, on their own, these means can suggest an effect almost independent of nature. Thomas's work may still be bound by physiognomic considerations, but he has understood the physiology of the new abstraction.

What Kenneth Noland's *Virginia Site* (1959) (fig. 55) teaches us is that abstraction can be site-specific while being formally hermetic. For all its detachment, it remains attached to certain "illuminations" not unconnected to place. According to Kenworth Moffett, Noland's piece is part of his "breakthrough" into significant modernism—which had begun earlier in works such as *Ex-Nihilo* (cat. no. 150)—extending its sense of "opticality" and touch with a new finesse. Yet the title seems to me far from accidental; it indicates that a particular Southern presence was in part responsible for an abstract vision. Jules Olitski has written:

> Although I enjoy the Florida landscape, sea and sky, it does not influence my painting. Painting is an internal vision—there is no escape from oneself. I express visually what is most meaningful to me.[18]

This implies a solipsistic sense of vision, which Noland's title throws in doubt. Can vision remain exclusively internal, unaffected by what is external? However much the external is filtered by what is meaningful to the artist and however much the meaningful becomes entirely a matter of what Greenberg called the "formal facts" of art, these facts are charged with the reality of their external origin. Internal vision is the residue of an external vision; even the formalist filter that is used to clarify the former originates externally. The sense of reduction to the elementary and the elemental that is evident in the Noland is not entirely a matter of inner necessity but a purification of external experience until certain variables in it appear to be autonomous, partly because they are isolated. Embedded in the canvas, Noland's concentric circles may appear to have an integrity of their own; but it is the experience of them as site-specific that gives that integrity its energy.

I do not mean that Noland found his circles in nature or that their color is naturalistic, but that the intensity and specificity with which they are rendered are inseparable from an experience of being profoundly at home in actual space. Noland's painting is an epiphany of what it means to be contained, in Ezra Pound's phrase, by "bright space"—space alert with the life of color. This is more than a formal matter. It is

Figure 58. *Edith London*, Dawn and Dusk in Unison *(cat. no. 173).*

the calculated result of a response to the shape of the canvas; a shape antithetical to it is used. There is nothing inherent in the shape of the canvas or its flatness to generate the kind of intensity Noland achieves. Are the qualities of space more discoverable in the South? I don't think so. I am only saying that for Noland, a Southerner, the sense of pictorial integrity is inseparable from the sense of experienced space which was first "real" in the South. Noland's shapes are sited on the canvas not to function as metaphors for the Virginia cosmos, but rather the "cosmic" aspects of Noland's image are inseparable from an external perception of what is original or basic to space. Nonobjectivity can never escape externality and always implies an abstraction from certain fundamental qualities of space. The point is not that Virginia is somehow implicit in Noland's painting, but that a reference to real experience is. This opens the way to an alternate understanding of modernist works, an understanding that is cultural to the extent that it implies an "original" world that is the source of the artist's vision of sensibility.

In any case, the South had a hand in the development of modernist painting. Certainly Noland's attempt to develop his own "special configuration" is inseparable from Black Mountain, where he studied (1946-48) and where it was believed that such a "configuration never quite seen before" might, depending on its "force . . . end up by changing local

'reality.' "[19] It may not have originated in response to local reality; but its transformation and transcendence of that reality cannot help but clarify the meaning of what is local. The kind of intensification and clarification—of the meaning of local?—Noland offers is inseparable from Black Mountain idealism, which was based on "a concern with the relationship between art and life." Black Mountain, said Albers, "represented a 'creative vacuum—freedom,' " and as such offered "opportunities, not necessities."[20] In this sense it was like the South as a whole, at least with respect to art. It was a vacuum which one could fill with one's own "special configuration," which had the aura of a free creation about it. Paradoxically, in art the South was free territory. Modern art, in the person of Albers, appeared as a reification of its freedom, not as a new slavery. The real slavery was to the image of the South as a unique scene.

In the mid sixties numerous Southern artists began moving, in their own ways, toward what Gauguin called "decorative abstraction," a good part of which had to do with what he regarded as "the musical role" color would "play in modern painting."[21] In the work of Ida Kohlmeyer, William Halsey, Syd Solomon, and Edith London one sees a number of different approaches to "musical painting." Kohlmeyer's planes of color—seen in *Cluster #1* of 1973 (cat. no. 159)—are arranged in a grid, and London's—*Dawn and Dusk in Unison* (fig. 58; cat. no. 173)—are arranged in terms

of a more informal Cubism, derivative from its Synthetic phase. Solomon and Halsey show a more expansive touch, both tending to the calligraphic—Solomon in *Tripeast* of 1977 (cat. no. 163), Halsey in *Thira* of 1981 (cat. no. 148). In Halsey, this becomes explicitly hieroglyphic. An early scenic work of Halsey, the 1946 *Back Street, Charleston* (cat. 147) is included in the exhibition by way of contrast; his development embodies the change from the realist to the abstract, the scenic to the modernist in Southern painting. In Kohlmeyer and London there is a greater acceptance of pictorial closure than in Solomon and Halsey, although the discontinuity between the two parts of London's diptych opens the space within each part. In the Solomon and Halsey the spill of color and stroke—the emphasis on their gestural potential—is in the name of latent symbolist intentions. The display of instinct, the readiness to take the picture more as a dream space than as truly autonomous or truly continuous with ordinary space, is more evident in their works than in those of Kohlmeyer and London. For the latter the forms are more autonomously what they are, especially in Kohlmeyer. Yet their independence is mediated by lyric color, giving them a potential for what Albert Aurier called "transcendental emotivity." In Kohlmeyer and London the forms function iconically, in a restrained way. In Solomon and Halsey the iconic implications are perhaps more blatant, as if they want to command the detached space with their color. The level of energy differs in the four, but their level of intention does not. It involves a search for lyric effect within formal autonomy, essentially a symbolist search within the decorative ideal. The decorative is for them realized, as it was not for Gauguin. Their problem is not to take it for granted, to keep it from being mechanical. They achieve this by understating its meditative potential.

The exhibited works of Sam Gilliam, Richard Kevorkian, Frank Faulkner, and Ray Kass search for what I would call an epic effect within the modernist idiom. While the work of Kohlmeyer, London, Solomon, and Halsey share in their different ways what Aurier called "the gift of emotivity," Gilliam, Kevorkian, Faulkner, and Kass have a hallucinatory dimension, which, in Maurice Denis's words, is something "about which aesthetics has nothing to say, since reason itself depends upon it and exerts no control."[22] For all its emotivity, the former group of artists is more esthetic and rational in its modernism than the latter, who offer, however obscurely, an exalted image of

surreal effect. Where the former achieve, in Hans Hofmann's words, "the symphonic animation of the picture plane"[23]—in Kohlmeyer and London almost entirely of slow movements, in Solomon and Halsey predominantly of fast movements—the latter discover in the musical surface a disguised image. In Henry James's phrase, they reveal "the figure in the carpet." This figure never quite emerges into total objectivity, although a snake and hands are clearly visible in Faulkner, wings in Kass, a horizon in Kevorkian, and narrative implication seems evident in Gilliam. What emerges instead is a sense of unresolved contrast within the piece, creating a tension from which an image seems to emerge, a tension that is itself the end result of the work and seems to articulate itself in a form.

Their works are visionary rather than merely esthetic, spiritual rather than merely modernist. Their surface wants to reach a certain destination—wants to be intimidating, not simply playful; truly adventurous, not simply impassioned. In this sense, there is something indiscreet about the paintings of Gilliam, Kevorkian, Faulkner, and Kass—something potentially heroic and uncomfortable. Gilliam works with a number of boldly conceived yet chance-created forms in *Blue Isolate* of 1980 (cat. no. 167). He sets them against an indefinite, gritty blue surface, which ecstatically isolates in the contrast. Kass, in *Winged Earth, St. John's Mountain* of 1980 (fig. 57; cat. no. 166), uses the sense of light as emanation rather than illumination, giving the planes a certain transparency for all their heaviness, creating a peculiarly idyllic restlessness. In Kevorkian's *Toluidine Red* of 1974 (fig. 59; cat. no. 162), the confrontational directness of the red on its pedestal of yellow, blue, and white—a weighted pedestal built up of subtly conflicting densities—becomes oppressively forceful, exhausting the resources of our perception. It becomes clogged with the weight of red, with its overwhelming material fullness. The lushness of the pulsing surface in Faulkner's *Arabia Felix* of 1981 (cat. no. 170) makes the snake more emphatically voluptuous than its own sinewy movement. The decorative repetition of hands also becomes voluptuous. Most sensual of all, however, is the compulsive interplay between the patterns, especially in the constant shift of relations between the color pools. These finally make all placement not only unstable but incomprehensible.

All of these works show tenacious evocative power. They go beyond the denotative display of forms

Figure 59. Richard Kevorkian, Toluidine Red *(cat. no. 162).*

to a realm of connotation, caught as if in the process of formation. They have that hallucinatory intensity that suggests an attempt to reconstitute vision, to give it a new urgency and mystery. Elements immanent to art are explored for their suggestive potential; the "suggested" image is not imposed yet arises with a certain inevitability. It is not easily forgotten and seems to correspond to what is basic to consciousness, understood to work in elemental metaphors. Wings, a snake, the horizon, abstract narrative flow—these all make manifest the latent movement and openness, the sense of the infinite, inherent to our own consciousness, its very substance. Where Kohlmeyer, London, Solomon, and Halsey make clear consciousness' need for finitude, Gilliam, Kevorkian, Faulkner, and Kass disclose its inner infinity, constantly asserting itself in half-familiar forms, in half-"other-worldly" images.

In James Herbert's *Plump Head* (1978) (cat. no. 172), Mike Nicholson's *500 Years of Rape* (1980) (cat. no. 168), and George Bireline's *Crushed Cups, Coat Hanger, and Tape* (cat. no. 154), modernist conventions are pushed into irony. In Herbert's work, splashes accumulate into figures; in Nicholson the field becomes the setting for "collaged" events; and in Bireline the canvas shape becomes a scenic frame, a kind of proscenium arch, for objects. In all three cases there is a sense of using what is inherent for external purposes, thus a sense of the arbitrary. Yet that arbitrariness is the sign of an adventurous extension of artistic possibilities. The possibilities of figuration that emerge in all three cases signal not a desire for referentiality but the experience of representation as an issue in all art. It is one that is not dismissed at will or avoided by abstraction, nor met indirectly by it. Abstraction—whether in the form of emphatic touch, field, or shape—becomes instead the raw material of representation, the possibility of which is always inherent in the imagination. Indeed, in the work of Herbert, Nicholson, and the late work of Bireline, we see the urge to representation that was already evident in the work of Faulkner and Kass emerge from and slowly begin to dominate the reductionist tendency of modernism. Modernism is counteracted from within; imagination—in Baudelaire's sense of the term, the recreation of the world—shows its inescapability in art. Indeed, it can be argued that modernism, with its reduction of art to the terms of the medium, is an attempt to eradicate imagination, which is blindly regarded as extraneous "literature." In this group of works we see a demonstration that imagination is inherent to all art-

making. Imagination cannot help "decomposing all creation, and with the raw materials accumulated and disposed in accordance with rules whose origins one cannot find save in the furthest depths of the soul, it creates a new world."[24] It is these "rules . . . in the furthest depths of the soul" that reassert themselves in Herbert, Nicholson, and Bireline. They give us the sense, despite their difference in means, of being involuntarily possessed or haunted by their own depth-perception of reality. Herbert evokes figures monstrous to the extent that they cannot be purged, much as Bireline is haunted by inescapable objects of everyday life that loom abstractly over us, paradoxically dominating us. Nicholson's charged field is the setting for ghost figures of past conflicts. Even history, if only as a residue, enters abstract art, showing us that it is not as hermetic and "transcendent" as it supposes. Figures, objects, events are all historical; subjects of the historical imagination—and all are martyred by abstraction, yet revived through it. Informal yet nonetheless potent presences, disputing the dominance of empty material and form—the figures emerging from the paint in different ways in Herbert and Nicholson, the cups against the triangles in Bireline—make clear not only that representation haunts abstraction but also that the conflict and subtle cooperation between the two is the essence of art. They can coincide and coordinate, but they also negate one another. Art may be ultimately imaginative, but it sometimes pretends to be pure. While it sometimes must be pure to be imaginative, the imaginative is only fully there when one has the sense of the world reconstructed on subjective grounds.

In the Gorky, de Kooning, and Johns landscapes—and I do not hesitate to call Johns's *Studio* (1964) (cat. no. 152) a landscape (perhaps more properly, a still-life landscape)—the subjective is signalled not only by the vigor of the stroke but also by the general sense of alienation of the scene. The Southern landscape was terra incognita for Gorky and de Kooning, who imposed their own dreams and agitation, their expectations, on it. As in *Virginia Landscape* (cat. no. 146) and *Ashville* (fig. 60), they responded to the landscape as psychological catalyst or opportunity, rather than as objective terrain. In Johns's work the landscape was habitual and included the everyday objects of his studio home, which was then on Edisto Island off the South Carolina coast. These objects exist as collage shadows of place, traces of external environment signalling internal environ-

ment, the inner life of the studio. It is no accident that Johns chooses the door that guards his privacy and the palmetto pine leaf that guards his hearth as emblems of his studio. He absorbs tokens of the environment into his art until they become emblems of its preoccupations: the inner meaning of public signs is personalized in memory, and the equivocal mediative power of art's materials and forms tend to become mediative ends in themselves. The work itself becomes an alternate environment, full of worldly accumulations, exhibited for a half-formed purpose. It is the quizzical aspect of all three landscapes that is most entrancing. They suggest an inner uncertainty of relationship to the environment, a searching of it not just to confirm that one has instincts but to "guarantee" them by evoking them. For this uncertainty reminds us of the South's own uncertain relationship to its nature, to its suspicion that it may not be so ideal after all, that it may not signal the best of all possible worlds. We personally want it to satisfy our desire—to draw out and to evoke the last bit of desire so that we are finally "free," if only momentarily and in our own consciousness. But nature may be a reminder that desire is inexhaustible and regenerates spontaneously, that it is only temporarily and illusorily quiescent. Nature becomes the symbol of unregenerate desire rather than desire tranquilized. The toothing of Johns's palmetto leaf is emblematic of this treachery of nature. The asymmetry of the work is as much a form of angry responsiveness to nature as De Kooning's, and to a lesser extent Gorky's more aggressive handling of it. Nature is handled roughly, or treated in one of its aggressive manifestations, to signal an unhappiness with it. It defeats the happy expectations that first led the artist to turn to it. It can be no accident that this kind of ambiguity is played out in the South.

David Parrish's *K. C. Suzuki* of 1982 (cat. no. 174) is more generally American. The macho motorcycle is a symbol of the open road, which also exists in, one might say has invaded, the South, as Hoffman and Huggins also make clear. And Vernon Pratt's *Atmospheric Perspective (129 Grays)* of 1978 (cat. no. 164) is more generally modernist, in a Systemic Minimalist vein. One can regard both, each of which is "classic" in its own way, as "accidents" in the South yet signs of the authentic sophistication and professionalism of its best artists. Both strike me—peculiar as it is to say this—as unusually introverted for Photorealist and Systemic Minimalist works. The image in the former is totally objectified, and the rule that led to the latter is

Figure 60. Willem de Kooning, Ashville, 1949, oil and Duco enamel on Masonite, 26 by 32 inches (66 by 81.3 cm). The Phillips Collection, Washington, D.C.

followed through consistently. The isolation of the motorcycle and the gray of the atmosphere seem to signal a certain inwardness—an untested, indirect inwardness—which I associate, if not uniquely, with the South. One has the sense of Parrish and Pratt as isolated practitioners of their art, whose technical precision becomes all the more insistent the more irreducible their isolation. This isolation has given them clarity and has forced them to triumph over it through the deliberateness of professionalism. They implicitly represent another kind of response to the Southern environment—to its social environment, the art-indifferent environment talked about by Waters. They suggest that artists can steel themselves against their environment by seriously making art based on a principle or attitude alien to it. Indeed, the minimalization of touch, the air of austerity to both their works, makes them alien to the South. They are authentically cosmopolitan works that imply a reaction to the provincial, down-home South.

Maud Gatewood offers us close up what Hoffman and Huggins render from a distance: the South's natural environment dominating the mentality. In Gatewood's *Swinger in Summer Shade* of 1981 (cat. no. 171) the figure blends with the environment; the child has the same density as the trees and is lit the same way. Gatewood has told me of her interest in an interior spatial or "tunnel" effect in an exterior environment. This sense of interiority is psychic as well; it correlates with the sense of nature as indwelling as well as dwelling in nature. This is more than a matter of assimilating nature, of a figure making itself at home in nature. Rather, it articulates the Southern condition of being saturated with nature from the beginning. Nature in this sense is not simply a paradise of plenty but the rhythm determining the inner life's unfolding—a moral force, not simply a platitudinous presence. The distance that is so elemental in Hoffman and Huggins—a sense of visible space as great as the sense of visible light—means exactly what at first glance seems opposite to it: the penetration of a realm of inwardness. Even the fact that the space is too sublime to be at home in signals this, for inwardness is known to the extent we move through it, not to the extent it is there like an object. The movement that is explicit in the Gatewood is implicit in the Hoffman and the Huggins. In both cases it is movement through an unmeasurable space, despite the fact that the swing in Gatewood seems to set a limit to the space. However, the swing only spans the space of our perception, not

the depth of the space which illusionistically tunnels into the picture infinitely. Space is not really blocked by the broad tree trunks, whose clutter is also deceptive. It is the horizon that counts in all three pictures, however compressed in the Gatewood and blocked in the Huggins. The Gatewood also forms an interesting contrast with Edward Hopper's *Carolina Morning* (fig. 56), where the space is static, even stagnant, as if in reflection of the social condition of the black woman depicted. The foreground space is positively clogged by the perimeter of the house, which in its decrepit state also seems "unmoving."

Hopper's painting sounds the social note that is so crucial in the South—the sense of stopped lives, or lives on a certain social track they can no longer even think of leaving. These lives become entirely allegorical, static emblems of a static condition. Despite his assertion that he was interested in the imaginative rendering of perceived reality with the emphasis on "perceived," Hopper deals with social reality. "All dressed up and no place to go" is the message of this picture and of many others in Hopper's oeuvre. A subordinate message is "coming out of nowhere," a weak utopian message. The South was part of the American Scene for Hopper, and he visited it extensively, if irregularly over the years. An earlier work, *The Battery, Charleston, S.C.* of 1929 (cat. no. 118), conveys a sense of stagnation and isolation similar to *Carolina Morning.* But he saw through its seemingly blameless, utopian nature to its guilt, its version of the human condition. Human isolation was far from being a Southern phenomenon; however, the rural aspect of the South perhaps accentuated it. Nonetheless, the South seems to demand a more complete identification with its world and thus gives one a greater sense of being trapped in an exclusively social identity than other parts of the country. One becomes more submerged in the South than elsewhere, for the South seems more demanding in its expectations, in its insistence on loyalty. Much as its nature seems all-consuming, so its society can be all-consuming. Because it does not let one alone, it makes one lonely.

This is the point of Rivers's *Last Civil War Veteran* (cat. no. 151), which deals with an identity swamped by history, an identity that is alive only through history, i.e., only to the extent it is public. It is spiritually as well as physically dying and had been static long before Rivers "recorded" it. Benny Andrews's *Symbols* (1971) (cat. no. 156) deals with the same kind of stasis, allegorically fixed. Indeed, the

basis of the kind of social allegory that both offer is a realistic sense of the way society—specifically Southern in Andrews—"fixes" lives. Such "fixing" has partly to do with the way a pet animal is said to be "fixed," and partly with the way society subverts our potential by categorizing us and then insisting we live within the boundaries of the abstract classification. Both Rivers and Andrews deal with prejudice, pre-judging people whether according to class or skin color, giving them a simple location so as to be able to manage them better. Whatever the symbolic meaning of Andrews's figures,[25] the point is that their lives, as well as the life of Rivers's veteran, are so constricted, so narrow, that they easily lend themselves to unequivocal symbolic meaning. In *The Last Civil War Veteran* ambiguity is introduced by the handling, yet there is the same sense of the absurd as in *Symbols.* In Rivers, the evaporating figure pales beside the flags, also disintegrating and tattered. In Andrews, the contrast between the black and white figures, between poverty and relative wealth, also articulates a sense of the absurdity of everyday reality. But the absurdity simply describes a reality that is immutably fixed, ultimately unchangeable. This sense of the status quo is what the works are finally about. The ironical "devotional" aspects of both works confirm the sanctity, the untouchability of the status quo in American life in general (Rivers), and in Southern life in particular (Andrews).

There is another kind of absurdity indicated in Robert Rauschenberg's *Slow Fall* (1961) (fig. 61) and Blue Sky's *Air Brakes* (1976) (cat. no. 160). We see the South—as many people see the world—from inside an automobile, an absurd position to be in from the point of view of really seeing the world. This is more implicit than explicit in both works, yet they imply the other side of the South—the South as contemporary scene rather than eternal nature. They deal with the South as part of the American highway culture, and two extremes of that culture are represented: the "elegant" backside of a truck and the junk culture and literal junk that flourishes along the highway. Death also exists in the paradise of the South in the form of debris amalgamated by Rauschenberg into some kind of loosely esthetic structure but still demonstrative and threatening. Death is isolated in these works, which imply both a local world and the modern world of progress, whose signs literally litter the environment. In the Rauschenberg, originally entitled *South Carolina*, these come together in the license plate, which is hand-lettered as if to suggest the primitive rural envi-

Figure 61. Robert Rauschenberg, Slow Fall, 1961, mixed media, 59 by 20 by 8¹/₂ inches (149.9 by 50.8 by 21.6 cm). Leo Castelli Gallery, New York.

Figure 62. Russ Warren, Temptation *(cat. no. 169).*

ronment yet at the same time a "modern" sign. An old world of nature and a new world of technology conflict in these works, even though the old world is implicit and the new world is present in its artifacts.

Both works are sinister. The potential for death is great in the painting by Blue Sky; we are following too close behind the truck, close enough to read and to be hypnotized by every detail of its rear. Death's actuality is explicit in the Rauschenberg. It deals with ruined objects built up into a fragile, highly perishable house of cards. Here, the art work is a home for the aged, a haven for the used and abused, things handicapped by their life experience. The irony of the view-from-behind evident in both works is the irony of how "behind" the South is. By catching up, however, it is still "behind," only now in a more universal way.

Subject to conditions universal in our society, it has become even more pathetically common than the rest of the society, for it once was able to resist the ordinariness of American society. The South's nature and closed society, which were confirmed rather than broken by defeat in the Civil War, could not resist modernity, in the form of the machine and the junk it brought in its wake. I find both works morbid in their physiognomy, but elegant physically.

Robert Gordy's 1971 *Arcadian Still Life with Fe-males (Wrinkled Version)* (cat. no. 157), Russ Warren's 1980 *Temptation* (fig. 62; cat. no. 169), and Victor Faccinto's 1976 *Winged Fork* (cat. no. 165) show, in Gordy's words, the "kind of Yankee surreal quality [that] seems to have appealed to an awful lot of artists." This quality involves "a feeling for materials, and a

kind of reductionist scale, a kind of modesty, an introspective, personal autobiographical quality."[26] In Gordy, the surreal quality is conveyed through an ironical sense of the idyllic, with its subject matter of females in a landscape or with the fruits of life. This Arcadian aspect, however ironically mediated and reductively decorative by reason of the style of patterning, seems to me inseparable from the Southern mentality. It is the element of parody in Gordy that seems to me more specifically modern than the element of "luxury, calm, and voluptuousness." A stylized—one might almost say slick—Dadaism masks a quasi-Mediterranean longing for the idyllically erotic, for a lavish, sensual nature. There is more bite in Faccinto and Warren, despite the humor of their images. The seriousness of their subject matter is mitigated by the caricatural nature of their styles. This is madcap, funhouse art, deliberately bizarre and almost routinely naive—artifically naive to give us some distance from the urgency of its theme. The style lets us stand back from the subject matter and makes it almost quaint. This style and the return to figuration in all three artists is as much a sign of the new professionalization of Southern art as Bireline's post-painterly abstract work, perhaps even more so. Bireline was essentially isolated in the South, and in this early period he was linked in the public's mind with New York art. But the Southern neo-Surrealists are not isolated in the South, nor can they be easily linked with a strictly New York movement. Also, as Colin L. Westerbeck, Jr., remarked in the quotation already used, these works are specifically Southern in that they share "something incongruous, manic, vaguely sinister." Despite their reductionist scale, they have a baroque visionary quality; in fact, the scale heightens that quality and makes it more intimate. Even the touch of vulgarity—vulgarity used for visionary purposes, as a touchstone for the absurd—is used with baroque fantasy.

The sense of encountering a vulgar fantasy underneath all gentility, exploding the gentility, seems to me a typically Southern, if not entirely un-American, experience. The tacky, the touching, the sense of charm gone crazy, all masking a sense of something amiss and involuted, are in general at the heart of the contemporary meaning of the provincial, which is inseparable from the strategies and imagery of popular culture. It may be this charm, ironically treated more than some particularly Southern version of popular culture, that animates the styles of Gordy, Warren, and Faccinto. That the craziness behind it cannot be separated from the South makes it particularly compelling. Their work has simultaneously a popular culture and a Southern insanity. Dadaism implies an anti-idealistic vision of social and artistic bankruptcy that neo-Dadaism expects the popular culture to simultaneously end and objectify. The South not only has as much popular culture as any other place in America, but also the advantage of a tradition of eccentricity. So far has the "resistance" of the South degenerated in meaning that it allows a personal assimilation of popular-culture style. It is perhaps finally in its extravagant eccentricity that the work of Gordy, Warren, and Faccinto shows its "provinciality," i.e., its Southernness. ✿

NOTES

1. Alfred North Whitehead, *Modes of Thought* (Cambridge, England: Cambridge University Press, 1956), p. 5.

2. Pat Watters, *The South and the Nation* (New York: Random House, 1971; Vintage Books), pp. 194-95.

3. Elizabeth C. Baker, "Southern Exposure," *Art in America* 64 (July-August 1976):51.

4. Donald B. Kuspit, "Mythical Regionalism and Critical Realism," *Contemporary Art/Southwest* 1 (April/May 1977):10.

5. Quoted by Donald B. Kuspit, "Regionalism Reconsidered," *Art in America* 64 (July-August 1976):68-69.

6. Heinrich Wölfflin, *Principles of Art History* (New York: Dover Publications, n.d.), p. 235.

7. Ibid., pp. 230-32.

8. John Shelton Reed, *The Enduring South* (Chapel Hill: University of North Carolina Press, 1975), p. 9.

9. Richard M. Weaver, "Aspects of the Southern Philosophy" in *Southern Renascence: The Literature of the Modern South,* eds. Louis D. Rubin, Jr., and Robert D. Jacobs (Baltimore: The Johns Hopkins Press, 1953), p. 20.

10. Robert Gordy, interviewed by William Fagaly, "On Location: 4 Interviews, 6 Artists," *Art in America* 64 (July-August 1976):78.

11. Colin L. Westerbeck, Jr., review of " 'I Shall Save One Land Unvisited': Eleven Southern Photographers," *Artforum* 20 (Nov. 1981):83.

12. Arnold Hauser, *The Social History of Art* (New York: Random House, 1956; Vintage Books), vol. 4, pp. 168-69.

13. Herschel B. Chipp, ed., *Theories of Modern Art* (Berkeley: University of California Press, 1968), p. 94.

14. Martin Duberman, *Black Mountain, An Exploration in Community* (New York: E. P. Dutton & Co., 1972), p. 69.

15. Ibid., p. 63, quoting George Heard Hamilton.

16. Ibid., p. 64.

17. Ibid.

18. Jules Olitski, brochure for International Florida Artists exhibition (Sarasota: Ringling Museum of Art, 1980).

19. Duberman, *Black Mountain,* p. 24.

20. Ibid., p. 62.

21. Chipp, *Theories,* p. 75.

22. Ibid., p. 96.

23. Ibid., p. 540.

24. Charles Baudelaire, "The Salon of 1859," *The Mirror of Art,* ed. Jonathan Mayne (Garden City, N.Y.: Doubleday and Company, 1956; Anchor Books), pp. 234-35.

25. Lawrence Alloway, *Benny Andrews: The Bicentennial Series* (Atlanta: High Museum of Art, 1975; exhibition catalogue), pp. 6-7.

26. Gordy, "On Location," p. 78.

Catalogue

The catalogue is arranged in chronological order, according to the dates of the paintings. The five sections of the catalogue correspond to the time frames and themes of the five curators' essays (some overlapping occurs between sections).

Dimensions are given in inches and centimeters, height preceding width. In cases where the owner has provided measurements in inches, these figures have been converted to their metric equivalents.

Provenance is given where known.

Most paintings are to be shown at all exhibition tour locations; exceptions are noted at the end of the appropriate catalogue entries.

1564 to 1790

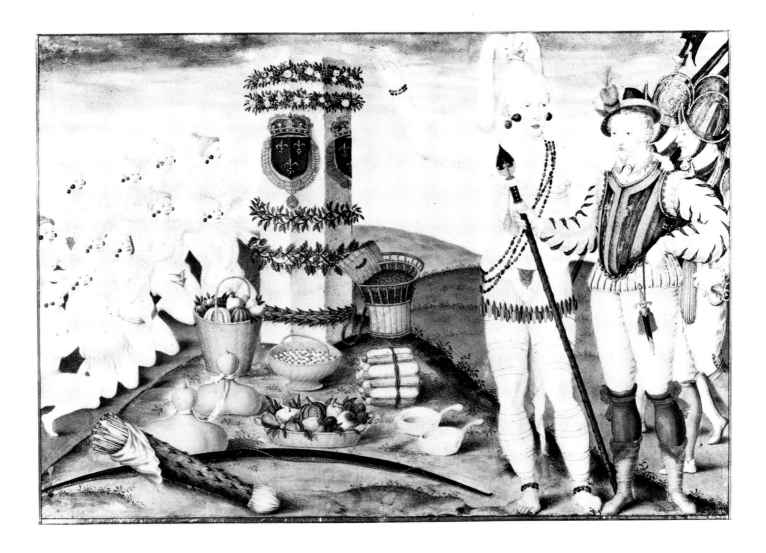

JACQUES LE MOYNE DE MORGUES (died 1588)

1. *René de Laudonnière and the Indian Chief Athore Visit Ribaut's Column*, ca. 1564

 Gouache, watercolor, and gold on vellum, 7 by 10¼ (17.7 by 26)

 Unsigned

 Print Collection, Arts, Prints, and Photographs Division, The New York Public Library, Astor, Lenox and Tilden Foundations

 Provenance: Le Comte de Behague; La Comtesse de Ganay; James Hazen Hyde; bequest to the New York Public Library, 1959.

Le Moyne, a watercolorist often credited with being the earliest European artist to visit and work in the United States, accompanied René de Laudonnière on the second expedition of French explorers to Georgia, Florida, and the Carolinas in 1564. He was ultimately one of the few survivors of the Huguenot settlement on the St. John's River in Florida, which was devastated by the Spanish in 1565. Le Moyne's narrative of the expedition and engravings after his paintings were eventually published by Theodore de Bry (see catalogue entry 2).

This is Le Moyne's sole surviving painting and the earliest known painting of the South and of its native inhabitants. The stone column depicted in this scene was erected in 1562 by Jean Ribaut, leader of an earlier expedition. When the French returned to Florida in 1564, commanded by René de Laudonnière, they were taken to the column by the Indian Chief Athore, whose people now worshipped it as an idol.

Exhibited at the Virginia Museum.

Illustrated in color, figure 1, page ii.

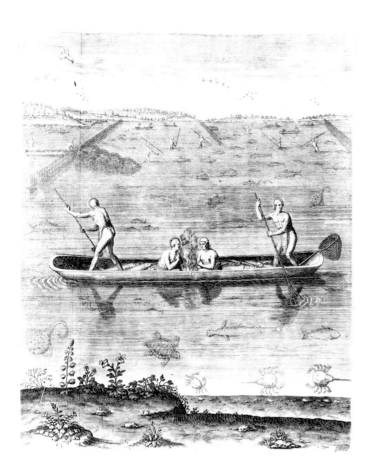

THEODOR DE BRY (1528-1598)

2. *A Brief and True Report of the New Found Land in Virginia. . . ,* 1590 (English language edition)

 Bound volume with engraved illustrations by Theodor de Bry after John White, text by Thomas Hariot

 Arents Collection, The New York Public Library, Astor, Lenox, and Tilden Foundations, Arents no. S. 95

3. *Merveilleux et Estrange Rapport, Toutesfois Fidele, Des Commoditez Qui se Trouvent en Virginia. . . ,* 1590 (French edition)

 Bound volume with engraved illustrations by Theodor de Bry after John White, text by Thomas Hariot

 The Virginia Historical Society, Richmond, Virginia

4. *Admiranda Narratio Fida Tamen, de Commodis et Incolarum Ritibus Virginiae. . . ,* 1590 (Latin edition)

 Bound volume with engraved illustrations by Theodor de Bry after John White, text by Thomas Hariot

 Virginia Museum, Richmond, Virginia, 71.44

5. *Der ander Theyl, der newlich erfundenen Landtschafft Americae . . . Mit Beschreibung und . . . Contrafactur . . . durch Jacob Le Moyne, sonst Morgues gennant,* 1591 (German edition)

 Bound volume with engraved illustrations by Theodor de Bry after Jacques Le Moyne de Morgues, text by Jacques Le Moyne de Morgues

 Arents Collection, The New York Public Library, Astor, Lenox, and Tilden Foundations, Arents no. 40

Theodor de Bry first established himself at Frankfurt-am-Main as a book and art dealer in 1570. He was from a wealthy Protestant family in Liège but had to leave that city to escape religious persecution.

Visiting England in 1587 or 1588, de Bry acquired drawings of American subjects by Jacques Le Moyne de Morgues and John White. It was these drawings that he reproduced as engraved illustrations for his first two volumes on the New World, published in 1590 and 1591—books that strongly influenced the European view of America. His first volume, *A Brief and True Report of the New Found Land in Virginia,* was a published account of Thomas Hariot's narrative, with engravings after drawings by John White. The second volume was published in 1591 in German, Latin, and French.

The second part of DeBry's American travel literature was an account of Jacques Le Moyne's expedition to the French colony in Florida. Le Moyne's drawings, probably made after his return from America, were copied by White and served as the basis for de Bry's engravings.

Unfortunately, only one of Le Moyne de Morgues's original drawings survives, *René de Laudonnière and the Indian Chief Athore Visit Ribaut's Column* (see catalogue entry 1).

A Brief and True Report and *Der ander Theyl:* exhibited at the Virginia Museum

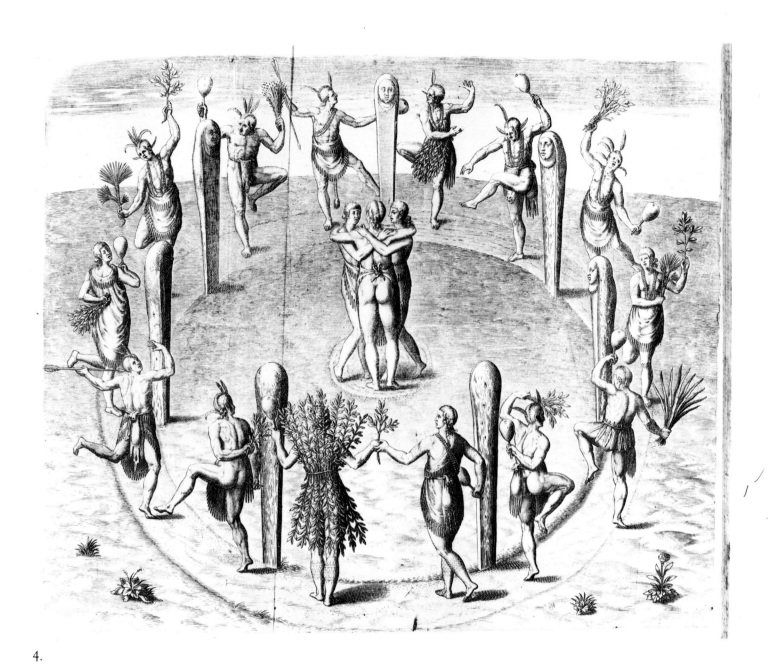

4.

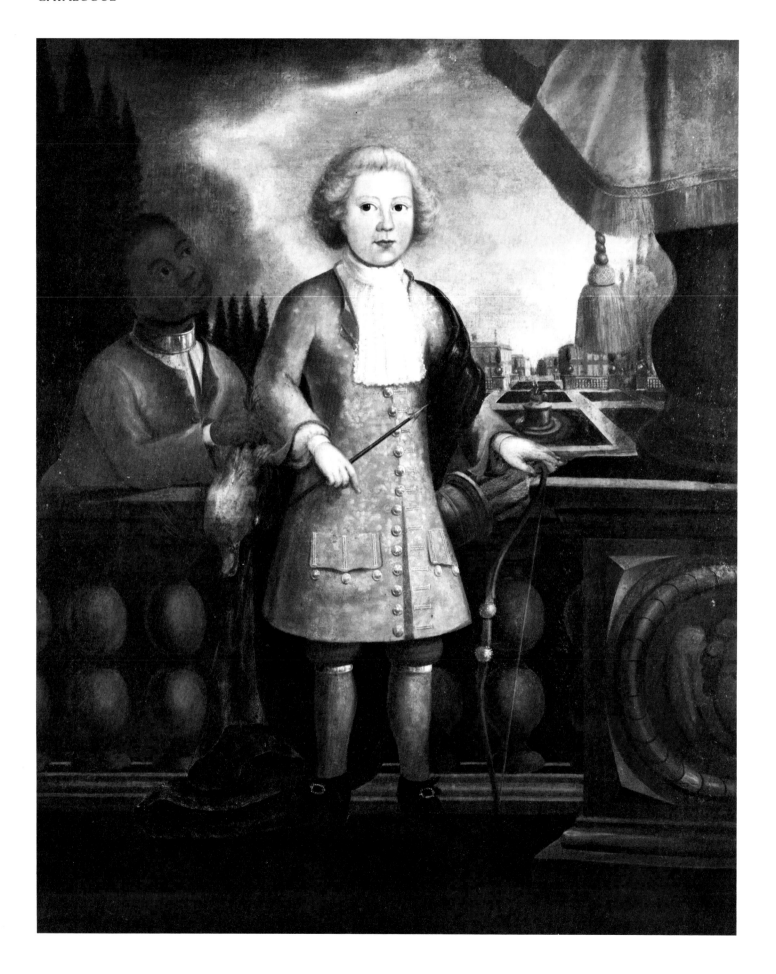

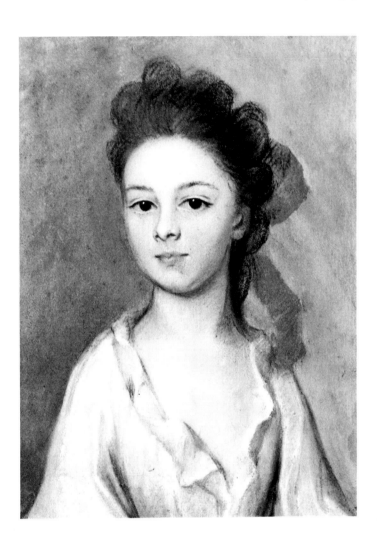

JUSTUS ENGELHARDT KÜHN (died 1717)

6. *Henry Darnall III*, ca.1710

> Oil on canvas, 54½ by 44½ (138.4 by 113)
> Unsigned
> The Maryland Historical Society, Baltimore, Bequest of Miss Ellen C. Daingerfield, 12.1.3

A German immigrant, Justus Engelhardt Kühn's name first appears in records of December 3, 1708, the date he applied for naturalization. Settling in Annapolis, he worked in the Maryland area until his death. He is only known to have executed portraits.

The painting of *Henry Darnall III* is extremely important for its inclusion of one of the earliest known depictions of a Negro in American painting. The elaborate architectural setting and the formal landscape vista in which the child stands were probably either invented by the artist or borrowed from an unknown European source.

HENRIETTA JOHNSTON (died 1728 or 1729)

7. *Henriette C. Chastaigner*, 1711

> Pastel on paper, 11½ by 8 ¾ (29.2 by 22.2)
> Unsigned
> Carolina Art Association/Gibbes Art Gallery, Charleston, South Carolina, 38.20.4
> *Provenance*: Alexander Broughton; Mary Broughton (Mrs. Isaac Motte); Elizabeth Motte (Mrs. Hezekiah Maham Haig); H. Maham Haig, M.D.; Miss Mary Mott Haig.

The first woman to work exclusively in pastels in America—and possibly the first woman to work as a professional artist in this country—Henrietta Johnston came to Charleston, South Carolina, with her second husband, the Reverend Mr. Gideon Johnston, Commissary of the Bishop of London in South Carolina and Rector of St. Philip's Church there. She was active in Charleston from around 1707 to 1728–29, contributing to the family income through the sale of portraits of local persons, all of whom seem to have been among the Johnstons' personal friends. She made at least one trip to New York about 1725; the reason for this journey is unknown. She died in Charleston.

Henriette C. Chastaigner was a child of eleven years when this work was executed. She later married into the Broughton family of Charleston. This small portrait is one of Johnston's most appealing works.

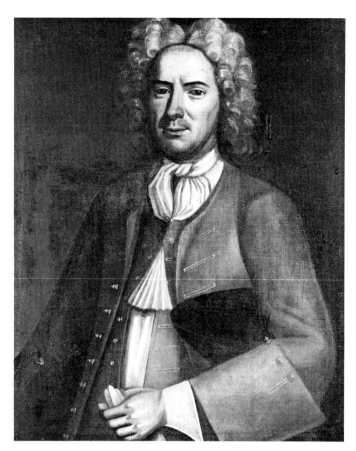 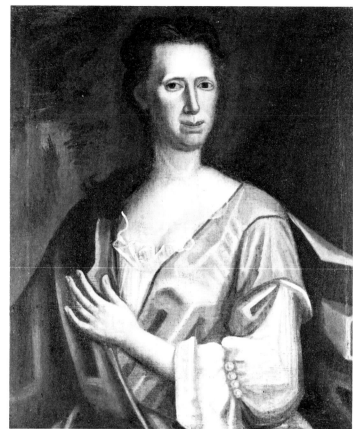

JAQUELIN-BRODNAX LIMNER (active in Virginia
 ca. 1721)

8. *William Brodnax I*, ca. 1721

Oil on canvas, 30 by 25 (76.2 by 63.5)
Unsigned
William F. Brodnax III, St. Croix, U.S. Virgin Islands, on loan
 to the Virginia Museum, L6.39.3

9. *Rebeckah Brodnax*, ca. 1721

Oil on canvas, 30 by 25 (76.2 by 63.5)
Unsigned
William F. Brodnax III, St. Croix, U.S. Virgin Islands, on loan
 to the Virginia Museum, L6.39.4

10. *William H. Brodnax*, ca. 1721

Oil on canvas, 30 by 25 (76.2 by 63.5)
Unsigned
William F. Brodnax III, St. Croix, U.S. Virgin Islands, on loan
 to the Virginia Museum, L6.39.5

11. *Elizabeth Rebecca Brodnax*, ca. 1721

Oil on canvas, 30 by 25 (76.2 by 63.5)
Unsigned
William F. Brodnax III, St. Croix, U.S. Virgin Islands, on loan
 to the Virginia Museum, L 6.39.7

12. *Edward Brodnax*, ca. 1721

Oil on canvas, 30 by 25 (76.2 by 63.5)
Unsigned
William F. Brodnax III, St. Croix, U.S. Virgin Islands, on loan
 to the Virginia Museum, L 6.39.6

Although we do not know the name of the painter responsible for the Jaquelin-Brodnax portraits, more than eleven paintings of the two well-known Virginia families survive. It is reasonable to assume that they were executed in the Jamestown-Yorktown area of Virginia, since all of the sitters lived there.

The compositions for most of these paintings were inspired by portrait prints of English notables found in the colonies during the eighteenth century. European paintings that settlers brought to America also served as source material from which a patron could select appropriate dress, drapery, poses, and background. Some of the gestures and fabric arrangements seem exaggerated and awkward, but they were probably purposefully selected. It is theorized that the unusual poses were designed to complement those of a painting of another member of the family, and that the works were meant to be displayed next to each other.

As some of the earliest surviving portraits done on Southern soil, the Jaquelin-Brodnax paintings are critical to the study of the art of the region.

GUSTAVUS HESSELIUS (1682-1775)

13. *Bacchanalian Revel*, ca. 1730

> Oil on canvas, 24½ by 32¾ (62.2 by 83.2)
> Unsigned
> Pennsylvania Academy of the Fine Arts, Philadelphia, Pennsylvania, Temple Fund Purchase, 1949.14

Born in Falun, Dalecarlia, Sweden, Gustavus Hesselius was a painter of portraits, religious subjects, and other figures. He was also known for building organs. Trained in Europe, he came to America with his brother in 1711, first residing in Wilmington, Delaware, and later moving to Prince George's County, Maryland sometime before 1726. He painted in Maryland and Delaware and is rumored to have visited Virginia.

By 1730, Hesselius had traveled to Philadelphia, where he lived until his death. His son John, who was born around 1728, had a far more extensive painting career in Maryland and Virginia than did his father; however, it was to be at least twenty years before the younger Hesselius established himself as a portraitist.

Bacchanalian Revel, along with Hesselius's *Bacchus and Ariadne*, are the earliest extant paintings of mythological scenes by an artist working in America.

Illustrated in color, figure 9, page 11.

MARK CATESBY (ca. 1679-1749)

14. *Black Squirrel*, plate 73 from *Natural History of Carolina, Florida, and the Bahama Islands*, Volume II

Copperplate engraving with watercolor on paper, 20¾ by 14 ⅜ (52.7 by 36.5)
Unsigned
Mrs. Cabell Mayo Tabb, Richmond, Virginia

15. *Natural History of Carolina, Florida, and the Bahama Islands*, Volumes I and II, 1731-1743

Bound volumes of copperplate engravings
Two sets of Volumes I and II lent by Henry Francis duPont Winterthur Museum, Winterthur, Delaware and The Garden Club of America, New York

A native of England, the naturalist Mark Catesby made two trips to the American continent. Catesby visited his sister and brother-in-law in Virginia from 1712 to 1719 and returned to America in 1722 to record, over a three-year period, the flora and fauna of the Carolinas, Georgia, and Florida. He also spent time in the Baha-

mas before returning to England in 1726. His travels resulted in the two volumes of the *Natural History of Carolina, Florida, and the Bahama Islands*, which were published in several editions.

After his second trip, Catesby learned to etch copper plates, and he produced more than 100 plates for each volume. He even hand-colored many plates for the first edition of volume one.

Catesby was considered a pioneer in his field. As a major illustrator of North American ornithology, he was among the first to illustrate animals and birds in their natural habitats. Elected to the Royal Society in 1733, Catesby continued his botanical studies and writings until his death in 1749.

Natural History, Vols. I and II: Winterthur Museum copies exhibited at the Virginia Museum.

Black Squirrel is illustrated in color, figure 10, page 15.

BISHOP ROBERTS (active 1735-1739; died 1739)

16. *Prospect of Charles Town*, ca. 1738-39

> Watercolor and ink on paper, 15 by 43⅜ (38.1 by 110.2)
> Unsigned
> The Colonial Williamsburg Foundation, Williamsburg, Virginia, 1956-103

Bishop Roberts, husband of Mary Roberts, the Charleston miniaturist, was an engraver and painter. He advertised his services in Charleston newspapers during his lifetime, soliciting customers for portrait painting, engraving, heraldic and house painting, landscapes for chimney pieces, and making drawings of houses in colors or India ink. Roberts's *Prospect of Charles Town* is his only known work. Attribution of the piece is based on an engraving by W. H. Toms (a London engraver) that cites Roberts as the artist. The painting is considered the earliest surviving example of marine painting for the coastal Southeast.

CHARLES BRIDGES (1670-1747)

17. *John Bolling, Jr.*, ca. 1740

> Oil on canvas, 30⅛ by 25⅜ (76.5 by 64.5)
> Unsigned
> The College of William and Mary in Virginia, Williamsburg, Virginia, 1940.004
> *Provenance:* Thomas Bolling; Richard M. Bolling; Anne M. Bolling; Mrs. Robert Malcolm Littlejohn, New York; gift to the College of William and Mary, 1940

Charles Bridges was the fourth son of John and Elisabeth Trumbull Bridges of Barton Seagrave, Northamptonshire, England. Bridges became an agent for the Society for Promoting Christian Knowledge in 1699. Particulars of his artistic training are not known, but his earliest portrait, depicting the Reverend Thomas Baker of St. John's College, Cambridge, England, was presumably painted before 1717.

In 1733, Bridges wrote to Henry Newman, secretary of the Society, to say that he wanted to go to Georgia. It is not known if he made the trip, but by May 1735 he, his daughters, and a son were living in Williamsburg, Virginia. Not only did his paintings provide him with an income, they also afforded him an entrée into the homes of Virginia's governmental and religious leaders and its wealthiest families, all of whom were essential to the work that Bridges hoped to carry out for the Society in Virginia.

The subject of this portrait, John Bolling of Cobbs, Virginia, was Burgess for Henrico and Chesterfield Counties. A justice of the peace, he also held the rank of Colonel and commanded the Chesterfield militia. The painting reflects Bridges's sensitivity to detail and characterization, and it also indicates his English training and familiarity with the formats and styles popularized in London studios.

Bridges is believed to have worked in Virginia from 1735 to 1740. He returned to England in 1746.

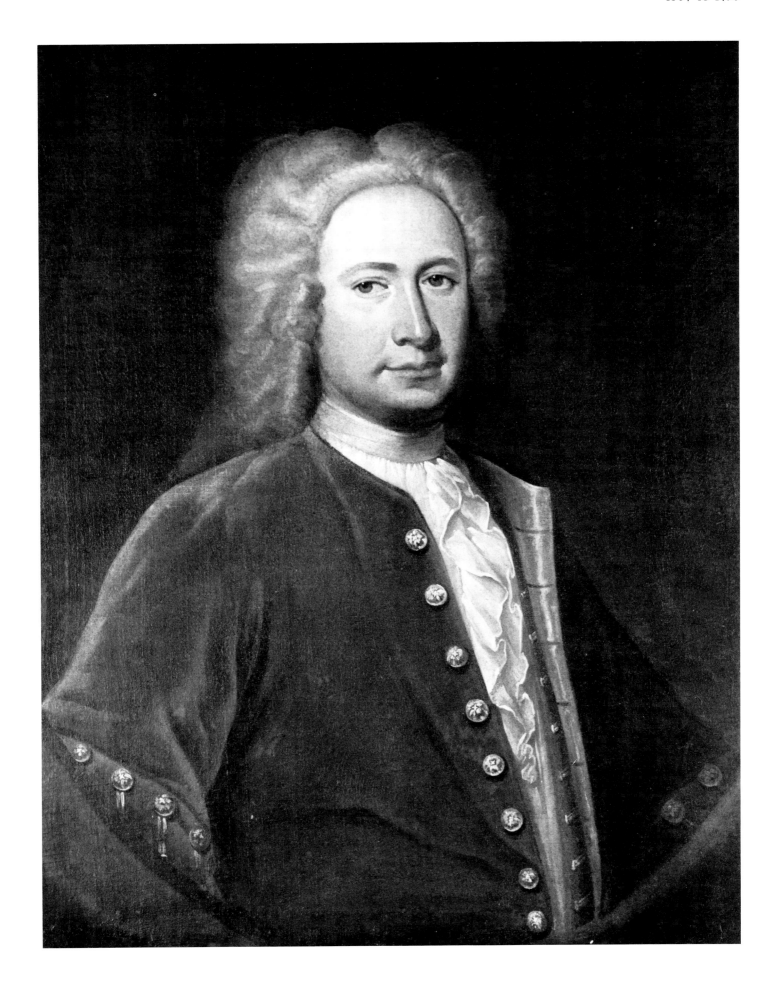

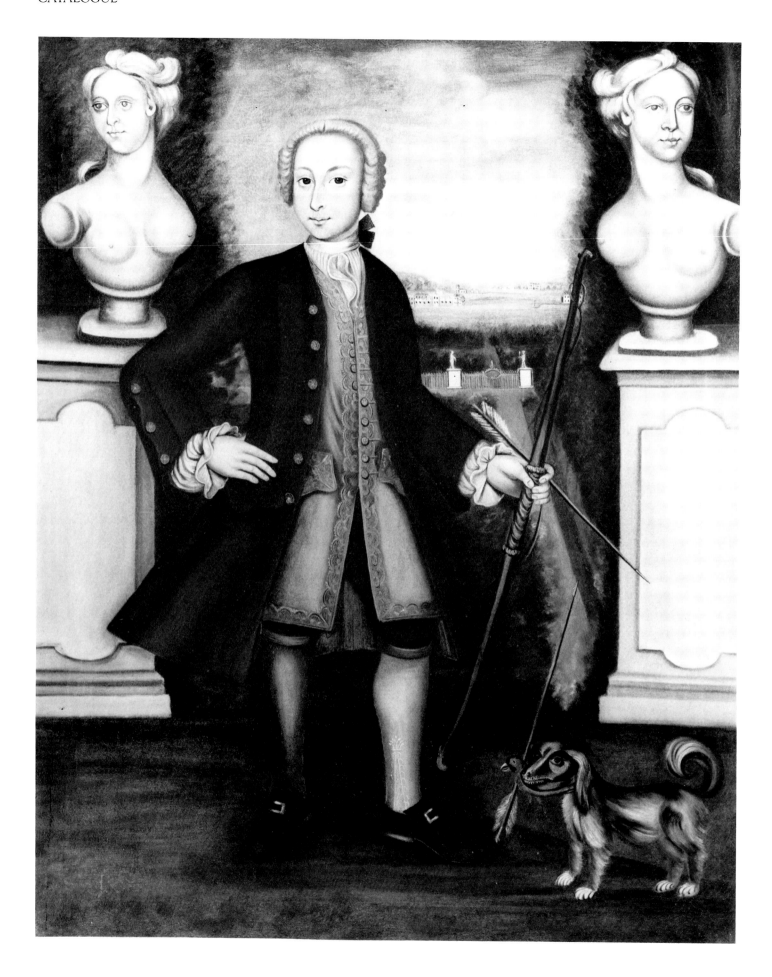

Attributed to WILLIAM DERING (active in Virginia 1737-1750)

18. *George Booth as a Young Man*, ca. 1740-50

Oil on canvas, 50 by 40 (127 by 101.6)
Unsigned
The Colonial Williamsburg Foundation, Williamsburg, Virginia, 1975-242

The earliest reference to William Dering is found in a 1735 issue of the *Pennsylvania Gazette*, where he advertised as a dancing master. The next year he advertised in the same newspaper, offering "various lessons for young girls."

Dering came to Virginia around 1737; by 1739 he had established his home in Williamsburg, where he lived in what is now the Brush-Everard House on Palace Green. By the mid 1740s he was in poor financial straits, and by 1750 he had moved on to South Carolina. Dering's name can be found in public records for Charleston as late as 1764.

The painting of George Booth of Gloucester County is considered to be the most elaborate portrait now assigned to Dering. The setting is unusual, although it does not appear to be based on any specific location in Virginia. His Virginia paintings, which are the only ones known, are as pretentious as any images commissioned by the colonists.

MARY ROBERTS (died 1761)

19. *Charles Pinckney*, ca. 1745

Tempera on ivory, 1⅛ by ¹⁵/₁₆ oval (2.9 by 2.4)
signed lower right: *MR*
Mr. and Mrs. Thomas Pinckney, Richmond, Virginia

Mary Roberts was the wife of Bishop Roberts of Charleston, South Carolina. After her husband's death in 1739, she continued his printing business and also advertised her services as a "face painter." She gave up printing in 1746 but probably continued to paint miniature portraits. She died in 1761 and was buried in St. Philip's Parrish.

The miniature of Charles Pinckney (1699-1758) is thought to be the earliest miniature executed in the South, if not in all the American colonies. Pinckney, an important South Carolinian, was appointed to several noteworthy political positions. He was the father of Charles Cotesworth Pinckney, who became an American Revolutionary General, and Thomas Pinckney, the first United States Ambassador to England.

JOHN HESSELIUS (1728-1778)

20. *Portrait of Alice Thornton Fitzhugh*, 1751

 Oil on canvas, 30 by 25 (76.2 by 63.5)
 Signed on back: *Alice, wife of John Fitzhugh, daughter of Richard Thornton, Aetatis 28, John Hesselius Pinx, May 1751*
 Private collection (Fitzhugh family descendant)

21. *Portrait of Margaret (Lloyd) Tilghman*, ca.1760-65

 Oil on canvas, 36 by 28¾ (91.4 by 73)
 Unsigned
 Virginia Museum, Richmond, Virginia, The Williams Fund, 77.22

The son of Gustavus Hesselius, John Hesselius was probably born in Philadelphia or Maryland. He showed little of his father's influence in his portraits and instead sought out the Baroque style of Rebert Feke, whose work he doubtless saw in Philadelphia.

Hesselius left the North to begin a twenty-year association with a Virginia family, the Fitzhughs. His portrait of Alice Thornton Fitzhugh, one of his earliest, typifies his early style and reveals his indebtedness to Feke in the formal, rigid pose, Baroque coloration, and details of costume. Mrs. Fitzhugh, born in 1729 in King George County, Virginia, married John Fitzhugh (1727-1809) of Bellair, Stafford County, Virginia in 1746. She died in 1790.

Among Hesselius's finest portraits is that of Mrs. William Tilghman. The preciseness of the painting attests to Hesselius's skill as a painter of detail rather than of overall personality.

In 1760, Hesselius moved permanently to Anne Arundel County, Maryland. Later, in 1762, another noteworthy American painter, Charles Willson Peale, received his first painting instruction from Hesselius at Annapolis.

Hesselius is buried at "Bellefield" near Annapolis.

Portrait of Margaret Tilghman is illustrated in color, figure 4, page xviii.

JOHN WOLLASTON (ca. 1710-after 1775)

22. *Mrs. Anthony Walke* II, ca. 1755

> Oil on canvas, 36¼ by 28¼ (92 by 71.8)
> Unsigned
> The College of William and Mary in Virginia, Williamsburg, Virginia, 1936.005.
> *Provenance:* Howard Shield; William Walke Shield; Mrs. William Walke Shield, later Mrs. B. Lewis Clarke, Jr.; Robert Carlin, Philadelphia; Mr. and Mrs. O. W. June, New York; gift to the College of William and Mary, 1963.

John Wollaston, the son of John Woolaston (or Wollaston), a portrait painter and amateur musician, is thought to have been born in London, England. The younger Wollaston probably studied with his father and later studied at one of the numerous London studios devoted to portrait painting. His work compares closely with early portraits by the English painters Thomas Hudson, Richard Wilson, and Bartholomew Dandridge, with whom he may have studied or had some association.

Wollaston went to New York in 1749, painting there until the early 1750s. He visited Philadelphia and Maryland, and later painted in Virginia from 1755 to either late 1757 or early 1758, since he was apparently in Philadelphia again at that time. His whereabouts from 1759 to 1763 are unknown. By 1764 he was on St. Kitts, an island in the Caribbean. From there it is believed that he went directly to Charleston, South Carolina, where he worked from 1765 to 1767. He returned to England between 1767 and 1769.

Wollaston had a marked influence on his American contemporaries, including Benjamin West, Matthew Pratt, John Mare, and the elder Hesselius.

The portrait of Mrs. Anthony Walke II (née Jane Randolph) is typical of Wollaston's style and technique and is one of his finest Virginia portraits.

JEREMIAH THEÜS (1715-1774)

23. *Daniel Ravenel II of Wantoot*, ca. 1768

Oil on canvas, 43½ by 37 (110.5 by 94.0)
Unsigned
Private collection (direct descendant of Daniel Ravenel II)

24. *Martha Vinson*, no date

Oil on canvas, 30 by 25 (76 by 63.6)
Unsigned
Carolina Art Association/Gibbes Art Gallery, Charleston, South Carolina, 34.9.2.

Jeremiah Theüs was born into a Protestant family living in Felsburg, Grison, in eastern Switzerland, in the early eighteenth century. As the result of religious persecution, many members of the Theüs family emigrated in the mid 1730s to South Carolina, having been encouraged by Jean Pierre Purry, an early Swiss colonizer in the region. They settled initially in Orangeburg on the Edisto River, then in 1739 moved to Charleston, where Theüs became the city's principal resident artist before the American Revolution. Known primarily as a portrait painter, he also advertised that he was available to execute landscapes and various types of decorative painting, including gilding. During his lengthy career in Charleston, he achieved social prominence as well as financial success.

Theüs's painting of Daniel Ravenel II is an exceptionally fine portrait of a young boy in the popular trappings of the formal portrait; it is reminiscent of European and English portraiture in the Baroque period. A member of a distinguished South Carolina family, the young Ravenel grew up on "Wantoot" plantation in St. John's Parish, Berkeley, one of three designated sites of refuge during the Yamasee Indian uprisings. A lover of horses who was renowned for his fine stables, Ravenel later served under Francis Marion.

The portrait of Martha Vinson reflects a meticulously elegant painting style that is characteristic of Theüs's work in Charleston.

Daniel Ravenel II: exhibited at the Virginia Museum

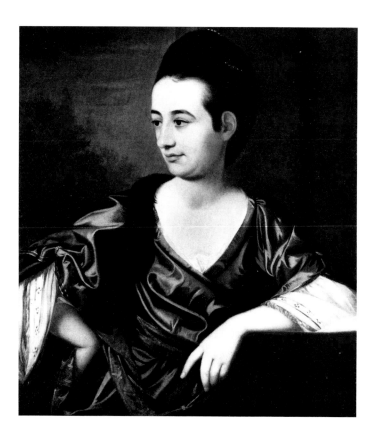

HENRY BENBRIDGE (1793-1812)

25. *Rachel Moore*, ca. 1774

Oil on canvas, 28 by 24¹³/₁₆ (71 by 63)
Unsigned
Museum of Early Southern Decorative Arts, Winston-Salem,
North Carolina, 2023-11
Provenance: William Allston and wife, Rachel Moore; Washington Allston; Miss Helen Alston [sic]; descended to private owner

26. *Richard Moncrief*, ca. 1785

Oil on ivory, 1⅜ by 1³/₁₆ (3.5 by 3)
Unsigned
Charleston Museum, Charleston, South Carolina, 1920.98 (858)

27. *Mr. and Mrs. Boswell Lamb and their Daughter, Martha Anne*, ca. 1803

Oil on canvas, 30 by 24⁵/₈ (76.2 by 62.5)
Unsigned
Museum of Early Southern Decorative Arts, Winston-Salem, North Carolina, Gift of Mr. and Mrs. Alban K. Barrus, 2943

Born in Philadelphia, Henry Benbridge is known to have painted as early as 1758. Encouraged by his stepfather, he studied in both Italy and in England, and returned to Philadelphia in 1770. In 1772 he married Esther Sage, an accomplished miniature painter who had taken lessons from Charles Willson Peale. The couple moved to Charleston, South Carolina, where Benbridge worked throughout the mid 1790s. His wife died in 1773, and sometime before 1801 Benbridge moved to Norfolk, Virginia to live with his son.

Most of the full-size works Benbridge painted in Charleston are of superb quality. Rachel Moore, great-grandchild of James Moore, Governor of South Carolina, was the mother of Washington Allston, the artist and patron. Following the death of her first husband, William Allston, Rachel married a Northern army major, Henry Collins Flagg of Newport, Rhode Island.

Benbridge also executed miniatures in Charleston, including his painting of Richard Moncrief. The likeness, typical of Benbridge's miniature work, is realistic in its representation of the robust sitter. Moncrief was one of numerous merchant-class citizens who by the 1770s could afford to commission pictures from Charleston's chief artist.

Benbridge's Virginia paintings are less well known; only two paintings from that period are attributed to him. The painting of *Mr. and Mrs. Boswell Lamb and their Daughter, Martha Anne* compares favorably in style with the artist's earlier work, however the basic distinction between his Norfolk paintings and those executed in Philadelphia and Charleston seems to be the change in the style of dress and fabric at the turn of the century. The Virginia portraits are dull in color and embellishment compared with the more flamboyant attire reflected in the paintings executed in Charleston during the 1770s and 1780s.

Rachel Moore illustrated in color, fig. 22, p. 35.

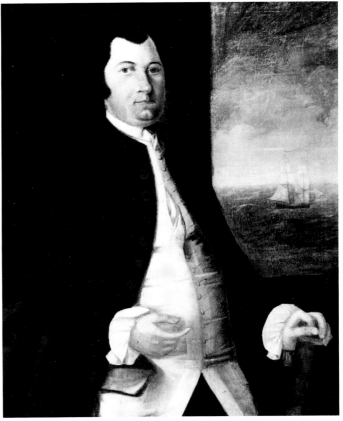

JOHN DURAND (active 1766-1782)

28. *Portrait of Edward Archer II,* ca. 1775

Oil on canvas, 34¾ by 29 (88.3 by 73.7)
Unsigned
Private collection (Archer family descendant)

John Durand remains one of the most elusive figures in American colonial painting. Possibly of French ancestry, he is known to have worked in the New York area in the 1760s. His first visit to Virginia was in 1765; later sojourns, documented by signed portraits and manuscript references, took place from 1767 to 1771, and in 1775 and 1780, and resulted in a large number of portraits.

Edward Archer II (1747-1807), the subject of Durand's painting, was engaged in trade with West India and served as a commissary for army supplies during the American Revolution. Appointed Postmaster of Norfolk by George Washington, Archer, a strong Federalist, was turned out of office in 1804 by Thomas Jefferson. Durand's portrait of Archer, with its crisp delineation of fabrics and other details, achieves the kind of decorative interest that held great appeal for the eighteenth-century patron.

Illustrated in color, figure 18, page 29.

JOHN SINGLETON COPLEY (1738-1815)

29. *Henry Laurens, 1782*

Oil on canvas, 54⅛ by 40⅝ (137.5 by 103.2)
Signed lower right: *JS Copley R.A. Pinx 1782*
National Portrait Gallery, Smithsonian Institution, Washington, D.C., Gift of Andrew W. Mellon, NPG 65.45

Born in or near Boston, John Singleton Copley began his career about 1753, having received some training with his stepfather, Peter Pelham. After achieving considerable success in the colonies, Copley went to Europe with his family in 1774; the following year he settled in London, which was his home for the rest of his life. He was made an associate of the Royal Academy in 1776 and elected to full membership in 1783.

The subject of this portrait, Henry Laurens of Charleston, South Carolina, was on a diplomatic mission to the Netherlands when he was captured by the British and imprisoned in the tower of London. In 1781 he was exchanged for Lord Cornwallis and released. Soon after, he sat for his portrait in Copley's London studio. The resulting portrait is a fine example of Copley's work, and it is also significant since it depicts an extremely important American statesman and wealthy Southern colonist.

Although Copley never actually worked in the South, a number of wealthy Southerners knew of his reputation and commissioned portraits from him when traveling in Europe.

Exhibited at the Virginia Museum.

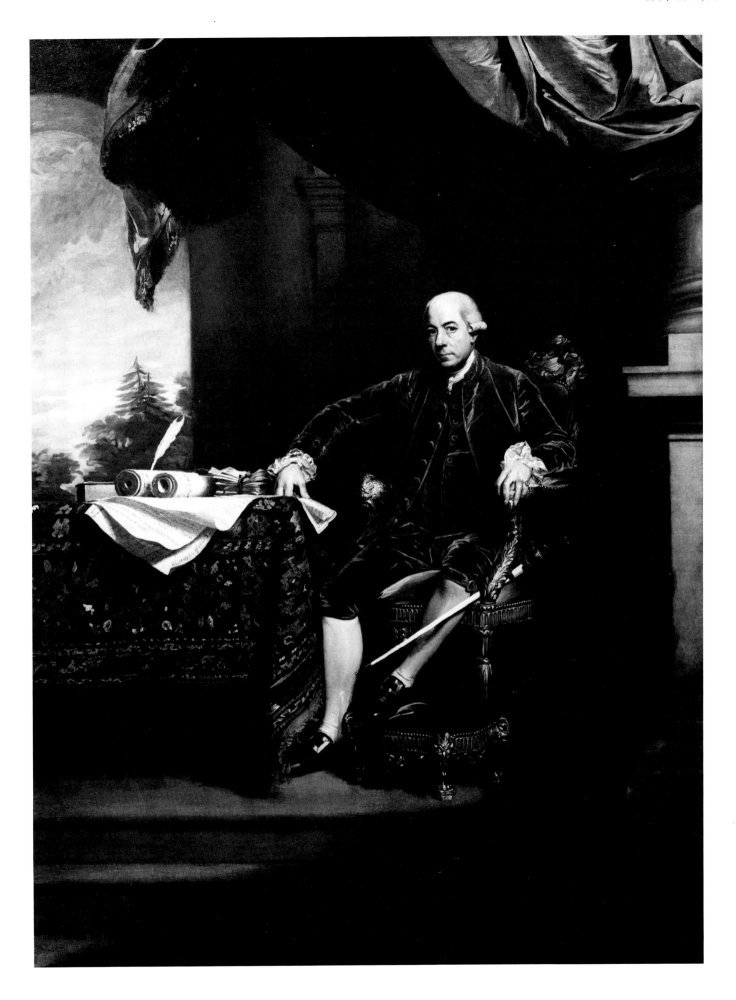

CHARLES WILLSON PEALE (1741-1827)

30. *William Smith and His Grandson*, 1788

Oil on canvas, 51⅜ by 40¼ (130.5 by 102.2)
Signed lower right: *C.W. Peale painted 1788*
Virginia Museum, Richmond, Virginia, The Robert G. Cabell
III and Maude Morgan Cabell Foundation and the A. G.
Glasgow Fund, 75.11

Born in Queen Anne's County, Maryland, Charles Willson Peale began his career as a saddler in Annapolis, Maryland, in 1762. Soon thereafter he received his first painting lessons from John Hesselius in exchange for a saddle. He subsequently received a few commissions, and his work became well known in Annapolis. In 1766, eleven wealthy gentlemen from Maryland "subscribed 74 guineas and eight pounds" to allow Peale to study painting in London. He went there in 1767 and studied under Benjamin West until 1769, at which time he returned to the colonies.

After he reestablished himself in Annapolis, Peale began traveling throughout Maryland, Virginia, and the middle colonies painting portraits. His reputation developed quickly, and he became the chief portrait painter of upper-class and middle-class households.

One of the leading men of his time, Peale had broad interests, ranging from the politics of the Revolution to many branches of the arts and sciences. Destined to become one of America's most prominent artists, he was a skilled engraver, a clever inventor, and the founder of one of America's first museums. He was also the first of a long line of successful artists; the Peale dynasty has no parallel in the history of American painting.

The double portrait *William Smith and His Grandson* is a superior example of his work that provides an important glimpse into Peale's working method. Executed in Baltimore, it was intended to commemorate Smith in his new role as a congressman from Maryland in the new federal government. Smith's son-in-law, Otho Holland Williams, commissioned the work with the intent of portraying Smith alone. However, Smith asked that his grandson be included and Peale agreed; the result was a painting that Charles Coleman Sellers has called "half state portrait, half domestic piece." Sellers's interpretation of the painting is particularly accurate:

> Peale would add a view of the family homestead and busy little mill outside the town and then, to that, still-life appropriate to the country gentleman . . . proclaiming in one breath the public and private citizen. Foreground table and books are a thing apart from the columns and they from the Hall of Congress, which abuts directly upon the wall of the mill. By sloping path and lawn, however, Peale relates the home views to the child and foreground. The elements can be read without confusion, the domestic prevailing, the monumental a background statement only. (Charles Coleman Sellers, "Monumentality with Love," *Arts in Virginia* 16, nos. 2 and 3 [1976]: 16.)

Illustrated in color, figure 3, page xii.

1790 to 1830

JAMES EARL (1761-1796)

31. *Elizabeth Fales Paine and Her Aunt Martha Paine,* ca.
1794-96

Oil on canvas, 40 by 50 (101.6 by 127)
Unsigned
Museum of Art, Rhode Island School of Design, Providence,
Rhode Island, 24.052

James Earl, younger brother of the portraitist Ralph
Earl of Connecticut, was trained as a painter in Eng-
land. After arriving in Charleston, South Carolina, in
about 1794, he found patrons eager for his work. Earl
enjoyed two years as a major painter in the city before
the yellow fever epidemic of 1796, which caused his
death at the age of thirty-five.

This double portrait was executed during a visit of
the young Elizabeth Fales Paine of Bristol, Rhode
Island, to her aunt's home in Charleston in the late
1790s. It was probably executed at the same time as a
similar work, *Eliza Shrewsbury and Her Mother,* now in
the collection of the Henry Francis duPont Winterthur
Museum. The flattering yet precise rendering of the
women's features, combined with Earl's bravura treat-
ment of textiles, reflect the artist's London training and
indicate why he was so successful in a city that main-
tained close cultural ties with England.

GEORGE BECK (1748/50-1812)

32. *View of Baltimore from Howard's Park*, ca. 1796

> Oil on canvas, 37 by 46¼ (94 by 117.5)
> Unsigned
> The Maryland Historical Society, Baltimore, Maryland, Gift of
> Robert Gilmor, 1844.1.1

George Beck, who was born in Ellford, England, trained and exhibited in London in the 1790s before emigrating to America in 1795 with his wife, the painter Mary Renessier Beck. During the following decade, Beck worked primarily in Baltimore and Philadelphia, although his travels took him as far north and west as Niagara Falls and Pittsburgh.

From 1795 to 1797 Beck worked in Baltimore; he introduced a picturesque view of nature in his various depictions of the city. His English training is evident in *View of Baltimore from Howard's Park*, which was painted soon after his arrival in the city. Like other artists in Baltimore, Beck was encouraged and patronized by collector Robert Gilmor, in whose home works by major European painters—such as Nicholas Poussin and Claude Lorrain—were displayed for the benefit of local aspiring artists.

With time, Beck's career languished and his reputation faltered. During the last years of his life, the embittered and impoverished artist painted and directed a girls' school in Lexington, Kentucky.

Illustrated in color, figure 31, page 58.

View of Mount Vernon looking towards the South West

View of Mount Vernon looking to the North. July 17th 1796. The portico faces to the East.

BENJAMIN HENRY LATROBE (1764-1820)

33. *View of Mount Vernon Looking towards the Southwest* and *View of Mount Vernon Looking to the North,* both 1796

 From Latrobe's Sketchbook 2, nos. 11 and 13 respectively (framed together)
 Watercolor on paper, each 7 by 11 (17.8 by 27.9)
 Unsigned
 The Maryland Historical Society, Baltimore, The Benjamin Henry Latrobe Collection, Ms 2009

34. *The Capitol at Washington, D.C.,* 1810

 Watercolor on paper, 16½ by 25½ (41.9 by 64.8)
 Signed lower right: *B. H. Latrobe/1810*
 The Maryland Historical Society, Baltimore, Gift of Charles H. Latrobe, 1897.1.1

Born in Yorkshire, England, Benjamin Latrobe was sent to Germany for schooling in 1776. From 1786 to 1789 he studied engineering and architecture in London, and in 1796 he emigrated to America, where he remained until his death, in New Orleans, in 1820. Recognized for his abilities in architecture, Latrobe served as the chief architect for public buildings in the District of Columbia for ten years beginning in 1803. In this capacity he was responsible for the second design of the United States Capitol. Latrobe's concern for a uniquely American image in architecture resulted in his use of corn and tobacco motifs on the capitals.

Like many architects of his day, Latrobe was an accomplished landscape and topographical painter, filling voluminous sketchbooks with pencil and watercolor drawings of the landscape and architecture of Maryland, Virginia, and other areas of the South.

Latrobe's large watercolor of the Capitol gives a clear depiction of the building's various architectural details. The inclusion of the lawn and trees, and the bustling activity of carriages and visitors add life, dimension, and exuberance to the work. On a smaller scale, the watercolors of Mount Vernon reveal his ability to depict a scene with rapid and masterful brushstrokes.

Views of Mount Vernon: exhibited at the Mississippi Museum of Art, the J. B. Speed Art Museum, and the New Orleans Museum of Art.
The Capitol: exhibited at the Virginia Museum, the Birmingham Museum, and the National Academy of Design.

JAMES PEALE (1749-1831)

35. *Portrait of Mrs. John P. Van Ness (née Marcia Burns),*
 1797

 Watercolor on ivory, 2¾ by 2½ oval (7.0 by 6.4)
 Signed lower right: *JP/1797*
 Corcoran Gallery of Art, Washington, D.C., Gift of Mrs. Philip
 Hinkle, 1897, 97.8

James Peale of Maryland, the younger brother of the
artist Charles Willson Peale, was a veteran of the
American Revolution. Initially a cabinetmaker, he
learned to paint from his brother, with whom he
lived before his marriage to Mary Claypoole in 1782.
Although James Peale's earliest works were miniatures,
he also painted a number of still-lifes in oil, until 1818
when failing eyesight limited his artistic activity.

 This miniature depicts the vivacious daughter of
David Burns of Washington, one of nineteen proprie-
tors whose land was purchased for the establishment of
the District of Columbia. Following her marriage in
1802 to New York Congressman John Peter Van Ness,
the couple employed Benjamin Latrobe to design a
house for them; the structure, on the present site of the
Pan-American Union Building, was the first to boast
hot-and-cold running water in each room. On her
death in 1832, Marcia Van Ness was honored with the
first public funeral accorded a woman in the city of
Washington.

PHILIPPE ABRAHAM PETICOLAS (1760-1841)

36. *Miniature of Two Unidentified Young Ladies Before a*
 Pianoforte, 1798

 Watercolor on ivory, 3¾ diameter (9.5 diameter)
 Signed left center: *P. A. Peticolas/Pinxt 1798/Baltimore*
 The Maryland Historical Society, Baltimore, Maryland, The
 Mrs. Edwin Howar Purchase Fund, 82.34

Philippe Abraham Peticolas, a Frenchman who
achieved prominence in America as a miniature
painter, was born in Meziers. In his youth Peticolas
served in the army of the King of Bavaria; during this
time he learned the art of miniature painting. In 1790,
as a captain in the King's Infantry, he was sent to Santo
Domingo to help suppress a slave uprising. Unhappy
with his service career and fearful for his family's safety,
Peticolas determined at that point to emigrate, with his
wife and child, to America. Settling first in Philadel-
phia, then in Lancaster, Pennsylvania, he later es-
tablished himself as a music teacher and miniaturist in
Richmond, Virginia, in 1804. Two of his sons, Edward
and Theodore, followed their father's success and be-
came known in the Richmond area as portrait and
miniature painters.

 While a resident of Lancaster and Richmond,
Peticolas traveled as an itinerant painter throughout
Maryland and the northern sections of Virginia. On
one of his journeys to Baltimore, he painted a double
miniature of two young women whose identities remain
unknown. The miniature, which was used as decora-
tion for a tortoise-shell box in which beauty patches
were kept, shows the women sitting in Windsor chairs,
with a pianoforte behind them.

CHARLES PEALE POLK (1767-1822)

37. *Portrait of Thomas Jefferson, 1799*

Oil on canvas, 26½ by 23⅛ (67.3 by 58.7)
Unsigned
Victor D. Spark, New York

Born in Annapolis, Maryland, and orphaned as a small child, Charles Peale Polk was raised in Philadelphia by his uncle, Charles Willson Peale, who taught him to paint. In 1791 Polk moved with his wife and children from Philadelphia to Baltimore, where he achieved success and recognition as a painter of portraits. The increasing size of his family required that Polk seek additional employment, so for a while he also worked as a shopkeeper. He left Baltimore in 1796 to find work in Frederick County, Maryland, then traveled as an itinerant painter through western Maryland and Virginia.

Soon after the turn of the century Polk moved to Washington, hoping to receive some kind of federal employment. Finally appointed a government clerk, he held the position for sixteen years; during this time he did little painting but continued to draw portraits in the medium of *verre églomisé*, a type of painting on glass

that first became popular in France in the late eighteenth century. In 1820 Polk moved with his third wife to a farm she had inherited in Richmond County, Virginia. Artist's supplies found at his death two years later have led to speculation that Polk continued to paint late in his lifetime.

Polk painted his *Portrait of Thomas Jefferson* in Frederick County, Maryland while involved with the Republican Party during the 1799 presidential campaign. The work was commissioned by Isaac Hite, brother-in-law of James Madison. Polk elected to show the candidate from Virginia in what has been termed a "republican" portrait: youthful, plainly-clad, and determined. At the time of the commission, the artist's distinguished uncle hinted that Polk's general lack of commissions was the result of political opinions that were at odds with those of many potential patrons. Although most of Polk's work of the late 1790s was characterized by an exaggerated elongation of the human figure, this portrait of Jefferson reflects his earlier style in its more regular proportions and strong colors.

JACOB FRYMIRE (1765/74-1822)

38. *Portrait of Ann Lucretia Deneale*, 1800

> Oil on canvas, 29 by 24 (73.6 by 61)
> Signed on back: *Painted by J. Fryning* [sic]/*Oct. 10th 1800*
> Private collection (Deneale family descendant)

It is not known whether folk painter Jacob Frymire was entirely self-taught or whether he had been briefly apprenticed to an established artist in his native Lancaster, Pennsylvania, or nearby Philadelphia. Whatever his artistic background, by 1790 he was working as an itinerant limner, journeying from New Jersey inland as far as Kentucky. During the course of his travels, Frymire maintained a residence in Hamilton Township, Pennsylvania, moving in 1810 to Shippensburg in adjacent Cumberland County, where he opened a "painting room." For the last six years of his life, he returned to live at the family's Hamilton Township farm.

At the turn of the century, Frymire was at work in three Virginia towns, Winchester, Warrenton, and Alexandria. It was in Alexandria that he painted the young Ann Lucretia Deneale, daughter of the Clerk of the Court of Fairfax, Virginia, and a member of the Potomack Company, which had been contracted to dredge a canal in the Washington area. The girl is shown scattering berries for her pet bird.

EDWARD GREENE MALBONE (1777-1807)

39. *Portrait of James McPherson*, ca. 1801

> Watercolor on ivory, 2½ by 2 oval (6.5 by 5.1)
> Unsigned
> Carolina Art Association/Gibbes Art Gallery, Charleston, South Carolina, Gift of Victor Morawetz, 36.7.9
> *Provenance:* Miss Rose Pringle, Charleston; Miss Rose Ravenel, Charleston.

A major American miniaturist, Edward Greene Malbone was born in Newport, Rhode Island, and began his career in nearby Providence in 1794. From that year until 1807, Malbone traveled the eastern seaboard, painting numerous miniatures in every major community. In 1801 he spent several months in Charleston, where he executed several commissions. He also met and strongly influenced Charles Fraser. In May of that year he departed for England with a former Charlestonian, Washington Allston, to visit the Royal Academy and to meet Benjamin West and other artists then working in London. When he returned to New England by way of Charleston, he once again met with great success. On a subsequent visit to Charleston in 1806, he contracted an illness that led to his death a year later in Savannah.

Malbone's miniature of James McPherson, painted at Charleston, shows a young boy approximately five years old. The sober nature of the sitter is characteristic of many portraits and miniatures of children in an era of high infant mortality.

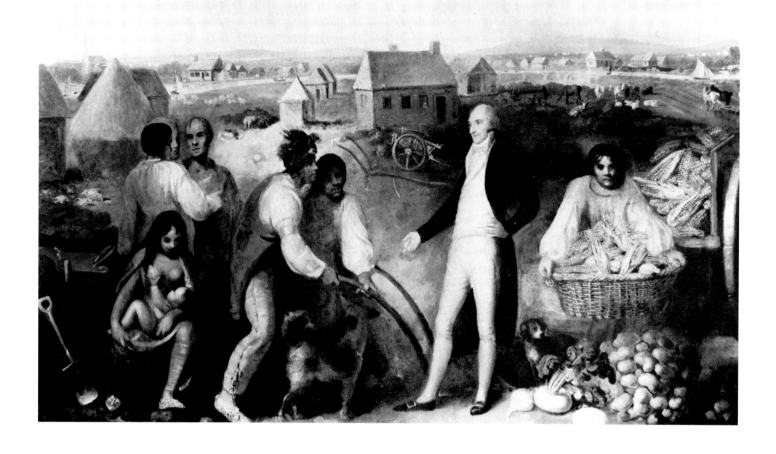

40. *William Bowles and the Creek Indians*, ca. 1800

Oil on canvas, 35 7/8 by 49⅞ (91.1 by 126.7)
Unsigned
Museum of Early Southern Decorative Arts, Winston-Salem,
North Carolina, 2313

Although the artist of this work has never been identified, there is speculation that it may have been William Bowles himself, who is known to have painted his own portrait with important Indian leaders for propaganda purposes.

Born in 1763 in Frederick County, Maryland, Bowles served with the British Army until a charge of insubordination cost him his commission. He subsequently joined a tribe of Creek Indians and lived with them for approximately twenty years, learning their language and marrying a chief's daughter. In the 1781 defense of Pensacola, Florida, Bowles led the Creek forces. Later, in 1783 Bowles journeyed to London with a number of Creek and Cherokee Indians to enlist aid for their scheme to invade Mexico. They were appreciated more for their exotic appearance than for their proposal of invasion.

On his return to America without English support, Bowles embarked on a career as a pirate. Captured in New Orleans, he was sent first to Spain and then to Havana, where he died in prison in 1805.

Illustrated in color, figure 24, page 42.

CHARLES BALTHAZAR JULIEN FEVRET DE SAINT-MÉMIN (1770-1852)

41. *Mary Abigale Coale* (Mrs. William Tower Proud), 1802
 Watercolor on paper, 5⅝ by 4¾ (14.3 by 12.1)
 Signed lower left: *St. Memin fect*
 The Maryland Historical Society, Baltimore. Gift of Francis
 Tazewell Redwood, xx.4.213

42. *Harriet Rogers* (Mrs. John Robert Murray), ca. 1806
 Watercolor on paper, 7 by 5¹³⁄₁₆ (17.8 by 14.8)
 Signed lower left: *St. Memin pinx*
 The Maryland Historical Society, Baltimore, Gift of Mrs. J. H.
 Ten Eyck Burr, Miss Helen Hubbard, and Mrs. Walter
 Oakman, S0.103.4
 Provenance: Mrs. John Robert Murray; John Robert Murray, Jr.;
 Mrs. J. Wolters Ledyard; Miss Elizabeth Ledyard (Mrs. J. H.
 Ten Eyck Burr); Mrs. Walter Oakman and Miss Helen
 Hubbard.

Charles B. J. F de Saint-Mémin, was born in Dijon. He fled from France to Switzerland during the French Revolution; after emigrating to America in 1793 he worked initially as an engraver in New York. He subsequently achieved great success as an itinerant portrait painter in Philadelphia, Baltimore, Annapolis, Washington, Norfolk, Richmond, and Charleston. In 1814 he returned to Dijon to spend the remaining thirty-seven years of his life.

Saint-Mémin's reputation was established by his more than 800 profile portraits of prominent citizens. Using a physiognotrace, a tracing device, he produced an exact, life-sized profile; after filling in the details, he then reduced the image to a two-inch high miniature profile by means of a pantograph. In addition, he executed a number of profiles in small watercolor paintings that often included furniture and landscape backgrounds.

The subjects of these two portraits, young ladies from Baltimore, posed for Saint-Mémin when he visited that city in 1802 and 1806.

Harriet Rogers was the daughter of the prominent Baltimore merchant and amateur architect Colonel Nicholas Rogers IV, who designed the family home, "Druid Hill," which is pictured in the background of this watercolor. In 1807 Miss Rogers married John Robert Murray of New York, a wealthy art connoisseur, skilled amateur lithographer, a director of the American Academy of Arts, and an honorary member of the National Academy of Design. Mary Abigale Coale, a descendant of a prominent Harford County, Maryland family, became Mrs. William Tower Proud.

Harriet Rogers: exhibited at the Virginia Museum, the Birmingham Museum, and the National Academy of Design.
Mary Abigale Coale: exhibited at the Mississippi Museum of Art, the J. B. Speed Art Museum, and the New Orleans Museum of Art.

REMBRANDT PEALE (1778-1860)

43. *Benjamin Henry Latrobe*, ca. 1810-15

Oil on canvas, 22 by 17½ (55.9 by 44.5)
Unsigned
The Maryland Historical Society, Baltimore, Maryland, Gift of
Mrs. Gamble Latrobe, 81.15

Rembrandt Peale was born in Bucks County, Pennsylvania, the second son of Charles Willson Peale, from whom he inherited his artistic and scientific interests. Best known for his often-copied 1824 "porthole portrait" of George Washington, he was a prolific painter. His first portrait was executed at the age of thirteen. Later works included miniatures, landscapes, large history and allegorical scenes, and some early experiments in lithography. In addition to studying with his father, Peale also studied abroad, in London at the Royal Academy and in Paris with the Neoclassical Academician Jacques-Louis David, from whom he learned the encaustic technique.

In 1797, following a winter in Charleston, Peale, with his older brother Raphaelle, opened a public museum in Baltimore. Both this museum and a second short-lived one begun in 1814 were patterned after the Peale Museum in Philadelphia.

Although he continued to travel extensively and to paint profusely between 1803 and 1822, Peale's time was spent primarily in Philadelphia. An entrepreneur as well as an artist, Peale toured his massive allegorical painting *The Court of Death* in 1820, amassing $9,000 in one year's time.

Between 1822, when Peale moved to New York, and his final return to Philadelphia nine years later, the artist was instrumental in founding the National Academy of Design.

Rembrandt Peale's portrait of Benjamin Henry Latrobe, the second architect of the United States Capitol, was executed on a visit to Baltimore while the architect was living there. Sensitive and precise, its brilliant and limpid enamel-like surface reflects the hot-wax technique Peale had learned from David in Paris.

LOUIS ANTOINE COLLAS (1775-1829)

44. *Portrait of the Ralph Izard Children*, 1817

Watercolor on porcelain, 7⁵/₁₆ by 9¹/₁₆ (18.6 by 23)
Signed lower left center: *Collas 1817*
Carolina Art Association/Gibbes Art Gallery, Charleston, South Carolina
Provenance: Mrs. Julius H. Heyward, Charleston, South Carolina; bequest to the Carolina Art Association, 1943 (43.4.1).

Louis Antoine Collas (also known as Louis Augustin Collas and as Lewis Collers) was born and trained in Bordeaux, France. Between 1808 and 1811 he worked in St. Petersburg, Russia, and by 1816 he had arrived in New York City; that same year he exhibited sixteen miniatures at the American Academy of Fine Arts. He first journeyed to Charleston late in 1816 and worked as a miniature painter. This portrait, which depicts Anne Stead and Ralph Stead Izard, seventh generation of their family in South Carolina, is meticulously painted with dry brushstrokes. An elaborate landscape setting unites the two figures. The work's dimensions indicate the early-nineteenth-century concept of the miniature as a small painting rather than as a decorative ornament.

Although Collas exhibited again in New York in 1820, he spent the years 1822 to 1824 and 1826 to 1829 in New Orleans, where he was highly regarded as a miniaturist.

JOSHUA JOHNSTON (active 1796-1824)

45. *Mrs. Thomas Everette and Children*, 1818

Oil on canvas, 38⅞ by 55³/₁₆ (98.7 by 140.2)
Unsigned
The Maryland Historical Society, Baltimore, Maryland, Bequest
of Miss Mary Augusta Clarke, 76.96.4

One of the earliest known black painters in the United States, Joshua Johnston worked primarily in Washington, D.C., and Baltimore, where the city directories listed him as a "free man." Since certain stylistic similarities exist in the work of Johnston and Charles Peale Polk, there is speculation that Polk may have been both Johnston's teacher and master. In his own newspaper advertisements, however, Johnston indicated that no such relationship existed and that he was self-taught.

Although only one work is known to have been signed by Johnston, the portrait of Mrs. Thomas Everette and her children is attributed to him on the basis of information found in Mrs. Everette's will. The direct simplicity of the figures, grouped stiffly in front of a simple background, is characteristic of much of Johnston's work, as is his use of upholstery tacks in an elongated pattern to define the space in which the figures are depicted.

ANNA CLAYPOOLE PEALE (1791-1878)

46. *Andrew Jackson*, 1819

Watercolor on ivory, 3 by 2½ oval (7.6 by 6.4)
Signed lower right: *Anna C. Peale 1819*
Yale University Art Gallery, New Haven, Connecticut, The
Mabel Brady Garvan Collection, 1936.302

Born in Philadelphia, Anna Claypoole Peale was instructed in both oil and miniature painting by her father, the artist James Peale. She may also have received training from her illustrious uncle, Charles Willson Peale. Between 1820 and 1827, Anna Peale painted in Baltimore, where her still lifes and miniatures were exhibited at the Peale Museum to favorable response. During this period she also exhibited at the Pennsylvania Academy of the Fine Arts and the Boston Atheneum.

Among Anna Peale's sitters were a number of prominent Southerners, among them President James Monroe and General and Mrs. Andrew Jackson. At the time of the sitting for this portrait, Jackson was involved in the acquisition of the Florida territory from Spain.

Exhibited at the Virginia Museum, the Birmingham Museum, and the National Academy of Design.

PIETRO BONANNI (1789-1821)

47. *Portrait of Mary Sumner Blount, 1820*

Oil on canvas, 26¼ by 25¼ (66.8 by 64.1)
Signed lower right: *Bonanni 1820*
Mordecai Square Historical Society, Inc., Raleigh, North Carolina
Provenance: Mrs. Thomas Blount (*née* Mary Sumner), Tarboro, North Carolina; Moses Mordecai, Raleigh, North Carolina; Henry Mordecai, Raleigh; Martha Mordecai, Raleigh; Burke Haywood Little.

Pietro Bonanni, a student in Paris from 1812 to 1814, worked for a time in Rome and in his native Carrara, Italy, before sailing to America in 1817. In Washing-ton, he received a commission to decorate the ceiling of the old House of Representatives and painted por-traits as a means of livelihood. He was also an exhibitor at the Pennsylvania Academy of Fine Arts.

Bonanni's 1820 oil painting of Mary Sumner (Jackey) Blount is a fine example of his precise and appealing portrait style. The daughter of a Revolution-ary War officer, Brigadier-General Jethro Sumner of Warren County, North Carolina, she was painted during a sojourn to Washington with her husband, Thomas Blount of Tarboro.

SARAH MIRIAM PEALE (1800-1885)

48. *Still-Life of Watermelon and Grapes*, 1820

Oil on canvas, 14⅜ by 19⅛ (36.5 by 48.6)
Signed lower left: *Sarah M. Peale 1820*
The Maryland Historical Society, Baltimore, Maryland, Gift of
 Virginia A. Wilson, 58.52.4
Provenance: Descended in the family of William Wilson of
 Baltimore

Sarah Peale, the daughter of James Peale, was born in Philadelphia, where she lived and worked as a still-life and portrait painter. In her youth she made numerous trips of varying length to Baltimore, at one point setting up a studio in the city's Peale Museum, which was run by her cousins Rembrandt and Rubens Peale.

Midway in life she established residence in St. Louis, returning to her native city of Philadelphia only a few years before her death.

Sarah Peale's *Still Life of Watermelon and Grapes*, painted during one of her visits to Baltimore, indicates her sharp eye and carefully controlled brush. Reminiscent of several trompe l'oeil paintings executed by other members of the Peale family, the small work provides a visually pleasing study of contrasting textures.

Illustrated in color, figure 32, page 62, and also on cover, in detail.

PHILIP TILYARD (1785-1830)

49. *Jonathan Granville,* 1824

Oil on canvas, 20 by 19 (50.8 by 48.3)
Unsigned
The Baltimore Museum of Art, Baltimore, Maryland, Purchase
 Fund, 1945.92
Provenance: Mrs. Irene Tilyard (the artist's granddaughter).

The son of a glazier and sign-painter in Baltimore, Philip Tilyard trained with his father for a career as a sign- and ornament-painter. About 1814, however, he began to experiment with painting portraits. Basically self-taught, Tilyard may have sought advice from the painter Thomas Sully on one of his visits to Baltimore. From 1816 to 1822 he abandoned painting to become a dry-goods merchant; when he failed at this venture, he resumed painting, continuing until his death at age forty-five.

Tilyard's portrait of Jonathan Granville, painted during the second phase of his career as a portraitist, depicts the First Envoy from Santo Domingo to the United States. Sent by the president of Haiti to help improve the quality of life in his homeland, Granville's mission was to promote the sending of free American blacks to the island. During his visit to Baltimore, Granville spoke before the Baltimore Emigration Society and, as a result, arranged for twenty-one blacks to be sent by ship to the island.

JOHN JAMES AUDUBON (1785-1851)

50. *Carolina Parrot,* 1811
 Pencil, pastel, and watercolor on paper, 15 by 11 (38 by 28)
 Unsigned
 Houghton Library, Harvard University

John James Audubon was born in Haiti, but he spent his youth in post-Revolutionary France, emigrating to the United States in 1806. Though he is best known for his *Birds of America,* Audubon began his artistic career as a portrait painter.

After moving to Kentucky, Audubon opened a store, which soon failed. At that point he turned to painting. In a time of increased interest in the American landscape, Audubon made nature his primary subject. From about 1820 until his death, he devoted his life to depicting and writing about the birds and mammals of North America. The culmination of his life's work, *Birds of America* depicts, life-size, 1,065 birds in 435 plates. A set of double-elephant folios ("books of the largest kind") consists of four volumes, weighing eighty pounds each. Although Audubon's primary medium was watercolor, he also used pencil, pastel, ink, oil, crayon, and even egg-white to render the appropriate texture, sheen and coloration of the birds.

Unable to find a publisher for his volumes in the United States, Audubon was forced to travel to England. There, the work was eventually published by Robert Havell and his son in London between the years 1827 and 1838, but only after an unsuccessful attempt in Edinburgh by William H. Lizars, who engraved the first ten plates. Production of the series involved engraving, aquatint, and etching processes, followed by the hand-coloring of each printed image. Two hundred bound sets were produced and sold by subscription, either as complete sets or in single-volume series, as each was issued. Today fewer than 150 sets still exist.

Between 1826 and 1839, Audubon spent much of his time in Great Britain, but he spent the last decade of his life in the New York area.

RALPH ELEAZER WHITESIDE EARL (1785-1838)

51. *Mr. and Mrs. Ephraim Hubbard Foster and their Children,* ca. 1825

Oil on canvas (possibly mattress ticking), 53 3/16 by 70 1/16 (135.1 by 178)
Unsigned
The Fine Arts Center, Cheekwood, Nashville, Tennessee, Gift of Mrs. Josephus Daniels, Jr., 69.2
Provenance: Ephraim H. Foster; Robert Coleman Foster II, 1854; Mr. and Mrs. Edgar M. Foster, 1873; Mrs. Josephus Daniels, Jr.

Ralph E. W. Earl, son of the eighteenth-century Connecticut portraitist Ralph Earl, learned the rudiments of painting from his father before making several trips abroad. The work of John Trumbull and Benjamin West, which he would have seen at London's Royal Academy, and the paintings he saw at the Louvre made lasting impressions on him. A letter of recommendation indicates that during his stay in Paris Earl studied with the French Neoclassical history painter Jacques-Louis David.

Influenced by Trumbull's history painting, Earl returned to America to paint his own large-scale work, *The Battle of New Orleans.* The hero of the battle, Andrew Jackson, soon became Earl's mentor and patron. In 1818 Earl married Jackson's niece and moved to Nashville, where he became a popular portraitist. On his wife's death a year later, Earl was invited to live permanently at the Jackson home, "The Hermitage," outside the city. Although he continued as an active and appreciated local portraitist, his greatest contribution came through his numerous portraits of Jackson. These were reproduced and circulated as engravings to increase Jackson's public recognition, and to serve as propaganda for his political candidacy. On Jackson's election to the Presidency, Earl moved into the White House, serving as secretary and public relations advisor during Jackson's eight-year term of office. Earl returned to Nashville with Jackson in 1837 to continue his career in portraiture and to supervise the completion of "The Hermitage."

Ephraim Hubbard Foster, shown in this portrait, was born in Bardstown, Kentucky in 1794. He served as secretary to Andrew Jackson in the Creek War of 1813-14 and was the General's color-bearer during the Battle of New Orleans. He was a lawyer and later became a U.S. Senator. Foster is shown with his wife, her son by an earlier marriage (left), and their four children. Their exuberant young daughter, Jane Ellen, wearing an elaborate plumed hat, stands in front of the open window. The portrait was painted soon after the birth of the Foster's youngest child and long before Foster, who became disenchanted with Jackson, founded the rival Whig Party in Tennessee.

Illustrated in color, figure 26, page 47.

CHARLES FRASER (1782-1860)

52. *The Marquis de Lafayette,* 1825

Watercolor on ivory, 4 3/4 by 3 15/16 (12.1 by 10)
Unsigned
The City of Charleston, South Carolina

Charles Fraser was an outstanding miniaturist in his native Charleston in the early nineteenth century. He did his first works as a schoolboy, sketching landscape views of the area and experimenting with miniatures and oil painting. For eleven years he studied and practiced law in order to finance his artistic career. His friendship with Edward Greene Malbone and Washington Allston is thought to have influenced his style of painting and his ultimate choice of a career. Rarely leaving Charleston, Fraser was a highly regarded figure in the artistic life of the community. In 1857, three years before his death, over 400 of his miniatures were shown in a retrospective exhibition.

In 1825 Fraser received a double commission from the city of Charleston. The occasion was the Marquis de Lafayette's first return to the city since 1777, and Fraser was asked to paint two miniatures: one, a portrait of the French statesman for the city to keep; the second, a portrait of Francis Huger, son of Lafayette's host on his earlier visit, to give to Lafayette. During the French Revolution, the younger Huger had attempted unsuccessfully to secure the noble Lafayette's freedom from the Austrian prison where he was being held.

MATTHEW HARRIS JOUETT (1788-1827)

53. *Portrait of Justice Thomas Todd*, ca. 1825

 Oil on canvas, 35¼ by 28⅜ (89.5 by 72.1)
 Unsigned
 The Kentucky Supreme Court, Kentucky Historical Society,
 Frankfort, Kentucky

Matthew Harris Jouett, a native of Harrodsburg, Kentucky, studied law in Lexington at Transylvania College—the first institution of higher learning west of the Alleghenies—and later practiced law in the same city. Following his service in the War of 1812, Jouett turned to portraiture. Initially self-taught, he later studied with Gilbert Stuart in Boston and Thomas Sully in Philadelphia.

 Returning to Lexington, Jouett soon exhausted his market, and he found it necessary to travel to Louisiana and Mississippi to find patrons. In addition to portraits, including one of the Marquis de Lafayette commissioned by the Kentucky State Legislature, Jouett painted landscapes and organized art exhibitions for a number of philanthropic causes.

 Jouett's *Portrait of Justice Thomas Todd* reflects Stuart's influence in its modeling, fluid brushstroke, and compositional arrangement. The subject, a Virginian who settled in Danville, Kentucky, in 1786, served as Judge of the State Court of Appeals, was Kentucky's Chief Justice, and was as an Associate Justice of the United States Supreme Court.

CHARLES BIRD KING (1785-1862)

54. *Mistipee*, 1825

 Oil on panel, 17½ by 14 (44.5 by 35.6)
 Unsigned
 Museum of Early Southern Decorative Arts, Winston-Salem,
 North Carolina

Charles Bird King, a native of Newport, Rhode Island, was the leading painter in Washington, D.C., during the early nineteenth century. A pupil of Edward Savage in New York and Benjamin West in London, King spent several years in Philadephia and Baltimore before settling in Washington in 1801. For the next forty years he operated a studio-gallery. As a member of the National Academy, King added considerably to the cultural life of the city.

 In the winter of 1821-22, the Bureau of Indian Affairs commissioned King to paint the visiting chiefs from the Great Plains tribes of the upper Missouri River. Over the following ten years, King produced approximately 140 works for an Indian archive, and for many years his portraits were a popular tourist attraction because of their attention to detail. Although a number of replicas exist, many of the originals—rare examples of Federal patronage of the arts—were destroyed in a fire at the Smithsonian Institution in 1865.

 King's portrait of Mistipee shows the young Creek warrior casually posed, bow in hand. In spite of accurate depiction of dress, the young brave's facial features suggest the Caucasian race rather than the Indian, a characteristic of many of King's Indian portraits for which he was sharply criticized.

JACOB MARLING (1774-1833)

55. *The North Carolina State House at Raleigh, 1830*

Oil on canvas, 20 by 26½ (50.8 by 67.3)
Unsigned
North Carolina Museum of History, Raleigh, North Carolina,
Gift of Dr. F. J. Haywood, Raleigh, 1914, 14.231.1

Little is known of the training and early career of Jacob Marling, a portrait and landscape painter. In 1813 Marling arrived in Raleigh with his wife, a teacher of painting on silk, velvet, and glass. He continued to paint, but his wife became a milliner. Marling's best-known work is his 1830 representation of the old North Carolina State House at Raleigh, a building that was destroyed by fire one year later.

SAMUEL FINLEY BREESE MORSE (1791-1872)

56. *Portrait of Mrs. Robert Young Hayne*, 1832

Oil on canvas, 30¼ by 25 ⅛ (76.8 by 63.9)
Unsigned
Chrysler Museum at Norfolk, Virginia, 80.120
Provenance: Robert Young Hayne; Mrs. William Alston Hayne,
San Francisco; Mrs. Alan G. Pattee; private collection,
Youngstown, Ohio; Walter P. Chrysler, Jr.

Although Samuel F. B. Morse is best remembered for his inventions, he was a major figure in the development of American art in the first half of the nineteenth century. Known for his portraits, miniatures, and history paintings, Morse, along with Thomas Cole and Rembrandt Peale, was instrumental in the founding of the National Academy of Design in 1826. Morse also served as the Academy's first president.

Born in Charlestown, Massachusetts, Morse attended Yale College, then traveled to London in 1811 to study with Benjamin West. On his return he settled in New York, but he did not paint there exclusively. From 1829 to 1833 he worked abroad on a commission to paint copies of old masters and views of European scenery. Morse frequently wintered in Charleston,

South Carolina, enjoying both its mild climate and the enthusiastic patrons there. On a visit in 1832, he painted the lovely young wife of a distinguished Charleston lawyer and United States Senator, Robert Young Hayne. The gracefully ordered composition and soft but vibrant tones of the portrait reflect Morse's awareness of the work of Gilbert Stuart and Thomas Sully.

Embittered by the federal government's selection of John Trumbull to execute four large canvases for the Capitol Rotunda, Morse began to turn away from painting to focus on scientific pursuits.

Illustrated in color, figure 25, page 45.

GEORGE COOKE (1793-1849)

57. *Tallulah Falls*, 1834-49

Oil on canvas, 35¼ by 28¼ (89.5 by 71.8)
Unsigned
Georgia Museum of Art, The University of Georgia, Athens,
 Georgia, 59.646

George Cooke of St. Mary's County, Maryland, showed an early ability to paint, but he was directed toward the mercantile trade in order to help earn the high fee required by the painter Rembrandt Peale to serve as an apprentice. After several unsuccessful business ventures, Cooke was able to secure instruction without cost from the Washington painter Charles Bird King.

Establishing himself initially as a portraitist, the genial Cooke had as early sitters individuals connected by birth or by business to his wife's prodigious family. According to the artist himself, he executed forty portraits in Richmond, out of a total 130, in slightly over two years.

In 1826 Cooke sailed to the Continent for five years' study to broaden his skills to include both landscape and history painting. His subsequent versatility is evident in his work of the 1830s, which was executed primarily in New York and Washington, D.C., and on occasion in other communities along the Atlantic seaboard. In addition to exhibiting his work in various cities, Cooke was also a successful illustrator for the *Family Magazine* and a writer on art and travel for the *Southern Literary Messenger*.

A portraitist out of financial necessity, Cooke hoped to be awarded a federal commission to execute a painting for the Capitol. Supported by a strong Southern (but anti-Jackson) faction, Cooke was passed over in favor of Virginian John Gadsby Chapman, whose success as a painter had, ironically, resulted from Cooke's own influence. Through the efforts of his former teacher, C. B. King, Cooke received a commission to paint the six Indian chiefs who came to Washington in 1837; his work was later reproduced in McKenney and Hall's *Indian Tribes of North America*.

In the 1840s Cooke based himself in the Deep South, traveling out of Athens, Georgia, and New Orleans. In 1844 the Alabama industrialist Daniel Pratt established a studio and gallery for Cooke in New Orleans, where the artist was able to display his own work as well as that of other major American artists of the nineteenth century.

Cooke's *Tallulah Falls* depicts a well-known north Georgia landmark that attracted many of the nineteenth century's Nature Romantics.

JOHN BLAKE WHITE (1781-1859)

58. *The Arrival of the Mail,* 1836
Oil on canvas, 29¾ by 24½ (75.6 by 62.2)
Signed lower right: *J. B. White 1836*
The City of Charleston, South Carolina, City Hall Collection
Provenance: Descended in the family of the artist.

Born near Eutaw Springs, South Carolina, John Blake White spent three years in London as a student of Benjamin West. After returning to America in 1803, he painted portraits in Boston and later Charleston. Unsuccessful as a portraitist, White proceeded to study and practice law in Charleston although his interest in painting persisted. With the exception of living one year in Columbia, South Carolina, his time in Charleston was divided between his law practice and his painting. A playwright as well as a painter of scenes of American history, White served as Director of the South Carolina Academy of the Fine Arts and held honorary membership in the National Academy of Design.

The Arrival of the Mail shows Broad Street in Charleston, seen from the Post Office lobby, at an important time to any merchant, the arrival of the mail. The view includes the Ashley River, the Courthouse, and the spire of St. Michael's Church.

FRANCIS C. HILL (1784-1857)

59. *Old St. John's Lutheran Church, East*, 1838

Oil on canvas, 17 by 23¼ (43.2 by 59)
Signed lower right: *F. C. Hill pinxt/1818*
St. John's Lutheran Church, Charleston, South Carolina
Provenance: C. F. Matthieson

In 1804 Francis C. Hill first advertised his services in Charleston, South Carolina, as a painter specializing in furniture and signs. Three years later he was listed among the limners and miniature painters in the city. His surviving sketchbooks attest to his interest in landscape and cityscape; they include a number of views of St. John's Lutheran Church, where Hill was a vestryman. Various surviving oil paintings and prints based on Hill's sketches show the first church, which was built in 1756 but demolished in 1818. The east

view of the structure, seen from the graveyard, is signed and dated 1818, an indication that the group of paintings was done to record the appearance of the older building before its destruction. An inscription on the back of the painting reads as follows:

Back view of the German Lutheran Church
Charleston So Ca built 1759. taken down in 1818
painted in Charleston 1838 from Recollection by
Francis C. Hill. the building was Wood.
Mr. C. F. Matthieson begs leave to present this
to the Luthern [sic] Church. Feby 27th 1839
(East View)

The quiet setting, the obvious record-keeping, and the deaccentuation of other nearby structures combine to create a strong graphic portrait of this simple building.

THOMAS SULLY (1783-1872)

60. *Portrait of Conway Robinson,* 1850

Oil on canvas, 24 by 20½ (61 by 52.1)
Signed on back: *TS*
Virginia Historical Society, Richmond, Virginia
Provenance: Moncure Robinson, 1850; Agnes Conway Robinson, Washington, D.C. (presented to the Virginia Historical Society in 1929 by Agnes Conway Robinson, the sitter's daughter).

Thomas Sully, whose family of actors emigrated to Charleston, South Carolina, from England in 1792, received his first instruction in art from his brother-in-law, Jean Belzons, and from his brother Lawrence. His own career as a portraitist, miniaturist, and figure painter began in Richmond, Virginia, in 1804.

Between 1805 and 1810, Sully traveled extensively, making contact with John Wesley Jarvis in New York, Gilbert Stuart in Boston, and Charles Bird King, Benjamin West, and Sir Thomas Lawrence in London. Settling in Philadelphia on his return, Sully became the leader of his generation of portraitists, influencing and assisting a number of young American painters.

Sully's highly successful portraits of women and children, romantic in their fluid brushstroke and dramatic chiaroscuro, are often reminiscent of Lawrence's work. Although based in Philadelphia, Sully made many professional visits throughout his life to cities in the South. Paintings executed in Washington, D.C., Baltimore, Richmond, and Charleston comprise a large number of his 2,000 known portraits.

Portrait of Conway Robinson conveys the character of a noted Richmond lawyer. Robinson, author of the 1848 volume *Early Voyages to America,* was a founding member of the Virginia Historical Society, an organization he served in many capacities for more than fifty years.

1830 to 1900

JEAN JOSEPH VAUDECHAMP (1790-1886)

61. *A Creole Lady* (possibly Françoise St. Amant), 1832

Oil on canvas, 32 by 25¾ (81.3 by 65.4)
Signed upper left: *Vaudechamp 1832*
New Orleans Museum of Art, New Orleans, Louisiana, Gift of
the Art Association Guild of New Orleans, 54.2
Provenance: Dr. I. M. Cline Collection, New Orleans; John F.
Lewis, Sr., Philadelphia; the Pennsylvania Academy of the
Fine Arts, Philadelphia; the Art Association Guild of New
Orleans.

Born in Rambervillers, France, Jean Joseph
Vaudechamp studied with Anne Louise Girodet-
Triosin and after 1814 exhibited with some regularity in
the Paris Salons. Between 1831 and 1839, Vaude-
champ spent his winters in New Orleans, arriving in
November or early December to remain until the
spring. His success in New Orleans is evidenced by

records that indicate that in a period of three consecu-
tive winters he amassed $30,000. Although his visits to
New Orleans became sporadic after 1839, he is known
to have painted in the city as late as 1845.

Vaudechamp's portraits, seventy-eight of which
were executed in New Orleans, are characterized by
fine, precise draughtsmanship, which is indicative of
the discipline of his French Academic training. Care-
fully delineated features and details of dress are often set
against plain backgrounds.

Vaudechamp's 1832 portrait, *A Creole Lady*, de-
picts a mature New Orleans woman with sympathy and
realism. If the identification of the portrait as Françoise
St. Amant is correct, the sitter lived near Vaude-
champ's studio on Royal Street and may have been a
personal friend.

EDWARD TROYE (1808-1874)

62. *Captain Willa Viley's Richard Singleton, with Viley's Harry, Charles, and Lew*, ca. 1834

Oil on canvas, 24½ by 29½ (62.2 by 74.9)
Unsigned
Mr. and Mrs. Paul Mellon, Upperville, Virginia

63. *Bay Maria and Foal, Cornelia*, 1840

Oil on canvas, 25¼ by 30¼ (64.1 by 76.8)
Unsigned
Historic Columbia Foundation, Columbia, South Carolina

Edward Troye, the most highly regarded horse painter in America during the nineteenth century, was born Edouard de Troy, the son of a sculptor, in Lausanne, Switzerland. Trained in London, he emigrated to America in the early 1830s, painting in Philadelphia, New York, Virginia, South Carolina, and Tennessee before going to Lexington, Kentucky. There, he an-

nounced that he would paint "the noblest of animals," the horse. His reputation as an equestrian painter was quickly established by word-of-mouth, and for the rest of his life he never lacked patronage. Three hundred fifty-six paintings and eleven drawings by Troye have been documented; the majority depict horses, which are often shown with their trainers, grooms, and jockeys. He is also known to have executed portraits and paintings of prize livestock.

Although Troye considered himself a citizen of Kentucky, he served as a professor of drawing and French at Spring Hill College, outside Mobile, Alabama from 1849 to 1855. His academic work ended when he left for an extended tour of the Middle East with A. Keene Richards to assist in stocking the latter's farms with Arabian horses. Prior to the Civil War,

227

Troye is known to have visited New Orleans three times; following the war, two years of which Troye spent in Europe, he returned to America to settle at Owens Cross Roads, near Huntsville, Alabama. He traveled frequently during the summers as his commissions demanded.

Richard Singleton, foaled in 1828 by Bertrand out of Black-Eyed-Susan, was named after Richard Singleton of Melrose in the High Hills of Santee, South Carolina, who was considered one of the most distinguished citizens of the state. The bay colt started in fourteen three- and four-mile heat races, losing only two. Soon after arriving in Kentucky in 1834, Troye painted the horse, which was the property of Captain Willa Viley of Scott County, near Georgetown, South Carolina. The horse, in racing condition, is shown by his trainer, Viley's Harry, who is in top hat and green frock coat. A former slave who had been purchased for $1,500, Harry was subsequently given his freedom and a $500 annuity to train Viley's horses. To left and right stand Charles, the groom, and Lew, the jockey, the latter dressed in light blue cap and jacket. Although the portrait is neither signed nor dated, it must have been painted soon after Richard Singleton's last race in October 1834 at Louisville's Oakland Course, where he won two four-mile heats.

Bay Maria, owned by Wade Hampton II of Columbia, South Carolina, was said to be one of Hampton's most brilliant successes. The horse won the Jockey Club purse in 1837 and was recognized at the time as "the model of a brood mare."

Richard Singleton: exhibited at the Virginia Museum.

228

GEORGE CATLIN (1796-1872)

64. *Mick-e-no-pah*, 1838

> Oil on canvas, 29 by 24 (73.7 by 70)
> Unsigned
> National Museum of American Art, Smithsonian Institution, Washington, D.C., Gift of Mrs. Sarah Harrison, L.1965.1.300
> *Provenance*: Joseph Harrison, Philadelphia; Mrs. Joseph Harrison, Philadelphia (gift to the Smithsonian Institution, May 15, 1879).

A native of Wilkes-Barre, Pennsylvania, George Catlin abandoned the study of law to establish himself as a miniaturist and portrait painter, first in Philadelphia, then in New York. In 1829 he moved to Richmond, Virginia, and one year later he made his first trip west. He went on to devote most of his career to portraying the American Indian, sometimes in his studios in St. Louis and New Orleans.

In 1834 he visited a group of Seminole Indians who were being held prisoner at Fort Moultrie near Charleston, South Carolina. The "first chief" of the tribe, Mick-e-no-pah, agreed to allow the artist to paint his likeness once he discovered that whiskey and wine were rewards for those who posed. When the chief insisted that Catlin paint a "fair likeness of his legs" in their handsome red leggings, the artist drew in the lower part of the canvas first, leaving room for the body and head above. Mick-e-no-pah is said to have owned 100 slaves when the Seminole war broke out and to have been raising large and valuable crops of corn and cotton.

Between 1837 and 1851, Catlin toured Central and South America and Europe to great acclaim. His collection of Indian paintings, the so-called "Indian Gallery," along with the Indians who traveled with the exhibit, made Catlin the forerunner of Buffalo Bill's "Wild West Show."

ROBERT BRAMMER (active 1838-1853)
AUGUSTUS VON SMITH (active 1835-1848)

65. *Oakland House and Race Course, Louisville, Kentucky, 1840*

Oil on canvas, 28¼ by 35¾ (71.8 by 90.8)
Signed lower left (on tree trunk): *Brammer and Von Smith 1840*
J. B. Speed Art Museum, Louisville, Kentucky, 56.19

Little is known of Robert Brammer and Augustus Von Smith beyond a few scattered references in newspapers and city directories. Von Smith, recorded as "foreign born," is believed to have lived in the 1830s in Vincennes, Indiana. The two are listed together as artists in the 1841 Louisville directory, and one year later in the New Orleans directory. It is known that Brammer died at his summer home in Biloxi, Mississippi, in 1853.

The Oakland House and Race Course opened on the outskirts of Louisville in 1832, only four years after

the city was incorporated. In September of 1839 it was the scene of a race famous in turf history, a four-mile $14,000 run between "Grey Eagle" of Lexington and "Wagner" of Tennessee and Louisiana, a race that attracted national attention. The crowds were said to have been "the largest ever up to that time seen at a race in America." The crisp painting, executed shortly after the event, shows the carriages and equipages of owners and spectators gathering for a race.

By 1865 there were twenty-two major race courses in the North, including Washington, D.C., and eighty-three in the South. The larger number of Southern tracks indicates the region's stronger interest in racing and horse-breeding.

WILLIAM JAMES HUBARD (1807-1862)

66. *Henrietta and Sarah Mayo,* ca. 1840

Oil on canvas, 27¼ by 34½ (69.2 by 87.6)
Unsigned
Valentine Museum, Richmond, Virginia, 57.184.1
Provenance: the James J. Tabb family, Richmond, Virginia.

Considered a child prodigy in his native England for his ability to cut silhouettes, Hubard came to the United States in 1824 with his manager. He pursued his career for three years in New York and Boston. With Gilbert Stuart's encouragement, Hubard switched to oil painting, spending several years in England, Philadelphia, and Baltimore before settling in Gloucester County, Virginia, in 1832. Returning from a European trip in 1841, he moved permanently to Richmond, Virginia, to continue his painting career. During the 1850s Hubard's interest in sculpture led him to establish a foundry for casting bronzes in the city, and during the Civil War the foundry provided ammunition for the Confederate government. Hubard was fatally injured in an explosion at the foundry during the second year of the War.

Henrietta and Sarah Mayo were the daughters of Joseph and Marianna Tabb Mayo, members of a prominent Richmond family; their father served as mayor of Richmond during the Civil War. Although Sarah Mayo never married, her sister Henrietta became the mistress of "Pratt's Castle," a famous Richmond landmark (now demolished) upon her marriage to Samuel H. Cornick in 1880. Hubard's painting of the two young girls is indicative of his precise and pleasing portrait style.

Artist Unknown, possibly JULES (or JULIEN) HUDSON
(active ca. 1831-1844)

67. *Maid of the Douglas Family,* ca. 1840

Oil on canvas, 24¾ by 20¼ (62.9 by 51.4)
Unsigned
Louisiana State Museum, New Orleans, Louisiana, 11943A
Provenance: Douglas family, New Orleans (gift to the Louisiana
State Museum, 1938).

Identified in the terms of the day as "a free man of
color," Jules (or Julien) Hudson was born in New
Orleans and is known to have received some instruc-
tion from the Italian-born Antonio Meucci, who
worked in the city in 1818 and again in 1826-27. In
1831, after studying with Abel de Pujol in Paris,
Hudson opened his own studio in New Orleans at 117
Bienville Street. Listed in the city directories as a
portrait painter, he advertised as a miniaturist.

The young black woman, who is depicted in a
straightforward manner, may have been a slave or a so-
called "free woman of color." On her head she wears
the traditional *tignon,* here rich red in color.

The subject and the placement of the sitter's head
in relation to the plain background suggest a possible
attribution to Hudson.

L. SOTTA (dates unknown, mid to late 19th century)

68. *Mrs. Leonard Wiltz of New Orleans*, 1841

 Oil on canvas, 31⅝ by 25 (80.3 by 63.6)
 Signed lower right: L. *Sotta 1841*
 Louisiana State Museum, New Orleans, Louisiana, 8415

Little is known of L. Sotta, the only female French portraitist at work in New Orleans in the nineteenth century. An exhibitor at the Paris Salons of 1833 and 1838, Sotta is recorded as living on St. Louis Street in New Orleans in 1841-42. During that time she painted this strong portrait of Mrs. Leonard Wiltz, a resident of Dauphine Street and the mother of the artist Leonard Wiltz, Jr. Deep shadows and precise detail mark this skillfully realistic portrait of a Louisiana matriarch, who is shown with her spectacles perched atop her turban.

JACQUES G. L. AMANS (1801-1888)

69. *Portrait of a Gentleman*, 1845

 Oil on canvas, 37¹⁵⁄₁₆ by 29¹⁵⁄₁₆ (96.4 by 76)
 Signed upper right: *Amans 1845*
 The Brooklyn Museum, Brooklyn, New York, 28.208

Little is known either of Jacques Amans's early life in Belgium or of his early artistic training; however, he is recorded as an annual exhibitor at the Paris Salon between 1831 and 1837. In the winter of 1836-37, Amans—in the company of his fellow French artist Jean Joseph Vaudechamp—made his first visit to Louisiana. For Amans, this trip began a series of annual visits to New Orleans, where he became known as a portrait painter. After his marriage in the mid 1840s to a woman from Louisiana, he lived year-round in the South until 1856, when he returned permanently to France with his wife. On his death, he willed his Louisiana property to his sisters in Brussels, Belgium.

 Portrait of a Gentleman is one of more than seventy portraits signed by or attributed to the artist. The careful delineation of features and dress, in combination with the plain background, indicate Amans's disciplined Academic training in Paris. His unknown sitter's easy pose and direct glance reflects the dashing quality of many of the young men who were attracted to New Orleans in the 1840s in hopes of making their fortunes.

ALFRED BOISSEAU (1823-1901)

70. *Louisiana Indians Walking Along a Bayou*, 1847

> Oil on canvas, 24 by 40 (61 by 101.6)
> Signed over center: *Al Boisseau 1847*
> New Orleans Museum of Art, New Orleans, Louisiana, Gift of
> Mr. and Mrs. William E. Groves, 56.34
> *Provenance:* Dr. Isaac M. Cline, New Orleans; William E.
> Groves, New Orleans, 1956.

Alfred Boisseau was born in Paris, where he studied at the Ecole des Beaux-Arts. He also studied with Paul Delaroche and exhibited at the Paris Salon from 1842 to 1848.

By 1845 Boisseau was in New Orleans, where his brother was secretary to the French consul. Fascinated by the Indians, as well as the blacks and Creoles, Boisseau painted a number of works—among them *Louisiana Indians Walking Along a Bayou*—that he sent to Paris for the Salon of 1848. Harriet Martineau, in the 1837 publication *Society in America*, describes a scene similar to that depicted by Boisseau:

The squaws went by, walking one behind the other. . . . These squaws carried large Indian baskets on their backs, and shuffled along, barefooted, while their lords paced before them. . . . with blue and red clothing and embroidered leggings, with tufts of hair at the knees, while pouches and white fringes dangled about them. They looked like grave merry-andrews; or, more still, like solemn fanatical harvest men going out for largess. By eight o'clock they had all disappeared; but the streets were full of them again the next morning.

At mid century Boissseau was living in New York and exhibiting at both the American Art Union and the National Academy of Design. He remained active painting portraits and landscapes and teaching, both in Cleveland and in Montreal, until he died in Buffalo, New York in 1901.

Illustrated in color, figure 36, page 83.

HIPPOLYTE VICTOR VALENTIN SEBRON (1801-1897)

71. *Giant Steamboats at New Orleans,* 1853

> Oil on canvas, 47 by 71 (119.4 by 180.3)
> Signed on back, lower right: *H. Sebron New Orleans 1853*
> Tulane University Art Collection, Tulane University, New
> Orleans, Louisiana, 0.1892.1
> *Provenance:* D. H. Holmes, 1892.

Hippolyte Sebron, a French artist who lived in New Orleans between 1850 and 1854, achieved renown as an associate of L. J. M. Daguerre, inventor of the daguerreotype and the diorama. During his stay in the United States from 1849 to 1855 and later, upon his return to France, Sebron specialized in views and interior scenes.

Sebron's panoramic view of the New Orleans levee, with giant steamboats docked at anchor, records the city's waterfront at a time of great economic prosperity. The varied waterfront activity in the foreground contrasts with the remote line of row houses set along the crescent shape of the river. In the distance, the steeple of St. Patrick's Church and the dome of the St. Charles Hotel are also visible. The high vantage point, the near-photographic rendering of the panorama, and the strong, steady glow of light on the horizon appear to reflect Sebron's contact with Daguerre and his experiments with both dioramas and photography.

FLAVIUS J. FISHER (1832-1905)

72. *The Dismal Swamp,* ca. 1858

Oil on canvas, 30 by 50 (76.2 by 127)
Unsigned
Randolph-Macon Woman's College Art Gallery, Lynchburg,
 Virginia, Gift of Mrs. Robert N. Winfree, Lynchburg

Although born in Wytheville, Virginia, Flavius J. Fisher grew up in eastern Tennessee and is said to have studied art in Philadelphia. Returning to Virginia about 1855, he worked in Petersburg in 1858. While studying in Germany in 1859-60, Fisher apparently became the first American painter to be admitted to the German Art Institute in Berlin. On his return to America, Fisher lived in Lynchburg, Virginia from 1860 to 1882. Thereafter, he painted from his studio in the Corcoran Building in Washington, D.C., until his death in 1905.

Although known primarily for his portraits, Fisher also occasionally painted landscapes. In one of these he depicted the Great Dismal Swamp, the 750-square-mile tract of marsh land that extends from southern Virginia into North Carolina. The glow of light in the sky and on the water symbolizes the isolation and mystery inherent in this imposing feature of the Southern landscape.

GEORGE PETER ALEXANDER HEALY (1813-1894)

73. *Portrait of Alexander Hamilton Stephens*, 1858

Oil on canvas, 29½ by 24½ (74.9 by 62.2)
Signed lower left: *G. P. A. Healy, 1858*
The Georgia State Law Library, Atlanta, Georgia

G. P. A. Healy, a native of Boston and a partially self-taught artist, opened a studio there at the age of seventeen. In 1834 he journeyed to Paris, where he was initially a student of the Napoleonic painter Baron Gros. At this time he also met the artist Thomas Couture, who became his lifelong friend. Through the United States Minister to France he was able to gain entrée into the Court of Louis Phillippe, and he was eventually awarded royal commissions to execute portraits of a number of American statesmen, including Andrew Jackson. Healy subsequently traveled between Europe and America, acquiring many commissions and an international reputation as an accurate and facile portraitist.

In the 1840s and 1850s, Healy also visited a number of Southern cities in the United States. Since he was in New Orleans in 1843 and his brother Thomas was in Jackson, Mississippi, in 1844, speculation exists that the brothers may have traveled south together. In 1861 Healy traveled to Charleston with General P. G. T. Beauregard. Following the bombardment of Fort Sumter, however, he returned to the North. At war's end, Healy moved again to Europe and lived in Paris and Rome. He returned to Chicago in 1892, two years before his death.

Healy's *Portrait of Alexander Hamilton Stephens*, executed in Georgia several years before the outbreak of the Civil War, presents the sitter in what must have been a characteristic pose, looking up from a book. A slight man who was often in ill health, Stephens was known for his intellectual brilliance and personal integrity. A graduate of the University of Georgia in 1832, he originally studied for the ministry but later pursued law. Stephens's long political career began in 1836 with his election to the Georgia Legislature. Elected Vice-President of the Confederacy in 1861, he was arrested by federal troops in May of 1865 and was briefly held prisoner. Ironically, during the War, one of his primary concerns had been the exchange of prisoners of war. On his election to the United States Senate in 1866, he was disqualified from holding federal office for having been a member of a rebellious state. Stephens later served for a decade as a member of Congress and, shortly before his death, as Governor of Georgia.

FRANCIS BLACKWELL MAYER (1827-1899)

74. *Independence (Squire Jack Porter)*, 1858

Oil on paperboard, 12 by 15⅞ (30.5 by 40.3)
Signed lower right: *F. B. Mayer 1858*
National Museum of American Art, Smithsonian Institution, Washington, D.C., Harriet Lane Johnston Collection, 1906.9.11

F. B. Mayer, a native of Baltimore, is remembered for his landscapes and small genre scenes. Mayer was a student of Alfred Jacob Miller in Baltimore and of Marc-Gabriel-Charles Gleyre and Gustave Brion in Paris. He painted for most of his career in the area around his native city. In a number of canvases, in which he depicted the people of rural Maryland in their daily activities, he sought to point a moral by means of the narrative.

John M. Porter, the subject of *Independence*, was a veteran of the War of 1812 and, at the time of the painting, owner of a farm near Frostburg, Maryland. Posed casually, pipe in hand, Porter exemplifies the confidence that results from an independence of spirit and life.

Exhibited at the Virginia Museum, the Birmingham Museum of Art, and the National Academy of Design.

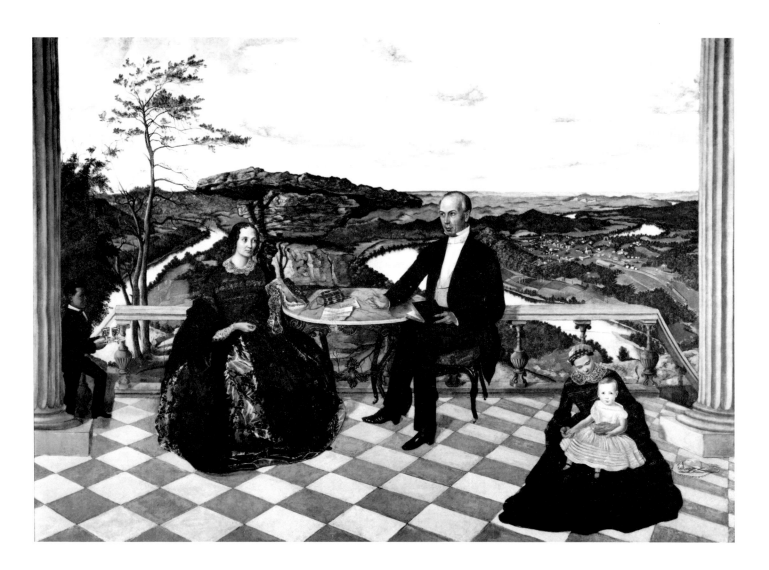

JAMES A. CAMERON (1817-1882)

75. *Colonel and Mrs. James A. Whiteside, Son Charles, and Servants*, ca. 1858-59

Oil on canvas, 53 by 75¼ (134.6 by 191.1)
Signed on letter on table: *James Cameron*
Hunter Museum of Art Collection, Chattanooga, Tennessee, Gift of Mr. and Mrs. Thomas B. Whiteside, 75.7
Provenance: Colonel and Mrs. James A. Whiteside; taken from the Whiteside family by Union soldiers during the Civil War; returned anonymously from New York to the family in the twentieth century.

James Cameron, who was born in Greenock, Scotland, emigrated to Philadelphia in 1833. An exhibitor at both the American Art Union and the Pennsylvania Academy of the Fine Arts, Cameron moved to Nashville, Tennessee around 1850. Not long afterwards the Chattanooga railroad financier Colonel James A. Whiteside encouraged the artist to relocate in the hopes that the artist's presence there would stimulate

new cultural interest in the east Tennessee community. The outbreak of the Civil War cut Cameron's career short and forced his temporary departure from Chattanooga. On his return in 1865, he found no patronage in what had become a wasted and poverty-stricken area, and he moved on. He spent the rest of his life in California, where he painted and eventually became a minister in the Presbyterian Church.

Cameron's portrait is set on a terrace high above the Tennessee River at Moccasin Bend. The wide vista and foreshortened perspective are typical of Cameron's work at this time. Showing close attention to detail and using precise brushwork, he presented a carefully-articulated view of Southern family life in the mid nineteenth century.

Illustrated in color, figure 35, page 81.

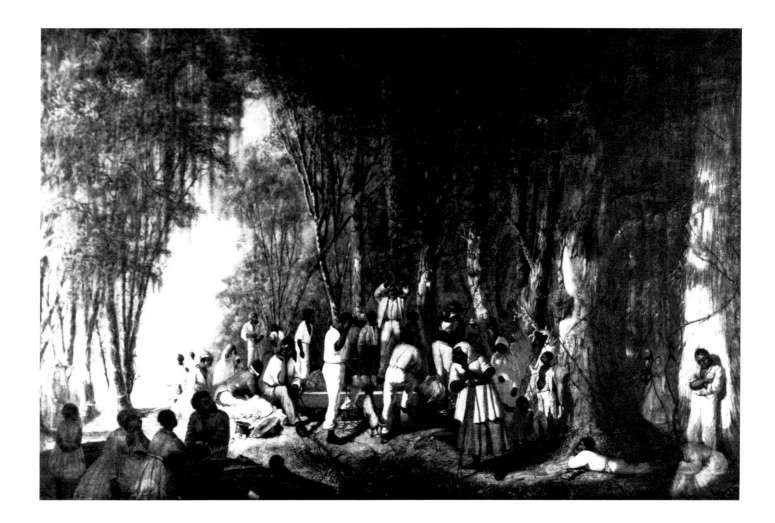

JOHN ANTROBUS (1837-1907)

76. *A Plantation Burial*, 1860

> Oil on canvas, 52¾ by 81⁵⁄₁₆ (134 by 206.5)
> Unsigned
> The Historic New Orleans Collection, New Orleans, Louisiana,
> 1960.46

John Antrobus, a painter of portraits, landscapes, and genre scenes, arrived in the United States from his native England at mid century. Records indicate that he had worked in Montgomery, Alabama, prior to 1859, the year he arrived in New Orleans, determined to depict Southern life and nature in a series of twelve paintings. The whereabouts of the first painting—a cotton-picking scene—is unknown. The second, and apparently the only other painting of the series that was completed, was exhibited in New Orleans in the spring of 1860. *A Plantation Burial* is based on an event Antrobus had observed during a visit to the Tucker plantation in northern Louisiana's Carroll Parish. He organized his figures within a forest setting. A black preacher and the family and friends of the deceased surround the centrally-placed coffin; to the left and right, at a discrete distance from this private event, stand the overseer, the master, and mistress.

One year after *A Plantation Burial* was exhibited, Antrobus enlisted in the Confederate cause and served with the Delhi Southrons. After the war he married a woman from New Orleans and moved with her to Chicago, then to Washington, and finally to Detroit. Antrobus was also known for his poetry, which was published in Detroit newspapers.

EASTMAN JOHNSON (1824-1906)

77. *Negro Boy*, 1860
 Oil on canvas, 14 by 17⅛ (35.6 by 43.5)
 Unsigned
 National Academy of Design, New York, Gift of the
 Artist, 1860, NAD671

A native of Lovell, Maine, Eastman Johnson spent part of his youth in Augusta, where his father served as Maine's Secretary of State. After a year's apprenticeship to J.H. Bufford in Boston, Johnson abandoned the study of lithography in favor of conté crayon portraiture, subsequently working as a portraitist in cities from Augusta to Washington, D.C. At mid century he traveled in Europe, where he studied with Emmanuel Leutze in Dusseldorf. Johnson's greatest success in Europe came in the four years he spent in The Hague, where he was known as "the American Rembrandt" and was offered the position of court painter.

In 1855 Johnson returned to the United States and worked in a succession of cities, including Washington, D.C., before establishing permanent residence in New York just prior to the outbreak of the Civil War. For a number of years after the war, he painted both genre scenes and portraits; late in his life he limited his work to portraiture.

Johnson's greatest success came from *Negro Life in the South* (now titled *Life in the South*), a painting he executed in Washington in 1859 that was the basis for his selection to membership in the National Academy of Design. With its title changed to *My Old Kentucky Home*, after the popular Stephen Foster song, the painting was subsequently exhibited at the Paris World's Fair of 1867, where it was viewed as a picturesque description of Southern life before the Civil War.

On his election as a full member of the National Academy of Design in 1860, Johnson, in accordance with custom, contributed to the Academy both a self-portrait and another example of his work, *Negro Boy*. This small painting of a seated boy absorbed in playing a flute presents a quiet contrast to the more active *Life in the South*.

Attributed to FRANÇOIS FLEISCHBEIN (ca. 1804-1868)

78. *Portrait of Marie LeVeau's Daughter,* after 1860

Oil on canvas, 26 by 21 (66.0 by 53.3)
Unsigned
New Orleans Museum of Art, New Orleans, Louisiana, Gift of
Mr. and Mrs. William E. Groves, 66.29.

François Fleischbein was a young man when he left his native Bavaria to study in France. By 1834 he was in New Orleans, where he remained for the rest of his life. On his arrival there with his French wife, he advertised as a portrait painter, but by his death he was fully employed as a daguerreotypist and ambrotypist.

A work attributed to Fleishbein depicts with great sensitivity a young black woman whose legal designation was "free woman of color" *(femme de couleur libre,* or *f.c.l.).* In the thirty years before the Civil War, members of this group, who were set between the slaves and the dominant white segment of the New Orleans population, frequently achieved a degree of economic and cultural independence and became property owners, skilled craftsmen, preachers, and poets.

Neatly dressed in a simple black garment trimmed with lace, the young woman in this portrait holds a watch or locket suspended on a gold chain. She may have been either Marie LeVeau herself, or her daughter. LeVeau was a legendary "voodoo queen" and an important personality in the New Orleans black Creole community. Mother and daughter may have shared certain activities, and there is some question as to which was indeed the "voodoo queen." The subject of the painting is, nonetheless, a young, attractive, dignified, and apparently well-to-do black woman.

Illustrated in color, figure 33, page 72.

RICHARD CLAGUE (1821-1873)

79. *Trapper's Cabin*, ca. 1860-70
> Oil on canvas, 12 by 16 (30.5 by 40.6)
> Signed lower left: *R.Clague*
> The New Orleans Museum of Art, New Orleans, Louisiana, 66.27
> *Provenance*: Mr. and Mrs. William E. Groves, (gift to the Delgado Museum, now New Orleans Museum of Art, in 1966).

80. *Spring Hill, Alabama*, 1872
> Oil on canvas, 16 by 24 (40.6 by 61)
> Signed lower right: *R. Clague*
> The New Orleans Museum of Art, New Orleans, Louisiana, 71.2

Thought to have been born in Paris while his parents were visiting there, Richard Clague grew up in New Orleans. At the time of his parents' legal separation in 1832, he moved back to Paris with his mother; he then studied in Switzerland for a year with a pupil of Ingres, Jean Charles Humbert.

After his father's death, Clague returned to New Orleans, where he studied and worked with the French-born muralist and panorama painter Leon Pomarede. Between 1844 and 1857 he lived, studied, and exhibited in Paris before returning to New Orleans. In 1856 he joined the engineer Ferdinand de Lesseps on the French expedition to Egypt to plan the digging of the Suez Canal, serving as draftsman. After 1857 he lived in New Orleans; he served one year in the Confederate Army.

During the last ten years of his life, Clague frequently painted simple rustic landscapes in the low-lying areas of Louisiana, Mississippi, and Alabama. He was one of the first artists to make the land of the lower Mississippi River Delta and the Gulf Coast his recurring theme, and he was probably the first to earn his living utilizing the disciplined precepts of the French Academy. During the latter years of his life, he was acquainted with, taught, and influenced a number of artists in the New Orleans area, including William Buck, Marshall Smith, E.B.D. Fabrino Julio, Charles Giroux, and William Aiken Walker. He contracted hepatitis and died at the age of fifty-two.

CONRAD WISE CHAPMAN (1842-1910)

81. *Camp near Corinth, Mississippi, 1862*

 Oil on board, 5½ by 9¼ (14 by 23.5)
 Signed lower left: CWC/ *Camp near Corinth, Miss., May 10th, 1862*
 Valentine Museum, Richmond, Virginia, 41.49.598
 Provenance: Mrs. Conrad Wise Chapman; Virginia State Library.

82. *Battery Marshall, Sullivan's Island, Dec. 4, 1863*

 Oil on board, 9⅞ by 14 (25.1 by 35.6)
 Unsigned
 Valentine Museum, Richmond, Virginia.
 Provenance: Mrs. Conrad Wise Chapman; Virginia State Library, 41.49.615

83. *Quaker Battery, ca. 1864*

 Oil on board, 9¾ by 13¾ (24.8 by 34.9)
 Unsigned
 Museum of the Confederacy, Richmond, Virginia, 983.1

84. *Submarine Torpedo Boat H.L. Hunley, Dec. 6, 1863,* 1864

 Oil on board, 9¾ by 13¾ (24.8 by 34.9)
 Signed lower right: CWC
 Museum of the Confederacy, Richmond, Virginia, 983.2

85. *Fort Sumter Interior, 1864*

 Oil on canvas, 23 by 47 (58.4 by 119.4)
 Signed lower right: CWChapman
 Valentine Museum, Richmond, Virginia, 41.49.169

Born in Washington, D.C., Conrad Wise Chapman was the second son of the Alexandria, Virginia, artist John Gadsby Chapman. In his youth, he spent considerable time in Rome; he was trained in large part by his father.

At the outbreak of the Civil War, Chapman sailed for America and enlisted in the Confederate Army; his fellow soldiers soon nicknamed him "Old Rome." Wounded during the Battle of Shiloh when his weapon exploded during reloading, he was taken to Memphis to recover. At the elder Chapman's urging, Brigadier-General Henry A. Wise, former governor of Virginia, ordered the wounded soldier transferred to his own Virginia regiment. Promoted to ordinance sergeant and reassigned with his regiment to Charleston, South Carolina, he was attached to the staff of General P.G.T. Beauregard, who ordered him to illustrate the city's fortifications. His sketches, done between September 1863 and March 1864, form the basis for thirty-one small oil-on-board paintings that are noteworthy for their freshness and clarity.

Of *Fort Sumter Interior,* a larger work for which no known sketch exists, Chapman wrote: "A scene at sunrise; it was cool in the early morning, and the negroes before starting to work would warm themselves at the fires; there was continual work to be done, getting ready sand-bags for breaks in fortifications."

After the war, Chapman lived in a variety of places—Rome, Paris, Mexico, Virginia, and New York—before his death in 1910 in Hampton, Virginia.

Fort Sumter Interior is illustrated in color, figure 38, page 87.

WILLIAM D. WASHINGTON (1833-1870)

86. *The Burial of Latane*, 1864

 Oil on canvas, 36⅛ by 46⅛ (91.8 by 117.2)
 Unsigned
 Judge John E. DeHardit, Gloucester, Virginia
 Provenance: Judge James W. Morton, Orange, Virginia; Mrs.
 Carrie Bruce Morton Muir, South Orange, New Jersey.

William D. Washington was born in Clarke County, Virginia. After studying in Europe, he returned to the United States and exhibited his work in both Philadelphia and Washington, D.C. He also helped found the Washington Art Association.

At the beginning of the Civil War, Washington moved to Richmond and worked for a year as assistant draftsman in the office of the state engineer. In 1862 he made paintings depicting the war in the Valley of Virginia. By 1864, he had established a studio in Richmond; after the fall of the city, however, he journeyed to Europe, where he remained until 1868. One year later he was appointed chairman of the Fine Arts Department at the Virginia Military Institute in Lexington, and he served in this capacity for only a short time before his death in 1870.

Washington's best-known painting, completed in his Richmond studio in 1864, depicts an event that had occurred two years earlier just north of the city. Captain William Latane, a young doctor and officer, was the only Confederate killed in Jeb Stuart's sweep around McClellan's army. Latane's brother borrowed a farm cart from a servant boy and took the body to Westwood Plantation near Old Church, Hanover County. There, the mistress of Westwood, Catherine Brockenbrough, sent John Latane back to battle with the assurance that his brother would be properly buried. Under Mrs. Brockenbrough's direction, the few remaining slaves constructed a coffin and prepared a grave in the family cemetery of nearby Summer Hill plantation, home of Mrs. William B. Newton. Because the Episcopal minister summoned from Hanover was unable to cross Union lines, the service was read by Mrs. Willoughby Newton, Mrs. Brockenbrough's sister-in-law, in the company of her daughter-in-law, and the children and slaves who remained on the two farms.

Washington's painting was inspired by John R. Thompson's poem "The Burial of Latane." At its first showing, to large crowds in Richmond, a bucket was set beneath it to collect contributions for the Confederate cause. After 1868, it was reproduced as an engraving by A. G. Campbell of New York, and it became for many Southerners a symbol of "the Lost Cause," as well as a reminder of the valiant endurance of Southern women during the war.

EDWARD LAMSON HENRY (1841-1919)

87. *The Old Westover Mansion*, 1869

Oil on panel, 11¼ by 14⅝ (28.6 by 37.1)
Signed lower right: *E.L. Henry.* 69
The Corcoran Gallery of Art, Washington, D.C., Gift of the
American Art Association, 1900, 00.11
Provenance: Mr. Whitney, Philadelphia, 1870.

Born in Charleston, S.C., Edward Lamson Henry was orphaned early in life and was taken to New York as a child of seven. There, in 1855, he received some instruction in painting from Walter M. Oddie. After studying at the Pennsylvania Academy of the Fine Arts in 1858, he journeyed to Europe for two years of additional study and travel. In 1864-65, when he served in the Union Army as a captain's clerk, he kept a sketchbook. He later developed several of the sketches as wash drawings, and finally executed them as oil paintings.

The Old Westover Mansion, painted from a sketch made in Octobr 1864 during Grant's James River campaign, reveals Henry's keen interest in architecture, an attraction that stayed with him throughout his life.

The following inscription is attached to the panel: " 'Westover House' James River Va/Painted from a drawing made in Oct-/1864 During the Campaign of Gen. Grant, 1864-5./painted for Mr. Whitney of Logan Sqr./Phila-1869-70-/E L Henry." The original pencil-and-wash sketch, *Westover, James River*, 1864, is now in the collection of the New York State Museum at Albany. A somewhat different version from the Corcoran painting, also based on the same drawing, is owned by the Century Association, New York.

After the Civil War, Henry returned to New York, where he established himself as a painter of historical and transportation scenes. He also painted landscapes and portraits. His work of the 1860s and 1870s, characterized by precise observation of details and clear, jewel-like color, is possibly the result of the influence of the Pre-Raphaelites.

In the 1880s Henry traveled in Georgia and visited the Great Smoky Mountains of North Carolina and Tennessee; he was in Virginia in 1887 and in Tennessee again in 1890 and 1906. A number of somewhat sentimental paintings of Negroes and genre scenes of Southern subjects are among his works.

Henry died at his summer home in Ellenville, New York, in 1919.

Exhibited at the Virginia Museum

WILLIAM MORRIS HUNT (1824-1879)

88. *View of the St. John's River, Florida Sunset,* 1874

Oil on canvas, 25½ by 39½ (64.8 by 100.3)
Signed lower right: *WMH 74*
Ira Spanierman Inc., New York
Provenance: Peter C. Brooks, Jr; Mrs. Richard M. Saltonstall; Richard and Leverette Saltonstall; private institution, Massachusetts, 1962.

William Morris Hunt was born in Vermont and studied briefly at Harvard College. He then lived and studied in Europe. After travel to France and Italy, Hunt spent a year in Dusseldorf, returning to Paris in 1846. There, he studied in the atelier of Thomas Couture and became a friend of Jean-François Millet and the Barbizon painters, whose interests and enthusiasm he shared.

Returning to America in 1856, Hunt spent time in Newport, Rhode Island, and Brattleboro, Vermont. In 1862, he settled in Boston, where he was known primarily for his portraits and genre paintings. At this time, Hunt was also instrumental in making Americans more aware of recent movements in French painting.

In the "great Boston fire" of 1872, Hunt's studio, his preparatory studies, and his collection of French paintings were destroyed. In need of rest and a change of scenery, Hunt journeyed the following spring to Florida as the guest of his friend, the financier John Murray Forbes, at Magnolia Springs, a resort on the St. John's River, south of Jacksonville. This visit proved to be a turning point in Hunt's career; thereafter, landscape painting dominated his work, and his scenes of quiet waters and semi-tropical settings were well-received on his return to Boston. He returned to Florida the following year, subsequently journeying as well to Cuba and Mexico.

Later he outfitted a wagon to be used for painting *en plein air* through New England. Hunt's most famous work is *The Flight of Night,* a mural executed for the state capitol building in Albany, New York. Hunt drowned off the Isle of Shoals, New Hampshire, in September, 1879.

WILLIAM AIKEN WALKER (1838-1921)

89. *View of Galveston Harbor, 1874*

Oil on canvas, 29 by 63 (73.7 by 160)
Signed lower left: *W.A. Walker*
The Rosenberg Library, Galveston, Texas, Gift of R.D. Bowen
of New Orleans, 1922, RL71.5

William Aiken Walker reached maturity at the time of the Civil War. He enlisted in the Confederate Army, and was made responsible for the preparation of maps and sketches of the defenses of his native Charleston. After 1865 Walker lived and worked in several cities, including Baltimore (1868-72) and, later, New Orleans, Charleston, and Augusta, Georgia. He journeyed forth from these cities as an itinerant painter, spending part of each year in the resort areas of the South, among them Arden, North Carolina, the Blue Ridge Mountains, and Ponce Park, Florida, on the Atlantic coast.

Many of Walker's works are small scenes of blacks engaged in everyday activities or wearing work clothes. Although they were often considered somewhat ideal-ized and sympathetic mementoes of the pre-Civil War South, these paintings reflect the lack of change in black life following Emancipation.

In its breadth and scale, Walker's view of Galveston Harbor is reminiscent of earlier harbor scenes of Charleston, Baltimore, and New Orleans. Like them, Walker's painting was designed to suggest the prosperity of an American port. Vessels include the fisherman's simple punt, cotton carriers, and a transatlantic steamship. The Sutor Building, one of Galveston's finest brick structures, rises in the background above the waters of the Gulf. Executed in the same year as the first Impressionist exhibition in Paris, Walker's seascape is characteristically American in its concern for accurate portrayal and attention to detail.

WINSLOW HOMER (1836-1910)

90. *A Visit from the Old Mistress*, 1876

> Oil on canvas, 18½ by 24½ (47 by 62.2)
> Signed lower left: *HO*; lower right: *Homer/76*
> National Museum of American Art, Smithsonian Institution,
> Washington, D.C, Gift of William T. Evans, 1909.7.28

91. *The Carnival*, 1877

> Oil on canvas, 20 by 30 (50.8 by 76.2)
> Signed lower right: *Winslow Homer N.A./1877*
> The Metropolitan Museum of Art, New York, Lazarus Fund,
> 22.220

92. *Sunday Morning in Virginia*, 1877

> Oil on canvas, 18 by 24 (47 by 61)
> Signed upper left: *HOMER 1877*; lower left: *Virginia 1877*
> Cincinnati Art Museum, John J. Emery Endowment, 1924.247

Winslow Homer, who was born in Boston, is thought to have learned the rudiments of drawing and painting from his mother. He was apprenticed between 1855 and 1857 to the lithographer J. H. Bufford and worked thereafter as an illustrator for *Harper's Weekly*, serving as the publication's on-site reporter in the Civil War. It was at this time that he first visited Virginia.

After the war, Homer visited France, then returned to the U.S. and settled in New York. Beginning in 1873, he made periodic visits to Virginia, painting a number of black genre scenes in the area around Petersburg. In the early 1880s, he traveled to England, where he painted scenes along the British coast. On his return, the increasingly reclusive artist settled in Prout's Neck, Maine, leaving that isolated community only for occasional winter visits to Nassau, Florida, and Bermuda.

Homer began to receive critical acclaim several years after he first exhibited at the National Academy of Design in New York in 1860. On his death at Prout's Neck, he was recognized as a superb watercolorist as well as one of America's most distinguished painters in the realist tradition.

Most of Homer's illustrations executed in the South for *Harper's Weekly* depicted scenes of military life behind the Union lines. The paintings done on his return to Virginia in the 1870s, however, were directed toward the life of Southern blacks during Reconstruction. With quiet sensitivity, compelling realism, and a forthright manner, he examined a frequently ridiculed subject.

Two paintings executed at Petersburg, *A Visit from the Old Mistress* and *Sunday Morning in Virginia*, employ

the same setting, the interior of a ramshackle cabin. In the former, the plantation mistress visits her former slaves. In spite of Emancipation and the aftermath of war, little has changed; although there is a change in status, the same hierarchical relationship remains between black and white. The second painting apparently depicts a chilly morning; in the cabin, children huddle together for warmth on a rude bench.

The Carnival, originally thought to record festivities associated with a Fourth of July celebration, depicts a group of blacks flamboyantly costumed in homemade finery. According to an anecdote related to Homer's stay in Virginia, the people he wanted to paint asked to be shown in the elaborate garb they traditionally wore for their Christmas festivities. This custom among blacks in Virginia—to deck themselves in finery and go about asking for presents—was called "Carnival."

Visit from the Old Mistress and *The Carnival*: exhibited at the Virginia Museum, the Birmingham Museum of Art, and the National Academy of Design.
Sunday Morning in Virginia: exhibited at the Mississippi Museum of Art, the J. B. Speed Art Museum, and the New Orleans Museum of Art.

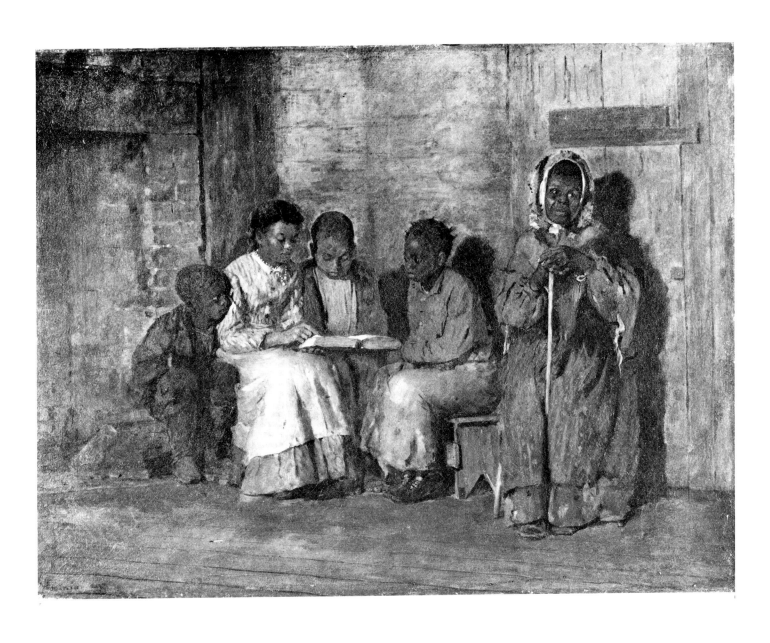

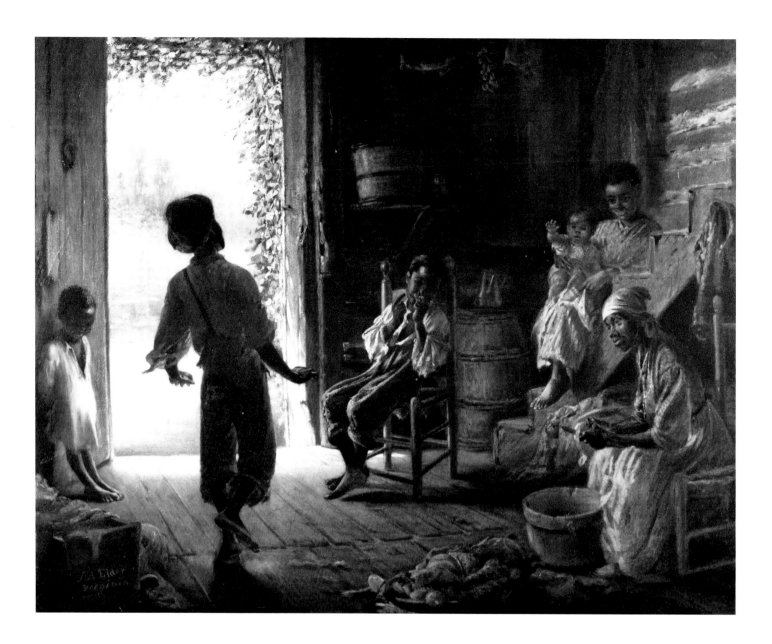

JOHN ADAMS ELDER (1833-1895)

93. *A Virginny Breakdown*, ca. 1877

Oil on canvas, 18½ by 22¼ (47 by 56.5)
Signed lower left: *J A Elder/Virginia*
The Virginia Museum, Richmond, 71.48

John Adams Elder of Fredericksburg, Virginia, was sent to New York in 1850 by John Minor, an interested patron; he studied with Daniel Huntington. The first of his five years in Europe was spent in Dusseldorf as a student of Emmanuel Leutze. Although he set up a studio in New York in 1856, Elder later returned to Fredericksburg, where he lived until the city was bombarded by the Union Army in 1862.

An aide in the Confederate Army, Elder served with the War Department in Richmond. One of his best-known works, the *Battle of the Crater*, was painted in 1869 from sketches made at or just after the famous

Petersburg battle. Elder is also known for his portraits of Lee and Jackson, and for other scenes dealing with the war.

During the 1870s and 1880s, Elder produced a number of genre scenes that often reflected black life in the South following Emancipation. *A Virginny Breakdown*, which was exhibited at the National Academy of Design in 1877, portrays a family that was still living in their slave cabin. The cabin interior is typical of the kind inhabited by both slaves and tenant farmers in the South. Family members watch a young boy perform the rapid shuffling jig known as a "breakdown," a fast version of traditional dances like the jig-and-reel—sometimes a two-step, sometimes a three-step. It was danced competitively by individuals, in pairs, or in succession.

Illustrated in color, figure 39, page 89.

THOMAS MORAN (1837-1926)

94. *Florida Scene*, no date

 Oil on canvas, 10½ by 15½ (26.7 by 39.4)
 Unsigned
 Norton Gallery and School of Art, West Palm Beach, Florida,
 Gift of Mr. Will Richeson, Jr., 1979

Born at Bolton, Lancashire, England, Thomas Moran journeyed with his family to Maryland in 1844. After studying briefly with his brother in the 1850s, he returned to England. There, the paintings of J. M. W. Turner made an indelible impression on him.

On his return to America, Moran participated in an 1871 government expedition to Yellowstone National Park. The purchase by Congress of two grandiose paintings he did on this expedition inspired him to hope for similar patronage and increased recognition from an 1877 visit to Florida with Julia E. Dodge for *Scribner's Magazine*. Moran's visit to Fort George, one of the sea islands near the mouth of the St. John's River in Florida, resulted in a large-scale work dealing with Ponce de Leon's early landing in the area. Congress, however, refused to purchase the work. Although Moran made at least one more trip to Florida after 1877, his dominant theme thereafter was the landscape of the American West.

Florida Scene is one of approximately twenty paintings Moran executed in Florida. In depicting a former cotton-growing area newly planted with orange trees, the artist has captured the fine light of an isolated American region with the kind of fluid brushstroke that suggests watercolor.

JOSEPH RUSLING MEEKER (1827-1887)

95. *Bayou Scene*, 1878

Oil on canvas, 27 by 22 (68.6 by 55.9)
Signed lower right: *J R MEEKER 78*
Dr. and Mrs. James A. Freeman, Plaquemine, Louisiana

In 1845, Joseph R. Meeker left his native Newark, New Jersey, for New York City, where he studied at the National Academy of Design with Charles Loring Elliott and was much influenced by the works of the Hudson River School. Between 1852 and 1859 Meeker lived in Louisville, Kentucky, before establishing himself permanently in St. Louis. As a paymaster in the U.S. Navy during the Civil War, he journeyed to the Deep South, making numerous sketches of the swamplands of the Mississippi River as he went.

Early in his career, Meeker specialized in portraits, but during the 1870s and 1880s he painted and frequently exhibited landscapes based on his studies along the Mississippi. *Bayou Scene* of 1878 reflects the dense atmospheric quality of the bayou and its muted but glowing light, which he had found so appealing on his earlier trip to the area.

ANDREW W. MELROSE (1836-1901)

96. *Whiskey Still by Moonlight*, ca. 1880

Oil on canvas, 20 by 15½ (51 by 39.4)
Signed lower left: *A. Melrose*
Robert P. Coggins Collection of American Art, Marietta, Georgia

Few records exist of Andrew Melrose's artistic activity prior to the Civil War. In the two decades after 1865, he worked out of New Jersey, where he had studios in both Hoboken and Guttenburg. In his search for appealing subject matter, he visited various parts of the United States, the British Isles, and Austria.

In 1880 or 1881, Melrose visited the mountainous region of North Carolina, which he characterized as "The Land of the Sky." His work, which was frequently exhibited at the National Academy of Design between 1868 and 1883, reflects his interest in landscapes rendered softly and atmospherically. In addition to being impressed with the beauty of the region, he was also intrigued by certain aspects of rural life, such as the manufacture of corn whiskey, which is depicted in this painting.

ANDREW JOHN HENRY WAY (1826-1888)

97. *A Bunch of Black Grapes,* no date

> Oil on canvas, 20¹/₁₆ by 14¹/₈ (51 by 35.9)
> Signed lower left: *A. J. H. Way*
> Walters Art Gallery, Baltimore, Maryland, Gift of Mrs. Jesse M. Goldstein, 37.2591

A native of Washington, D.C., A. J. H. Way was a recognized painter of still-life subjects. After instruction in art from John Frankenstein in Cincinnati and Alfred Jacob Miller in Baltimore, Way studied for four years in Paris and Florence. He then settled permanently in Baltimore. He was encouraged by his fellow painter Emmanuel Leutze to consider still-life painting, and he was subsequently awarded a medal for excellence at the 1876 Philadelphia Centennial.

Almost obsessed with grapes, Way usually elected to show them at close range, with a deep shadow cast upon the wall behind them. This work shows a typical arrangement. According to a contemporary, Way painted the grapes with "loving care, every detail."

MARSHALL SMITH (1854-1923)

98. *Bayou Farm*, 1881

Oil on canvas, 15 by 26 (38.1 by 66)
Signed lower right: *Marshall J. Smith, 1881*
Mr. and Mrs. W. E. Groves, Jr., New Orleans, Louisiana
Provenance: E. R. Conway, New Orleans, Louisiana.

When he was an infant, Marshall Smith moved with his family from Norfolk, Virginia, to New Orleans. They spent the Civil War years in a log cabin in Mississippi. Smith received two years of college education in Virginia and studied in Rome from 1874 to 1876.

Louisiana was Smith's primary base of operation. After returning there from Virginia in 1869, he studied with and was greatly influenced by New Orleans painter Richard Clague. Although intermittently involved in the insurance business, Smith's primary focus was on art. He worked briefly with artist Theodore Moise after Clague's death, and he chose as his recurring theme the rural South. In 1880 he was one of the founders of the Southern Art Union, a group primarily comprised of New Orleans artists, and he taught for a time at St. Mary's Dominican Academy in New Orleans.

Smith's forte was landscape painting, most often quiet scenes in the area along the bayous or near Lake Ponchartraine. Many of his works contain references to the lives of the farmers and fishermen of the region, such as mosquito nets draped on porches, cypress palings as protection between houses and farm buildings, and cold frames for plants set between large trees hung with Spanish moss.

CLARENCE BOYD (1855-1883)

99. *Futurity*, 1882

> Oil on canvas, 30 by 50 (76.2 by 127)
> Signed lower right: *Clarence Boyd 1882*
> J. B. Speed Art Museum, Louisville, Kentucky, Gift of Young E.
> Allison, 1956

Clarence Boyd, son of a wealthy iron merchant, moved as a youth from his native Ohio to Louisville, Kentucky. Recognized for his artistic skills while still a student, Boyd later spent two years, 1872 to 1874, at the National Academy of Design. He subsequently traveled to Paris, where he studied at the ateliers of Léon Bonnat and Carolus Duran, and he returned to Louisville in 1877. Between 1878 and 1883, Boyd exhibited both at the National Academy of Design and the Southern Expositions in Louisiana. His promising career as a master of landscape and figure painting ended abruptly when he was murdered by his brother-in-law during a family quarrel.

This painting, which was exhibited for the first time at the National Academy in 1883, shows Miss Maggie Allison of Louisville, Kentucky, who may have been Boyd's fiancée. The title suggests, in racing parlance, hope for the future and a gamble on future performance.

JOHANNES ADAM SIMON OERTEL (1823-1909)

100. *Chincoteague Ponies*, 1884

Oil on canvas, 31½ by 37½ (80 by 95.3)
Signed lower right: *J. A. Oertel*
Gordon Fraser Collection, Minneapolis, Minnesota

As a youth in Bavaria, Germany, J. A. S. Oertel was determined to study for the ministry, but because of his skill in drawing he was encouraged to study art. In 1848 Oertel emigrated to the United States, settling first in Newark, New Jersey. By 1858 he was designing decorations for the ceiling in the House of Representatives in Washington, D.C.; during the Civil War he served with the Army of the Potomac.

Ordained a priest in the Protestant Episcopal Church, Oertel moved in 1871 to Lenoir, North Carolina, where he was in charge of a rural church and two mission stations. He later took parishes in Florida and in Washington, D.C., ending up in Sewanee, Tennessee, where he held the Chair of Christian Art at the University of the South. From 1889 to 1891 he was Instructor of Fine Arts at Washington University in St. Louis. The last eighteen years of his life were spent in Washington, D.C.

Chincoteague Ponies portrays the wild ponies that roam the marshes and off-shore islands of Virginia and North Carolina—Chincoteague, Assateague, and Ocracoke—open spaces that Oertel visited during his tenure in North Carolina.

ROBERT JENKINS ONDERDONK (1852-1917)

101. *House and Figure*, 1884

Oil on canvas, 21¾ by 18¼ (55.2 by 46.4)
Signed lower right: *R. J. Onderdonk*
San Antonio Museum Association, San Antonio, Texas
Provenance: Robert K. Winn

Born in Catonsville, Maryland, Robert Onderdonk was educated at the College of St. James, Hagerstown, Maryland, where his father was headmaster. His stepmother was the daughter of the noted architect and painter Benjamin Latrobe. Onderdonk enrolled at New York's National Academy of Design and studied subsequently at the newly-founded Art Students' League with Walter Shirlaw, a master of genre painting.

Onderdonk arrived in San Antonio, Texas, in 1879 at the age of twenty-seven. According to tradi-

tion, he had been persuaded by boyhood friends to journey there to seek his fortune. Except for a six-year period in Dallas and occasional travel, he remained in San Antonio for the rest of his life. With his children, several of whom became artists, Onderdonk exerted an important and lasting influence on the artistic life of San Antonio.

Although he painted portraits and genre scenes, Onderdonk is best known for his small-scale scenes in and around San Antonio. *House and Figure* of 1884, which depicts a Mexican girl seated at roadside before a cluster of ramshackle huts, or *jacals,* is an example of his serene, firmly constructed style.

JOHN LEON MORAN (1864-1941)

102. *Natural Bridge, Virginia*, 1885

Oil on canvas, 24 by 16 (61 by 40.6)
Signed lower left: *J. Moran*
Commonwealth of Virginia, The Governor's Mansion, Richmond, Gift of General Electric, 79.43

John Moran, a native of Philadelphia, worked in New York in the 1880s, and exhibited there at the National Academy of Design and the American Art Society. Moran was drawn to the geographical wonders of America that best reflected Edmund Burke's description of the Sublime in nature. He journeyed to Virginia in the mid 1880s to study and paint the Natural Bridge. In so doing, he continued the search, begun by artists as early as the 1830s, to discover the beauties of the American landscape and to present them for comparison with other natural wonders. Although the diffuseness of the South's scenic attractions prevented many artists from easy exploration and record-making, the Natural Bridge of Virginia remained a constant attraction for landscape painters, including Jacob O. Ward, Frederick Church, and David Johnson.

MARTIN JOHNSON HEADE (1819-1904)

103. *Four Cherokee Roses*, ca. 1885-95

> Oil on artist's board, 10½ by 18¼ (26.7 by 46.4)
> Signed lower right: *M. J. H.*
> The Henry Morrison Flagler Museum, Palm Beach, Florida, W32

104. *Afterglow, Florida*, ca. 1890-1900

> Oil on canvas, 17 by 36 (43.2 by 91.4)
> Signed lower left: *M. J. Heade*
> Chrysler Museum at Norfolk, Virginia, Gift of Walter P. Chrysler, Jr., 71.726

Martin Johnson Heade was born in Lumberville, Bucks County, Pennsylvania. He received his initial training in art from the painter Thomas Hicks, and early study in Italy, France, and England further prepared him for a career in painting. Heade spent the two decades following his return to America painting and exhibiting throughout the East and Midwest. An initial journey to the subtropics in 1863-64 whetted his interest in the region's exotic flora. Later, more extensive trips took him to Nicaragua, Brazil, Jamaica, and California.

Favorable reports of excellent hunting and fishing lured Heade to Florida in 1883. At the age of sixty-four

he returned there to make it his home; he married for the first time and settled in St. Augustine. There, he met Henry Morrison Flagler, a newcomer to the region who embarked on the first of a series of hotel and railroad enterprises that would spark a boom in Florida. Flagler became Heade's patron.

Afterglow, Florida, one of a number of paintings Heade made of the Florida sunset, celebrates the last primitive wilderness of the American South.

Heade became interested in painting flowers in the 1860s. The luxuriant floral specimens of Florida's tropical region became natural subjects for him when he established residence in St. Augustine. *Four Cherokee Roses* is an example of his desire to depict the visual perfection of flowers.

Afterglow, Florida is illustrated in color, figure 42, page 98.

WILLIAM GILBERT GAUL (1855-1919)

105. *Sunset Landscape,* ca. 1886

> Oil on canvas, 52 by 40 (132.1 by 101.6)
> Signed lower right: *Gilbert Gaul*
> First Tennessee Bank / Heritage Collection, Memphis, Tennessee

Gilbert Gaul was born in Jersey City, New Jersey, six years before the outbreak of the War Between the States. He studied with John George Brown at the National Academy of Design, and in 1882 he became the youngest painter to be named a full academician.

Although Gaul traveled extensively throughout the Americas, his inheritance in 1881 of a small farm in Van Buren County, Tennessee, brought him a close association with the area that would last for thirty years. Soon after the turn of the century he established residence in Nashville, where he taught private art lessons as well as art classes at the Watkins Institute.

The Civil War fascinated Gaul, and he made close studies not only of the actual combat but also of other events that pertained to the lives of the soldiers, both Union and Confederate. A number of works executed during the last two decades of the nineteenth century reveal his concern for the drama of the war. For his subjects he chose episodes from specific battles, as well as poignant events in the lives of families during the struggle. One of his battle paintings, *Charging the Battery,* was awarded a medal in the Paris Exposition of 1889. In 1907, a number of Gaul's works formed the portfolio *With the Confederate Colors,* which was published by the newly-created Southern Art Publishing Company. But in spite of this, he experienced financial hardships, an increasing lack of recognition, and ill health, and in 1910 he moved to Ridgefield, New Jersey, where he died in relative obscurity.

Gaul also executed a number of paintings of the Southern landscape after the war. The soft colors and atmospheric haze of *Sunset Landscape* are typical of his rural scenes in Tennessee and are reminiscent of the work of the French Barbizon School of about 1850. His painting also typifies the response of many artists at the turn of the century (among them Elliott Daingerfield and Gari Melchers) who looked to the South as a source of inspiration.

WILLIE M. CHAMBERS (died 1919)

106. *Still Life: Basket of Cherries,* no date
 Oil on canvas, 13¼ by 18½ (33.7 by 47)
 Signed lower right: *Willie M. Chambers*
 Robert P. Coggins Collection of American Art, Marietta,
 Georgia

Little is known about this artist, except that she was a
seamstress by profession who lived in Atlanta, Georgia.
Her paintings were apparently executed during summer
holidays with her family in Montezuma, Macon
County, Georgia. Still-life canvases, such as *Basket of
Cherries,* were her speciality, and she is also known to
have painted on china.

Illustrated in color, figure 41, page 95.

JULIUS STOCKFLETH (1857-1935)

107. *The T. J. Gallagher Dairy, Galveston,* 1904

Oil on canvas, 21⅞ by 48 (55.6 by 121.9)
Signed lower right: *J. Stockfleth/Galveston 1904*
The Rosenberg Library, Galveston, Texas, RL76.147

Julius Stockfleth, born in the village of Wyk in Schleswig-Holstein on the North Sea, emigrated to America in 1883 to join members of his family already settled in Lake Charles, Louisiana. By 1885, Stockfleth had settled with other relatives in Galveston, Texas, and had embarked on a career as a marine and landscape painter. He is also known to have executed portraits and paintings of houses. A number of his canvases record the aftermath of the disastrous hurricane of 1900 in which twelve members of his family perished. In 1907 he returned with his sister to Wyk, where he lived and painted until his death.

Although little is known of Stockfleth's artistic training, it is speculated that he served an apprenticeship to a painter in Wyk prior to his departure for America. The sharp-edged quality of his work also indicates that he may have been largely self-taught.

The size and scope of the T. J. Gallagher Dairy outside Galveston are accentuated by Stockfleth's choice of a horizontal canvas, across which he has spaced the buildings and stock of the owner.

1900 to 1950

WILLIAM POSEY SILVA (1859-1948)

108. *Georgia Pines at Sunset*, no date
 Oil on canvas, 30 by 25 (76.2 by 63.5)
Signed lower right: *William Silva*
The Fine Arts Center, Cheekwood, Nashville, Tennessee, 75.2.1

After attending the University of Virginia, William Posey Silva worked in his father's chinaware business in his native Savannah. In 1887 he moved to Chattanooga to establish his own chinaware and art works. Between 1907 and 1909 he studied in Paris at the Académie Julian, exhibiting in the 1908 Salon d'Automne. In 1910, following his return to Chattanooga, he moved to Washington, D.C., where he served as President of the Society of Washington Artists. In 1913 he moved to Carmel-by-the-Sea, California, where he built his own art gallery; he remained there until his death.

A successful and recognized landscapist, Silva exhibited in France and throughout the United States, winning prizes and medals, among them a number from the Southern States Art League, the Mississippi Art Association, the New Orleans Art Association, and the Paris Salon.

The atmospheric treatment of this scene of the Georgia pine forests indicates Silva's awareness of French Impressionist techniques.

CLARA WEAVER PARRISH (1861-1925)

109. *Portrait of Anne Goldthwaite,* ca. 1900

Oil on canvas, 20⅝ by 19⅝ (52.4 by 49.8)
Signed lower left: *Clara Weaver Parrish*
Montgomery Museum of Fine Arts, Montgomery, Alabama

Clara Weaver Parrish was born in Dallas County near Selma, Alabama. To encourage her artistic ability, her parents sent her to New York to study at the Art Students' League; there, her teachers included William Merritt Chase, H. Siddons Mowbray, Kenyon Cox, and Julian Alden Weir. First active as a pastellist, Parrish soon became equally fluent in oils. She also established a reputation as an artist for Tiffany Studios in New York, executing designs for many stained-glass windows and mosaic murals.

Parrish was active in the Women's Art Club in New York, serving as an officer in 1892 and winning an award in 1901. In addition to spending time in her native Alabama, she also traveled to Italy and France, where she exhibited in the Paris Exposition of 1900 and received wide acclaim in exhibitions just prior to World War I. While making plans to return to her home in Selma to teach and found an art museum, she was taken ill and died.

The subject of this portrait is the young Anne Goldthwaite, a Montgomery artist who had just arrived in New York and would later pursue an illustrious career as a painter of Alabama subjects and as a champion of women's rights. It is one of the best-known works of a notable Southern woman artist.

WILLIAM WOODWARD (1859-1939)

110. *Old Mattress Factory*, 1904

Oil crayon on cardboard, 28 by 22 (71.1 by 55.9)
Signed lower left: *W Woodward 04*
New Orleans Museum of Art, New Orleans, Louisiana, Gift of
the Edgar Stern Family, 61.17

Born in Seekonk, Massachusetts, William Woodward spent six years at the Rhode Island School of Design in nearby Providence. Woodward then entered the Massachusetts Normal Art School (now Massachusetts College of Art). While continuing to work for his degree, he traveled to New Orleans to teach at the newly-established Tulane University. After a year's study at the Académie Julian in Paris, Woodward returned to New Orleans in 1887 to assist in the organization of Newcomb College, where he installed his younger brother, Ellsworth, as head of the art department.

By the turn of the century, the efforts of the Woodward brothers had achieved national recognition for the Tulane art department. In 1907, William Woodward was instrumental in founding the Tulane School of Architecture. Completely involved in the artistic life of the community, he served in many capacities, including secretary of the Louisiana Art Association, and president of the Artist's Association of New Orleans and of the Louisiana Art Teachers Association, which he had organized along with the Democratic Art League for Women.

While working on a mural commission in 1921, Woodward fell from the scaffolding; the injuries forced his retirement from Tulane the following year, and he spent the remainder of his life painting and traveling from his home in Biloxi, Mississippi, to other parts of the United States. He also began to chronicle the varied buildings of the French Quarter of New Orleans and scenes of the life there. Executed in an early form of oil crayon, his works instilled a new awareness and sense of community pride in architectural preservation. Through paintings such as *Old Mattress Factory*, Woodward was directly responsible for saving many dilapidated structures from demolition.

ALEXANDER JOHN DRYSDALE (1870-1934)

111. *Early Morning in a Louisiana Marsh*, 1912

 Oil on canvas, 24 by 36 (61 by 91.4)
 Signed lower left: *A J Drysdale/1912*
 New Orleans Museum of Art, New Orleans, Louisiana, Gift of
 the Artist, 13.4

Alexander Drysdale, a native of Marietta, Georgia, studied with Paul Poincy in New Orleans before attending the Art Students' League in New York. There, he worked with Charles Curran and Frank Vincent DuMond, two painters with strong Symbolist leanings. After three years in New York, Drysdale returned to New Orleans, where he primarily painted landscapes of mysterious and vaporous bayous, using a kerosene-wash oil-painting technique that resembles watercolor.

Although Drysdale spoke of the importance of atmosphere and color in his work, *Early Morning in a Louisiana Marsh* becomes a closer evocation of the tonal moods inherent in Symbolist landscapes.

Acting as his own agent, Drysdale was often able to convince prospective buyers of the importance of purchasing his work. A painting of a Lousiana marsh, a small scene with no known provenance, hangs today at Sagamore Hill, Theodore Roosevelt's former home on Long Island. Like George Inness, whose facile work he admired, Drysdale painted the transitory aspects of nature from memory.

ELLSWORTH WOODWARD (1861-1939)

112. *Winter in Southern Louisiana*, 1912

Oil on canvas, 30⅝ by 24⅝ (77.8 by 62.5)
Signed lower left: *E. Woodward*
Mississippi Museum of Art, Jackson, Mississippi, Art Study Club
 and Mississippi Art Association Purchase, 1912.005

Ellsworth Woodward was born in Seekonk, Massachu-
setts. On his graduation in 1885 from the Rhode Island
School of Design, he was appointed by his brother
William to a teaching position in art at Tulane College
in New Orleans. Two years later he was instrumental in
founding Newcomb College, where he became head of
the art department, a position he held for forty-one
years until his retirement in 1931. Long a champion of
art in the South, Woodward helped establish the
Newcomb Art Pottery and the Southern States Art
League, of which he was director for many years.

Woodward was also one of the founders of the Isaac
Delgado Museum of Art in New Orleans (now the New
Orleans Museum of Art), serving as both director and
head of the board of trustees. For many years he was
president of the Art Association of New Orleans.

With his brother William, Ellsworth Woodward
was a pivotal figure in promoting the art of the South.
In addition to his many civic and academic activities,
he produced a large number of paintings, watercolors,
etchings, and bronze medallions.

Although Woodward feared that he could not
truly capture the Southern sense of place because he
had been born in the North, his painting *Winter in
Southern Louisiana* typifies those scenes the artist sought
out in his annual pilgrimages into the wooded regions
of the Deep South.

ELLIOTT DAINGERFIELD (1859-1932)

113. *Carolina Sunlight*, ca. 1915

 Oil on canvas 24¼ by 28⅛ (61.6 by 71.4)
 Signed lower left center: *Elliott Daingerfield*
 Robert P. Coggins Collection of American Art, Marietta,
 Georgia

Elliott Daingerfield was raised in Fayetteville, North Carolina. In 1880, he began his art studies in New York, where he later exhibited at the National Academy of Design. During the summers he spent at Blowing Rock, North Carolina, he painted many landscapes. Later in his career, Daingerfield often traveled abroad to paint. Eventually his work began to reflect stronger and stronger religious overtones. Secure in his reputation, he spent considerable time after 1900 in North Carolina and Virginia.

Carolina Sunlight, executed in the latter part of his career, has an atmospheric quality reminiscent of the late work of George Inness, with whom Daingerfield had been acquainted in New York, and whose late work he found particularly appealing. His painting activity was severely curtailed after a serious illness in 1924; eight years later, he died in New York.

RODERICK MACKENZIE (1865-1941)

114. *Mixers and Converters*, 1922

 Pastel on board, 34 ¼ by 26 ¼ (87 by 66.7)
 Signed lower left: *Roderick D. MacKenzie 1922*
 Birmingham Museum of Art and Birmingham Board of Education, Birmingham, Alabama
 Provenance: Bequest of the artist to the City of Birmingham public schools.

The son of a Scottish painter of heraldry and carriages, Roderick MacKenzie was born in London, England. The family lived in Mobile, Alabama, from 1872 to 1882. As a boy, MacKenzie was educated at the Barton Academy in Mobile. He later studied at the School of the Museum of Fine Arts, Boston, and at the Académie Julian and the École des Beaux Arts in Paris.

 Between 1893 and 1913, MacKenzie lived primarily in India. Many of his landscapes and portraits of potentates and royalty were exhibited to acclaim in London and Paris. A major work commemorating the coronation of Edward VII hangs in the Victoria Memorial in Calcutta. In 1906 he was elected to membership in the Royal Society of Arts of the British Empire.

 In 1913, MacKenzie returned to Alabama. Attracted by the burgeoning steel industry in Birmingham, he began a lengthy series of pastels of the Tennessee Coal and Iron steel plants at Ensley and Westfield. *Mixers and Converters* is a work from this series. At the invitation of the American Iron and Steel Industry, MacKenzie's pastels were exhibited at its annual meeting in New York in 1933. Their success as powerful and evocative depictions of one of the South's newest and increasingly dominant industries resulted in additional showings at museums and galleries in the New York area.

 In 1929, MacKenzie received the commission to decorate the domed central portion of the Alabama State House with four large murals depicting the history of the commonwealth. He was subsequently elected to the Alabama Hall of Fame.

GARI MELCHERS (1860-1932)

115. *The Hunters*, ca. 1922

Oil on canvas, 55 ½ by 60 ½ (141 by 153.7)
Signed lower left: *Gari Melchers*
Robert G. Beck, courtesy of Belmont, The Gari Melchers
 Memorial Gallery, Fredericksburg, Virginia

In 1877, Gari Melchers, the son of an immigrant Westphalian sculptor, was sent by his father to the Royal Academy at Dusseldorf for formal academic training. Six years later, Melchers moved on to study at the École des Beaux Arts in Paris, where he shared gold-medal honors with John Singer Sargent at the 1889 Paris Exposition Universelle. Melchers's selection to decorate one of the buildings at the 1893 Columbian Exposition in Chicago resulted in other important mural commissions from the Library of Congress, the Detroit Public Library, and the Missouri State House. In addition to his work as a muralist, Melchers was a sought-after portraitist whose well-known sitters included William K. Vanderbilt and Theodore Roosevelt.

In 1902, Melchers married the painter Corinne Lawton Mackall of Savannah. Their purchase in 1916 of "Belmont," an eighteenth-century house situated on twenty acres of property near Fredericksburg, Virginia, led to Melchers's involvement with the arts in Virginia. A participant in early efforts at historic preservation in Fredericksburg, Melchers was appointed to the Virginia Arts Commission. During his tenure on the Commission, Melchers oversaw the renovation of Jefferson's Virginia capitol and aided in the design of the seal of the Commonwealth of Virginia. In addition, from 1923 until his death in 1932, he served as chairman of the federal commission to establish a National Gallery of Art.

After 1916, Melchers's subject matter increasingly reflected his new environment. *The Hunters*, a winter scene executed in a coarse impasto, is one of a number of landscapes and genre scenes depicting various aspects of life in Stafford County, Virginia.

Illustrated in color, figure 45, page 113.

ROBERT JULIAN ONDERDONK (1882-1922)

116. *Dawn in the Hills*, 1922

Oil on canvas, 30 by 40 (76.2 by 101.6)
Signed lower left: *Julian Onderdonk*
San Antonio Museum Association, San Antonio, Texas,
 66-86-23 G

Julian Onderdonk, son of the Texas painter Robert Jenkins Onderdonk, was encouraged by his father to paint at an early age. During his formal training at the Art Students' League in New York, he was most influenced by the teaching of William Merritt Chase, in whose Long Island studio he later worked.

In 1908, in spite of a budding reputation in the New York area, Onderdonk chose to return to Texas. He became involved in the cultural development of East Texas, particularly through his yearly activity as chairman of the art education committee of the Dallas State Fair. By 1914, his oils and watercolors were commanding national attention. In the midst of several demanding projects to benefit the Texas art community, Onderdonk died suddenly at the age of forty.

Dawn in the Hills, his last completed work, became a symbol of his notable achievement. In it, he viewed an unspoiled expanse of the Southern wilderness with poetic sensibility as well as a concern for depicting a landscape with a specific time and place.

Illustrated in color, figure 44, page 108.

AARON DOUGLAS (1898-1978)

117. *Go Down, Death,* 1927

> Oil on Masonite, 48 by 36 (121.9 by 91.4)
> Signed lower right: *A. Douglas*
> Mr. and Mrs. David C. Driskell
> *Provenance:* Grace Jones, Nashville, Tennessee, 1968.

Aaron Douglas was born in Topeka, Kansas. After earning a bachelor's degree in art from the University of Nebraska in 1925, Douglas enrolled in the Winold Reiss Art School in New York, where he was encouraged to explore his Afro-American heritage. He subsequently became deeply involved in the Harlem Renaissance and was closely associated with its leading figures, W. E. B. DuBois, James Weldon Johnson, and Alain Locke.

Besides illustrating many important Afro-American literary works of the period, in 1929 Douglas was commissioned to paint a series of murals on the history of Negro life for Fisk University in Nashville, Tennessee. Eight years later Douglas was appointed the only instructor in art at Fisk, a post he held for the next twenty-nine years until his retirement in 1966. Regarded as the most important Afro-American teacher in the South in the modern period, Douglas traveled and exhibited widely, achieving fame and recognition for his early efforts to promote recognition of Afro-American art.

Go Down, Death, which uses two-dimensional figures in combination with fetish motifs and arcs of color, reflects Douglas's combination of modernist aesthetics with African ancestral sources.

EDWARD HOPPER (1882-1968)

118. *The Battery, Charleston, S.C.*, 1929

 Watercolor on paper, 13⁷/8 by 19¹⁵/₁₆ (35.2 by 50.6)
 Signed lower right: *Edward Hopper, Charleston, S.C.*
 Whitney Museum of American Art, New York, Bequest of
 Josephine N. Hopper, 70.1145

A native of the Hudson River community of Nyack, New York, Edward Hopper studied with Robert Henri, leader of New York's Ash Can School in the early years of the twentieth century. Among his fellow students were George Bellows, Rockwell Kent, and Patrick Henry Bruce.

On his return from Europe in 1910, Hopper earned his living in New York as a commercial artist, painting in his spare time. He exhibited in the 1913 Armory Show, and in that same year he sold his first painting; but he did not sell another work until 1923.

The success of a 1924 exhibition of his watercolors, and their subsequent sale, allowed Hopper to turn his full attention to art.

On two occasions—in 1929 and again in 1951—Hopper traveled in the South, stopping in Charleston, South Carolina, and Chattanooga, Tennessee. Among the many drawings and watercolors from his earlier trip is a simple study of Charleston's Battery, with its Civil War cannon pointed to sea as a poignant reminder of the city's stormier past. This small work reflects Hopper's ability to capture the sense of place with utmost economy.

Recognized during his lifetime as a major American realist, Hopper died at his studio in New York's Washington Square.

CONRAD A. ALBRIZIO (1892-1973)

119. *Allegory of Louisiana—North Wall of the Governor's Reception Room*, 1930

 Watercolor on paper, 14 by 21½ (35.6 by 54.6)
 Signed lower left: *C. A. Albrizio*
 Anglo-American Art Museum, Louisiana State University, Baton Rouge, Gift of Mr. and Mrs. Victor A. Sachse, Jr., 71.17

120. *Old Plantation Life in Louisiana*, 1930

 Watercolor on paper, 14¼ by 14¼ (36.2 by 36.2)
 Signed lower right: *C. A. Albrizio*
 Anglo-American Art Museum, Louisiana State University, Baton Rouge, 71.18.2

121. *Trucking Cotton and Cutting Sugar Cane*, 1930

 Watercolor on paper, 14⅜ and 21¾ (36.5 by 55.2)
 Signed lower right: *C. A. Albrizio*
 Anglo-American Art Museum, Louisiana State University, Baton Rouge, 71.18.3

122. *Industrial Louisiana*, 1930

 Watercolor on paper, 14¼ by 14¼ (36.2 by 36.2)
 Signed lower left: *C. A. Albrizio*
 Anglo-American Art Museum, Louisiana State University, Baton Rouge, 71.18.4

Born in New York City, Conrad Albrizio trained and worked initially as an architectural designer. He later studied with George Luks at the Art Students' League. In 1930 he was given a commission to execute a four-part mural for the Governor's Room in the new Louisiana State Capital at Baton Rouge. In addition, he completed several other murals in Detroit (1934); De Ridder, Louisiana (1938); Russellville, Alabama (1938); Shreveport, Louisiana (1939); and New Iberia, Louisiana (1940).

In 1936, Albrizio became Professor of Art at Louisiana State University, a post he held until his retirement in the late 1950s. In 1937 he became the first Louisiana artist to have work acquired by the Whitney Museum of American Art in New York. In 1946 and 1947, he had one-man shows at the Passadoit Gallery and the Delgado Museum, both in New Orleans. Throughout this period he continued to execute mural commissions—in Mobile, Alabama (1947-49), New Orleans (1951-54), and Baton Rouge (1954)—as well as to complete a number of mosaic series. Long a major proponent of public art in the South, as well as a respected teacher, Albrizio died in 1973.

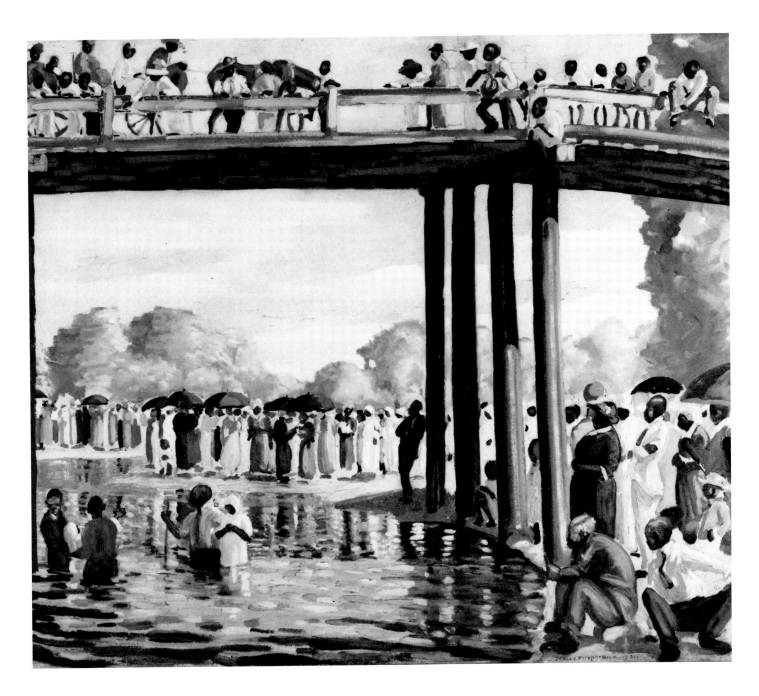

JOHN KELLY FITZPATRICK (1888-1953)

123. *Negro Baptising,* 1931

Oil on canvas, 42⅛ by 49½ (107 by 125.7)
Signed lower right: *J. Kelly Fitzpatrick-1931*
Montgomery Museum of Fine Arts, Montgomery, Alabama,
 Gift of the Artist, 1930.23b

Born in Kellyton, Alabama, John Kelly Fitzpatrick attended the University of Alabama, where he majored in journalism. After serving in France in World War I, he studied for a year at the Académie Julian. Returning to Alabama in 1927, he became a leading artist in the state and remained there for the rest of his life.

Fitzpatrick co-founded and became president of the Alabama Art League and also taught at the Montgomery Museum Art School from its inception until his death. During this period, he painted scenes of his native state in a lively palette. *Negro Baptising,* an early example of his regional sensibility, serves to illustrate the power of religion in the life of the Southern black.

In 1933, Fitzpatrick founded the Poka-Hutchi Art Colony on Lake Martin, Alabama, which flourished during the summers until 1948; it attracted some of the South's leading artists.

In 1935, President Roosevelt selected one of Fitzpatrick's paintings for the White House, and four years later one of his paintings was selected to represent the State of Alabama at the New York World's Fair. In addition, Fitzpatrick painted several post office murals as well as a series of paintings for the Public Works Art Project that were presented to the University of Alabama.

Illustrated in color, figure 2, page vi.

RICHARD BLAUVELT COE (born 1904)

124. *Birmingham Steel Mill*, 1934

Oil on canvas, 19¾ by 23¾ (50.2 by 60.3)
Signed on back: *Coe/34*
Montgomery Museum of Fine Arts, Montgomery, Alabama,
 1940.31

In 1925, Richard Coe, a native of Selma, Alabama, won a scholarship, sponsored in part by the Allied Arts Club of Birmingham, to study at the Grand Central School of Art with George Elmer Browne. Coe later studied at the School of the Museum of Fine Arts, Boston, with Philip Leslie Hale and received a two-year scholarship to study in Europe. He established his own studio in Birmingham in 1934, and in that same year

he painted *Birmingham Steel Mill*, a work that reflects the artist's activity as a New Deal follower of Thomas Hart Benton's nativist aesthetics. Coe applied these aesthetics to the South, proclaiming a new age where art would be produced "for the education and delight of the people."

Coe eventually became head of the Works Progress Administration section in Alabama. He painted murals in the State Library at Birmingham and at the capitol in Montgomery. His portraits and landscapes were highly acclaimed throughout the South during this period, and he received numerous regional awards.

HOWARD COOK (1901-1981)

125. *Alabama Cotton Pickers*, 1934

Conté crayon, charcoal, colored chalk on paper, 24⅜ by 38⅜ (61.9 by 97.5)

Signed lower left center: *Howard Cook 1934/Alabama*

Georgia Museum of Art, The University of Georgia, Athens, Georgia, Gift of the Artist and Friends of the Art Department and Museum, 67.1934

Howard Cook was born in western Massachusetts and studied at the Art Students' League in New York. After 1922, he made illustrations for *The Forum*, *Survey Graphic*, and *The Century*, and in 1927 he embarked on a long and noted career as a printmaker.

In 1932, following several earlier sketching trips to Europe, the Orient, and South America, Cook was awarded a Guggenheim Fellowship to study in Mexico. An important renewal fellowship allowed him to travel for two years throughout the southern United States where, in his own words, he recorded "the Virginia and Alabama Negroes and their rituals, the poor whites and remote mountain people of the Cumberland mountains, steel workers, miners, cattlemen and the diverse activities connected with these rural workers." The artist used this material for several Public Works Arts Project murals, most notably in the United States Post Office in San Antonio, Texas; the Federal Court House in Pittsburgh; and the post office in Springfield, Massachusetts. During World War II, Cook was a teacher at the University of Texas; he also served in the Pacific with the War Art Effort. Since the late 1940s, Cook has lived and worked in Taos, New Mexico, exhibiting his paintings and receiving numerous awards.

JOHN McCRADY (1911-1968)

126. *Political Rally*, 1935

> Multi-stage on canvas, 32 by 48 (81.3 by 121.9)
> Signed lower right: *J. McCrady*
> Mr. and Mrs. Jack M. McLarty, Jackson, Mississippi

A native of Canton, Mississippi, John McCrady entered the University of Mississippi at Oxford in 1930; two years later he enrolled at the New Orleans Art School. In 1933, he was awarded a year's study with Kenneth Hayes Miller at the Art Students' League in New York. After returning to New Orleans, he began to exhibit nationally and was acclaimed as a major regionalist painter. In 1938 he helped form an association of artists in New Orleans called A New Southern Group. A 1939 Guggenheim Fellowship enabled him to paint the life of the Southern Negro. During this time, McCrady also worked for the Works Progress Administration, and in 1942 he opened an art school in New Orleans. He illustrated several books by Hod-

ding Carter, Sr., and he continued to receive numerous private commissions until his death in 1968.

Political Rally, begun in the summer of 1934 at Oxford, Mississippi, depicts a political huckster holding forth before a group of townspeople while children on roller-skates and a dog pass them by, oblivious to his harangue. One figure in the small group to the right represents the writer William Faulkner, who was a resident of Oxford. The scene is reminiscent of those created verbally by his friend, the writer Robert Penn Warren, in *All the King's Men*. McCrady employed the technique known as multi-stage, which was introduced into the United States through the 1934 English translation of a German manual, *The Materials of the Artists and Their Uses* by Max Doerner. During his year's study at the Art Students' League, McCrady learned this method, in which oil glazes are applied over a tempera underpainting to achieve a luminous surface effect.

ANNE GOLDTHWAITE (1869-1944)

127. *Springtime in Alabama*, no date

Oil on canvas, 18 by 22 (45.7 by 55.9)
Signed lower left: *Anne Goldthwaite*
J. B. Speed Art Museum, Louisville, Kentucky, 50.23.2
Provenance: Lucille Goldthwaite, 1950.

In 1898 Anne Goldthwaite, a young art student from Montgomery, Alabama, arrived in New York to study at the National Academy of Design. She soon left the city for further study in Paris, where she became a member of the American avant-garde and helped to organize the Académie Moderne. On her return to America, Goldthwaite exhibited one work in the Armory Show of 1913; at this time, she became friends with Katherine Dreier, who later founded Société Anonyme, Inc.

Although Goldthwaite's studio was in New York and she spent the years from 1922 until her death teaching at the Art Students' League, she went to Montgomery each summer to paint the Alabama locale. *Springtime in Alabama* depicts typical rural life in a spontaneous sketch that preserve the vitality of her initial conception better than a more finished work.

An ardent champion of women's rights, Goldthwaite has been hailed as one of the leading women painters in the United States, as well as one of the leading painters of the South.

LAMAR DODD (born 1909)

128. *The Railroad Cut*, 1936

> Oil on canvas, 37⅝ by 49¾ (95.6 by 126.4)
> Signed lower right: *Lamar Dodd / '36*
> Georgia Museum of Art, The University of Georgia, Athens,
> GMOA 74.2 (on extended loan from the University of
> Georgia Foundation, 1974, Gift of the Artist to the Univer-
> sity of Georgia Foundation)

Lamar Dodd, who was born in Fairburn, Georgia, studied art at LaGrange (Georgia) College and then went on to the School of Architecture of the Georgia Institute of Technology. In 1928, he enrolled at the Art Students' League in New York, where he studied inter-mittently with Boardman Robinson, Jean Charlot, and John Steuart Curry. Later, after moving to Birming-ham, Alabama, Dodd managed an art-supply store by day and painted by night.

The Railroad Cut, a Depression-era Southern land-scape showing a slag dump outside Wyland, Alabama, is Dodd's attempt to capture mood through the use of solid forms. The painting won a major award at the annual exhibition of the Art Institute of Chicago and was exhibited in 1937 at the Whitney Museum of American Art in New York.

In 1937, Dodd joined the art faculty of the Uni-versity of Georgia at Athens, where he remained until his retirement in 1976. Regarded as one of America's outstanding artists, he has won many regional and national awards over the past forty years and has achieved renown as one of the most important artists in the South in this century.

ALICE RAVENEL HUGER SMITH (1876-1958)

129. *The Pinelands,* from a series completed in 1936

Watercolor on board, 21¾ by 16 (55.3 by 40.6)
Unsigned
Carolina Art Association / Gibbes Art Gallery, Charleston,
 South Carolina, Gift of the Artist, 37.9.7

Alice Smith was the daughter of Daniel Elliott Huger Smith, an avid Charleston historian and naturalist. She received some instruction at the Carolina Art Association in Charleston and from a friend, Birge Harrison, but she was primarily self-taught as an artist.

Attracted to the delicate quality of Japanese prints, she shifted her focus from oils to watercolors and emulated the fluid sensuality of Oriental painting. With her father she worked on two books, illustrating accounts of early architecture in Charleston and a biography of Charles Fraser. By 1924 her works were being exhibited in New York and Washington.

The Pinelands, an illustration from Smith's most acclaimed series, *A Carolina Rice Plantation of the Fifties,* represents a mystical view of the Southern landscape, showing the woods and marshes of the Ashley River. Her work at this time paralleled the rise of the Poetry Society of South Carolina, which was led by Du Bose Heyward and Hervey Allen; the group sought to glorify regional culture through lyricism and tradition. Widely acclaimed, the artist continued to paint the marsh land of South Carolina until her death.

CHARLES SHANNON (born 1914)

130. *The Lover*, 1937

 Oil on canvas, 30 by 45 (76.2 by 114.3)
 Signed lower right: *Chas. Shannon*
 Collection of the artist

Born in Montgomery, Alabama, Charles Shannon studied for two years at Emory University and four years at the Cleveland School of Art. During his studies at Cleveland, he built a log cabin in Butler County, Alabama, in order to paint scenes of the life in his native state.

On his graduation, Shannon won a prestigious traveling fellowship that enabled him to visit Mexico, where he studied the works of José Orozco and Rufino Tamayo. In 1983, after exhibiting to great acclaim in New York, Shannon won the first Julius Rosenwald Fellowship to be awarded an artist for work in the South. The prize money enabled Shannon to continue painting in Butler County.

In 1940 Shannon participated in the formation of New South, an art center in Montgomery organized to raise public awareness of Southern art. Following a brief teaching career at West Georgia College, Shannon served as an artist in the Pacific during World War II. At the war's end, he returned to Montgomery and later served as Alabama's representative to a number of national art organizations. After several years of teaching, Shannon formed the Auburn University art department, which he headed until his retirement in 1973. Today he lives and paints in Montgomery.

The Lover is an example of the vibrant and expressionistic style Shannon employs in his continuing study of the Southern Negro.

MARIE HULL (1890-1980)

131. *Sharecroppers,* 1938

Oil on canvas, 40 by 40¼ (101.6 by 102.2)
Signed lower left: *Marie Hull*
Mississippi Museum of Art, Jackson, Mississippi, Gift of the
Artist, W5356

Marie Hull, a native of Summit, Mississippi, taught piano after graduating from Belhaven College in Jackson, Mississippi in 1909. Her interest in art began when she studied in 1912 with Aileen Phillips, a former student at the Pennsylvania Academy of the Fine Arts. In 1912 she enrolled in the Pennsylvania Academy, studying with Hugh Breckenridge. In 1913 and 1914 she taught art at Hillman College in Mississippi, spending her summers at the Colorado Springs Art Center. She attended the Art Students' League in New York in 1922, studying anatomy with Frank Vincent Dumond and landscape with Robert W. Vonnoh. A major purchase award in 1926 allowed her to travel abroad with a class taught by George Elmer Browne.

On her return to Mississippi, Hull began to paint portraits and figure studies of sharecroppers and tenant farmers, including the work in this exhibition. *Sharecroppers,* which depicts two destitute laborers, combines the same close scrutiny and awareness of human dignity that marked the photographs of Walker Evans during the same period. Hull continued to teach, travel, and exhibit widely until her death in 1980.

EVERETT SPRUCE (born 1907)

132. *Arkansas Landscape*, 1938

Oil on canvas, 21¼ by 25 (54.0 by 63.5)
Signed lower left: *E. Spruce '38*
The Phillips Collection, Washington, D.C.

A native of Faulkner County, Arkansas, Everett Spruce received a scholarship to the Dallas Art Institute in 1925. Spruce worked at the city's Museum of Fine Arts during the depression, rising to the position of Assistant Director by 1935. He worked and was closely associated with the Dallas School of regionalist painters, especially Otis Dozier, William Lester, Jerry Bywaters, and Alexander Hogue. Appointed to the art faculty of the University of Texas in 1940, he achieved the rank of full professor fourteen years later.

Spruce was the first Texas artist to achieve national renown. His works were included in the Whit-

ney Museum's biennial exhibition of contemporary art and in the Art Institute of Chicago's annual exhibition of painting and sculpture. Prizes won in national and international exhibitions between 1936 and 1945 earned him the reputation as one of America's preeminent artists. In 1959 he was named one of twelve United States artists to participate in a series of retrospective exhibitions organized by the American Federation of Arts.

Arkansas Landscape was painted during Spruce's association with the Dallas regionalists, or "The Nine," as they called themselves.

His use of severely stylized forms often caused his work to be labeled primitive and folk-like, appealing characteristics in a region concerned with the establishment of its cultural identity.

ALEXANDER BROOK (1898-1980)

133. *Georgia Jungle, 1939*

> Oil on canvas, 35 by 50 (89 by 127)
> Signed lower right: *A. Brook 1939*
> Museum of Art, Carnegie Institute, Pittsburgh, Pennsylvania, 39.7

134. *Savannah Street Corner, no date*

> Oil on canvas, 26⅛ by 34 (66.4 by 86.4)
> Signed lower right, *A. Brook*
> Telfair Academy of Arts and Sciences, Inc., Savannah, Georgia, Gift of the Artist, 72.22.7

Alexander Brook, who was born in Brooklyn, studied at the Art Students' League in New York with Kenneth Hayes Miller from 1914 to 1918. A critic for *The Arts* during the early 1920s, Brook became an assistant at the newly-founded Whitney Studio Club in 1924. It was at this time that he began to paint in earnest, traveling and exhibiting widely with his artist-wife Peggy Bacon. During the depression, Brook taught art at the League, meanwhile winning many fellowships and prizes.

Between 1938 and 1943, Brook and his wife lived in Savannah, Georgia. It was just after he moved to Savannah that he painted *Georgia Jungle*, which was set

in Yamacraw, an Indian settlement west of Savannah that had become the home of poor blacks during the depression. Brook's view of the impoverished district brought home with startling immediacy the plight of its inhabitants. Less poignant in its execution, Brook's *Savannah Street Corner* sets forth with boldness and strength the flavor of life in a depression-bound Southern city.

Brook later returned to New York to teach at the League; in addition, he performed numerous services for the war effort and painted commissions for *Life* magazine. At war's end, he returned to Savannah, but in 1947 he left the South permanently to settle in Sag Harbor, New York, where he painted and exhibited until his death.

Georgia Jungle: exhibited at the Virginia Museum.

WILLIAM H. JOHNSON (1901-1970)

135. *Chain Gang*, 1939-40

> Oil on panel, 45½ by 38⅜ (115.6 by 97.5)
> Signed lower left: *W.H. Johnson*
> National Museum of American Art, Smithsonian Institution, Washington, D.C., Gift of the Harmon Foundation, 1967.59.675

William H. Johnson was born in Florence, South Carolina. In 1918, he left for New York where he did odd jobs in order to save money for art school. Admitted on probationary terms to the Art Students' League in 1921, Johnson continued to work so that he could send money home to his family. In 1922 he became a full student, beginning studies one year later in Provincetown, Massachusetts, with Charles W. Hawthorne. Between 1923 and 1926, he won several prizes at the League, where he worked for George Luks in return for instruction.

298

In 1926, using $1,000 raised by Hawthorne, Johnson went to Paris, where he immediately sought out a fellow black artist, Henry O. Tanner. Returning briefly to New York in 1930, he won the William E. Harmon Award for Distinguished Achievement Among Negroes and then exhibited at the Harmon Foundation National Exhibition to wide acclaim.

From 1930 to 1935, Johnson lived and worked in Kerteminde, Denmark, while continuing to exhibit actively in national shows organized by Afro-American organizations. He later journeyed to Norway to work and travel. While there he met the noted Expressionist painter Edvard Munch. Upon his return to America in 1938, he painted for the WPA and taught at the Harlem Community Center in New York.

In 1956, the Harmon Foundation acquired all of Johnson's works in storage and in 1967 presented 1,154 of his paintings to the National Collection of Fine Arts in Washington, D.C.

Johnson's *Chain Gang,* which was exhibited at the New York World's Fair in 1940, presents a vibrant commentary on the difficult problem of race relations in the South, which worsened during the depression. The painting is also autobiographical, a bitter reference to Johnson's arrest in 1930 in his native Florence, South Carolina: he had been painting a view of a building and was imprisoned for vagrancy.

Illustrated in color, figure 49, page 125.

WILL HENRY STEVENS (1891-1949)

136. *Abstraction*, ca. 1940

> Oil and tempera on Masonite, 40½ by 34½ (102.9 by 87.6)
> Signed lower right: *Stevens*
> New Orleans Museum of Art, New Orleans, Louisiana, Museum
> Purchase, 46.1

Will Henry Stevens of Vevay, Indiana, received his initial art training with Frank Duveneck at the Cincinnati Art Institute, and later studied at the Art Students' League in New York with William Merritt Chase. In 1921, he was appointed Instructor at the Newcomb School of Art in New Orleans, a post he held until his retirement in 1948. He spent nearly all of his summers in western North Carolina, where he painted the woods and hillsides.

In 1940, Stevens effectively began to lead a double life, artistically speaking. On the one hand he painted Cézanne-like studies in vibrant, limpid colors; on the other, he executed abstractions in oil and tempera that were inspired by the work of Paul Klee and Wassily Kandinsky. He even exhibited these two types of work at two different galleries. *Abstraction*, an example of his non-objective work, was inspired by the Southern environment.

JULIEN BINFORD (born 1908)

137. *The Crapshooter*, 1941

> Oil on canvas, 35¾ by 69½ (90.8 by 176.5)
> Signed lower left: *Binford*
> Collection of the artist, courtesy of Midtown Galleries, New York

A native of Powhatan, Virginia, Julien Binford entered pre-medical school at Emory University in Atlanta, but he dropped out of school to become a seaman. This took him to ports in Europe before returning to Atlanta to continue his education. In 1928 he enrolled at the Art Institute of Chicago, where he studied for three years with Boris Anisfeld.

After a lukewarm response to his first one-man show in New York in 1936, Binford returned to Virginia, where he began a series of works depicting his black neighbors at work and play. Following naval duty in World War II, Binford became well-known for his mural paintings, most notably those in the Virginia State Library in Richmond.

The Crapshooter, winner of the Chicago Art Institute's Annual Award in 1941, depicts Binford's neighbors near Fine Creek, Virginia, engaged in an amusing pastime. His models for the painting included a preacher, a local deacon, a mail carrier, a logger, and a grave digger.

Illustrated in color, figure 50, page 129.

ZELDA SAYRE FITZGERALD (1900-1948)

138. *Circus*, ca. 1943

Oil on canvas, 35⅝ by 23½ (90.5 by 59.7)
Unsigned
Montgomery Museum of Fine Arts, Montgomery, Alabama,
 Gift of the Artist, 1943.5

The daughter of an affluent Montgomery, Alabama family, Zelda Sayre married writer F. Scott Fitzgerald in 1920. She first began to paint in Europe, where the couple lived until 1927. After returning to America, she continued to expand her painting activities, particularly following her first mental breakdown in 1931. Her first solo exhibition, held in New York in 1934, received favorable comment. The troubled couple moved often, and for a time they lived in Montgomery. Zelda spent several long periods in sanitariums in Baltimore and in Asheville, North Carolina.

Following her husband's death in 1940, she lived with her widowed mother in Montgomery. There she exhibited her paintings to much praise. *Circus* is one of her more interesting works from the Montgomery period. Intensely autobiographical, the work refers to her life on the tightrope, as it were, between being a gifted, genteel Southern woman and a precocious Bohemian.

She continued to go to Highlands Hospital near Asheville for periodic treatment, and she died there in a fire in 1948.

ROBERT GWATHMEY (born 1903)

139. *Hoeing,* 1943

Oil on canvas, 40 by 60¼ (101.6 by 153)
Signed upper left: *Gwathmey*
Museum of Art, Carnegie Institute, Pittsburgh, Pennsylvania,
Patrons Art Fund, 44.3

Robert Gwathmey, a native of Richmond, Virginia, studied at the Pennsylvania Academy of the Fine Arts before traveling to Europe. On his return, a WPA mural commission for an Alabama post office provided valuable experience. After three years as an art teacher at the Carnegie Institute in Pittsburgh, he was ap-pointed art instructor at New York's Cooper Union, a post he held until his retirement twenty-five years later.

Many of Gwathmey's paintings were inspired by frequent summers spent in Virginia. *Hoeing,* a typical work, depicts impoverished sharecroppers, white and black, in their bleak and equally impoverished environment. The large central figure, the dilapidated church, and the parched countryside all serve less as details than as symbols of Gwathmey's broad social commentary.

CLAUDE HOWELL (born 1915)

140. *Mullet Haul,* 1947

Oil on canvas, 30 by 24 (76.2 by 61)
Signed lower right: *howell 47*
St. John's Museum of Art, Inc., Wilmington, North Carolina

Claude Howell was born in Wilmington, North Carolina. In need of a job during the depression, he was employed by the Atlantic Coastline Railroad, a position he held for over twenty years. During his brief summer vacations, however, Howell studied art in Woodstock, Vermont, with painters Jan Corbino, Bernard Karfiol, and Charles Rosen, and in Washington, D.C., where he studied examples of American art in the Phillips Collection.

While still employed by the railroad, Howell won the 1939 North Carolina State Art Association prize, and the 1940 IBM and Carnegie purchase prizes. A member of the Southern States Art League, Howell exhibited with the League and in museums throughout the Carolinas. In 1953, Howell's night classes formed the nucleus of the Art Department of the University of North Carolina at Wilmington; since its inception, Howell has served as department chairman.

Mullet Haul, executed in the mid forties, shows Howell's attempt to build a regional style influenced by the work of Thomas Hart Benton, Ben Shahn, and Yasuo Kuniyoshi, in combination with his personal approach to abstraction.

HOBSON PITTMAN (1900-1972)

141. *The Conversation*, no date

Oil on canvas, 31³/₈ by 49¹/₄ (79.7 by 125.1)
Signed upper left: *Hobson Pittman*
North Carolina Museum of Art, Raleigh, North Carolina, Gift
 of the Artist, 67.32.1

Although Hobson Pittman moved permanently to Pennsylvania at the age of eighteen, he explored Southern themes throughout his life. Born in Epworth, North Carolina, he studied at the Rouse Art School in Tarboro, North Carolina. In the 1920s, he attended Pennsylvania State College and the Carnegie Institute of Technology.

A regular exhibitor in the New York area by the 1940s, he became widely known and respected.

In 1945, Pittman began teaching at the Philadelphia Museum of Art; one year later he received a commission from *Life* magazine to paint the interiors of well-known houses in Charleston, South Carolina. The imaginary, almost dream-like room of *The Conversation*, painted in the late 1940s, is reminiscent of the high-ceilinged structures of the artist's childhood, and it represents his attempt to recapture an almost otherworldly Southern past that perhaps exists only in myth.

In 1949, Pittman became a member of the faculty of the Pennsylvania Academy of the Fine Arts, and he also served as visiting lecturer at schools in Virginia and Texas. Pittman's first retrospective exhibition was held at the North Carolina Museum of Art in 1963, five years before he received the North Carolina Award in the Fine Arts for creative ability.

WALTER INGLIS ANDERSON (1903-1965)

142. *Horn Island,* ca. 1950

Watercolor on paper, 8¹/₂ by 11 (21.6 by 27.9)
Unsigned
Mississippi Museum of Art, Jackson, Mississippi, 1967.025

A native of New Orleans, Walter Anderson studied at
the Parsons Institute in New York and the Pennsylvania Academy of the Fine Arts, as well as in France. In
1933 he moved with his wife to Ocean Springs, Mississippi, where he painted in virtual seclusion, emerging
only to execute two WPA murals in 1935 and 1937.

Hospitalized for mental illness in 1939, Anderson
was released to the care of his wife's family in 1941. Six
years later he returned to Ocean Springs and lived as a
recluse, filling the walls of his cottage with vibrant
murals depicting local flora and fauna. He also drew
pen-and-ink illustrations of classic literary works, made
sculptures, and decorated pottery. The better part of
his time was spent on Horn Island, Mississippi, where
he executed hundreds of watercolor studies and kept a
detailed log of Thoreau-like meditations that recorded
the ever-changing flora and fauna about him. Late in
his life he was hospitalized again, this time for lung
cancer, and he died in 1965.

Illustrated in color, figure 51, page 133.

FRANCIS SPEIGHT (born 1896)

143. *Demolition of Avoca*, 1963

Oil on canvas, 32½ by 37½ (82.5 by 95)
Signed lower right: *Francis Speight / 1963*
Mint Museum of Art, Charlotte, North Carolina, Gift of Mr.
 Mason Page Thomas, Jr., in memory of Mason Page Thomas
 and William Bryan Grimes Thomas

Francis Speight, a native of Windsor, North Carolina, studied at the Pennsylvania Academy of the Fine Arts, where he later served as instructor of painting and drawing from 1925 to 1961. Recognized early for his talent, Speight was awarded numerous prizes and fellowships. In 1934 and 1935, he served as visiting professor of art at the University of North Carolina, Chapel Hill. One year later he received a Public Works Arts Project commission to paint a mural tracing the story of cotton for the Gastonia, North Carolina Post Office.

Speight traveled widely, working and exhibiting in England as well as the United States. On his retirement from the Pennsylvania Academy in 1961, he was given a large retrospective exhibition at the North Carolina Museum of Art in Raleigh, and he became artist-in-residence at East Carolina University in Greenville. Once established in Greenville, where he still lives and paints, Speight set about to rediscover the North Carolina of his boyhood. In 1964 he was awarded the North Carolina Medal of Achievement in the Fine Arts.

Avoca, a plantation belonging to a Confederate surgeon named Dr. Capehart, was located in Bertie County, North Carolina, on Albemarle Sound. Following the Civil War, Capehart used the property as a base of operations for the largest herring fishery on the East Coast. In the early 1960s, Avoca was purchased by the R. J. Reynolds Tobacco Company and was demolished to make way for an experimental plant.

Illustrated in color, figure 43, page 104.

CARROLL CLOAR (born 1913)

144. *Where the Southern Cross the Yellow Dog*, 1965

Casein tempera on Masonite, 23 by 34 (58.4 by 86)
Signed lower left: *Carroll Cloar*
Brooks Memorial Art Gallery, Memphis, Tennessee, 65.17

Carroll Cloar, an Arkansas native, first studied art at the Lee Academy (later the Memphis Academy of Arts) in Tennessee. In 1934, after graduating from Southwestern Presbyterian College in Memphis, he traveled to Europe. On his return, he entered the Art Students' League of New York and subsequently established his reputation as a lithographer. During World War II, Cloar traveled throughout the United States and Mexico, serving in the Army Air Corps in the Pacific. Returning to New York in the late 1940s, he began to use casein tempera as a medium. During this period, his work was twice featured in *Life* magazine. Cloar returned to Memphis in the mid 1950s and began a series of works based on his boyhood in the Arkansas delta. Cloar's fresh vision and his use of two-dimensional pattern in his paintings often caused them to be labeled "primitive," in spite of his professional training.

Where the Southern Cross the Yellow Dog, painted when the blues revival was well under way, depicts the legendary railroad crossing at Moorhead, Mississippi, that jazz musician W. C. Handy immortalized in his music. Cloar's chronicles of the timeless moments in the daily lives of both whites and blacks have established his reputation as one of the leading artists of the mid South.

ROMARE BEARDEN (born 1914)

145. *The Prevalence of Ritual: Tidings*, 1973

 Cut and torn paper with polymer paint on composition board,
 20¼ by 28 (51.4 by 71.1)
 Signed lower left: *romare bearden*
 North Carolina National Bank Corporation, Charlotte, North
 Carolina

Soon after Romare Bearden's birth in Charlotte, North Carolina, his family moved to New York. There, his father worked for the New York Department of Health; his mother was the New York editor of the Chicago *Defender,* and she also was founder and first president of the Negro Women's Democratic Association.

 A student of George Grosz at the Art Students' League in the mid thirties, Bearden formed the "306 Group," an informal association of black artists living in Harlem. He consistently drew upon his Southern and rural origins as inspiration for his paintings, which chronicle the migration of the African-American to the urban North.

 Bearden's first one-man show in 1940 was a success; bandleader Duke Ellington purchased one of his works, and painter Stuart Davis supported his efforts, urging him to explore jazz and the musical analogies inherent in his work.

 During a tour of duty in the United States Army in World War II, Bearden had his second one-man show, this time in Washington, D.C. On his discharge, he painted his *Passion of Christ* series, which received great praise when it was shown in Washington and New York.

 For four years after the war, Bearden was employed as a caseworker for the New York Department of Social Services. He eventually took advantage of the G.I. education bill to study at the Sorbonne in Paris. There, he became acquainted with novelist James Baldwin, sculptor Constantin Brancusi, and painter Georges Braque.

 Returning to New York, Bearden was employed once again as a caseworker; at the same time, he painted increasingly abstract works on Afro-American themes while pursuing his new interest in songwriting. A member of ASCAP, a musicians' and performers' union, he has had many songs published.

 Bearden was profoundly influenced by the civil rights movement. In 1963, he was instrumental in the formation of the Spiral Group, an organization concerned with the problems of the Afro-American artist. He simultaneously began a series of collages based on Southern themes, and the series was later widely exhibited. One year later he was appointed Art Director of the Harlem Cultural Council. He also helped to organize the Cinque Gallery, which provided younger black artists with needed exhibition space in the city. Two recent retrospective exhibitions of Bearden's work, organized by the Museum of Modern Art in New York (1971) and the Mint Museum in Charlotte (1980), have focused on the artist's continuing concern for the lives of Southern Afro-Americans.

 Tidings, part of a series begun in the 1960s called *The Prevalence of Ritual,* illustrates Bearden's use of personal memories to set forth the many customs and ceremonies that unify the black family in the South.

1950 to 1980

ARSHILE GORKY (1904-1948)

146. *Virginia Landscape*, 1944

Oil on canvas, 40 by 51 (101.6 by 129.5)
Unsigned
The Cincinnati Art Museum, Cincinnati, Ohio, Gift of Mrs.
Benjamin Tate, Peter Gibson, and Horace Carpenter by
exchange, and The Edwin and Virginia Irwin Memorial,
1979.220

The artist who later became world renowned as Arshile Gorky was born Vosdanck Manoog Adoian in Turkish Armenia. Because his father abandoned the family and there was an uneasy political atmosphere around him, Gorky was so disturbed as a young boy that he did not speak until the age of five. He did, however, begin to draw at a very early age. With his mother and four sisters, he traveled from place to place. The family experienced extreme poverty, and the mother died of starvation in her son's arms. Able at last to secure funds from his father (who had moved to Providence, Rhode Island), the sixteen-year old boy emigrated with one of his sisters to America, arriving at Ellis Island in 1920.

Although many conflicting stories exist—many of them of the artist's own making—little is known of Gorky's early years in the United States. In 1925, he changed his name to Arshile Gorky ("bitter one"), and five years later he entered the Grand Central School of Art. Impoverished once again during the Great Depression, Gorky turned to drawing when he was unable to purchase painting supplies. In 1935, he found work with the Federal Art Project of the Works Progress Administration; one of his works was later installed in the Newark Airport. Although Gorky was too old to serve in World War II, he managed to convince the Grand Central School of Art to allow him to teach a course in camouflage. Although the course was not considered a success, its subject indicates Gorky's interest in disguise, in his work as well as in his personal life.

In 1941, Gorky married his second wife, Alice Magruder. Two years later, on their visit to the bride's family farm in Hamilton, Virginia, he began to draw from nature. Gorky's first one-man show took place at the Julien Levy Gallery in New York in 1945. The following year, after the birth of his second daughter, the family moved to Sherman, Connecticut.

In 1946, in the aftermath of two disastrous events—the complete destruction by fire of his Sherman studio and its contents, and the discovery that he had terminal cancer—Gorky made one final visit to the Virginia farm and turned out over 300 drawings. Two years later, with his neck broken and his painting arm paralyzed as the result of an automobile accident, Gorky was abandoned by his wife and children. Disillusioned and depressed, the artist hanged himself in a woodshed near his Connecticut home.

Virginia Landscape, painted during one of the early visits to the Magruder farm, conveys the general sense of alienation that characterizes Gorky's vigorous and personal style. In spite of his expectations and his hopes for success in a new environment, he continued to work with bitter, inharmonious colors and fragmented forms, which seem to reveal his personal anxieties and a fear of the unknown in nature.

Exhibited at the Virginia Museum, the Birmingham Museum, the National Academy of Design, and the Mississippi Museum of Art.

WILLIAM MELTON HALSEY (born 1915)

147. *Back Street, Charleston,* 1946

 Oil on Masonite, 19 by 26 (48.3 by 66)
 Signed lower left: *Halsey*
 Collection of the artist

148. *Thira,* 1981

 Oil on Masonite, 48 by 72 (121.9 by 182.9)
 Signed lower right: *Halsey*
 Collection of the artist

William Halsey, who was born in Charleston, South Carolina, exhibited a talent for drawing at an early age and was encouraged by Charleston artist Elizabeth O'Neill Verner. After two years of study at the University of South Carolina, Halsey attended summer school in Boothbay Harbor, Maine, before enrolling for four years at the School of the Museum of Fine Arts in Boston. Halsey's interest in fresco painting during this time resulted in a WPA commission to decorate Charleston's Dock Street Theatre.

Awarded the Boston Museum's prestigious Paige Fellowship for two years of study in Europe, Halsey studied instead in Mexico, a change necessitated by the outbreak of World War II. On his return, he gave art lessons in Charleston before moving to Savannah, Georgia, in 1942. There, he first served as Director of the Art School of the Telfair Academy, later joining the war effort as timekeeper at the city's Southeastern

Shipyard Corporation. Following the war, Halsey returned to Charleston to paint and to teach at the Gibbes Art Gallery, the Charleston School of Art, and the College of Charleston. Recognized for his paintings and murals, he has exhibited with the Southern States Art League, has been accorded numerous one-man shows, and has been represented in both national and international group exhibitions.

The 1946 painting *Back Street, Charleston* shows the type of scenic work Halsey was doing in his native city soon after World War II. An expressionistic view executed with a heavy impasto, it provides a vivid contrast to the artist's 1981 painting *Thira.* The earlier work is more intimate while the later is a large-scale abstraction. The title *Thira* refers to a volcanic Greek island, and Halsey's choice of a fiery palette reveals his strong interest in archaeology and the forms and symbols of vanished civilizations.

JOSEF ALBERS (1888-1976)

149. Untitled (*Adobe*), 1947

> Oil on paper, 17½ by 24 (44.5 by 61)
> Signed lower right: A
> Mrs. Anni Albers and the Josef Albers Foundation, Inc.,
> Orange, Connecticut

Born in Bottrop, in Germany's Rhur District, Josef Albers became one of the most acclaimed artists and teachers of the twentieth century. For thirteen years between the two World Wars, Albers studied and taught at the Bauhaus, Germany's revolutionary school of design in Weimar, until it was closed, in 1933, on Hitler's order. Later the same year, Albers emigrated to the United States, where, on the recommendation of the Museum of Modern Art in New York, he was invited to join the faculty of Black Mountain College near Asheville, North Carolina. Intrigued by the easy rhythms of the mountains, Albers began his explorations into color perception and visual illusion during his stay there. Working thirteen-hour days in his studio at Black Mountain, Albers began the series *Homage to the Square*, which intrigued and challenged him for the next twenty years. Using chromatic runs, he was able to produce as many as forty variations on a single color. Albers left Black Mountain in 1949 to become head of the Yale University Art School, where he remained for the rest of his life.

In its cool discipline, this work represents the mainstream of modern art at mid-century, much as Albers's residence in North Carolina represented the serious beginning and the first strong awareness of modernism in the American South.

While it is true that Southern artists and critics did not readily accept the new modernism that was being explored at Black Mountain, the school eventually had a far-reaching effect on Southern art, as well as American art in general, in its liberated and innovative approach to the study of art, in theory, as well as in practice.

Illustrated in color, figure 52, page 135.

KENNETH NOLAND (born 1924)

150. *Ex-Nihilo*, 1958

> Acrylic on canvas, 64¹⁄₂ by 71¹⁄₂ (163.8 by 181.6)
> Signed on back: *Kenneth Noland*
> Collection of the artist

Kenneth Noland was born in Asheville, North Carolina. His grandfather's funeral home in Asheville served as the model for Horse Hines's funeral home in Thomas Wolfe's *Look Homeward, Angel*. Noland's father, a "Sunday painter" and amateur musician, took him to Washington's National Gallery of Art when he was a teen-ager, a visit that had a profound influence on him. During World War II, he served in the Air Force as a glider pilot and cryptographer; late in the war he was stationed in Egypt and Turkey. He returned to Asheville after the war and enrolled at Black Mountain College; there, from 1946 to 1948, he studied with Josef Albers and Ilya Bolotowsky, whom he regards as his most important teacher. Through Bolotowsky, Noland became increasingly aware of color as a vehicle for expression.

Noland's service in World War II enabled him to travel to Paris in 1948 on the G.I. Bill; he studied with Ossip Zadkine. He had his first one-man show in Paris one year later. On his return to America, he settled in Washington, D.C., where he first studied, then taught at the Institute of Contemporary Art.

During this time, two factors assumed tremendous importance for Noland: his awareness and study of the

works of Paul Klee, and his introduction to Reichian therapy. Returning to Black Mountain College in the summer of 1951, Noland made the acquaintance and friendship of critic Clement Greenberg. The following year, when he began to teach at the Washington Workshop Center for the Arts, he encountered painter Morris Louis, who became his close friend. Under the aegis of Greenberg, Noland and Louis visited Helen Frankenthaler's New York studio in 1953; there, both painters were strongly affected by Frankenthaler's use of washes of paint to create her "stained" canvases. Subsequently, as one of the most powerful practitioners of the "minimal" art in the 1960s, Noland employed bands of color separated by "spaces between" (which can be read as figure or ground) as the format of his paintings.

By the late fifties Noland had begun a series of paintings using concentric circles of color; here, intense colors set against a flat ground created an illusion of dynamic tension and reflected Noland's awareness of the energy inherent in nature. *Ex-Nihilo,* the title of this work, means "out of nothing." From a strong palette set against the void of the canvas, there emerges a series of shapes which, in their lack of regimentation, evoke the chaotic beginnings of creation.

Noland was elected to the American Academy of Arts and Letters in 1978. He lives today in Vermont on a farm once owned by poet Robert Frost.

LARRY RIVERS (born 1923)

151. *The Last Civil War Veteran,* 1961

Oil on canvas, 82½ by 64½ (209.6 by 163.8)
Signed lower right: *Rivers '61*
David Anderson Gallery, Inc., New York, Collection of David Anderson, DAG #6735

The son of Polish-Russian immigrants, Larry Rivers was born and raised in the Bronx. Interested initially in jazz, he played the saxaphone, and in 1944-45 he studied composition at the Juilliard School of Music in New York. A painter he met there inspired him to study art instead, and two years later he became a student of Hans Hofmann. He received his B.A. degree in Art Education from New York University in 1951.

During his career as a painter, Rivers's style has shifted from Abstract Expressionism to a representational style that combines tradition and innovation.

He draws his inspiration from a variety of sources, including political issues, pornographic magazines, actual events, and advertisements. Historically, his art falls between Abstract Expressionism and the New Objectivism of Robert Rauschenberg and Jasper Johns.

The Last Civil War Veteran is one of a series of works Rivers executed during the Civil War Centennial. The painting provides an example of a non-Southern artist displaying "sentiment" for the South. As Donald Kuspit has written in his essay earlier in this book, this "responsiveness to [the South] as an environment and a mentality, unmistakable interest in what could be conventionally taken as signs of the South... count more as authentic indications of Southernness than the fact of physical presence."

JASPER JOHNS (born 1930)

152. *Studio*, 1964

Oil on canvas, 88½ by 145½ (224.8 by 369.6)
Unsigned
Whitney Museum of American Art, New York, Gift of the
Friends of the Whitney Museum of American Art and
Purchase, 1966.661

Although he was born in Augusta, Georgia, Jasper
Johns spent most of his childhood in South Carolina.
He later studied at the University of South Carolina in
Columbia. After a tour with the United States Army in
Japan in 1949, he worked first as a sales clerk for a
bookstore, then as a window-display artist for Tiffany's
in New York.

Johns is often credited with initiating the era of
Pop Art in 1958 with a one-man show in New York.
Abstract Expressionism had reached the peak of its
influence, after acknowledging the two-dimensional
surface, the primacy of the medium, and the artist's
subjective presence in the work. Johns introduced a
contrasting objective view, through his rendering of
impersonal subjects ranging from flags to numerals, but
he focused the viewers' attention on the act of painting
itself rather than on the visual representation; he also
often appeared to introduce actual objects onto the
picture plane.

In *Studio*, Johns included an angled yardstick and
a line of suspended paint cans; with the wooden door
projecting beneath the horizontal edge of the canvas,
he signaled the area as a private one. To the right of the
door, the imprint of a palmetto frond serves as a
reminder both of Johns's Southern origin and of the site
he chose for his studio, Edisto Island off the South
Carolina coast.

A sculptor as well as a painter, Johns is probably
best known for his realistic images of beer cans. The
theme of illusion versus reality again surfaces in his
sculpture: the highly fashioned objects are often diffi-
cult to distinguish from the originals.

Johns lived in Japan twice during the mid sixties,
later moving back to New York. In addition to his many
varied art activities, he has designed sets and costumes
for the Merce Cunningham Dance Company.

Exhibited at the Virginia Museum.

320

GEORGE LEE BIRELINE (born 1923)

153. *Malcolm's Last Address*, 1965
Acrylic on canvas, 83½ by 101½ (212.1 by 257.8)
Unsigned
Mrs. Nina Kaiden Wright, Ontario, Canada

154. *Crushed Cups, Coat Hanger, Tape*, 1981
Acrylic on canvas, 60 by 144 (152.4 by 365.8)
Signed on back: G. *Bireline*
Collection of the artist

George Bireline was born in Peoria, Illinois. He holds
two degrees, a B.F.A. from Bradley University and an
M.A. from the University of North Carolina. His first
major interest was in stage and set design, and he
gained valuable experience as a stage technician in
New York in the early 1950s. He moved to Raleigh,
North Carolina, to work with an architectural firm, but
he painted very little. Eventually, however, he became
increasingly involved with painting, and as an instruc-
tor in the School of Design at North Carolina State

University he began to produce great quantities of work.

Bireline was one of the artists whose style was most influenced by Josef Albers's presence in North Carolina. *Malcolm's Last Address*, which was shown in Clement Greenberg's *Post-Painterly Abstraction* exhibition in New York in 1965, reveals his ability to assimilate reductionist methods. The grand scale and orderly quality are indicative of Bireline's awareness of artistic developments more closely associated with New York than with the South, even though the work was painted in the South, a region dominated by realism. A later work by the same artist, *Crushed Cups, Coat Hanger, and Tape*, shows his later shift away from the strict abstraction characteristic of Albers. The two-dimensional rectangle of the early work becomes an irregularly-shaped scenic frame from which objects are suspended. The urge for representation has begun to assert itself over pure abstraction.

Although he is no longer affiliated with North Carolina State University, Bireline continues to live and work in Raleigh.

HOWARD THOMAS (1899-1971)

155. *Festival Mountain*, 1970

 Polymer on canvas, 40 by 50 (101.6 by 127)
 Signed lower right: *Howard Thomas*
 Brenton National Bank of Des Moines, Iowa, William H.
 Brenton, Chairman

With encouragement from his father, Howard Thomas began to paint at the age of nine. His studies took him to a variety of institutions: Ohio State University; the Art Institute of Chicago, where he worked with George Bellows and Randall Davey; the University of Southern California; and the University of Chicago. In his twenties, Thomas became a friend of the composer Gustav Mahler, and for the next seven years the two frequently painted landscapes together. In 1924, Thomas moved to Greensboro, North Carolina, to serve as acting head of the Department of Art at the Woman's College of the University of North Carolina. There, he began to conduct research into the use of native earth pigments. On his retirement in 1965, Thomas moved to Carrboro, North Carolina.

Works like *Festival Mountain* indicate Thomas's understanding of Cubism and the dynamic equilibrium of the Dutch abstractionist Piet Mondrian. Thomas often uses natural earth pigments to create an energized surface by means of a loosely defined grid and strong accents of color. The result—at once lyric, instantaneous, and restrained—has been described as an "interior landscape" that finds its earlier parallel in the Luminist works of the nineteenth century.

BENNY ANDREWS (born 1930)

156. *Symbols*, 1971

> Oil and collage on canvas in eleven sections, 101¾ by 445¾
> (258.4 by 1132.2)
> Unsigned
> Edwin A. Ulrich Museum of Art, Wichita State University
> Endowment Association Art Collection, Wichita, Kansas,
> 77.5

The son of sharecroppers in rural Madison, Georgia, Benny Andrews became determined early in his life to become an artist. At eighteen, he enrolled at Ft. Valley State College, and he subsequently attended the University of Chicago. In 1968, ten years after he received his B.F.A. from the Art Institute of Chicago, Andrews became co-chairman of the Black Emergency Cultural Coalition, which was established to recognize gifted black artists.

In *Symbols*, a thirty-seven-foot work in eleven sections, Andrews contrasts black and white societies, poverty and relative wealth, and he presents a depiction of the absurdity of everyday reality. Emphasizing the South's rural aspects, with which he is completely familiar, Andrews implies the constrictions within the status quo of life in the South.

ROBERT P. GORDY (born 1933)

157. *Arcadian Still Life with Females (Wrinkled Version)*, 1971
Acrylic on canvas, 68 by 104 (172.7 by 264.2)
Signed lower right: *RG '71*
Museum of Contemporary Art, Chicago, Illinois, 7732
Provenance: Paul and Camille Oliver-Hoffmann

The son of the manager of a salt mine in Jefferson Island, Louisiana, Robert Gordy grew up and attended school in nearby New Iberia. Acutely interested in art as a young child, he began to paint seriously in his freshman year in high school with the encouragement of New Iberia artist Weeks Hall, who introduced Gordy to modern French and American painting. As a high-school student, Gordy won several awards in national exhibitions and competitions.

After his sophomore year in college, Gordy spent a summer studying with Hans Hofmann in Province-town, Massachusetts. This opportunity, combined with his first encounter with contemporary art in New York City, exerted a profound influence on Gordy's later work. He received a B.A. degree from Louisiana State University, and one year later he earned his master's degree. His thesis topic was *The Human Figure: A Search for the Meaning of an Image*.

On his subsequent travels, Gordy saw the late cut-out works of Henri Matisse in Paris and was intrigued by their decorative quality. He traveled throughout the United States and Mexico, working at a variety of jobs, visiting museums and galleries whenever possible. In 1961, he moved to New York to work for a year for a textile designer; during this time, his work became more controlled and more decorative. Although he returned to New Orleans in 1964, he continued to travel at every opportunity, remaining open to the many influences presented by artists whose work he saw. He is recognized nationally and internationally for a style that combines both abstract and representational elements.

In 1961, on a visit to the Philadelphia Museum of Art, Gordy was profoundly influenced by a Cézanne painting, *The Large Bathers*. Cézanne's impact is evident in many of Gordy's later works, among them *Arcadian Still Life with Female Figures (Wrinkled Version)*.

MARTIN HOFFMAN (born 1935)

158. *Open Road*, 1972

> Acrylic on canvas, 60 by 80 (152.4 by 203.2)
> Signed lower left on back: *Martin Hoffman/Sept, 72, N.Y.C./*
> *"Open Road" (from the "Landscape of the Apocalypse" Series)*
> *60" − 80"*
> The Virginia Museum, Sydney and Frances Lewis Contemporary
> Art Fund Collection, 72.51

A native of St. Augustine, Florida, Martin Hoffman moved to Miami in 1950. Before he became a professional artist, he toured as a percussion player. Before he was twenty years old, he had been to Cuba, the Dominican Republic, and throughout the United States. He then attended Florida State University for two years. In addition to painting, Hoffman has worked successfully as a graphic designer, contemporary furniture designer, and art director.

Open Road, part of the *Apocalypse* series Hoffman painted in Florida, places the contemporary viewer on a highway in the midst of the natural environment. In spite of the central vortex that represents the road and the lights of a car on the far horizon, the dominant and all-inclusive presence within the work is the somewhat mystical Florida landscape.

IDA KOHLMEYER (born 1912)

159. *Cluster # 1, 1973*

Oil on canvas, 68½ by 104½ (174 by 265.4)
Signed lower right: *Kohlmeyer*
Robert Hering and James Stringer, San Francisco, California

Ida Kohlmeyer, a native of New Orleans, is both a painter and a printmaker; she has both B.A. and M.F.A. degrees from Newcomb College, Tulane University. Kohlmeyer was influenced by her association with two major twentieth-century modernists: Hans Hofmann, with whom she studied in 1956, and Mark Rothko, during his term as artist-in-residence at Newcomb College.

On the decorative surface of Kohlmeyer's work, planes or clusters of color are arranged in grid-like patterns which suggest a correlation to music.

BLUE SKY (born 1938)

160. *Air Brakes, 1976*

Mixed media, 65½ by 44 (166.4 by 111.8)
Signed lower right center: *Blue Sky*
Mississippi Museum of Art, Jackson, Mississippi, Lent by Mr. and Mrs. Lyle Cashion, Jr.

Blue Sky was born in Columbia, South Carolina, as Warren Johnson. He received a degree in art from the state university there and later studied at the University of Mexico and at the Art Students' League in New York. He returned to the University of South Carolina to earn his master's degree.

In the early 1970s, because he wanted to assume a more pastoral self-image, Johnson changed his name to Blue Sky. Some of his works are murals on urban walls. In this mixed-media painting, he has made a masterful use of materials in presenting a contemporary—if absurd—image of the South through the theme of the American highway. The viewer, mesmerized by the clearly rendered details on the back of a large truck ahead, is made to feel uneasy by the implied danger of the vantage point. At first glance, *Air Brakes* appears to be a serious realist work. But on closer study, one notices that bottle-caps are used for tail-lights, a zipper serves as a closure for the rear doors, and behind the wheels are satin mud-flaps inscribed "Passing Side" and "Sssuicide."

Blue Sky recently received grants from the General Services Administration and the National Endowment for the Arts to allow him to continue his work with wall murals.

VICTOR HUGGINS (born 1936)

161. *Pilot Mountain*, 1976

Acrylic on canvas, 36½ by 42½ (92.7 by 108)
Signed on back: *Victor Huggins 1976 Acrylic/Blacksburg, Va.*
The Pitt County Mental Health Center, Greenville, North
 Carolina

Currently head of the Department of Art and professor of art at Virginia Polytechnic Institute and State University in Blacksburg, Victor Huggins was born in Chapel Hill, North Carolina. In the late 1950s he served in the United States Army, returning to North Carolina to receive his bachelor's and master's degrees from the University of North Carolina at Chapel Hill. He received a Virginia Museum Fellowship in 1973.

Huggins paints and works in collage to depict the Appalachian landscape. In *Pilot Mountain*, he presents an unusual geological formation outside Winston-Salem, North Carolina, so named because of its use as a point of reference for air traffic over the area. The mountain, looming in the background behind a divided super-highway, seems to dominate man's encroachment into the natural landscape, thus forcing the viewer to reflect on the contrasting rhythms of natural and man-made environments.

RICHARD KEVORKIAN (born 1937)

162. *Toluidine Red,* 1976

Acrylic on canvas, 84 by 78¼ (213.4 by 198.8)
Unsigned
Sydney and Frances Lewis Collection, Richmond, Virginia

A native of Dearborn, Michigan, Richard Kevorkian studied at the Pennsylvania Academy of the Fine Arts and in 1961 earned a B.F.A. in art from Richmond Professional Institute (now Virginia Commonwealth University) in Richmond. One year later he received his M.F.A. at the California College of Arts and Crafts in Oakland.

A frequent participant in national and regional exhibitions, Kevorkian has won numerous awards, among them a Guggenheim Fellowship for painting and two grants from the National Endowment for the Arts. Since 1964, he has been on the faculty of the Department of Painting and Printmaking at VCU's School of the Arts.

Monumental in scale, Kevorkian's *Toluidine Red* presents the suggestion of a distant horizon, although the image never quite emerges as representational. "What emerges," according to Donald Kuspit, "is a sense of unresolved contrast within the piece that creates a tension that is itself the end result of the work."

Illustrated in color, figure 59, page 155.

SYD SOLOMON (born 1917)

163. *Tripeast*, 1977
>Oil and acrylic on canvas, 76 by 82¾ (193 by 210.2)
>Signed lower left center: *Syd Solomon*
>Guild Hall Museum, East Hampton, New York, Guild Hall
> Purchase Fund, 1978, GH78.11

The son of Hungarian immigrants, Syd Solomon was born in Pennsylvania. After studying at the Art Institute of Chicago and the Ecole des Beaux-Art in Paris, he worked during World War II as a camouflage designer in Washington, D.C. In 1946, Solomon settled in Sarasota, Florida, where he served during the 1950s as director of painting classes at the city's Ringling Museum of Art, and in the 1960s as professor of art at New College. His love of the Southeast's tropical landscape is reflected in two murals executed for the *Times* Building and the Far Horizons Hotel, both in St. Petersburg.

Tripeast, executed on a scale that reflects his interest in mural painting, presents a brightly-colored, calligraphic approach. Interested in various parallels between music and color, Solomon seeks to convey both a lyrical and a decorative effect in his work.

VERNON PRATT (born 1940)

164. *Atmospheric Perspective (129 Greys)*, 1978
 Acrylic on canvas, 66 by 77¼ (167.6 by 196.2)
 Signed on back: *Pratt 78*
 Collection of the artist

Vernon Pratt, who was born in Durham, North Carolina, received his B.F.A. with highest honors from the San Francisco Art Institute in 1962. For the following two years he worked toward his M.F.A. degree, advised by painter Richard Diebenkorn. Pratt's activities have been varied; among them was a commission in 1981 to design and produce the sets for MGM's production of *Brainstorm,* which was to have starred the late Natalie Wood. Currently a resident of Durham, North Carolina, Pratt has served as professor of art at Duke

University, and he now chairs its undergraduate design department.

Painted in a Systemic Minimalist style, *Atmospheric Perspective (129 Greys)* displays the clarity and precision characteristic of his work. Using a consciously limited palette, he deliberately applied color to compartmentalized areas to create a sense of isolation.

As *New York Times* critic John Russell observed in 1980, "Pratt's a systematic painter who thinks nothing of moving from an absolute white to an absolute black in 1,025 easy stages. . .[he] achieves this with the aid of cunning mathematical progressions that make us feel we are part of an immensely complicated dance structure in which we shall never get out of step."

VICTOR FACCINTO (born 1945)

165. *Winged Fork*, 1979

Acrylic on wood, 11 by 16½ by 3¾ (27.9 by 41.9 by 9.5)
Unsigned
Martin Sklar, New York, courtesy of Phyllis Kind Gallery, New
York

A native of Albany, California, Victor Faccinto re-
ceived a B.A. in psychology and a master's degree in art
from California State University in Sacramento. A
filmmaker as well as a painter, Faccinto was represented
in many one-man and group exhibitions during his
college career and received numerous grants and
awards. Since that time he has achieved both a na-
tional and international reputation. Formerly instruc-
tor in art at California State University, he is now
director of the Fine Arts Gallery at Wake Forest
University in Winston-Salem, North Carolina.

In this three-dimensional painting, Faccinto com-
bines elements of the naive with the bizarre. The result
is a work that evokes a sense of the irrational or the evil
in nature similar to that found in the writings of Erskine
Caldwell or William Faulkner.

RAY KASS (born 1944)

166. *Winged Earth, St. John's Mountain*, 1979-80

Watercolor on rag paper, coated with beeswax and mounted on
canvas with methyl cellulose, 63¼ by 94¼ (160.7 by 239.4)
Signed lower right: *RK*
Collection of the artist

Ray Kass, a native of New York, has spent most of his
adult life in the South. With a B.A. in philosophy from
the University of North Carolina, Kass focused on
painting for his M.F.A., with additional studies in the
history of twentieth-century art and criticism. He has
received three grants from the National Endowment for
the Arts. Since 1976 he has been associate professor of
drawing, painting, and design at Virginia Polytechnic
Institute and State University in Blacksburg.

Injecting a note of "Southernness" in his abstrac-
tions, Kass titled this recent work *Winged Earth, St.
John's Mountain*. Utilizing non-representational means,
he evokes both a sense of flight and an awareness of the
land that is also found in the work of his colleague
Victor Huggins.

Illustrated in color, figure 57, page 149.

SAM GILLIAM (born 1933)

167. *Blue Isolate,* 1980

Acrylic on canvas, 88 by 176 (223.5 by 447)
Signed on back: *Sam Gilliam*
Middendorf-Lane Gallery, Washington, D.C.

Sam Gilliam was born in Tupelo, Mississippi, and was raised in Louisville, Kentucky. Encouragement from his fifth-grade teacher and a special high school arts program whetted Gilliam's interest in painting. In 1961, the same year he received his master's degree at the University of Louisville, he was given a one-man show at the Museum of Modern Art in New York.

Today his paintings are included in many public and private collections throughout the United States.

Gilliam's *Blue Isolate,* a large scale work in which primary colors are dominant, produces what *Painting in the South* curator Donald Kuspit calls "an epic effect within the Modernist idiom." Although no recognizable image emerges from the picture plane, Gilliam has created an almost Surrealistic tension that is suggestive of form.

Exhibited at the Virginia Museum.

MIKE NICHOLSON (born 1936)

168. *500 Years of Rape (Institutional Order Defined)*, 1980
Liquitex, spackling paste, and collage on canvas, 60 by 120
(152.4 by 304.8)
Signed on reverse: *Mike Nicholson*
Collection of the artist

Mike Nicholson was born in Henderson, North Carolina. He served for nine years in the United States Air Force, where he enrolled in the Armed Forces University Extension Program; at the end of his tour of duty, he studied at Florida State University in Tallahassee, where he received a B.A. in Creative Arts with emphasis in painting. Two years later in 1967 he earned an M.F.A. from the University of North Carolina at Greensboro.

Now an associate professor of art at the University of Georgia, Nicholson formerly served as assistant to the curator of the Weatherspoon Gallery in Greensboro, North Carolina. He has taught courses in drawing, painting, and design in several colleges and universities. In addition to a number of one-man shows, he has shown his work in regional, national, and international exhibitions. A speaker and published poet, he has also received grants from the Carnegie and Ford Foundations to study abroad.

RUSS WARREN (born 1951)

169. *Temptation*, 1980

> Acrylic on canvas, 46 by 64½ (116.8 by 163.8)
> Signed on back: *Warren-80*
> Mr. and Mrs. Alan Koppel, Chicago, courtesy of Phyllis Kind
> Gallery, Chicago

Russ Warren was born in Washington, D.C., and grew up in Houston, Texas. While working towards a B.F.A. degree at the University of New Mexico and an M.F.A. at the University of Texas at San Antonio, he was represented in a number of one-man and group shows throughout the Southwest. Since 1977 his works have been seen in other regions of the country, primarily the South and East. He is currently assistant professor of printmaking at Davidson College in North Carolina.

Temptation combines a serious theme with a humorous style that borders on caricature. Donald Kuspit has described his style as "madcap, funhouse art, deliberately bizarre and almost routinely naive—artifically naive, to give us some distance from the urgency of its theme." In combination with his style, Warren produces a fantasy bordering on the sinister and reminiscent of similar characteristics in Southern writing in this century.

Illustrated in color, figure 62, page 160.

FRANK FAULKNER (born 1946)

170. *Arabia Felix*, 1981

> Acrylic on canvas, 72 by 96 (182.8 by 243.8)
> Signed on reverse: *Faulkner 1981.*
> Collection of Nona Hanes Porter, New York, courtesy of Monique Knowlton Gallery, New York

A native of Sumter, South Carolina, Frank Faulkner earned both his B.F.A. and M.F.A. degrees from the University of North Carolina at Chapel Hill. A grant from the National Endowment for the Arts in 1974 enabled him to work with the Urban Walls Project in Winston-Salem, North Carolina. Two years later he was recognized by two additional grants, one from the Southeast Center for Contemporary Arts in Winston-Salem, the other a Collaborative Artists Award from the American Institute of Architects. Faulkner has exhibited widely in one-man and group exhibitions in the United States and Europe.

Although the richly-woven, patterned surface of Faulkner's *Arabia Felix* seems non-representational at first, upon closer examination images of both a snake and hands become apparent. The colors and patterns that constantly shift focus across Faulkner's pulsing canvas suggest a mood of instability.

MAUD GATEWOOD (born 1934)

171. *Swinger in Summer Shade*, 1981

> Acrylic on canvas, 60 by 72 (152.4 by 182.9)
> Signed lower right: MFG
> Mr. and Mrs. Frank P. Ward, Jr., Raleigh, North Carolina

Maud Gatewood was born in Yanceyville, North Carolina. After completing her master's degree at Ohio State University, she received a 1962-63 Fulbright Grant to study in Vienna, where she worked with Austrian artist Oscar Kokoschka. On her return to the United States, she held the position of professor of art at Averett College in Danville, Virginia. The 1972 winner of the American Academy of Arts and Letters Award, Gatewood later returned to Yanceyville, where she now lives and paints.

In *Swinger in Summer Shade*, Gatewood depicts a young girl in a natural setting. The figure and the trees are painted with the same density and are lighted in the same manner. In addition to reflecting the girl's sense of being at ease in nature, the painting reveals Gatewood's interest in achieving an interior spatial effect within an exterior environment and in conveying the somewhat typical Southern condition of being saturated with nature.

JAMES ARTHUR HERBERT (born 1938)

172. *Plump Head*, 1981

Acrylic on canvas, 115 by 150 (292.1 by 381)
Signed on back: *James Herbert*
Collection of the artist

A native of Boston, Massachusetts, James Herbert was a Rufus Choate Scholar at Dartmouth. He graduated *magna cum laude* in art history and earned his M.F.A. degree from the University of Colorado. A 1971 Guggenheim fellow, Herbert has studied with Clyfford Still, Kenzo Okada, and Stan Brakhage. In addition to his paintings, which have been exhibited widely, Herbert's talent as a filmmaker has resulted in more than fifty prizes from major national and international film festivals.

In *Plump Head*, Herbert arbitrarily splashed strong color across the canvas and produced the title-giving image of this work. His painting is an example of the fact that representation can neither be diminished by will nor avoided by abstraction but is always inherent in the imagination.

EDITH LONDON (born 1904)

173. *Dawn and Dusk in Unison*, 1981

> Oil on canvas in two sections, 36 by 36 (91.4 by 91.4) each panel
> Signed on right panel: *Edith London 1981*
> Collection of the artist

Born in Berlin, Edith London studied art at the Berlin Federation of Women Artists under Wolf Roehricht. She also studied in Paris, Oxford, and Rome. Just before the outbreak of World War II, she moved with her husband to Durham, North Carolina. In 1955, she became a member of the art department of Duke University, a position she held for fourteen years. Still a resident of North Carolina, she continues to paint and exhibit her works, many of which are included in both national and international collections.

Like her contemporary Ida Kohlmeyer, London has long displayed a concern for the parallels that exist between music and color in contemporary painting. In a manner reminiscent of European Cubism in its Synthetic phase, London arranges broad areas of color across the two panels of *Dawn and Dusk in Unison*.

Illustrated in color, figure 58, page 153.

DAVID BUCHANAN PARRISH (born 1939)

174. *K. C. Suzuki*, 1982

> Oil on canvas, 90 by 63 (228.6 by 160)
> Signed on back: *David Parrish*
> Richard Manney, New York, courtesy of Nancy Hoffman Gallery, New York

David Parrish was born in Birmingham, Alabama. His early interest in art was encouraged by his mother, a writer who also painted. After receiving his B.F.A. from the University of Alabama in 1961, he headed for New York in hopes of a career as a magazine illustrator. One year later, he was in Huntsville, Alabama, working for the aerospace industry, doing concept paintings and technical drawings. In 1964 he began to paint works based on photographs, and by 1970 he had concentrated his realistic style solely on the motorcycle.

It has been suggested that Parrish's choice of subject is directly related to his father's preoccupation with the motorcycle. The elder Parrish had, in his youth, traveled the country by motorcycle, first as part of a circus, and after his marriage on pleasure trips with his wife. Parrish's coolly sophisticated treatment of a portion of a Suzuki motorcycle is superreal in its accurate and clinical study of surface textures, highlights, and reflections.

Bibliography

AMERICAN AND SOUTHERN HISTORY AND CULTURE

Allen, Hervey, and Heyward, Dubose. "Poetry South." *Poetry* 20 (1922): 35-48.

Bowen, Frances Jean. "The New Orleans *Double Dealer*, 1921-26." *Louisiana Historical Quarterly* 39 (1956): 443-56.

Bridenbaugh, Carl. *The Colonial Craftsman*. Chicago: University of Chicago Press, 1950.

————. *Cities in Revolt: Urban Life in America, 1743-1776*. New York: A. A. Knopf, 1955.

————. *Myths and Realities: Societies of the Colonial South*. New York: Athenaeum, 1979.

Brooks, Van Wyck. "On Creating a Usable Past." *The Dial* 64 (April 11, 1918): 337-41.

Carter, Hodding. *Southern Legacy*. Baton Rouge: Louisiana State University Press, 1966.

Core, George. "One View of the Castle: Richard Weaver and the Incarnate World of the South." *Spectrum* 2 (June 1972): 1-9.

Couch, W. T. *Culture in the South*. Chapel Hill: University of North Carolina Press, 1934.

Cowan, Louise. *The Fugitive Group: A Literary History*. Baton Rouge: Louisiana State University Press, 1959.

Dabbs, James M. *Haunted by God: The Cultural and Religious Experiences of the South*. Richmond, Virginia: John Knox Press, 1972.

————. *Who Speaks for the South?* New York: Funk and Wagnalls, 1964.

Davidson, Donald. "The Artist as Southerner." *Saturday Review of Literature* 2 (May 15, 1926): 781-83.

————. *Southern Writers in the Modern World*. Athens: University of Georgia, 1958.

Davis, Richard Beale. *Intellectual Life in Jefferson's Virginia, 1790-1830*. Chapel Hill: University of North Carolina Press, 1964.

————. *Intellectual Life in the Colonial South, 1585-1763*. 3 vols. Knoxville: University of Tennessee Press, 1978.

————. *Literature and Society in Early Virginia, 1608-1840*. Baton Rouge: Louisiana State University Press, 1973.

————. "The South: 1690-1820." Research files for *Painting in the South: 1564-1980*. Richmond, Virginia Museum.

Dewey, John. "Americanism and Localism." *The Dial* 68 (June 1920): 687-88.

Dickey, James. *Poems 1957-1967*. New York: Collier, 1968.

Dolmetsch, Joan D., ed. *Eighteenth-Century Prints in Colonial America: To Educate and Decorate*. Williamsburg: Colonial Williamsburg Foundation, 1979.

Downs, Robert B. *Books That Changed the South*. Chapel Hill: University of North Carolina Press, 1977.

Elzell, John S. *The South since 1865*. Norman: University of Oklahoma, 1978.

England, Kenneth. "They Came Home Again: Fugitives' Return." *Georgia Review* 14 (1960): 248-57.

Ford, Charles Henri, and Tyler, Parker. "Blues." *Sewanee Review* 39 (January/March 1931): 62-67.

Fraser, Charles. *Reminiscences of Charleston, Lately Published in the Charleston Courier, and Now Revised and Enlarged by the Author*. Charleston, 1854.

Glascock, Harriet Belt. "Lexington: A Cultural Center in the Eighteenth Century West." Masters' thesis. Lexington: University of Kentucky, 1928.

Grady, Henry. *The New South and Other Addresses*. (American History and Americana series) no. 47, 1969.

Green, Constance McLaughlin. *Washington, Village and Capitol, 1800-1878*. Princeton, New Jersey: Princeton University Press, 1962.

Hamer, Philip; Rogers, George; et al., eds. *The Papers of Henry Laurens*. 8 vols. Columbia: University of South Carolina Press, 1968-1980.

Havard, William C. "The New Mind of the South." *Southern Review* 4 (Fall 1968): 865-82.

Hemphill, George. *Allen Tate*. Minneapolis: University of Minnesota, 1964.

Hough, Graham. "John Crowe Ransom: The Poet and the Critic." *Southern Review* 1, new series (January 1965): 1-21.

Jareckie, Stephen. *The Early Republic: Consolidation of Revolutionary Goals*. Worcester, Massachusetts: Worcester Art Museum, 1976.

Jensen, Merrill, ed. *Regionalism in America*. 1951. Reprint, paperback. Madison: University of Wisconsin, 1965.

King, Richard H. *A Southern Renaissance: The Cultural Awakening of the American South, 1930-1955*. New York: Oxford University Press, 1980.

Klingburg, Frank J., ed. *Carolina Chronicle: The Papers of Gideon Johnston: 1707-1716*. Berkeley and Los Angeles: University of California Press, 1946.

Larkin, Oliver. *Art and Life in America*. New York: Holt, Rinehart, and Winston, 1966.

Miller, Lillian B. *Patrons and Patriotism, The Encouragement of the Fine Arts in the United States, 1790-1860*. Chicago: University of Chicago Press, 1966.

New Orleans Museum of Art. *Early Views of the Vieux Carré: Guide to the French Quarter*. New Orleans: New Orleans Museum of Art, 1968.

O'Brien, Michael. *The Idea of the American South: 1920-1941*. Baltimore: Johns Hopkins University Press, 1979.

Olson, Charles. *The Special View of History*. Berkeley: Oyez Press, 1970.

Potter, David M. "The Enigma of the South." *Yale Review* 51 (Autumn 1961): 142-51.

Pratt, William. *The Fugitive Poets*. New York: E. P. Dutton, 1965.

Quinn, David B. *Virginia Voyages from Hakluyt*. London: Oxford University Press, 1973.

Ransom, John Crowe. "Art and the Human Economy." *Kenyon Review* 7 (Autumn 1945): 683-88.

Ravenel, Harriet. *Eliza (Lucas) Pinckney*. New York: Macmillan Company, 1896.

Reed, John Shelton. *The Enduring South*. Chapel Hill, North Carolina: University of North Carolina Press, 1975.

Rubin, Louis D. Jr., ed. *The American South: Portrait of a Culture.* Baton Rouge: Louisiana State University Press, 1980.

Rubin, Louis D. Jr., and Jacobs, Robert D., eds. *South: Modern Southern Literature in Its Cultural Setting.* Westport, Connecticut: Greenwood Press, 1961.

————. *Southern Renascence: The Literature of the Modern South.* Baltimore: The Johns Hopkins University Press, 1953.

Sackheim, Eric. *The Blues Line: A Collection of Blues Lyrics.* New York: Grossman Publishers, 1969.

Sartain, John. *The Reminiscences of a Very Old Man, 1808-1897.* New York: D. Appleton and Company, 1899.

Sellers, Charles Grier, Jr., ed. *The Southerner as American.* New York: E. P. Dutton, 1966.

Shuptrine, Hubert and Dickey, James. *Jericho: The South Beheld.* Birmingham, Alabama: Oxmoor House, 1974.

Simkins, Francis B., ed. *Art and Music in the South.* Farmville, Virginia: Longwood College, 1961.

Simpson, Lewis P., ed. *The Poetry of Community: Essays on the Southern Sensibility of History and Literature.* Vol. 2, Spectrum Monograph Series. Atlanta: Georgia State University School of Arts and Sciences, 1972.

Stanard, Mary Newton. *Colonial Virginia: Its People and Customs.* Philadelphia: J. B. Lippincott Company, 1917.

Sullivan, Walter. *Death by Melancholy: Essays on Modern Southern Fiction.* Baton Rouge: Louisana State University Press, 1972.

Tate, Allen. *Essays of Four Decades.* Chicago: Swallow Press, 1968.

Tentarelli, Ronda Cabot. "The Life and Times of *The Southern Review.*" *Southern Studies* 16 (Summer 1977): 129-51.

Tindall, George B. *The Emergence of the New South, 1913-1945.* Baton Rouge: Louisiana State University Press, 1967.

————. *The Ethnic Southerners.* Baton Rouge: Louisiana State University Press, 1976.

Van Devanter, Ann C. *"Anywhere So Long As There Be Freedom": Charles Carroll of Carrollton, His Family and His Maryland.* Baltimore: Baltimore Museum of Art, 1975.

Warren, Robert Penn. *The Legacy of the Civil War.* New York: Random House, 1961.

Watters, Pat. *The South and the Nation.* New York: Random House, Vintage Books, 1971.

Weaver, Richard M. *Visions of Order: The Cultural Crisis of Our Time.* Baton Rouge: Louisiana State University Press, 1964.

————. *The Southern Tradition at Bay: A History of Postbellum Thought.* Edited by Core, George; and Bradford, M. E. New Rochelle, New York: Arlington House, 1968.

Weinberg, Meyer, ed. *W.E.B. DuBois: A Reader.* New York: Harper & Row, 1970.

Woodward, C. Vann. *Origins of the New South, 1877-1913.* Baton Rouge: Louisiana State University Press, 1971.

————. *The Burden of Southern History,* 2nd rev. ed. Baton Rouge: Louisiana State University Press, 1968.

Young, Thomas Daniel. *The Past in the Present, A Thematic Study of Modern Southern Fiction.* Baton Rouge: Louisiana State University Press, 1981.

Yorke, Philip C., ed. *The Diary of John Baker.* London: Hutchinson & Co., 1931.

AMERICAN AND SOUTHERN PAINTING: GENERAL AND REGIONAL SURVEYS

Alexandria Association. *Our Town, 1749-1865: Likenesses of This Place and Its People Taken From Life by Artists Known and Unknown.* Alexandria, Virginia: Alexandria Association, 1956.

Amon Carter Museum. *Texas Painting and Sculpture: The 20th Century.* Forth Worth, 1971.

Bacot, H. Parrott. *The Louisiana Landscape, 1800-1969.* Baton Rouge: Anglo-American Art Museum, 1969.

Baker, Elizabeth C. "Southern Exposure." *Art in America* 64 (July-August 1976): 49-51.

Barker, Virgil. *American Painting: History and Interpretation.* New York: Macmillan Company, 1950.

Berry, Wendell. "The Regional Motive." *Southern Review* 6 (Fall 1970):49-51.

Bilodeau, Francis W. "American Art at the Gibbes Art Gallery in Charleston." *The Magazine Antiques* 98 (November 1970): 782-86.

————, and Tobias, Mrs. Thomas J., eds. *Art in South Carolina 1670-1970.* Charleston: South Carolina Tricentennial Commission, Carolina Art Association, 1970.

Bishop, Budd H. "Art in Tennessee: The Early 19th Century." *Tennessee Historical Quarterly* 29 (1970): 378-89.

Black, Mary. "Folk Painting." *Arts in Virginia* 12 (Fall 1971): 6-15.

————. "Contributions Toward a History of Early Eighteenth-Century New York Portraiture." *The American Art Journal* 12 (1980): 5-31.

Boles, John B., ed. *Maryland Heritage: Five Baltimore Institutions Celebrate the American Bicentennial.* Baltimore, Maryland: The Walters Art Gallery, The Baltimore Museum of Art, The Maryland Historical Society, The Peale Museum, and The Maryland Academy of Science, 1976.

Bolton, Theodore, and Wehle, Harry B. *American Miniatures, 1730-1850: One Hundred and Seventy-three Portraits Selected with a Descriptive Account.* 1927. Reprint. New York: Garden City Publishing Company, 1937.

Bolton-Smith, Robin. *Portrait Miniatures from Private Collections.* Washington, D.C.: National Collection of Fine Arts, Smithsonian Institution, 1977.

Carolina Art Association. *An Exhibition of Miniatures Owned in South Carolina and Miniatures of South Carolinians Owned Elsewhere Painted Before the Year 1860.* Charleston: Gibbes Memorial Art Gallery, 1936.

————. *Selections from the Collection of the Carolina Art Association.* Charleston, South Carolina, 1977.

Cavaliere, Barbara, and Hobbs, Robert C. "Against a Newer Laocoön." *Arts Magazine* 51 (April 1977): 110-17.

Cline, Isaac N. *Art and Artists in New Orleans during the Last Century.* New Orleans: Louisiana State Museum, 1922.

Collins, Richard H. "Artists of Kentucky." *History of Kentucky,* vol. 1, pp. 619-26. Covington, Kentucky: Collins and Company, 1882.

Corcoran Gallery of Art. *American Painters of the South.* Washington, D.C., 1960.

Craig, James H. *The Arts and Crafts in North Carolina, 1699-1840.* Winston-Salem, North Carolina: Museum of Early Southern Decorative Arts, 1965.

Daingerfield, Elliott. "Color and Form—Their Relationship." *The Art World* 3 (December 1917): 179-80.

Duberman, Martin. *Black Mountain: An Exploration in Community.* New York: E. P. Dutton, 1972.

Dunlap, William. *A History of the Rise and Progress of the Arts of Design in the United States.* 1834. Reprint. Introduction by James Flexner, edited by Rita Weiss. New York: Dover Publications, 1969.

Eldredge, Charles C. *American Imagination and Symbolist Painting.* Lawrence, Kansas: Helen Foresman Spencer Museum of Art, University of Kansas, 1979.

Fairman, Charles E. *Art and Artists of the Capital of the United States of America.* Washington, D.C.: U.S. Government Printing Office, 1927.

Flexner, James Thomas. *First Flowers of Our Wilderness: American Painting, the Colonial Period.* New York: Dover Publications, 1969.

Floyd, William Barrow. "Portraits of Ante-Bellum Kentuckians." *The Magazine Antiques* 105 (April 1974): 808-17.

Foushee, Ola Maie. *Art in North Carolina: Episodes and Developments, 1585-1970.* Published by the author, 1972.

Gardner, Albert Ten Eyck, and Feld, Stuart P. "Painters Born by 1815." In *American Paintings: A Catalogue of the Collection of the Metropolitan Museum of Art,* vol. 1. New York: Metropolitan Museum of Art, 1965.

Groce, George C., and Wallace, David H. *The New-York Historical Society's Dictionary of Artists in America, 1564-1860.* New Haven: Yale University Press, 1957.

Gussow, Alan. *A Sense of Place: The Artist and the American Land.* 2 vols. New York: Saturday Review Press, 1972-73.

Hall, Virginius Cornick, Jr. *Paintings in the Collection of the Virginia Historical Society: A Catalogue.* Charlottesville: University Press of Virginia, 1982.

Harris, Neil. *The Artist in American Society: The Formative Years, 1790-1860.* New York: George Braziller, 1966.

Harter, John Burton, and Tucker, Mary Louise. *The Louisiana Portrait Gallery,* vol. 1 (to 1870). New Orleans: Louisiana State Museum, 1979.

Hills, Patricia, and Tarbell, Roberta K. *The Figurative Tradition and the Whitney Museum of American Art.* Newark: University of Delaware Press, 1980.

Historical Society of York County. *Lewis Miller: Sketches and Chronicles. The Reflections of a Nineteenth-Century Pennsylvania Folk Artist.* Introduction by Donald A. Shelley. York, Pennsylvania: The Historical Society of York County, 1965.

Hogue, Alexandre. "A Texas View." *Arts Digest* 7 (January 1, 1933): 26.

Hudson, Ralph N. *Black Artists/South.* Huntsville, Alabama: Huntsville Museum of Art, 1979.

Huger, Elliott, "Painting in the South." In *The South in the Building of the Nation,* vol. 10. Richmond, Virginia: The Southern Historical Publication Society, 1909.

Huggins, Nathan Irvin. *Harlem Renaissance.* New York: Oxford, 1971.

Huntsville Museum of Art. *Contemporary Painting in Alabama.* Huntsville, Alabama, 1980.

Hutson, Ethel. "The Southern States Art League." *The American Magazine of Art* 21 (February 1930): 86-92.

Jones, Arthur F. and Weber, Bruce. *The Kentucky Painter from the Frontier Era to the Great War.* Lexington, Kentucky: University of Kentucky Art Museum, 1981.

Kolbe, John Christian, and Holcomb, Brent. "Fraktur in the 'Dutch Fork' Area of South Carolina." *The Journal of Early Southern Decorative Arts* 5 (November 1979): 41.

Kozloff, Max. "American Painting During the Cold War." *Artforum* 11 (May 1973): 43-54.

Kuspit, Donald B. "The Indispensable Land." *Art Voices/South* 2 (January/February 1979): 46-54.

———. "Mythical Regionalism and Critical Realism," *Contemporary Art/Southeast* 1 (April/May 1977): 9-12.

———. "The New Regionalism: Art as a Social Ecological Factor." *Art Voices/South* 2 (March/April 1979): 37-38.

———. "Regionalism Reconsidered," *Art in America* 64 (July-August 1976): 64-69.

Lipman, Jean, and Winchester, Alice. *The Flowering of American Folk Art, 1776-1876.* Whitney Museum exhibition catalogue. New York: Viking Press, 1974.

Locke, Alain. "The American Negro as Artist." *The Magazine of Art* 23 (July-December 1931): 210-20.

Looney, Ben Earl. "Historical Sketch of Art in Louisiana." *Louisiana Historical Quarterly* 18 (April 1935): 2.

Lytle, Sarah. "Thomas Middleton: At Ease with the Arts in Charleston." *Art in the Lives of South Carolinians, Nineteenth-Century Chapters,* edited by David Moltke-Hansen, pp. SL 1-13. Charleston, South Carolina: Carolina Art Association, 1979.

McCormack, Helen G. "Expatriate Portraits: Charlestonians in Museums Outside of Charleston." *The Magazine Antiques* 98 (November 1970): 787-93.

Mellow, James R. *The World of Miss Josephine Crawford, 1878-1952.* New

Orleans: Isaac Delgado Museum of Art (now New Orleans Museum of Art), 1965.

Mississippi Museum of Art. *Southern Realism.* Jackson: Mississippi Museum of Art, 1979.

Moltke-Hansen, David, ed. *Art in the Lives of South Carolinians: Nineteenth-Century Chapters.* Charleston: Carolina Art Association, 1979.

Morris, Jack A., Jr. *Contemporary Artists of South Carolina.* Greenville, South Carolina: Greenville County Museum of Art, 1970.

Mount, Mary W. *Some Notables of New Orleans: Biographical and Descriptive Sketches of the Artists of New Orleans. . . .* New Orleans: privately printed, 1896.

Mouzon, Harold A. *The Carolina Art Association: Its First Hundred Years.* Charleston: Carolina Art Association, 1958.

Museum of Fine Arts, Boston. *M. and M. Karolik Collection of American Paintings, 1815 to 1865.* Cambridge, Massachusetts: Harvard University Press, 1949.

National Society of the Colonial Dames of America in the State of Alabama. *Alabama Portraits Prior to 1870.* Mobile, Alabama, 1969.

National Society of the Colonial Dames of America in the State of Georgia. *Early Georgia Portraits 1715-1870.* Athens, Georgia: University of Georgia Press, 1975.

National Society of the Colonial Dames of America in the State of Louisiana, *Louisiana Portraits,* New Orleans, 1975.

National Society of the Colonial Dames of America in the State of North Carolina. *The North Carolina Portrait Index 1700-1860.* Compiled by Laura MacMillan. Chapel Hill: University of North Carolina Press, 1963.

New Orleans Museum of Art. *1980 New Orleans Triennial.* New Orleans, 1980.

R. W. Norton Art Gallery. *Louisiana Landscape and Genre Paintings of the 19th Century.* Shreveport, Louisiana, 1981.

Novak, Barbara. *Nature and Culture: American Landscape Painting 1825-1875.* New York: Oxford University Press, 1980.

Pinckney, Pauline A. *Painting in Texas, The Nineteenth Century.* Amon Carter Museum of Western Art, Austin: University of Texas Press, 1967.

Pleasants, Jacob Hall. *Two-Hundred Fifty Years of Painting in Maryland.* Baltimore, Maryland: The Baltimore Museum of Art, 1945.

Poesch, Jessie. *The Art of the Old South: Painting, Sculpture, Architecture, and the Products of Craftsmen 1560-1860.* New York: Alfred A. Knopf. 1983.

———. "Arts and Crafts of the Gulf Coast, 1870-1940." In *The Cultural Legacy of the Gulf Coast,* edited by Lucius F. Ellsworth and Linda K. Ellsworth. Pensacola, Florida: Gulf Coast History and Humanities Conference, 1976.

Prime, Alfred Coxe. *The Arts and Crafts in Philadelphia, Maryland, and South Carolina Part II, 1786-1800. Series Two, Gleanings from Newspapers.* 1932. Reprint. New York: Da Capo Press for The Walpole Society, 1969.

Rewald, John, et al. *Edgar Degas, His Family and friends in New Orleans.* New Orleans: Isaac Delgado Museum of Art (now New Orleans Museum of Art), 1965.

Richardson, E. P. *Painting in America: The Story of 450 Years.* New York: Thomas Y. Crowell Company, 1956.

Rogers, George C., Jr. "Changes in Taste in the Eighteenth Century: A Shift from the Useful to the Ornamental." *The Journal of Early Southern Decorative Arts* 8 (1982): 3.

Rutledge, Anna Wells. "Beyond the Smell of the Salt: Artists in Upcountry South Carolina Before 1865." In *Art in the Lives of South Carolinians, Nineteenth-Century Chapters,* edited by David Moltke-Hansen. Charleston, South Carolina: Carolina Art Association, (1979): ARa 1-10.

———. "Paintings in the Council Chamber of Charleston's City Hall." *The Magazine Antiques* 98 (November 1970): 794-99.

———. "A French Priest, Painter, and Architect in the United States, Joseph-Pierre Picot de Limoëlan de Clorivière." *Gazette des Beaux Arts* 33 (March 1948): 159-76.

———. *Artists in the Life of Charleston, Through Colony and State from Restoration to Reconstruction.* In *American Philosophical Society Trans-*

actions, new series 39 (November 1949): 101-260.

—————. *Catalogue of Painting and Sculpture in the Council Chamber, City Hall, Charleston, South Carolina*. Charleston, South Carolina: The City Council of Charleston, 1943.

Severens, Martha. *Reflections of a Southern Heritage: 20th Century Black Artists of the Southeast*. Charleston, South Carolina: Gibbes Memorial Art Gallery, 1979.

Singal, Daniel J. *The War Within: From Victorian to Modernist Thought in the South, 1919-1945*. Chapel Hill: University of North Carolina Press, 1982.

Stewart, John L. *The Burden of Time: The Fugitives and Agrarians, the Nashville Group of the 1920s and 1930s and the Writing of John Crowe Ransom, Allen Tate, and Robert Penn Warren*. Princeton: Princeton University Press, 1965.

Sutton, Cantey Venable. *History of Art in Mississippi*. Gulfport, Mississippi: The Dixie Press, 1929.

Tate, Allen. *Essays of Four Decades*. Chicago: Swallow Press, 1968.

Valentine Museum. *Richmond Portraits in an Exhibition of Makers of Richmond, 1737-1860*. Richmond, Virginia: The Valentine Museum, 1948.

Viola, Herman J. "Washington's First Museum: The Indian Office Collection of Thomas L. McKenney." *The Smithsonian Journal of History* 3 (Fall 1968): 1-18.

Virginia Museum. *An Exhibition of Nineteenth-Century Virginia Genre*. Richmond: Virginia Museum of Fine Arts, 1946.

—————. *Virginia Painting and Sculpture 1981*. Richmond: Virginia Museum of Fine Arts, 1981.

Virginia State Library. "A List of the Portraits and Pieces of Statuary in the Virginia State Library." *Bulletin of the Virginia State Library* 13 (January-April 1920):1-29.

Waterhouse, Ellis. *Painting in Britain: 1530-1790*. Baltimore: Penguin Books, 1969.

Weddell, Alexander W. *A Memorial Volume of Virginia Historical Portraiture, 1585-1830*. Richmond: Virginia Historical Society, 1930.

Weekley, Carolyn J. "Artists Working in the South, 1750-1820." *The Magazine Antiques* 110 (November 1976): 1046-47.

—————. "Portrait Painting in Eighteenth-Century Annapolis." *The Magazine Antiques* 101 (February 1977): 345-53.

—————, and Walters, Donald. *American Folk Portraits: Paintings and Drawings from the Abby Aldrich Rockefeller Folk Art Center*. Series 1. Edited by Beatrix T. Rumford. Boston: New York Graphic Society, in association with Williamsburg: The Colonial Williamsburg Foundation, 1981.

Westerbeck, Colin L., Jr. Review of " 'I Shall Save One Land Unvisited': Eleven Southern Photographers." *Art Forum* 20 (Nov. 1981): 83.

White, John Blake. "The Journal of John Blake White." Edited by Paul R. Weidner. *South Carolina Historical and Genealogical Magazine* 42 (1941): 57-71 ff and 43 (1942): 34-46.

White, Raymond D. "Marine Art in the South: A Brief Overview." *Journal of Early Southern Decorative Arts* 2 (November 1980): 50-55.

Whitley, Edna Talbot. *Kentuck Ante-Bellum Portraiture*. Louisville: The National Society of the Colonial Dames of America in the Commonwealth of Kentucky, 1956.

Wiesendanger, Martin and Margaret. *Nineteenth-Century Louisiana Painters and Paintings from the Collection of W.E. Groves*. Gretna, Louisiana: Pelican Publishing Co., 1971.

Williams, Ben F. *The Carolina Charter Tercentenary Exhibition*. Raleigh: North Carolina Museum of Art, 1963.

—————. *Two Hundred Years of the Visual Arts in North Carolina*. Raleigh: North Carolina Museum of Art, 1976.

Williams, Mary Frances. *Catalogue of the Collection of American Art at Randolph-Macon Woman's College: A Selection of Paintings, Drawings, and Prints*. Charlottesville: University Press of Virginia, 1977.

Willis, Patty. "Jefferson County Portraits and Portrait Painters." *Magazine of Jefferson County Historical Society* 6 (December 1940): 2.

Wood, Peter H. *Black Majority: Negroes in Colonial South Carolina from 1670 through the Stono Rebellion*. New York. W. W. Norton, 1974.

Yale University. *Yale University Portrait Index, 1701-1951*. New Haven: Yale University Press, 1951.

BY AND ABOUT INDIVIDUAL ARTISTS

ALLSTON, Washington

Gerdts, William, and Stebbins, Theodore E., Jr. *A Man of Genius: The Art of Washington Allston (1779-1843)*. Boston: Museum of Fine Arts, 1979.

AMANS, Jacques G.L.

Mary Louise Tucker. "Jacques G.L. Amans, Portrait Painter in Louisiana, 1836-1856." Master's thesis, Tulane University, 1970.

ANDERSON, Walter Inglis

Brooks Memorial Art Gallery. *The World of Walter Anderson, 1903-1965*. Memphis, Tennessee: Brooks Memorial Art Gallery, 1967.

Sugg, Redding S., Jr., ed. *The Horn Island Logs of Walter Inglis Anderson*. Memphis: Memphis State University Press, 1979.

—————. *A Painter's Psalm: The Mural in Walter Anderson's Cottage*. Memphis: Memphis State University Press, 1978.

—————. *Walter Anderson's Illustrations of Epic and Voyage*. Carbondale: Southern Illinois University Press, 1980.

ANDREWS, Benny

Alloway, Lawrence. *Benny Andrews: The Bicentennial Series*. Atlanta: High Museum of Art, 1975.

AUDUBON, John James

Audubon, John James. *The Birds of America*. Introduction and descriptive text by William Vogt. New York: Macmillan Company, 1931.

Davidson, Marshall B., ed. *The Original Water-color Paintings by John James Audubon for The Birds of America*, 2 vols. New York: American Heritage Publishing Co., and Boston: Houghton Mifflin, 1966.

Dwight, Edward H. *Audubon Watercolors and Drawings*. Utica: Munson-Williams-Proctor Institute, and New York: Pierpont Morgan Library, 1965.

Ford, Alice. *John James Audubon*. Norman, Oklahoma: University of Oklahoma, 1964.

Keating, Clark. *Audubon: The Kentucky Years*. Lexington, Kentucky: University Press of Kentucky, 1977.

Louisiana State Museum, Friends of the Cabildo. *Audubon in Louisiana*. New Orleans, 1966.

Lyman Allyn Museum. *John J. Audubon Centennial Exhibition*. New London, Connecticut, 1951.

Teale, Edwin Way. *Audubon's Wildlife, with Selections from the Writings of John James Audubon*. New York: Castle Books, 1964.

BARTRAM, William

Ewan, Joseph. *William Bartram: Botanical and Zoological Drawings, 1756-1788*. Philadelphia: American Philosophical Society, 1968.

BEARDEN, Romare

Ashton, Dore. "Romare Bearden—Projections." *Quad* 17 (1964): 99-111.

Berman, A. "Romare Bearden: I Paint Out of the Tradition of the Blues." *Art News* 79 (December 1980): 60-67.

Campbell, Mary Schmidt. "Romare Bearden: Rites and Riffs." *Art in America* 69 (December 1981): 134-41.

Childs, Charles. "Bearden: Identification and Identity." *Art News* 63 (October 1964): 24-25 ff.

Ellison, Ralph. Introduction to *Romare Bearden: Paintings and Projections*. Albany: State University of New York, 1968.

Murray, Albert and Ashton, Dore. *Romare Bearden: 1970-1980*. Charlotte: Mint Museum, 1980.

Pomeroy, R. "Black Persephone." *Art News* 66 (October 1967): 44-45.

Washington, M. Bunch. *Romare Bearden: The Prevalence of Ritual*. New York: Abrams, 1972.

BECK, George

Pleasants, Jacob Hall. "George Beck, an Early Baltimore Landscape Painter." *Maryland Historical Magazine* 35 (1940): 241-43.
———. *Four Late-18th-Century Anglo-American Landscape Painters. Proceedings of the American Antiquarian Society* 52 (October 1942): 187-324.

BENBRIDGE, Henry

Stewart, Robert G. *Henry Benbridge (1743-1812): American Portrait Painter.* Washington, D.C.: Smithsonian Institution Press, 1971.
Weekley, Carolyn J. "Henry Benbridge: Portraits in Small from Norfolk." *Journal of Early Southern Decorative Arts* 4 (1978): 52-55.

BENTON, Thomas Hart

Benton, Thomas Hart. *An Artist in America.* New York: Robert M. McBridge & Co., 1937.
———. *The Arts of Life in America.* New York: Whitney Museum of American Art, 1932.
———. "Form and the Subject." *The Arts* 6 (June 1924): 303-08.
Cate, Philip Dennis. *Thomas Hart Benton: A Retrospective of his Early Years, 1907-1929.* New Brunswick, N.J.: Rutgers University Art Gallery, 1972.
Johnson Alvin. *Notes on the New School Murals.* New York: New School for Social Research, 1931.
Lieban, H. "Thomas Benton, American Mural Painter." *Design* 36 (December 1934): 31-35.

BINFORD, Julien

Binford, Elizabeth. "Julien Binford." *American Artist* 17 (April 1953): 24-29, 70.
Frost, Rosamund. "Julien Binford: Return of the Native." *Art News* 41 (November 15, 1942): 24.

BIRELINE, George

Brown, Charlotte. *George Bireline: A Retrospective.* Raleigh: North Carolina Museum of Art, 1976.

BRIDGES, Charles

Hood, Graham. *Charles Bridges and William Dering: Two Virginia Painters, 1735-1750.* Williamsburg: The Colonial Williamsburg Foundation, 1978.

BROOK, Alexander

Kelly, A.W. *A Retrospective Exhibition of Paintings by Alex Brook 1898-1980.* New York: Salauder-O'Reilly Art Gallery, 1980.
King, Alma S. *Alexander Brook (1898-1980): Looking Back.* Santa Fe, New Mexico: Santa Fe East, 1981.

CAMERON, James

Bishop, Budd H. "Three Tennessee Painters: Samuel M. Shaver, Washington B. Cooper, and James Cameron." *The Magazine Antiques* 100 (September 1971): 432-37.

CATESBY, Mark

Catesby, Mark. *The Natural History of Carolina, Florida, and the Bahama Islands.* 2 vols. London: C. Marsh, T. Wilcox, and B. Stichall, 1754.
Frick, Frederick, and Stearns, Raymond Phineas. *Mark Catesby: The Colonial Audubon.* Urbanna: University of Illinois Press, 1961.

CATLIN, George

Truettner, William H. *The Natural Man Observed: A Study of Catlin's Indian Gallery.* Washington, D.C.: Smithsonian Institution Press, 1978.

CHAPMAN, Conrad Wise

Catterall, Louise F., ed. *Conrad Wise Chapman, 1842-1920.* Richmond, Virginia: The Valentine Museum, 1962.

CLAGUE, Richard

Toledano, Roulhac. *Richard Clague 1821-1873.* New Orleans: New Orleans Museum of Art, 1974.

CLOAR, Carroll

MacBeth, Russell. *Carroll Cloar.* Nashville: Tennessee Fine Arts Center, 1969.
Northrup, Guy. *Hostile Butterflies and Other Paintings by Carroll Cloar.* Memphis: Memphis State University Press, 1977.
Southwestern University. *Catalog of Paintings by Carroll Cloar.* Monograph 6. Memphis: Burrow Library, 1963.

CRAWFORD, Ralston

Freeman, Richard B. *Ralston Crawford.* University, Alabama: University of Alabama Press, 1953.
Sweeney, James Johnson. *Ralston Crawford.* Baton Rouge: Louisiana State University Press, 1950.

CRUISE, Boyd

Christovich, Mary Louise. *Boyd Cruise.* New Orleans: Historic New Orleans Collection, 1976.

DAINGERFIELD, Elliott

Daingerfield, Elliott. "Ralph Albert Blakelock." *Art in America* 2 (December 1914): 55-68.
Hobbs, Robert. *Elliott Daingerfield Retrospective Exhibition.* Charlotte: Mint Museum, 1971.

DeBRY, Theodore

Cruger, George. "Renaissance Collaboration." *Arts in Virginia* 13 (Spring 1973).
Giuseppi, M. S. "The Work of Theodore DeBry and His Sons, Engravers." Huguenot Society *Proceedings.* London: Huguenot Society: 1916.

DERING, William

Hood, Graham. *Charles Bridges and William Dering.* Williamsburg: Colonial Williamsburg Foundation, 1978.
Pleasants, Jacob Hall. "William Dering, A Mid-Eighteenth-Century Portrait Painter." *Virginia Magazine of History and Biography* 60 (January 1952): 56-63.
Weekley, Carolyn J. "Further Notes on William Dering, Colonial Virginia Portrait Painter." *Journal of Early Southern Decorative Arts* 1 (May 1975): 2-28.

DODD, Lamar

Collier, Graham. "Lamar Dodd: Serene and Clear." *American Artist* 44 (June 1980): 56-59 ff.
Dodd, Lamar. "A Juryman Speaks." *College Art Journal* 1 (Spring 1951): 223-32.
High Museum of Art. *Lamar Dodd: A Retrospective Exhibition.* Athens: The University of Georgia Press, 1970.

DOUGLAS, Aaron

Driskell, David C.; Ridley, Gregory D.; and Graham, D. L. *Retrospective Exhibition: Paintings by Aaron Douglas.* Nashville: Carl Van Vechten Art Gallery, Fisk University, 1971.

DRINKER, John

Adams, E. Bryding. "John Drinker, Portrait Painter and Limner." *Journal of Early Southern Decorative Arts* 7 (November 1981): 15-29.

DURAND, John

Archer, Dr. Robert. *Archer and Silvester Families: A History Written in 1870.* Privately published for Andrew D. Christian, 1937.

EARL, Ralph E. W.

MacBeth, Russell. "Portraits by Ralph E. W. Earl." *The Magazine Antiques* 100 (September 1971): 390-93.

Spencer, Harold. *The American Earls: Ralph Earl, James Earl, R.E.W. Earl.* Storrs, Connecticut: The William Benton Museum of Art, 1972.

ELDER, John Adams

Virginia Museum. *A Retrospective Exhibition of the Work of John Adams Elder, 1833-1895.* Richmond, Virginia, 1947.

FAULKNER, Frank

Chicago Arts Club. *Frank Faulkner: Paintings.* Chicago, 1981.

FITZGERALD, Zelda Sayre

Milford, Nancy. *Zelda: A Biography.* New York: Harper & Row, 1970.

Patillo, Edward. *Zelda Sayre Fitzgerald Retrospective.* Montgomery, Alabama: Montgomery Museum of Fine Arts, 1974.

Tillotson, Jery and Robbie. "Zelda Fitzgerald Still Lives." *Feminist Art Journal* 4 (Spring 1974): 31-33.

FITZPATRICK, John Kelly

Montgomery Museum of Fine Arts. *John Kelly Fitzpatrick: Retrospective Exhibition.* Montgomery, Alabama, 1970.

FRASER, Charles

Carolina Art Association. *Charles Fraser, 1782-1860: A Short Sketch of Charles Fraser and List of Miniatures Exhibited.* Charleston, South Carolina: Gibbes Art Gallery, January 1934.

Smith, Alice R. Huger and Smith, D. E. Huger. *Charles Fraser.* 1924. Reprint. Charleston, South Carolina: Garnier and Company, 1967.

Tolman, Ruel Pardee. "The Technique of Charles Fraser, Miniaturist." *The Magazine Antiques* 26 (January and February 1935): 19-22 and 60-62.

FRYMIRE, Jacob

Simmons, Linda Crocker. *Jacob Frymire, American Limner.* Washington, D.C.: Corcoran Gallery of Art, 1975.

GAUL, Gilbert

Davis, Louise. "Turnips and Triumphs in Tennessee: A Portrait of the Artist Gilbert Gaul." *Tennessean Magazine,* August 18-September 1, 1974.

Reeves, James F. *Gilbert Gaul.* Nashville: Tennessee Fine Arts Center, 1975.

GOLDTHWAITE, Anne

Breeskin, Adelyn D. *Anne Goldthwaite, 1869-1944.* Montgomery, Alabama: Montgomery Museum of Fine Arts, 1977.

GORDY, Robert

Falagy, William. "Robert Gordy" in "On location: 4 Interviews, 6 Artists." *Art in America* 84 (July-August 1976): 78-79.

New Orleans Museum of Art. *Robert Gordy, Paintings & Drawings: 1960-1980.* New Orleans, 1981.

GORKY, Arshile

Rand, Harry. *Arshile Gorky, The Implication of Symbols.* Montclair, New Jersey: Allan Held and Schram, 1981.

GUY, Francis

Colwill, Stiles Tuttle. *Francis Guy, 1760-1812.* Baltimore, Maryland: The Maryland Historical Society, 1981.

GWATHMEY, Robert

Ingersoll, Jonathan. *Robert Gwathmey.* St. Mary's City, Maryland: St. Mary's College of Maryland, 1976.

McCausland, Elizabeth. "Robert Gwathmey." *Magazine of Art* 39 (April 1946): 149-52.

Robeson, Paul. *Robert Gwathmey.* New York: ACA Gallery, 1946.

HALSEY, William

Morris, Jack A., Jr. *William M. Halsey: Retrospective.* Greenville, South Carolina: Greenville County Museum of Art, 1972.

HARDING, Chester

Harding, Chester. *My Egotistiography.* Cambridge, Massachusetts, 1866.

HEADE, Martin Johnson

Cummer Gallery. *Martin Johnson Heade.* Jacksonville, Florida: De Ette Holden Cummer Museum Foundation, 1981.

Mackle, Elliott James, Jr. "The Eden of the South: Florida's Image in American Travel Literature and Painting, 1865-1900." Ph.D. dissertation, Emory University, Atlanta, Georgia, 1977.

Stebbins, Theodore E., Jr. *The Life and Works of Martin Johnson Heade.* New Haven: Yale University Press, 1975.

Wilmerding, John et al. *American Light, The Luminist Movement 1850-1875.* Washington, D.C.: National Gallery of Art, 1980.

HEALY, George Peter Alexander

Kennedy Galleries, Inc. *George P. A. Healy, Reminiscences of a Portrait Painter.* 1894 Reprint. New York: Kennedy Galleries, Inc., 1970.

Virginia Museum of Fine Arts. *Healy's Sitters, 1837-1899,* Richmond: Virginia Museum, 1950.

HEALY, Thomas Cantwell

Reynolds, Elizabeth R. *To Live Upon Canvas, The Portrait Art of Thomas Cantwell Healy.* Jackson, Mississippi: Mississippi Museum of Art, 1980.

HENRY, Edward Lamson

McCausland, Elizabeth. *The Life and Work of Edward Lamson Henry.* Albany, New York: 1945.

Corcoran Gallery of Art. *A Catalogue of the Collection of American Paintings in the Corcoran Gallery of Art,* vol. 1: *Painters born before 1850.* Washington, D.C.: Corcoran Gallery of Art, 1966.

HESSELIUS, Gustavus

Fleischer, Roland E., "Gustavus Hesselius: A Study of His Style." In *Winterthur Conference Report: American Painting to 1776, A Reappraisal,* edited by Ian M. G. Quimby, Charlottesville: University Press of Virginia (1971): 127-58.

Richardson, E. P. "Gustavus Hesselius." *The Art Quarterly* 12 (1949): 220-26.

HESSELIUS, John

Doub, Richard K. "John Hesselius, Maryland Limner." *Winterthur Portfolio* 5. Charlottesville: University Press of Virginia, 1969.

HOMER, Winslow

Adams, Karen M. "Black Images in Nineteenth-Century American Painting and Literature: An Iconological Study of Mount, Melville, Homer, and Mark Twain." Ph.D. dissertation, Emory University, 1977.

Bowdoin College Museum of Art. *The Portrayal of the Negro in American Painting.* Bowdoin, Maine: Bowdoin College, 1964.

Calo, Mary Ann. "Winslow Homer's Visits to Virginia During Reconstruction." *American Art Journal* 2 (Winter 1980): 4-27.

Cummer Gallery. *Winslow Homer's Florida.* Jacksonville, Florida: De Ette Holden Cummer Museum Foundation, 1977.

Hannaway, Patti. *Winslow Homer in the Tropics.* Richmond, Virginia: Westover Publishing Co., 1973.

Hendricks, Gordon. *The Life and Work of Winslow Homer.* New York: Abrams, 1979.

Parry, Elwood. *The Image of the Indian and the Black Man in American Art 1590-1900.* New York: Braziller, 1974.

Quick, Michael. "Homer in Virginia." *Los Angeles County Museum of Art Bulletin* 24 (1978): 60-81.

HOPPER, Edward

Levin, Gail. *Edward Hopper: The Art and the Artist.* New York: W. W. Norton & Co. for the Whitney Museum of American Art, 1980.

HOWELL, Claude

Tucker, Virginia A. *Claude Howell: A Retrospective Exhibition of His Paintings.* Raleigh: North Carolina Museum of Art, 1975.

HULL, Marie

Norwood, Malcolm M.; Elias Virginia McGehee; and Hayne, William S. *The Art of Marie Hull.* Jackson: University of Mississippi Press, 1975.

HUNT, William Morris

Knowlton, Helen M. *Art-Life of William Morris Hunt.* 1899. Reprint. New York: Benjamin Blom, 1971.

Landgren, Marchal E. and McGurn, Sharman Wallace. *The Late Landscapes of William Morris Hunt.* College Park, Maryland: University of Maryland Art Gallery, and Albany, New York: Albany Institute of History and Art, 1976.

INNESS, George

Cummer Gallery. *George Inness in Florida 1890-1894 and the South 1884-1894.* Jacksonville, Florida: De Ette Holden Cummer Museum Foundation, 1980.

Daingerfield, Elliott. "George Inness." *Century* 95 (November 1917): 71.

JACQUELIN-BRODNAX LIMNER

Black, Mary. "The Case of the Red and Green Birds." *Arts in Virginia* 3 (Winter 1963): 2-9.

———. "The Case Reviewed." *Arts in Virginia* 10 (Fall 1969): 12-18.

JARVIS, John Wesley

Dickson, Harold E. *John Wesley Jarvis, American Painter, 1780-1840, with a Checklist of His Works.* New York: New-York Historical Society, 1949.

JOHNSON, William H.

National Collection of Fine Arts. *William H. Johnson, 1901-1970.* Washington, D.C. 1971.

JOHNSTON, Henrietta

Middleton, Margaret Simons. *Henrietta Johnston of Charles Town, South Carolina: America's First Pastellist.* Columbia, South Carolina: University of South Carolina Press, 1966.

JOHNSTON, Joshua

Pleasants, Jacob Hall. "Joshua Johnston, the First American Negro Portrait Painter." *Maryland Historical Society* 37 (June 1942): 1-39. Reprinted 1970.

JOUETT, Matthew Harris

Floyd, William Barrow. *Jouett, Bush, Frazer: Early Kentucky Artists.* Lexington, Kentucky, 1968.

———. *Matthew Harris Jouett, Portraitist of the Ante-Bellum South.* Lexington, Kentucky: Transylvania University, 1980.

Price, Samuel W. *The Old Masters of the Blue Grass: Jouett, Bush, Grimes, Frazer, Morgan, Hart.* Filson Club Publication no. 17. Louisville: John P. Morton and Company, 1902.

KING, Charles Bird

Cosentino, Andrew J. *The Paintings of Charles Bird King (1785-1862).* Washington, D.C.: The National Collection of Fine Arts, Smithsonian Institution Press, 1977.

Ewers, John C. "Charles Bird King, Painter of Indian Visitors to the Nation's Capital." *Smithsonian Report for 1953* (1954): 463-82.

Viola, Herman J. *The Indian Legacy of Charles Bird King.* Washington, D.C.: Smithsonian Institution Press, 1976.

KÜHN, Justus Englehardt

Pleasants, Jacob Hall. "Justus Englehardt Kühn: An Early-Eighteenth-Century Maryland Portrait Painter." *Proceedings of the American Antiquarian Society* 46 (October 1936): 243-80.

LATROBE, Benjamin Henry

Carter, Edward C. II, et. al., eds. *The Virginia Journals of Benjamin Henry Latrobe 1795-1798.* 2 vols. New Haven: Yale University Press, 1977.

Hamlin, Talbot Faulkner. *Benjamin Henry Latrobe.* New York: Oxford University Press, 1955.

———. "Benjamin Henry Latrobe: The Man and the Architect." *Maryland Historical Magazine.* 37 (December 1942): 339-60.

LE MOYNE DE MORGUES, Jacques

Lorant, Stefan, ed. *The New World: The First Pictures of America.* New York: Duell, Sloane and Pearce, 1946.

MALBONE, Edward Greene

Halsey, R. T. H. "Malbone and His Miniatures." *Scribners Magazine* 47 (May 1910): 558-65.

Tolman, Ruel Pardee. *The Life and Works of Edward Greene Malbone 1777-1807.* New York: The New-York Historical Society, 1958.

MARLING, Jacob

Williams, Ben F. *Jacob Marling, Retrospective Exhibition.* Raleigh: North Carolina Museum of Art, 1964.

McCRADY, John

Marshall, Keith C. *John McCrady, 1911-1968.* New Orleans: New Orleans Museum of Art, 1975.

MEEKER, Joseph Rusling

Brown, C. Reynolds. *Joseph Rusling Meeker, Images of the Mississippi Delta.* Montgomery, Alabama: Montgomery Museum of Fine Arts, 1981.

MELCHERS, Gari

Donaldson, Bruce M. *Gari Melchers: A Memorial Exhibition of His Work.* Richmond: Virginia Museum, 1938.

Orseman, Janice C. *Gari Melchers 1860-1932: American Painter.* New York: Graham Gallery, 1978.

351

Reid, Richard S. "Gari Melchers: An American Artist in Virginia." *Virginia Cavalcade* 28 (Spring 1979): 154-71.

MORSE, Samuel Finley Breese

Lipton, Leah. "William Dunlap, Samuel F. B. Morse, John Wesley Jarvis, and Chester Harding: Their Careers as Itinerant Portrait Painters." *The American Art Journal* 13: 34-50.

Morse, Samuel F. B. *Samuel F. B. Morse, His Letters and Journals.* Edited by Edward Lind Morse. 2 volumes. Boston: Houghton Mifflin Company, 1914.

Staiti, Paul J. and Reynolds, Gary A. *Samuel F. B. Morse.* New York: Grey Art Gallery and Study Center, New York University, 1982.

Wehle, H. B. *Samuel F. B. Morse, American Painter, A Study Occasioned by an Exhibition.* New York: The Metropolitan Museum of Art, 1932.

OERTEL, Johannes Adam Simon

Downes, William Howe. "Oertel, Johannes Adam Simon." *Dictionary of American Biography* 13. pp. 630-31.

Oertel, J. F. *A Vision Realized: A Life Story of Rev. J. A. Oertel.* Privately printed, 1917.

ONDERDONK FAMILY

Steinfeldt, Celia. *The Onderdonks: A Family of Texas Painters.* San Antonio: Trinity University Press, 1976.

PARRISH, Clara Weaver

Brown, C. Reynolds. *Clara Weaver Parrish.* Montgomery, Alabama: Montgomery Museum of Fine Arts, 1980.

PARRISH, David

Montgomery Museum of Fine Arts. *David Parrish.* Montgomery, Alabama, 1980.

PEALE FAMILY

Born, Wolfgang. "The Female Peales: Their Art and Its Tradition." *American Collector* 15 (August 1946): 12-14.

Colwill, Stiles Tuttle; Holland, E. C.; Sommerville, R. S.; and Young, K. B. W. *Four Generations of Commissions: The Peale Collection of the Maryland Historical Society.* Baltimore, Maryland: Maryland Historical Society, 1975.

PEALE, Charles Willson

Sellers, Charles Coleman. *The Artist of the Revolution, The Early Life of Charles Willson Peale.* Hebron, Connecticut: Feather and Good, 1939.

————. "Monumentality with Love: Charles Willson Peale's Portrait of William Smith and his Grandson." *Arts in Virginia* 16 (Winter/Spring 1976): 14-21.

————. *Charles Willson Peale and the First Popular Museum of Natural Sciences and Art.* New York: W. W. Norton, 1980.

PEALE, James

Brockway, Jean. "The Miniatures of James Peale." The *Magazine Antiques* 22 (October 1932): 130-34.

PITTMAN, Hobson

Hull, William. *The World of Hobson Pittman.* University Park: Pennsylvania State University Museum of Art, 1972.

Turner, Evan. *Hobson Pittman.* New York: Babcock Galleries, 1970.

Williams, Ben F. *Hobson Pittman, Retrospective Exhibition: His Work Since 1920.* Raleigh: North Carolina Museum of Art, 1963.

POLK, Charles Peale

Batson, Whaley. "Charles Peale Polk, Gold Profiles on Glass." *Journal of Early Southern Decorative Arts* 3 (November 1977): 51-57.

Johnston, William R. "Charles Peale Polk: A Baltimore Portraitist." *Annual 3*, pp. 33-37. Baltimore, Maryland: The Baltimore Museum of Art, 1968.

Simmons, Linda Crocker. *Charles Peale Polk, 1767-1822: A Limner and His Likenesses.* Washington, D.C.: Corcoran Gallery of Art, 1981.

ROBERTS, Mary

Horton, Frank L. "America's Earliest Woman Miniaturist." *Journal of Early Southern Decorative Arts* 5 (November 1979): 1-5.

DE SAINT-MÉMIN, Charles Balthazar Julien Fevret

Norfleet, Fillmore. *Saint-Mémin in Virginia: Portraits and Biographies.* Richmond, Virginia: The Dietz Press, 1942.

SHANNON, Charles

Gingold, Diane. *Charles Shannon: Paintings and Drawings.* Montgomery: Art South Inc., 1981.

SMITH, Alice Ravenel Huger

Charleston. South Carolina Historical Society. Papers of Alice Ravenel Huger Smith, 1901-1962.

Severens, Martha. "Reveries: The Work of Alice Ravenel Huger Smith." *Art Voices South* 1 (January-February 1978): 74-6.

Smith, Alice R. Huger. *A Charleston Sketchbook 1796-1806, Forty Watercolor Drawings of the City and the Surrounding Country, Including Plantations and Parish Churches.* Charleston, South Carolina: Carolina Art Association, 1940.

SOLOMON, Syd

Museum of Fine Arts, St. Petersburg. *Syd Solomon: The Seventies.* St. Petersburg, Florida: Museum of Fine Arts, 1979.

John and Mable Ringling Museum of Art. *Syd Solomon.* Sarasota, 1974.

SPEIGHT, Francis

Hull, William. *Manayunk and Other Places: Paintings and Drawings by Francis Speight.* University Park, Pennsylvania: Pennsylvania State University Press, 1974.

Turner, Evan. *Francis Speight.* Philadelphia: Pennsylvania Academy of Fine Arts, Peale House Galleries, 1979.

Williams, Ben F. *Francis Speight: A Retrospective Exhibition.* Raleigh: North Carolina, 1961.

SPRUCE, Everett

Danes, Gibson. "Everett Spruce, Painter of the Southwest." *The Magazine of Art* 37 (January 1944): 12-15.

Leeper, John Palmer. *Everett Spruce.* New York: American Federation of Arts, 1959.

STEVENS, Will Henry

Neumann, James E. *An Exhibition of Late Works by Will Henry Stevens.* Greenville, North Carolina: Greenville County Museum of Art, 1967.

STOCKFLETH, Julius

McGuire, James Patrick. *Julius Stockfleth, Gulf Coast Marine and Landscape Painter.* San Antonio: Trinity University Press, 1976.

SULLY, Thomas

Biddle, Edward, and Fielding, Mantle. *The Life and Works of Thomas Sully (1783-1872).* Philadelphia: Wickersham Press, 1921.

Hart, Charles Henry. *A Register of Portraits Painted by Thomas Sully, 1801-1871.* Philadelphia, 1909.

Rossheim, Beth N. "Thomas Sully (1783-1872), Beginning Portraits in Norfolk." Master's thesis, Old Dominion University, 1981.

THEÜS, Jeremiah

Middleton, Margaret Simons. *Jeremiah Theüs: Colonial Artist of Charles Town.* Columbia: University of South Carolina Press, 1953.

THOMAS, Howard

High Museum of Art. *Howard Thomas/A Retrospective Exhibition.* Atlanta, 1967.
University of Iowa Museum of Art. *Howard Thomas: The Later Paintings, 1958-1971.* Iowa City: University of Iowa Museum of Art, 1972.

TILYARD, Philip

Hunter, Wilbur Harvey. "The Paintings of Philip Tilyard." *The Peale Museum History Series* 4. Baltimore: The Peale Museum, 1949.

TROTT, Benjamin

Bolton, Theodore. "Benjamin Trott." *Art Quarterly* 7 (Autumn 1944): 257-90.
————, and Tolman, Ruel Pardee. "A Catalog of Miniatures by or attributed to Benjamin Trott." *Art Quarterly* 7 (1944): 278-90.

TROYE, Edward

MacKay-Smith, Alexander. *The Race Horses of America 1832-1872: Portraits and Other Paintings by Edward Troye.* Saratoga Springs, New York: National Museum of Racing, 1981.

TRUMBULL, John

Jaffe, Irma B. *John Trumbull, Patriot-Artist of the American Revolution.* Boston: New York Graphic Society, 1975.

VAUDECHAMP, Jean Jacques

Farwell, Lynne W. *Jean Jacques Vaudechamp. An Exhibition at the Louisiana State Museum November 13, 1967-January 7, 1968.* New Orleans: Louisiana State University Press, 1967.

VON RECK, Philip Georg Friedrich

Heidt, Kristian, ed. *Von Reck's Voyage: Drawings and Journal of Philip Georg Friedrich Von Reck.* Savannah: The Beehive Press, 1980.

WALKER, William Aiken

Trovaiolo, August P., and Toledano, Roulhac B. *William Aiken Walker: Southern Genre Painter.* Baton Rouge: Louisiana State University Press, 1972.

WASHINGTON, William D.

Salmon, Emily J. "The Burial of Latane: Symbol of the Lost Cause." *Virginia Cavalcade* 28 (Winter 1979): 118-29.

WOLLASTON, John

Bolton, Theodore, and Binsse, Harry L. "Wollaston, An Early American Portrait Manufacturer." *The Antiquarian* 28 (June 1931): 30.
Weekley, Carolyn J. "John Wollaston, Portrait Painter: His Career in Virginia, 1754-1758." Master's thesis, University of Delaware, 1976.

WOODWARD, Ellsworth

Barkemeyer, Estelle. "Ellsworth Woodward: His Life and Work." Master's thesis, Tulane University, 1942.
Woodward, Ellsworth. "Advice to the South." *Art Digest* 10 (December 1, 1935): 9.

WOODWARD, William

Heidelberg, Michelle Favrot. "William Woodward." Master's thesis, Tulane University, 1974.

For biographical information about notable English and Continental artists who worked in the American South during the colonial period, or who executed commissioned works for American patrons, see:

Bénézit, Emmanuel, ed. *Dictionnaire Critique et Documentaire des Peintres, Sculpteurs, Dessinateurs et Graveurs. . . .* Paris, 1911-1923.

Index

Works are indexed both by title and under the artist's name. Italicized numerals indicate pages where works are illustrated.

Abstraction (Will Henry Stevens; cat. no. 136), 134, 300, *300.*
Abstract painting. *See* Modernism.
Académie Julian, 107, 112, 119, 272, 274, 279, 287.
Admiranda Narratio Fida Tamen (Theodor De Bry; cat. no. 4.), 7, 170; plates from, *6, 7.*
Advertisements by artists, 10, 19, 22, 23, 50, 53, 54, 59, 64, 65, 67, 74, 78, 181, 185, 206, 221.
Afterglow, Florida (Martin Johnson Heade; fig. 42, cat. no. 104), 98, *98,* 265-66, *266.*
Agrarian movement, xiii, 118-19, 120, *See* Fugitives.
Air Brakes (Blue Sky; cat. no. 160), 328, *329.*
Alabama, art and artists in, 76, 93, 109-10, 111-12, 119, 120, 126, 244, 273, 289, 292; Birmingham, 279, 288, 292; Huntsville, 228, 342; Mobile, 111-12, 277, 285; Montgomery, 111, 119, 127, 240, 273, 287, 288, 291, 294, 302; New South Gallery, Montgomery, 127; Poka-Hutchi Art Colony, 119.
Alabama Cotton Pickers (Howard Cook; cat. no. 125), 120, 289, *289.*
Albers, Josef, xiv, 135, 151, 153, 316, 317, 322; *Homage to the Square,* 316; *Untitled (Adobe)* (fig. 52, cat. no. 149), 135, *135,* 151, 316, *316.*
Albrizio, Conrad A., 118, 119, 285; *Allegory of Louisiana* (cat. no. 119), 118, 285, *285; Industrial Louisiana* (cat. no. 122), 118, 285, 286; *Old Plantation Life in Louisiana* (cat. no. 120), 118, 285, 286; *Trucking Cotton and Cutting Sugar Cane* (cat. no. 121), 118, 285, 286.
Album of Virginia (Edward Beyer), 80.
Aldworth, Boyle, 10.
Allegory of Louisiana (Conrad A. Albrizio; cat. no. 119), 118, 285, *285.*
Allen, Hervey, 112, 293.
Allston, Washington, 34, 44, 51, 65, 186, 201.
Amadas, Philip, 7.
Amans, Jacques G.L. 75, 233; *Portrait of a Gentleman* (cat. no. 69), 75, 233, *233.*
Amelia Lauck (Jacob Frymire), 55.
Anderson, Walter Inglis, xvi, 132-34, 136, 306; *Horn Island* (fig. 51, cat. no. 142), 132, *133,* 306, *306.*
Andrew Jackson (Anna Claypoole Peale; cat. no. 46), 51, 207, *207.*
Andrews, Benny, 158-59, 325; *Symbols* (cat. no. 156), 158-59, *324-25,* 325.
Anisfeld, Boris, 128, 301.
Antrobus, John, 82-85, 240; *A Plantation Burial* (cat. no. 76), 83, 240, *240.*

Arabia Felix (Frank Faulkner; cat. no. 170), 154, 339, *339.*
Arcadian Still Life with Females (Wrinkled Version) (Robert P. Gordy; cat. no. 157), 160, 326, *326.*
Arkansas, art and artists in, 123, 131, 296, 308.
Arkansas Landscape (Everett Spruce; cat. no. 132), 123, 296, *296.*
Arrival of the Mail, The (John Blake White; cat. no. 58), 56, 220, *220.*
Art education. *See* Education.
Artists Association of New Orleans, 106.
Arts of the South, The (Thomas Hart Benton; fig. 47), 117, *117.*
Art Students' League, 96, 105-07, 109, 110, 118, 120, 121, 130, 134, 273, 276, 282, 285, 289, 290, 291, 292, 295, 297, 298, 300, 308, 328.
Ashville (Willem de Kooning, fig. 60), 156, *157.*
Association of Georgia Artists, 121.
Atmospheric Perspective (129 Grays) (Vernon Pratt; cat. no. 164), 156, 333, *333.*
Audubon, John James, xvi, 14, 57, 66, 74, 211; *Carolina Parrot* (cat. no. 50), 211, *211.*

Bacchanalian Revel (Gustavus Hesselius; fig. 9, cat. no. 13), 10, *11,* 176, *176.*
Bacchus and Ariadne (Gustavus Hesselius), 176.
Back Street, Charleston (William Melton Halsey; cat. no. 147), 154, 314, *314.*
Bacon, Peggy, 297.
Baker, Elizabeth C., 148.
Baltimore, Maryland, growth of, 43. *See* Maryland.
Banvard, John, 79-80.
Baptism of Pocahontas (John Gadsby Chapman), 81.
Barbizon School, 267.
Barlowe, Arthur, 7.
Baroque style in painting, 10, 19, 23, 25, 43, 54, 182.
Bartram, John, 34.
Bartram, William, 34; *Turtle* (fig. 23), *36.*
Battery, Charleston, S.C., The (Edward Hopper; cat. no. 118), 118, 158, 284, *284.*
Battery Marshall, Sullivan's Island, Dec. 4, 1863 (Conrad Wise Chapman; cat. no. 82), 87, 246, *247.*
Battle of the Crater (John Adams Elder), 88, 256.
Bauhaus, 151, 316.
*Bay Maria and Foal, Cornelia Edward Troye; cat. no. 63), 227-28, *228.*
Bayou Farm (Marshall Smith; cat. no. 98), 93, 260, *260.*
Bayou Scene (Joseph Rusling Meeker; cat. no. 95), 94, 258, *258.*

Beach Cottage (Claude Howell; fig. 54), *138, 139.*
Bearden, Romare, 130-31, 309; *Passion of Christ,* 309; *The Prevalence of Ritual: Tidings* (cat. no. 145), 131, 309, *309.*
Beastall, William, 10.
Beck, George, 57, 59, 66, 195; *View of Baltimore from Howard's Park* (fig. 31, cat. no. 32), *58,* 59, 195, *195.*
Beck, Mary Renessier, 66, 195.
Belanger, F. J., 65.
Bellows, George, 284, 323.
Belzons, Jean, 44, 46, 66.
Benbridge, Henry, 33, 34, 36, 37, 46, 186; *Mr. and Mrs. Boswell Lamb and their Daughter, Martha Anne* (cat. no. 27), 34, 186, *187; Rachel Moore* (fig. 22, cat. no. 25), 34, *35,* 186, *186; Richard Moncrief* (cat. no. 26), 34, 186, *187.*
Benjamin Henry Latrobe (Rembrandt Peale; cat. no. 43), 61, *204,* 205.
Benton, Thomas Hart, 116-18, 120, 127, 140, 288; *Cotton Pickers, Georgia* (fig. 46), 116-18, *116; The Arts of the South* (fig. 47), 117, *117.*
Beyer, Edward, 80; *Album of Virginia,* 80.
Bigot, Toussaint François, 78.
Binford, Julien, 128, 301; *The Crapshooter* (fig. 50, cat. no. 137), 128, *129,* 301, *301.*
Bireline, George Lee, 147, 151-52, 155-56, 161, 321; *Malcolm's Last Address* (cat. no. 153), 147, 151, 321-22, *321; Crushed Cups, Coat Hanger, and Tape* (cat. no. 154), 147, 155, 321-22, *322.*
Birmingham Steel Mill (Richard Blauvelt Coe; cat. no. 124), 119, 288, 288.
Black Mountain College, N.C., xiv, xvi, 134-36, 137-39, 151, 153, 316, 317.
Black Americans: Afro-American origins, 91, 123-24, 126, 127, 130; as artists, 54, 79, 124, 126, 127, 130, 136, 154, 158-60, 206, 232, 298-99, 325; depictions of, xvi, 3, 9-10, 27, 63, 75, 81-83, 86, 88-93, 99, 117-18, 119-20, 121, 123, 124, 126, 128, 129, 158-60, 173, 228, 232, 240, 241, 242, 252, 253-54, 256, 289, 290, 294, 298-99, 301, 309; in civil rights movement, 130; in colonial period, 3, 9, 10, 27; *homme/femme de couleur libre,* 75; migration from South, 111.
Black Squirrel (Mark Catesby; fig. 10, cat. no. 14), *15,* 177, *177.*
Blair, James (portrait of by Charles Bridges), 18.
Blue Isolate (Sam Gilliam; cat. no. 167), 154, 336, *336.*
Blue Sky [Warren Johnson], 159, 160, 328; *Air Brakes* (cat. no. 160), 159, 328, *329.*
Blumenschein, Ernest, 123.

Boisseau, Alfred, 82, 234; *Louisiana Indians Walking Along a Bayou* (fig. 36, cat. no. 70), 82, 83, 234, *234*.

Bolling, Robert (portrait of, by unidentified artist), 8.

Bolotowsky, Ilya, 317.

Bonanni, Pietro, 44, 208; *Portrait of Mary Sumner Blount* (cat. no. 47), 44, 208, *208*.

Books illustrated, 7, 13, 14, 57, 169, 170, 177, 211.

Boqueta de Woiseri, John L., 60; *First Cities of the United States*, 60; *A View of New Orleans Taken from the Plantation of Marigny*, 60.

Boudon, David, 64, 66.

Bowles, William 57, 202; painting of by unidentified artist, *William Bowles and the Creek Indians* (fig. 24, cat. no. 40), *42*, 57, 202, *202*.

Boyd, Caleb, *61*.

Boyd, Clarence, 94, 261; *Futurity* (cat. no. 99), 94, 261, *261*.

Brammer, Robert, 78, 230; *Oakland House and Race Course, Louisville, Kentucky* (with Augustus Von Smith) (cat. no. 65), 78, 230, *230*.

Breckenridge, Hugh, 121, 295.

Bridgeman, Charles, 120.

Bridges, Charles, 17, 18, 178; *John Bolling, Jr.* (cat. no. 17), 18, 178, *179*; portrait of Alexander Spotswood, 18; portrait of James Blair, 18.

Brief and True Report of the New Found Land in Virginia, A (Theodor De Bry; cat. no. 2), 7, 170.

Britanus-Americanus (Mark Catesby), 14.

Brook, Alexander, 127, 297-98; *Georgia Jungle* (cat. no. 133), 127, 297-98, *297*; *Savannah Street Corner* (cat. no. 134), 297-98, *298*.

Brooke, Richard Norris, xvi, 91-93; *The Dog Swap* (fig. 40), 91-93, *92*; *The Pastoral Visit*, 91-93.

Brown, Henry James, 46.

Brown, William Garl, 76.

Browne, George Elmer, 119, 288, 295.

Bruce, Patrick Henry, 136, 284.

Buck, William, 94.

Build Thee More Stately Mansions (Aaron Douglas), 126.

Bunch of Black Grapes, A (Andrew John Henry Way; cat. no. 97), 94, 259, *259*.

Burial of Latane, The (William D. Washington; cat. no. 86), 87, 249, *249*.

Burke, Edmund, xvi.

Bush, Joseph Henry, 44, 46, 66.

Bywaters, Jerry, 123, 296.

Cage, John, 135.

Caldwell, Erskine, 334.

Cameron, James A., 80, 239; *Colonel and Mrs. James A. Whiteside, Son Charles, and Servants* (fig. 35, cat. no. 75), 80, *81*, 239, *239*.

Camp Near Corinth, Mississippi (Conrad Wise Chapman; cat. no. 81), 86, 246, *246*.

Cantor, Joshua, 59.

Capitol at Washington, D.C., The (Benjamin Henry Latrobe; cat. no. 34), 60, 197, *197*.

Captain Willa Viley's Richard Singleton, with Viley's Harry, Charles, and Lew (Edward Troye; cat. no. 62), 227-28, *227*.

Captured Liberators (Winslow Homer), 86.

Carlin, Etienne-Constant, 75.

Carnival, The (Winslow Homer; cat. no. 91), 90, 253-54, *254*.

Carolina Art Association. See Charleston, S.C.

Carolina Morning (Edward Hopper; fig. 56), 145-47, *146*, 158.

Carolina Parrot (John James Audubon; cat. no. 50), 211, *211*.

Carolina Sunlight (Elliott Daingerfield; cat. no. 113), 99, 105, 278, *278*.

Carter, Robert (King), 25.

Catesby, Mark, xvi, 13, 14, 177; *Black Squirrel* (fig. 10, cat. no. 14), *15*, 177, *177*; *Britanus-Americanus*, 14; *Natural History of Carolina, Florida, and the Bahama Islands*, Volumes I and II (cat. no. 15), 13-14, 177.

Catlin, George, 77, 229; *Mick-e-no-pah* (cat. no. 64), 77, 229, *229*.

Cézanne, Paul, 116, 326.

Chain Gang (William H. Johnson; fig. 49, cat. no. 135), 124, *125*, 298-99, *299*.

Chambers, Willie M., 94-96, 268; *Still Life: Basket of Cherries* (fig. 41; cat. no. 106), 94-96, *95*, 268, *268*.

Champney, J. Wells, 96.

Chapman, Conrad Wise, xvi, 86-87, 246; *Battery Marshall, Sullivan's Island, Dec. 4, 1863* (cat. no. 82), 87, 246, *247*; *Camp Near Corinth, Mississippi* (cat. no. 81), 86, 246, *246*; *Fort Sumter Interior* (fig. 38, cat. no. 85), 86, 87, 246, *248*; *Quaker Battery* (cat. no. 83), 87, 246, *247*; *Submarine Torpedo Boat H. L. Hunley, Dec. 6, 1863* (cat. no. 84), 87, 246, 248.

Chapman, John Gadsby, 64, 81, 86, 219, 249; *Baptism of Pocahontas*, 79.

Charging the Battery (William Gilbert Gaul), 267.

Charles Calvert (John Hesselius; fig. 16), 27, *27*.

Charles Pinckney (Mary Roberts; cat. no. 19), 23, 181, *181*.

Charleston, South Carolina, art and artists in, 9, 12, 13, 18-23, 26-27, 33-34, 36, 43, 44, 48, 50, 51-53, 54, 55, 56, 59, 60, 61, 65-66, 76, 79, 86, 94, 97, 114, 118, 124, 173, 178, 181, 183, 185, 186, 194, 201, 203, 205, 213, 217, 220, 221, 223, 229, 237, 246, 252, 284, 293, 305, 314; as art center, 65-66; Carolina Art Association, 114; early settlement of, 19; Gibbes Art Gallery, 134; growth of, 43; Poetry Society of South Carolina, 114; South Carolina Academy of the Fine Arts, 61, 66, 220. *See also* South Carolina.

Charlot, Jean, 120, 136, 292.

Chase, William Merritt, 107, 109, 110, 134, 273, 283, 300.

Chattanooga, Tennessee, art and artists in. *See* Tennessee.

Chincoteague Ponies (Johannes Adam Simon Oertel; cat. no. 100), 98, 262, *262*.

Christ Rejected (William Dunlap), 56.

Church, Frederick, 80.

Circus (Zelda Sayre Fitzgerald; cat. no. 138), 111, 302, *302*.

Cityscapes, 22, 43, 59, 60, 82, 96, 97, 127, 147, 297-98.

Civil War: impact on art and artists, xv, 80, 86-88, 91-92, 93, 97, 99, 106, 158-59, 160, 239, 240, 244, 246, 249, 250, 253, 262; as subject of paintings, xvi, 76, 85-88, 97, 158-59, 246-48, 249, 250, 253, 267, 318-19.

Clague, Richard, 83, 94, 244, 260; *Spring Hill, Alabama* (cat. no. 80), 244, *245*; *Trappers Cabin* (cat. no. 79), 93, 244, *244*.

Clark, Kate Freeman, 110.

Clay, Henry, 46.

Cloar, Carroll, 131, 308; *Where the Southern Cross the Yellow Dog* (cat. no. 144), 131, 308, *308*.

Cluster #1 (Ida Kohlmeyer; cat. no. 159), 153, 328, *328*.

Coe, Richard Blauvelt, 119, 288; *Birmingham Steel Mill* (cat. no. 124), 119, 288, *288*.

Cogdell, John S., 65.

Cole, Thomas, 217.

Collas, Louis Antoine, 53, 74, 205; *Portrait of the Ralph Izard Children* (cat. no. 44), 53, 205, *205*.

Collinson, Peter, 14.

Colonel and Mrs. James A. Whiteside, Son Charles, and Servants (James A. Cameron; fig. 35, cat. no. 75), 80, *81*, 239, *239*.

Colonel Barnard Elliott (Jeremiah Theüs; fig. 12), 19, *21*.

Colt, Thomas, 126.

Conversation, The (Hobson Pittman; cat. no. 141), 131-32, 305, *305*.

Cook, Howard, 120, 289; *Alabama Cotton Pickers* (cat. no. 125), 118, 289, *289*.

Cooke, George, 60, 64, 78-79, 219; *Tallulah Falls* (cat. no. 57), 60, *218*, 219.

Cooper, Washington Bogart, 67.

Copley, John Singleton, 28, 36, 188; *Henry Laurens* (cat. no. 29), 36, 188, *189*.

Coram, Thomas, 59.

Corbino, Jan, 304.

Corcoran Gallery of Art, Washington, D.C., 91, 92, 93, 127.

Corwine, Aaron Houghton, 46, 66.

Cotton Pickers, Georgia (Thomas Hart Benton; fig. 46), 116-18, *116*.

Cox, Kenyon, 109, 273.

Crapshooter, The (Julien Binford; fig. 50, cat. no. 137), 128, *129*, 301, *301*.

Crawford, Josephine, 110, 136.

Crawford, Ralston, 136, 137.

Creole Lady, A (Jean Joseph Vaudechamp; cat. no. 61), 75, 226, *226*.

Cress, George, 136-37, 139; *Spring Earth* (fig. 53), 137, *137*.

Crowe, Eyre, 82.

Crushed Cups, Coat Hanger, and Tape (George Lee Bireline; cat. no. 154), 147, 155, 321-22, *322*.

Cubism. *See* Modernism.

Curran, Charles, 106, 276.

Curry, John Steuart, 120, 292.

Cunningham, Merce, 135, 320.

Dadaism, 115, 161.

Daguerre, L.J.M., 235.

Daingerfield, Elliott, 98, 99, 105-06, 107, 112, 278; *Carolina Sunlight* (cat. no. 113), 99, 105, 278, *278*.

Daniel Ravenel II of Wantoot (Jeremiah Theüs; cat. no. 23), 19, 184, *185*.

Dandridge, Bartholomew, 183.

Davey, Randall, 323.

David, Jacques-Louis, 57, 61, 205, 213.

Davidson, Donald, 115, 119.

Davis, Stuart, 130, 136, 309.

Dawn and Dusk in Unison (Edith London; fig. 58, cat. no. 173), 153-54, *153*, 342, *342*.

Dawn in the Hills (Robert Julian Onderdonk; fig. 44, cat. no. 116), 107, *108*, 282, *282*.

Dearborn, Samuel H., 66.

de Beet, Cornelius, 59.

De Bry, Theodor, 6, 7, 169, 170; *Admiranda Narratio Fida Tamen . . .* (cat. no. 4), 6, 7, *7*, 170; *A Brief and True Report of the New Found Land in Virginia . . .* (cat. no. 2), 7, 170; *Der Ander Theyl, Der Neulich Erfunden Landtschaft Americae . . .* (cat. no. 5), 7, 170; *Merveilleux et estrange rapport, toutesfois fidele, des commoditez qui se trouvent en Virginia . . .* (cat. no. 3), 7, 170.

de Coligny, Gaspard, 6.

De Kooning, Willem, xiv, 136, 156; *Ashville* (fig. 60), 156, *157*.

Demolition of Avoca (Francis Speight; fig. 43, cat. no. 143), *104*, 131, 307, *307*.

Depression, the Great, 105, 111, 112, 118, 123, 127, 292, 297, 298, 313.

Derain, André, iii.

Der Ander Theyl, Der Neulich Erfunden Landtschaft Americae . . . (Theodor De Bry; cat. no. 5), 7, 170.

Dering, William, 23, 25, 30, 181; *George Booth as a Young Man* (cat. no. 18), 23, *180*, 181; portrait of Elizabeth Drury Stith, 23.

Deveaux, James, 46.
Dewey, John, 109.
Dickey, James, 129.
Diebenkorn, Richard, 333.
Dismal Swamp, The (Flavius J. Fisher; cat. no. 72), 94, 236, *236.*
Dodd, Lamar, 120-21, 136, 137, 292; *The Railroad Cut* (cat. no. 128), 120, 292, *292.*
Dodge, Julia E., 95.
Doerner, Max, 290.
Dog Swap, The (Richard Norris Brooke; fig. 40), 91-93, *92.*
Dooley, A., 10.
Double Dealer, The, See New Orleans.
Doughty, Thomas, 59.
Douglas, Aaron, 126, 130, 137, 283; *Build Thee More Stately Mansions,* 126; *Go Down, Death* (cat. no. 117), 126, 283, *283.*
Dowsing, Robert, 13.
Dozier, Otis, 123, 296.
Dreier, Katherine, 110, 291.
Drouth-Stricken Area (Alexandre Hogue; fig. 48), 122, *123.*
Drysdale, Alexander John, 106, 107, 114, 276; *Early Morning in a Louisiana Marsh* (cat. no. 111), 106, 276, *276.*
DuBois, W.E.B., 124, 283.
Dufy, Raoul, 110.
Dumond, Frank Vincent, 106, 121, 276, 295.
Dunlap, William, 55-56, 63, 64, 65, 66, 68, 75; *Christ Rejected,* 56.
Durand, John, 28-30, 37, 187; *Mr. Gray Briggs* (fig. 19), 30, *31; Mrs. Gray Briggs* (fig. 20), 30, *31; Portrait of Edward Archer II* (fig. 18, cat. no. 28), 28-30, *29,* 187, *187.*
Duveneck, Frank, 300.

Earl, James, 44, 65, 194; *Elizabeth Fales Paine and her Aunt Martha Paine* (cat. no. 31), 44, 194, *194; Eliza Shrewsbury and her Mother,* 194.
Earl, Ralph, 194, 213.
Earl, Ralph E. W., 44, 46, 67, 213; *Mr. and Mrs. Ephraim Hubbard Foster and their Children* (fig. 26, cat. no. 51), 46-47, *47,* 212, 213.
Early Morning in a Louisiana Marsh (Alexander John Drysdale; cat. no. 111), 106, 276, *276.*
Ecole des Beaux Arts, 112, 279, 280, 332.
Economy, Southern, 60, 65, 73, 106, 111, 121; artists' reactions against economic growth, 114-15, 120, 139-40; colonial expansion, 6, 7; New Deal programs, 118, 128, 139-40; and World War II, 127. *See also* The Great Depression; Public Works Art Project; Works Progress Administration.
Education, Southern art, 43, 107-09, 112, 116, 121, 124, 140; Southern University Conference, 121.
Edward Brodnax (Jaquelin-Brodnax Limner; cat. no. 12), 13, 174, *175.*
Eichholtz, Jacob, 61.
Elder, John Adams, xvi, 86, 88, 90, 93, 256; *Battle of the Crater,* 88, 256; *A Virginny Breakdown* (fig. 39, cat. no. 93), 88, 89, 256, *256.*
Elizabeth Fales Paine and her Aunt Martha Paine (James Earl; cat. no. 31), 44, 194, *194.*
Elizabeth Rebecca Brodnax (Jaquelin-Brodnax Limner; cat. no. 11), 12, 174, *175.*
Eliza Shrewsbury and her Mother (James Earl), 194.
Elliott, Charles Loring, 258.
English influences on American art. *See* Landscape painting; Portraiture.
Equestrian painting, 77-78, 227-28, 230.
European influences on American art. *See* Landscape painting; Portraiture; Still-life painting.
Evans, Walker, 295.

Ex-Nihilo (Kenneth Noland; cat. no. 150), 152, 317-18, *317.*

Fabrino Julio, Everett B. D., 88, 94, 244; *The Last Meeting of Lee and Jackson,* 88.
Faccinto, Victor, 160, 334; *Winged Fork* (cat. no. 165), 160, 334, *334.*
Fall of the Alamo, The (Robert Jenkins Onderdonk), 96.
Faulkner, Frank, 154-55, 339; *Arabia Felix* (cat. no. 170), 154, 339, *339.*
Faulkner, William, xiii, 115, 123, 150, 290, 334.
Feininger, Lionel, 136.
Feke, Robert, 182.
Festival Mountain (Howard Thomas; cat. no. 155), 152, 323, *323.*
Finn, Henry Williams, 66.
First Cities of the United States (John L. Boqueta de Woiseri), 60.
Fisher, Alvan, 65.
Fisher, Flavius J., 94, 236; *The Dismal Swamp* (cat. no. 72), 94, 236, *236.*
Fitzgerald, Zelda Sayre, 111, 302; *Circus* (cat. no. 138), 111, 302, *302.*
Fitzpatrick, John Kelly, 119-20, 287; *Negro Baptising* (fig. 2, cat. no. 123), *vi,* 119, 287, *287.*
500 Years of Rape (Institutional Order Defined) (Mike Nicholson; cat. no. 168), 155, 337, *337.*
Flagler, Henry Morrison, 97-98, 266.
Fleischbein, François, 75, 242; *Portrait of Marie LeVeau's Daughter* (fig. 33, cat. no. 78), 72, 75, 242, *243.*
Flight of Night, The (William Morris Hunt), 251.
Florida, art and artists in, 77, 91, 96, 97-98, 177, 251, 252, 253, 257, 262, 265-66, 327, 337; early settlement of, 6, 43, 169, 170; Sarasota, 332.
Florida Scene (Thomas Moran; cat. no. 94), 97, 257, *257.*
Floyd, Charles Renaldo, 66.
Folk painting, xv, 47, 53-55, 60, 127, 201.
Forbes, John Murray, 97.
Fort Sumter Interior (Conrad Wise Chapman; fig. 38, cat. no. 85), 86, *87,* 246, *248.*
Four Cherokee Roses (Martin Johnson Heade; cat. no. 103), 96, 265-66, *265.*
Frankenthaler, Helen, 318.
Franklin, Benjamin, 30.
Fraser, Charles, 51, 53, 59, 60, 65, 66, 213; *The Marquis de Lafayette* cat. no. 52), 213, *213.*
Frazer, Oliver, 44, 46, 66.
Frerichs, William Charles Anthony, 80.
Frye, William, 76.
Frymire, Jacob, 54, 55, 201; *Amelia Lauck,* 55; *Portrait of Ann Lucretia Deneale* (cat. no. 38), 55, 200, 201.
Fugitives, The, xiii, 114, 115, 119.
Fuller, Buckminster, 136.
Futurity (Clarence Boyd; cat. no. 99), 94, 261, *261.*

Galveston, Texas, development of art in, 96, 97.
Gatewood, Maud, 158, 340; *Swinger in Summer Shade* (cat. no. 171), 158, 340, *340.*
Gaul, William Gilbert, 106, 267; *Charging the Battery,* 267; *Sunset Landscape* (cat. no. 105), 106, 267, *267; With the Confederate Colors,* 267.
General George Washington (John Trumbull; fig. 28), 48, *49.*
General Marion Inviting a British Officer to Dinner (John Blake White), 81-82.
Genre painting, 43, 53, 56, 59, 67, 82, 86, 238, 241, 250, 253, 256.
George Booth as a Young Man (attributed to William Dering; cat. no. 18), 23, *180,* 181.

George Washington at Yorktown (Charles Willson Peale; fig. 21), *32,* 33.
George Washington in Masonic Regalia (William Joseph Williams; fig. 27), 48-50, *48.*
George Whitefield in the Attitude of Preaching (John Wollaston), 26.
Georgia, art and artists in, 59, 76, 86, 97, 120-21, 124, 127, 177, 250, 268, 272, 292, 294, 325, 337; articles describing scenery of, 78-79; Association of Georgia Artists, 121; Athens, 79; Atlanta, 94-96, 124, 268; Augusta, 241, 252; depictions of rural life in, 116-17; depictions of urban life in, 127, 297-98; *Georgia Illustrated,* 79; Savannah, 34, 51, 59, 66, 201, 272, 297-98, 314; Tallulah Falls, 60, 79, 219.
Georgia Jungle (Alexander Brook; cat. no. 133), 127, 297-98, *297.*
Georgia Pines at Sunset (William Posey Silva; cat. no. 108), 99, 272, *272.*
Giant Steamboats at New Orleans (Hippolyte Sebron; cat. no. 71), 82, 235, *235.*
Gilliam, Sam, 154-55, 336; *Blue Isolate* (cat. no. 167), 82, 336, 336.
Gilmor, Robert, 59, 61, 195.
Giroux, Charles, 244.
Gleizes, Albert, 110.
Godefroy, Eliza, 59.
Go Down, Death (Aaron Douglas; cat. no. 117), 126, 283, *283.*
Goff, Lloyd, 123.
Goldthwaite, Anne, 109, 110, 119, 273, 291; *Springtime in Alabama* (cat. no. 127), 110, 291, *291.*
Gordon, Peter, 22.
Gordy, Robert, 150, 160-61, 326; *Arcadian Still Life with Females (Wrinkled Version)* (cat. no. 157), 160-61, 326, *326.*
Gorky, Arshile, 156, 313; *Virginia Landscape* (cat. no. 146), 156, *312,* 313.
Gray, James, 64.
Greenberg, Clement, 127, 136, 151, 318, 322.
Groombridge, William, 57, 59.
Gropius, Walter, 136.
Gros, Antoine Jean, 237.
Grosz, George, 130.
Guy, Francis, 59.
Gwathmey, Robert, 128-30, 136, 303; *Hoeing* (cat. no. 139), 128-29, 303, *303.*

Hakluyt, Richard, 7.
Hale, Philip Leslie, 119, 288.
Halsey, William Melton, 153-54, 314; *Back Street Charleston* (cat. no. 147), 154, 314, *314; Thira* (cat. no. 148), 154, 314, *315.*
Harding, Chester, 61, 66.
Harding, Horace, 66.
Hariot, Thomas, 7, 170.
Harlem Renaissance, 124, 126, 283. *See also* Black Americans.
Harleston, Edwin, 124, 126.
Harriet Rogers (Charles B.F.J. de Saint-Mémin; cat. no. 42), 203, *203.*
Hawthorne, Charles W., 124, 298.
Heade, Martin Johnson, 96, 97-98, 265-66; *Afterglow, Florida* (fig. 42, cat. no. 104), 98, *98,* 265-66. *266; Four Cherokee Roses* (cat. no. 103), 96, 265-66, *265.*
Healy, George Peter Alexander, 76-77, 237; *Portrait of Alexander Hamilton Stephens* (cat. no. 73), 76-77, 237, *237.*
Healy, Thomas Cantwell, 74.
Henri, Pierre, 64.
Henri, Robert, 110, 284.
Henrietta and Sarah Mayo (William James Hubard; cat. no. 66), 76, 231, *231.*
Henriette C. Chastaigner (Henrietta Johnston; cat. no. 7), 12, 173, *173.*

Henry Darnall III (Justus Engelhardt Kühn; cat. no. 6), 9-10, 173, *172.*

Henry, Edward Lamson, xvi, 86, 250; *Old Westover Mansion, The* (cat. no. 87), 86, 250, *250.*

Henry Laurens (John Singleton Copley; cat. no. 29), 36, 188, *189.*

Herbert, James Arthur, 155-56, 341; *Plump Head* (cat. no. 172), 155-56, 341, *341.*

Hesselius, Gustavus, 3, 10, 61, 176, 182, 183; *Bacchanalian Revel* (fig. 9, cat. no. 13), 10, *11,* 176, *176; Bacchus and Ariadne,* 176; *Last Supper,* 10.

Hesselius, John, 10, 27-28, 30, 36, 61, 176, 182, 190; *Charles Calvert* (fig. 16), 27, *27; Portrait of Alice Thornton Fitzhugh* (cat. no. 20), 27, 182, *182; Portrait of Margaret (Lloyd) Tilghman* fig. 4, cat. no. 21), xvii, 27-28, 182, *182; Portrait of Mrs. Thomas Gough* (fig. 17), 28, *28.*

Heyward, DuBose, 112, 293.

Hicks, Thomas, 265.

Hill, Francis C., 59, 65, 66; *Old St. John's Lutheran Church, East* (cat. no. 59), 59, 221, *221.*

Hill, John, 59.

History painting, 43, 53, 55-56, 61, 63, 64, 67, 80, 81-82, 96, 97, 213. *See also* Civil War.

Hoeing (Robert Gwathmey; cat. no. 139), 128-29, 303, *303.*

Hoffman, Martin, xvi, 147, 156, 158, 327; *Open Road* (cat. no. 158), 147, 327, *327.*

Hoffman, Hans, 318, 326, 328.

Hogue, Alexandre, 123, 296; *Drouth-Stricken Area* (fig. 48), *122,* 123.

Homage to the Square (Josef Albers), 316.

Homer, Winslow, 86, 90-91 , 253-54; *Captured Liberators,* 86; *The Carnival* (cat. no. 91), 88-90, 253, *254; Sunday Morning in Virginia* (cat. no. 92), 90, 91, 253, *255; A Visit from the Old Mistress* (cat. no. 90), 90, 91, 253, *253.*

Hopper, Edward, xiv, 118, 145-47, 158, 284; *The Battery, Charleston, S.C.* (cat. no. 118), 118, 158, 284, *284; Carolina Morning* (fig. 56), 145-47, *146,* 158.

Horn Island (Walter Anderson; fig. 51, cat. no. 142), 132-34, *133,* 306, *306.*

House and Figure (Robert Jenkins Onderdonk; cat. no. 101), 92, 263, *263.*

Howard, Richard Foster, 121.

Howell, Claude, 139, 304; *Beach Cottage* (fig. 54), *138,* 139; *Mullet Haul* (cat. no. 140), 136, 304, *304.*

Hubard, William James, 76, 231; *Henrietta and Sarah Mayo* (cat. no. 66), 74, 231, *231.*

Hudson, Jules (or Julien), 75, 232; possibly by, *Maid of the Douglas Family* (cat. no. 67), 75, 232, *232.*

Hudson River School. *See* Landscape Painting.

Hudson, Thomas, 25, 26; *Robert Carter "Councillor"* (fig. 15), *24,* 25.

Huggins, Victor, xvi, 147, 156, 158, 330; *335; Pilot Mountain* (cat. no. 161), 147, 330, *330.*

Hull, Marie, 121, 295; *Sharecroppers* (cat. no. 131), 121, 295, *295.*

Humbert, Jean Charles, 244.

Hunt, William Morris, 97, 251; *The Flight of Night,* 251; *View of the St. John's River, Florida Sunset* (cat. no. 88), 97, 251, *251.*

Hunters, The (Gari Melchers; fig. 45, cat. no. 115), 112, *113,* 280, *281.*

Huntington, Daniel, 256.

Immigration of artists to America, 5-6, 74; English artists, 17-18, 50, 59, 76, 111, 173, 178, 183, 194, 195, 197, 223, 231, 257, 279; European artists, 14-16, 18-19, 23, 28, 37, 44, 53, 76, 78, 93, 98, 151, 173, 176, 185, 187, 195, 197, 198, 203, 205, 211, 223, 226, 227,

233, 234, 235, 242, 244, 262, 269, 313, 316, 342.

Impressionism, 106, 107, 252, 272.

Independence (Squire Jack Porter) (Francis Blackwell Mayer; cat. no. 74), 82, 238, *238.*

Indians, American, 5, 6, 7, 14, 43, 56-57, 82; Indian Gallery, Washington, D.C., 56, 57, 64; 229; Indian Removal Act, 71; paintings of, by Alfred Boisseau, 234; by George Catlin, 77, 229; by George Cook, 219; by Charles Bird King, 56-57, 64; by Charles B.F.J. de Saint-Mémin, 56, 203; by Philip Georg Friedrich Von Reck, 17; by John White, 7-8.

Indians Dancing around a Circle Pole (John White; fig. 7), 5.

Indians Fishing (John White; fig. 6), *4.*

Industrial Louisiana (Conrad A. Albrizio; cat. no. 122), 118, 285, 286.

Industrial themes in art, 111-12, 118, 119, 279, 285.

Inman, Henry, 44, 57, 64.

Inness, George, 99, 105, 106, 107, 278.

Itinerant artists: folk painters working in South, 53, 55, 60, 67, 199, 201; foreign-born itinerant artists in South, 23, 25-26, 44, 198, 203, 205, 208, 226, 233, 234, 239, 240, 257, 269, 313; Northern artists in the South, 44, 64-67, 73-74, 78-79, 88, 96-97, 187, 195, 199, 201, 205, 209, 217, 223, 236, 237, 241, 251-53, 258, 264-65, 267, 289, 297, 300, 331, 332, 341.

Iwonski, Carl, 96.

Jackson, Andrew, 46-47, 51, 207.

Jackson, Stonewall, 88, 256.

Jaquelin-Brodnax Limner, 12-13, 174; *Edward Brodnax* (cat. no. 12), 174, *175; Elizabeth Rebecca Brodnax* (cat. no. 11), 12, 174, *175; Rebeckah Brodnax* (cat. no. 9), 12, 174, *174; William Brodnax I* (cat. no. 8), 12, 174, *174; William H. Brodnax* (cat. no. 10), 12, 174, *175.*

James Miles with his Son and Young Daughter (Cephas Thompson), 54.

Janssen, Cornelius; portrait of William Moseley II, attributed to, 8.

Jarvis, John Wesley, 44, 46, 53, 61, 64, 66, 223.

Jaume, Alexandre Charles, 75.

Jazz. *See* Music.

Jazz Age, 111.

Jefferson, Thomas, 2, 53, 80, 199.

Jervas, Charles, 18.

Jocelyn, Nathaniel, 65-66.

John Bolling, Jr. (Charles Bridges; cat. no. 17), 18, 179, *179.*

John Law's Concession (Jean Baptiste Michel Le Bouteux; fig. 5), 2, *2.*

John Page the Immigrant (Sir Peter Lely; fig. 8), 8, *8.*

Johns, Jasper, 149, 156; *Studio* (cat. no. 152), 149, 156, 320, *320.*

Johnson, David, 80.

Johnson, Eastman, xvi, 85-86, 90, 241; *My Old Kentucky Home—Life in the South* (fig. 37), 84, 85, 90, 241; *Negro Boy* (cat. no. 77), 84, *241,241.*

Johnson, James Weldon, 126, 283; *God's Trombone* (126).

Johnson, Warren. *See* Blue Sky.

Johnson, William H., 124-26, 136, 298; *Chain Gang* (fig. 49, cat. no. 135), 124-26, *125,* 298, *299.*

Johnston, Henrietta, 10-12, 23, 173; *Henriette C. Chastaigner* (cat. no. 7), 12, 173, *173.*

Johnston, Joshua, 54, 61, 206; *Mrs. Thomas Everette and Children* (cat. no. 45), 54, 206, *206.*

Jonathan Granville (Philip Tilyard; cat. no. 49), 63, 210, *210.*

Jouett, Matthew Harris, 44, 46, 66, 67, 74; *Marquis de Lafayette,* 67; *Portrait of Justice Thomas Todd* (cat. no. 53), 46, 214, *214.*

Kandinsky, Wassily, 134, 300.

Karfiol, Bernard, 304.

Kass, Ray, xvi, 149, 154-55, 335; *Winged Earth, St. John's Mountain* (fig. 57, cat. no. 166), xvi, 149, *149,* 154, 335, *335.*

K. C. Suzuki (David Buchanan Parrish; cat. no. 174), 156, 342, *343.*

Kemmelmeyer, Frederick, 61.

Kennedy, John Pendleton, 63.

Kent, Rockwell, 284.

Kentucky, art and artists in, 46, 55, 61, 66-67, 94, 106, 201; Lexington, 43, 59, 66, 67, 195, 214, 227; Louisville, 46, 57, 76, 78, 230, 258, 261, 336.

Kevorkian, Richard, 154, 155; *Toluidine Red* (fig. 59, cat. no. 162), 154-55, *155,* 331, *331.*

Kilburn, Lawrence, 28.

King, Charles Bird, 44, 46, 56-57, 61, 64, 214, 219, 223; *Mistipee* (cat. no. 54), 56, 214, *214.*

King, Edward, 96, 97.

Kipahalgwa (Philip Georg Friedrich Von Reck), 17.

Kitchen Ball at White Sulphur Springs (Christian Mayr), 82.

Klee, Paul, 134, 300, 318.

Kline, Franz, 136.

Kneller, Sir Godfrey, 18, 26.

Kohlmeyer, Ida, 153-54, 328; *Cluster #1* (cat. no. 159), 153-54, 328, *328.*

Kokoschka, Oscar, 340.

Kühn, Justus Engelhardt, 9-10, 16, 27, 61, 173; *Henry Darnall III* (cat. no. 6), 9, 27, *172,* 173.

Lafayette, Marquis de, 56, 67, 213.

Lambdin, James Reid, 66.

Lambert, James, 59.

Landscape painting: as influenced by published writings, 79, 96, 97; as interpreted by Modernist painters, 152-53, 156, 300, 313, 331; Edmund Burke, influence of, xvi, 264; development of, xvi, 3, 7-8, 13, 43, 57-60, 67, 74, 78, 88, 94, 99, 105, 107, 109, 114, 123, 132-34, 173, 197, 244, 264, 293, 330; displayed abroad, 79-80; English influence on, 57; European influence on, 59, 93, 219, 236, 251, 260, 261, 267; folk, 60; Hudson River School, 57, 59, 67, 258; the landscape as setting for portraits, 9, 26, 48, 50, 80, 173, 203, 239; nature as ideal, 143; panoramas, 22, 44, 65, 78, 79-80; "Southern light," 145, 236, 257, 258. *See also* Virginia landscape.

Lansot, Aimable Désiré, 75.

Last Civil War Veteran, The (Larry Rivers; cat. no. 151), 145, 158-59, 318, *319.*

Last Meeting of Lee and Jackson, The (E.B.D. Fabrino Julio), 88.

Last Supper (Gustavus Hesselius), 10

Latrobe, Benjamin Henry, 60, 64, 90, 197, 263; *The Capitol at Washington, D.C.* (cat. no. 34), 60, 197, *197; View of Mount Vernon Looking to the North* (cat. no. 33), 196, 197; *View of Mount Vernon Looking towards the Southwest* (cat. no. 33), 196, 197.

Latrobe, John H. B., 80.

Laudonnière, René de, 5, 6, 169.

Laurens, Henry, 36, 188.

Lawrence, Jacob, 136.

Lawrence, Sir Thomas, 46, 223.

Le Bouteux, Jean-Baptiste Michel, 2, 22; *John Law's Concession* (fig. 5), 2, *2,* 22.

Lee, Robert E., 76, 88, 256.

Leger, Fernand, 110.

Leigh, Judge Egerton, 36.

Leitch, Thomas, 22; *View of Charleston* (fig. 14), *22, 22.*

Lely, Sir Peter, 8, 18; *John Page the Immigrant* (fig. 8), 8, *8*.

Le Moyne de Morgues, Jacques, 5-7, 169, 170; *René de Laudonnière and the Indian Chief Athore Visit Ribaut's Column* (fig. 1, cat. no. 1), *ii*, 5, 169, *169*.

Lester, William, 123, 296.

Leutze, Emmanuel, 241, 256, 259.

Lewis and Clark expedition, 43, 56.

Lhôte, André, 110, 111.

Life in the South (Eastman Johnson). See *My Old Kentucky Home*.

Lippold, Richard, 136.

Locke, Alain, 124, 126, 283.

London: cultural impact of, 25, 26, 28; American artists working in, 36, 46, 51, 56, 82, 188, 211; American artists studying in, 30, 46, 82, 190, 194, 217, 220.

London, Edith, 153-54, 342; *Dawn and Dusk in Unison* (fig. 58, cat. no. 173), 153-54, *153*, 342, *342*.

Lost Cause, the, 87, 114, 249.

Louisiana, art and artists in, 2, 46, 76, 78, 93, 94, 106, 107, 109, 119, 214, 244, 269, 285, 326. See also, New Orleans.

Louisiana Indians Walking along a Bayou (Alfred Boisseau; fig. 36, cat. no. 70), 82, 83, 234, *234*.

Louis, Morris, 145, 147, 318.

Lover, The (Charles Shannon; cat. no. 130), 126, 294, *294*.

Luks, George, 118, 124, 285, 298.

Luminism, 152, 323.

Lungkwitz, Hermann, 96.

McCrady, John, 121, 123, 290; *Political Rally* (cat. no. 126), 121, 290, *290*; *The Shooting of Huey Long*, 121.

Mackall, Corinne Lawton, 112.

MacKenzie, Roderick, 111-12, 119, 279; *Mixers and Converters* (cat. no. 114), 111, 279, *279*.

Mahler, Gustav, 323.

Maid of the Douglas Family (artist unknown, possibly Jules, or Julien, Hudson; cat. no. 67), 75, 232, *232*.

Maier, John, 74.

Malbone, Edward Greene, 51, 53, 65, 201; *Portrait of James MacPherson* (cat. no. 39), 51, 201, *201*; *Washington Allston* (fig. 29), 51, *51*.

Malcolm's Last Address (George Lee Bireline; cat. no. 153), 147, 151, 321-22, *321*.

Marcoussis, Louis, 111.

Mare, John, 183.

Marine painting, 22, 96-97, 178, 252.

Marling, Jacob, 60, 65; *The North Carolina Statehouse at Raleigh* (cat. no. 55), 60, 215, *215*.

Marling, Louisa, 65.

Marquis de Lafayette (Matthew Harris Jouett), 67.

Marquis de Lafayette, The (Charles Fraser; cat. no. 52), 53, 213, *213*.

Marr, Carl, 107.

Marschall, Nicola, 76.

Martha Vinson (Jeremiah Theüs; cat. no. 24), 19, 184, *184*.

Mary Abigale Coale (Charles B. J. F. de Saint-Mémin; cat. no. 41), 50, 203, *203*.

Maryland, art and artists in, 9, 10, 33, 34, 48, 50, 53, 54, 55, 60, 76, 82, 173, 176, 182, 183, 190, 197, 198, 199, 219, 238, 257, 263; in Annapolis, 10, 13, 26, 27, 28, 30, 86, 173, 182, 190, 203; Baltimore, 31, 54, 57, 59, 60, 61-63, 64, 65, 67, 76, 82, 94, 97, 190, 195, 198, 199, 203, 205, 206, 207, 209, 210, 214, 223, 231, 238, 252, 259; Frederick, 53, 54. See Baltimore; Peale Museum.

Matisse, Henri, 326.

Mayer, Francis Blackwell, 82, 86, 238; *Indepen-*dence (Squire Jack Porter)* (cat. no. 74), 238, *238*.

Mayr, Christian, 82; *Kitchen Ball at White Sulphur Springs*, 82.

Meeker, Joseph Rusling, 94, 258; *Bayou Scene* (cat. no. 95), 94, 258, *258*.

Melchers, Gari, 112-14; *The Hunters* (fig. 45, cat. no. 115), 112, *113*, 280, *281*.

Mellish, T., 22.

Melrose, Andrew W., 94; *Whiskey Still by Moonlight* (cat. no. 96), 94, 258, *258*.

Merveilleux et estrange rapport, toutefois fidele, des commoditez qui se trouvent en Virginia (Theodor De Bry; cat. no. 3), 7, 170.

Metzinger, Jean, 110.

Mick-e-no-pah (George Catlin; cat. no. 64), 75, 229, *229*.

Miller, Kenneth Hayes, 121, 290, 297.

Millet, Jean François, 251.

Miniature of Two Unidentified Young Ladies before a Pianoforte (Philippe A. Peticolas; cat. no. 36), 53, 198, *198*.

Miniature painting. See Portraiture, miniatures.

Minimalism. See Modernism.

Mississippi, art and artists in, 46, 59, 76, 86, 93, 121, 214, 230, 244, 274, 295, 306, 308; Jackson, 237; Oxford, 290.

Mississippi River, 8, 118; depictions of, xvi, 78, 79-80, 93, 94, 244, 258.

Mistipee (Charles Bird King; cat. no. 54), 56, 214, *214*.

Mixers and Converters (Roderick MacKenzie; cat. no. 114), 111, 279, *279*.

Modernism, 139, 150-51, 152, 155, 336; abstract painting, 136, 145-47, 149, 151-52, 154, 155, 300, 304, 318, 326; American Modernists, in Paris, 110, 291; Cubism, 110, 136, 152, 154, 323, 342; introduced at Black Mountain College, N.C., 135, 151-52, 153, 316, 322; Minimalism, 156, 318; the Fugitives, 115; reaction against, 148.

Moise, Theodore, 93.

Mondrian, Piet, 152, 323.

Monroe, James: portraits of, 44, 207.

Moore, Joseph Thoits, 76.

Moran, John Leon, 264; *Natural Bridge, Virginia* (cat. no. 102), 264, *264*.

Moran, Thomas, 94, 96, 97, 257; *Florida Scene* (cat. no. 94), 97, 257, *257*.

Morse, Samuel Finley Breese, 44, 65, 217; *Portrait of Mrs. Robert Young Hayne* (fig. 25; cat. no. 56), 44, *45*, 216, 217.

Moseley, William II (portrait of, attributed to Cornelius Janssen), 8.

Motherwell, Robert, 136.

Mowbray, H. Siddons, 273.

Mr. and Mrs. Boswell Lamb and their Daughter, Martha Anne (Henry Benbridge; cat. no. 27), 34, 186, *187*.

Mr. and Mrs. Ephraim Hubbard Foster and their Children (Ralph E. W. Earl; fig. 26, cat. no. 51), 46-47, *47*, 212, 213.

Mr. Gray Briggs (John Durand; fig. 19), 30, *31*.

Mrs. Anthony Walke II (John Wollaston; cat. no. 22), 26, 183, *183*.

Mrs. Barnard Elliot (Jeremiah Theüs; fig. 13), 19, 20.

Mrs. Gray Briggs (John Durand; fig. 20), 30, *31*.

Mrs. Leonard Wiltz (L. Sotta; cat. no. 68), 75, 233, *233*.

Mrs. Thomas Everette and Children (Joshua Johnston; cat. no. 45), 54, 206, *206*.

Mullet Haul (Claude Howell; cat no 140), 139, 304, *304*.

Munch, Edvard, 299.

Mural painting, 118, 119, 120, 126, 128, 132, 279, 285, 287, 288, 289, 301, 306, 307, 328, 332.

Music: origins of in South, 90; bluegrass, 90;

blues, 124, 130, 131; influence of W. C. Handy, 131; jazz, 90, 126, 130, 136, 137, 309; ragtime, 90; related to painting, 153-54, 328, 332.

My Old Kentucky Home (Eastman Johnson; fig. 37), 84, 85, 90, 241.

Mythological subjects in painting, 10, 176.

Nashville, Tennessee, art and artists in. See Tennessee.

National Academy of Design, 79, 85, 94, 96, 107, 203, 205, 217, 220, 241, 253, 258, 261, 263, 264, 267, 278, 291.

National Gallery, New Orleans, 79.

National Gallery of Art, Washington, D.C., 114, 280, 317.

Natural Bridge, Virginia, as inspiration to artists, xvii, 60, 80, 264.

Natural Bridge, Virginia (John Leon Moran; cat. no 102), 264, *264*.

Natural History of Carolina, Florida, and the Bahama Islands, Volumes I and II (Mark Catesby; cat. no. 15), 13, 177.

Naturalists, artistic renderings by, xvi, 3, 13-14, 34, 57, 66, 74, 132, 177, 211. See also John James Audubon, William Bartram, Mark Catesby.

Neagle, John, 66.

Negro Baptising (John Kelly Fitzpatrick; fig. 2, cat. no. 123), *vi*, 119, 287, *287*.

Negro Boy (Eastman Johnson; cat. no. 77), 85, 241, *241*.

Neoclassical style in painting, 30, 36, 43, 44, 50, 67.

New Deal, The, 128, 139-40.

Newhall, Beaumont, 136.

Newman, Henry, 16, 17.

New Orleans, Louisiana: A New Southern Group, 121, 290; art and artists in, 54, 55, 60, 74-76, 78, 80, 82, 83, 85, 87, 88, 90, 93, 106, 107-09, 110, 112, 114, 118, 134, 136, 197, 205, 226, 228, 229, 230, 232, 233, 234, 235, 237, 240, 242, 244, 252, 260, 274, 276, 277, 285, 290, 300, 326, 328. Artists Association of New Orleans, 107-08; Delgado Museum of Art, 109, 277; *The Double Dealer*, 114, 115; growth of, 74; "National Gallery," 79; Newcomb College, Tulane University, 107, 109, 134, 274, 277, 300; Southern States Art League, 109, 136, 272, 314; Southern Art Union, 94. See also Louisiana.

New South, the, 88, 96, 114.

New York School, 136, 137, 151. See also Modernism.

Nicholson, Mike, 155, 156, 337; *500 Years of Rape (Institutional Order Defined)* (cat. no. 168), 155, 337, *337*.

Noland, Kenneth, 145, 147, 152-53; *Ex-Nihilo* (cat. no. 150), 152, 317, *317*; *Virginia Site* (fig. 55), *144*, 152-53.

North Carolina, art and artists in, 10, 34, 47, 48, 55, 59, 60, 61, 76, 80, 86, 94, 96, 97, 98-99, 105, 120, 131, 139, 177, 250, 252, 258, 262, 278, 300, 304, 305, 307, 317, 323; early settlement of, 7-8, 16, 169; North Carolina Museum, Raleigh, 65; Raleigh, 215, 321, 330, 333, 335, 337, 338, 339, 340, 342; Raleigh, as art center, 65; Winston-Salem, 334, 339. See also Black Mountain College.

North Carolina Museum. See North Carolina.

North Carolina Statehouse at Raleigh, The (Jacob Marling; cat. no. 55), 60, 215, *215*.

Oakland House and Race Course, Louisville, Kentucky (Robert Brammer and Augustus Von Smith; cat. no. 65), 78, 230, *230*.

Oertel, Johannes Adam Simon, 98, 262; *Chinco-teague Ponies* (cat. no. 100), 98, 262, *262*.

Officer, Thomas S., 76.

Oglethorpe, General James, 16.

Okada, Kenzo, 341.

Old Mattress Factory (William Woodward; cat. no. 110), 109, 274, *275.*

Old Plantation Life in Louisiana (Conrad A. Albrizio; cat. no. 120), 118, 285, *286.*

Old St. John's Lutheran Church, East (Francis C. Hill; cat. no. 59), 59, 221, *221.*

Old Westover Mansion (Edward Lamson Henry; cat. no. 87), 86, 250, *250.*

Olson, Charles, 137-39.

Onderdonk, Robert Jenkins, 96, 263; *The Fall of the Alamo,* 96; *House and Figure* (cat. no. 101), 96, 263, *263.*

Onderdonk, Robert Julian, 107, 112, 123; *Dawn in the Hills* (fig. 44; cat. no. 116), 107, *108,* 282, *282.*

Open Road (Martin Hoffman; cat. no. 158), 147, 327, *327.*

Orozco, José Clemente, 118, 294.

Panorama painting. *See* Landscape painting.

Park, Asa, 66.

Parker, C. R., 76.

Parrish, Clara Weaver, 109, 110, 273; *Portrait of Anne Goldthwaite* (cat. no. 109), 110, 273, *273.*

Parrish, David Buchanan, 156, 158, 342; *K. C. Suzuki* (cat. no. 174), 156, 342.

Passage of the Delaware by the American Troops under the Command of General Washington, The (Thomas Sully), 47, 55, 65.

Passion of Christ (Romare Bearden), 309.

Pastoral Visit, The (Richard Norris Brooke), 91-93.

Patch, Thomas, 33-34.

Patronage: governmental commissions, 47, 56, 64, 66, 118, 119, 128; landscape/documentary commissions, xvi, 13-14, 57, 65; patrons and their preferences, 1, 2, 3, 9, 12-13, 18, 25, 28, 37, 46, 59, 60-61, 66, 68, 74, 88, 94, 195, 239, 251, 266; portrait commissions, xv, 9, 18, 19-22, 25, 30, 34-37, 44, 46, 47, 50, 75. *See also* Public Works Art Project; Works Progress Administration.

Paul, Jeremiah, Jr., 66.

Peale, Anna Claypoole, 50-51, 207; *Andrew Jackson* (cat. no. 46), 51, 207, *207.*

Peale, Charles Willson: as artist, 30-33, 37, 190; brother of James Peale, 198; comparison with work by other artists, 48, 50; correspondence documenting work of other artists, 25, 27; father of Rembrandt Peale, 61, 205; father of Anna Claypoole Peale, 207; *George Washington at Yorktown* (fig. 21), 32, 33; portrait of, by Gilbert Stuart, 63; student of John Hesselius, 28, 182; teacher of miniaturist Esther Sage, 186; uncle of Charles Peale Polk, 199; *William Smith and his Grandson* (fig. 3, cat. no. 30), *xii,* 30-33, 190, *191.*

Peale, James, 50, 198, 207, 209; *Portrait of Mrs. John P. Van Ness (nee Marcia Burns)* (cat. no. 35), 50, 198, *198.*

Peale Museum, Baltimore, 60-61, 63, 67, 209.

Peale, Raphaelle, 61, 64, 66, 205.

Peale, Rembrandt, 44, 48, 50, 53, 55, 61, 63, 65, 66, 205, 209, 217, 219; *Benjamin Henry Latrobe* (cat. no. 43), 61, *204,* 205.

Peale, Rubens, 209.

Peale, Sarah Miriam, 61, 209; *Still-Life of Watermelon and Grapes* (fig. 32, cat. no 48), 61, *62,* 209, *209.*

Pelham, Peter, 188.

Peticolas, Edward, 64, 198.

Peticolas, Philippe Abraham, 47, 53, 64, 198; *Miniature of Two Unidentified Young Ladies before a Pianoforte* (cat. no. 36), 53, 198, *198.*

Peticolas, Theodore, 198.

Petri, Richard, 96.

Phillips, Aileen, 295.

Photography, 75, 76, 242; use by painters, 131, 342.

Photorealism, 156.

Physiognotrace, 50, 203.

Piaget, Jean, 150.

Picabia, Francis, 110.

Picasso, Pablo, 110.

Picot de Limoëlan de Clorivière, Joseph Pierre, 53, 66; portrait of Catherine L. Greene, 66.

Pilot Mountain (Victor Huggins; cat. no. 161), 147, 330, *330.*

Pinelands, The (Alice Ravenel Huger Smith; cat. no. 129), 114, 293, *293.*

Pittman, Hobson, 131-32, 305; *The Conversation* (cat. no. 141), 305, *305.*

Plantation Burial, A (John Antrobus; cat. no 76), 83, 240, *240.*

Plantou, Madame Anthony, 55.

Plump Head (James Arthur Herbert; cat. no. 172), 155, 341, *341.*

Poincy, Paul, 276.

Political Rally (John McCrady; cat. no 126), 121, 290, *290.*

Polk, Charles Peale, 48, 53-54, 64, 199; *Portrait of Thomas Jefferson* (fig. 30, cat. no 37), *52,* 53-54, 199, *199.*

Pollock, Jackson, 152.

Pomarède, Leon, 78.

Pop Art, 320.

Portrait of a Gentleman (Jacques G. L. Amans; cat. no. 69), 75, 233, *233.*

Portrait of Alexander Hamilton Stephens (G.P.A. Healy; cat. no. 73), 75, 237, *237.*

Portrait of Alice Thornton Fitzhugh (John Hesselius; cat. no. 20), 27, 182, *182.*

Portrait of Ann Lucretia Deneale (Jacob Frymire; cat. no. 38), 55, 200, *201.*

Portrait of Anne Goldthwaite (Clara Weaver Parrish; cat. no. 109), 110, 273, *273.*

Portrait of Colonel William Randolph II (John Wollaston), 26.

Portrait of Conway Robinson (Thomas Sully; cat. no. 60), 46, *222, 223.*

Portrait of Edward Archer II (John Durand; fig. 18, cat. no. 28), 28-30, *29,* 187, *187.*

Portrait of James MacPherson (Edward Greene Malbone; cat. no. 39), 51, 201, *201.*

Portrait of James Monk (John Wollaston), 26.

Portrait of Justice Thomas Todd (Matthew Harris Jouett; cat. no. 53), 46, 214, *214.*

Portrait of Margaret (Lloyd) Tilghman (John Hesselius; fig. 4, cat. no. 21), xviii, 27, 182, *182.*

Portrait of Marie LeVeau's Daughter (François Fleischbein; fig. 33, cat. no. 78), *72,* 75, 242, *243.*

Portrait of Mary Sumner Blount (Pietro Bonanni; cat. no. 47), 44, 208, *208.*

Portrait of Mrs. John P. Van Ness (nee Marcia Burns), (James Peale; cat. no. 35), 50, 198, *198.*

Portrait of Mrs. Robert Young Hayne (Samuel F. B. Morse; cat. no. 56), 44, *216,* 217.

Portrait of Robert E. Lee in the Dress Uniform of a Lieutenant of Engineers, United States Army (William Edward West; fig. 34), 76, *77.*

Portrait of the Ralph Izard Children (Louis Antoine Collas; cat. no. 44), 53, 205, *205.*

Portrait of Thomas Jefferson (Charles Peale Polk; fig. 30, cat. no. 37), *52,* 53-54, 199, *199.*

Portraiture: portraits by English artists in America, 26-27; development of in the South, 3, 8-9, 12-13, 23, 25, 43-55, 67, 174; English influence on, 9, 12-13, 18, 19, 28, 44, 51, 173, 174, 178, 185, 186, 190, 194, 213, 217, 233; European influence on, 3, 9, 12, 19, 25, 46, 53, 61, 173, 205, 213, 232, 237; folk, 53-55, 174; miniature, 10, 23, 33, 43, 47, 50-53,

59, 60, 66, 74, 76, 181, 186, 198, 201, 203, 205, 213; of Confederate leaders, 76, 77, 87-88, 237, 256; of Revolutionary leaders, 33, 36, 47-50, 53-54, 56, 67, 188, 199, 213; use of landscape setting in, 9, 26, 48, 50, 80, 173, 203, 239. *See also* Patronage.

Pratt, Matthew, 183.

Pratt, Vernon, 156-58, 333; *Atmospheric Perspective (129 Grays)* (cat. no. 164), 156-58, 333, *333.*

Pre-Raphaelite movement, 250.

Prevalence of Ritual: Tidings, The (Romare Bearden; cat. no. 145), 130, 131, 309, *309.*

Prospect of Charles Town (Bishop Roberts; cat. no. 16), 22, 178, *178.*

Public Works Art Project (PWAP), 120, 131, 132, 287, 289, 307.

Purry, Jean Pierre, 19.

Quaker Battery (Conrad Wise Chapman; cat. no. 83), 87, 246, *247.*

Rabineau, Francis, 65.

Rachel Moore (Henry Benbridge; fig. 22, cat. no. 25), 34, 35, 186, *186.*

Railroad Cut, The (Lamar Dodd; cat. no. 128), 120, 292, *292.*

Raleigh, Sir Walter, 6, 7.

Ramsay, Allan, 36

Randolph, William and Mary (early portrait of), 8.

Ransom, John Crowe, 115.

Rauschenberg, Robert, 159, 160, 318; *Slow Fall* (fig. 61), 159-60, *159.*

Rebecca Brodnax (Jaquelin-Brodnax Limner; cat. no. 11), 12, 174, *175.*

Rebeckah Brodnax (Jaquelin-Brodnax Limner; cat. no. 10), 12, 174, *174.*

Regionalism, 3, 115-17, 123, 147-50, 160.

Reinagle, Hugh, 78.

Reiss, Winold, 126.

Religion: Christian values reflected in art, 3, 18, 106; promotion of by artists, 18, 262; religious freedom, 3, 16, 19, 170; religious subjects in art, 3, 26, 56, 98, 120.

René de Laudonnière and the Indian Chief Athore Visit Ribaut's Column (Jacques Le Moyne de Morgues; fig. 1, cat. no. 1), *ii,* 5, 169, *169.*

Revolution, American: depiction of events from, 55, 56, 81-82; depiction of Revolutionary leaders, 33, 36, 47, 48, 50, 53-54, 67, 188, 199, 205, 213; impact of on artists, 27, 30.

Richard Moncrief (Henry Benbridge; cat. no. 26), 34, 186, *187.*

Richards, T. Addison, 79, 80.

Richmond, Virginia: art and artists in, 43, 46, 50, 53, 60, 64, 65, 76, 78, 79, 87, 88, 128, 198, 219, 223, 231, 249, 300, 331; as art center, 64-65; growth of, 43; *The Reviewer,* 115; *Southern Literary Messenger,* 78-79, 219; Valentine Museum, 76; Virginia Museum (first), 64-65; Virginia Museum of Fine Arts, 114, 128. *See also* Virginia.

Rinck, Adolph D., 75.

Rivers, Larry, 145, 158-59, 318; *The Last Civil War Veteran* (cat. no. 151), 145, 158-59, 318, *319.*

Roanoke Island (early N. C. settlement), 7-8.

Robert Carter, "Councillor" (Thomas Hudson; fig. 15), *24,* 25.

Roberts, Bishop, 22-23, 178; *Prospect of Charles Town* (cat. no. 16), 22, 178, *178.*

Roberts, Mary, 22, 23, 178, 181; *Charles Pinckney* (cat. no. 19), 22, 181, *181.*

Robinson, Boardman, 120, 292.

Rococo style in painting: as practiced by Southern artists, 27, 28, 30, 47; introduction into the Colonies of, 18, 25.

Roehrict, Wolf, 342.
Romantic style in painting, 43, 44, 50, 59, 67.
Roosevelt, Franklin D., 118, 119, 287.
Roosevelt, Theodore, 107, 112, 280.
Rosen, Charles, 304.
Rothko, Mark, 328.
Royal Academy, London, 30, 46, 51, 59, 188, 201, 205.
Ruckle, Thomas, 59.

Sage, Esther, 33, 186.
Saint-Mémin, Charles B.J.F. de, 48, 50, 56, 203; *Harriet Rogers* (cat. no. 42), 50, 203, *203*; *Mary Abigale Coale* (cat. no. 41), 50, 203, *203*.
Salons, of the French Academy, 55, 75, 93, 226, 233, 272.
Salzburgers, 16, 19.
San Antonio Art League, 107.
Sanbourne, Thomas, 65.
Sargent, John Singer, 112, 280.
Savannah, Georgia, development of art in. *See* Georgia.
Savannah Street Corner (Alexander Brook; cat. no. 134), 297-98, *298*.
Savage, Edward, 47, 214.
Scarborough, William Henry, 76.
Scheffer, Ary (portrait of Marquis de Lafayette), 67.
Schroeder, C., 64.
Sebron, Hippolyte, 82; *Giant Steamboats at New Orleans* (cat. no. 71), 82, 235, *235*.
Shannon, Charles, 126, 127, 294; *The Lover* (cat. no. 130), 126, 294, *294*.
Sharecroppers (Marie Hull; cat. no. 131), 121, 295, *295*.
Sharples, Felix Thomas, 48, 50.
Shaw, Joshua, 59.
Sherard, William, 13.
Shirlaw, Walter, 263.
Shooting of Huey Long, The (John McCrady), 121.
Silva, William Posey, 99, 272; *Georgia Pines at Sunset* (cat. no. 108), 99, 272, *272*.
Slow Fall (Robert Rauschenberg; fig. 61), 159-60, *159*.
Smith, Alice Ravenel Huger, 114, 293; *The Pinelands* (cat. no. 129), 114, 293, *293*.
Smith, Marshall, 93, 260, 294; *Bayou Farm* (cat. no. 98), 93, 260, *260*.
Society for Promoting Christian Knowledge, 16, 17.
Solomon, Syd, 153-54, 332; *Tripeast* (cat. no. 163), 153-54, 332, *332*.
Sotta, L., 75, 233; *Mrs. Leonard Wiltz* (cat. no. 68), 73, 233, *233*.
South Carolina Academy of the Fine Arts. *See* Charleston, S.C.
South Carolina: art and artists in, 13, 14, 25, 50, 59, 76, 77, 96, 177, 185, 227, 299, 328; Columbia, 220; early portraiture in, 10-12, 13; early settlement of, 6, 16, 19, 169, 185, 320. *See also* Charleston.
Southeastern Arts Association, 121.
Southern Literary Messenger, The. See Richmond.
Southern Magazine, The, 87.
Southern States Art League. *See* New Orleans.
Speight, Francis, 131, 307; *Demolition of Avoca* (fig. 43, cat. no. 143), *104*, 131, 307, *307*.
Spottswood, Alexander (portrait of, by Charles Bridges), 18.
Spring Earth (George Cress; fig. 53), 137, *137*.
Spring Hill, Alabama (Richard Clague; cat. no. 80), 93, 244, *245*.
Springtime in Alabama (Anne Goldthwaite; cat. no. 127), 110, 291, *291*.
Spruce, Everett, 123, 296; *Arkansas Landscape* (cat. no. 132), 123, 296, *296*.
Stein, Gertrude, 110.

Stevens, Will Henry, 134, 136, 300; *Abstraction* (cat. no. 136), 134, 300, *300*.
Stieglitz, Alfred, 115.
Still, Clyfford, 137, 341.
Still Life: Basket of Cherries (Willie M. Chambers; fig. 41, cat. no. 106), 94-96, *95*, 268, *268*.
Still-Life of Watermelon and Grapes (Sarah Miriam Peale; fig. 32, cat. no. 48), 61, *62*, 209, *209*.
Still-life painting, 43, 61, 67, 94-96, 209, 266, 268; European influence on, 259.
Stith, Elizabeth (portrait of, by William Dering), 23.
Stockfleth, Julius, 96, 269; *The T. J. Gallagher Dairy, Galveston* (cat. no. 107), 96, 269, *269*.
Strother, David Hunter, 80.
Stuart, Gilbert, 44, 46, 47, 48, 61, 63, 66, 214, 217, 223, 231.
Studio (Jasper Johns; cat. no. 152), 149, 156, 320, *320*.
Submarine Torpedo Boat H. L. Hunley, Dec. 6, 1863 (Conrad Wise Chapman; cat. no. 84), 87, 246, *248*.
Sully, Lawrence, 64.
Sully, Thomas, 44-46, 47, 53, 55, 61, 63, 64, 65, 210, 214, 217, 223; *Portrait of Conway Robinson* (cat. no. 60), 46, *222*, 223; *The Passage of the Delaware by the American Troops under the Command of General Washington*, 47, 55, 65.
Sunday Morning in Virginia (Winslow Homer; cat. no. 92), 90, 91, 253-54, *255*.
Sunset Landscape (William Gilbert Gaul; cat. no. 105), 104, 267, *267*.
Surrealism, 160-61, 336.
Swinger in Summer Shade (Maud Gatewood; cat. no. 171), 158, 340, *340*.
Symbolism, 106, 276.
Symbols (Benny Andrews; cat. no. 156), 158-59, 325, *324-25*.
Synchromism, 116.

Tallulah Falls (George Cooke; cat. no. 57), 60, *218*, 219.
Tamayo, Rufino, 294.
Tanner, Henry O., 299.
Tate, Allen, 115, 119.
Temptation (Russ Warren; fig. 62, cat. no. 169), 160-61, *160*, 338, *338*.
Tennessee: art and artists in, 46-47, 61, 67, 78, 86, 98, 106, 124, 213, 239, 250, 262, 267; Chattanooga, 80, 115-16, 137, 239, 272, 284; Fisk University, Nashville, 124, 126, 283; Memphis, 308; Nashville, 76, 78, 106, 114, 213, 227, 236, 267, 283; Nashville, growth of, 43; *The New South*, 115-16; Tennessee Arts Council.
Texas, art and artists in, 107, 123, 252, 282, 296, 305, 338; Dallas, 123, 263; Galveston, 96, 269; immigration of German artists to, 96; The Nine, 296; San Antonio, 96, 107, 263, 289; San Antonio Art League, 107.
Theüs, Jeremiah, 18-19, 26, 28, 36, 185; *Colonel Barnard Elliott* (fig. 13), 19, *21*; *Daniel Ravenel II of Wantoot* (cat. no. 23), 19, *184*, 185; *Martha Vinson* (cat. no. 24), 19, 185, *185*; *Mrs. Barnard Elliott* (fig. 12), 19, *20*.
Thira (William Melton Halsey; cat. no. 148), 154, 314, *315*.
Thomas, Howard, 149, 152, 323; *Festival Mountain* (cat. no. 155), 152, 323, *323*.
Thompson, Cephas, 54-55, 64, 74; *James Miles with his Son and Young Daughter*, 54.
Thorpe, Thomas Bangs, 94.
Tilyard, Philip, 44, 61, 63, 210; *Jonathan Granville* (cat. no. 49), 63, 210, *210*.
T. J. Gallagher Dairy, Galveston, The (Julius Stockfleth; cat. no. 107), 96, 269, *269*.
Toluidine Red (Richard Kevorkian; fig. 59, cat.

no. 162), 154-55, *155*, 331, *331*.
Toms, Peter, 26.
Transylvania College, 46.
Trapper's Cabin (Richard Clague; cat. no. 79), 93, 244, *244*.
Traylor, Bill, 127.
Tripeast (Syd Solomon; cat. no. 163), 154, 332, *332*.
Trott, Benjamin, 53, 65, 66.
Troye, Edward, xvi, 78, 86, 227-28; *Bay Maria and Foal, Cornelia* (cat. no. 63), 227-28, *228*; *Captain Willa Viley's Richard Singleton, with Viley's Harry, Charles and Lew* (cat. no. 62), 227-28, *227*.
Trucking Cotton and Cutting Sugar Cane (Conrad A. Albrizio; cat. no. 121), 118, 285, *286*.
Trumbull, John, 44, 48, 64, 65, 213, 217; *General George Washington* (fig. 28), 48, *49*.
Tucker, Joshua, 60.
Turner, J.M.W., 257.
Turpin, Baron, de, 80.
Turtle, (William Bartram; fig. 23), 36.

Untitled *(Adobe)* (Josef Albers; fig. 52, cat. no. 149), 135, *135*, 151, 316, *316*.
Urlsperger, Samuel, 16.

Vallée, Jean François de, 53.
Vanderbilt, William K., 112, 280.
Vanderlyn, John, 44, 64, 65, 66; *Palace and Garden of Versailles*, 65.
Vaudechamp, Jean Joseph, 74, 75, 226, 233; *A Creole Lady* (cat. no. 61), 75, 226, *226*.
Verner, Elizabeth O'Neill, 314.
View of Baltimore from Beech Hill (Thomas Doughty), 59.
View of Baltimore from Howard's Park (George Beck; fig. 31, cat. no. 32), 58, 59, 195, *195*.
View of Charleston (Thomas Leitch; fig. 14), 22, *22*.
View of Galveston Harbor (William Aiken Walker; cat. no. 89), 96-97, 252, *252*.
View of Mount Vernon Looking to the North (Benjamin Henry Latrobe, cat. no. 33), *196*, 197.
View of Mount Vernon Looking towards the Southwest (Benjamin Henry Latrobe; cat. no. 33), 196, 197.
View of New Orleans Taken from the Plantation of Marigny, A (John L. Boqueta de Woiseri), 60.
View of the St. John's River, Florida Sunset (William Morris Hunt; cat. no. 88), 97, 251, *251*.
Virginia, art and artists in, 8, 9, 10, 12-13, 14, 18, 23, 25, 26, 27, 28-30, 48, 50, 53, 54, 55, 59, 60, 61, 86, 87, 90-91, 94, 98, 112-13, 128, 174, 176, 178, 183, 187, 190, 197, 198, 199, 227, 229, 231, 236, 246, 249, 250, 253, 260, 262, 264, 278, 280, 289, 300, 303, 305, 313, 330, 335, 340; Alexandria, 55, 81, 86, 201; Fredericksburg, 256; Lynchburg, 94, 236; Norfolk, 33, 34, 46, 56, 186, 203; Petersburg, 60, 64, 88, 236, 252-53, 256; Warrenton, 55, 201; Winchester, 53, 55, 201; Williamsburg, 13, 17-18, 23, 178, 181. *See also* Richmond.
Virginia landscape: articles describing scenery of, 78-79; the landscape as catalyst for abstract paintings, 152-53, 156, 313. *See also* Landscape painting.
Virginia Landscape (Arshile Gorky; cat. no. 146), 156, *312*, 313.
Virginia Museum. *See* Richmond.
Virginia Site (Kenneth Noland; fig. 55), *144*, 152-53.
Virginny Breakdown, A (John Adams Elder; fig. 39, cat. no. 93), 89, 256, *256*.
Visit from the Old Mistress, A (Winslow Homer; cat. no. 90), 90, 91, 253-54, *253*.
Vonnoh, Robert W., 121, 295.

Von Reck, Philip Georg Friedrich, 7, 14-17, 18-19; *Kipahalgwa*, 17; *Water Snake, Chestnut, Alligator* (fig. 11), 17.

Von Smith, Augustus, 78, 230; *Oakland House and Race Course, Louisville, Kentucky* (with Robert Brammer) (cat. no. 65), 78, 230, 230.

Wagener, Peter, 13, 65, 66.

Waldo, Samuel, 65, 66.

Walker, William Aiken, xvi, 96-97, 244, 252; *View of Galveston Harbor* (cat. no. 89), 96-97, 252, 252.

Ward, Jacob O., 80.

Warrell, James, 64, 65.

Warren, Robert Penn, 115, 290.

Warren, Russ, 160-61, 338; *Temptation* (fig. 62; cat. no. 169), 160-61, 160, 338, 338.

Washington Allston (Edward Greene Malbone; fig. 29), 51, 51.

Washington, D.C., art and artists in, 50, 54, 55, 56-57, 59, 60, 63, 64, 79, 81, 85, 98, 197, 199, 203, 206, 208, 213, 214, 219, 223, 236, 240, 241, 249, 259, 262, 272, 304, 317; growth of, 43; Howard University, 124; Indian Gallery, 56-57, 64; Society of Washington Artists, 272.

Washington, George, 47, 48, 50, 205.

Washington, William D., 87, 249; *The Burial of Latane* (cat. no. 86), 87, 249, 249.

Water Snake, Chestnut, Alligator (Philip Georg Friedrich Von Reck; fig. 11), 17.

Way, Andrew John Henry, 94, 259; *A Bunch of Black Grapes* (cat. no. 97), 94, 259, 259.

Weaver, Richard M., 106, 150.

Weinedel, Charles, 65.

Weir, Julian Alden, 109.

Weir, Robert, 64.

West, Benjamin, 30, 36, 46, 51, 56, 59, 61, 183, 190, 201, 213, 214, 217, 220, 223.

West, William Edward, 46, 66, 67, 76; *Portrait of Robert E. Lee in the Dress Uniform of a Lieutenant of Engineers, United States Army* (fig. 34), 76, 77.

Where the Southern Cross the Yellow Dog (Carroll Cloar; cat. no. 144), 131, 308, 308.

Whiskey Still by Moonlight (Andrew W. Melrose; cat. no. 96), 94, 258, 258.

White, John, xvi, 5, 7-8; *Indians Dancing Around a Circle Pole* (fig. 7), 5; *Indians Fishing* (fig. 6), 4.

White, John Blake, 56, 59, 65, 81-82, 220; *The Arrival of the Mail* (Cat. no. 58), 56, 220, 220; *General Marion Inviting a British Officer to Dinner*, 81.

Wightman, Thomas, 94.

Wightman, William, 94.

William Bowles and the Creek Indians (artist unidentified; fig. 24, cat. no. 40), 42, 57, 202, 202.

William Brodnax I (Jaquelin-Brodnax Limner; cat. no. 8), 12, 174, 174.

William H. Brodnax (Jaquelin-Brodnax Limner; cat. no. 10), 12, 174, 175.

William Smith and His Grandson (Charles Willson Peale, fig. 3, cat. no. 30), xii, 30-33, 190, 191.

Williams, William Joseph, 48-50, 65; *George Washington in Masonic Regalia* (fig. 27), 48-50, 48.

Wilson, Richard, 183.

Winged Earth, St. John's Mountain (Ray Kass; fig. 57, cat. no. 166), 149, 149, 154, 335, 335.

Winged Fork (Victor Faccinto; cat. no. 165), 160, 334, 334.

Winter in Southern Louisiana (Ellsworth Woodward; cat. no. 112), 107, 277, 277.

With the Confederate Colors (William Gilbert Gaul), 267.

Wollaston, John, 25-26, 27, 28, 36, 61, 183; *George Whitefield in the Attitude of Preaching*, 26; *Mrs. Anthony Walke* (cat. no. 22), 26, 183, 183; *Portrait of Colonel William Randolph II*, 26; *Portrait of James Monk*, 26.

Women artists in the South, 109, 110; Mary Renessier Beck, 66, 195; Willie M. Chambers, 94-96, 268; Kate Freeman Clark, 110; Josephine Crawford, 110, 136; Zelda Sayre Fitzgerald, 111, 302; Maud Gatewood, 158, 340; Anne Goldthwaite, 109, 110, 119, 291; Marie Hull, 121, 295; Henrietta Johnston, 10-12, 23, 173; Ida Kohlmeyer, 153-54, 328; Edith London, 153, 154, 342; Corinne Lawton Mackall, 112; Louisa Marling, 65; Clara Weaver Parrish, 109, 110, 273; Anna Claypoole Peale, 150, 207; Sarah Miriam Peale, 61, 209; Mary Roberts, 22, 23, 178, 181; Esther Sage, 33, 186; Alice Ravenel Huger Smith, 114, 293; L. Sotta, 75, 233; Louisa Heuser Wueste, 96.

Wood, Joseph, 64.

Woodward, Ellsworth, 107, 109, 118, 277; *Winter in Southern Louisiana* (cat. no. 112), 109, 277, 277.

Woodward, William, 107, 109, 112, 118, 121, 274; *Old Mattress Factory* (cat. no. 110), 109, 274, 275.

Works Progress Administration (WPA), 118, 119, 121, 124, 288, 290, 299, 303, 306, 313, 314.

World War II, 127.

Wright, Thomas Jefferson, 66.

Wueste, Louisa Heuser, 96.

Zadkine, Ossip, 317.

This catalogue was produced by the Publications Department, Virginia Museum, Richmond, Virginia. Printed by Whittet & Shepperson, Richmond. The type is Goudy Old Style, set by Coghill Composition Company, Richmond; headline type is Lubalin Bold and Medium, set by 'Typographic Service, Philadelphia. Paper is Zanders Ikonorex, 90 lb; cover is Carolina Coated, 18 pt. Designed by Raymond Geary, Virginia Museum; assisted by the Office of Graphic Communications, Commonwealth of Virginia.